EARLY NETHERLANDISH PAINTING

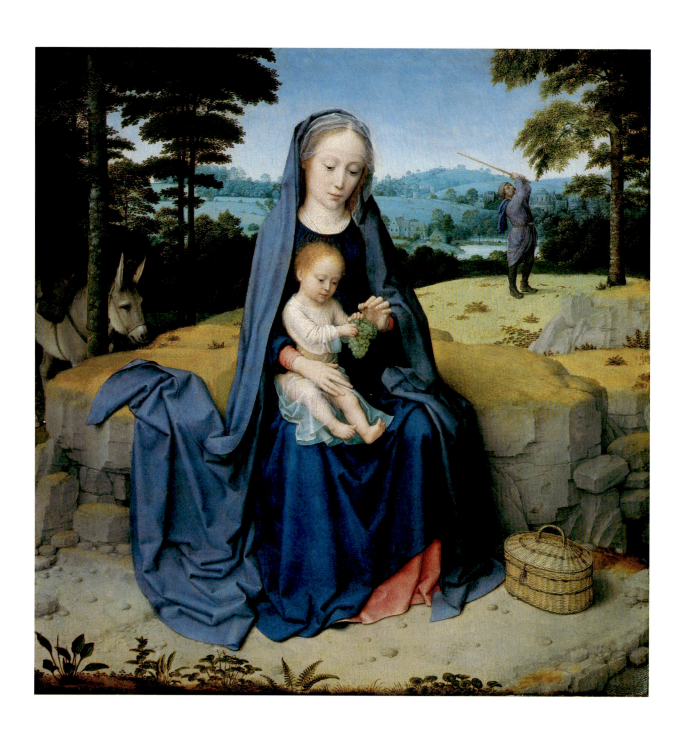

THE COLLECTIONS OF THE

NATIONAL GALLERY OF ART

SYSTEMATIC CATALOGUE

Early Netherlandish Painting

JOHN OLIVER HAND

MARTHA WOLFF

NATIONAL GALLERY OF ART · WASHINGTON

CAMBRIDGE UNIVERSITY PRESS

Edited by Mary Yakush.
Designed by Klaus Gemming, New Haven, Connecticut.
Typeset in Linoterm Sabon
by Meriden-Stinehour Press, Lunenburg, Vermont.
Printed by Rembrandt Press Inc., Milford, Connecticut,
on Quintessence Dull 80 lb. Text.
Color separations by Gamma One Inc., North Haven, Connecticut.
Bound by Meriden-Stinehour Press, Lunenburg, Vermont.

COVER: Jan Gossaert, *Portrait of a Merchant*, 1967.4.1
FRONTISPIECE: Gerard David, *The Rest on the Flight into Egypt*, 1937.1.43

LIBRARY OF CONGRESS CATALOGING-IN-PUBLICATION DATA
National Gallery of Art (U.S.)
Early Netherlandish painting.
(The Collections of the National Gallery of Art: systematic catalogue)
Includes bibliographies and indexes.
1. Panel painting, Flemish—Catalogs. 2. Panel painting,
Dutch—Catalogs. 3. Panel painting—15th century—Flanders—
Catalogs. 4. Panel painting—16th century—Flanders—Catalogs.
5. Panel painting—Washington (D.C.)—Catalogs. 6. National
Gallery of Art (U.S.)—Catalogs. I. Hand, John Oliver, 1941–
II. Wolff, Martha. III. Title. IV. Series: National Gallery of Art
(U.S.). Collections of the National Gallery of Art.
ND635.N37 1986 759.9492'074'0153 86–12418
ISBN 0–894–68093–5 (paper)
ISBN 0–521–34016–0 (cloth)

Printed in the United States of America

Contents

Preface

With this catalogue of the early Netherlandish paintings in the National Gallery of Art, we inaugurate a projected series of more than two dozen volumes fully cataloguing the Gallery's holdings of painting, sculpture, photographs, and decorative arts. Since the Gallery first opened its doors in 1941, information on the collection has been available in the form of preliminary catalogues, summary catalogues, in several detailed volumes on aspects of the Kress collection, and in the catalogue of Italian paintings produced by the late Fern Rusk Shapley. However, as a national museum, we have a responsibility toward both the inquiring general visitor and the community of specialized scholars in art history to provide the most complete description and interpretation of our extraordinary holdings. The series begun with this volume is written by Gallery curators and, in those fields for which there are no staff curators, by leading outside authorities, and thus takes into account the issues and methodologies unique to each field.

It is fitting that the series of National Gallery catalogues should begin with Netherlandish painting of the fifteenth and sixteenth centuries. Although the Gallery is a relatively young institution, to a large extent, its holdings reflect American collecting impulses and opportunities of the late nineteenth and early twentieth centuries. This is the period when the great Mellon and Widener collections were formed, and a period when the craftsmanship and elegant serenity of early Neth-

erlandish painting were much sought after. Subsequent gifts, notably those of Samuel H. Kress and the Samuel H. Kress Foundation, as well as purchases, many made possible by the Ailsa Mellon Bruce Fund, have added greatly to the breadth of the collection in this area. At the same time scholarship in this field has taught us much about the complex levels of meaning of these paintings, the diverse personalities who painted and commissioned them, and the functions they served in an emerging modern society.

On a completely personal level, it is also fitting that the early Netherlandish paintings should be the first. My love for this school came early on in life, after a trip through the low countries with my very knowledgeable parents, and it has stayed with me ever since. How could anyone be insensitive to the matchless beauty of Rogier van der Weyden's *Portrait of a Lady*, Jan van Eyck's *Annunciation*, or Gerard David's *The Rest on the Flight into Egypt*?

For all we have learned and continue to learn about the art of this period, scholars and lovers of art are drawn again and again to the sheer beauty of these paintings, which first captivated Andrew Mellon. We hope that this catalogue will make a permanent contribution to what is known about these and their sister paintings in the nation's gallery.

J. Carter Brown
Director

Acknowledgments

During the almost five years of preparation of this catalogue, we have benefited immeasurably from the support, advice, and stimulating conversation of our colleagues. While many of these contributions have been acknowledged at the appropriate place in the text, other more broad-ranging contributions were almost in the nature of collaborations. Colin Eisler's monumental catalogue of the non-Italian paintings of the Kress collection provided a basis for our work on these paintings, substantially lessening our task. He also very graciously made his working notes and correspondence available to us. The past and present members of the Gallery's conservation department, including Carol Christensen, Sarah Fisher, Beatrix Graf, Ann Hoenigswald, Ross Merrill, Barbara Miller, and Kay Silberfeld, were essential to the preparation of the catalogue, through their detailed examination reports, which formed the basis for the technical notes, and through their patience with our repeated questions. Molly Faries of Indiana University, who spent several months as a senior fellow at the Center for Advanced Study in the Visual Arts scanning and documenting the early Netherlandish and German paintings at the Gallery with infrared reflectography, was our enthusiastic guide through the intricacies of the study of underdrawing, and provided much additional information and encouragement. Josef Bauch and Peter Klein of the Institut für Holzbiologie, Universität Hamburg, undertook the dendrochronological examination of the panels. Both Molly Faries and Peter Klein have contributed appendices on these aspects of the Gallery's paintings, which expand the catalogue's usefulness. We also benefited greatly from conversations with Maryan Ainsworth in relation to her study of the paintings by Gerard David, Hans Memling, and Juan de Flandes at the Metropolitan Museum as well as with J. R. J. van Asperen de Boer and with Roger van Schoute. We are particularly grateful to these colleagues for their enthusiasm and willingness to share the results they have obtained in some of the most exciting new research on early Netherlandish paintings.

We wish to thank the staffs of the many museums that we visited in Europe and America. They were unfailingly helpful in making the works in their care available to us and in answering our questions. Micheline Comblen-Sonkes and the staff of the Centre des recherches primitifs flamands in Brussels and the staff of the Rijksbureau voor Kunsthistorisch Documentatie in The Hague, particularly Gerbrand Kotting, made us feel at home in their respective institutions.

Various departments of the Gallery had a large part to play in the research and production of the catalogue. We would like to thank Thomas McGill and Julia Wisniewski, speedy inter-library loan librarians, Ruth Philbrick and the staff of the Photo Archive, the art handlers headed by John Poliszuk and Andrew Krieger, who safely and patiently moved paintings back and forth for examination and treatment, and Richard Amt and the staff of the photography department, who cheerfully produced an array of excellent photographs. Special thanks go to the following summer interns who enthusiastically participated in our research: Anthony Colantuono, Lynn Jacobs, Jennifer Kilian, Harry Mergler, and Rachel Cropsey Simons. Our deep gratitude goes to the departmental secretaries who typed the manuscript, enduring numerous revisions: Marion Diffenderfer, Deborah Gómez, Samantha Johnston, Sara Morris, and Grace Nelson.

The catalogue was much improved by the comments of Sydney Freedberg, who read the text through in its early stages. We are deeply indebted to Suzannah Fabing, coordinator of the catalogue project, and to Lorne Campbell and Egbert Haverkamp-Begemann for further critical readings of the text and for comments on structure and content that made the task of revision much less arduous. It was a pleasure to work on the production aspects of the catalogue with Frances Smyth, editor-in-chief. Mary Yakush's careful editing, Melanie Ness' supervision of the production, and Klaus Gemming's thoughtful design smoothed the way for this first volume of the Gallery's systematic catalogue series.

Introduction and Notes to the Reader

This volume contains entries for those paintings in the National Gallery that were produced in the fifteenth and sixteenth centuries by artists from the Netherlands, a region corresponding roughly to present-day Holland, Belgium, Luxembourg, and parts of northern France. The art created in this region is usually termed early Netherlandish or Netherlandish, while the designations Dutch and Flemish are generally reserved for works of the seventeenth and succeeding centuries.

The domination of the Netherlands by the dukes of Burgundy, a cadet line of the Valois kings of France, began in 1369 when Philip the Bold married Margaret, daughter of the last count of Flanders, Louis de Mâle, and upon Louis' death in 1384 came into Flemish territories. The Burgundian duke's shrewd policy of aggrandizement continued under his heirs, especially Philip the Good, who added several provinces and established a secure government. The defeat and death of Charles the Bold at the Battle of Nancy in 1477 ended the ties of the ruling family of the Netherlands to the Burgundian territories. Subsequently, through the marriage of Charles' only child, Mary of Burgundy, to Maximilian of Habsburg, the affairs of the Netherlands became part of larger dynastic concerns of the imperial family, whose territories came to include Spain and large portions of the New World as well as the Holy Roman Empire. While Charles V attempted to oversee his far-flung empire, the Netherlands were ably governed by his aunt, Margaret of Austria. She was succeeded by Charles' sister, Mary of Hungary, who in turn was followed by Margaret of Parma, his illegitimate daughter. The last quarter of the sixteenth century saw increasing resistance to the Catholic, pro-Spanish, and autocratic policies of Philip II, son of Charles V. Resistance quickly turned into full revolt. The fall of Antwerp to Spanish troops in 1585 effectively marked the partition of the Netherlands into a Protestant north and a Catholic south.

The relatively small size of the Netherlands belied its economic dynamism and cultural vitality. The region produced a school of painting that was considered the equal of the Italian school. Early Netherlandish pictures have always been emulated by other artists, admired for their appeal to the eye and to the mind, and enthusiastically collected.

The collecting of early Netherlandish painting in the United States did not really begin until the late nineteenth century. One of the earliest acquisitions was the purchase in 1889 of Rogier van der Weyden's *Saint Luke Painting the Virgin* by Henry Lee Higginson, who gave it in 1893 to the Museum of Fine Arts, Boston. The late nineteenth and early twentieth centuries saw the formation of several private collections that became the nuclei of museum collections in such cities as Detroit, Philadelphia, and New York.

The bulk of the Gallery's collection of early Netherlandish painting was given by Andrew W. Mellon and by Samuel H. Kress and the Samuel H. Kress Foundation. Andrew Mellon's 1937 bequest to the nation included ten early Netherlandish paintings, mostly from the fifteenth century and of the highest level of quality. The Kress donation included twenty-four paintings, two groups given in 1952 and 1961 and a single panel given in 1959. It is more diverse, including outstanding examples of important trends in the sixteenth century. During the 1960s and 1970s, thanks to the funds provided by Ailsa Mellon Bruce, the Gallery added eight first-rate early Netherlandish pictures to its holdings. Donations by individuals have also played an important role in enriching the collection. The Gallery has indeed been fortunate to be the recipient of such gifts as the *Madonna and Child* by Jan Gossaert, given in 1981 by Grace Vogel Aldworth in memory of her grandparents Ralph and Mary Booth, who were themselves distinguished collectors and patrons.

A list of changes of attribution is included at the end of the catalogue. In the case of *The Rest on the Flight into Egypt*, 1961.9.36, close study of the artistic personalities of Scorel and Heemskerck by several scholars makes it possible to recognize this painting, traditionally given to Scorel, as an early work by Heemskerck. In most cases, however, changes of attribution reflect an attempt to describe more precisely the complex activity of artists' workshops in this period. Growing understanding of workshop practice and of variations on transmitted models will in the future lead to a more specific characterization of artists in the train of Campin, Van der Weyden, Memling, and others. In this task, methods of investigation of early Nether-

landish paintings as physical objects, notably infrared reflectography and dendrochronology, provide important new information. This catalogue incorporates the results of examination using these methods, made possible through the participation of Molly Faries and of Peter Klein and Josef Bauch, respectively, together with more conventional laboratory examination. This is probably the first museum catalogue to contain the results of infrared reflectography and dendrochronology (see appendices I and II), results that we hope will increase in usefulness as more comparative material from other collections becomes available.

Iconography continues to be a prime focus of research for historians of early Netherlandish painting. Here, however, a growing understanding of the complexity of the milieu in which the work of art was created leads to greater awareness of the limitations of iconographic analysis. To understand patterns of iconographic meaning or the often multiple meanings of a single object, the art historian must increasingly attempt to comprehend the context in which the work of art was created. In comparison to our colleagues studying Italian art of the same period, the historians of early Netherlandish painting have fewer documents at their disposal, and surviving documents are often not accompanied by extant paintings. This increases the importance of understanding the social, economic, and religious ambience of a painting. To a large extent the task of this catalogue has been to ask questions about the context in which the individual work of art functioned, its original appearance, and how it was understood in its own time. We hope that in so doing we point to fruitful directions for future investigations.

Entries are arranged alphabetically by artist. Each named artist is given a short biography and bibliography, with individual entries following in order of acquisition. Anonymous artists are also incorporated alphabetically under appropriate designations such as Antwerp Artist, Franco-Flemish Artist, or the Master of Frankfurt. In 1983, the Gallery assigned new accession numbers by year of acquisition; these are followed by the old number in parentheses.

The following attribution terms are used to indicate the nature of the relationship to a named artist:

Studio of, Workshop of: Produced in the named artist's workshop or studio, by students or assistants, possibly with some participation by the named artist. It is important that the creative concept is by the named artist and that the work was meant to leave the studio as his.

Follower of: An unknown artist working specifically in the style of the named artist, who may or may not have been trained by the named artist.

After: A copy of any date.

Imitator of: Someone working in the style of an artist with the intention to deceive.

School: Indicates a geographical distinction only and is used where it is impossible to designate a specific artist, his studio or following.

We have used the designation north Netherlandish for works produced in the provinces of present-day Holland. The following conventions for dates are used:

1575	executed in 1575
c. 1575	executed sometime around 1575
1575–1580	begun in 1575, completed in 1580
1575/1580	executed sometime between 1575 and 1580
c. 1575/1580	executed sometime around the period 1575–1580

Dimensions are given in centimeters, height preceding width, followed by the dimensions in inches in parentheses. Left and right refer to the viewer's left and right unless the context clearly indicates the contrary. Since, with rare exceptions, no paint samples were taken, the paint medium has not been analyzed. However, it is assumed that the medium corresponds to what is generally understood to be Netherlandish oil technique. The support of panels is described as oak only when examination by a wood expert determined that this was the case. In some instances the way in which a panel was cradled or marouflaged, or other circumstances, prevented a positive determination, though the support may well be oak. In the provenance section parentheses indicate a dealer, auction house, or agent. In the list of references we have attempted to be inclusive, but have omitted publication in picture books. Sales and exhibition catalogues cited in the provenance and exhibition sections are not repeated in the list of references. A list of standard abbreviations used throughout the volume follows.

J. O. H. AND M. W.

Abbreviations for frequently cited periodicals

AA	L'Art et les Artistes
AB	The Art Bulletin
AEA	Archivo Español de Arte y Arqueologia; Archivo Español de Arte
AQ	The Art Quarterly
ArtN	Art News
ArtNA	Art News Annual
BCMA	Bulletin of the Cleveland Museum of Art
BInstPat	Bulletin de l'Institut royal du Patrimoine artistique
BMRBA	Bulletin des Musées Royaux des Beaux-Arts de Belgique
BSocHAF	Bulletin de la Société de l'Histoire de l'Art Français
BurlM	The Burlington Magazine
Conn	The Connoisseur
GBA	Gazette des Beaux-Arts
JbAntwerp	Jaarboek van het Koninklijk Museum voor Schone Kunsten Antwerpen
JbBerlin	Jahrbuch der königlich preussischen Kunstsammlungen; Jahrbuch der preussischen Kunstsammlungen; Jahrbuch der Berliner Museen
JbWien	Jahrbuch der kunsthistorischen Sammlungen des allerhöchsten Kaiserhauses; Jahrbuch der kunsthistorischen Sammlungen in Wien
JMMA	Journal of the Metropolitan Museum of Art
JWCI	Journal of the Warburg and Courtauld Institutes
MagArt	Magazine of Art
MünchnerJb	Münchner Jahrbuch der bildenden Kunst
NKJ	Nederlands Kunsthistorisch Jaarboek
OH	Oud-Holland
RAAM	Revue de l'Art Ancien et Moderne
RBAHA	Revue Belge d'Archéologie et d'Histoire de l'Art
RevArt	Revue de l'Art
RfK	Repertorium für Kunstwissenschaft
RLouvre	La Revue du Louvre et des Musées de France
StHist	Studies in the History of Art
ZfbK	Zeitschrift für bildende Kunst

Abbreviations for books

Cairns and Walker 1966

Cairns, Huntington, and John Walker, eds. *A Pageant of Painting from the National Gallery of Art.* 2 vols. New York, 1966.

Cuttler, *Northern Painting*

Cuttler, Charles D. *Northern Painting from Pucelle to Bruegel. Fourteenth, Fifteenth, and Sixteenth Centuries.* New York, 1968.

Eisler 1977

Eisler, Colin. *Paintings from the Samuel H. Kress Collection: European Schools Excluding Italian.* Oxford, 1977.

Friedländer

Friedländer, Max J. *Die altniederländishe Malerei.* 14 vols. Berlin and Leiden, 1924–1937. (English ed., *Early Netherlandish Painting.* 14 vols. in 16. Brussels and Leiden, 1967–1976.)

Kress 1951

National Gallery of Art. *Paintings and Sculpture from the Kress Collection Acquired by the Samuel H. Kress Foundation 1945–1951.* Intro. by John Walker, text by William E. Suida. Washington, 1951.

Kress 1956

National Gallery of Art. *Paintings and Sculpture from the Kress Collection Acquired by the Samuel H. Kress Foundation 1951–1956.* Intro. by John Walker, text by William E. Suida and Fern Rusk Shapley. Washington, 1956.

Kress 1959

National Gallery of Art. *Paintings and Sculpture from the Samuel H. Kress Collection.* Washington, 1959.

Mellon 1949

National Gallery of Art. *Paintings and Sculpture from the Mellon Collection.* Washington, 1949. Reprinted 1953 and 1958.

NGA 1941

National Gallery of Art. *Preliminary Catalogue of Paintings and Sculpture.* Washington, 1941.

NGA 1975

National Gallery of Art. *European Paintings: An Illustrated Summary Catalogue.* Washington, 1975.

Panofsky, *ENP*

Panofsky, Erwin. *Early Netherlandish Painting. Its Origins and Character.* Cambridge, Mass., 1953.

Réau, *Iconographie*

Réau, Louis. *Iconographie de l'art chrétien.* 3 vols. in 6. Paris, 1955–1959.

Ryan and Ripperger, *The Golden Legend*

Ryan, Granger, and Helmut Ripperger, trans. *The Golden Legend of Jacobus Voragine.* 2 vols. London, 1941.

Shapley 1979

Shapley, Fern Rusk. *Catalogue of the Italian Paintings, National Gallery of Art.* 2 vols. Washington, 1979.

Thieme-Becker

Thieme, Ulrich, and Felix Becker. *Allgemeines Lexikon der bildenden Künstler von der Antike bis zur Gegenwart.*

Leipzig, 1907–1950. Continuation by Hans Vollmer. *Allgemeines Lexikon der bildenden Künstler des xx. Jahrhunderts.* Leipzig, 1953–1962.

Thurston and Attwater, *Butler's Lives of the Saints*	Thurston, Herbert, and Donald Attwater. *Butler's Lives of the Saints.* 4 vols. New York, 1956.
Walker 1956	Walker, John. *National Gallery of Art, Washington.* New York, 1956.
Walker 1963	Walker, John. *National Gallery of Art, Washington.* New York, 1963.
Walker 1964	Walker, John. *The National Gallery, Washington.* London [1964].
Walker 1976	Walker, John. *National Gallery of Art, Washington.* New York [1976].
Widener 1913	*Pictures in the Collection of P. A. B. Widener at Lynnewood Hall, Elkins Park, Pennsylvania.* 3 vols. Philadelphia, 1913–1916. *Early German, Dutch and Flemish Schools.* Notes by W. R. Valentiner and C. Hofstede de Groot, 1913.
Widener 1935	*Inventory of the Objects d'Art at Lynnewood Hall, Elkins Park, Pennsylvania, The Estate of the Late P. A. B. Widener.* Philadelphia, 1935.
Widener 1942	National Gallery of Art. *Works of Art from the Widener Collection.* Foreword by David Finley and John Walker. Washington, 1942.
Widener 1948	National Gallery of Art. *Paintings and Sculpture from the Widener Collection.* Washington, 1948.

CATALOGUE

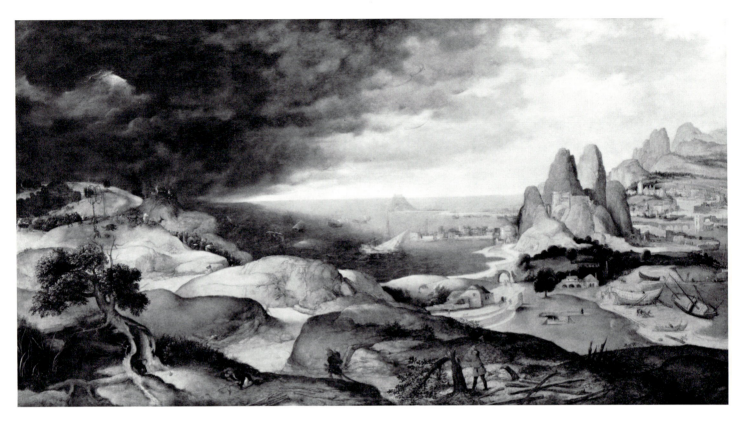

Antwerp Artist (Matthys Cock?), *The Martyrdom of Saint Catherine*, 1952.2.18

Antwerp Artist (Matthys Cock?)

1952.2.18 (1101)

The Martyrdom of Saint Catherine

c. 1540
Transferred from wood to plywood (cradled), 62.2 x 118.2
 (24¹/₂ x 46⁹/₁₆)
Samuel H. Kress Collection

Technical Notes: The transfer to plywood took place before 1936. According to Glück the original support was poplar. Sometime shortly after 1932 several figures in the foreground, which seem to have been later additions, were removed.[1] Fig. 1 shows the painting as it appeared before the alterations. It is likely that the painting was transferred at the same time. There are extensive, evenly scattered insect exit holes in the paint and ground layers and no sign in either of horizontal join lines. Poplar is more susceptible to insect damage and worm tunneling than oak and is more likely to exist as a single piece of wood the size of this painting. There are scattered losses of varying sizes throughout, but the actual extent of abrasion is difficult to gauge under the thick varnish. There are repainted losses in the upper and lower left corners and along the right and bottom edges. Extensive later glazes are found in the sky at the upper left and to a lesser extent in the upper right and in the foreground landscape. Underdrawing in what appears to be brown paint is visible with the naked eye. The only underdrawing revealed by infrared reflectography is in the mountain at the far right.

Provenance: (Van Dieman-Margraf Gallery, Berlin, by 1930.)[2] Karl Rösler, Germany and Holland, c. 1930.[3] (Van Diemen-Lilienfeld Galleries, New York, c. 1950.) Samuel H. Kress Foundation, New York, 1950.

Exhibitions: Antwerp, *Exposition d'Art flamand ancien,* 1930, no. 53, as Pieter Bruegel the Elder.

THE MARTYRDOM OF SAINT CATHERINE is of considerable importance in the history of landscape painting in the Netherlands, for it provides a link between two great masters, Joachim Patinir and Pieter Bruegel the Elder. When first exhibited it was attributed to Pieter Bruegel, but this was immediately contested by Michel, Glück, and de Tolnay.[4] Although Glück later recanted, publishing the picture as an early work by Bruegel of c. 1553–1554, and this attribution was accepted by the Gallery,[5] it never found widespread acceptance among Bruegel scholars.[6] A few authors felt that the painting might be the work of an artist working later than Pieter Bruegel, such as Lucas van Valckenborch or Jacob Grimmer.[7] The most satisfactory dating, however, is that put forward by Grossmann, for whom *The Martyrdom of Saint Catherine* represents the "stylistic phase between Patinir and Bruegel."[8] In 1976 the Gallery's attribution was changed to Antwerp Artist, c. 1540.

The Martyrdom of Saint Catherine is dependent on Joachim Patinir's painting of the same theme in the Kunsthistorisches Museum, Vienna (fig. 2).[9] Not only is the composition of the Gallery's painting with its horizontal format, fantastic rock formations, and view over a harbor based on Patinir's panel, so also are such details as the boats under construction, the fortified buildings, and the arched bridge over water. The differences are also important; in the Gallery's painting the horizon line is lower, the manner of painting is broader, and the ostensible subject, the attempted torture of Saint Catherine of Alexandria, has been moved from a position of prominence to a hilltop at the distant left.[10] Before he died in 1524 Joachim Patinir created a type of panoramic landscape that exercised a tremendous influence upon subsequent art in the Netherlands, particularly in Antwerp. *The Martyrdom of Saint Catherine* represents the next step in Patinir's continuing influence. The inclusion in the foreground of peasants[11] performing mundane activities such as chopping wood would not have occurred in Patinir's oeuvre and is indicative of the painting's later date. In this regard the picture presages the work of Pieter Bruegel the Elder. Bruegel's earliest generally accepted paintings, the panoramic landscapes of *Christ Appearing to the Apostles at the Sea of Tiberias,* 1553 (Charles de Pauw Collection, Wavre, Belgium), and *The Parable of the Sower,* 1557 (Timken Art Gallery, San Diego), grow out of the Patinir tradition and exhibit similarities to the Gallery's painting in such details as the tawny, sandy color of the foreground; the soft, almost malleable rocks; and, in the San Diego panel, the gathering storm clouds.[12]

It is not possible to identify with certainty the artist who painted *The Martyrdom of Saint Catherine.* Knowledge of landscape in the period between Patinir and Bruegel is still incomplete, partly as a result of a dearth of documented or dated landscape paintings. The most stimulating attribution builds upon the observation made in 1935 by de Tolnay that the rocks recall the drawings of Matthys Cock.[13] Grossmann

Fig. 1. *The Martyrdom of Saint Catherine*, 1952.2.18, before restoration [photo: NGA]

and Eisler have proposed Matthys Cock as the possible author of *The Martyrdom of Saint Catherine*.[14] Gibson and Riggs date the painting to the 1540s and associate it with both Matthys and Hieronymus Cock.[15] The attribution to Matthys merits serious attention.

Matthys Cock was born around 1509, the son of the Antwerp painter Jan de Cock and the elder brother of the artist, printer, and publisher Hieronymus Cock. Matthys presented a pupil to the guild in Antwerp in 1540 and died before 1548. Van Mander praises him as a landscape painter and it has been suggested, without definite proof, that he journeyed to Italy.[16] Although no paintings can be given to Matthys Cock with certainty,[17] there is a greater consensus of opinion in attributing drawings to him, and several drawings are dated. Comparison of *The Martyrdom of Saint Catherine* with such drawings as the *Landscape with Castle above a Harbor*, dated 1540 (National Gallery of Art, Washington) (fig. 3);[18] the *Coastal Scene*, dated 1540 (Victoria & Albert Museum, London);[19] the *Landscape with Rocky Island and Inlet* (Louvre),[20] and the *Calling of Saint Peter*, dated 1544 (British Museum, London),[21] reveals similarities in the conception of space, the composition, particularly in the Patinir-like juxtaposition of rocky structures to harbors and inlets, and perhaps most important in the peculiarities

of the rocks, which often have soft, rounded forms and appear to be made out of a doughlike material, as with the hills and rocks in the Gallery's painting.

I find the hypothesis that Matthys Cock was the author of *The Martyrdom of Saint Catherine* attractive and very useful, but must stop short of a definite attribution until a secure painting by Matthys can be found for comparison. I would suggest that Pieter Bruegel might have studied with Matthys Cock rather than with Pieter Coecke van Aelst as is traditionally believed.[22] Viewed in this light, the manner in which the Gallery's painting prefigures Bruegel's earliest landscapes is intriguing and significant.

J.O.H.

Notes

1. Glück 1936, no. 2, gives the support as plywood and cites the owner's statement that the painting was originally on poplar. The reproduction shows the picture with the extra figures removed. Michel 1932, 130, fig. 3, reproduces the painting with the figures present.

2. Eisler 1977, 92, and the 1930 Antwerp exhibition catalogue list the owner as Dr. Benedict; this refers to Curt Benedict who was with the Van Diemen–Margraf Gallery. I owe this information to Mrs. H. S. Schaeffer. The initial ownership of the painting by the Van Diemen-Margraf Gallery is verified in a letter of 27 January 1951 from Karl Lilienfeld to the Samuel H. Kress Foundation, in the curatorial files.

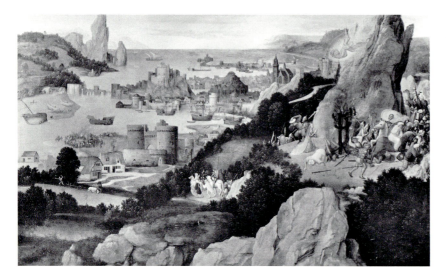

Fig. 2. Joachim Patinir, *The Martyrdom of Saint Catherine*, Vienna, Kunsthistorisches Museum [photo: Kunsthistorisches Museum]

3. A. B. de Vries, letter of 20 November 1952 to William Suida, in the curatorial files. Glück 1936, no. 2, and subsequent editions list the painting as being in a private collection, New York, but this is unverified.

4. Michel 1931, 75; Michel 1932, 74; Glück 1932, 93; de Tolnay 1935, 97.

5. Glück 1936, no. 2, and subsequent editions; Suida 1951, 202, and NGA 1975, 50, accept the attribution to Bruegel and a date of c. 1553–1554. In the curatorial files are opinions written on the backs of photographs from Max J. Friedländer, 17 November 1947, W. R. Valentiner, 28 June 1948, and Gustav Glück, 21 February 1948, accepting the early date and attribution to Bruegel.

6. *The Martyrdom of Saint Catherine* is not discussed or reproduced in: Friedländer, vol. 14 (1937); Gotthard Jedlicka, *Pieter Bruegel. Der Maler in seiner Zeit* (Erlenbach, 1938); Robert Genaille, *Bruegel l'Ancien* (Paris, 1953); Robert Delevoy, *Bruegel* (Geneva, 1959); Fritz Grossmann, *Pieter Bruegel. Complete Edition of the Paintings* (London, 1973; also 1955, 1966); and Wolfgang Stechow, *Pieter Bruegel the Elder* (New York, 1969). Bianconi 1967, 87, and Gandolfo 1968, 113, note the problematical nature and lack of support for the attribution.

7. Michel 1932, 132, thought that the painting might be by Lucas van Valckenborch. Gudlaugsson 1959, 129, n. 23, cites J. G. van Gelder's opinion that the picture is an early work by Valckenborch. Wied 1971, 137, does not comment or give an attribution except to say that it is not by the young Valckenborch. Glück 1932, 93, suggests Jacob Grimmer, whom he calls a follower of Matthys Cock.

8. Fritz Grossmann, letter of 25 January 1969 to Colin Eisler, in the curatorial files.

9. Koch 1968, 12, 15, 72, no. 4, figs. 67, 7. Koch places the painting among Patinir's earliest works, painted before 1515. See also Klaus Demus, et al., *Katalog der Gemäldegalerie. Flämische Malerei von Jan van Eyck bis Pieter Bruegel D. A.* (Vienna, 1981), 265–266, repro.

10. See Réau, *Iconographie*, vol. 3, part 1, 262–272; Thurston and Attwater, *Butler's Lives of the Saints*, 4: 420–421; Ryan and Ripperger, *The Golden Legend*, 2: 708–716. Eisler 1977, 91, suggests that the fiery hilltop to the right of the wheel refers to the martyrdom by fire of the fifty philosophers converted to Christianity by Catherine, though the area referred to by Eisler is occupied by a fortified building and no figures are visible. The martyrdom of the savants also figures in Patinir's Vienna painting, see Koch 1968, 25.

11. I tend to agree with Eisler 1977, 92, that the foreground peasants are slightly different in style from those in the background, but I am less convinced that they were possibly added by Jacob Grimmer.

12. See Grossmann, *Pieter Bruegel*, 190, nos. 18, 22, pls. 18, 22; Stechow, *Pieter Bruegel the Elder*, 18, fig. 7, 52, color pl. 1 (as in n. 6).

13. See above n. 4.

14. Fritz Grossmann, letter of 25 January 1969 to Colin Eisler; Eisler 1977, 91, attributes it to: Antwerp Master, active c. 1530 (Matthys Cock?).

15. Walter Gibson, letter of 16 April 1976 in the curatorial files, is inclined to see the painting as by an older Antwerp artist working in the 1540s, possibly in the circle of Matthys and Hieronymus Cock. Timothy Riggs, letter of 12 February 1974 in the curatorial files, sees connections with both artists in the landscape and finds that the style is not too advanced for the 1540s. There are no dated or documented paintings by Hieronymus Cock, and the secure drawings are neither dated before 1550 nor stylistically related to the Gal-

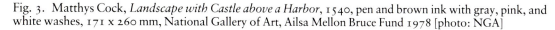

Fig. 3. Matthys Cock, *Landscape with Castle above a Harbor*, 1540, pen and brown ink with gray, pink, and white washes, 171 x 260 mm, National Gallery of Art, Ailsa Mellon Bruce Fund 1978 [photo: NGA]

lery's painting; see Timothy A. Riggs, *Hieronymus Cock. Printer and Publisher* (New York and London, 1977), 236–239, 307–308.

16. See Thieme-Becker 7 (1912), 145, s.v. Matthys Cock; Hanns Floerke, *Das Leben der niederländischen und deutschen Maler des Carel van Mander*, 2 vols. (Munich and Leipzig, 1906), 1: 248–251. There are no documents for a trip to Italy. However, An Zwollo, "De Landschaptekeningen van Cornelis Massys," *NKJ* 16 (1965), 44, sees in Matthys' late drawings an awareness of Venetian woodcuts from the circle of Titian and Campagnola. See also Giorgio T. Faggin, "Aspetti dell'influsso di Tiziano nei Paesi Bassi," *Arte Veneta* 18 (1964), 46–49.

17. Various paintings have been proposed, but there is no consensus of opinion. Ludwig Baldass, "Ein Landschaftsbild von Matthys Cock," *ZfbK* 61 (1927/1928), 90–96, gives to Matthys two paintings: *Christ Walking on the Water* (art market, Vienna), and *River Landscape* (National Gallery, London, no. 1298). Eisler 1977, 92, thinks it probable that the London painting is by Matthys. K. G. Boon, "De tekenaar van het Errera-Schetsboek," *BMRBA* 4 (1955), 224–225, also associated the painting with Matthys and with the drawings in the Errera Sketchbook in the Musées Royaux des Beaux-Arts, Brussels. See Martin Davies, *National Gallery Catalogues. Early Netherlandish School* (London, 1968), 141–143, no. 1298, where it is called probably Antwerp School and dated roughly between 1525 and 1550. It is, in my opinion, not by the same hand as the Gallery's painting, though it appears close in date and the sandy texture and light beige color in the rocks are similar. G. J. Hoogewerff, *De Noord-Nederlandsche Schilderkunst* (The Hague, 1936–1947), 3: 364, attributes the *Landscape with Saint Christopher* (Gendebien collection, Brussels) to Matthys partly on the basis of its similarity to a painting of the same theme then in the Bissing collection, Munich (now private collection, Germany), figs. 191, 190. Hoogewerff attributed the Bissing panel to Lucas Cornelisz., but it has also been given to Matthys' father, Jan de Cock, by Friedländer, vol. 11 (1974), no. 104, pl. 89, and by others. Not available to me was G. J. Hoogewerff, "Matthijs Wellens de Cock," *Feestbundel Prof. Dr. Willem Vogelsang* (Leiden, 1932) 31–35. Boon 1955, 220, fig. 4, believes that yet another *Landscape with Saint Christopher* (art market, Paris) is either by or a copy after Matthys. Fritz Grossmann, letter of 25 January 1969 in the curatorial files, found this attribution plausible.

18. 1978.19.2, Ailsa Mellon Bruce Fund 1978. See A. E. Popham, "Mr. Alfred Jowett's Collection of Drawings at Killinghall," *Apollo* 27 (1938), 137.

19. Thomas Muchall-Viebrook, "Matthys Cock (d. 1548). A Coast Scene," *Old Master Drawings* 6 (September 1931), 29–30, pl. 23.

20. See *Pieter Bruegel d. Ä. als Zeichner. Herkunft und Nachfolge* [exh. cat. Kupferstichkabinett, Staatliche Museen Preussischer Kulturbesitz] (Berlin, 1975), 113, no. 146, figs. 46–47.

21. See Riggs, *Hieronymus Cock*, 249–250, no. R-11, fig. 40 (as in n. 15); listed under drawings wrongly attributed to Hieronymus Cock. Riggs, 242–251, catalogues and briefly discusses several drawings given to Matthys Cock. In addition to the references cited in the notes above, for Matthys'

drawings see Wolfgang Stechow, "Matthys und Hieronymus Cock," *JbBerlin* 56 (1935), 74–79; Charles de Tolnay, "An Unknown Early Panel by Pieter Bruegel the Elder," *Scritti di Storia dell'Arte in Onore Lionello Venturi* (Rome, 1956), 1: 411–428.

22. Van Mander's biography states that Pieter Bruegel apprenticed with the Antwerp artist Pieter Coecke van Aelst, but several scholars, including Grossmann and Stechow, have pointed to a lack of documentary and stylistic evidence. Van Mander may have based his assumption on the fact that Bruegel married Coecke's daughter Mayken in 1563. See Floerke, *Carel van Mander*, 1: 254–262, esp. 254–255 (as in n. 16). Although we know that Bruegel was in contact with Hieronymus Cock by about 1555 and it is natural to assume that he would have known the art of Hieronymus' brother Matthys, Bruegel's activities in the 1540s, when Matthys was alive, are unknown to us. The idea that Matthys might have been the teacher of Pieter Bruegel the Elder has grown out of conversations with Timothy Riggs and Konrad Oberhuber. Since then Oberhuber has published this suggestion in "Des dessins de Pierre Bruegel l'Ancien," *Bruegel. Une dynastie de peintres* [exh. cat., Palais des Beaux-Arts] (Brussels, 1980), 60–61.

References

1931 Michel, Edouard. *Bruegel*. Paris: 75, pl. 46.

1932 Michel, Edouard. "Hypothèses sur quelques peintures flamandes à propos de Bruegel le Vieux." *GBA* 6e pér. 7: 132, fig. 3.

1932 Glück, Gustav. *Bruegels Gemälde*. Vienna (1937 ed.): 93, no. 81.

1935 Tolnay, Charles de. *Pierre Bruegel l'Ancien*. Brussels: 97, no. 56.

1936 Glück, Gustav. *Das Bruegel Buch*. Vienna: no. 2, repro. 10, 20.

1938 Wetering, Cornelis van de. *Die Entwicklung der niederländischen Landschaftsmalerei vom Anfang des 16. Jahrhunderts bis zur Jahrhundertmitte*. Berlin: 79, pl. 5 (diagram).

1951 Glück, Gustav. *Pieter Brueghel the Elder*. London: 9, 17, no. 2, repro. (also Vienna, 1951).

1951 Kress: 202, no. 89, repro. 203.

1959 Gudlaugsson, S. J. "Het Errera-schetsboek en Lucas van Valckenborch." *OH* 74: 129.

1967 Bianconi, Piero. *The Complete Paintings of Bruegel*. New York: 87, no. 2, repro. 88.

1968 Gandolfo, Giampaolo, et al. *National Gallery Washington*. Milan: 113.

1968 Koch, Robert A. *Joachim Patinir*. Princeton: 9.

1968 Klein, H. Arthur, and Mina Klein, *Peter Bruegel the Elder. Artist of Abundance*. New York: 184.

1969 Franz, Heinrich Gerhard. *Niederländische Landschaftsmalerei im Zeitalter des Manierismus*. 2 vols. Graz, 2: fig. 189.

1971 Wied, Alexander. "Lucas van Valckenborch." *JbWien* 31: 137.

1975 NGA: 50, repro. 51.

1976 Walker: no. 192, repro.

1977 Eisler: 91–93, fig. 90, text fig. 16.

Antwerp Artist (?)

1953.3.3 (1177)

A Member of the de Hondecoeter Family

1543
Probably oak, 25.6 x 20.1 (10¹/₁₆ x 7⁷/₈)
 painted surface: 24.5 x 18.8 (9⁵/₈ x 7³/₈)
Gift of Adolph Caspar Miller

Inscriptions:
On reverse on a banderole at top: *TART SVIS VENV.*
On a banderole at bottom: *Aᶜ (?) DE HONDECOVTRE 1543.*
Coat-of-arms on the reverse: The blazon of the shield of the coat-of-arms is bendy of six argent and azure, and for difference in the sinister chief a mullet of five of the last. Crest: out of a wreath of the liveries, a demi-swan wings elevated and displayed proper.[1]

Technical Notes: The painting is generally in good condition. There are tiny, inpainted losses scattered throughout, and an area of abrasion in the left shoulder has been inpainted. Over the background is a layer of dark green, pigmented varnish. It is possible that the original background was lighter in color but suffered from discoloration (yellowing) or some other damage and was restored. This restoration was partially removed and the background restored to its present appearance. Examination with infrared and infrared reflectography reveals underdrawing in the face and hands. The gloves were painted over the left hand and the position of the hand then lowered. Surface dirt was removed and minor treatment administered in 1957.

 Reverse: There are indications that the present design layer is not original. Small losses appear to lie under the lower banderole at the right, the black background seems to lie over cracks in a lower layer of blue, and the outlines of leaves lie over cracks and other damages. However, the present design layer does not look modern and may be a reinforcement of the original design. There appear to be several layers of varnish covering the surface and these have altered the colors of the blazon.

Provenance: Sir John Ramsden, Bart., Bulstrode, Gerrards Cross, Buckinghamshire (sale, Christie's, London, 11 July 1930, no. 23, as Joos van Cleve). (Hermann Ball, Berlin.)[2] (Schaeffer Gallery, Berlin, by 1930.) Adolph Caspar Miller, Washington, by 1937.

Exhibitions: Washington, Phillips Memorial Gallery, 1937, *Paintings and Sculpture Owned in Washington*, no. 2, as Ambrosius Benson.[3]

Notes
 1. I am indebted to Walter Angst for the heraldic description.
 2. This is known from an annotated copy of the Christie's sale catalogue. I am also grateful to Mrs. H. S. Schaeffer for information about the Ball Gallery.
 3. The catalogue erroneously refers to both paintings as being on canvas.

1953.3.4 (1178)

Wife of a Member of the de Hondecoeter Family

1543
Probably oak, 26 x 20.1 (10¹/₄ x 7⁷/₈)
 painted surface: 24.5 x 18.8 (9⁵/₈ x 7³/₈)
Gift of Adolph Caspar Miller

Technical Notes: The painting is generally in good condition. There are small scattered retouchings throughout and a small abraded loss in the hair on the right side of the face. As with its pendant, the background is covered with a green pigmented varnish that may cover damage and partial restoration. Infrared examination and infrared reflectography reveal underdrawing in the face and hands.

 Reverse: A layer of black paint has been applied over the ground.

Provenance: Same as 1953.3.3.

Exhibitions: Washington, Phillips Memorial Gallery, 1937, *Paintings and Sculpture Owned in Washington*, no. 1, as Ambrosius Benson.

In 1930 these portraits of a member of the de Hondecoeter family and his wife were sold under the name of Joos van Cleve. Shortly thereafter they were attributed to Ambrosius Benson by Friedländer.[1] This attribution was accepted by Marlier in his monograph on Benson.[2] Marlier considered the portraits to be important because of their high quality and because the male portrait bears on the reverse a date and coat-of-arms. The panels are seldom discussed and the attribution has remained unexamined and unchallenged. It is, however, impossible to maintain Benson's authorship of these pictures.[3]

 The oeuvre attributed to Benson is voluminous and,

Antwerp Artist (?), *A Member of the de Hondecoeter Family*, 1953.3.3

Antwerp Artist (?), *Wife of a Member of the de Hondecoeter Family*, 1953.3.4

as is the case with that of Adriaen Isenbrant, consists of works that were produced by different personalities. The corpus of paintings is constructed around two pictures that bear a monogram AB: the *Altarpiece of Saint Anthony* (Musées Royaux des Beaux-Arts, Brussels)[4] and the *Holy Family*, dated 1527 (Wildenstein & Co., New York).[5] There are no portraits that bear a monogram or can be given to Benson with certainty.[6]

The depictions of de Hondecoeter and his wife are stylistically unrelated to either monogrammed painting or to other works, including portraits, that are clustered around Benson's name. In contrast to the rounded, generalized forms, massive hands, warm tonalities, and dense, almost smoky shadows of the Benson group, the Gallery's portraits are tautly linear. Detail is crisply rendered, faces are evenly lit with thin shadows, and the modeling tends to emphasize the sculptural solidity of the heads. In fact, there is nothing to suggest that the portraits were produced in Bruges. Rather, the style points more toward Antwerp. While I have not found any other portraits by the same hand, the closest comparison is with the work of an artist known as the

Master of the 1540s who was active in Antwerp.[7] Portraits by this artist are dated between 1541 and 1547 and his association with Antwerp is strongly suggested by his depiction of Gillis van Schoonbeke, patron of the Antwerp hospital, and his wife (figs. 1, 2).[8] The straightforward presentation of half-length figures against a monochromatic background—the men often shown holding gloves—the clarity of light, usually coming from the left, and the linear rendering of detail are qualities that accord well with the portraits of de Hondecoeter and his wife.[9]

Unfortunately, the coat-of-arms does not assist us in localizing or specifically identifying the sitter. The mark of cadency on the upper right corner of the shield designates the sitter as a younger son,[10] but the initial or monogram preceding the family name is obscured. This monogram has been read as that of Niclaes (or Nicolas),[11] but the letter form seems closer to A than N. The motto TART SVIS VENV (I have come late) has not been encountered in conjunction with the name de Hondecoeter. We can only say that the arms are those of de Hondecoeter (Hondecoustre, Hondecouter) and

Fig. 1. Master of the 1540s, *Gillebert van Schoonbeke*, Antwerp, Koninklijk Museum voor Schone Kunsten [photo: Copyright A.C.L. Brussels]

Fig. 2. Master of the 1540s, *Elisabeth Heyndericx*, Antwerp, Koninklijk Museum voor Schone Kunsten [photo: Copyright A.C.L. Brussels]

Antwerp Artist (?), *A Member of the de Hondecoeter Family*, 1953.3.3, reverse: *Crested Coat of Arms*

correspond to a description of arms of an important family in the north of France in the early fifteenth century.[12] The names Hondecoeter, Hondecoter, and Hondecoutre can be found in Mechelen and Antwerp in the second half of the sixteenth century.[13] The well-known family of Dutch painters named Hondecoeter apparently stems from a Niclaes Hondekoten (or Hondekoeter) who was a member of the guild of Saint Luke in Antwerp in 1585/1586; but since a coat-of-arms is not known for this family there is no way of connecting them with the male sitter in the Gallery's portrait.[14]

A replica of the male portrait was in the Loewinstein collection, Dortmund, around 1932. Its present location is unknown.[15]

J.O.H.

Notes

1. Friedländer, vol. 11 (1933), 147, no. 296, erroneously stating that the coat-of-arms is on the reverse of the female portrait.

2. Marlier 1957, 256–257, 320–321, no. 146.

3. The attribution to Benson was first questioned by Anthony Colantuono, NGA department of northern European painting, intern, summer 1981.

4. Friedländer, vol. 11 (1974), no. 237, pl. 161.

5. Friedländer, vol. 11 (1974), no. 268, pl. 172.

6. The *Portrait of a Lady* in the John G. Johnson Collection, Philadelphia Museum of Art, no. 361, is monogrammed A.B., but is only distantly related to Benson. See Barbara Sweeny, *John G. Johnson Collection. Catalogue of Flemish and Dutch Paintings* (Philadelphia, 1972), 5, no. 361.

7. This master is discussed and catalogued in Friedländer, vol. 13 (1975), 46–48, 93–95. Not all of Friedländer's attributions are equally convincing. See also 1956.3.2, Antwerp Artist, *Portrait of an Almoner of Antwerp*, which is dated 1542.

8. Friedländer, vol. 13 (1975), no. 248, pl. 124; both portraits are dated 1544.

9. It is worth noting that in his discussion of the wife of de Hondecoeter, Marlier 1957, 256–257, compares both the style and the costume to the feminine portraits of the Master of the 1540s.

10. Flora Caquant-Popelier, Director, Genealogicum Belgicum, Brussels, letter to the author, 1 October 1981.

11. NGA 1975, 26, reads the letter as a monogram from Niclaes.

12. Baron de Kerchove d'Ousselghem, "Hondecoeter," *Le Parchemin*, no. 216 (November/December 1981), 479–480; also in a letter to the author of 10 July 1983. The arms correspond virtually to the description of "de Hondecoustre" in G. Dansaert, *Nouvel Armorial Belge* (Brussels, 1949), 251.

13. The letter from Flora Caquant-Popelier cited in n. 10, refers to a notary Guido de Hondecoutre living in Mechelen in 1579, and another notary Jan de Hondecoutere is mentioned in Mechelen in 1558. With the expert and gracious assistance of J. van den Nieuwenhuizen and G. Degueldre of the Stadsarchief, Antwerp, it was possible to find that an Antonius Hondecoter was baptized in 1580, a Niclaes Hondecoeter was married in 1572, and a Guido de Hondecoeter was mentioned in the *Certificatieboek* of 1559.

14. For the family of painters see H. Schneider, "Hondecoeter," Thieme-Becker 17 (1924), 431–434. The family apparently fled around 1585 to Delft and Amsterdam to escape religious persecution and seems to have come from Mechelen and Antwerp.

15. A photograph is in the curatorial files.

References

1933 Friedländer. Vol. 11: 107, 147, no. 296, pls. 93–94 (vol. 11, 1974: 61, 101, no. 296, pl. 183).

1957 Marlier, Georges. *Ambrosius Benson et la peinture à Bruges au temps de Charles-Quint*. Damme: 256–257, 320–321, no. 146, pl. 75.

1975 NGA: 26, repro. 27.

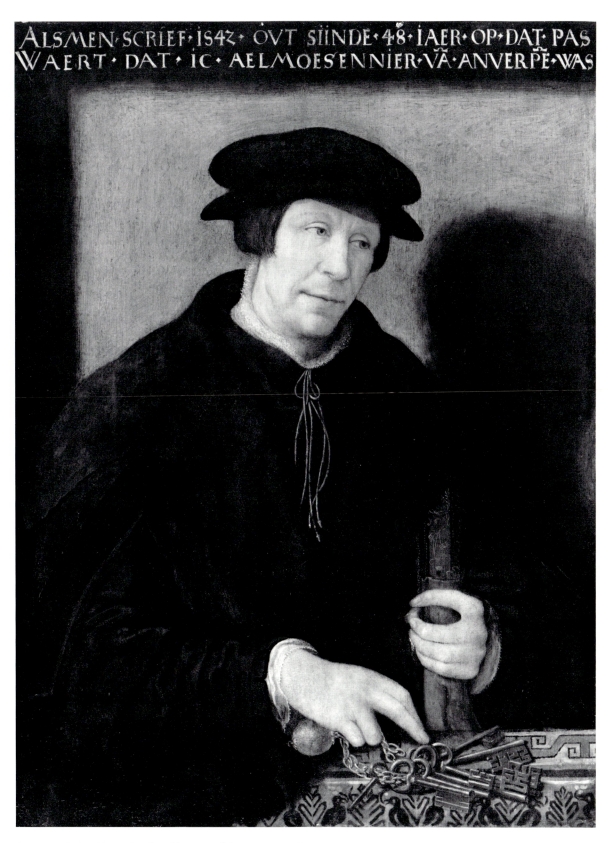

ALSMEN·SCRIEF·1542·OVT·SIINDE·48·IAER·OP·DAT·PAS
WAERT·DAT·IC·AELMOESENNIER·VÃ·ANVERPẼ·WAS

Antwerp Artist, *Portrait of an Almoner of Antwerp*, 1956.3.2

Antwerp Artist

1956.3.2 (1447)

Portrait of an Almoner of Antwerp

1542
Probably oak (cradled), 84.8 x 63.2 (33³/₈ x 24⁷/₈)
Gift of Lewis Einstein

Inscription:
At the top: *ALS MEN · SCRIEF · 1542 · OVT · SIINDE · 48 · IAER · OP · DAT · PAS / WAERT · DAT · IC · AELMOESENNIER · V̂Ã · ANVER̂P̂E WAS.*

Technical Notes: The picture is constructed of two boards joined vertically at the center. The lower left corner of the left board has been repaired with fills and added pieces. An old check extends appx. 41 cm down from the top edge and appx. 11 cm in from the left. There are numerous areas of loss and subsequent repaint which have discolored in some instances. This is especially apparent in the hands; the proper left hand in particular is very damaged and its original shape altered. Examination with infrared reflectography reveals changes in the hat and neckline. The thick varnish has discolored considerably.

Provenance: (Galerie Charles Sedelmeyer, Paris.[1]) Mr. Einstein. His son, Lewis Einstein, Paris.

Exhibitions: Alexandria, Virginia, Northern Virginia Fine Arts Association, 1972, *Styles in Portraiture.*

THE DATE and identification of the sitter's occupation are given in the inscription at the top of the painting, which may be loosely translated, "In 1542 when I was forty-eight years old, I was then almoner of Antwerp." Almoners were charged with providing charity for the city's poor and destitute citizens. The almoner's chamber, which was responsible for collecting money and administering relief, consisted of four active and four reserve volunteers. Almoners served two-year terms, but the terms were staggered so that each year two men retired and were replaced by two newcomers.[2] In 1542 the almoners were Jan de Lantmeter and Gillis van Bruysegem, appointed in 1540, and Goosen van Bauhus and Gomar Raye appointed in 1541; Fran-

ciscus Stuytelinck and Cornelius Adriaenssens were appointed in 1542.[3] At present it is not possible to determine which of the six is depicted, though Van Bauhus may be eliminated, since his age in 1542 does not correspond to that shown in the painting.[4]

The keys held in the proper right hand may allude to one of the almoner's duties, making sure that the inmates in jail were fed,[5] or they may be a general symbol of authority and responsibility. The object held in the proper left hand is badly damaged, but may originally have been a money bag.[6] It is unlikely that the artist will be identified, but it seems probable that he was active in Antwerp. The half-length figure and use of green background and cast shadow are consistent with other portraits produced in Antwerp, in particular with the work of the Master of the 1540s.[7]

J.O.H.

Notes

1. Date of purchase unknown; see memorandum by Lewis Einstein of 10 April 1962 in the curatorial files.

2. The position of almoner is discussed by Voet 1973, 111. He notes that almoners came from the upper strata of Antwerp society since they inevitably had to spend a lot of their own money.

3. Eva Pais-Minne, Maagdenhuismuseum, Antwerp, letter of 30 November 1983 in the curatorial files, notes that almoners were elected on Saint Barbara's Day (4 December) and had to be both rich and married. I am also grateful to Dr. J. van den Nieuwenhuizen, Stadsarchief, Antwerp, for his assistance.

4. Voet 1973, 99, observes that according to the inscription on Van Bauhus' funerary monument in Antwerp Cathedral, he died in 1548 at the age of forty-six, which means that in 1542 he would have been only forty years old. NGA 1975, 128, identifies the sitter as "Goosen van Bonhuysen," but the source of this identification is not to be found in the files.

5. Leon Voet, remarks recorded in a memorandum of 22 April 1968 in the curatorial files.

6. Identification proposed by Gwen Tauber, NGA conservation department intern, summer 1983.

7. See 1953.3.3, Antwerp Artist, *A Member of the de Hondecoeter Family*, figs. 1, 2.

References

1973 Voet, Leon. *Antwerp. The Golden Age.* Antwerp: 99, repro. 98.
1975 NGA: 128, repro. 129.

Hieronymus Bosch

c. 1450–1516

Hieronymus Bosch was born in the town of 's-Hertogenbosch (Bois-le-Duc) in northern Brabant. His true name was Joen or Jeroen van Aken. Both his grandfather Jan van Aken (d. 1454) and his father, Anthonius van Aken (d. c. 1478), were painters, and we may assume that he received his first instruction from his father.

Documents offer only meager information about his career. Sometime before 1481 Bosch married Aleyt van der Meervenne, a woman of wealth and property. In 1486/1487 Bosch is listed for the first time as a member of the religious confraternity of the Brotherhood of Our Lady (*Onze Lieve Vrouwe-Broederschap*) and he executed paintings for the Brotherhood as well as designs for a stained glass window for the chapel of the Cathedral of Saint John in 's-Hertogenbosch. The artist had a workshop of some sort, for it is recorded that in 1503–1504 Bosch's assistants (*knechten*) were paid for painting coats-of-arms. There are other references to Bosch's artistic activity in 's-Hertogenbosch. Perhaps the most important of these is a commission in 1504 from Philip the Fair, Duke of Burgundy, for a large altarpiece of the Last Judgment. The painting no longer exists. Hieronymus Bosch died in 1516; on 9 August of that year his funeral mass was attended by members of the Brotherhood of Our Lady.

Bosch's oeuvre consists of approximately thirty paintings, none of which is dated. Seven paintings are signed *Jheronimus Bosch*, which combines a Latinized form of the artist's first name with the shortened form of his home town. Obviously it is not possible to achieve a precise chronology, but de Tolnay and others have divided the works into three large groups. The early period, 1475–1485, includes such works as *The Cure of Folly* (Prado, Madrid), and *The Conjurer* (Musée Municipal, Saint Germain-en-Laye), both modest in size; the middle period, 1485–1505, contains the great triptychs, *The Haywain*, *The Garden of Earthly Delights* (both Prado, Madrid), and *The Temptation of Saint Anthony* (Museu Nacional de Arte Antiga, Lisbon); the late period, 1505–1516, includes

The Peddler (Museum Boymans-van Beuningen, Rotterdam), and *The Road to Calvary* (Musée des Beaux-Arts, Ghent).

Hieronymus Bosch is easily the most mysterious, provocative, and inexplicable of Early Netherlandish painters. His art has been discussed by myriad scholars and popular writers. Bosch has been seen as a surrealist and as a member of a heretical sect that celebrated sexual libertinism, both erroneous assumptions. Such diverse sources as folklore, proverbs, astrology, astronomy, alchemy, and Jewish legend have been used to interpret his paintings. Yet the intricacies of his subject matter and the sources of his imagery have resisted any cogent, unified explanation.

If not all the details in Bosch's paintings can be precisely explained, most critics would agree that Bosch was basically a moralist, a pessimist who viewed with a sardonic eye man's inevitable descent into sin and damnation.

It has recently been shown that *The Garden of Earthly Delights* hung in the Brussels palace of Hendrik III of Nassau by 1517 and was probably commissioned by him. This provides important evidence that Bosch's paintings were ordered by learned secular patrons as well as by religious institutions.

The art of Hieronymus Bosch had a tremendous influence upon Netherlandish painting and printmaking throughout the sixteenth century, and many followers and copyists emulated his bizarre and grotesque demons. Only Pieter Bruegel the Elder, however, had Bosch's painterly skill and moral intelligence.

J.O.H.

Bibliography

Tolnay, Charles de. *Hieronymus Bosch*. Basel, 1937 (Engl. ed., with catalogue, New York, 1966).

Gerlach, P. "Jeronimus van Aken alias Bosch en de Onze Lieve Vrouwe-Broederschap." *Jheronimus Bosch. Bijdragen bij gelegenheid van de herdenkstentoonstelling te 's-Hertogenbosch*. Eindhoven, 1967: 48–60.

Gibson, Walter. *Hieronymus Bosch*. New York, 1973.

Snyder, James, ed. *Bosch in Perspective*. Englewood Cliffs, New Jersey, 1973.

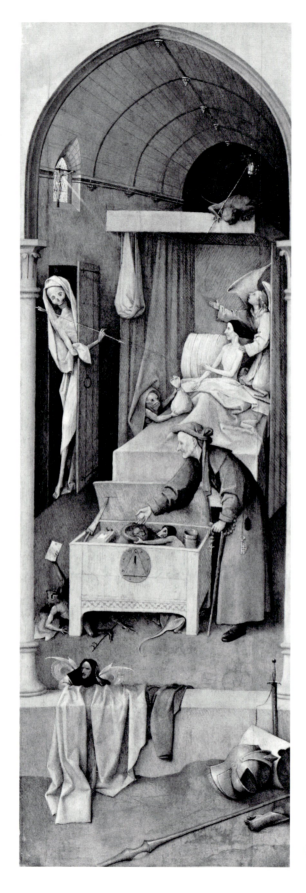

Hieronymus Bosch,
Death and the Miser, 1952.5.33

1952.5.33 (1112)

Death and the Miser

c. 1485/1490
Oak (cradled), 93 x 31 (36⅝ x 12³/₁₆)
Samuel H. Kress Collection

Technical Notes: The panel has been thinned to a veneer (maximum thickness 0.15) and laminated to another wooden panel, which has been cradled in turn; according to Eisler this was done around 1900.[1] The painting was restored in Belgium sometime prior to 1951.[2] The top left corner has been replaced with a triangular piece of veneer. Two vertical splits run the length of the painting, one 3.7 cm from the left edge and the other 4.0 cm from the right edge. There are small scratches and indentations throughout the support. The paint layer has been damaged. There are large areas of loss and subsequent restoration in the head and upper body of the figure of Death; in the approximate center of the painting, extending vertically through the lid of the chest, the left corner of the bed, and into the bed-curtain and arm of the demon; and at the right edge to the right of the corner of the bed and the standing figure in green. Moreover, extensive retouchings are scattered throughout the painting, including a narrow strip over the split at the right, extending downward from the bottom of the green robe into the low wall in the foreground. Some of the retouching has discolored. The underdrawing is discussed below.

Provenance: Private collection, England, possibly in or near Arundel, Sussex, around 1826.[3] (Unnamed dealer, Highgate Village, London, c. 1926.)[4] (Raven, Massey and Lester, London, by 1926.) (Asscher and Welker, London, by 1932.)[5] Baron Joseph van der Elst, Brussels, Biot, France, and numerous diplomatic posts, by 1932 or slightly later. Samuel H. Kress Foundation, New York, 1951.

Exhibitions: New York, M. Knoedler and Company, 1942, *Flemish Primitives. An Exhibition Organized by the Belgian Government*, 68, as *Allegory of Avarice*.

THE PAINTING shows a dying man seated in a testered bed set in a bare, narrow room. The figure of Death as a skeleton carrying an arrow enters at the left. Accompanying the dying man are a demon holding a sack and an angel who urges him to recognize the crucifix in the upper window. At the foot of the bed another figure stands next to an open chest and puts money into a sack held by a demon. In the foreground a demon leans on a low wall, his head supported by his hand in a gesture of melancholy. On the spectator's side of the wall are pieces of armor and weapons; a cloak and a sleeved garment are draped over the wall. The scene is framed by columns.

The consensus among critics is that the painting represents the death of a miser.[6] Further, most authors have agreed with de Tolnay's initial assessment that the subject is based on the text and images of the *ars moriendi*. There is, however, no agreement on the overall iconographic program of the painting, its exact relationship to the *ars moriendi*, or the interpretation of various details.

The text of the *ars moriendi* was probably written around 1400 and discusses death as a struggle between the forces of good and evil for the soul of the dying man. There are five stages, each consisting of demonic temptation and angelic inspiration, which the dying man must go through in order to achieve a happy death and salvation. The temptations are: infidelity, despair, impatience, vainglory, and avarice. The text of the *ars moriendi* began to be illustrated during the first half of the fifteenth century; the best-known images are found in the blockbooks produced in the 1460s and a related series of engravings by Master E. S.[7]

Fig. 1. Hieronymus Bosch, *Death and the Miser*, detail of *Tabletop*, Madrid, Prado [photo: Prado]

Bosch's awareness of the visual tradition of the *ars moriendi* can be seen, first, in the roundel showing Death as one of the Four Last Things in the *Tabletop* in the Prado, Madrid (fig. 1).[8] There are many points of correspondence between Bosch's painting and *ars moriendi* images, such as the figure of Death as a

shrouded skeleton, the juxtaposition of angel and devil on the headboard of the bed, and the oblique angle of the bed. In Bosch's picture, too, the presence of the monk holding a crucifix, the priest administering last rites, and the fact that the dying man holds a taper suggest the triumph of the Church that we find in the final text and image of the *ars moriendi*. The *ars moriendi* was very popular and available in several editions; it was printed in 1488 and 1491 by Peter van Os of Zwolle and in 1488 by Christian Snellaert of Delft and thus would have been accessible to Bosch.[9]

The relationship of *Death and the Miser* to the *ars moriendi* is less direct than that of the Prado *Tabletop*. In place of discrete, opposing images Bosch seems to have conflated scenes of the temptation by and triumph over avarice and introduced an element of suspense. The miser seems to ignore both the guardian angel who offers salvation and the toadlike demon who pops through the bed-curtain with a sack that almost certainly contains either money or gold. Instead, the dying man is transfixed by the figure of Death who, as in the Prado *Tabletop*, is represented as a shrouded skeleton holding an arrow. As with the *ars moriendi* images, demons scurry under the furniture or peer down at the dying man from the bed canopy. While the outcome of the struggle may not be immediately apparent, other elements in the scene show the dying man to be guilty of the sin of avarice, the last temptation mentioned in the *ars moriendi*.

The figure at the foot of the bed has been identified by some authors as the dying man himself in an earlier manifestation, as in the kind of "simultaneous narrative" found in medieval art.[10] Whether intentional or not, the figure seems to function as a personification of the dying man. There is virtual agreement that the standing figure is presented as evil and hypocritical; with one hand he puts coins into the strongbox where they are collected by a rat-faced demon and with the other he fingers a rosary, attempting to serve God and Mammon at the same time, so to speak. The lid of the chest is held open with a knife, a symbol of anger, another of the Seven Deadly Sins. A winged and rat-headed demon emerging from underneath the chest holds up a paper sealed with red wax. It has been suggested that the paper is a letter of indulgence, a mortgage, a paper of false legitimacy, or a promissory note.[11] Although there are no markings on the paper that would identify it as a specific type of document, it would seem likely that it refers to the money-making activities of misers, such as lending money at high rates of interest. Capitalism in the Netherlands of the late fifteenth and early sixteenth centuries resulted in an increasing use of paper credit as a substitute for hard currency.

The objects in the foreground—the heap of armor and weapons, the cloak, and the sleeved garment— have not been satisfactorily explained. The interpretations put forward are diverse, though many can be divided into two large groups: those that see the objects as referring to the previous life of the miser and those that see the objects as imbued with moral or allegorical significance.

De Tolnay saw in the armor a social satire against the nobility;[12] for Baldass the discarded weapons indicated not only that the dying man was a knight but that gold accomplishes more than bravery and courage.[13] De Tervarent interpreted the armor as an emblem of vanity that demonstrated that material weapons are powerless against death.[14] Combe and Fraenger also viewed the objects as symbols of vanity.[15] Boon thought that the weapons identified the dying man as a knight, as did Reuterswärd.[16] However, Reuterswärd went further and related the red mantle on the low wall to the red shroud draped over the oxen of death on the right wing of the Prado *Haywain* triptych. Philip also found an evil meaning in the red cloak, but for her the mantle and the armor refer to Saint Martin and the contrast between Christian generosity and avarice.[17] Cuttler found in the foreground objects a veiled disparagement of knights and chivalry, similar to that found in Sebastian Brant's *Narrenschiff*, and viewed the entire painting as a satire on the greed of false knights.[18] The author thought the weapons were symbolic of anger, while Seymour believed they alluded to the abandonment of the Christian active life.[19] Morganstern viewed the miser as a usurer and thought that the armor had been pawned by an impecunious knight.[20]

There is no single precise and satisfactory explanation for the armor, weapons, and garments. But given that the painting as a whole is concerned with the sin of avarice and with death, one can assume that these objects are also malevolent in nature and perhaps refer to the vanity of worldly possessions. It is also possible that the image is incomplete and that an accompanying panel would help to clarify the iconographic program.

Because *Death and the Miser* is thinly painted, much of the underdrawing is readily apparent to the naked eye. A fuller image is obtained through examination with infrared photography and infrared reflectography. The underdrawing is quite extensive and, while varied, consists mainly of parallel hatching strokes running from upper left to lower right.[21] Between the initial design and the final painted surface

several changes have been made. Underdrawn on the wall in the foreground are rosary beads, three metal tumblers (perhaps intended to be the same as those in the miser's chest), and a pilgrim's flask. As regards the figure standing by the chest (fig. 2), the size and position of his rosary have been altered, the key and purse have been made smaller, and hanging from the belt is the outline of either a scabbard or a portable writing implement. Death's arrow was originally closer to the dying man, and there are small adjustments in the ribs of the timbered roof.

The most striking changes were made to the dying miser. The underdrawing depicts the miser holding in his left hand a *pokal* or decorated goblet, wrongly identified by Frankfurter and others as the *viaticum*,[22] while his right hand grabs the neck of the sack offered by the demon (fig. 3). As seen in the underdrawing, then, the miser's greed is such that even in the last moments of life he is more preoccupied with material possessions than with his salvation. In the finished painting, Bosch opted for greater dramatic tension and ambiguity.

The underdrawing clarifies the relationship between the painting and a drawing in the Louvre.[23] The drawing essentially reproduces the finished painting, but excludes the foreground; the lance, gauntlet, helmet, and shield have been moved to the left wall inside the space of the bedchamber. As pointed out by Filedt Kok, however, the differences between the underdrawing and the Louvre drawing are strong evidence that the drawing is a copy, by a different hand, after the painting.[24]

Since its initial publication, the attribution of *Death and the Miser* to Hieronymus Bosch has been unanimously accepted, and even though the chronology of Bosch's works is far from certain, critics have generally accepted de Tolnay's placement of the painting in a middle period, which runs from 1480 to 1510. The painting is often compared to the *Haywain* triptych in the Prado and is usually dated to the beginning of the middle period, that is, c. 1485–1490,[25] though one author associates it with the *Saint Julia* altarpiece at the end of the middle period.[26]

While it is usually assumed that *Death and the Miser* was once part of an altarpiece, there have been different proposals on the original location of the panel within the altarpiece and on other works that might have been associated with it. Some authors, including Friedländer, have mistakenly called *Death and the Miser* a grisaille.[27] While Cuttler thought it was the interior right wing,[28] the normative view, expressed by Baldass, de Tolnay, and Reuterswärd, is that the panel

Fig. 2. Infrared reflectogram assembly of a detail of *Death and the Miser*, 1952.5.33 [infrared reflectography: Molly Faries]

Fig. 3. Infrared reflectogram assembly of a detail of *Death and the Miser*, 1952.5.33 [infrared reflectography: Molly Faries]

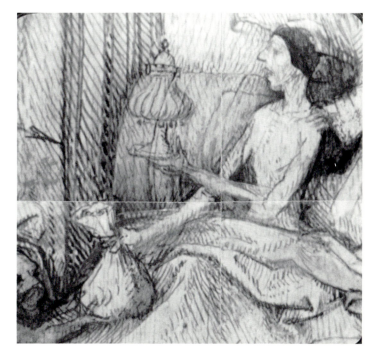

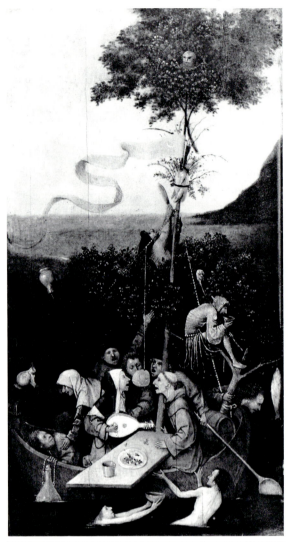

Fig. 4. Hieronymus Bosch, *Ship of Fools*, Paris, Louvre [photo: Cliché des Musées Nationaux-Paris]

is the exterior left wing of an altarpiece.[29] De Tolnay's proposed reconstruction has a scene of the Last Judgment on the center panel and representations of Paradise and Hell, presumably on the inner wings, together with *Death and the Miser* and perhaps another death scene on the right exterior wing. These would form a depiction of the Four Last Things. The Four Last Things and the Seven Deadly Sins are depicted on the Prado *Tabletop*. Reuterswärd suggested that the Gallery's panel was part of a triptych, the main panel of which was some vision of the world to come, perhaps a Last Judgment. No other extant panels by Bosch have been associated with this reconstruction.

In 1961 Eisler published Seymour's observation that the height of *Death and the Miser* equals the combined heights of Bosch's *Ship of Fools* in the Louvre (fig. 4) and the *Allegory of Intemperance* in the Yale University Art Gallery (fig. 5). The widths of the panels are also comparable.[30] Seymour proposed that the panels functioned jointly as the wings of a lost, small devotional triptych. Adhémar cautiously favored Seymour's reconstruction while Cuttler found the three panels disparate in character and cautioned against drawing firm conclusions about their relationship.[31] Eisler was also cautious, but suggested that if the Yale and Louvre panels were part of an altarpiece they might have formed part of a lost central panel.[32] Morganstern has demonstrated convincingly that the Louvre *Ship of Fools* and the Yale *Allegory of Intemperance* were originally one panel.[33] She also believes that *Death and the Miser* was part of the same triptych. Since the Louvre and Yale panels may be associated with Gluttony and Lust and the National Gallery's panel with Avarice, Morganstern suggests that these are the remnants of a triptych whose subject was the Seven Deadly Sins.

The association of the Louvre and Yale panels with *Death and the Miser* seems quite sensible. The paintings have always been grouped together in terms of style and date. The Yale panel, which has recently been cleaned, is very close in color to *Death and the Miser*. Further, as both Filedt Kok and Morganstern have noted, the underdrawing in all three panels is very similar.[34] While it appears likely that all three panels were

Fig. 5. Hieronymus Bosch, *Allegory of Intemperance*, New Haven, Conn., Yale University Art Gallery, The Rabinowitz Collection—Gift of Hanna D. and Louis M. Rabinowitz [photo: Yale University Art Gallery, Joseph Szaszfai]

joined, any speculation about the theme of the altarpiece must at present remain conjectural. If, as seems likely, *Death and the Miser* was the exterior left wing, then we may expect that the exterior right wing also bore painted columns.

Death and the Miser was copied in a drawing attributed to the English artist William Henry Brooke (1772–1860), perhaps made around 1826. The drawing is in the National Gallery of Art.[35]

J.O.H.

Notes

1. Eisler 1977, 66.
2. René Sneyers, Institut Royal du Patrimoine Artistique, Brussels, letter of 8 July 1968 to Eisler stating that the picture was restored by Albert Philippot without giving a date. Eisler 1977, 69, n. 2, cites de Tolnay 1966, 347, who says that the painting was cleaned and restored in 1937.
3. This may be deduced from the drawing after the painting attributed to William Henry Brooke. See below n. 35.
4. J. Massey, London, letter of 21 July 1961 to Perry Cott, in the curatorial files.
5. Glück 1932, 57.
6. Chailley 1978 sees the painting as representing the unjust steward of Luke 16:9. However, his arguments are not convincing.
7. A great deal of controversy surrounds the *ars moriendi* blockbooks and involves such questions as the date of the first edition of the blockbook, whether it was produced in the southern Netherlands, Germany, or the northern Netherlands, and its primacy in relation to manuscript sources and the series of small engravings by the Master E. S. For the *ars moriendi* and a discussion of these issues see Lionel Cust, *The Master of E. S. and the "Ars Moriendi"* (Oxford, 1898); Arthur M. Hind, *An Introduction to a History of Woodcut*, 2 vols. (Boston and New York, 1935), 1: 224–230; Wilhelm Schreiber, "Ars Moriendi," *Lexikon des gesamten Buchwesens*, 3 vols. (1935), 1: 86–87; Wilhelm Schreiber and Hildegarde Zimmerman, "Ars Moriendi," *Reallexikon zur deutschen Kunstgeschichte*, 7 vols. (Stuttgart and Munich, 1937–1981), 1: cols. 1121–1127; Fritz Saxl, "A Spiritual Encyclopedia of the Later Middle Ages," *JWCI* 5 (1942), 98–99, 124–126; Mary Catherine O'Connor, *The Art of Dying Well. The Development of the Ars Moriendi* (New York, 1942); Alan Shestack, *Master E. S. Five Hundredth Anniversary Exhibition* [exh. cat. Philadelphia Museum of Art] (Philadelphia, 1967), cat. nos. 4–15.
8. De Tolnay 1966, 15–16, cat. no. 2, 338–339, repro. 60. The *Tabletop* is dated to Bosch's early period by de Tolnay and others. However, Walter Gibson, "Hieronymus Bosch and the Mirror of Man," *OH* 87 (1973), 208, believes the work was painted around 1500 by Bosch and his workshop.
9. Schreiber, "Ars Moriendi," 1: 87.
10. Notably, Baldass 1943, Elst 1944, and Reuterswärd 1970.
11. Cuttler 1968, 202; Cuttler 1969, 275.
12. De Tolnay 1937, 27.
13. Baldass 1943, 236.
14. De Tervarent 1958, 34.
15. Combe 1946, 21; Fraenger 1975, 296.
16. Boon 1968, 157; Reuterswärd 1970, 266.

17. Philip 1956, no. 14.
18. Cuttler 1969, 275.
19. John Hand, Picture of the Week text, 27 September–3 October 1965, in the curatorial files; Seymour 1961, 78.
20. Morganstern 1982, esp. 33, 39, n. 10.
21. The direction of the strokes is consistent with the work of a left-handed artist, and it has been suggested several times that Bosch was left-handed. However, there is no agreement as to whether the drawings attributed to Bosch are by a left-handed or a right-handed artist. Reuterswärd 1970, 163–164, noted that use of a maulstick would reverse the direction of the strokes and suggested that Bosch might have been right-handed. This question is discussed in some detail by Filedt Kok 1972–1973, 152–153; see also Ironside 1973.
22. Frankfurter 1951, 14; Cuttler 1968, 202; Cuttler 1969, 276. The goblet is correctly identified as a *pokal* by Morganstern 1982, 37, 40, n. 30.
23. No. 6947, dark gray brush, white heightening, on gray prepared paper, 256 x 149 mm. Frits Lugt, *Musée du Louvre. Inventaire général des dessins des écoles du Nord: maîtres des anciens Pays-Bas nés avant 1550* (Paris, 1968), 25–26, no. 70, as by Bosch. For a discussion of the drawing see *Jheronimus Bosch*, 1967, 167–168, cat. no. 51. Opinions about the authorship of the drawing are divided. De Tolnay 1937, 90; de Tolnay 1966, 347; Baldass 1935, 89, n. 7; Baldass 1943, 236; Unverfehrt 1980, 44, all believe the drawing is not autograph but is a copy after the painting. Frankfurter 1951, 14, accepts the drawing as autograph as does Eisler 1977, 66, who considers it an alternate project for the painting. Popham 1955, 248, believes the underdrawings in the Yale panel and the Louvre panel are similar and by Bosch and that the drawing should be thought of as a modello. Martin 1979 also calls the drawing a modello.
24. Filedt Kok 1972/1973, 151–152, n. 43. Molly Faries, in a talk given at the Center for Advanced Study in the Visual Arts, National Gallery of Art, 3 December 1981, also discounted the authenticity and preparatory nature of the Louvre drawing on the basis of its lack of correspondence to the underdrawing. As Reuterswärd 1970, no. 19B, 268, has noted, the Louvre drawing is not considered of high quality, and when compared to other, more securely attributed works there would seem to be good cause for questioning Bosch's authorship.
25. Eisler 1977, 68, suggested a *terminus post quem* of 1468 because of the similarities to the illustrations to Saint Augustine's *La Cité de Dieu* printed in Abbeville in 1486. The relationship was first noted by Bax 1949, 244. For a reproduction, see Alexandre de Laborde, *Les manuscrits à peintures de la Cité de Dieu de Saint Augustin* (Paris, 1909), pl. cxxxvii.
26. Amsterdam, Rijksmuseum 1958, 139.
27. Friedländer, vol. 14 (1937), 101; New York, M. Knoedler & Co., 1942, 68.
28. Cuttler 1968, 202.
29. Baldass 1935, 89, n. 7; De Tolnay 1937, 27; Baldass 1943, 68; De Tolnay 1966, 347; Reuterswärd 1970, 266.
30. Eisler 1961, 48. The dimensions of the Yale panel are 36 x 31.5 cm and the Louvre panel, 57.9 x 32.6, giving a total height of 93.9 cm. These are virtually the same as the measurements of *Death and the Miser*.
31. Adhémar 1962, 29; Cuttler 1969, 274.
32. Eisler 1977, 68.
33. Morganstern 1984, 295–302. Morganstern, 298–300, believes that the drawing of the *Ship of Fools* in the

Louvre is by the same hand as the drawing of *Death and the Miser*, that is to say, a copy, and further, that both were done at the same time when the panels were together.

34. Filedt Kok 1972–1973, 151–152; Anne Morganstern, Center for Advanced Study in the Visual Arts talk of 28 October 1982.

35. 1983.48.1, pen and brown ink, 155 x 52 mm. The attribution to William Henry Brooke and date of c. 1826 were furnished by the previous owner, Mr. E. Kersley, London, in a letter of 17 June 1961 to John Walker in the curatorial files. The drawing was once part of a sketchbook, consisting primarily of topographical scenes, and Kersley's placement of the drawing in or near Arundel is based on its original position in the sketchbook.

References

1932 Glück, Gustav. *Bruegels Gemälde*. Vienna: 57.

1935 Baldass, Ludwig. "Ein Kreuzigungsaltar von Hieronymus Bosch." *JbWien* N.F. 9: 89.

1937 Friedländer. Vol. 14: 101. (vol. 5, 1969: 91, Supp. 135, pl. 117.)

1937 Tolnay, Charles de. *Hieronymus Bosch*. Basel: 27, 90, no. 7, fig. 20.

1942 Brian, Doris. "The Masters of Gothic Flanders." *ArtN* 41 (15–30 April): 14, 33, repros. 18–19.

1943 Baldass, Ludwig. *Hieronymus Bosch*. Vienna: 22–23, 30, 36, 68, 76–77, 236, figs. 29–30. (Engl. ed. New York, 1960.)

1944 Elst, Joseph van der. *The Last Flowering of the Middle Ages*. Garden City, New York: 103–104, pls. 90–91. (Fr. ed. Paris, 1951.)

1945 Tervarent, Guy de. "The Origin of One of Jérôme Bosch's Pictures." *Message: Belgian Review* 39 (January): 44–45, fig. 1.

1946 Combe, Jacques. *Jérôme Bosch*. Paris: 20–21, pl. 42. (Engl. ed. Paris, 1946.)

1949 Bax, Dirck. *Ontcijfering van Jeroen Bosch*. The Hague: 133, 239, 244, 248, 257–258, 261–263, 277, 283, fig. 58. (Engl. ed. Rotterdam, 1979.)

1951 Frankfurter, Alfred. "Interpreting Masterpieces. Twenty-Four Paintings from the Kress Collection." *ArtNA* 50, no. 7 (November): 113–114, repro. 108.

1953 Dorfles, Gillo. *Bosch*. Milan: 75, repro. 36, fig. 21.

1955 Popham, A. E. "An Unknown Drawing by Hieronymus Bosch." *Actes du XVIIᵐᵉ Congrès International d'Histoire de l'Art, Amsterdam, 23–31 Juillet 1952*. The Hague: 248.

1956 Philip, Lotte Brand. *Bosch*. New York: 18, no. 14, repro. 19.

1958 *Middeleeuwse Kunst der Noordelijke Nederlanden*. [Exh. cat., Rijksmuseum]. Amsterdam: 138–141, no. 180.

1958 Tervarent, Guy de. *Attributs et symboles dans l'art profane 1450–1600*. 2 vols. Geneva, 1: 34.

1959 Linfert, Carl. *Hieronymus Bosch. The Paintings*. Garden City, New York: 10, 113, pl. 26.

1960 Broadley, Hugh. *Flemish Painting in the National Gallery of Art*. Washington: 8, 30, 31. (Rev. ed. 1978).

1961 Eisler, Colin. *Primitifs Flamands. Corpus. New England Museums*. Brussels: 48.

1961 Seymour, Charles Jr. *Art Treasures for America. An Anthology of Paintings and Sculpture in the Samuel H. Kress Collection*. London: 78, pls. 70–71.

1962 Adhémar, Hélène. *Primitifs Flamands. Corpus. Le Musée National du Louvre, Paris*. Brussels: 25, 29.

1962 Winkler, Friedrich. Review of *Primitifs Flamands. Corpus. New England Museums* by Colin Eisler. In *Kunstchronik* 15: 321.

1963 Walker: 127, repro. 126.

1966 Tolnay, Charles de. *Hieronymus Bosch*. New York: 25, 347, cat. no. 7, repro. 91.

1966–1967 Lemmens, G., and E. Taverne. "Hieronymus Bosch. Naar aanleiding van de expositie in 's-Hertogenbosch." *Simiolus* 1: 88.

1967 Cinotti, Mia. *Tout l'oeuvre peint de Jérôme Bosch*. Paris: 92, no. 15, fig. 15 (Ital. ed. Milan, 1967).

1967 *Jheronimus Bosch*. Exh. cat. Noordbrabants Museum, 's-Hertogenbosch. Eindhoven: no. 51.

1968 Cuttler. *Northern Painting*: 201–202, fig. 252.

1968 Boon, Karel. Review of *Hieronymus Bosch* by Charles de Tolnay. In *BurlM* 110: 157.

1969 Cuttler, Charles. "Bosch and the *Narrenschiff*: A Problem in Relationships." *AB* 51: 275–276, fig. 8.

1970 Reutersward, Patrik. *Hieronymus Bosch*. Stockholm: 173–174, 266–267, cat. no. 19, figs. 35–36.

1972 Snyder, James. Review of *Musée du Louvre. Inventaire général des dessins des écoles du Nord: maîtres des anciens Pays-Bas nés avant 1550* by Frits Lugt. In *AB* 54: 89.

1972–1973 Filedt Kok, Jan Piet. "Underdrawing and drawing in the work of Hieronymus Bosch: a provisional survey in connection with the painting by him in Rotterdam." *Simiolus* 6: 151–153, fig. 16 (infrared).

1973 Gibson, Walter. *Hieronymus Bosch*. New York: 46–47, repro. 43, figs. 31–32.

1973 Ironside, Jetske. "Hieronymus Bosch; An Investigation of His Underdrawings." Ph.D. diss., Bryn Mawr College: 73–82, 90, 184, 196, 275–276, 305, pls. 1–5.

1975 Rowlands, John. *Bosch*. London: 8, pl. 16.

1975 Fraenger, Wilhelm. *Hieronymus Bosch*. Dresden: 296–297, figs. 93–94.

1977 Eisler: 66–69, figs. 60–61.

1977 Silver, Larry. "Power and pelf: a new-found *Old Man* by Massys." *Simiolus* 9: 87–88, fig. 24.

1978 Chailley, Jacques. "Jérôme Bosch et ses symboles. Essai de décryptage." Académie Royal de Belgique. Classe des Beaux-Arts. *Mémoires* 15. Fasc. 1: 106–108.

1978 Takashina, Shuji. *L'oeuvre complet de Hieronymus Bosch*. In Japanese. Tokyo: 246–247, no. 7, pls. 18–19.

1979 Martin, Gregory. *Hieronymus Bosch*. New York: no. 7, repro.

1980 Unverfehrt, Gerd. *Hieronymus Bosch. Die Rezeption seiner Kunst im frühen 16. Jahrhundert*. Berlin: 26, 36, 44–45, 54, 78–79, 223.

1981 Meijer, Bert W. "Titian Sketches on Canvas and Panel." *Master Drawings* 19: 284.

1982 Graziani, René. "Bosch's *Wanderer* and a Poverty Commonplace from Juvenal." *JWCI* 45: 212.

1982 Morganstern, Anne. "The Pawns in Bosch's *Death and the Miser*." *StHist* 12: 33–41, figs. 1–2, 4–5.

1984 Morganstern, Anne. "The Rest of Bosch's *Ship of Fools*." *AB* 66: 299–302, figs. 4, 12.

Dirck Bouts

c. 1415/1420—1475

According to Carel van Mander, Dirck (Dieric or Thierry) Bouts was born in Haarlem. The date of his birth is not known, though circumstantial evidence points to the time between 1415 and 1420. Bouts moved from Haarlem to Louvain and there married a well-to-do citizen, Katharina van der Brugghen; the marriage probably took place by 1447 or 1448, but the first document mentioning Dirck Bouts in Louvain is dated 1457. It has been suggested that Bouts emigrated to Louvain sometime between 1444 and 1448 and, further, that he might have visited Bruges or Antwerp after leaving Haarlem. Wolfgang Schöne and Georges Hulin de Loo, however, believe that Bouts returned to Haarlem after his marriage and remained there until 1456/1457. After the death of his first wife, Bouts re-married in 1472 or 1473. He made his last will and testament on 17 April, and apparently died on 6 May 1475. His two sons, Dirck the Younger and Aelbrecht, were artists. Aelbrecht painted more or less in the style of his father. Dirck the Younger's style is not known to us.

No paintings can be assigned to the Haarlem period with certainty and one can only speculate as to the nature of Dirck Bouts' activity in that city or his relationship to Albert van Ouwater, who worked in Haarlem at roughly the same time. Considerable ambiguity surrounds the earliest paintings attributed to Bouts. For example, the *Altarpiece of the Virgin* of c. 1445 in the Prado, Madrid, in addition to revealing the influence of Rogier van der Weyden in composition and Jan van Eyck in rendering of light and texture, is closely related to the work of Petrus Christus, in particular to the National Gallery's *Nativity* (1937.1.40, q.v.). The degree to which Bouts and Christus came into contact with each other, who influenced whom, or whether

both drew upon a common source remain mysteries.

Dirck Bouts' dated and documented paintings were produced after his arrival in Louvain. The *Portrait of a Man* (National Gallery, London), is dated 1462. Bouts' most famous work is the *Altarpiece of the Last Supper* (Church of Saint Peter, Louvain), which was commissioned by the Confraternity of the Eucharist of Saint Peter's; its iconographic program was dictated by two professors of theology at the University of Louvain. The contract is dated 16 March 1464, and payments were made between 1465 and 1467. The altarpiece illustrates the meticulous technique, noble solemnity of expression, and rational construction of space that distinguish Bouts' style. Around 1468 Bouts was asked to paint for the Hôtel de Ville, Louvain, four panels dealing with the subject of justice. Only two were actually painted. They depict the Justice of Emperor Otto III and are now in the Musées Royaux des Beaux-Arts, Brussels. The first, the *Ordeal by Fire*, was completed by 1473; the second, the *Execution of the Innocent Count*, was nearly finished when Bouts died in 1475; it was completed by another hand.

Dirck Bouts is one of the great artists who worked in the third quarter of the fifteenth century. Like Petrus Christus, he combines an empirical investigation of mass and void with an internalized yet intense piety and spirituality.

J.O.H.

Bibliography
Friedländer. Vol. 3, 1925 (vol. 3, 1968).
Schöne, Wolfgang. *Dieric Bouts und seine Schule*. Berlin and Leipzig, 1938.
Snyder, James. "The Early Haarlem School of Painting." *AB* 42 (1960): 39–55, 113–132.

Follower of Dirck Bouts, *Portrait of a Donor*, 1961.9.66

Follower of Dirck Bouts

1961.9.66 (1618)

Portrait of a Donor

c. 1470/1475
Transferred from wood to hardboard (cradled), 27.2 x 22.2
(10¹¹/₁₆ x 8³/₄); painted surface: 25.7 x 20.6 (10¹/₈ x 8¹/₈)
Samuel H. Kress Collection

Technical Notes: Although there is no written record of a transfer, laboratory examination strongly suggests that the paint and ground layers were removed from the original wood support and attached to a hardboard panel.[1] The reverse and edges of the panel were then veneered with what is probably oak. The background has been badly damaged and extensively overpainted in paint that is similar in tone to the original, but denser. The hair also has been heavily overpainted. There are losses, filled and unfilled, in the background and robe. The robe and areas of flesh are in relatively good condition. The painting was restored in 1949 and 1955.

Provenance: John Osmaston, Osmaston Manor, Derbyshire, by 1879.[2] Alfred Brown, Brighton, by 1906.[3] Mrs. M. A. T. Slark (sale, Christie's, London, 25 June 1948, no. 67, as Jan van Eyck). (Koetser Gallery, London.)[4] (M. Knoedler & Co., New York, by 1950.) Samuel H. Kress Foundation, New York, 1952.

Exhibitions: London, Royal Academy of Arts, 1879, *Exhibition of Works by the Old Masters and by Deceased Masters of the British School*, no. 218, as Jan van Eyck. // London, Art Gallery of the Corporation of London [Guildhall], 1906, *Exhibition of Works by Flemish and Modern Belgian Painters*, no. 4, as John van Eyck. // The Denver Art Museum, 1950–1951, *Art of the Middle Ages*, as Dirck Bouts.[5]

THE *Portrait of a Donor* gives every appearance of being a fragment. It may have been part of an altarpiece, perhaps the interior left wing, or the left wing of a diptych. It is not clear whether the figure was kneeling or standing, and thus it is difficult to extrapolate an approximate size for the original panel. After being exhibited as a work by Jan van Eyck in 1897 and 1906, the *Portrait of a Donor* was described by Friedländer in 1906 as Netherlandish, c. 1450, and close to Bouts.[6] He noted the overpainted background and suggested that the painting was part of the wing of an altarpiece. By 1925 Friedländer had decided the work was an autograph painting by Dirck Bouts.[7] Baldass also attributed the portrait to Bouts and dated it c. 1460/

1465.[8] He placed it between the *Martyrdom of Saint Erasmus* altarpiece (Church of Saint Peter, Louvain) and the *Madonna and Child* (Städel'sches Kunstinstitut, Frankfurt), along with the *Portrait of a Man* of 1462 (National Gallery, London).[9] Suida and Shapley accepted the attribution to Bouts and proposed a date of c. 1455.[10] James Snyder also believes the *Portrait of a Donor* is by Bouts and finds several points of comparison with figures in the *Altarpiece of the Last Supper*, 1464/1467 (Louvain, Church of Saint Peter).[11]

In 1938 Schöne asserted that the *Portrait of a Donor* was not by Bouts, but was perhaps either by an artist close to Bouts, the Master of the Munich *Taking of Christ*, or an artist who stood between this master and Hugo van der Goes.[12] Schöne noted a resemblance, especially in the hands, to the *Madonna and Child* in the John G. Johnson Collection, Philadelphia Museum of Art, which he thought was possibly by the Master of the Munich *Taking of Christ* but under the strong influence of Hugo van der Goes. Winkler, in discussing the Philadelphia *Madonna and Child* as a possible early work by Hugo van der Goes, stressed the similarity of Mary's left hand with its raised knuckles to the hands in the *Portrait of a Donor*.[13] Winkler did not agree with Friedländer's attribution of the Gallery's picture to Bouts; he observed that like the Philadelphia *Madonna and Child* it recalled both Dirck Bouts and Hugo van der Goes without attaining the quality of either. Eisler catalogued the painting as Circle of Bouts and thought it was probably painted around 1470 by an artist active in Louvain or Ghent.[14]

Along with Schöne, Winkler, and Eisler, I do not believe that the *Portrait of a Donor* was painted by Dirck Bouts. Even making allowances for the painting's poor condition, the angular, essentially linear handling of the face and thin, nervous hands do not accord with the smooth, solidly rounded forms found in those paintings securely attributed to Bouts. On a more Morellian level, the little fingers crossed over each other do not occur in Bouts' work. Despite the similarly prominent knuckles, the Philadelphia *Madonna and Child* is not by the same hand, though both may have been influenced by Hugo van der Goes. The *Portrait of a Donor* is closer to Dirck Bouts' style than to Hugo's and was perhaps painted in Louvain. I would date the painting c. 1470/1475.[15]

J.O.H.

Notes

1. NGA 1975, 44, lists the support as wood, while Eisler 1977, 54, states that the panel was transferred to hardboard (masonite), but gives no further information or date for the transfer.

2. John Osmaston is listed as owner in exh. cat. London 1879.

3. Alfred Brown is listed as owner in exh. cat. London 1906.

4. I am extremely grateful to Lorne Campbell for this and the preceding reference.

5. There seems to have been no printed catalogue for this exhibition.

6. Friedländer 1906, 574.

7. Friedländer, vol. 3 (1925), no. 7.

8. Baldass 1932, 93.

9. Friedländer, vol. 3 (1968), no. 8, pl. 14; no. 15, pl. 23; no. 12, pl. 20.

10. Suida and Shapley 1956, 42. Curiously, they found no evidence that the painting had been cut down.

11. James Snyder, letter to the author (1982) in the curatorial files, feels it is an autograph painting in bad condition and compares the facial features to those of the old man who stands behind Saint Peter in the *Last Supper* panel and to the aged donor(?) at the extreme left of the *Abraham and Melchizedek* panel of the Louvain altarpiece (Friedländer, vol. 3 [1968], no. 18, pls. 27–28).

12. Schöne 1938, 170.

13. Winkler 1964, 254. Winkler listed the Philadelphia painting as a disputed work; others, including Friedländer, suggest that it is an early work by Hugo van der Goes. See Barbara Sweeny, *John G. Johnson Collection. Catalogue of Flemish and Dutch Paintings* (Philadelphia, 1972), 41–42, no. 336, repro. 108.

14. Eisler 1977, 54.

15. Stella Mary Newton in a letter to Colin Eisler of 19 October 1967 in the curatorial files proposed a date in the 1470s based on the costume.

References

1906 Friedländer, Max J. "Die Leihausstellung in der Guildhall zu London.—Sommer 1906.—Hauptsächlich niederländische Bilder des 15. und 16. Jahrhunderts." *RfK* 29: 574.

1906 Weale, W. H. James. "Netherlandish Art at the Guildhall. Part I." *BurlM* 9: 186.

1925 Friedländer. Vol. 3: 106, no. 7, pl. 12 (vol. 3, 1968, no. 7, pl. 13).

1929 Fierens, Gevaert, and Paul Fierens. *Histoire de la peinture flamande des origines à la fin du XVᵉ siècle*. 3 vols. Paris and Brussels, 3: 18.

1932 Baldass, Ludwig. "Die Entwicklung des Dirk Bouts. Eine stilgeschichtliche Untersuchung." *JbWien* N.F. 6: 93.

1938 Schöne, Wolfgang. *Dieric Bouts und seine Schule*. Berlin and Leipzig: 41, 170, no. 54, pl. 72a.

1950 Bach, Otto Karl. "Art of the Middle Ages." *Denver Art Museum Quarterly* (Winter): 7–8, repro.

1956 Kress: 42, no. 12, repro. 43.

1964 Winkler, Friedrich. *Das Werk des Hugo van der Goes*. Berlin: 254, fig. 200.

1975 NGA: 44, no. 1618, repro. 45.

1977 Eisler: 54, fig. 56.

Pieter Bruegel the Elder

c. 1525–1569

Although the primary source of knowledge about the life of Pieter Bruegel the Elder is Carel van Mander's *Het Schilder-Boek* of 1604, his account is sometimes untrustworthy and anecdotal. Relatively few facts have been added to Van Mander's biography.

Bruegel's birth date and place are unknown, but it is generally assumed that he was born sometime between 1525 and 1530, most likely in Breda. Van Mander's statement that Bruegel first studied with Pieter Coecke van Aelst of Antwerp is not documented; there is, however, some visual evidence that Bruegel was aware of Coecke's art. A recently discovered document indicates that in 1550 Bruegel was working in Mechelen in the shop of Claude Dorizi on an altarpiece for the church of Saint Rombaut. Although the altarpiece is lost and Bruegel worked only on the exterior wings, he would have been trained in the technique of painting on linen, a specialty of the city, which he used in some of his later works.

In 1551 Bruegel became a master in the guild of Saint Luke in Antwerp. Almost immediately thereafter he set off for Italy. Drawings with Italian motifs are dated 1552, and by 1553 the artist was in Rome, where he worked with the miniaturist Giulio Clovio. He seems also to have visited Naples and traveled through the Alps, returning to Antwerp sometime in 1554. In 1555 Bruegel began to provide the Antwerp artist and publisher Hieronymus Cock with designs for prints; their close association and friendship continued until Bruegel's death. The artist seems to have stayed in Antwerp until 1563. In 1563 he married Pieter Coecke's daughter Mayken and moved to Brussels. Bruegel worked in Brussels until his death on 9 September 1569. His two sons, Pieter Brueghel the Younger (1564/1565–1638) and Jan Brueghel the Elder (1568–1625), were artists.

The majority of Bruegel's paintings are signed and dated, and his development can be followed in detail. The earliest paintings are landscapes, *Christ Appearing to the Apostles at the Sea of Tiberias*, dated 1553 (Charles de Pauw collection, Wavre, Belgium), and

The Parable of the Sower, dated 1557 (Timken Art Gallery, San Diego), and are signed Brueghel. From 1559 on the artist spelled his name Bruegel. The works produced in Antwerp are encyclopedic and folkloristic, as for example, the *Netherlandish Proverbs* of 1559 (Gemäldegalerie, Berlin). The influence of the art of Hieronymus Bosch can be seen in the designs for prints and in such paintings as *The Fall of the Rebel Angels*, 1562 (Musées Royaux des Beaux-Arts, Brussels), and the *Dulle Griet*, probably 1562 (Museum Mayer van den Bergh, Antwerp).

With the move to Brussels Bruegel's style changed. Italian influence, specifically Raphael's, became apparent, and at the same time Bruegel became one of the greatest landscape painters of the sixteenth century. This can be seen in the series of paintings depicting the Labors of the Months, created in 1565 for the Antwerp home of the wealthy banker and government official Niclaes Jonghelinck. The series is apparently incomplete; three of the pictures are in the Kunsthistorisches Museum, Vienna, one is in the National Gallery, Prague, and another in the Metropolitan Museum of Art. The true subject is nature, presented on a panoramic, cosmic scale; each painting is unique in its composition and depiction of seasonal atmospheric effects. Bruegel was also a master of figural compositions, as for example the *Peasant Wedding*, c. 1567 (Kunsthistorisches Museum, Vienna), or the *Wedding Dance* of 1566 (Detroit Institute of Arts). His late paintings, such as *The Peasant and the Birdnester* (Kunsthistorisches Museum, Vienna) and the *Misanthrope* and *The Parable of the Blind* (both Museo Nazionale, Naples), all dated 1568, concentrate upon a few large figures who often recall Michelangelo and are moralizing, even pessimistic, in tone.

Pieter Bruegel the Elder was the preeminent artist of the mid-sixteenth century. His patrons included the rich and powerful, like Cardinal Granvelle, Archbishop of Mechelen and advisor to Philip II of Spain, and the German merchant Hans Franckert, and he counted among his friends the humanist and geographer Abra-

ham Ortelius. Although the precise interpretation of many works is debated, Bruegel, like his predecessor Bosch, seems to be a moralist who views man as foolish and intolerant. This may be contrasted to the artist's delight in nature, which he describes lovingly and imbues with the heroic grandeur lacking in man.

<div align="right">J.O.H.</div>

Bibliography
Stridbeck, Carl Gustaf. *Bruegelstudien*. Stockholm, 1956.
Grossmann, Fritz. "Bruegel, Pieter the Elder." *Encyclopedia of World Art*. 16 vols. New York, Toronto, and London, 1959–1983. Vol. 2, 1960: cols. 632–651.
Grossmann, Fritz. *Pieter Bruegel. Complete Edition of the Paintings*. London, 1973.
Bruegel. Une dynastie de peintres. Exh. cat., Palais de Beaux-Arts. Brussels, 1980.

Follower of Pieter Bruegel the Elder

1952.2.19 (1102)

The Temptation of Saint Anthony

c. 1550/1575
Oak (cradled), 58.5 x 85.7 (23 x 33¾)
Samuel H. Kress Collection

Technical Notes: The panel consists of two boards whose grain runs horizontally. A split along the join line of the boards has been repaired across the center with a wide fill. This damage may have occurred prior to 1935, when the painting apparently fell off a wall.[1] A strip of wood 1.3 cm wide has been added to the top of the painting. With the exception of the center split and the top edge, the painting is relatively free of inpainting. There is some retouching along the edges. A dendrochronological examination by Josef Bauch in 1977 suggested that $1543^{+x}_{-\frac{x}{2}}$ was the earliest possible felling date.[2] Infrared reflectography discloses underdrawing in the trees (fig. 1) and other portions of the landscape, but none apparently in the figures. The painting received minor treatment in 1965, 1968, 1977, and 1982.

Provenance: Private collection, Brussels. (Robert Frank, London, by 1935.)[3] (Knoedler & Co., New York, on consignment from Robert Frank, 1937–1945; owned with Pinakos [Rudolf Heinemann] 1945–1950.)[4] Samuel H. Kress Foundation, New York, 1950.

Exhibitions: Brussels, 1935, *Exposition Universelle et Internationale de Bruxelles. Cinq Siècles d'Art*, no. 151, as Pieter Bruegel the Elder. // Paris, Musée de l'Orangerie, 1935, *De Van Eyck à Bruegel*, no. 16, as Pieter Bruegel the Elder. // The Baltimore Museum of Art, 1943, *An Exhibition of Paintings by Living Masters of the Past*, 9, as Pieter Bruegel the Elder. // Portland Art Museum, 1944, *8 Masterpieces of Painting*, not paginated, as Pieter Bruegel the Elder. // The Baltimore Museum of Art, 1948, *Themes and Variations in Painting and Sculpture*, no. 98, as Pieter Bruegel the Elder.

THE PRIMARY SOURCE for our knowledge of Saint Anthony Abbot is the life written by his contemporary, Saint Athanasius. In the year 272 at the age of twenty-one Anthony gave away his possessions and retired to the desert in his native Egypt to become a hermit and ascetic. There he was tempted and tormented by the Devil and numerous demons. In the late Middle Ages the life of Saint Anthony was popularized, especially by *The Golden Legend*.[5] Anthony's temptations were amplified and codified. The Gallery's painting depicts essentially two scenes: the saint's terrestrial torment and, at the left, his aerial torment, in which he was carried high into the air and attacked by demons.

The attribution of *The Temptation of Saint Anthony* to Pieter Bruegel the Elder has been doubted almost from the moment of the painting's discovery in 1935. The first to publish the painting was Leo van Puyvelde, who gave it to Bruegel the Elder and dated it c. 1555; he also, somewhat confusingly, compared it to the *Magpie on the Gallows*, Hessisches Landesmuseum, Darmstadt, painted only a year before Bruegel's death.[6] Glück thought the painting was autograph and dated it c. 1558.[7] Friedländer considered it genuine.[8] In the same year, 1935, de Tolnay listed the painting under Bruegel's contested works; for de Tolnay the touch and coloring raised the possibility that it was an early work by Jan Brueghel the Elder.[9] In subsequent publications Glück, Friedländer, and Puyvelde reaffirmed their attribution of the panel to Pieter Bruegel the Elder along with an early dating.[10] Bruegel's authorship was accepted by Hoogewerff, Delevoy, Claessens, and Rousseau as well as by the National Gallery of Art until 1976.[11]

Most scholars, however, have questioned or rejected the attribution to Pieter Bruegel the Elder. Raczyński, following de Tolnay, gave the painting to Jan Brueghel the Elder and thought that the painterly handling could not be before the 1580s.[12] Van de Wetering, while not taking a definite stand, observed that the cool greenish-blue tonality was typical of the generation following Bruegel.[13] For Genaille the finesse and "sentiment" of the landscape indicated a hand other than Pieter the Elder's and suggested that of Jan the Elder.[14] Grossmann did not accept the painting as by Pieter Bruegel the Elder.[15] He found the monsters harmless and unconvincing and the fussy surface texture and lack of solidity separate from Pieter the Elder. While he thought the attribution to Jan the Elder deserved consideration, the landscape composition seemed to him to fit better into the middle than the late sixteenth century. Gibson gave the painting to a Flemish artist working later than Pieter Bruegel the Elder.[16] Although Eisler indicated that the force and plasticity usually found in Bruegel's work were lacking, he left open the possibility that the painting might have been executed in the master's atelier.[17] In 1976 the National Gallery's attribution was changed to Follower of Pieter Bruegel

Fig. 1. Infrared reflectogram assembly of a detail of *The Temptation of Saint Anthony*, 1952.2.19 [infrared reflectography: Molly Faries]

the Elder and the work was loosely dated to the second half of the sixteenth century.

In this author's view, *The Temptation of Saint Anthony* is not from the hand of Pieter Bruegel the Elder. The figures lack the emotional and physical power characteristic of Bruegel; the cool tonalities of blue and green and feathery, delicate brushwork are not traits of the master. Yet the painting is of exceptionally high quality and uses Bruegel's artistic vocabulary in a synthetic way that is not seen in the work of other followers.

Of the numerous figures in the painting, the one closest to Bruegel is that of Saint Anthony himself, seated under the rough lean-to. As noted by Grossmann, the source is Bruegel's drawing of *The Temptation of Saint Anthony* (fig. 2) of 1556 in the Ashmolean Museum, Oxford.[18] The Boschian demons and biomorphic hybrids, while at once related to the creatures that inhabit Bruegel's works, are also part of the larger tradition of copies and variants that satisfied the demand for Bosch-like paintings throughout the sixteenth century.[19] The scene of Saint Anthony's aerial torment, while not occurring elsewhere in Bruegel, does appear in a woodcut of 1522 depicting *The Temptation of Saint Anthony*, usually attributed to Jan de Cock, as well as in Jan Mandyn's painting in the Frans Halsmuseum, Haarlem.[20]

What separates the Gallery's painting from the work of Bosch followers like Jan Mandyn (1502–c.1560) or Pieter Huys (1519–1584)[21] is the dominance of the landscape. As several writers have observed, the influence of Joachim Patinir is evident in the panoramic view and fantastic rock formation at the

Fig. 2. Pieter Bruegel the Elder, *The Temptation of Saint Anthony*, 1556, pen and brown ink, 216 x 326 mm, Oxford, Ashmolean Museum [photo: Ashmolean Museum]

Follower of Pieter Bruegel the Elder, *The Temptation of Saint Anthony*, 1952.2.19

left.[22] More direct is the dependence on Bruegel's works, both early and late; the painting seems to combine the panoramic river views of the early engravings such as the *Way to Emmaus* or the *Flight into Egypt*[23] with the juxtaposition of leafy forest to deep space found in the late paintings of *The Peasant and Bird-Nester* of 1568 in the Kunsthistorisches Museum, Vienna, and to a lesser extent the *Magpie on the Gallows* of the same year.[24] This basically mannerist composition, "open" on one side and "closed" on the other, occurs in Netherlandish landscapes of the second half of the sixteenth century, in the work of Hans Bol and Gillis van Coninxloo, for example.[25] While *The Temptation of Saint Anthony* may initially resemble the landscapes produced in the 1580s and 1590s by Gillis van Coninxloo or Jan Brueghel the Elder,[26] the absence of a patterned contrast of light and dark in the foliage argues for an earlier date. I agree with Grossmann and would date *The Temptation of Saint Anthony* to c. 1550/1575. While the possibility that the painting preserves a lost composition by Pieter Bruegel the Elder cannot be excluded, the heterogeneous nature of the painting suggests that the artist drew from several of Bruegel's works as well as from those of contemporary followers of Bosch.

J.O.H.

Notes

1. Puyvelde 1935, 17.

2. See Appendix I.

3. The 1935 Brussels exhibition catalogue states that before being acquired by Frank the painting was in Brussels in the collection of an unnamed aristocrat. On the reverse are: an illegible stamp, possibly an Austrian customs stamp; a paper sticker, "Cinq Siècles d'Art (Bruxelles 1935)"; and a paper sticker, "Exposition De Van Eyck."

4. I am grateful for information provided by Burton Fredericksen. The 1943 Baltimore exhibition catalogue and Eisler 1977, 95, list Countess Montblanc, Belgium, as owner of the painting, but this is otherwise unverified.

5. Réau, *Iconographie*, vol. 3, part 1, 101–115; Thurston and Attwater, *Butler's Lives of the Saints*, 1: 104–109; Ryan and Ripperger, *The Golden Legend*, 1: 99–103. A discussion of the life of Saint Anthony and late fifteenth-century translations into Dutch of *The Golden Legend* and the *Vitae Patrum* are found in Dirk Bax, *Hieronymus Bosch. His Picture-Writing Deciphered* (Rotterdam, 1979), 7–12.

6. Puyvelde 1935, 47–48, 50.

7. Glück 1935, 151–156.

8. Friedländer 1935, 90.

9. De Tolnay 1935, 96.

10. Glück 1936, 11, 23, no. 3; Glück 1937, 15–16, 40, no. 6a and in several later editions; Friedländer, vol. 14 (1937), 11–12, 58, no. 5, mentioned as on the art market in Paris, London, or New York; Puyvelde 1962, 118, 132.

11. Hoogewerff 1954, 48–49; Delevoy 1959, 31–32; Claessens and Rousseau 1969, 230; Suida 1951, 204, no. 90; NGA 1975, 50, no. 1102.

12. Raczyński 1937, 53.

13. Wetering 1938, 66.

14. Genaille 1953, 82.

15. Letter to Colin Eisler 25 January 1969 in the curatorial files. The omission of the Gallery's painting from Fritz Grossmann, *Pieter Bruegel. Complete Edition of the Paintings* (London, 1973) as well as from Wolfgang Stechow, *Pieter Bruegel the Elder* (New York, 1969), given the nature of both books, signifies rejection of the attribution.

16. Walter Gibson, letter to the author 16 April 1976 in the curatorial files.

17. Eisler 1977, 95.

18. Reproduced and discussed in Ludwig Münz, *Bruegel, The Drawings. Complete Edition* (London, 1961), 225, no. 127, pl. 124. In his letter of 25 January 1969, Grossmann, without elaboration, states that the figure is based on the drawing and not on the engraving made from it.

19. Bruegel's use of Bosch-inspired figures is well known and perhaps most evident in the engravings, for example *Patience* (1556–1557), the series of the Seven Deadly Sins (1556–1557), and later prints of *Saint James and the Magician Hermogenes* and *The Fall of the Magician Hermogenes* (1564–1565), reproduced in Jacques Lavalleye, *Pieter Bruegel the Elder and Lucas van Leyden. The Complete Engravings, Etchings, and Woodcuts* (New York, 1967), pls. 35, 41–47, 138–139. Perhaps the most Boschian of the paintings is the *Dulle Griet*, probably 1562 (Museum Mayer van den Bergh, Antwerp), reproduced in Wolfgang Stechow, *Pieter Bruegel the Elder* (New York, 1969), 71, color pl. 10. I have not found any exact correspondences between Bruegel's demons and those in the Gallery's painting. See Unverfehrt 1980, 151–186 for the extensive influence of Bosch upon sixteenth-century northern European art and depictions of the temptation of Saint Anthony in particular. He focuses more upon the first rather than the second half of the sixteenth century.

20. Hoogewerff 1954, 49, and Eisler 1977, 95, call attention to the woodcut as a possible antecedent; for a reproduction see Robert A. Koch, *Joachim Patinir* (Princeton, 1968), fig. 48. Mandyn's *Temptation of Saint Anthony* is reproduced in color in Jacques Lassaigne and Robert Delevoy, *Flemish Painting. From Bosch to Rubens* (Geneva, 1977), 34.

21. *The Temptation of Saint Anthony* by Pieter Huys, signed and dated 1577, in the Museum Mayer van den Bergh, Antwerp, demonstrates the continuation of Bosch's imagery into the third quarter of the sixteenth century. See Jozef de Coo, *Museum Mayer van den Bergh. Catalogus 1. Schilderijen, Verluchte Handschriften, Tekeningen* (Antwerp, 1978), 78–79, no. 25, pl. 42.

22. Patinir's influence on the Gallery's painting was noted by Glück 1935, 152; Friedländer, vol. 14 (1937), 12; Wetering 1938, 66; Genaille 1953, 82; and Eisler 1977, 95. For Patinir see Koch, *Joachim Patinir* (as in n. 20). Eisler 1977, 96, n. 21, also observes the similarity of the rock formation to that found in Joos van Cleve's *Rest on the Flight into Egypt*, Musées Royaux des Beaux-Arts, Brussels; Friedländer, vol. 9, part 1 (1972), no. 49, pl. 63. For the continuation of Patinir's influence in the first half of the sixteenth century, see 1952.2.18, Antwerp Artist, *The Martyrdom of Saint Catherine*.

23. Reproduced in Lavalleye, *Pieter Bruegel the Elder and Lucas van Leyden*, pls. 14–15 (as in n. 19).

24. Reproduced in Stechow, *Pieter Bruegel the Elder*, color pls. 44–45. There are also some similarities of spatial

organization to Bruegel's drawing *Forest Landscape with Five Bears*, dated 1554, in the National Gallery, Prague; discussed and reproduced in Karl Arndt, "Pieter Bruegel d.Ä. und die Geschichte der 'Waldlandschaft,'" *JbBerlin* 14 (1972), 87–90, 88, fig. 3.

25. See Heinrich Gerhard Franz, *Niederländische Landschaftsmalerei im Zeitalter des Manierismus*, 2 vols. (Graz, 1969), 2; for Hans Bol, figs. 306, 312–313, and for Gillis van Coninxloo, figs. 412, 419–420.

26. In a letter to the author of 7 March 1978, Klaus Ertz states that *The Temptation of Saint Anthony* is definitely not an early work by Jan the Elder as de Tolnay and others have suggested.

References

1935 Puyvelde, Leo van. "Zwei Gemälde von Pieter Bruegel d.Ä." *Pantheon* 15: 47–50, repros. 47, 49, facing 47.

1935 Friedländer, Max J. Review of *Bruegel's Gemälde* by Gustav Glück. In *BurlM* 67: 90.

1935 Tolnay, Charles de. *Pierre Bruegel l'Ancien*. Brussels: 96, no. 54.

1935 Glück, Gustav. "Über einige Landschaftsgemälde Pieter Bruegels des Älteren." *JbWien* N.F. 9: 151–157, 161–162, pl. 3, 154, fig. 105.

1936 Glück, Gustav. *Das Bruegel Buch*. Vienna: 9–10, no. 4, repro. (Also eds. 1941, 1951).

1936 Glück, Gustav. *Pieter Brueghel the Elder*. Paris: 11, 23, no. 3, repro.

1937 Glück, Gustav. *Bruegels Gemälde*. Vienna: 15–16, 27, 40, no. 6a, repro.

1937 Friedländer. Vol. 14: 11–12, 58, no. 5, pl. 5 (vol. 14, 1976: 18, 42, no. 5, pl. 5).

1937 Raczyński, Joseph Alexander. *Die flämische Landschaft vor Rubens*. Frankfurt: 53.

1938 Wetering, Cornelis van de. *Die Entwicklung der niederländischen Landschaftsmalerei vom Anfang des 16. Jahrhunderts bis zur Jahrhundertmitte*. Berlin: 66, pl. 456.

1938 Jedlicka, Gotthard. *Pieter Bruegel. Der Maler in seiner Zeit*. Erlenbach: 540.

1951 Kress: 204, no. 90, 205.

1951 Frankfurter, Alfred. "Washington: Celebration, Evaluation." *ArtN* 50 (April): 31, 62, repro.

1951 Frankfurter, Alfred. "Interpreting Masterpieces. Twenty-four Paintings from the Kress Collection." *ArtNA* 50 (November): 115–116, repro. 110.

1952 Castelli, Enrico. *Il Demoniaco nell'Arte*. Milan and Florence: 67, 69, pl. 42.

1953 Genaille, Robert. *Bruegel l'Ancien*. Paris: 82, pl. 51.

1954 Hoogewerff, G. J. *Het Landschap van Bosch tot Rubens*. Antwerp: 48–49.

1956 Walker: unpaginated, repro.

1957 Shapley, Fern Rusk, and John Shapley. *Comparisons in Art: A Companion to The National Gallery of Art, Washington, D.C.* New York: 136, repro.

1959 Delevoy, Robert. *Bruegel*. Geneva: 31–32, 39, repro.

1960 Broadley, Hugh. *Flemish Painting in the National Gallery of Art*. Washington: 8, 32, repro. 33. (Rev. ed. 1978).

1961 Seymour, Charles. *Art Treasures for America. An Anthology of Paintings & Sculpture in the Samuel H. Kress Collection*. London: 92, repro.

1961 Denis, Valentin. *All the Paintings of Pieter Bruegel*. New York: 45.

1962 Cairns and Walker: 76, repro. 77.

1962 Puyvelde, Leo van. *La peinture flamande au siècle de Bosch et Breughel*. Paris: 118, 132, pl. 40.

1963 Walker: 128, repro. 129.

1968 Klein, H. Arthur, and Mina Klein. *Peter Bruegel the Elder. Artist of Abundance*. New York: 184.

1969 Roberts-Jones, Philippe. *Bruegel, le peintre et son monde*. Brussels: 47, no. 5, repro.

1969 Classens, Bob, and Jeanne Rousseau. *Our Bruegel*. Antwerp: 229–230, fig. 7.

1975 NGA: 50, repro. 51.

1976 Walker: fig. 191.

1977 Eisler: 93–96, figs. 91–92.

1980 Unverfehrt, Gerd. *Hieronymus Bosch. Die Rezeption seiner Kunst im frühen 16. Jahrhundert*. Berlin: 184.

Robert Campin

c. 1375–1444

The precise date of Robert Campin's birth is unknown, but a document of 1422 gives his age as forty-seven. He was active in Tournai by 1406. He purchased citizenship there in 1410, which has been taken as an indication that he was born elsewhere, though this need not be the case. He evidently enjoyed a prosperous career, receiving a number of civic commissions and taking on several apprentices. He must also have had some court contacts, as the countess of Hainaut interceded on his behalf after he had been sentenced for immoral behavior in 1432. He died in 1444.

None of the pictorial works documented to Campin survives. Campin, the historical figure, was first linked to a surviving body of work through comparison with documented paintings datable to 1434 by his pupil Jacques Daret. The early works attributed to his most important pupil, Rogier van der Weyden, a native of Tournai, in particular the *Deposition* in the Prado, further support the connection between surviving paintings and the historical figure of Campin. The paintings thus given to Campin had previously been ascribed to the anonymous Master of Flémalle, named after altarpiece wings of the *Virgin and Child*, *Saint Veronica*, and *The Trinity* said to come from Flémalle, all now in the Städel'sches Kunstinstitut, Frankfurt. Related paintings include a fragment from a monumental altarpiece of the Deposition also in Frankfurt; the Entombment triptych in the Princes Gate Collection, Courtauld Institute Galleries; the Mérode triptych in the Cloisters, New York; and a *Nativity* in the Musée des Beaux-Arts, Dijon. Because his oeuvre has been assembled on the basis of stylistic associations, and because Campin evidently headed an active workshop, the attribution of a number of works to him is still debated. In general, the four paintings in Frankfurt should be viewed as forming the core of his oeuvre.

Together with Jan van Eyck, Campin is a key figure in the emergence of the Netherlandish school with its emphasis on observation of the natural world. His influence is traceable through later generations of painters, due probably to his importance as a teacher as well as to the expressive power of his devotional types. In what must be Campin's mature works, such as the fragment from the Deposition altarpiece, strongly modeled forms appear to project forward from the panel's surface with the effect of polychromed sculpture. For Campin, who began his career in the period of the International Gothic, the panel as a physical surface remained an expressive element. The tension between illusion and painted surface intensifies the emotional power of his compositions.

M.W.

Bibliography

Tschudi, Hugo von. "Der Meister von Flémalle." *JbBerlin* 19 (1898): 8–34, 89–116.

Hulin de Loo, Georges. "An Authentic Work by Jacques Daret, Painted in 1434." *BurlM* 15 (1909): 202–208.

Tolnay, Charles de. *Le Maître de Flémalle et les frères Van Eyck*. Brussels, 1939.

Campbell, Lorne. "Robert Campin, the Master of Flémalle and the Master of Mérode." *BurlM* 116 (1974): 634–646.

Schabacker, Peter H. "Notes on the Biography of Robert Campin." *Mededelingen van de Koninklijke Academie voor Wetenschapen, Letteren en Schone Kunsten van België. Klasse der Schone Kunsten* 41 (1980): 3–14.

Follower of Robert Campin

1959.9.3 (1388)

Madonna and Child with Saints in the Enclosed Garden

c. 1440/1460
Oak (cradled), 122.2 x 151.2 (48¼ x 59⁹/₁₆);
 painted surface: 119.8 x 148.5 (47¼ x 58½)
Samuel H. Kress Collection

Technical Notes: The panel is made up of five horizontal boards. The unpainted edge on all sides suggests that the panel was painted in an engaged frame. The present frame is a composite construction, the oak bottom member, including the inscription, being older than the softwood top and side elements to which it is joined (fig. 1).[1] The painting was cleaned and disfiguring overpaint removed in the 1830s.[2] The panel was cradled in 1947 by Stephen Pichetto, and the painting was partially cleaned and restored at that time. A fire on 26 December 1956 left the paint surface blistered, stained, and darkened. Mario Modestini secured the blisters and in 1958–1959 cleaned and restored the painting. In spite of its history, the painting is in relatively good condition. There is inpainting along the joins and in scattered areas throughout the picture. There is also a certain amount of abrasion throughout. Larger areas of loss and inpainting occur in the Baptist's proper right leg and the robe above it, in some lower parts of the Virgin's robe, and at the base of her neck.

The figures are underdrawn with the brush, using long strokes and some rather widely spaced cross hatching. The position of the heads has been adjusted slightly in relation to the underdrawing. The four saints originally had round halos with concentric rings that were incised in the ground layer and apparently prepared in gold. These are visible under the microscope and with infrared reflectography (fig. 2). They seem to have been overpainted in the course of the painting process. Gold is also used as the background of the cloth hanging from the back wall. A green paint layer forms the brocade pattern, with the gold background showing through as schematized flowers.

Provenance: A church in Bruges.[3] Imbert de Mottelettes, Bruges, by 1831.[4] Jonkheer de Potter-Soenens, Ghent, by 1839.[5] Countess de Oudemard.[6] (Wildenstein and Co., New York, 1946–1949.) Samuel H. Kress, New York, 1949.

Exhibitions: Tucson, University of Arizona Museum of Art, 1951–1953, *Twenty-Five Paintings from the Collection of the Samuel H. Kress Foundation*, no. 15, as studio of the Master of Flémalle.

THIS IMPOSING PANEL is the only surviving painting of a Madonna and Child with saints from the circle of Robert Campin. The enthroned Madonna and Child are flanked by Saint Catherine, identifiable by the wheel and sword of her martyrdom; Saint John the Baptist whose pointing gesture recalls his admonition, "Behold the Lamb of God"; Saint Barbara identified by the miniature tower behind her, and Saint Anthony Abbot whose attribute of a little pig refers to his temptations. The walled garden both delimits the space in which these holy figures exist and serves as a symbol of the Virgin's purity. The enclosed garden is frequently cited in Marian hymns as a metaphor for the Virgin and derives from the passage in the Song of Solomon, "A garden enclosed is my sister, my spouse; a spring shut up, a fountain sealed."[7] In a more general sense, the enclosed garden indicates that the setting for this meeting of the enthroned Madonna and saints is Paradise.[8] The associations with Paradise and the relationship of the composition to representations of the Madonna and Child with saints and donors suggest that the panel may have served as an epitaph.[9]

As is typical for the works of Campin and his circle, this painting employs figure types that are repeated and varied in a number of works. The Madonna type has much in common with that in two drawings in Paris showing the Madonna and Child enthroned with saints and donors, which probably copy a lost painting by Campin or a member of his circle.[10] The connection is particularly evident in the fall of drapery over the Virgin's lap and in the Child's gesture. Dirk de Vos has shown convincingly that this type derives from a compositon of the Madonna and Child with a flower originated by Campin and known only through copies.[11] The Washington version includes variations in the spirit of Campin, notably the Christ Child's shirt falling open, his hand drawn back with the palm forward, and the Virgin's hands intertwined over the Child's chest. The character of these variations as well as the fact that some of them also occur in the *Holy Family* in the cathedral of Le Puy[12] suggest that the design of the Washington Madonna is close to Campin himself. The figure of Saint Barbara appears to be an adaptation of the woman bending toward the swooning Virgin in Campin's monumental Deposition triptych, as it is known through the copy in Liverpool.[13] The figure of Saint Catherine in the Washington painting is closely

Fig. 1. Detail of frame of *Madonna and Child with Saints in the Enclosed Garden*, 1959.9.3 [photo: NGA]

related in pose and compositional function to the *Magdalene Reading* in the National Gallery, London. This fragment originally formed the lower right corner of a relatively early painting by Rogier van der Weyden.[14] The pose of the Baptist in the Washington panel echoes a type current in the circle of Campin and Van der Weyden. Related figures include the Baptist on the left wing of the *Werl Altarpiece*, dated 1438, whose attribution to Campin has been questioned,[15] and the Baptist in Rogier's *Medici Madonna* in Frankfurt (fig. 3).[16]

The Baptist in the *Enclosed Garden* is particularly close to the Frankfurt figure in the distribution of weight, the contour of the bent leg, and the way the drapery falls around the legs. Yet the stance of the latter is more logical, being dictated by his placement with other saints on steps leading up to the Madonna. This suggests that the Baptist in the Washington painting is a stock design. The repetition of established types is also traceable in smaller details. Thus the clump of six-petalled yellow flowers just to the left of Saint

Fig. 2. Infrared reflectogram assembly of a detail of *Madonna and Child with Saints in the Enclosed Garden*, 1959.9.3 [infrared reflectography: Molly Faries]

Follower of Robert Campin, *Madonna and Child with Saints in the Enclosed Garden*, 1959.9.3

Fig. 3. Rogier van der Weyden, *Medici Madonna*, Frankfurt, Städel'sches Kunstinstitut und Städtische Galerie [photo: Städel'sches Kunstinstitut, Ursula Edelmann, photographer]

Anthony is also found in the Frankfurt *Madonna and Child* by Campin (fig. 4).[17]

The way these different elements are used raises the question of the work's distance from Campin himself. Is it a work by Robert Campin, a repetition of a lost prototype by him, or a recombination of elements derived from Campin and Van der Weyden? Although the Gallery attributed the painting to the Master of Flémalle and assistants at the time of its acquisition, it appears to be the work of a single hand. Virtually unanimous scholarly opinion gives it to a follower of Campin.[18] Indeed, the possibility that the painting is an autograph work by Campin can readily be excluded if the four paintings in Frankfurt together with such early works as the *Entombment* triptych from the Seilern collection[19] are taken as the basis for the painter's style. Though almost as large as the panels in Frankfurt, the *Enclosed Garden* nevertheless lacks the extraordinary tension between surface pattern and strongly modelled form that characterizes these works. The density of textures, which endows the Frankfurt paint-

ings with an effect of heightened reality, is not present in the *Enclosed Garden*. This is particularly evident from the comparison of such a specific detail as the yellow flower mentioned above. Even in earlier works, such as the Seilern *Entombment* or the Cleveland *Saint John*,[20] the way the figures stand out in relief against the patterned ground differs from the effect of the same formal elements in the Washington painting.

Several authors have tried to link this painting with other workshop productions, most notably with the *Annunciation in a Church* in the Prado and the *Annunciation* in Brussels.[21] While it may eventually be possible to arrive at a better understanding of workshop production based on the analysis of underdrawing (fig. 2), such groupings seem premature. Moreover, this painting may be an example of a more complex process whereby Campin's types are repeated with an admixture derived from Rogier van der Weyden. The *Madonna and Child with Saints in the Enclosed Garden* is pervaded by a more rhythmic linear pattern than that found in the works attributed to Campin. This is felt in the interlocking pyramidal outlines of the figures, which are emphasized by Catherine's sword, Anthony's walking stick, and the arms of the Virgin's throne. Rather than overlap each other, the figures fit neatly together. A process of recombination may also explain a certain ambiguity in the relationship of the different figures in space. Thus it is unclear from the way Saint Barbara and her attribute fill the space between the Madonna and Saint Anthony whether she is placed behind the Madonna or beside her. The setting of the enclosed garden may be noteworthy in this context too. The drawings in Paris presumably after Campin and the dismembered Van der Weyden altarpiece of which the *Magdalene Reading* was a part are

Fig. 4. Robert Campin, *Madonna and Child*, detail, Frankfurt, Städel'sches Kunstinstitut und Städtische Galerie [photo: Städel'sches Kunstinstitut, Ursula Edelmann, photographer]

set in domestic interiors. In Northern painting the enclosed garden tends to be the preserve of courtly saints and, above all, of female saints as attendants to the Virgin.[22] The inclusion of the somber hermits John the Baptist and Anthony along with the elegant Barbara and Catherine is thus rather unusual and may be further evidence of a process of recombination.

Such a recombination is difficult to place in time. The painting probably belongs to the decades after Campin's death in 1444 because of the more pronounced linear quality of the design as well as the kinship of the Baptist with the same figure in Rogier's *Medici Madonna*.[23] The flat halos painted out during the course of work attest to a desire to update Robert Campin's vocabulary. It does not seem likely that this smooth fusion of Campin and Rogier would have been achieved by a painter working at the end of the century.

The *Enclosed Garden* remains a very compelling work and an important example of the effect of tradition on early Netherlandish painters, though it cannot be regarded as a work by Campin himself or as the unalloyed reflection of a lost painting by him.

M. W.

Notes

1. The frame and inscription are shown in the print in Speyers 1839, opp. 182. The inscription reads: *O maria consolatrix. Esto nobis advocatrix Rogans regem glorie Ut nos Jungat Superis Donans nobis miseris / Post Spem frui Specie Que regina diceris · Miserere [p?]osteris · Virgo mater Gracie · Amen ·* (O Mary, our comforter, intercede for us asking the King of Glory that we may rejoin those on high, granting to us, wretches, the fulfillment of hope of seeing him. Thou, who art called Queen, Have mercy on us later born, Virgin Mother of Grace). The inscription is followed by a housemark. The same housemark appears as part of the illumination of a copy of Boethius' *De Consolatione Philosophiae* printed in Ghent in 1485 by Arend de Keysere, now in the Library of Congress; repro. in Sandra Hindman and James Douglas Farquhar, *Pen to Press: Illustrated Manuscripts and Printed Books in the First Century of Printing* [exh. cat. University of Maryland Art Department Gallery] (College Park, Maryland, 1977), pl. 3. While noting that the calligraphy of inscriptions needs further study, both Paul Saenger of the Northwestern University Library and P.F.J. Obbema of the Leiden University Library were inclined to date this inscription to the early sixteenth century, citing, for example, the type of flourishes and the form of the *s* (letters of 31 March 1983 and 23 June 1983 in curatorial files).

2. See n. 5.

3. According to Passavant 1833, 349.

4. Passavant saw the picture on his journey through England and Belgium in 1831.

5. Speyers 1839, 188. Shortly after entering the De Potter–Soenens collection, the picture was cleaned and disfiguring overpaint, which had caused Passavant to consider it

a pre-Eyckian tempera painting, was removed; see Passavant 1843, 230 and Nagler 1858, 1. I am grateful to Lorne Campbell for the first of these references.

6. According to Suida 1951, 168, no. 74.

7. Song of Solomon 4:12.

8. Howard Rollin Patch, *The Other World According to Descriptions in Medieval Literature* (Cambridge, Mass., 1950). The Garden of Eden, the earthly paradise, was commonly depicted as an enclosed garden, as, for example, in the *Très Riches Heures*; repro. Jean Longnon, Raymond Cazelles, and Millard Meiss, *The 'Très Riches Heures' of Jean, Duke of Berry* (New York, 1969), pl. 20. Hence the playful action of Saint Barbara offering an apple to the Christ Child in the Gallery's painting refers to his role as Redeemer and the new Adam.

9. Eisler 1977, 47–48, made this suggestion, noting the relationship of the composition to Tournai funerary sculpture.

10. The drawings are in the Louvre and the École des Beaux-Arts, the latter probably being a copy after the Louvre drawing; Micheline Sonkes, *Primitifs flamands. Contributions à l'étude des primitifs flamands. Dessins du XVe siècle: groupe Van der Weyden* (Brussels, 1969), 98–103, nos. C7–8, pls. 22 a–b.

11. De Vos 1971, 63–80.

12. Here the Madonna has shifted the Child off her lap, as De Vos notes, 1971, 74–76, fig. 12. See also Jacques Dupont, "La Sainte Famille des Clarisses du Puy," *Monuments historiques de la France* n.s. 12 (1966), 150–157.

13. Davies 1972, 248–250, pl. 133.

14. Friedländer, vol. 2 (1967), 62, no. 12, pls. 20–21, and Ward 1971, 27–35, with a reconstruction of the dismembered panel that is usually dated c. 1435–1440. The Magdalene's pose is also very close to that of Saint Barbara on the right wing of the *Werl Altarpiece* in the Prado; Friedländer, vol. 2 (1967), 72–73, no. 67, pl. 97.

15. Friedländer, vol. 2 (1967), pl. 96. On the problem of the attribution of the Werl panels, see Davies 1972, 258, and Lorne Campbell, "Robert Campin, the Master of Flémalle and the Master of Mérode," *BurlM* 116 (1974), 645.

16. Städel'sches Kunstinstitut und Städtische Galerie; Friedländer, vol. 2 (1967), 64, no. 21, pl. 42, usually dated about 1450, but placed even later by Anne Markham Schulz, "The Columba Altarpiece and Rogier van der Weyden's stylistic development," *MünchnerJb* ser. 3, 22 (1971), 72–80, 84.

The origin of this delicately balanced pose has been much debated; for a summary of this question and the connection of the type to Rogier's Christ appearing to his mother, see Davies 1972, 258, Campbell 1974, 645–646, and Rainald Grosshans, "Rogier van der Weyden. Der Marienaltar aus der Kartause Miraflores," *JbBerlin* 23 (1981), 106–107, 110–111, figs. 25, 28.

17. Lottlisa Behling, *Die Pflanze in der mittelalterlichen Tafelmalerei*, 2d ed. (Cologne and Graz, 1967), pls. XLIV and XLV, as an unidentified flower.

18. The only dissenting opinions are Friedländer, in an opinion of 12 August 1948 (in curatorial files), who called it a work by the Master of Flémalle equal in quality to the paintings in Leningrad and Aix-en-Provence, and Seymour 1961, 12, 14, who published the painting as by the Master of Flémalle and assistants. Stange 1966, 19, gave it to Campin himself. While still in the Kress collection, the painting was

attributed to the studio of the Master of Flémalle; Suida 1951, no. 74, and exh. cat., Tucson 1951, no. 15.

19. See Biography. In judging the autograph quality of the work, it is helpful to refer to photographs taken before and during cleaning (in curatorial files).

20. Friedländer, vol. 2 (1967), 91–92, nos. Add. 147, 149, pl. 141.

21. Friedländer, vol. 2 (1967), 70, nos. 52, 54b, pls. 75, 80. Frinta 1966, 113–120, gave it, the Brussels *Annunciation*, the Berlin *Madonna on a Grassy Bank*, and other pictures to Jacques Daret. Van Gelder 1967, 3–4, included it in a slightly different group of pictures that he felt was by Daret. Sterling 1971, 5, gave the Washington panel and the two Annunciations to a pupil distinct from Daret.

The extensive study of underdrawings in paintings associated with Rogier van der Weyden undertaken by J. R. J. van Asperen de Boer, Roger van Schoute, and others should provide a firmer basis for hypotheses of workshop groupings. Van Asperen de Boer found the underdrawing in 1959.9.3 to be closer to the Van der Weyden group than to Campin; in conversation 25 March 1983.

22. Thus, the *Mystic Marriage of Saint Catherine* in London, painted by Gerard David for the altar of Saint Catherine in the chapel of Saint Anthony, Saint Donatian's, Bruges, is a typically lyrical treatment of the enclosed garden; Friedländer, vol. 6b (1971), 80, 108, no. 216, pl. 221, and Martin Davies, *National Gallery Catalogues. Early Netherlandish School*, 3d ed. (London, 1968), 44–45. Female saints accompany the Virgin, and, though Saint Anthony was the titular saint of the chapel, he is included only in the distance. If the Gallery's painting was indeed in a church in Bruges, as Passavant reported, it is possible that it was one of the sources for this painting by David of a similar scale and function, and with a related type of enthroned Madonna.

23. J. K. Steppe has identified an analogous development of Campin's style in the *Trinity* in Louvain; "Het paneel van de Triniteit in het Leuvense Stadsmuseum. Nieuwe gegevens over een enigmatisch schilderij," in *Dirk Bouts en zijn tijd* [exh. cat.] (Louvain 1975), 447–495.

References

1833 Passavant, J. D. *Kunstreise durch England und Belgien*. Frankfurt-am-Main: 348.

1833 "Nachrichten über die alt-niederländische Malerschule." *Kunst-Blatt* 81: 321.

1839 Spyers, F. A. "Beschryving van twee merkwaerdige Schilderyen uit de School der Gebroeders Van Eyck." *Belgisch Museum voor der Nederduitsche Tael- en Letterkunde en de Geschiedenis des Vaderlands*. Ghent, 3: 182–189, repro. opp. 183 (print by Ch. Onghena).

1843 Passavant, J. D. "Beiträge zur Kenntniss der alt-niederländischen Malerschulen bis zur Mitte des sechzehnten Jahrhunderts." *Kunst-Blatt* 55: 230.

1845 Michiels, Alfred. *Histoire de la peinture flamande et hollandaise*. 4 vols. Brussels, 1: 410–412.

1858 Nagler, Georg Kasper. *Die Monogrammisten*. 5 vols. Munich and Leipzig, 1: 1, no. 1.

1951 Kress: 168, no. 74, repro. 169.

1953 Panofsky. *ENP*: 425–426.

1954 Davies, Martin. *Primitifs flamands. Corpus. The National Gallery London*. 3 vols. Antwerp, 2: 177, under no. 57.

1961 Meiss, Millard. "'Highlands' in the Lowlands: Jan van Eyck, the Master of Flémalle and the Franco-Italian Tradition." *GBA* 6ᵉ pér. 57: 277, 310, fig. 5.

1961 Seymour, Charles Jr. *Art Treasures for America*. London: 12, 14, 218, pls. 9–11.

1964 Koch, Robert A. "Flower Symbolism in the Portinari Altar." *AB* 46: 75.

1966 Frinta, Mojmír S. *The Genius of Robert Campin*. The Hague: 118, 120–121, figs. 72–73.

1966 Stange, Alfred. "Vier südflandrische Marientafeln. Ein Beitrag zur Genese der niederländischen Malerei." *Alte und moderne Kunst* 11, no. 89: 19, fig. 21.

1967 Van Gelder, J. G. "An early Work by Robert Campin." *OH* 82: 3–4.

1971 Sterling, Charles. "Observations on Petrus Christus." *AB* 53: 5.

1971 Ward, John L. "A Proposed Reconstruction of an Altarpiece by Roger van der Weyden." *AB* 53: 32–33, fig. 9.

1971 De Vos, Dirk. "De Madonna-en-Kindtypologie bij Rogier van der Weyden." *JbBerlin* 13: 71, 74–80, 92, 97, 154, 156, 158, fig. 11.

1972 Davies, Martin. *Rogier van der Weyden*. London: 261.

1972 Kerber, Ottmar. "Die Hubertus-Tafeln von Rogier van der Weyden." *Pantheon* 30: 299.

1974 Bruyn, Josua. Review of *Rogier van der Weyden* by Martin Davies. In *BurlM* 116: 540.

1975 Verdier, Philippe. "La Trinité debout de Champmol." In *Etudes d'art français offertes à Charles Sterling*. Paris: 85.

1975 NGA: 220, repro. 221.

1977 Eisler, Colin. Review of *Petrus Christus* by Peter H. Schabacker. In *AB* 59: 141.

1977 Eisler: 46–50, fig. 47.

Petrus Christus

active by 1444–1472/1473

Petrus Christus is first mentioned in the record of those purchasing Bruges citizenship, which he acquired on 6 July 1444. He was described in the record of this transaction as a native of Baerle, which probably meant the town of Baerle-Duc on the present Belgian-Dutch border. He continued to be mentioned in Bruges documents after 1444. He and his wife were listed as new members of the Confraternity of the Dry Tree, which they joined by 1463. The last reference to him in Bruges is dated 19 March 1472.

Christus' oeuvre has been assembled around a number of works that he signed and dated, on either the original frame, the back, or the picture itself. These include the *Portrait of a Carthusian* in the Metropolitan Museum, New York, and the *Portrait of Edward Grymeston* on loan to the National Gallery, London, both dated 1446; *Saint Eloy* in the Lehman Collection at the Metropolitan Museum and a *Madonna and Child* in the Thyssen-Bentinck collection, Paris, both dated 1449; a pair of altarwings with the Annunciation and Nativity on one and the Last Judgment on the other in the Gemäldegalerie, Berlin-Dahlem, dated 1452, and the *Madonna and Child with Saints Francis and Jerome* in the Städel'sches Kunstinstitut, Frankfurt, the date of which is usually read as 1457. The form of the inscriptions, as well as the fact that the paintings are signed and dated at all, recall the working method of Jan van Eyck. Moreover, several of Christus' paintings, notably the Last Judgment on the Berlin altarwings and the *Exeter Madonna* also in Berlin, derive from Eyckian compositions. As a result many critics have assumed that Christus studied with Van Eyck and completed those works left unfinished at that master's death in 1441. However, we have no information on Christus' activity or whereabouts before his 1444 purchase of Bruges citizenship, and those paintings possibly left unfinished on Van Eyck's death, the *Saint Jerome* in Detroit and the *Madonna and Child with Saints Barbara and Elizabeth and a Donor* in the Frick Collection, do not, after all, show Christus' intervention.

Moreover, his earliest dated paintings do not show a pronounced Eyckian style.

Whether or not Christus had any personal contact with Van Eyck, his art has an eclectic character, making use of motifs from the works of Robert Campin, Rogier van der Weyden, and Albert van Ouwater as well as those of Van Eyck. Nevertheless, Christus' style is highly distinctive, emphasizing the integrity of individual forms and the clarity and continuity of spatial recession. Recasting elements taken from contemporary painting, he frequently brings about a particularly direct and poignant confrontation of the viewer with the devotional subject or sitter portrayed.

M.W.

Bibliography
Pächt, Otto. "Die Datierung der Brüsseler Beweinung des Petrus Christus." *Belvedere* 9/10 (1926): 155–166.
Panofsky. *ENP.* 1953.
Schabacker, Peter H. *Petrus Christus.* Utrecht, 1974.
Upton, Joel M. "Petrus Christus." Ph.D. diss., Bryn Mawr College, 1972.

1937.1.40 (40)

The Nativity

c. 1450
Oak (cradled), 130 x 97 (51¼ x 38¼);
 painted surface: 127.6 x 94.9 (50¼ x 37⅜)
Andrew W. Mellon Collection

Technical Notes: There are overpainted losses along the three vertical joins of the panel and along several vertical cracks, as well as scattered small overpainted losses along the fine fracture crackle pattern and where abrasion has occurred along the raised edges of cupped paint. The only larger area of loss is in Joseph's left shoulder. The Virgin's robe has been almost completely overpainted. The robe may have been overpainted to mask the effect of somewhat more extensive losses along the crackle pattern; such losses are evident in sections of the original robe still visible between strands of the Virgin's hair. In spite of these small areas of loss and the overpainting of the Virgin's robe, the paint layers are generally in good condi-

tion, as is the support. The varnish has yellowed unevenly and is marked throughout by tiny gray matte spots.

Infrared reflectography reveals what appears to be a brush underdrawing for the main figural group. The contours of the figures and of drapery folds are defined by a long contour line which is sometimes repeated. Widely spaced parallel hatching strokes indicate areas of shadow (fig. 1). The wings of the two angels to the left of the Virgin were painted over the underdrawn design of the Virgin's robe; the presumed underdrawing elsewhere in her robe is obscured by overpaint. No underdrawing was made visible in the background or architecture.

Provenance: Señora O. Yturbe, Madrid.[1] (F. M. Zatzenstein, 1930.) (Duveen Brothers, London and New York, 1930–1937.) Purchased January 1937 by The A. W. Mellon Educational and Charitable Trust, Pittsburgh.

Fig. 1. Infrared reflectogram assembly of *The Nativity*, 1937.1.40 [infrared reflectography: Molly Faries]

THE NATIVITY IS among Petrus Christus' most important devotional paintings in the complexity of its iconography, in the harmony of its composition and color, and in its scale. The emphasis on the sacrificial nature of Christ's coming finds an echo in later Netherlandish Nativity scenes, including Hugo van der Goes' Portinari altarpiece. However, Christus' well-known susceptibility to the influence of other artists, together with the appearance of motifs from the *Nativity* in paintings by Rogier van der Weyden and Dieric Bouts, raise the question of the degree to which Christus himself originated this impressive synthesis.

The blue-robed Virgin and the four diminutive angels kneel in adoration before the newborn Christ Child. Joseph, clad in a red-brown robe and red cloak with green lining, has reverently removed his pattens and hat, and completes the semi-circle of worshippers. A brilliant radiance, taking the form of a solid golden mandorla, emanates from the Christ Child, whose body seems to glow with light. The space occupied by the Christ Child and worshippers is delimited by the rectangular framework of the wooden shed. Beyond the shed, shepherds lean quietly against the ruined wall of a Romanesque building. In the green landscape other shepherds follow their flocks, heedless of the event which has just taken place. A marble doorsill and a carved arch decorated with figures of Adam and Eve and scenes from Genesis divide the sacred space from that of the worshipper contemplating the picture.

The Virgin kneeling in adoration before the newborn Christ Child lying naked on the ground derives from the revelation of Saint Bridget, which had become the conventional visualization of the Nativity by the early fifteenth century.[2] The angels are not shown singing, as described by Saint Bridget, but kneel in solemn adoration. The fact that the angels wear eucharistic vestments, including the deacon's cope but not the chasuble worn by the celebrant at a solemn high mass, indicates that the celebrant's role is reserved for Christ Himself.[3] The semicircle of worshippers around the exposed body of the Child underscores Christ's role as priest and victim.[4] With its two domed buildings, the town in the background would be understood to be Jerusalem, the scene of the events of Christ's Passion.[5]

The necessity of Christ's sacrifice is demonstrated by the story of the Fall on the framing portal separating the scene from the viewer's space. Above the figures of Adam and Eve are scenes of, from left to right, the expulsion from Paradise, Adam and Eve working the land and spinning, the sacrifices of Cain and Abel, Cain slaying Abel, the Lord admonishing Cain, and a scene that has been variously interpreted as the banished Cain taking leave of his parents, or Seth, another of

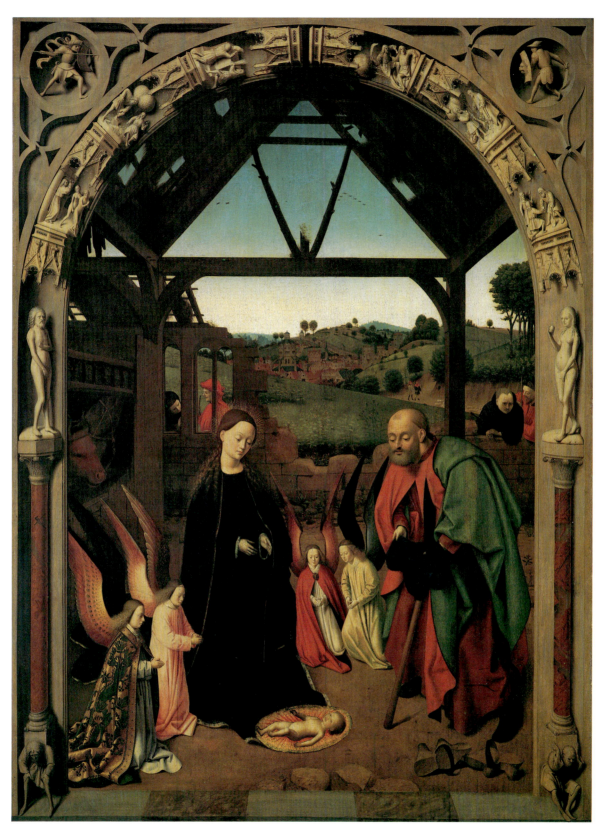

Petrus Christus, *The Nativity*, 1937.1.40

Adam's sons, setting off in search of the Tree of Life.[6] Man's inability, before Grace, to live according to God's dictates is further emphasized by the roundels with figures of fighting warriors, imagery commonly associated with the Temple of Jerusalem, as were the crouching figures which support the statues of Adam and Eve.[7]

A number of details seem to supplement the explicit contrast between Old and New Testament and between man's sin and ineffectual sacrifices and the sufficiency of Christ's sacrifice. Upton suggested that Joseph's cast-off pattens and the plant sprouting from the broken central beam of the gable are references to the incidents of the burning bush and Aaron's flowering rod respectively.[8] Both are Old Testament types of the Nativity. The pattens must in any case be a more general sign of Joseph's reverence, as is his gesture of removing his hat.[9] The shoots prominently placed at the base of the gable and framed by the arch telling the story of the consequences of the Fall may also allude to the Tree of Life, whose fruit Adam and Eve ate and from whose wood the cross was made.[10] It is possible that these details carry multiple meanings. The pervasive geometry of the picture must also have been intended to give added resonance to the contrast between the old and the new order, through the relation of the framing arch to the pattern of repeated triangles and squares in the structure of the shed. Although Upton has interpreted this geometry as a reference to the Trinity and to the conventional *schema* of the *Defensorium inviolatae virginitatis Mariae*, we cannot now read its precise meaning with confidence.[11]

Critics have been unanimous in attributing the *Nativity* to Christus,[12] but there is less agreement as to its date. Most authors have dated the painting early, in the mid-1440s.[13] Exceptions include Sterling, who thought that the sculptural elements presupposed Rogier van der Weyden's *Saint John Altarpiece* in Berlin and therefore dated it after 1450.[14] Presuming that Christus traveled to Italy after 1454, Bazin and Collier proposed a date after this trip.[15] Schabacker, who placed the Brussels *Lamentation* toward the end of Christus' career, also suggested a later date for the Gallery's *Nativity*.[16] Bruyn associated both the *Lamentation* and the *Nativity* with the *Saint Eloy* of 1449.[17]

The most commonly cited date of 1445 derives in part from the notion that Christus was already a mature artist at the time he first appeared in Bruges documents in 1444, that he was in some sense the inheritor of Jan van Eyck's shop, and that the influence of Rogier van der Weyden supplanted that of Van Eyck in Christus' work. However, as Upton has demonstrated, there is no documentary evidence for these assumptions con-

cerning Christus' early career.[18] Further, the notion that Christus came under the influence of other artists in orderly sequence seems overly mechanical. Rather, stylistic differences in versions of the same subject by Christus may result from differences in scale and function as well as from varying degrees of dependence on other artists. Thus other treatments of the *Nativity* by Christus, the Nativity scene on the altarwings dated 1452 in Berlin and the *Nativity* formerly with Wildenstein in New York, do not materially help date the Gallery's painting.[19]

However, among Christus' known works, earlier dated paintings—the *Portrait of a Carthusian* in the Metropolitan Museum[20] and the *Edward Grymeston* lent to the National Gallery, London,[21] both dated 1446, and the 1449 *Saint Eloy* in the Lehman Collection[22]—are characterized by a long, heavy facial type in which particular emphasis is placed on blocking out the planes of browbone and jutting nose. The facial types in the Brussels *Lamentation* can be associated with these works. The treatment of the head of Saint Joseph in the Gallery's painting is comparable to that of Joseph of Arimathea in the Brussels *Lamentation* (fig. 2). Yet in general this tendency toward heavy facial types appears somewhat softened in the *Nativity*, while the coordination of figures in the spatial setting is more complex and fluent, suggesting a date close to, but somewhat later than, the *Saint Eloy* and the *Lamentation*. On these grounds a date of about 1450 to 1455 is most probable.[23]

Linked to the problem of date is the question of the relationship of the Gallery's *Nativity* to works by Bouts and Rogier van der Weyden. Although the Gallery's painting presents a particularly impressive, complex, yet focused rendering of the Nativity, the details of the carved arch relate closely to Bouts' Mary altar in the Prado (fig. 3)[24] and, in a more general way, to Rogier van der Weyden's Miraflores triptych and Saint John triptych, both in Berlin.[25] Thus, while Rogier's Miraflores altarpiece, datable before 1445,[26] provides a precedent for archivolt sculpture and column figures commenting on a sacred scene, Bouts' Mary altarpiece even includes the warriors in roundels and the crouching figures, this time as consoles supporting the statues of prophets.

The close correspondence of the Bouts Nativity scene to the Gallery's painting is also striking, above all in the shape of the shed, the role and dress of the angels, and the inclusion of the shepherds leaning pensively against a Romanesque window. Opinion is divided as to whether Christus or Bouts originated the composition or whether both paintings reflect a common source. Bouts' early work is undated, but is usually

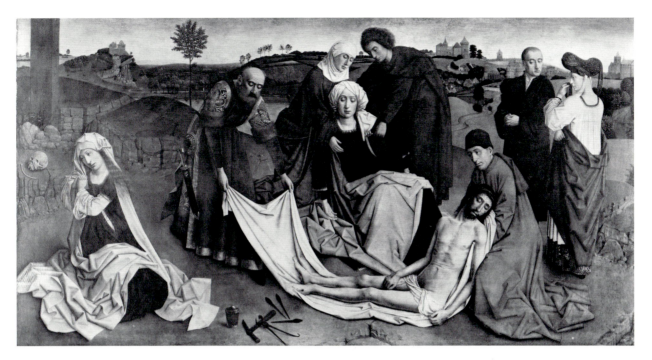

Fig. 2. Petrus Christus, *Lamentation*, Brussels, Musées Royaux des
Beaux-Arts de Belgique [photo: Copyright A.C.L. Brussels]

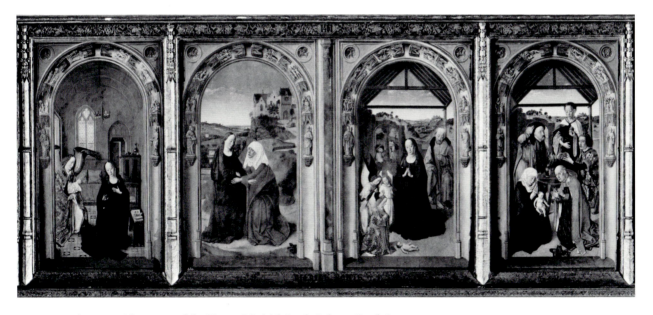

Fig. 3. Dirck Bouts, *Altarpiece of the Virgin*, Madrid, Prado [photo: Prado]

placed in the mid-1440s.[27] However, it seems unlikely
that Christus' version is directly dependent on Bouts'
Nativity, since its composition is more complex. More-
over, the various scenes of Bouts' triptych include oth-
er explicitly Rogerian figure conventions, notably the
group of Mary and Elizabeth.[28] It is possible that the

Nativity scenes by Christus and Bouts reflect a com-
mon Rogerian model. Indeed, there are a number of
indications that Van der Weyden may have executed
an influential Nativity composition with a frontally-
placed shed.[29]

Regarding the placement of the Nativity within a

sculpted arch, the direction of influences and Christus' own contribution are less ambiguous. Christus apparently adapted a device conceived by Rogier for a linked series of devotional images, using it instead to frame a single scene. In the triptychs by Van der Weyden and Bouts, the choice of subjects for the enframed scenes, the continuation of the narrative sequence of archivolt scenes across several arches, and the use of repeated pairs of saints or prophets as column figures all indicate the appropriateness of the format to a series. The function of the Van der Weyden and Bouts triptychs as devotional sequences is further emphasized by the repetition of bays echoing the springing of the arches in the Miraflores altarpiece and in the repetition of the gabled shed in the Prado Mary altarpiece. However, it is unlikely that the Gallery's painting was conceived as part of such a linked series since the figures of Adam and Eve could not be supplemented by comparable pairs of figures on other panels.[30] They stand alone and, with the Genesis narrative, point to the meaning of this particular devotional subject. By contrast, in Bouts' altarpiece, Genesis scenes fill the arch of the Annunciation section, while Passion scenes run across the arches of the Visitation, Nativity, and Adoration of the Magi. On the Annunciation panel fewer archivolt scenes are devoted to the consequences of the Fall, and the column figures are prophets as in the other sections.

Christus thus distills the elements of the arch altarpiece, using them to focus and elaborate the meaning of a single devotional image. The whole work is made more evocative by Christus' characteristically sensitive treatment of light and space and by the care with which degrees of distance from the newborn Child are expressed.

M. W.

Notes

1. The picture seems never to have belonged to the Duchess of Parcent, as claimed in *Duveen Pictures* 1941, no. 177; see letter of 8 April 1982 from her daughter, the Princess of Hohenlohe-Langenburg, in curatorial files.

2. Henrik Cornell, *The Iconography of the Nativity of Christ* (Uppsala Universitets Årsskrift), Uppsala, 1924, 1–21, for Saint Bridget's revelation. The most comprehensive discussion of the iconography of the Gallery's painting is Upton 1975, 49–79.

3. M. B. McNamee, S.J., "Further Symbolism in the Portinari Altarpiece," *AB* 45 (1963), 142–143, in connection with the Portinari altarpiece.

4. Upton 1975, 66–68, and Lane 1975, 480, 484–485, stress the Eucharistic symbolism of the *Nativity*. Particularly interesting is Upton's suggestion that the solid radiance on which the Christ Child lies can be interpreted as a paten. Contemporary Netherlandish Nativity scenes with a similar solid radiance include the *Breviary of Philip the Good*, Brus-

sels, Bibl. Royale, Ms. 9511, f. 43 verso (repro. Paul Durrieu, *La miniature flamande* [Brussels and Paris, 1921], pl. 9) and the *Nativity* of 1448 in the Groot Vleeshuis (*Gent: Duizend Jaar Kunst en Cultuur*, 3 vols., exh. cat. [Ghent, 1975], 1: 63–70, fig. 9). However, as the radiance in the Gallery's painting overlaps the heavily overpainted robe of the Virgin, there may be some doubt as to its original form.

5. The prominent octagonal building with flying buttresses and domed roof recurs in other Netherlandish recreations of Jerusalem, most particularly in the miniature of the Betrayal of Christ from the Turin-Milan Hours, repro. Friedländer, vol. 1 (1967), pl. 29. To the right of this octagonal structure in the Gallery's painting is a lower domed building with buttress-like turrets. These two exotic buildings in an otherwise typical Flemish town presumably represent sacred monuments in Jerusalem, possibly the Temple and the Church of the Holy Sepulchre respectively. For fifteenth-century notions of the appearance of these monuments, see Carol Krinsky, "Representations of the Temple of Jerusalem before 1500," *JWCI* 33 (1970), 1–19; for the Church of the Holy Sepulchre, see also Richard Krautheimer, "Introduction to an 'Iconography of Christian Architecture,'" *JWCI* 5 (1942), 1–20.

6. De Tolnay 1941, 180, interpreted the scene as Cain founding his race in the land of Nod, while Panofsky 1953, 312, 490, suggested the apocryphal incident of Seth's departure in search of the Tree of Life. Karl Birkmeyer 1961, 105, reasserted de Tolnay's interpretation. Steefel 1962, 237–238, connected Panofsky's suggestion with a possible reference to the Tree of Life in the shoot growing from the kingpost of the shed. Upton 1975, 62–63, and 77–78, considered that the sculptural group represents Cain taking leave of his parents, but that the figure "might well have a double identity" and represent Seth as well.

In this archivolt group the elderly figures with spade and distaff presumably represent Adam and Eve. The gestures of Adam and his son are quite unexpressive; each extends a clasped fist. This scene does not conflict with representations of Seth's leavetaking. While Adam's approaching death is emphasized in the cycle in the *Cleves Hours* where he is shown on his deathbed (repro. John Plummer, *The Hours of Catherine of Cleves* [New York, 1966], pl. 79), in the *Boec van den Houte*, published by Veldener in Kuilenberg in 1483 and probably employing cuts of an earlier date, Adam and Seth stand opposite each other and Adam holds a spade (repro. J. P. Berjeau, *Geschiedenis van het heyliche Cruys; or History of the Holy Cross* [London, 1863]). Nevertheless, it is unlikely that Christus would conclude the narrative sequence devoted to the Fall and its evil consequences with a scene that was the beginning of a long apocryphal cycle tracing the history of the Cross, with its promise of health and eternal life, into the Christian era. As Birkmeyer pointed out, the relationship between the arch and the scene beyond it is one of contrast, not continuity.

7. Ward 1975, 203, cites other examples of warriors on buildings understood as the Synagogue. For the association of the crouching figures with sin, see Upton 1975, 62, and Krinsky 1970, 8–9 (as in n. 5). The combination of warriors and atlas figures occurs on a drawing in the Städel'sches Kunstinstitut; Baldass 1952, 15, fig. 16.

8. Upton 1975, 72–73.

9. Discarded pattens carrying this more general meaning occur in Christus' own *Portrait of a Male Donor* in the Na-

tional Gallery (1961.9.10), as well as in Van Eyck's *Arnolfini Wedding Portrait* (Friedländer, vol. 1 [1967], pl. 20). In the Portinari altarpiece Joseph has also removed his pattens and hood (Friedländer, vol. 4 [1969], no. 10, pl. 15). Saint Bridget's description of the Virgin removing her shoes, mantle, and veil before the birth may also be relevant here; see Cornell 1924, 12 (as in n. 2).

10. Steefel 1962, 237–238, and Upton 1975, 77–78.

11. Upton 1975, 73–74. It should also be pointed out that the *Defensorium inviolatae virginitatis Mariae*, which in some simplified versions employs a scheme of superimposed rectangle and rhombus as a frame for typological devices, is found almost exclusively in Austria and southern Germany. No Netherlandish examples are cited by Julius von Schlosser, "Zur Kenntnis der künstlerischen Überlieferung im späten Mittelalter," *JbWien* 23 (1902), 287–313, and Cornell 1924, 76–81 (as in n. 2).

12. The only dissenting opinions are Wilenski 1960, 33, and a doubt as to the painting's authenticity on the part of Colin Eisler recorded by Panofsky 1953, 311, 489.

13. Baldass 1932, 114, and 1952, 98–99; Schöne 1938, 56; De Tolnay 1941, 179; Panofsky 1953, 310–311; Bruyn 1957, 107; Birkmeyer 1961, 103, 105; Cuttler 1968, 129; Ward 1968, 187; Gellman 1970, 147; and Lane 1975, 484.

Otto Pächt did not know the Gallery's *Nativity* when he wrote his important article on Christus' chronology, "Zur Datierung der Brüsseler Beweinung des Petrus Christus," *Belvedere* 9/10 (1926), 155–166.

14. Sterling 1971, 19, using the *Nativity* as an example of the difficulty in finding sure grounds for dating Christus' work. He notes that the prominent shoot growing from the shed may be connected with Christus' membership in the Confraternity of the Dry Tree, which he had joined by 1463; hence, he considered a date as late as the early 1460s to be possible.

15. Bazin 1952, 199–202, hypothesizing a trip to Italy between 1454 and 1463, and Collier 1979, 34. There is, however, no documentary basis for such a trip; see under 1961.9.11, *Portrait of a Female Donor* by Christus.

16. Schabacker 1974, 44–46, 66–67, dating the *Nativity* 1458–1460 and the *Lamentation* c. 1465. For the *Lamentation*, see Friedländer, vol. 1 (1967), pl. 93.

17. Bruyn 1975, 71–72. See also Châtelet 1980, 90, 184, and Panhans-Bühler 1978, 71–72.

18. Joel M. Upton, "Petrus Christus," Ph.D. diss., Bryn Mawr College, 1972, 36–41.

19. Friedländer, vol. 1 (1967), pls. 77, 82. Closest in composition to the Gallery's painting is a *Nativity* with a sculpted arch recently acquired by the Groeningemuseum, Bruges, together with a companion piece, *The Annunciation*, signed and dated 1457; Pieper 1984, 114–123, pls. I, II, and Eisler 1984, 451–469, figs. 1, 5. A thorough technical report on the Bruges panels is a prerequisite for any analysis of their relationship to the *Nativity* and other dated works.

20. Friedländer, vol. 1 (1967), pl. 74.

21. Friedländer, vol. 1 (1967), pl. 73.

22. Friedländer, vol. 1 (1967), pl. 75.

23. In this context, it may be noteworthy that the halo of closely spaced gold rays, like that of the Virgin in the *Nativity*, occurs only in the 1449 *Saint Eloy* and the 1449 *Madonna and Child* in the Thyssen-Bentinck collection (Friedländer, vol. 1 [1967], pls. 75–76) among Christus' surviving works.

24. Friedländer, vol. 3 (1968), no. 1, pls. 1–2.

25. Friedländer, vol. 2 (1967), nos. 1–2, pls. 1–5.

26. See Rogier van der Weyden biography and also Grosshans 1981, 49–112.

27. Friedländer, vol. 3 (1968), 24, Schöne 1938, 4–5, 7, and Panofsky 1953, 314.

28. Compare Rogier's early *Visitation* in Leipzig; Friedländer, vol. 2 (1967), no. 5, pl. 12.

29. Schabacker 1974, 67–69, also raised this possibility. The Bladelin triptych in Berlin, with its obliquely placed shed, is the only surviving full-scale Nativity by Rogier. However, the arch above the Birth of the Baptist in Rogier's Saint John triptych in Berlin includes a Nativity with frontal shed, Joseph carrying a walking stick and removing his hat, and the ox and ass, which are arrayed parallel to the plane of the shed; repro. Anne Markham Schulz, "The Columba Altarpiece and Rogier van der Weyden's stylistic development," *MünchnerJb* series III, 22 (1971), fig. 25. The repetition of these and other elements including adoring angels in several depictions of the Nativity produced under the influence of Rogier suggests a Rogerian prototype apart from the Bladelin altarpiece. Compare the epitaph of Jehan du Sart (d. 1456) and Margrite de Gherles (d. 1435) in the Musée d'Histoire, Tournai (repro. Schulz 1971, fig. 29); the Nativity scene on the Schöppingen Altar by the Master of the Schöppingen Altar (Paul Pieper, "Zum Werl-Altar des Meisters von Flémalle," *Wallraf-Richartz-Jahrbuch* 16 (1954), 101–102, fig. 65, who considers that the Westphalian painter, known for his rather literal references to Netherlandish painting, here reflects a lost work by the Master of Flémalle); the central Nativity scene on an altarpiece in the Cloisters by an anonymous Brussels artist, which also includes borrowings from the Leipzig *Visitation* and from the Bladelin altarpiece for the episodes of the Tiburtine Sibyl and the vision of the Three Magi (repro. Schabacker 1974, fig. 36); and a *Nativity* in the Prado, one of four panels from the monastery of Sopetrán by an anonymous Hispano-Flemish master (repro. Enrique Lafuente Ferrari, "Las Tablas de Sopetrán," *Boletin de la Sociedad Española de Excursiones* 37 [1929], 89–91, pl. 2). The Berlin archivolt scene and the Nativities in Schöppingen and in the Prado, as well as the Gallery's *Nativity*, show Joseph with hat in hand, rather than his more usual gesture of holding a candle.

In style, Bouts' Prado altarpiece relates, not to Rogier, but to Ouwater and Northern Netherlandish painting. References to Ouwater's one surviving documented work are also detectable in Christus' *Saint Eloy* and *Lamentation*; see Schabacker 1974, 63–65. These common stylistic connections do not necessarily bear on the compositional similarities between the Nativities by Christus and Bouts, however.

30. Birkmeyer 1961, 107, also noted that the statues of the first parents implied a single scene rather than a series. These observations on structure and function also tend to suggest a common source for Christus and Bouts.

References

1925 Friedländer, Max J. "Neues über Petrus Christus." *Der Kunstwanderer* (May): 297.

1932 Baldass, Ludwig. "Die Entwicklung des Dirk Bouts: Eine Stilgeschichtliche Untersuchung." *JbWien* N.F. 6: 114.

1937 Cortissoz, Royal. *An Introduction to the Mellon Collection*. Privately printed: 33–34, repro. opp. 33.

1937 Frankfurter, Alfred M. "The Mellon Gift to the Nation." *ArtN* 35 (9 January): 10, repro. 11.

1937 Friedländer. Vol. 14: 78–79, pl. Nachtrag III (vol. 2. 1967: 104, 110, pl. 102).

1937 Schöne, Wolfgang. "Über einige altniederländische Bilder, vor allem in Spanien." *JbBerlin* 58: 159.

1938 Vaughan, Malcolm. "Painting in the Age of Faith." *Parnassus* 10, no. 7: repro. 2.

1938 Schöne, Wolfgang. *Dieric Bouts und seine Schule.* Berlin and Leipzig: 23–24, 28, 55–56.

1939 Held, Julius S. Review of *Die altniederländische Malerei* by Max J. Friedländer. In *Art in America* 27: 88.

1941 *Duveen Pictures in Public Collections of America.* New York: no. 177, repro.

1941 NGA: 39–40.

1941 Tolnay, Charles de. "Flemish Paintings in the National Gallery of Art." *MagArt* 34: 179–181, figs. 7–9.

1941 Held, Julius S. "Masters of Northern Europe in the National Gallery." *ArtN* 40 (June): 11–12, repro.

1941/1942 Einem, Herbert von. "Entwicklungsfragen bei Hugo van der Goes." *Das Werk des Künstlers* 2: 167.

1942 Schapiro, Meyer. "'Cain's Jaw-Bone that Did the First Murder.'" *AB* 24: 208.

1946 Friedländer, Max J. "The *Death of the Virgin* by Petrus Christus." *BurlM* 88: 159.

1948 Puyvelde, Leo van. *The Flemish Primitives.* New York: 27, pl. 51.

1949 Mellon: 53, repro.

1952 Baldass, Ludwig. *Jan van Eyck.* London: 98.

1952 Bazin, Germain. "Petrus Christus et les rapports entre l'Italie et la Flandre au milieu du XVᵉ siècle." *La Revue des Arts* 2: 199–202.

1953 Panofsky. *ENP*: 203, 311–315, 321, 333, 489–490, fig. 402.

1957 Shapley, Fern Rusk, and John Shapley. *Comparisons in Art: A Companion to the National Gallery of Art, Washington, D.C.* New York: 44, fig. 3.

1957 Bruyn, Josua. *Van Eyck Problemen: De Levensbron.* Utrecht: 107–108.

1960 Wilenski, R. H. *Flemish Painters, 1430–1830.* 2 vols. New York, 1: 33, 524, 686, pl. 30.

1960 Snyder, James E. "The Early Haarlem School of Painting: I. Ouwater and the Master of the Tiburtine Sibyl." *AB* 42: 44, fig. 5.

1961 Birkmeyer, Karl M. "The Arch Motif in Netherlandish Painting of the Fifteenth Century: A Study in Changing Religious Imagery." *AB* 43: 103–109, fig. 25.

1962 Birkmeyer, Karl M. "Notes on the Two Earliest Paintings by Rogier van der Weyden." *AB* 44: 331.

1962 Steefel, Lawrence D., Jr. "An Unnoticed Detail in Petrus Christus' *Nativity* at the National Gallery, Washington." *AB* 44: 237–238.

1962 Philippot, Paul. "La fin du XVᵉ siècle et les origines d'une nouvelle conception de l'image dans la peinture des Pays-Bas." *BMRB* 11: 9–10.

1964 Walker: 98, repro. 99.

1964 Gaya Nuño, Juan Antonio. *Pintura europea perdida por España de Van Eyck a Tiépolo.* Madrid: 22, no. 15.

1965 Châtelet, Albert. "Sur un jugement dernier de Dieric Bouts." *NKJ* 16: 37.

1968 Jongh, E. de. "Speculaties over Jan Gossaerts Lucas-madonna in Praag." *Bulletin Museum Boymans-van Beuningen* 19: 52–53.

1968 Cuttler. *Northern Painting*: 129–130, 134, fig. 151.

1968 Ward, John L. "A New Look at the *Friedsam Annunciation.*" *AB* 50: 186–187.

1968 Whinney, Margaret. *Early Flemish Painting.* New York and Washington: 69, 151, pl. 37.

1969 Blum, Shirley Neilsen. *Early Netherlandish Triptychs.* Berkeley and Los Angeles: 121–122.

1970 Koch, Robert A. Review of *Northern Painting* by Charles Cuttler. In *AB* 52: 204.

1970 Gellman, Lola B. "The 'Death of the Virgin' by Petrus Christus: An Altar-piece Reconstructed." *BurlM* 112: 147.

1971 Sterling, Charles. "Observations on Petrus Christus." *AB* 53: 19, figs. 37, 39.

1972 Dogaer, Georges. "Miniature flamande vers 1475–1485." *Scriptorium* 26: 104.

1972 Schabacker, Peter H. "*Saint Eloy*: Problems of Provenance, Sources and Meaning." *AQ* 35: 114.

1972 Schabacker, Peter H. Review of *Rogier van der Weyden* by Martin Davies. In *AQ* 35: 423.

1974 Schabacker, Peter H. *Petrus Christus.* Utrecht: 25, 27, 29, 34, 43–46, 48, 50, 58, 60–61, 67–69, 74, 108, 114, 118, cat. no. 19, fig. 19.

1975 Bruyn, Josua. Review of *Petrus Christus* by Peter H. Schabacker. In *OH* 89: 71–72.

1975 Pächt, Otto, and Ulrike Jenni. *Die illuminierten Handschriften und Inkunabeln der Österreichischen Nationalbibliothek, Holländische Schule.* Vienna: 65.

1975 Lane, Barbara G. "'Ecce Panis Angelorum': The Manger as Altar in Hugo's Berlin *Nativity.*" *AB* 57: 480, 484–485, fig. 15.

1975 Upton, Joel M. "Devotional Imagery and Style in the Washington *Nativity*, by Petrus Christus." *StHist* 7: 49–79, figs. 1, 8–9, 17–18, 22–23.

1975 Ward, John L. "Hidden Symbolism in Van Eyck's *Annunciations.*" *AB* 57: 203.

1975 NGA: 68, repro. 69.

1976 Lane, Barbara G. Letter to the editor, *AB* 58: 641.

1977 Decker, Bernhard. "Zur geschichtlichen Dimension in Michael Pachers Altären von Gries und St. Wolfgang." *Städel-Jahrbuch* N.F. 6: 309, 318.

1978 Panhans-Bühler, Ursula. *Eklektizismus und Originalität im Werk des Petrus Christus.* Vienna: 71, 76, 78–79, fig. 52.

1979 Collier, James M. "The Kansas City Petrus Christus: Its Importance and Dating." *The Nelson Gallery and the Atkins Museum Bulletin* 5 (September): 34.

1980 Châtelet, Albert. *Early Dutch Painting: Painting in the Northern Netherlands in the Fifteenth Century.* New York: 90, 184.

1981 Grosshans, Rainald. "Rogier van der Weyden. Der Marienaltar aus der Kartause Miraflores." *JbBerlin* N.F. 23: 61, 65, 94.

1984 Eisler, Colin T. "A Nativity Signed PETRUS XPI ME FECIT 1452." *Album Amicorum Herman Liebaers.* Brussels: 451–469, fig. 2.

1984 Pieper, Paul. "Petrus Christus, Verkündigung und Anbetung des Kindes." *Pantheon* 42: 120–122, fig. 6.

1984 Sterling, Charles. "A la recherche des oeuvres de Zanetto Bugatto: une nouvelle piste." *Scritti di storia dell'arte in onore di Federico Zeri.* 2 vols. Milan, 1984, 1: 177.

1984 Lane, Barbara G. *The Altar and the Altarpiece. Sacramental Themes in Early Netherlandish Painting.* New York: 59, fig. 37.

1961.9.10 (1367)

Portrait of a Male Donor

c. 1455
Oak (cradled), 42 x 21.2 (16½ x 8⅜)
Samuel H. Kress Collection

Technical Notes: Wooden strips, appx. 0.5 cm wide, were attached to all sides of the original oak panel, which has been planed down, mounted on a thin layer of softwood, and cradled. The top strip has now been removed. The panel has no unpainted edges and may have been trimmed very slightly within the painted area on all four sides. The painting was restored by Stephen Pichetto about 1938. The paint surface is, in general, in very good condition. There is some scattered repainting along the crackle pattern in the robe and on the right side of the donor's face, as well as larger areas of thin repaint along the right edge of the painting, in the door sill, and to the right of the donor's sleeve. Retouching to the right of the donor's face appears to mask traces of an earlier contour here.

Provenance: Private collection, Genoa.[1] Count Alessandro Contini-Bonacossi, Florence, by 1937. Samuel H. Kress, New York, 1937–1961.

Notes

1. I have been unable to find a basis for the Genovese provenance of the panels beyond an unattributed statement in the Gallery's file from the Kress Foundation. No donor portraits or triptych positively identifiable with 1961.9.10 and 1961.9.11 are listed in Carlo Giuseppe Ratti, *Instruzione di quanto puo' vedersi di più bello in Genova in pittura, scultura ed architettura,* 3 vols. (Genoa, 1780), or Federigo Alizeri, *Guida artistica per la Città di Genova,* 2 vols. (Genoa, 1846).

1961.9.11 (1368)

Portrait of a Female Donor

c. 1455
Oak (cradled), 41.8 x 21.6 (16⁷⁄₁₆ x 8½)
Samuel H. Kress Collection

Inscription:
On woodcut: *O s . . . a elisab. / O . . . / . . .*

Technical Notes: Wooden strips appx. 0.5 cm wide have been attached to all sides of the original oak panel, which has been planed down, mounted on a thin layer of softwood, and cradled. Both this panel and 1961.9.10 are made from single boards, each cut from the same tree.[1] The painting was restored by Stephen Pichetto about 1938. The paint surface is in general in very good condition. There are scattered small retouchings in the face, robe, and background, as well as some larger areas of repaint. These are in the wall just above the figure's hands, at the left edge of the painting above the book, and at the bottom of the dress. Infrared reflectography and infrared photographs show that the prie-dieu was painted over the floor tiles and the robe of the donor. Guidelines for the tiled floor also extend beneath the donor's robe. Before the inclusion of the prie-dieu, the wall of the chamber met the tiled floor appx. 10 cm from the bottom edge of the panel. This junction is also visible in raking light.

Provenance: Same as 1961.9.10.

THESE TWO PANELS must have flanked a central devotional image to form a triptych or small private altarpiece. The two donor figures kneel in a complex interior space that opens onto a hilly landscape through an archway and terrace on the left and an arcaded porch on the right. Hence, the central panel would also have depicted a domestic interior, probably as a setting for the Madonna and Child. In deference to the holy figures in the missing central scene[2] the husband has taken off his pattens and *chaperon*. The woman's devotions are aided by the prayer book open before her and by the woodcut of Saint Elizabeth of Hungary affixed to the wall.[3] A restrained harmony of gray and brown tones links the two panels, which are enlivened by the blue-green distant landscape and by touches of deep scarlet in the woman's velvet robe, the man's *chaperon*, and the coats of arms. Some subtleties of color and texture have probably been lost with time. Thus, the husband's deep purple velvet robe, the green cloth on which the wife kneels, and the marble insets of the arcade behind her have darkened almost to black.

In spite of their characteristic Flemish dress, the two donors were probably Italian. The coats of arms hanging behind each figure are apparently those of the Lomellini and Vivaldi respectively, two prominent families in the mercantile patriciate of Genoa.[4] The two panels are also said to have come from Genoa. If the woodcut image refers to the patron's name saint, as seems likely, an Elisabetta or Isabella Vivaldi whose husband was a Lomellini may eventually be singled out as the commissioner of the small altarpiece.[5]

Since the two donor portraits first came to light in the mid 1930s, they have been attributed without res-

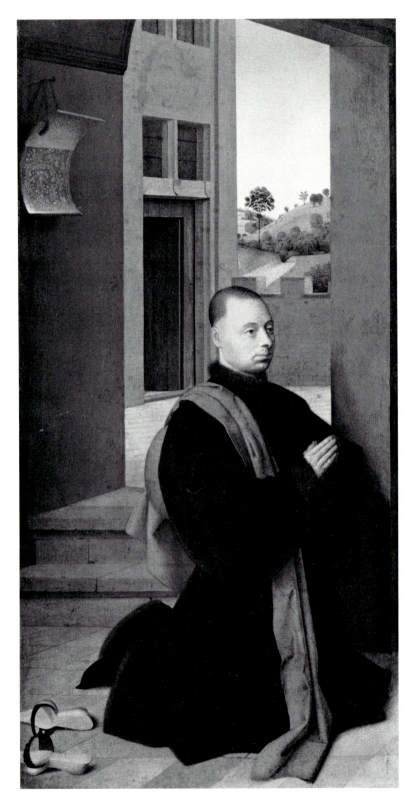

Petrus Christus, *Portrait of a Male Donor*, 1961.9.10

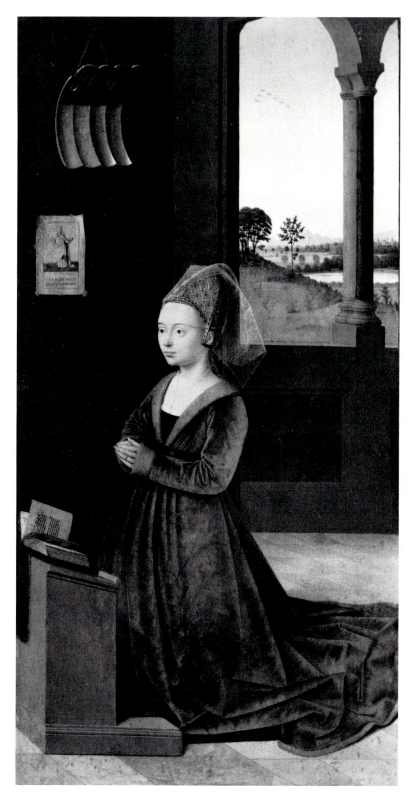

Petrus Christus, *Portrait of a Female Donor*, 1961.9.11

ervation to Petrus Christus. Their date is more difficult to determine, both because of the eclectic nature of Christus' work and because his surviving dated paintings all fall within a relatively short time span, with none between 1457 and his death after 19 March 1472.[6] Most critics place the Gallery's donor portraits among Christus' mature paintings in the 1450s.[7] However, the dating of the Gallery's pair has been complicated by the possibility of an Italian trip by Christus and by the question of the panels' relationship to the *Madonna and Child with Saints Jerome and Francis* in Frankfurt (figs. 1–2), whose date is usually read as 1457.[8]

The assumption of an Italian trip by Christus stems from the lack of references to the painter in Bruges documents from 1454 to 1463,[9] from mention of a *Piero di Burges* at the Sforza court in a document of March 1456,[10] and from Christus' evolution toward a rational projection of space. The documentary evidence for an Italian trip does not bear close scrutiny.[11] Nor does the question seem relevant to the Gallery's two donor portraits because the northern dress of the sitters suggests that the panels were painted in Flanders. The resident Genovese community in Bruges or Genovese merchants with business in Bruges could have provided Christus with this commission.[12] Members of the Lomellini family played a prominent role in the flow of letters of exchange between Bruges, London, and Genoa during this period.[13]

Barbara Lane first suggested that the two donor portraits originally flanked the *Madonna and Child with Saints Jerome and Francis* in Frankfurt, noting that Italian patrons were particularly likely to favor these two saints.[14] In terms of their dimensions the three panels could indeed make up a triptych, though the *Madonna and Child* is 4.9 centimeters taller than the wings. The Frankfurt panel has been cut slightly on the left so that the Madonna is no longer in the center of the panel and Saint Jerome has lost the cardinal's hat that would have hung down his back.[15] Lane's hypothesis is also plausible in terms of subject and general style. The tonal balance between interior and landscape is very similar in the Frankfurt and Washington panels, as are the doll-like figure types. The way the heads of the female donor and Saint Francis are formed is analogous. Yet small private altarpieces were undoubtedly an important part of Christus' production, being especially well suited to the quiet nature of his art, and the survival of parts of such works need not lead to the assumption that they belong together. Somewhat stereotyped figures such as those inhabiting the Frankfurt and Washington panels are characteristic of Christus, as is the repetition of architectural elements like the tiled floor, the brick wall with stone top, or the balustrade with marble insets.[16] Moreover, as Schabacker pointed out, the juxtaposition of these three panels presents problems given the very fine adjustments in space, light, and surface pattern habitually made by Christus.[17] The donor figures dominate the proposed whole because of their larger scale and their position in the front plane. Apart from this disproportion, the combined interior space is not coherent. Thus the door standing open behind Saint Francis would effectively block the female donor's view of the holy figures. The arcaded porch in the right wing is not continuous with the porch visible through the door in the Frankfurt panel. The latter is supported by a full-length column barely visible to the right of Saint Francis, rather than by a half column, and its capital appears to have a different profile from those in the arcade behind the female donor. The two donors themselves seem to kneel at the entrance of a shallower room, which would contain the sacred figures they adore and whose space, as is evident from the orthogonals of the two doorjambs, would be projected at a wider angle than that of the Frankfurt panel. Above all, the juxtaposition of the three panels would leave the donors isolated on the wings, rather than presented to the Madonna and Child by the two saints, which is the customary arrangement.

Fig. 1. Petrus Christus, *Madonna and Child with Saints Jerome and Francis*, Frankfurt, Städel'sches Kunstinstitut und Städtische Galerie [photo: Städel'sches Kunstinstitut, Ursula Edelmann, photographer]

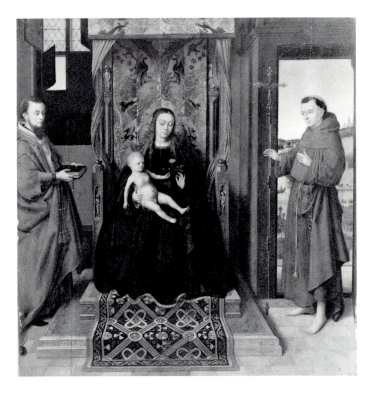

In conclusion, the Gallery's two wings must be quite close in date to the Frankfurt *Madonna and Child*, though in all probability they did not form a single altarpiece. Some subtle stylistic differences detectable between the donors and the dated panel in Frankfurt tend to suggest a date slightly before 1457 for the Washington pair. As Collier pointed out,[18] the projection of space is less disciplined in the donor panels. Moreover, the drapery folds are stiffer and more angular. A softer, more shadowy atmosphere surrounds the Frankfurt figures, though this may be due in part to the paintings' condition, since the donors have been cleaned more recently. Finally, while dress cannot give a firm indication of date, the lady's rather loose sleeves and the bulky fabric of her bodice pleated into the waistband reflect an earlier fashion than the constricted silhouette of the later 1450s.[19] Therefore a date of about 1455 seems likely for the donor portraits.

<div align="right">M.W.</div>

Notes

1. See Appendix I.

2. See also the *Nativity* by Christus, 1937.1.40.

3. Three crowns, on her head and in either hand, identify her as Saint Elizabeth, as does the barely legible inscription in red below the image. The print is attached to the wall with sealing wax. Along with the *Annunciation* in Brussels by a follower of Robert Campin (Friedländer, vol. 2 [1967], no. 54b, pl. 80), this is one of the earliest depictions of the everyday use of a woodcut; see also Alan Fern, "The Print as Subject," *The Baltimore Museum of Art, Annual IV*, Part 2 (1972), 98–105.

4. Or, a chief gules (with a decorative foliate scroll in silver) for the left panel. This corresponds to the Lomellini arms as given in the *Libro d'oro*, Genoa, Biblioteca Berio, sezione di conservazione, m.r. cf. bis 4.6., under Lomellini (I am grateful to Susan Barnes for this information), and in Vittorio Spreti, *Enciclopedia storico-nobiliare italiana*, 9 vols. (Milan, 1928–1936), 8: 227; however, in his main entry Spreti describes the upper portion as purple, not red, 4: 140. For the Vivaldi arms on the right panel, per pale gules and argent, on a chief or a demi-eagle naissant sable, see Spreti, 6: 955. Eisler 1977, 51, 53, noted that the husband's arms could also belong to a member of the Van Meghem family.

5. The family trees culled from Genovese records and listed in Natale Battilana, *Geneologie delle famiglie nobili di Genova*, 3 vols. (Genoa, 1825–1833), include relatively few Vivaldi women married to Lomellini men within the time frame of the portraits, for example, several daughters of Luca Vivaldi, including a Battina Vivaldi married to Domenico Lomellino, listed in Battilana under Vivaldi, 10. An attempt to identify the sitters should go back to the archival documents on which Battilana based his lists.

6. See Biography.

7. Exceptions are Upton 1975, 52, who dated them c. 1445, and Burroughs 1938, 250, who erroneously placed them in the 1460s on the basis of costume (see n. 19 below).

8. In the Städel'sches Kunstinstitut und Städtische Galerie. 46.7 x 44.4 cm; the panel has edging strips rather than unpainted margins on all four sides. The third digit of the date is not clearly legible. First recorded by J. D. Passavant in the Aders collection, London, *Kunstreise durch England und Belgien* (Frankfurt, 1833), 92.

9. Documents of late April and early May 1454 relate to Christus' commission from the Count of Etampes to make three copies of a revered icon in Cambrai; W. H. James Weale, "Peintres brugeois. Les Christus," *Annales de la société*

Fig. 2. Composite of 1961.9.10, 1961.9.11, and Fig. 1 [photo: NGA]

d'émulation de Bruges 59 (1909), 101–102. 1463 is the very approximate date by which Christus and his wife were inscribed in the Confraternity of the Dry Tree, Bruges; see Joel M. Upton, "Petrus Christus," Ph.D. diss., Bryn Mawr College, 1972, 35, 44, 432, no. 9, with a useful compilation of documents relating to Christus.

10. Francesco Malaguzzi-Valeri, *Pittori lombardi del quattrocento* (Milan, 1902), 88–89, 217, first called attention to this name and to an *Antonello da Sicilia* and *il Pisanello* in a list of Sforza dependents. C. de Mandach, "Un atelier provençal du XVᵉ siècle," Académie des Inscriptions et Belles-Lettres, Paris. Fondation Eugène Piot, *Monuments et mémoires* 16 (1909), 196–199, linked this reference to PetrusChristus; see also Bazin 1952, 195–208.

11. Fernanda Wittgens showed that the document quoted by Malaguzzi-Valeri was actually a letter requesting payment for a long list of *provisionati et balestieri*, that is, soldiers; "La pittura lombarda nella seconda metà del quattrocento," *Storia di Milano*, 16 vols. (Milan, 1953–1966), 7: 751–752.

12. For Genovese merchants living in or trading with Bruges, see Jacques Heers, *Gênes au XVᵉ siècle: Activité économique et problèmes sociaux* (Paris, 1961). Some early documentary references indicate that Christus' work was appreciated in Italy. A portrait of a French lady by *Pietro Cresti di Bruggia*, included in Lorenzo de' Medici's 1492 inventory, has frequently been associated with the *Portrait of a Lady* in Berlin; Schabacker 1974, 109–110, fig. 16. In his 1524 letter to Marcantonio Michiel, Pietro Summonte mentioned having seen, in the Sannazaro collection, Naples, a little painting of Christ in Majesty by *Petrus Christi, pictor famoso in Fiandra*; Fausto Nicolini, *L'arte napoletana del rinascimento e la lettera di Pietro Summonte a Marcantonio Michiel* (Naples, 1925), 163. Payment in 1451 to a *mᵒ piero de fiandra* for an altarpiece for the church of the Carità in Venice has been linked to Christus; Lorne Campbell, "Notes on Netherlandish pictures in the Veneto in the fifteenth and sixteenth centuries," *BurlM* 123 (1981), 467–468.

13. Heers 1961, 80–81, and "Les génois en Angleterre: La crise de 1458–1466" in *Société et économie à Gênes (XIV–XVᵉ siècles)* (London, 1979), 819. For the activity of the Vivaldi family in Bruges, see Eisler 1977, 51, 53.

14. Lane 1970, 390–393, crediting Judith Levenson, "Petrus Christus and the Rational Use of Space," Master's thesis, Institute of Fine Arts, New York, 1965, 35–45, with the same conclusion. See also Lola B. Gellman, "Petrus Christus," Ph.D. diss., The Johns Hopkins University, 1970, 237–244, 447–449. The proposed triptych was accepted by Gellman 1975/1976, 33, and Panhans-Bühler 1978, 118–123. Eisler, in his review of Schabacker 1977, 141, and in his catalogue of the Kress collection, 1977, 52–54, appears to accept this reconstruction and the possibility of an Italian trip; see also Eisler 1984, 465, and Sterling 1984, 177. Lane's hypothesis was rejected by Schabacker 1971, 281–282, and 1974, 112–114; Paolini 1980, 164; and Paul Eich (conversation of 28 March 1983).

15. Paul Eich, who graciously helped me examine the Frankfurt painting, suggested that the round object at Jerome's feet could be the paw of his attendant lion.

16. These elements recur, for example, in the *Madonna and Child* in Budapest, in the *Madonna and Child in a Porch* in Madrid, and in the *Madonna and Child* in Kansas City; Friedländer, vol. 1 (1967), pls. 83, 88, 109.

17. See n. 14. He notes that the distant hills in the *Madonna* and the *Female Donor* are not in the same plane.

18. Collier 1979, 36–37.

19. Letters from Stella Mary Newton to Colin Eisler, 4 May 1967 and from Margaret Scott to the author, 7 May 1982, in curatorial files. Margaret Scott suggests that, since the man's gown would have been fashionable about 1430, this may be a case of an older or conservative man married to a more fashionable woman. For the more constricted silhouette that came into fashion in the course of the 1450s, see 1937.1.44, Rogier van der Weyden, *Portrait of a Lady*.

References

1937 Friedländer. Vol. 14: 78–79 (vol. 1, 1967: 104, 110, pl. 104).

1938 Burroughs, Alan. *Art Criticism from a Laboratory.* Boston: 250.

1946 Friedländer, Max J. "The *Death of the Virgin* by Petrus Christus." *BurlM* 88: 159, pls. IIA–B.

1948 Puyvelde, Leo van. *The Flemish Primitives.* Brussels: 27, pl. 53.

1951 Kress: 15, 170, no. 75, repro. 171, 173.

1951 Frankfurter, Alfred M. "Interpreting Masterpieces." *ArtNA* 50: 100–101, repro. 103.

1952 Bazin, Germain. "Petrus Christus et les rapports entre l'Italie et la Flandre au milieu du XVᵉ siècle." *La Revue des Arts* 2: 199, 208.

1953 Panofsky. *ENP*: 313, 430–431, 491.

1960 Broadley, Hugh T. *Flemish Painting in the National Gallery of Art.* Washington: 5, 20, repro. 21.

1961 Seymour, Charles, Jr. *Art Treasures for America.* London: 72, 208, figs. 63–64.

1968 Ward, John L. "A New Look at the *Friedsam Annunciation*." *AB* 50: 187.

1968 Cuttler. *Northern Painting*: 133, fig. 158.

1969 Blum, Shirley Neilsen. *Early Netherlandish Triptychs.* Berkeley and Los Angeles: 117.

1970 Lane, Barbara G. "Petrus Christus: A Reconstructed Triptych with an Italian Motif." *AB* 52: 390–393, figs. 1, 3.

1971 Schabacker, Peter H., and Barbara G. Lane. Exchange of letters. *AB* 53: 281–283.

1972 Schabacker, Peter H. Review of *Rogier van der Weyden* by Martin Davies. In *AQ* 35: 424.

1974 Schabacker, Peter H. *Petrus Christus.* Utrecht: 51, 55, 108–109, 112–114, 120, 136, no. 18, fig. 18.

1975 Upton, Joel M. "Devotional Imagery and Style in the Washington *Nativity* by Petrus Christus." *StHist* 7: 52, 72, fig. 2.

1975/1976 Gellman, Lola B. Review of *Petrus Christus* by Peter H. Schabacker. In *Simiolus* 8: 33.

1976 Sterling, Charles. "Tableaux espagnols et un chef d'oeuvre portugais méconnus du XVᵉ siècle." *Actas del XXIII congreso internacional de historia del arte. España entre el mediterraneo y el atlantico.* Granada, 1973. 3 vols. Granada, 1: 501–502, fig. 6.

1977 Eisler, Colin. Review of *Petrus Christus* by Peter H. Schabacker. In *AB* 59: 141.

1977 Eisler: 51–54, figs. 48–49, text fig. 17.

1978 Panhans-Bühler, Ursula. *Eklektizismus und Originalität im Werk des Petrus Christus.* Vienna: 118–123, fig. 75.

1979 Campbell, Lorne. Review of *Eklektizismus und Originalität im Werk des Petrus Christus* by Ursula Panhans-Bühler. In *BurlM* 121: 802.

1979 Collier, James M. "The Kansas City Petrus Christus: Its Importance and Dating." *The Nelson Gallery and Atkins Museum Bulletin* 5, no. 5: 27, 31, 36, fig. 6.

1980 Scott, Margaret. *The History of Dress Series. Late Gothic Europe, 1400–1500*. London: 165, 241, fig. 96, pls. 6–7.

1980 Paolini, Maria Grazia. "Problemi antonelliani. Rapporti tra pittura fiamminga e italiana." *Storia dell' arte* 38–40: 164–165.

1981 Lurie, Ann Tzeutschler. "A Newly Discovered Eyckian *St. John the Baptist in a Landscape*." *BCMA* 67: 115, 118.

1984 Eisler, Colin T. "A Nativity Signed PETRUS XPI ME FECIT 1452." *Liber Amicorum Herman Liebaers*. Brussels: 465.

1984 Sterling, Charles. "A la recherche des oeuvres de Zanetto Bugatto: une nouvelle piste." *Scritti di storia dell'arte in onore di Federico Zeri*. 2 vols. Milan, 1984, 1: 177.

Joos van Cleve

active 1505/1508–1540/1541

The exact date and place of birth of Joos van Cleve (alias Joos van der Beke) are unknown, though, as his name implies, he most likely came from the region around the Lower Rhenish city of Kleve. He was probably born around 1485, as it is assumed that he entered the workshop of Jan Joest about 1505 and assisted in painting the panels of the high altar for the Nikolaikirche in the Lower Rhenish city of Kalkar.

Joos van Cleve emigrated to Antwerp, perhaps by way of Bruges, and in 1511 he was accepted as a freemaster in the guild of Saint Luke in Antwerp. In 1519, 1520, and 1525 he was a co-deacon of the guild and is listed as presenting pupils in 1516, 1523, 1535, and 1536. From his first marriage there were two children, a daughter and a son, Cornelis, born in 1520, who became a painter. On 10 November 1540 Joos van Cleve made his will and testament. The exact date of his death is not known, but on 13 April 1541 his second wife is listed as a widow.

Throughout most of the seventeenth century and in the eighteenth and greater part of the nineteenth centuries, the name of Joos van Cleve was lost. During the nineteenth century there were several attempts to identify an artist known as the Master of the Death of the Virgin, so called after a triptych now in the Wallraf-Richartz-Museum, Cologne. It was not until 1894, however, that Eduard Firmenich-Richartz recognized a monogram in the central panel as that of Joos van der Beke and thus identified the Master of the Death of the Virgin with Joos van Cleve alias van der Beke. This identification formed the basis of the reconstitution of Joos' oeuvre by Baldass and Friedländer.

The earliest dated panels, an *Adam and Eve* of 1507 in the Louvre, show the influence of Kalkar and Bruges. The *Death of the Virgin* (Wallraf-Richartz-Museum, Cologne), is datable to 1515 and was commissioned for a house-chapel in Cologne. A masterpiece, it shows an awareness of the emotional intensity of Hugo van der Goes, the iconographic schema of Jan van Eyck and Robert Campin, and the influence of Italian art as

well as Joos' own sensitivity to effects of color and light. Particularly in his paintings of the *Adoration of the Magi*, the influence of the "Antwerp Mannerists" is evident, though it is also possible that Joos influenced them in turn.

Like his compatriot Quentin Massys, Joos van Cleve was aware of the achievement of Leonardo da Vinci, and in works from the 1520s onward Joos appropriates Leonardesque motifs or, as in the *Virgin and Child* (Fitzwilliam Museum, Cambridge), emulates Leonardo's *sfumato*. Joos created several types of tender, slightly sentimental depictions of the *Madonna and Child* and the *Holy Family*; these images must have been very popular, for they were produced in quantity by the artist and his workshop.

According to Guicciardini, writing in 1567, Joos van Cleve's skill as a portraitist caused him to be summoned to the court of Francis I of France where he depicted the king and queen and other members of the court. Portraits of Francis I (Johnson Collection, Philadelphia Museum of Art) and Eleanor of Austria (Royal Collection, Hampton Court) tend to verify Guicciardini's statement. The portraits may date to 1530, the year Francis and Eleanor were married. Joos is not documented in Antwerp between 1529 and 1534, and it is quite possible that his journey included Italy as well as France.

Along with Quentin Massys, Joos van Cleve was one of the major artists working in Antwerp in the first decade of the sixteenth century.

J.O.H.

Bibliography

Baldass, Ludwig. *Joos van Cleve. Der Meister des Todes Mariä*. Vienna, 1925.
Friedländer. Vol. 9. 1931 (vol. 9, part 1, 1971).
Białostocki, Jan. "Joos van Cleve in dem Kalkarer Altar." *Kunsthistorische Forschungen Otto Pächt zu seinem 70. Geburtstag*. Salzburg, 1972: 189–195.
Hand, John Oliver. "Joos van Cleve: The Early and Mature Paintings." Ph.D. diss., Princeton University, 1978.

1962.9.1 (1662)

Joris Vezeleer

Probably 1518
Probably oak, rounded top, 58 x 40 (22⁷/₈ x 15³/₄)
 painted surface: 56.3 x 38.2 (22³/₁₆ x 15¹/₁₆)
Ailsa Mellon Bruce Fund

Technical Notes: The panel is made up of two members joined vertically. It is likely that sometime in the past the panel was taken apart, perhaps because of movement along the join line. X-radiographs show three empty dowel holes, and it is possible that the dowels were replaced by the five butterfly reinforcements now in place. Moderate losses along the join line have been repainted, with the heaviest retouching on the bottom half of the join.

The panel is in generally good condition. The bottom finger of the sitter's gloved hand is repainted; there is feathered retouching along the left side of the black robe and scattered retouching in the face and throat and along the edges of the hat.

Examination with infrared reflectography revealed scattered areas of underdrawing in the outline of the gloved hand, in the knuckles, and along the edge of the sitter's nose.

At the bottom left is a resinous circular seal that is partially destroyed and has been covered with black paint. This is almost certainly the same seal of the house of Liechtenstein as that found on the reverse. Reverse: At the center is a black, resinous circular seal that is largely destroyed. At the top center is a red, resinous, circular seal bearing the coat-of-arms of the house of Liechtenstein and the date 1733. Also on the reverse are a paper label from the Lucerne exhibition of 1948 and a black stamp.

Provenance: Probably Joris Vezeleer, Antwerp [d. 16 October 1570]. Probably Margaretha Boghe, his widow, Antwerp [d. perhaps 20 August 1574]; both portraits are probably mentioned in the inventory of 1574/1575 made at the time of her death.[1] Possibly Prince Karl Eusebius of Liechtenstein [d. 1684]. Prince Johann Adam of Liechtenstein, "Fideikommiss-galerie," Vienna, by 1712, the year of his death. Prince Emanuel of Liechtenstein, his nephew, 1712–1722 [d. 1777]. Reigning Prince Josef Johann of Liechtenstein, Vienna, by 1722 [d. 1732].[2] Prince Johann Nepomuk, Reigning Prince of Liechtenstein, Vienna [d. 1748].[3] Reigning Princes of Liechtenstein. Prince Franz Josef II of Liechtenstein, Vienna, until 1945; afterward Vaduz, Principality of Liechtenstein. (Feilchenfeldt, Zürich, 1962.)

Exhibitions: Lucerne, Kunstmuseum, 1948, *Meisterwerke aus den Sammlungen des Fürsten von Liechtenstein*, no. 74.

Notes

1. Denucé 1932, "Een contrefeytsel van Joris Veselaer ende Jouffr. Margrieten Boge syner huysvrouwen op twee doeren."

2. A family contract of 1722 established that the "Fidei-komiss" set up by Prince Johann Adam, which included the art collection and property in Vienna, would belong to the reigning princes of the house of Liechtenstein in succession.

3. When Prince Josef Johann died, his son, Prince Johann Nepomuk, was under age and his uncle Prince Josef Wenzel was appointed guardian. In 1733 Prince Josef Wenzel applied seals bearing the arms of Liechtenstein and the date 1733 to all paintings that were part of the "Fideikomissgalerie." In effect this commemorates the heritage of Prince Johann Adam and separated the works from Prince Josef Wenzel's own collection. See the essay by Wilhelm, "Die Liechtenstein-Galerie," in the 1948 Lucerne exhibition catalogue, 19–20. I am most grateful to Dr. Reinhold Baumstark, Director of Collections of the Prince of Liechtenstein, for information on this aspect of the provenance (letters of 28 June 1982 and 28 May 1985 in the curatorial files).

1962.9.2 (1663)

Margaretha Boghe, Wife of Joris Vezeleer

Probably 1518
Probably oak, rounded top, 57.1 x 396 (22⁷/₁₆ x 15⁵/₈)
 painted surface: 55.1 x 37.2 (21¹¹/₁₆ x 14⁵/₈)
Ailsa Mellon Bruce Fund

Technical Notes: The panel consists of two boards joined vertically. Unlike 1962.9.1, the boards seem not to have been separated, and the dowels can be seen in the x-radiograph.

The painting is in very good condition. There is retouching along the join line, most apparent in the lower portion. Scattered areas of retouching are in both cheeks, the throat, the upper bodice, the kerchief, and the sitter's left hand.

At the bottom right there is a resinous circular seal that has been covered with black paint. At the top center of the reverse is a red, resinous seal; this and the seal on the front are the same as the seals of the house of Liechtenstein of 1733 that appear on 1962.9.1. Also on the reverse are a partially destroyed black circular resinous seal, a paper label from the Lucerne exhibition of 1948, and a black stamp.

Provenance: same as 1962.9.1.

Exhibitions: Lucerne, Kunstmuseum, 1948, *Meisterwerke aus den Sammlungen des Fürsten von Liechtenstein*, no. 75.

THE EVENTUAL ATTRIBUTION of these panels to Joos van Cleve reflects the rediscovery of this artist that took place during the nineteenth century and parallels the general "rehabilitation" of Early Netherlandish painters.[1] In 1767 the paintings were ascribed to Holbein; they were still listed under Holbein's name when they were catalogued by Waagen in 1866. However,

Joos van Cleve, *Joris Vezeleer*, 1962.9.1

Joos van Cleve, *Margaretha Boghe, Wife of Joris Vezeleer*, 1962.9.2

Waagen thought that because of their coloring the portraits were by the Master of the Death of the Virgin, who was thought to be German or Netherlandish.[2] After 1894 the identification of the Master of the Death of the Virgin with Joos van Cleve became more and more certain, and in Baldass' monograph of 1925 the portraits were firmly attributed to Joos van Cleve.[3]

It was not until 1955 that Gerson was able to identify the sitters as Joris Vezeleer and his wife Margaretha Boghe.[4] The identification is based on the fact that the couple were the great grandparents of the Dutch statesman and poet Constantijn Huygens (1596–1687). On 23 December 1652 Huygens wrote to the Antwerp dealer Musson about portraits of his ancestors sold to Huygens' wife by Musson.[5] In the letter one of the portraits is described as a man pulling on a glove and it is remarked that the original paintings are in Vienna. Huygens notes that while Quentin Massys was usually named as the author, Musson had also spoken of Joos van Cleve. Unfortunately Musson's reply is not recorded. On 8 January 1653 Huygens wrote to J. Buycx, the widower of his niece, mentioning the original portraits in Vienna and stating that the copies owned by Huygens were made by an Antwerp artist named de Vos. In this letter the sitters are identified as "great-grandfather and mother Vezelaer."[6]

Although absolute proof is lacking it seems highly likely that the original portraits mentioned by Huygens as in Vienna were the Gallery's panels, which had entered the collection of Prince Johann Adam of Liechtenstein, Vienna, by 1712. What became of the copies belonging to Huygens is not known; the paintings were last mentioned in the inventory of Suzanna Louisa Huygens who died in The Hague in 1785.[7]

The mention of Joos van Cleve demonstrates that a tradition in the seventeenth century linked his name with works later given to the Master of the Death of the Virgin. It is, however, hard to gauge the strength of this tradition, for beginning with Lampsonius and Van Mander the biography and works of Joos were confused with those of his son Cornelis, and a Joos van Cleve the Younger, who never existed, was created.

Joris Vezeleer was a prominent member of the Antwerp mercantile community and thanks to the research of Coornaert, Van den Kerkhove, and others we have a great deal of information about his life and career.[8] While the tombs of Joris Vezeleer and his wife in the Sint Andrieskerk, Antwerp, no longer exist, the inscriptions on them have been preserved. They record that Joris Vezeleer died on 16 October 1570 at the age of seventy-seven. He was therefore born in 1493.

The place of Joris Vezeleer's birth is not known; the name Vezeleer may indicate an origin in the Lower Rhenish city of Wesel. In 1515–1516 he was listed as a citizen in the Antwerp *Poortersboek*.

Joris Vezeleer began his career as a goldsmith. In 1519 he owned a studio in Antwerp and in 1524 was dean of the gold and silversmiths' guild. The greater part of his career, however, was spent as a merchant, financier, and entrepreneur. From 1545 onward, probably until the end of his life, he was the mintmaster general of the Brabant mint. Without citing specific dates, Coornaert notes that he was "prévôt de la monnaie" in Antwerp.

Vezeleer was the head of a small family company with relatives stationed in Paris, Lyon, and Bordeaux. He also adopted the expedient tactic of marrying his three daughters to merchants.[9] To the extent that he specialized Joris Vezeleer seems to have dealt in *objets de luxe*. From 1528 onward he furnished first to Francis I of France[10] and later to Henry II plates and dishes, articles of vermeil, jewels of all sorts, including table-cut diamonds, and several tapestries. The French court was not the only client, for in 1548 Vezeleer is recorded as selling a tapestry series of *Vertumnus and Pomona* to Mary of Hungary. In 1544 Vezeleer entered into a transaction with fellow Antwerp merchant Pierre de Moucheron involving the shipment of wool, quicksilver, vermilion and copper, an indication that he did not deal exclusively in luxury items.

As a well-to-do merchant Joris Vezeleer was able to have constructed a château called "het Lanternhof" in the town of Deurne, just outside of Antwerp. The château was built between 1533 and 1535, but is no longer standing. Vezeleer also collected paintings and seemed to have a special interest in mythological scenes.[11]

We know very little about Margaretha Boghe. Two items, however, are of considerable importance. First, the inscription on her funerary monument states that she was married to Joris Vezeleer for fifty-two years. Since Joris died in 1570, this means that they were married sometime in 1518. In Joos van Cleve's portrait Margaretha holds a pink, traditional symbol of engagement or conjugal fidelity,[12] and it therefore seems plausible to suggest that the portraits were commissioned on the occasion of their marriage. In 1518 Joris Vezeleer would have been twenty-five years old, which accords well with his appearance in the Gallery's portrait. Prior to the publication of the funerary inscription, Baldass had dated the portraits to c. 1515 and Friedländer and Hand, on stylistic grounds, had proposed a date of c. 1520.[13]

Second, Margaretha Boghe survived her husband by four years and died sometime between 2 November 1574 and 21 January 1575, perhaps on 20 August 1574.[14] At the time of her death an inventory of the

paintings in the estate was made. Included in the inventory are portraits of Joris Vezeleer and Margaretha Boghe "op twee doeren"[15] that can be identified with the Gallery's panels with a high degree of probability.

The portraits of Joris Vezeleer and Margaretha Boghe are sensitively painted autograph works by Joos van Cleve and since the publication of Baldass' monograph in 1925 have been universally recognized as such. Friedländer cited Joris Vezeleer's action of drawing on his glove as an example of Joos' more decisive use of hand gestures. While gloves often occur in Netherlandish and German portraits of upper or merchant class men and may be generally considered to be the mark of a gentleman, it is difficult to assign a specific meaning to gloves or the act of putting them on. Van Regteren Altena suggested that Rembrandt's portrait of Jan Six of 1654 was influenced in pose by the portrait of Joris Vezeleer.[16] The visual similarities and the fact that the gesture of pulling on a glove is rarely seen in Netherlandish portraits lend credence to this idea. However, it would seem that Rembrandt saw the copy in Huygens' possession and not the original, then in Vienna.

Two copies of the portrait of Joris Vezeleer are extant; one is in the Rijksmuseum, Amsterdam, and the other is in a private collection, Newport Beach, California.[17]

J.O.H.

Notes

1. For a discussion of this process see Suzanne Sulzberger, *La Réhabilitation des primitifs flamands 1802–1867* (Brussels, 1961).

2. Fanti 1767, 91; Waagen 1866, 279–280.

3. The identification was made by Eduard Firmenich-Richartz, "Der Meister des Todes Mariae, Sein Name und Seine Herkunft," *ZfbK* 5 (1894), 187–194. Baldass 1925, nos. 37–38.

4. Gerson 1955, 129. Gerson gives an incorrect death date of 1567 for Joris Vezeleer and provides him with a middle initial W, the source of which is unknown.

5. Denucé 1949, 127–128.

6. Worp 1916, 162–163. Both Worp, 763, n. 2, and Gerson suggest that the artist who painted the copies might be Cornelis de Vos; however, there is no proof of this, and de Vos is a rather common name.

7. Van den Kerkhove 1974, 327.

8. The biographical material in this and following paragraphs is based on Emile Coornaert, *Les français et le commerce international à Anvers*, 2 vols. (Paris, 1961), 1: 343–344; 2: 35, n. 2, 49, 167, n. 5; Jozef Duverger, "Jan Gossaert te Antwerpen," *Bulletin Museum Boymans–Van Beuningen* 19 (1968), 21, and Van den Kerkhove 1974. Joris Vezeleer's name is spelled in a variety of ways: Vezeler, Vezelaer(e), Veseleer, and in France, Bezellet or Vezelees. I have adopted the spelling used by Van den Kerkhove.

9. Vezeleer had three daughters and one son. The eldest daughter, Elisabeth, married Jacob Hoefnagel, a merchant, and had twelve children. Her eldest son was the well-known Antwerp painter Joris Hoefnagel (1542–1600). After the surrender of Antwerp in 1585, the family moved north, and in 1592 Elisabeth's youngest daughter, Suzanna, married Christian Huygens in Amsterdam. Four years later on 2 September 1596 Constantijn Huygens was born in The Hague. In addition to Van den Kerkhove 1974, see H. E. van Gelder, *Ikonographie van Constantijn Huygens en de zijnen* (The Hague, 1957), 4–13.

10. Given Joos van Cleve's likely presence at the court of Francis I from 1529 onward, it is possible that he could have met Joris Vezeleer in France. See Hand 1978, 13, 268, n. 17. If, as his name implies, Vezeleer came from the lower Rhenish city of Wesel, he might have known or been attracted to Joos because of their common geographical origins.

11. The inventory published by Denucé 1932, 6–7, lists eleven mythological paintings.

12. For the symbolism of the flower, see Fernand Mercier, "La valeur symbolique de l'oeillet dans la peinture du moyenâge," *RAAM* 71 (1937), 233–236; Guy de Tervarent, *Attributs et symboles dans l'art profane* (Geneva, 1958), cols. 288–289.

13. Baldass 1925, 21, nos. 37–38. The reproductions show the painting as having square corners; Baldass stressed the proximity of the panels to the master's first Bruges-inspired portrait style. Friedländer, vol. 9, part 1 (1972), 72, no. 117, and Hand 1978, 147–299, no. 30, stressed the stylistic affinity with the pair of portraits in the Uffizi, Florence; the female sitter is dated 1520.

14. According to Van den Kerkhove 1974, 326, the inventory bears two dates: 2 November 1574 and 21 January 1575. The published funerary inscription gives a death date of 20 August 1564; this is probably an error of transcription for the year but the day and month may well be correct.

15. See n. 1 under 1962.9.1.

16. Van Regteren Altena 1973.

17. Rijksmuseum, Amsterdam, no. A3292, wood, 58 x 38.5 cm, rounded top; listed as a "copy after Joos van Cleve" in Pieter J. J. van Thiel, et al., *All the Paintings of the Rijksmuseum, Amsterdam* (Amsterdam and Maarsen, 1976), 169–170. The second panel, 56.5 x 39 cm, rounded top, was sold at Sotheby's, New York, 11 June 1981, lot 239.

References

1767 Fanti, Vincenzio. *Descrizzione Completa di Tutto ciò che Ritrovasi nella Galleria di Pittura e Scultura di Sua Altezza Giuseppe Wenceslao del S. R. I. Principe Regnante della Casa di Liechtenstein*. Vienna: 91, nos. 450, 451.

1780 Liechtenstein, François Joseph de. *Description des Tableaux et des pièces de sculpture que renferme la gallerie de son altesse François Joseph, Chef et Prince regnant de la maison de Liechtenstein*. Vienna: 179, 181, nos. 586, 589.

1866 Waagen, Gustav. *Die vornehmsten Kunstdenkmäler in Wien*. Vienna: 279–280.

1873 *Katalog der Fürstlich Liechtensteinischen Bilder-Galerie im Gartenpalais der Rossau, zu Wien*. Vienna: 124, nos. 1077, 1079.

1916 Worp, Jacob Adolf, ed. *De Briefwisseling van Constantijn Huygens*. 6 vols. The Hague, 5: 162–163.

1925 Baldass, Ludwig. *Joos van Cleve. Der Meister des Todes Mariä*. Vienna: 21, nos. 37–38, figs. 41–42.

1927 Kronfeld, Adolph. *Führer durch die Fürstlich*

Liechtensteinsche Gemäldegalerie in Wien. Vienna: 136, 138, nos. 704, 707.

1931 Friedländer. Vol. 9: 53, 144, no. 117 (vol. 9, part 1, 1972: no. 117, pls. 122–123).

1932 Denucé, Jan. *The Antwerp Art-Galleries. Inventories of the Art-Collections in Antwerp in the 16th and 17th Centuries.* The Hague: 6.

1948 Baldass, Ludwig. "Die niederländischen Bilder in der Liechtenstein-Galerie." *Meisterwerke aus den Sammlungen des Fürsten von Liechtenstein.* Exh. cat. Kunstmuseum. Lucerne: xxvii.

1949 Denucé, Jan. *Na Peter Paul Rubens. Documenten uit de Kunsthandel te Antwerpen in de XVIIᵉ eeuw van Matthijs Musson.* Antwerp: 127–128.

1955 Gerson, Horst. "Joos van Cleve." *OH* 70: 129–130, figs. 1–2.

1955 Cairns, Huntington. "Report on the National Gallery of Art." *Smithsonian Institution.* Report of the Secretary and Financial Report of the Executive Committee of the Board of Regents: 208, pl. 12.

1963 "Acquisti della National Gallery di Washington." *Domus,* No. 406 (September): 57, repro.

1973 Regteren Altena, J. Q. van. "Rembrandts Persönlichkeit. Versuch einer Profilierung." *Neue Beiträge zur Rembrandt-Forschung.* Berlin: 186, pl. 37, fig. 150.

1974 Kerkhove, A. van den. "Joris Vezeleer, Een Antwerps Koopman-Ondernemer van de XVIde Eeuw." *Annalen, 63 Congres Sint-Niklaas-Waas 1974*: 326–334, figs. 1–2.

1978 Hand, John Oliver. "Joos van Cleve: The Early and Mature Paintings." Ph.D. diss., Princeton University: 18, 147–150, 299, no. 30, figs. 37–38.

Gerard David

c. 1460–1523

Gerard David was born in Oudewater, near Gouda. He died in Bruges on 13 August 1523. In January 1484 he was admitted as a master to the painters' guild in Bruges. He was an officer (*Vinder*) in the guild in the years 1487–1488, 1495–1496, and 1497–1498; in 1501 he was dean of the guild. It is generally accepted that David was a member of the Antwerp guild in 1515, though the duration and purpose of his membership are not known.

The *Virgo inter Virgines* now in the Musée des Beaux-Arts, Rouen, which was painted by David for the Carmelite monastery of Sion, in Bruges, is documented to 1509. This panel contains a self-portrait of the artist, which because of his apparent age of about fifty is used as the basis for setting the year of his birth. While not as firmly documented as the *Virgo inter Virgines*, the two panels illustrating the *Judgment of Cambyses* in the Groeningemuseum, Bruges, are associated with works commissioned from David for the town hall in Bruges. The documents run from 1487 to 1498/1499, and one of the panels is dated 1498. It is also possible to establish dates for several other paintings by Gerard David. The *Baptism of Christ* in the Groeningemuseum, Bruges, was painted between 1502 and 1510, as can be deduced from the portraits of the donor's wives on the wings. The panel in the National Gallery, London, of *Bernardino de Salviatis with Saints Bernardin, Martin, and Donatian* is part of an altarpiece commissioned by Bernardino de Salviatis in 1501 for the Church of Saint Donatian in Bruges. *The Betrothal of Saint Catherine* (National Gallery, London), also done for Saint Donatian, was commissioned by Richard de Visch van der Capelle between 1500 and 1511. *The Marriage at Cana* (Louvre) can be dated to soon after 1503, the year the donor, Jan de Sedano, joined the Confraternity of the Holy Blood in Bruges.

Several drawings have been attributed to Gerard David with a reasonable degree of certainty, and illuminated manuscripts of the Bruges-Ghent School show the influence of David's style and compositions. It is

still a matter of conjecture whether David actually engaged in manuscript illumination.

Gerard David is usually considered the last great painter of the Bruges School and, in his early works especially, manifests the archaizing tendencies of the late fifteenth and early sixteenth centuries; that is, the conscious quotation from the work of earlier masters such as Jan van Eyck and Rogier van der Weyden. Recent scholarship, however, has stressed the progressive elements in David's art in the areas of iconography and composition as well as the history of landscape in the Netherlands.

J.O.H.

Bibliography
Weale, W. H. James. "Gerard David." *Le Beffroi* 1 (1863): 223–234; 2 (1864–1865): 288–297; 3 (1866–1870): 334–346.
Bodenhausen, Eberhard Freiherr von. *Gerard David und seine Schule*. Munich, 1905.
Winkler, Friedrich. "David, Gerard." In Thieme-Becker. Vol. 8 (1913): 452–455.
Friedländer. Vol. 6. 1928 (vol. 6, part 2, 1971).
Folie, Jacqueline. "Les oeuvres authentifiées des primitifs flamands," *BInstPat* 6 (1963): 230–232.

1937.1.43 (43)

The Rest on the Flight into Egypt

c. 1510
Oak, 44.3 x 44.9 (17⁷/₁₆ x 17¹¹/₁₆)
 painted surface: 41.9 x 42.2 (16¹/₂ x 16⁵/₈)
Andrew W. Mellon Collection

Technical Notes: The painting is in very good condition, with only small scattered areas of repaint. There are faint remains of gold halos behind the heads of the Christ Child and the Virgin. The Virgin's robe was originally larger at the lower left, as can be seen in infrared photographs and with the naked eye. Examination with infrared reflectography (fig. 1) reveals underdrawing in what appears to be brush in the blue robe of the Madonna. Restored 1984/1985.

Provenance: The Rev. Montague Taylor, London, acquired

c. 1845 [d. 1896] (sale, Christie's, London, 19 May 1897, no. 152). (P. & D. Colnaghi and Co., London.) Rodolphe Kann, Paris, acquired March 1898 [d. 1905].[1] (Duveen Brothers, New York, 1907.) J. Pierpont Morgan, New York, acquired c. 1908 [d. 1913].[2] (Knoedler & Co., New York.) Purchased December 1935 by The Andrew W. Mellon Educational and Charitable Trust, Pittsburgh.

Exhibitions:[3] Lent by J. Pierpont Morgan to the Metropolitan Museum of Art, New York, between 1911 and 1916. // New York, Metropolitan Museum of Art, 1920, *Fiftieth Anniversary Exhibition*. // Washington, Phillips Memorial Gallery, 1937, *Paintings and Sculpture Owned in Washington*, no. 7.

WHILE MATTHEW (2:13) provided the basic text for the theme of the Flight into Egypt, the Rest on the Flight and related picturesque episodes are to be found in apocryphal accounts, notably the *Gospel of Pseudo-Matthew* and *The Golden Legend*. Chapter twenty of the *Gospel of Pseudo-Matthew* recounts how on the third day of the journey the Virgin rested beneath a palm tree and how the Infant miraculously made the tree bend down to provide fruit for the Virgin.[4] He also caused a spring to issue from the base of the tree to quench the thirst of the Holy Family. In David's painting a stream can be seen at the extreme right corner, at the base of the ledge. Joseph's nut gathering may be interpreted as a variation on the palm tree miracle in that both actions are concerned with providing nourishment.

As in many representations of the Rest on the Flight into Egypt from the late fifteenth century, the Madonna and Child dominate the composition.[5] The grouping also carries overtones of both the Madonna of Humility and the Enthroned Madonna without specifically being either.

Gerard David depicted trees and plants with great accuracy, and it is quite possible that much of the flora was invested with symbolic meaning. In the foreground is a row of plants, each prominently displayed. At the far left is plantain, an effective stauncher of blood and hence associated with Christ's death. Next to it is mint, a healing and purifying herb that could symbolize virtue. More plantain is present and then strawberry, whose tripartite leaves allude to the Trinity and whose fruit and petals are emblematic of the blood and wounds of Christ. The fern was regarded as protection against evil and the Devil in particular. Last is violet, which symbolizes the humility of both Virgin and Child.[6]

The bunch of grapes held by the Madonna is a well-known symbol of the Eucharist and may also refer to divine generation and salvation in which the vine stands for Mary and the grapes for Christ.[7] Mundy suggests that the cluster of grapes is to be equated with the breasts of Mary, in function of providing nourishment, and stresses the association with the *Song of Solomon* (7:7–8) and with the writings of Bernard of Clairvaux.[8]

In addition to referring to the miracle described by Pseudo-Matthew, the spring at the far right may allude to the well of living waters mentioned in the *Song of Solomon* (4:15). It is even possible to see in the chestnuts gathered by Joseph symbols of modesty and chastity, though I believe it is sufficient to interpret them simply as a source of food, especially since they were a staple in the northern European diet.[9] The motif of striking the tree may have been derived from manuscript illumination.[10]

The attribution of *The Rest on the Flight into Egypt* to Gerard David has never been questioned.[11] Virtually all authors have dated the painting to about 1510 on the basis of its proximity to David's *Virgo inter Virgines* in Rouen, which is documented to 1509. This dating is eminently acceptable. Bodenhausen and de Tolnay discern in the panel the influence of the Antwerp School and of Quentin Massys in particular,[12] though I am unable to see such an influence.

The Rest on the Flight into Egypt is one of Gerard David's loveliest and most peaceful creations. It has a remarkable consistency and subtlety in the use of mass and void, a simplification of natural shapes, a feeling for the unity of landscape and atmosphere, and a highly sensitive use of color, especially the varied tones of blue and blue-gray.

Several paintings produced in Bruges in the early sixteenth century are closely related to this composition. In her study of Adriaen Isenbrant and workshop practices in Bruges, Wilson formed a grouping of nine paintings in which the configuration of folds in the Madonna's robes is practically identical to that in David's panel.[13]

Close to the Gallery's panel is another depiction of the *Rest on the Flight into Egypt* that shows a nursing Child and a different drapery configuration. The best example is in the Prado, and is probably by Gerard David; an excellent replica is in the Metropolitan Museum of Art.[14]

J.O.H.

Notes

1. I am indebted to Burton Fredericksen for the date of acquisition and for the preceding sale and dealer information as well as the date of acquisition by Duveen.

2. Information in Knoedler brochure in curatorial files.

3. The curatorial files contain a presentation brochure

Gerard David, *The Rest on the Flight into Egypt*, 1937.1.43

Fig. 1. Infrared reflectogram assembly of *The Rest on the Flight into Egypt*, 1937.1.43 [infrared reflectography: Molly Faries]

prepared by Knoedler & Co., which states that the painting was exhibited in London, Knoedler Galleries, *Twenty Masterpieces in Aid of King George's Jubilee Trust*, 1935. However, it is not listed in the catalogue.

4. Montague Rhodes James, *The Apocryphal New Testament* (Oxford, 1924), 75. Brief mention of the bending tree is found in the chapter on the Holy Innocents (28 December) in *The Golden Legend*; see Ryan and Ripperger, *The Golden Legend*, 1: 66. See also Réau, *Iconographie*, vol. 2, part 2, 278–280.

5. Gertrud Schiller, *Iconography of Christian Art*, 2 vols. (Greenwich, Conn., 1971), 1: 122.

6. Mundy 1981–1982, 213–215.

7. E. de Jongh, "Grape symbolism in paintings of the 16th and 17th centuries," *Simiolus* 7 (1974), 182–184, 190–191.

8. Mundy 1981–1982, 216–219.

9. Mundy 1981–1982, 213, n. 3. For chestnuts as a foodstuff, see Waverly Root, *Food. An Authoritative and Visual History and Dictionary of the Foods of the World* (New York, 1980), 63–65.

10. For example, in the November calendar page of the *Très Riches Heures* of Jean, Duke of Berry, Musée Condé, Chantilly, fol. 11v, or the Grimani Breviary, Biblioteca Marciana, Venice, fol. 11v.

11. Bodenhausen 1905, 186, without elaboration, questioned if the painting were entirely autograph. See also Helbig 1900, pl. 8, who gives it to Patinir.

12. Bodenhausen 1905, 186; de Tolnay 1941, 185.

13. Wilson 1983, 60–64, 212–213. The pictures comprising this grouping are:

1. *Rest on the Flight into Egypt*, Groeningemuseum, Bruges, no. 223, attributed to Ambrosius Benson. (Georges Marlier, *Ambrosius Benson et la peinture à Bruges au temps de Charles-Quint* [Damme, 1957], 297–298, no. 61, pl. 14 facing 53.)

2. *Rest on the Flight into Egypt*, National Gallery of Ireland, Dublin, no. 498, attributed to Adriaen Isenbrant. (Friedländer, vol. 11 [1974], no. 183, pl. 136.)

3. *Madonna and Child in a Niche*, Museo Lázaro Galdiano, Madrid, no. 2683, attributed to Adriaen Isenbrant. (Friedländer, vol. 11 [1974], no. 174a, pl. 132.)

4. *Madonna and Child in a Niche*, National Pushkin Museum, Moscow, attributed to Adriaen Isenbrant. (Friedländer, vol. 11 [1974], no. 183b, pl. 136.)

5. *Rest on the Flight into Egypt*, private collection, New York, attributed to Adriaen Isenbrant. (Friedländer, vol. 11 [1974], no. 183a, pl. 136.)

6. *Rest on the Flight into Egypt*, A. J. Barton Collection, Oxford, after Gerard David. (Friedländer, vol. 6, part 2 [1971], no. 214b, pl. 16.)

7. *Rest on the Flight into Egypt*, present location unknown, attributed to Adriaen Isenbrant. (*Sammlung Heinz Kisters* [exh. cat. Germanisches Nationalmuseum] [Nuremberg, 1963] no. 75, pl. 84.)

8. *Rest on the Flight into Egypt*, present location unknown. (Art market, Brussels, 25 June 1923.)

9. *Rest on the Flight into Egypt*, present location unknown, attributed to Adriaen Isenbrant. (Sale, Parke-Bernet, New York, 23 March 1950, lot 51, repro.)

That these paintings are attributed to different artists and are not all representations of the same subject allows one to postulate the existence of a common workshop model.

14. Friedländer, vol. 6, part 2 (1971), nos. 212, 212a, pl. 215.

References

1900 Helbig, Jules. "Joachim Patenier." *Revue de l'art chrétien* 11: pl. 8.

1900 Bode, Wilhelm. *Gemälde-Sammlung des Herrn Rudolf Kann in Paris*. Vienna: xxx, pl. 83.

1901 Michel, Émile. "La Galerie de M. Rodolphe Kann." *GBA* 3ᵉ pér. 25: 498.

1903 Marguillier, Auguste. "La Collection de M. Rodolphe Kann." *Les Arts* 3ᵉ pér. 13 (January): 4, repro.

1905 Bodenhausen (see Biography): 186–188.

1907 Bode, Wilhelm von. *Catalogue of the Rodolphe Kann Collection*. Paris: 1, xxxi; 2, 7, repro. 6.

1908 Nicolle, Marcel. "La Collection Rodolphe Kann." *RAAM* 23: 193.

1911 *Catalogue of the Paintings in the Metropolitan Museum of Art*. New York, 1905; Addenda: not paginated.

1914 Burroughs, Bryson. *The Metropolitan Museum of Art. Catalogue of Paintings*. New York: 61 (also 1916 ed.: 66).

1916 Friedländer, Max J. *Von Eyck bis Bruegel*. Berlin: 181.

1920 Ivins, W. M. Jr. "Pictures Lent for the Fiftieth Anniversary Exhibition." *BMMA* 15 (August): 189.

1921 Conway, Martin. *The Van Eycks and Their Followers*. London: 350–351.

1928 Friedländer. Vol. 6: 155, no. 214 (vol. 6, part 2, 1971: no. 214, pl. 217).

1935 "Twenty Masterpieces at Messrs. Knoedler's." *BurlM* 66: 299, frontispiece.

1941 NGA: 53–54.

1941 Tolnay, Charles de. "Flemish Painting in the National Gallery of Art." *MagArt* 34: 182–185, fig. 12.

1960 Broadley, Hugh T. *Flemish Painting in the National Gallery of Art*. Washington: 42, repro. cover (rev. ed. 1978).

1963 Walker: 104, repro. 105.

1968 Cuttler. *Northern Painting*: 195–196, fig. 245.

1975 Bermejo, Elisa. "Nuevas Pinturas de Adrian Isenbrant." *AEA* 48: 16.

1976 Walker: 132, repro. 133.

1979 Dufey-Haeck, Marie-Louise. "Le Thème du repos pendant la fuite en Egypte dans la peinture flamande de la seconde moitié du XVᵉ au milieu du XVIᵉ siècle." *RBAHA* 48: 54, 53, fig. 2.

1981/1982 Mundy, E. James, "Gerard David's *Rest on the Flight into Egypt*: further additions to grape symbolism." *Simiolus* 12: 211–222, figs. 1–3.

1983 Wilson, Jean. "Adriaen Isenbrant Reconsidered. The Making and Marketing of Art in Sixteenth-Century Bruges." Ph.D. diss., The Johns Hopkins University: 51–52, 60–64, 212–213, pl. 66.

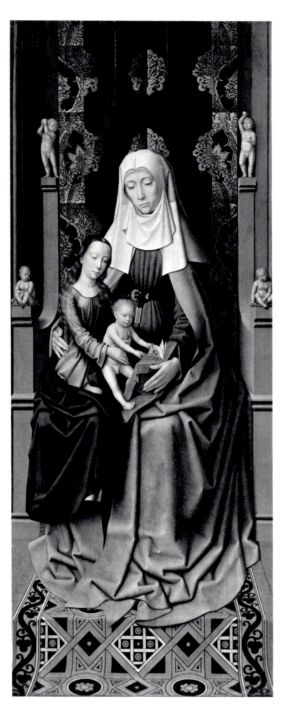
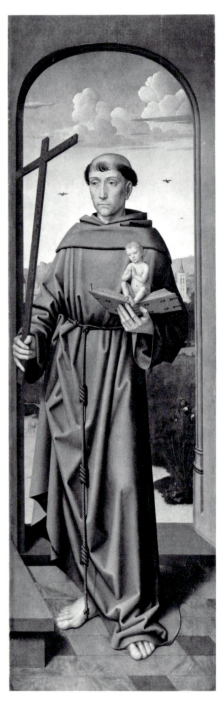

Gerard David and Workshop, *The Saint Anne Altarpiece*, 1942.9.17.a-c

Gerard David and Workshop

1942.9.17.a–c (613)

The Saint Anne Altarpiece

Oak (cradled), left panel: 236.1 x 75.9 (92^{15}/$_{16}$ x 29^{13}/$_{16}$); painted surface: 234 (including addition at top) x 74.9 (92^{1}/$_{8}$ x 29^{7}/$_{16}$); Center panel: 236.1 x 97.5 (92^{15}/$_{16}$ x 38^{3}/$_{8}$); painted surface: 232.5 (including addition at top) x 96 (91^{9}/$_{16}$ x 37^{13}/$_{16}$); Right panel: 235.4 x 75.9 (92^{11}/$_{16}$ x 29^{13}/$_{16}$); painted surface: 234 (including addition at top) x 73.8 (92^{1}/$_{8}$ x 29^{1}/$_{16}$)
Widener Collection

Inscription:
On a band around the Virgin's forehead on center panel:
SVSSIPE MARIA MATER GRACIE.

Technical Notes: Left panel: *Saint Nicholas.* The panel is composed of three boards with the grain running vertically. A painted section that is not original was added to the top of the panel; it is 21.9 cm high and composed of four pieces of wood. There is a barbe on the right edge; strips of bare wood 1.2 cm wide have been added to the left and bottom edges. There is a large oval repaired loss, approximately 15 cm long, centered at height 149 cm, width 53 cm from the left edge. There is extensive paint loss in the sky at the upper left which follows the pattern of the wood grain. Small losses are scattered across the paint surface and there are fine losses along the joins as well as an old check at the lower right.

Center panel: *Saint Anne with the Virgin and Child.* The panel is composed of four boards with the grain running vertically. The painted section added to the top is 20.5 cm high and composed of five pieces of wood. There is a barbe on the left and right edges. Small rounded losses are present throughout and there is a diagonal scratch approximately 25 cm long in the lower right of Saint Anne's robe.

Right panel: *Saint Anthony of Padua.* The panel is composed of three boards with the grain running vertically. The painted section added to the top is 20.8 cm high and composed of four pieces of wood. Strips of bare wood 1.2 cm wide have been added to the right and bottom edges. There is no barbe present at the left and a thin layer of ground covers much of the unpainted edge. This suggests that, unlike the other two panels, the ground and paint were applied before the panel was set into the frame. There are extensive tiny losses along the joins and, following the pattern of the wood grain, in the saint's face and surrounding sky. Small, rounded losses are scattered throughout. There is a diagonal scratch approximately 40 cm long near the center of the right edge and a smaller curved scratch on the left below the saint's sleeve.

Examination with infrared photography and infrared re-flectography reveals underdrawing in all three panels. Extensive underdrawing, in brush, is visible throughout the center panel (figs. 1, 2). In the Virgin's arm there is what can be presumed to be a correction in a medium that has beaded and appears greasier than the other underdrawing (fig. 3). The underdrawing in the side panels is in a drier medium with thinner lines. The face of Saint Nicholas is underdrawn. In the right panel there are curving lines at the upper right and left and underdrawing in the face, robe, and feet of Saint Anthony.

The painting is currently under restoration.

Provenance: Cardinal Antonio Despuig y Dameto, Raxa, Palma de Mallorca [d. 1813]. By descent to Counts of Montenegro, Raxa, Palma de Mallorca.[1] Leon de Somzée, Brussels, by 1899.[2] Gaston de Somzée, Brussels, until 1902.[3] (Agnew & Sons, London, May 1902–January 1906.)[4] (Sedelmeyer Gallery, Paris, by January 1906.)[5] (Eugene Fischhof, Paris and New York, 1907.) Peter A. B. Widener, Elkins Park, Pennsylvania, April 1907.[6] Inheritance from Estate of Peter A. B. Widener by gift through power of appointment of Joseph E. Widener, Elkins Park, Pennsylvania.

Exhibitions: London, The New Gallery, 1899–1900, *Exhibition of Pictures by Masters of the Flemish and British Schools including a Selection from the Works of Sir Peter Paul Rubens,* no. 52. // Paris, Belgian Pavilion, 1900, *Exposition Universelle.* // Bruges, Hôtel de Gouvernement Provincial, 1902, *Exposition des Primitifs flamands et d'art ancien,* no. 125.

THE LEFT PANEL depicts Saint Nicholas of Bari wearing a bishop's mitre and chasuble and holding a crozier. The center panel shows Saint Anne on a throne decorated with four putti. Behind her is a cloth of honor and underfoot, an orientalizing carpet.[7] Seated on her knee is the Virgin holding the Christ Child, who turns the pages of a book held by Anne. On the right panel stands Saint Anthony of Padua who holds a cross and a book, upon which the Infant Jesus sits.[8] The architecture is continuous throughout all three panels.

There is little doubt that the three large panels of *The Saint Anne Altarpiece* are part of an altarpiece that included three small panels depicting scenes from the life of Saint Nicholas, now in the National Gallery of Scotland, Edinburgh (fig. 4),[9] and three small panels with scenes from the life of Saint Anthony of Padua, in the Toledo Museum of Art, Toledo, Ohio (fig. 5).[10] There are, however, questions about the original location of the altarpiece and whether a *Lamentation*[11] in

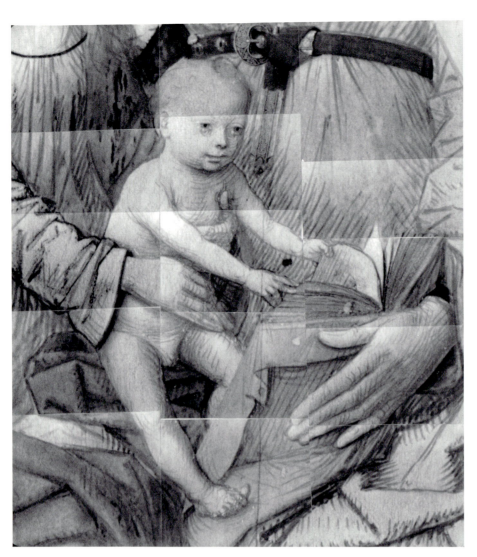

Fig. 1. Infrared reflectogram assembly of a detail of *The Saint Anne Altarpiece*, 1942.9.17.b, center panel [infrared reflectography: Molly Faries]

Below, left: Fig. 2. Infrared reflectogram assembly of a detail of *The Saint Anne Altarpiece*, 1942.9.17.b, center panel [infrared reflectography: Molly Faries]

Below, right: Fig. 3. Infrared reflectogram assembly of a detail of *The Saint Anne Altarpiece*, 1942.9.17.b, center panel [infrared reflectography: Molly Faries]

The Art Institute of Chicago was also a part of the ensemble.

The earliest description of all ten panels was written by Justi in 1886 when they were in Palma de Mallorca, in the gallery of the Counts of Montenegro, which was formed by Cardinal Despuig. Justi's comments do not, however, make it clear whether the pictures were exhibited as an ensemble or separately.[12] He assumed that the panels came from the parish church of Saint Nicholas in Palma de Mallorca. Upon entering the De Somzée Collection, Brussels, the smaller panels, with the apparent exception of the *Lamentation*, were put together to form a "shrine" resembling Memling's *Shrine of Saint Ursula* (Hospital of Saint John, Bruges).[13] In 1902 the three large and six small panels went to Agnew & Sons, London. The smaller panels immediately entered the collection of Lord Wantage, Berkshire, while the large panels remained with Agnew until 1906. The history of the *Lamentation* is not clear; it may be the one recorded in a Paris sale in 1903.[14]

The first serious attempt to reconstruct *The Saint Anne Altarpiece* occurred in 1976 when Farmer discussed whether the *Lamentation* might have been part of the retable.[15] Without coming to a conclusion, Farmer demonstrated that there is enough room for the *Lamentation* and the six small panels to be a predella to the large panels. The original location of the altarpiece is not often addressed. Weale and Friedländer believed it was produced for Spain, and only the 1956 Bruges exhibition catalogue suggested that it might have been bought in Italy by Cardinal Despuig.[16]

From the evidence at hand, a few suggestions regarding the original appearance of the retable can be made. The large panels formed an Italianate non-folding triptych, with Saint Anne and the Virgin and Child in the center, Saint Nicholas on the left, and the Saint Anthony on the right. The panels may have been rounded at the top, echoing the shape of both the painted architecture and the smaller panels. It has been suggested that the center panel was taller than the side panels.[17] The smaller panels were probably arranged underneath in the manner of a traditional predella. I believe it unlikely that the space at the center of the predella was occupied by the *Lamentation*. Its bright, blond tonality is in contrast to the darker, more saturated colors found in the Edinburgh and Toledo panels, and its draftsmanship and modeling are more assured. Also, the juxtaposition of Saint Anne with the Virgin and Child to a Lamentation, while not impossible, is iconographically odd.

This reconstruction suggests that *The Saint Anne Altarpiece* was designed for export to either Spain or Italy, for such an arrangement is not typical of Northern altarpieces. Cardinal Despuig, the first known owner of the retable, was an avid collector who spent time in both Italy and Spain.[18] The altarpiece could have been acquired in either country, and Justi's suggestion that it was in the church of Saint Nicholas in Palma de Mallorca should not be discounted. The combination of Saint Anne, Saint Nicholas, and Saint Anthony of Padua in the same altarpiece is highly unusual, but does not help to localize the altarpiece, for by the late fifteenth and early sixteenth centuries all three had achieved widespread popularity. While the question of whether Gerard David ever traveled outside the Netherlands remains moot, he and his shop presumably produced pictures for export to both Italy and Spain.[19]

In the case of Gerard David the relationship of date to style is especially thorny. With only the *Virgo inter Virgines* in Rouen securely documented to 1509, one of the *Justice* panels dated, and a few panels datable by external means, establishing a viable chronology is difficult. With *The Saint Anne Altarpiece* the problem is compounded by the fact that the quality of execution is not on the highest level, reflecting the intervention of David's workshop.[20] An early date of 1494/1498 is proposed by Mundy who stresses the influence of Memling.[21] Several authors suggest a date in David's maturity, roughly 1510/1515.[22] Boon considers the altarpiece to be a product of David's last years, though the "emptiness," "dryness," and "stiffness" he ascribes to the last phase of David's work are also the terms that he applies to the contributions of less skilled assistants.[23] In the absence of a secure chronology one can only observe that *The Saint Anne Altarpiece* is not close to the *Virgo inter Virgines* or the *Justice of Cambyses* panels, but until it can be proved that David's late style is marked by increased collaboration with assistants as well as diminished performance, the question of the date must remain open.[24]

The motif of the Christ Child seated on the Virgin's lap and turning the pages of a book can be found, in reverse, in David's *Altarpiece of the Virgin Enthroned* (Louvre, Paris).[25] This picture is placed by Friedländer in David's early period, before 1498. Replicas of the Louvre composition are in the Hessisches Landesmuseum, Darmstadt, and the John G. Johnson Collection, Philadelphia Museum of Art, and show the Child facing in the same direction as in the Gallery's painting and with a very similar carpet underfoot.[26]

J.O.H.

Fig. 4. Here attributed to Gerard David and Workshop, *Three Miracles of Saint Nicholas*, Edinburgh, National Galleries of Scotland [photo: National Galleries of Scotland]

Fig. 5. Here attributed to Gerard David and Workshop, *Three Miracles of Saint Anthony of Padua*, Toledo, Ohio, The Toledo Museum of Art, Gift of Edward Drummond Libbey [photo: The Toledo Museum of Art]

Notes

1. The first mention of the painting is Bover 1845, 178, no. 152, 194, no. 207, and 195, no. 216. See also Justi 1886, 137–138. For the life of Cardinal Despuig see n. 18 below.

2. Exh. cat. London 1899–1900, no. 52.

3. Exh. cat. Bruges 1902, no. 125, lists C. and G. de Somzée, but Sedelmeyer Gallery 1906, 9, lists Gaston de Somzée.

4. Letter of 17 July 1981 from William Joll of Agnew & Sons to the author, in the curatorial files.

5. Sedelmeyer Gallery 1906, 9.

6. Unpublished document from the Widener papers in the curatorial files that appears to be a copy of a receipt of 1 April 1907; the transaction was part purchase, part exchange, with Fischhof receiving an *Assumption of the Virgin* by Murillo. Fischhof is not mentioned in the provenance given in Widener 1908, 155.

7. According to Charles Grant Ellis, research associate, The Textile Museum, Washington, in conversation 9 September 1980, the carpet is Western and probably of Flemish manufacture. Bodenhausen 1905, 170, seems to have been the first to point out its similarity to the carpet in Jan van Eyck's *Madonna of Canon van der Paele*, Bruges, Groeningemuseum; Cuttler, *Northern Painting*, pl. 8.

8. For Saint Nicholas see Réau, *Iconographie*, vol. 3, part 2, 976–988; for Saint Anthony of Padua see Réau, *Iconographie*, vol. 3, part 1, 115–122; Réau notes that the Christ Child sitting on the book refers to an apparition that came to Saint Anthony, but does not appear in art until the sixteenth century. For Saint Anne with the Virgin and Child see 1976.67.1, Master of Frankfurt.

9. Colin Thompson and Hugh Brigstocke, *National Gallery of Scotland. Shorter Catalogue* (Edinburgh, 1970), 19–20, no. 2213; each panel is 55.9 x 33.7 cm (22 x 13 1/4 in). The legends depicted are: Saint Nicholas gives thanks to God on the day of his birth; he bestows a dowry on the three daughters of an impoverished nobleman; he restores to life three dismembered children.

10. *The Toledo Museum of Art. European Paintings* (Toledo, 1976), 48, no. 59.21; the drowned child restored to life, 55.1 x 32.7 cm (21 11/16 x 12 7/8 in); no. 59.22, the mule kneeling before the host, 57.3 x 34 cm (22 7/16 x 13 3/8 in); no. 59.23, Saint Anthony preaching to the fishes, 55.6 x 32.6 cm (21 7/8 x 12 13/16 in).

11. Farmer 1976, no. 1933.1040, 54.7 x 62.4 cm (21 1/2 x 24 1/2 in).

12. Justi 1886, 138.

13. *Catalogue of Pictures forming the Collection of Lord and Lady Wantage* (London, 1905), 53. See also the description in exh. cat. London 1899–1900, no. 32.

14. Farmer 1976, 57–58, n. 16.

15. Farmer 1976, esp. 47, fig. 7, 48, fig. 9; Hofstede de Groot and Valentiner 1913 propose an arrangement whereby the smaller panels were arranged one above the other on the exterior of the side wings and the Lamentation was placed under the center panel. This presumes that the wings were hinged.

16. Friedländer 1903, 87, Weale 1903, 39, *L'Art flamand dans les collections Britanniques et la Galerie National de Victoria* [Exh. cat. Groeningemuseum] (Bruges, 1956), nos. 24–25, for the six small panels then in the collection of Christopher Loyd.

17. Colin Thompson, Director, National Gallery of Scot-

land, letter of 6 May 1981 in the curatorial files. I would agree; the springing of the simulated arch is visible at the top of the original portion of the side panels, but not in the center panel, which seems to indicate that the arch began at a greater height.

18. On the life of Cardinal Despuig see Luis Ripoll, *Raxa y el Cardenal Despuig* (Palma de Mallorca, 1954), 8–15, and Jaime Salva, *El Cardenal Despuig* (Palma de Mallorca, 1964). Despuig was in Italy in 1782–1783 (his passport was valid for Parma, Bologna, Florence, Rome, and Naples); he returned to Palma de Mallorca, but was again in Rome by 1785. He remained in Italy until at least 1788 and, while he stayed primarily in Rome, he visited several other cities. In 1794/1795 he was named archbishop of Valencia. He was in Palma de Mallorca from 1804 until 1807, after which he was in Paris and Rome. He died in Lucca in 1813. The chances of obtaining new information about Cardinal Despuig's collection are very slim; according to Joana Palou i Sampol, curator of Museo de Mallorca, direct descendants of the Counts of Montenegro have disappeared along with the family archives (letter of 5 March 1981 in the curatorial files).

19. David's altarpiece of the *Virgin Enthroned*, Friedländer, vol. 6, part 2 (1971), nos. 202, 172–173 (divided among the Louvre, Paris, the Metropolitan Museum of Art, New York, and the Palazzo Bianco, Genoa), comes from the della Cervara Abbey near Genoa. The *Virgin and Child*, Friedländer, vol. 6, part 2 (1971), no. 212, in the Prado, comes from a convent in Navarre, and another *Virgin and Child*, Friedländer, vol. 6, part 2 (1971), no. 213, (Museum Boymans–van Beuningen, Rotterdam), comes from a Carmelite convent in Salamanca.

20. Bodenhausen 1905, 171–172, was the first to observe the unevenness of execution and the contribution of David's assistants in both the predella and the main panels. Friedländer 1900, 249, and vol. 6, part 2 (1971), 90–91, commented on the emptiness of form, especially in the large panels, but explained it as a result of the large size. Marlier 1957, 49, saw in the figure of Saint Anthony of Padua the hand of Ambrosius Benson. While the large hands and feet do recall Benson, differences in the manner of painting become apparent if one examines the *Altarpiece of Saint Anthony* in the Musées Royaux des Beaux-Arts, Brussels, monogrammed A.B. and considered one of the core works for the Benson group (repro. Friedländer, vol. 11 [1974], no. 237, pl. 161). It is noteworthy that Anthony's pose and drapery configuration are virtually identical to the Saint Anthony on the interior right wing of the *Saint Michael Altarpiece* in the Kunsthistorisches Museum, Vienna (repro. Friedländer, vol. 6, part 2 [1971], no. 166, pl. 178), which implies that a model or pattern was available in the David shop.

In regard to the predella panels, the presence of pouncing in two of the Edinburgh panels may be taken as evidence of workshop participation. In the scene of Saint Nicholas bestowing a dowry, pouncing was observed by Johannes Taubert, "Pauspunkte in Tafelbildern des 15. und 16. Jahrhunderts," *BInstPat* 15 (1975), 390, fig. 3, and by Jean Wilson (undated note to the author) in the scene of the birth of Saint Nicholas. The composition of the scene of the mule kneeling before the host in Toledo is found, often in reverse, in several manuscripts of the Ghent-Bruges School. Perhaps the earliest appearance of this motif is the miniature (fol. 187v) in the *Hours of Isabel la Católica* in the Cleveland Museum of Art; see Patrick de Winter, "A Book of Hours of Queen Isabel la

Católica," *BCMA* 68 (1981), 342–427, esp. 418, color pl. 4, figs. 124–126. De Winter dates the illumination by Horenbout to c. 1491–1492, but a *terminus ante quem* for the entire manuscript is 1504, the year of Isabel's death.

For a discussion of the workshop practices and procedures in Bruges see Jean Wilson, "Adriaen Isenbrandt Reconsidered. The Making and Marketing of Art in Sixteenth Century Bruges," Ph.D. diss., The Johns Hopkins University, 1983, 47–139.

21. Mundy 1980, 28.

22. Bodenhausen 1905, 168–172; Friedländer, vol. 6, part 2 (1971), 101, no. 167, 90, calls it "rather late vintage"; Cuttler 1968, 196.

23. Boon 1946, 46–47.

24. I am indebted to James Mundy and Jean Wilson for sharing their thoughts on the problems of David's workshop and the chronology of his paintings, and also to Maryan Ainsworth for sharing the results of her technical investigation of David's paintings.

25. Friedländer, vol. 6, part 2 (1971), no. 165.

26. Friedländer, vol. 6, part 2 (1971), nos. 165a, 165b. The motif of the Christ Child holding a book may be derived from the paintings of Memling and his circle, where it occurs with some frequency; see Friedländer, vol. 6, part 1 (1971), nos. 59–60, 63.

References

1845 Bover, Joaquín María. *Noticia Histórico-Artística de los Museos del Eminetísimo Señor Cardenal Despuig Existentes en Mallorca*. Palma: 178, 194, 195, nos. 152, 207, 216.

1886 Justi, Karl. "Altflandrische Bilder in Spanien und Portugal." *ZfK* 21: 137–138.

1899 "Bibliographie." *La Chronique des Arts et de la Curiosité* no. 37: 342.

1900 Lafenestre, Georges. "Les arts à l'Exposition Universelle de 1900. La peinture ancienne." *GBA* 3ᵉ pér. 24: 537–538.

1900 Friedländer, Max J. "Die Leihausstellung der New Gallery in London, Januar–März 1900.—Hauptsächlich niederländische Gemälde des XV. und XVI. Jahrhunderts." *RfK* 23: 249–250.

1900 C. H. "Correspondance d'Angleterre. L'Exposition des maîtres anciens à la New Gallery." *La Chronique des Arts et de la Curiosité* no. 5: 43.

1902 Hulin de Loo, Georges. *Bruges 1902. Exposition de tableaux flamands des XIV, XV et XVI siècles. Catalogue critique*. Ghent: 32–33.

1903 Friedländer, Max J. "Die Brügger Leihausstellung von 1902." *RfK* 26: 87.

1903 Dülberg, Franz. "Die Ausstellung altniederländischer Malerei in Brügge." *ZfbK* 14: 141.

1903 Weale, W. H. James. "The Early Painters of the Netherlands as Illustrated by the Bruges Exhibition of 1902." *BurlM* 2: 39.

1905 Bodenhausen, Eberhard Freiherr von. *Gerard David und seine Schule*. Munich: 168–172, repro. opp. 168.

1906 Friedländer, Max J. "Die Leihausstellung in der Guildhall zu London—Sommer 1906—Hauptsächlich niederländische Bilder des 15. und 16. Jahrhunderts." *RfK* 29: 579.

1906 Sedelmeyer Gallery. *Illustrated Catalogue of the Tenth Series of 100 Paintings by Old Masters*. Paris: 9, repro. opp. 16.

1908 *Catalogue of Paintings forming the Private Collection of P. A. B. Widener*. Ashbourne: 155.

1911 Bodenhausen, Eberhard Freiherr von, and Wilhelm Valentiner. "Zum Werk Gerard Davids." *ZfbK* 22: 184, 189.

1913 Winkler, Friedrich. "David, Gerard." In Thieme-Becker 8: 453.

1913 Widener: not paginated, repro.

1916 Friedländer, Max J. *Von Eyck bis Bruegel*. Berlin: 43, 181.

1921 Conway, Martin. *The Van Eycks and Their Followers*. London: 286–287.

1928 Friedländer. Vol. 6: 97–98, 146, no. 167, pl. 76 (vol. 6, part 2, 1971: 90–91, 101, no. 167, 132, pl. 181–183).

1929 Erdmann, Kurt. "Orientalische Tierteppiche auf Bildern des XIV. und XV. Jahrhunderts. Eine Studie zu den Anfängen des Orientalischen Knüpfteppichs." *JbBerlin* 50: 296.

1931 Kleinschmidt, Beda. *Antonius von Padua in Leben und Kunst, Kult und Volkstum*. Düsseldorf: 197, fig. 162.

1932 Laurent, Marcel. "Les Miracles de Saint Antoine de Padoue." *OH* 49: 79, 87–88, fig. 9.

1935 Widener: 25.

1938 Waldman, E. "Die Sammlung Widener." *Pantheon* 22: 338, repro. 336.

1942 Widener: 5, no. 613.

1946 Boon, Karel G. *Gerard David*. Amsterdam: 46–47, repro.

1948 Widener: no. 613, repro. 68–69. (Also cat. of 1959.)

1957 Marlier, Georges. *Ambrosius Benson et la peinture à Bruges au temps de Charles-Quint*. Damme: 46–50.

1960 "Neuerwerbungen in den USA." *Die Weltkunst* 30 (15 January): 8.

1961 Birkmeyer, Karl M. "The Arch Motif in Netherlandish Painting of the Fifteenth Century: A Study in Changing Religious Imagery." *AB* 43: 111–112, fig. 26.

1964 Nuño, J. Gaya. *Pintura Europea Perdida por España, de van Eyck a Tiépolo*. Madrid: nos. 43–45, pl. 25.

1968 Cuttler. *Northern Painting*: 196.

1969 Osten, Gert von der, and Horst Vey. *Painting and Sculpture in Germany and The Netherlands 1500 to 1600*. Harmondsworth and Baltimore: 142.

1975 NGA: 94, repro. 95.

1976 Farmer, John David. "Gerard David's Lamentation and an Anonymous St. Jerome." *Museum Studies* (The Art Institute of Chicago) 8: 39–57, repro. 47–48.

1980 Mundy, Edwin James. "Gerard David Studies." Ph.D. diss., Princeton University: 28–29.

Jan van Eyck

c. 1390–1441

It is a traditional belief that Jan van Eyck and his brother Hubert were natives of Maaseik, a town north of Maastricht. Jan van Eyck first appeared in The Hague, in October of 1422, as painter and *varlet de chambre* to John of Bavaria, Count of Holland. Since Van Eyck was referred to at that time as a "master," it seems likely that he was born no later than c. 1390. Following the death of John of Bavaria, Van Eyck moved to Bruges and on 19 May 1425 was appointed painter and *varlet de chambre* to Philip the Good, Duke of Burgundy. Until the end of 1429 he resided mainly in Lille but, in addition to his duties as painter, Van Eyck was also entrusted with various secret missions. In 1427 he may have gone to Spain to negotiate a marriage between the Duke of Burgundy and Isabella of Aragon; this was not successful, but in 1428 and 1429 Van Eyck was in Lisbon, where a marriage contract between Philip the Good and Isabella of Portugal was signed, and in December 1429 Isabella, perhaps accompanied by Van Eyck, arrived in Flanders. Following the marriage of Philip and Isabella in 1430, it is assumed that Van Eyck moved to Bruges where, with the exception of certain secret missions, he spent the rest of his life as court artist to Philip. He also undertook civic commissions; in 1435 he painted and gilded six statues and their tabernacles for the facade of the Town Hall of Bruges. Van Eyck died in late June 1441.

Although none of Van Eyck's works can be authenticated by documents, he was—as Panofsky pointed out—the first Early Netherlandish artist to sign his paintings and the only one to emulate the nobility in adopting a personal motto, *Als ich chan* (As Best I Can). The combination of inscriptions, signatures, mottos, and dates, for the most part found on the frames, has made it possible to establish a canonical oeuvre for Van Eyck. The earliest painting is the exceptionally large altarpiece of the *Adoration of the Lamb* in the cathedral of Saint Bavo, Ghent, which was completed in 1432. The quatrain inscribed on the frame, which mentions both Jan van Eyck and his brother Hubert, has engendered enormous controversies and endless at-

tempts to define the artistic contribution of each brother. It has even been suggested that Hubert was only the creator of an elaborate frame for the Ghent Altarpiece, and his very existence has been doubted. Of Hubert van Eyck almost nothing is known save that he died on 18 September 1426 and is mentioned in four documents. There are no paintings that can be given to him with any degree of certainty.

At the core of Jan van Eyck's oeuvre are the Ghent Altarpiece and the nine signed paintings that date from 1432 to 1439. Included in this group is the triptych in the Staatliche Gemäldesammlung, Dresden, which recently has been found to bear a signature, motto, and date of 1437. The question of which, if any, of Van Eyck's works dates before 1432 continues to be debated as does the date and Van Eyck's involvement in the partially destroyed manuscript known as the Turin-Milan Hours. A single drawing, the portrait of Cardinal Albergati in Dresden, is accepted as autograph.

Van Eyck's fame and reputation were established by the middle of the fifteenth century and since then have continued undiminished. He is one of the greatest artists of all time and, with Robert Campin and Rogier van der Weyden, is one of the founders of the Early Netherlandish school of painting. His work combines meticulous technique, detailed observation, and superior intellect and learning. In Friedländer's words, "He knows fabrics like the weaver, from whose looms they have flowed, buildings like an architect, the earth like a geographer, plants like a botanist."

J.O.H.

Bibliography

Weale, W. H. James. *Hubert and John van Eyck. Their Life and Work*. London, 1908.
Friedländer. Vol. 1. 1924 (vol. 1, 1967).
Baldass, Ludwig. *Jan van Eyck*. London, 1952.
Panofsky. ENP. 1953.
Löhneysen, Hans-Wolfgang. *Die ältere niederländische Malerei. Künstler und Kritiker*. Eisenach and Kassel: 1956, 189–254.
Folie, Jacqueline. "Les oeuvres authentifiées des primitifs flamands." *BInstPat* 6 (1963): 192–203.

Sterling, Charles. "Jan van Eyck avant 1432." *RArt* no. 33 (1976): 7–82.

Dhanens, Elisabeth. *Hubert and Jan van Eyck.* Antwerp, 1980.

1937.1.39 (39)

The Annunciation

c. 1434/1436
Canvas (transferred from wood), 92.7 x 36.7 (36½ x 14⁷/₁₆) painted surface: 90.2 x 34.1 (35³/₈ x 13⁷/₈)
Andrew W. Mellon Collection

Inscriptions:
Top of back wall to the right of furthest left figure: MOYSES F[I]SCELLA
Above second figure from left: FI ... PHARAONIS
On banderole: O IN ... VS HEBREORVM HIC EST¹
On globe in window: ASIA
Above third figure from left: MOYSES
On banderole: N̄O ASSVMES NŌM D̄I TVI Ī VAN [VM]
Above fourth figure from left: D̄N̄S
Middle of back wall on roundel left: ISAAC
Roundel right: JACOB
To the right of Gabriel: AVE GR̂A PLENA
To the left of Mary: IN̄D ⱯꞀꞀIƆNA D̄NI
On floor, lower left: A DALIDA VXORE S²
Lower center: SAVL REX; DAVID; GOLIAS
Second row center: SAMSSON MVLTAS GENTES INTERFECIT T ꝗ VIVIO.

Technical Notes: The painting was transferred from wood to canvas after it entered the Imperial Hermitage Museum, Leningrad, probably after 1864.³ The picture has been extensively restored, though it is hard to say whether this was necessitated by the transfer or by previously existing conditions. Areas of craquelure have been repainted and the repaint has discolored; this is most evident in the background. Repaint is also present in portions of the angel's face and hair and in the Virgin's blue robe. It appears that large portions of the top glaze of the Virgin's robe have been lost and the surface has been altered by mechanical or chemical actions. The unsightly appearance of the robe is compounded by the fact that in certain areas the varnish has become opaque and milky. There are small losses in the book and the cushion.

Examination with infrared reflectography discloses underdrawing in several different areas. Parallel hatching and clusters of longer strokes can be seen in the Virgin's robe (fig. 1). Underdrawing exists in the face and hair and a portion of the wing of the angel Gabriel. The hem of Gabriel's robe bears an illegible inscription.⁴ What appear to be perspective lines go through the capitals of the triforium at the left, and these indicate slight shifts of perspective. A diamond-shaped grid is underdrawn on the floor in the area depicting David slaying Goliath (fig. 2). There are broad indications of shad-

ows at the edge of Gabriel's robe and thinner lines indicating shadows at the left of the stool.

Provenance: Possibly the Chartreuse de Champmol, near Dijon.⁵ Sale, Paris, 1819. (C. J. Nieuwenhuys, Brussels.) William II, King of the Netherlands [d. 1849], in Brussels until 1841, thereafter The Hague⁶ (sale, The Hague, 12 August 1850, no. 1). Czar Nicholas I of Russia [d. 1855] for the Imperial Hermitage Museum, Leningrad. (Knoedler & Co., New York.) Purchased June 1930 by Andrew W. Mellon, Washington. Deeded 5 June 1931 to The A. W. Mellon Educational and Charitable Trust, Pittsburgh.

Exhibitions: Bruges, 1907, *Exposition de la toison d'or et de l'art néerlandais sous les Ducs de Bourgogne,* no. 175.

THE ANNUNCIATION, or Angelic Salutation, recounted in its most basic form in Luke 1:26–38, is one of the fundamental events of Christianity. It marks the origin of the human life of Christ and the incarnation of the Savior in a necessary prelude to the redemption of mankind through Christ's death and resurrection.⁷ For modern critics what is perhaps most remarkable about Jan van Eyck's *Annunciation* is the complexity and erudition of the iconographic program through which these concepts are set forth.

The *Annunciation* takes place in a church interior; this and a bourgeois interior were the two major settings used in northern Europe. Jan van Eyck was probably the first to present the scene in this manner in a painting, though it appears earlier in manuscript illumination. The church is fictitious, but the details of the architecture have been associated with specific buildings such as the Cathedral of Tournai or Notre Dame in Dijon.⁸ Gabriel holds a sceptre and wears a crown and elaborate cope.⁹ Pointing upward, he pronounces the Angelic Salutation, "Ave gratia plena" (Hail, full of grace, Luke 1:28). Mary, dressed in a blue robe trimmed in ermine, is shown in an ambiguous pose; it is not clear if she is kneeling, crouching, or standing. Her reply, "Ecce ancilla domini" (Behold the Handmaiden of the Lord, Luke 1:38), is written upside down so that it can be read from above. The same device is used in the Annunciation panels of the Ghent altarpiece. In relation to the architecture the figures are disproportionately large, and this may relate to the identification of Mary with the Church, a concept found in Van Eyck's *Madonna in a Church* in Berlin (fig. 3).¹⁰

Other elements in the painting pertain either to the Annunciation proper, to the prefiguration of Christ's life and works in the Old Testament, or to Mary's role as intermediary.

Light streams through the window at the upper left and takes the form of seven rays; the dove of the Holy

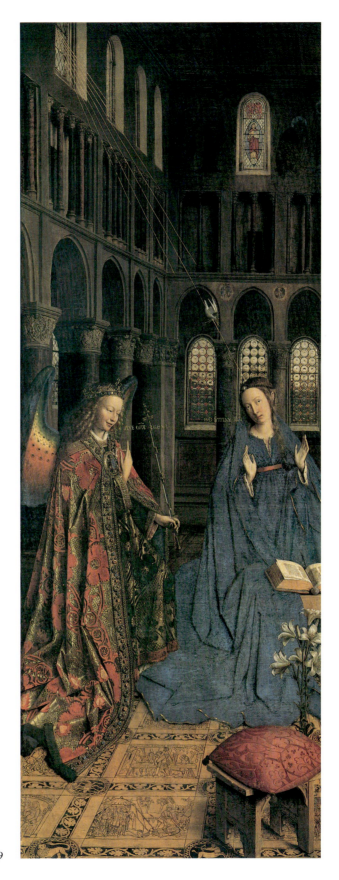

Jan van Eyck, *The Annunciation*, 1937.1.39

Fig. 1. Infrared reflectogram assembly of a detail of *The Annunciation*, 1937.1.39 [infrared reflectography: Molly Faries]

Fig. 2. Infrared reflectogram assembly of a detail of *The Annunciation*, 1937.1.39 [infrared reflectography: Molly Faries]

Fig. 3. Jan van Eyck, *Madonna in a Church*, Berlin, Staatliche Museen Preussischer Kulturbesitz, Gemäldegalerie [photo: Jörg P. Anders]. *Above, right:* Fig. 4. *The Annunciation*, 1937.1.39, detail

Spirit descends along the longest of these rays. The rays allude to the seven gifts of the Holy Spirit (Isaiah 11:2–3) that will descend on Christ as a branch of the Tree of Jesse.[11] At the lower right is a vase of lilies (*Lilium candidum*), traditional symbols of Mary's purity. Seven of the lilies are open and two are closed.[12] The divine light entering from the upper left may be contrasted to the natural light that illuminates the scene from the lower right.[13]

The symbolism deals primarily with the relationship of the Old Testament to the New Testament and the transition from the era *sub lege* (under law) to the era *sub gratia* (under grace). As Panofsky pointed out, this idea is manifest in the transition from the Romanesque round-arched windows of the clerestory to the early Gothic pointed arches of the lower zone. This architectural peculiarity is found, however, in several Belgian ecclesiastical structures of the late Middle Ages, which means that while the arrangement may be and probably is symbolic, it is not an architectural and historical anachronism.[14] Similarly, the single stained-glass window at the top of the painting containing a figure of the Lord may be contrasted to the three lead-shot windows behind the Virgin and thus alludes to the passage from the Jewish to the Christian era.

The stained-glass window is in itself a complex and ambiguous image (fig. 4). Enclosed in a mandorla, the bearded figure who holds a scepter and a tablet with an illegible inscription is usually identified as the Old Testament Lord of Sabaoth. That he stands upon a world globe labelled ASIA may refer to the Lord's statement in Isaiah 66:1, "Heaven is my throne and the earth is my footstool." However, this figure is a generalized image that does not seem to correspond to any single biblical description of God.[15] The winged red angels standing on wheels refer to the vision of four-winged cherubim in Ezekiel 10.

On either side of the stained-glass window are murals that, while difficult to see, appear close in style to the late medieval wall paintings found in some Belgian churches.[16] At the left is depicted the presentation of the infant Moses to Pharoah's daughter. In this scene from Exodus 2, Ward and others find a parallel to the life of Christ; a woman of royal blood is presented with and raises a son not of her husband, and this child will transmit God's covenant to man.[17] The finding of Moses has been interpreted as a symbol of baptism or a prefiguration of the reception of Christ by the faithful.[18] At the right is a depiction of the Lord presenting Moses with a scroll bearing the words of the command-

ment, "You shall not take the name of the Lord your God in vain" (Exodus 20:7). The giving of the Ten Commandments, which established the Old Covenant, is a parallel to the Incarnation, which established the New Covenant *sub gratia*.[19]

Painted on the rear wall of the lowest zone are two roundels depicting Isaac and Jacob. The blessing of Jacob by Isaac (Genesis 27) is also a parallel to the Annunciation and carries with it the promise of earthly blessing. Spiritual blessings, however, must be found in Christ; but as Williams points out, Luke 1:32–33 states that Christ will reign over the house of Jacob.[20]

The iconographic program is continued in the floor of the church (fig. 5). The floor is decorated with nielli that form two sets of symbolic images, the signs of the zodiac and scenes from the Old Testament. There are also framing borders of stylized columbine and clover.[21] In medieval churches signs of the zodiac were sometimes incorporated into the pavement to show that God has dominion over the physical universe and the movement of the planets as well as over the world of the spirit.[22] Not all of the signs are visible, but Panofsky attempted a reconstruction that calls for four rows of signs with, respectively, two, three, four, and three signs in each row (from upper left).[23] Consequently, the angel Gabriel would be over the sign of Aries, standing for the month of March and the date of the Annunciation (25 March), while the Virgin covers Virgo, the sign with which she was traditionally allied. The last visible sign at the far right is Capricorn, the sign for December and the Nativity. Ward alters and

elaborates upon Panofsky's analysis.[24] While agreeing that Gabriel and Mary are linked to Aries and Virgo, he proposes a different sequence. Ward notes that, with the exception of the Lion which is the sign of Leo (August), the creatures that inhabit the roundels are impure hybrids—a merman replaces Libra, a scorpion is substituted for the crab of Cancer, and for Capricorn a goat head emerges from a shell. These corrupted beasts, Ward believes, mirror the disruption of the cosmos by the forces of evil prior to the advent of Christ. Ward's interpretation should not be accepted uncritically, for many of the images used by Van Eyck may be seen as simply continuation of traditional symbols.[25] The malevolence in the world may also be alluded to by the armed figures in the capital of the corner pier at the rear of the church. The lion is unaltered because Leo is the house of the sun and hence associated with Christ both generally, as the "light of the world," and specifically, as the "sun of justice" (*sol justitiae*, Malachi 4:2).

The Old Testament scenes that adorn the pavement have been interpreted typologically as prefigurations of Christ's redemptive activity. Three are concerned with Samson, who was viewed by medieval commentators as a type of Christ in the guise of *sol justitiae*. At the left below the hem of Gabriel's robe is Samson slaying the Philistines (Judges 15), a prefiguration of Christ's triumph over sin; below it, Samson's betrayal by Delilah (Judges 16:4–5), which foretells Christ's betrayal by the Synagogue. In the center row, the uppermost niello is almost entirely obscured by the Vir-

Fig. 5. *The Annunciation*, 1937.1.39, detail

gin's robe, but Ward identifies the scene as the death of Abimelech (Judges 9:8–20, 54), whom he interprets as a prefiguration of the Antichrist. Below this is Samson pulling down the temple (Judges 16:23–30). Samson's death prefigures the Crucifixion, and the destruction of the Philistines in their temple presages the Last Judgment. At the bottom of the row is David cutting off the head of the slain Goliath (1 Samuel 17:51), which symbolizes Christ's victory over the Devil. The last scene at the bottom right is covered in part by the footstool, but Ward identifies it as the death of Absalom (2 Samuel 18:9–15), an antitype of Christ's Crucifixion.[26] The footstool itself is subject to multiple interpretations. Because of its proximity to Mary and the lilies, it may refer to the Virgin's humility; in its polarity to the image of the Lord at the top of the painting it may refer to Isaiah 66:1, "the earth is my footstool"; it may also allude to the throne prepared for the Second Coming of Christ.[27]

Broadly speaking, then, the lower portion of the painting is concerned with the human, earthly aspects of Christ's existence, particularly his sacrificial death, while the upper portion refers primarily to Christ's divine nature and association with the Lord of the Old Testament. These two zones come together compositionally and theologically in the person of the Virgin, in whose body Christ was made incarnate and who also functioned as intermediary between God and man. Mary's upraised hands have been associated by Purtle with the *expansis manibus* gesture used by the priest during parts of the Mass and in particular with the *Golden Mass*, which includes a dramatization of the Annunciation as part of the Mass.[28]

Depictions of the Annunciation in the late fourteenth and early fifteenth centuries fall into three basic categories: those set in a portico, in a bourgeois interior, and in an ecclesiastical structure. Van Eyck's *Annunciation* belongs to the last group, which, as Robb and others have shown, grows out of the traditions of courtly French manuscript illumination.[29] Iconographically and compositionally the closest antecedent is the *Annunciation* in the Book of Hours of c. 1405/1408 by the Boucicaut Master, in the Musée Jacquemart-André, Paris (fig. 6). The setting is ecclesiastical, the Virgin makes the same *expansis manibus* gesture, and a bearded God the Father holding a globe appears at the upper left.[30]

It is astounding to realize that the *Annunciation* is only the left wing of what was probably a triptych and that the same density, ingenuity, and iconographic complexity must have extended into the other two sections. This may also help to explain why the various iconographic interpretations put forward, no matter

Fig. 6. The Boucicaut Master, *The Annunciation*, Boucicaut Hours, Ms. 2. fol. 53v, Paris, Musée Jacquemart-André [photo: Bulloz]

how erudite, appear incomplete. It has been suggested that a Nativity or an Adoration of the Kings formed the center panel and that a Visitation or a Presentation in the Temple was on the right wing.[31] Such reconstructions are, of course, conjectural.

Allied to the problem of reconstruction are questions regarding the patronage and original location of Van Eyck's painting. The painting is first mentioned as coming from Dijon and, according to the dealer Nieuwenhuys, it was painted for Philip the Good and destined for an unspecified religious monument in Dijon.[32] A description of the Chartreuse de Champmol written in 1791 and published in part by Reinach mentions three paintings that were originally in the ducal chapel; one is an Annunciation whose tall, narrow shape suggests that of the Gallery's painting.[33] Unfortunately, the picture is not described and there is no way of connecting it with Van Eyck's painting, apart from the fact that both were in Dijon. While it is tempting to believe that *The Annunciation* was in the Chartreuse

de Champmol and hence conceivably commissioned by Philip the Good, there is no concrete evidence for this. O'Meara suggests that the Virgin has been given the features of Isabella of Portugal.[34] Although the argument is not conclusive, the idea is provocative and if true would certainly ally the painting to Isabella's husband, Philip the Good.

As regards the attribution and date of *The Annunciation*, scholarly opinions fall into three large categories. A small group of writers gives the painting to Hubert van Eyck and therefore dates it before Hubert's death in 1426.[35] With the exception of Thalheimer and Dhanens,[36] all other authorities consider the picture to be an autograph work by Jan van Eyck but vary in dating the painting before or after the Ghent altarpiece. Friedländer and de Tolnay propose c. 1433/1434, Baldass suggests 1432/1435, and Beenken puts the picture as late as 1436/1437.[37] On the other hand, Panofsky dates *The Annunciation* 1428/1429 and is joined in this opinion by Robb and Meiss.[38] Panofsky's dating had been adopted by the National Gallery.[39] Those who date the picture early associate it with the *Madonna in the Church* in Berlin, which was generally placed in the mid to late 1420s.

The chronology of Van Eyck's paintings was fundamentally altered, however, by the discovery of the date of 1437 on the triptych of the *Enthroned Madonna with Saints and a Donor* in Dresden, which had consistently been placed early.[40] Snyder has persuasively argued that the Berlin *Madonna in the Church* should also be placed among the late works, which would include the Dresden triptych, the *Saint Barbara* of 1437 in the Koninklijk Museum voor Schone Kunsten in Antwerp, and the *Madonna by the Fountain* of 1439 in the same museum.[41] Van Eyck's development after 1436, then, moves not in the direction of monumentality, but toward courtly refinement, almost a self-conscious continuation of the International Style. Eliminating the Berlin and Dresden pictures as works that predate the Ghent altarpiece makes it all but impossible to continue dating *The Annunciation* before 1432.

With Van Eyck's works compressed into less than a decade, it becomes difficult to assign precise dates. Stylistically, *The Annunciation* is not readily associated with the Ghent altarpiece, nor does it seem to belong with the very latest works. Perhaps the best dating would be c. 1434/1436.

The picture cited by Weale and others as a copy, in the collection of J. J. van Hal, Antwerp, in the early nineteenth century, is in actuality the Friedsam *Annunciation* now in the Metropolitan Museum of Art, New York.[42]

J.O.H.

Notes

1. Although it is almost illegible, I believe the second word is *INCARNATVS*.

2. Panofsky 1953, 414, believes the inscription can be completed as: *SAMSON TRADITVR A DALIDA VXORE SVA*.

3. In the 1850 sales catalogue of the collection of William II the painting is recorded as being on wood, and Waagen 1864, 115, gives the support as wood. The earliest Hermitage catalogue available to me, that of 1870, lists the picture as having been transferred to canvas at the Hermitage.

4. First observed by Carol Purtle. The author and Molly Faries, communication of August 1984, have noted that the first word is close to the cabalistic ΑΓΛΑ (AGLA), which appears in the Ghent Altarpiece; see Panofsky 1953, 210–211; Elisabeth Dhanens, *Van Eyck: The Ghent Altarpiece* (New York, 1973), 75.

5. Nieuwenhuys 1843, 2, on the history of the painting says: "D'après les meilleurs renseignements qu'on a pu obtenir, ce tableau faisait suite à deux autres peintures du même maître; il a été peint pour *Philippe le Bon, duc de Bourgogne*, et destiné à orner un monument religieux à Dijon." Reinach 1927, 239, published a fragmentary description written in 1791 of three paintings kept in the Prior's room, but originally in the ducal chapel of the Chartreuse de Champmol. This reads in part: "Dans la chambre du Prieur on conserve deux tableaux sur bois dans le genre des premiers peintres flamands, qui proviennent des chapelles [*sic*] des Ducs: ils ont environ 4 pieds de haut. Le premier, d'à peu près un pied de large, est un *Annonciation*...." Although the dimensions do not match those of the Gallery's painting, the general shape is similar and the tall, narrow format is rather unusual for a Netherlandish Annunciation. Nieuwenhuys' statement that the painting came from Dijon, coupled with the 1791 description, raises the possibility that 1937.1.39 is identical with the painting mentioned as being in the Chartreuse de Champmol. See below n. 33.

6. Nieuwenhuys 1843, ii; in 1841 the works of art were transported from Brussels to a gallery built for them in The Hague.

7. Réau, *Iconographie*, vol. 2, part 2, 174.

8. Weale and Brockwell 1912, 100; Beenken 1943, 78–80, and Panofsky 1935, 471, and 1953, 138, note similarities with the Cathedral of Tournai, while Kern 1912, 50–51, makes comparison to the Church of Notre Dame in Dijon. For other discussions of the architecture see Kern 1904, Saintenoy 1908, and de Jong 1934. See below n. 14.

9. McNamee 1963 points out that the cope marks Gabriel as an attendant at a Solemn High Mass, thus emphasizing the connection between the Incarnation and Christ's sacrifice on the Cross and its perpetuation in the Mass.

10. Discussed by Panofsky 1953, 144–148, and by Herzog 1956.

11. The gifts are: wisdom, understanding, counsel, strength, knowledge, piety, and fear. See Meiss 1945, 178.

12. Ward 1975, 197, sees the lilies as referring to Christ rather than solely to the purity of the Virgin, and the fact that seven lilies are open as further strengthening the association with Isaiah's prophecy of the seven gifts of the Holy Spirit.

13. Panofsky 1953, 147–148.

14. Panofsky 1953, 137–139; compare de Tolnay 1941. Lyman 1981 points out that the "upside down" elevation actually occurs in several churches in Tournai, with the church of Saint Quentin most resembling the architecture of Van Eyck's painting. Saint Quentin is also highly unusual in

that its sanctuary faces west rather than east. Not mentioned by Lyman but also displaying "upside down" elevations are the Cistercian abbey at Villers-la-Ville and the cloister of the abbey at Orval, reproduced in A. van de Walle, *Gothic Art in Belgium* (Brussels, 1971), pls. XXII–XXIII.

15. Ward 1975, 206, sees the figure as the God of both the Old and New Testaments; de Tolnay 1941, 176, and Baldass 1952, 277, identify it as Christ, while Panofsky 1953, 138, terms the figure the Lord Sabaoth of the Old Testament. Panofsky 1938, 433, however, observes that a single image of the Deity is sufficient to imply the entire Trinity.

16. Panofsky 1953 sees the style of the murals as close to that found in Tournai, perhaps around 1200. See Paul Rolland, *La Peinture murale à Tournai* (Brussels, 1946), especially the paintings in the Église Saint-Brice, pls. 37–38, which are later and show a moderate similarity to the images in Van Eyck's painting. Purtle 1982, 46, notes that the churches of Saint Salvator and Saint Jacob in Bruges also give evidence of having had wall decoration.

17. Ward 1975, 205; Purtle 1982, 51.

18. Williams 1977, 24, for the association of Moses and baptism; Panofsky 1953, 138, for Moses as prefiguring Christ's reception.

19. Purtle 1982, 51, discusses a medieval tradition whereby the first three commandments were associated with the three persons of the Trinity. The Second Commandment, then, pertains to the Son, who was further interpreted by medieval commentators as the Word become flesh to accomplish the task of redemption. This of course is allied to the subject of the Annunciation and the Incarnation of Christ.

20. Williams 1977, 27–28, notes that Jacob's disguising himself in goatskins to resemble Esau and receive Isaac's blessing parallels the fooling of the Devil by Christ's incarnation. The putting on of flesh and with it the appearance of sin tricks the Devil and vanquishes him. Compare Meyer Schapiro, "*Muscipula Diaboli*: The Symbolism of the Mérode Altarpiece," *AB* 27 (1945), 182–187.

21. Ward 1975, 205, for the identification and interpretation of the two plants. Columbine is an attribute of Christ and the Holy Spirit or a symbol of the sorrows of the Virgin. Ward points out that columbine was also called "lion's herb" and hence associated with the sign of Leo, the house of the sun, and by extension with Christ. Clover is a symbol of the Trinity but may also be appropriate to Samson because of its use against disease.

22. De Tolnay 1941, 200, calls attention to zodiac representations on the floors of San Giovanni Battista and San Miniato, Florence. See James Webster, *The Labors of the Months in Antique and Medieval Art* (New York, 1970), 148, and pl. 32, fig. 51, for the pavement at San Savino, Piacenza. I have not located any pavement nielli that closely resemble Van Eyck's creation in style or in the combination of zodiac signs with Old Testament scenes.

23. Panofsky 1953, 414.

24. Ward 1975, 196; he believes there are only three rows of signs, arranged 5-4-3.

25. Ward 1975, 202–204. The sign of Capricorn as a goat emerging from a shell or Sagittarius as a centaur with bow and arrow occurs not only in the Limbourgs' *Très Riches Heures*, but also in earlier manuscripts. See, for example, a zodiacal-anatomical correlation of the late eleventh century in the Bibliothèque Nationale, Paris, discussed and reproduced in Harry Bober, "The Zodiacal Miniature of the *Très Riches Heures* of the Duke of Berry—Its Sources and Mean-

ing," *JWCI* 11 (1948), 14, pl. 3b. Very similar to the merman occupying the sign of Libra is the marine knight, a misericord from a choir stall in the church of Saint Sulpice in Diest dating to c. 1491; repro. *Flanders in the Fifteenth Century: Art and Civilization* [exh. cat. Detroit Institute of Arts] (Detroit, 1960), 250, where it is also noted that combats of marine knights were popular and were staged on the occasion of the reception of Philip the Good at Bruges in 1440 and at Ghent in 1458. It is possible that the mermaid in the sign of Gemini could also have a popular or folkloristic meaning.

26. Typological interpretation is to be found in Panofsky 1953, 138, and Ward 1975, 198–202.

27. Ward 1975, 196, stresses the association with the throne prepared for the Second Coming of Christ, while Williams 1977, 44–49, emphasizes the stool as emblem of Mary's humility as well as its possible allusion to the Throne of Wisdom (*Sedes Sapientiae*).

28. Purtle 1982, 46–50. The Golden Mass was celebrated in Flanders in mid-December. The "stage directions" of the Mass call for Gabriel to carry a scepter and to point to the dove of the Holy Spirit, who descends upon the Virgin Mary. She, who has been kneeling, then stands, faces the altar, makes the *expansis manibus* gesture with her hands, and says "Ecce ancilla domini. . . ." These actions mirror closely the activity in Van Eyck's painting.

29. Robb 1936, esp. 499–500; Panofsky 1953, 59.

30. Meiss 1968, 72–73, fig. 29. There are several versions of this theme by the Boucicaut workshop. In the *Annunciation* in the Bibliothèque Royale, Brussels, Ms. 10767, fol. 30, Meiss 1968, fig. 199, the angel's standing posture is close to that of Gabriel in the painting. Purtle 1982, 41–45, carefully analyzes the connection between the Boucicaut Master's *Annunciation* and Jan van Eyck's, while pointing out, 41, that "the Boucicaut Master was the first to successfully visualize the entry of Christ into the body of the Virgin as a parallel event to the entry of Christ into the body of the Church."

31. Schmarsow 1924 suggests that the center panel might have been a Nativity with a Presentation in the Temple on the wing. Beenken 1943 thought that the center panel contained either an Adoration of the Kings or a Nativity, and that a Visitation was on the right wing.

32. Nieuwenhuys 1843, 2; see n. 5. It may be significant that he speaks of a "monument religieux" rather than a church.

33. Reinach 1927, 239; see n. 5. The manuscript is in the Bibliothèque Publique, Dijon, Ms. 88, fol. 53. The other two paintings are a *Presentation in the Temple* identified with the picture by an anonymous follower of Robert Campin, now on loan from the Louvre to the Musée des Beaux-Arts, Dijon (repro. Reinach 1927, 241) and the *Way to Calvary* by Simone Martini in the Louvre.

34. O'Meara 1981 makes comparison to only two portraits, a painting in the Louvre (lent to Dijon) and the panel attributed to Rogier van der Weyden in the J. Paul Getty Museum, Malibu. At least seven other representations of Isabella are discussed by Bauch 1963, 102–109 (repr. 1967, 85–91). Of particular interest is a drawing in a private collection in Germany that purports to be a copy of the drawing Van Eyck made in 1429 of Isabella, reproduced in Sterling 1976, 34, fig. 42.

35. Durand-Gréville 1910, Burger 1925.

36. Thalheimer 1967; in addition to the National Gallery's painting he does not accept the Madonna of Canon van der Paele and the Maelbeke Madonna. Reasons for rejection

are not given. Dhanens 1980 believes the picture "probably has its source in a workshop model used also for one of the Llangattock miniatures." I am unable to see a viable connection between the painting and the Llangattock Hours or to accept Dhanens' attribution of the picture to a follower of Van Eyck.

37. Friedländer 1967, 64; De Tolnay 1939, 31; Baldass 1952, 278; Beenken 1943, 78, 88.

38. Panofsky 1935, 473; 1953, 194; Robb 1936, 506; Meiss 1945, 178; Cuttler 1968, 86. It is Robb's contention that *The Annunciation* must be earlier than the Ghent Altarpiece because the Ghent Altarpiece employs the new bourgeois interior used by Robert Campin in the Mérode triptych and hence it is unlikely that Van Eyck would have reverted to the older ecclesiastical setting. Voll 1901, 218, dates the painting c. 1425.

39. As in NGA 1975, 124.

40. H. Menz, "Zur Freilegung einer Inschrift auf dem Eyck-Altar der Dresdener Gemäldegalerie," *Jahrbuch der Staatliche Kunstsammlung Dresden* (1959), 28–29.

41. James Snyder, "The Chronology of Jan van Eyck's Paintings," *Album Amicorum J. G. van Gelder* (The Hague, 1973), 295–296. Philip 1971, 136–137, argues that the Berlin Madonna should be dated after the Ghent Altarpiece and further, 139, puts forward a date for *The Annunciation* after the Dresden triptych.

42. Weale 1908, 121. I am extremely grateful to Lorne Campbell for the correct identification of this painting.

References

1833 Passavant, J. D. "Nachrichten über die alt-niederländische Malerschule." *Kunst-Blatt* (no. 83): 320.

1843 Nieuwenhuys, C. J. *Description de la Galerie des Tableaux de S. M. le Roi des Pays-Bas.* Brussels: 1–2.

1847 Michiels, Alfred. *Histoire de la peinture flamande et hollandaise.* 4 vols. Paris, 2: 127.

1850 *Catalogue des Tableaux Anciens et Modernes, de Diverses Écoles; Dessins et Statues, Formant la Galerie de feu sa Majesté Guillaume II.* Amsterdam: 1, no. 1.

1858 Hotho, H. G. *Die Malerschule Hubert's van Eyck nebst Vorgängern und Zeitgenossen.* Berlin: 2, 171.

1864 Waagen, Gustav Friedrich. *Die Gemäldesammlung in der Kaiserlichen Ermitage zu St. Petersburg.* Munich: 115–116, no. 443.

1866 Michiels, Alfred. *Histoire de la peinture flamande depuis ses débuts jusqu'en 1864.* 6 vols. Paris, 2: 317–318.

1870 Ermitage Impérial. *Catalogue de la galerie des tableaux. Les Écoles germaniques.* 2d ed. 3 vols. Saint Petersburg, 2: 3–4. no. 443.

1872 Crowe, J. A., and G. B. Cavalcaselle. *The Early Flemish Painters: Notices of Their Lives and Works.* London (2d ed.): 113–114.

1879 Ris, L. Clément de. "Musée Impérial de l'Ermitage à Saint-Pétersbourg." *GBA* 2e pér. 19: 573–574, repro. 577 (drawing by Goutzwiller).

1887 Conway, William. *Early Flemish Artists and Their Predecessors of the Lower Rhine.* London: 140–141.

1898 Kaemmerer, Ludwig. *Hubert und Jan van Eyck.* Bielefeld and Leipzig: 69–71, repro.

1899 Seeck, Otto. *Die charakterischen Unterschiede der Brüder van Eyck.* Berlin: 41, 70.

1900 Voll, Karl. *Die Werke des Jan van Eyck.* Strasbourg: 62–65.

1900 Kaemmemer, Ludwig. "Die neueste Eycklitteratur." *Kunstchronik* 12 (8 November): cols. 67–68, 70.

1900 Friedländer, Max J. Review of *Die Werke des Jan van Eyck* by Karl Voll. In *RfK* 23: 474.

1901 Somof, A. *Ermitage Impérial. Catalogue de la galerie des tableaux. Écoles néerlandaises et école allemande.* 2 vols. Saint Petersburg, 2: 110–111.

1901 Voll, Karl. "Jan van Eyck en France." *GBA* 3e pér. 25: 217–218.

1903 Dvořák, Max. "Das Rätsel der Kunst der Brüder van Eyck." *JbWien* 24: 237, repro. 236 (printed in book form, Munich, 1925: 119).

1903 Weale, Frances. *Hubert and Jan van Eyck.* New York: 30.

1904 Kern, G. Joseph. *Die Grundzüge der linear-perspektivischen Darstellung in der Kunst der Gebrüder van Eyck und ihrer Schule.* Leipzig: 13–14, diagram pl. 7.

1906 Wurzbach, Alfred von. *Niederländisches Künstler-Lexikon.* 3 vols. Vienna and Leipzig, 1: 514.

1906 Kleinclausz, A. "Les Peintres des Ducs de Bourgogne." *RAAM* 20: 258, repro. 259.

1906 Voll, Karl. *Die altniederländische Malerei von Jan van Eyck bis Memling.* Leipzig: 36.

1907 Girodie, André. "La Toison d'or et l'art néerlandais sous les ducs de Bourgogne." *L'Art de les Artistes* 5 (September): 289–290, repro.

1907 *Les Chefs-d'oeuvre de l'art flamand à l'exposition de la toison d'or.* Bruges: 16–17, repro.

1907 Hymans, Henri. *Les Van Eyck.* Paris: 111–112, repro. 109.

1907 Hymans, Henri. "L'Exposition de la toison d'or à Bruges." *GBA* 3e pér. 38: 203–204, repro. opp. 204.

1907 Strange, Edward. "The Exhibition of the Golden Fleece at Bruges." *Conn* 19, no. 73: 32, repro.

1907 Mandach, C. de "L'Exposition de la toison d'or et de l'art néerlandais sous les ducs de Bourgogne." *RAAM* 22: 155.

1907 "Correspondance de Belgique. L'exposition de la toison d'or à Bruges." *La Chronique des Arts et de la Curiosité* no. 26: 252.

1908 Weale, W. H. James. *Hubert and John van Eyck. Their Life and Work.* London: 119–122, no. 16, repro. betw. 118 and 119.

1908 *Les Chefs-d'oeuvre d'art ancien à l'exposition de la toison d'or à Bruges en 1907.* Brussels: 78, pl. 361.

1908 Saintenoy, Paul. *L'Église Saint-Jacques de Compostelle et le décor architectural de l'Annonciation de Jean van Eyck.* Antwerp: 4–5, 8–10.

1909 Wrangell, Nicolas. *Les Chefs-d'oeuvre de la galerie de tableaux de l'Ermitage Impérial à St. Pétersbourg.* Munich: XI, repro. 62.

1910 Durand-Gréville, E. *Hubert et Jean van Eyck.* Brussels: 80–85, repro. opp. 80.

1910 "Extraits des procès-verbaux des séances. Séance de rentrée du 13 novembre 1907." *Mémoires de l'Académie des sciences, arts et belle-lettres de Dijon* 4e sér. 11: LXX.

1912 Réau, Louis. "La galerie de tableaux de l'Ermitage et la collection Semenov." *GBA* 4e pér. 8: 471–472.

1912 Kern, G. Joseph. "Perspective und Bildarchitektur bei Jan van Eyck." *RfK* 35: 50–51.

1912 Weale, W. H. James, and Maurice Brockwell. *The Van Eycks and Their Art.* London: 98–102, pl. 19.

1913 Durand-Gréville, E. Review of *The Van Eycks and their Art* by W. H. James Weale and Maurice Brockwell.

In *La Chronique des Arts et de la Curiosité* no. 32: 254.

1915 Friedländer, Max J. "Eyck, Jan van." In Thieme-Becker 11: 129–133.

1919 Huizinga, Johan. *Herfsttij der Middeleeuwen.* Haarlem: 474–476.

1921 Conway, Martin. *The Van Eycks and Their Followers.* London: 64–65.

1921 Brockwell, Maurice. "Exposition des Beaux-Arts de Burlington Club." *La Chronique des Arts et de la Curiosité* no. 2: 14.

1922 Pfister, Kurt. *Van Eyck.* Munich: 62, pl. 14.

1924 Winkler, Friedrich. *Die altniederländische Malerei.* Berlin: 49.

1924 Schmarsow, August. *Hubert und Jan van Eyck.* Leipzig: 135–141, pl. 29.

1924 Friedländer. Vol. 1: 104–105, pl. 44 (vol. 1, 1967: 63–64, pl. 57).

1925 Burger, Willy. *Die Malerei in den Niederlanden 1400–1550.* Munich: 18–20, pl. 10.

1927 Reinach, S. "Three Early Panels from the Ducal Residence at Dijon." *BurlM* 50: 234–245.

1928 Demonts, Louis. "Le Maître de l'Annonciation d'Aix, des van Eyck à Antonello de Messine." *RAAM* 53: 265, 278.

1932 Tolnai, Karl von. "Zur Herkunft des Stiles der van Eyck." *MünchnerJb* 9: 322.

1934 Friedländer, Max J. "A New Painting by van Eyck." *BurlM* 65: 3.

1934 Jong, Johannes de. *Architektuur bij de Nederlandsche Schilders vóór de Hervorming.* Amsterdam: 70–71, 134, 155–156, figs. 65, 128, 149.

1935 "Mellon to Give Gallery and 19,000,000 of Art to Nation." *Art Digest* 9 (1 March): 6, repro.

1935 "Mellon Holdings Are Announced by Knoedler & Co." *ArtN* 33 (23 February): 4, repro. 9.

1935 Tietze, Hans. *Meisterwerke europäischer Malerei in Amerika.* Vienna: 333, no. 122, repro. 123.

1935 Panofsky, Erwin. "The Friedsam Annunciation and the Problem of the Ghent Altarpiece." *AB* 17: 449, 468, 471, 473, fig. 22.

1936 Robb, David. "The Iconography of the Annunciation in the Fourteenth and Fifteenth Centuries." *AB* 18: 506–508, fig. 31.

1937 Dupont, Jacques. "Les peintures de la Chartreuse de Champmol." *BSocHAF*: 155–157.

1937 Beenken, Hermann. "The Annunciation of Petrus Christus in the Metropolitan Museum and the Problem of Hubert van Eyck." *AB* 19: 231.

1938 Burroughs, Alan. *Art Criticism from a Laboratory.* Boston: 201–202.

1939 Tolnay, Charles de. *Le Maître de Flémalle et les frères van Eyck.* Brussels: 25, 66, no. 5, repro. 71–73.

1941 NGA: 61–62, no. 39.

1941 Held, Julius S. "Masters of Northern Europe, 1430–1660, in the National Gallery." *ArtN* 40 (June): 11, repro.

1941 Tolnay, Charles de. "Flemish Paintings in the National Gallery of Art." *MagArt* 34: 175–176, 178, figs. 1, 3–5.

1942 Friedländer, Max J. *On Art and Connoisseurship.* London: 186–187.

1943 Beenken, Hermann. *Hubert und Jan van Eyck.* 2d ed. Munich: 78–80, 88, pl. 106.

1945 Meiss, Millard. "Light as Form and Symbol in Some Fifteenth-Century Paintings." *AB* 27: 178–179, fig. 4.

1948 Musper, Theodor. *Untersuchungen zu Rogier van der Weyden und Jan van Eyck.* Stuttgart: 104–105, pl. 165.

1948 Beer, E. S. de. "Gothic: Origin and Diffusion of the Term; the Idea of Style in Architecture." *JWCI* 11: 159.

1950 Kauffmann, Hans. "Jan van Eycks 'Arnolfinihochzeit.'" *Geistige Welt* 4 (January): 48–49, repro.

1952 Baldass, Ludwig. *Jan van Eyck.* London: 54–55, 277–278, no. 9, pls. 113–115.

1952 Meiss, Millard. "'Nicolas Albergati' and the Chronology of Jan van Eyck's Portraits." *BurlM* 94: 137.

1952 Ladoué, Pierre. "La Scène de L'Annunciation vue par les peintres." *GBA* 6e pér. 39: 355.

1953 Panofsky. *ENP*: 137–139, 147–148, 193–194, fig. 238.

1954 Fourez, Lucien. "L'Évêque Chevrot de Tournai et sa Cité de Dieu." *RBAHA* 23: 100–101, fig. 16.

1955 Winkler, Friedrich. Review of *Early Netherlandish Painting* by Erwin Panofsky. In *Kunstchronik* 8: 22.

1956 Herzog, Erich. "Zur Kirchenmadonna van Eycks." *Berliner Museen* 6: 5, 14.

1956 Pächt, Otto. Review of *Early Netherlandish Painting* by Erwin Panofsky. In *BurlM* 98: 274.

1957 Quarré, Pierre. "Fragment d'un primitif de la Chartreuse de Champmol au Musée des Arts Decoratifs." *La Revue des Arts* 7: 63.

1960 Broadley, Hugh. *Flemish Painting in the National Gallery of Art.* Washington: 2–3, 12, repro. 13 (rev. ed., 1978).

1960 [Pierre Quarré]. *La Chartreuse de Champmol: Foyer d'art au temps des Ducs Valois.* Exh. cat. Musée de Dijon: 15.

1960 Wilenski, R. H. *Flemish Painters 1430–1830.* 2 vols. New York, 1: 3.

1961 Kurz, Otto. "Eyck, Hubert, and Jan van." *Encyclopedia of World Art*, 16 vols. New York, Toronto, and London, 5: col. 327.

1961 Meiss, Millard. "'Highlands' in the Lowlands. Jan van Eyck, the Master of Flémalle and the Franco-Italian Tradition." *GBA* 6e pér. 57: 310.

1961 Faggin, Giuseppe. *Van Eyck.* Verona: 116, 126, 195, no. 14, figs. 73–76.

1961 Seznec, Jean. "Michelet et l'Annonciation." *GBA* 6e pér. 58: 147, fig. 151.

1961 Denis, Valentin. *All the Paintings of Jan van Eyck.* New York: 28, 48, pls. 81–85.

1961 Schilling, Rosy. "Das Llangattock-Stundenbuch. Sein Verhältnis zu Van Eyck und dem Vollender des Turin-Mailänder Stundenbuches." *Wallraf-Richartz-Jahrbuch* 23: 225.

1963 McNamee, M. B. "Further Symbolism in the Portinari Altarpiece." *AB* 45: 143.

1963 Walker: 96, repro. 97.

1963 Bauch, Kurt. "Bildnisse des Jan van Eyck." *Heidelberger Akademie der Wissenschaften. Jahresheft 1961/1962.* Wiesbaden: 101. Repr. in Kurt Bauch, *Studien zur Kunstgeschichte.* Berlin, 1967: 83.

1963 Bruyn, Josua. "Twee Kardinaalsportretten in het werk van Jan van Eyck." *Album Discipulorum J. G. van Gelder.* Utrecht: 30.

1965 Bol, L. J. *Jan van Eyck.* New York: 87, repro. 47.

1966 Cairns and Walker: 74, repro. 75.

1967 Thalheimer, Siegfried. *Der Genter Altar.* Munich: 71.

1968 Cuttler. *Northern Painting*: 85–86, fig. 101.

1968 Meiss, Millard. *French Painting in the Time of Jean de Berry. The Boucicaut Master*. London: 72–73.

1968 Faggin, Giorgio T. *L'opera completa dei van Eyck*. Milan: 94–95, repro. no. 18, pls. 35–36.

1969 Blum, Shirley Neilsen. *Early Netherlandish Triptychs*. Berkeley and Los Angeles: 10.

1969 Peman y Pemartin, Cesar. *Juan van Eyck y España*. Cadiz: 43–44, fig. 24.

1969 Pauwels, H. Review of *Der Genter Altar* by Siegfried Thalheimer. In *BurlM* 111: 393.

1969 Minott, Charles. "The Theme of the Mérode Altarpiece." *AB* 51: 267.

1971 Philip, Lotte Brand. *The Ghent Altarpiece and the Art of Jan van Eyck*. Princeton: 139, fig. 138.

1972 Braunfels, Wolfgang. *Monasteries of Western Europe*. Princeton: 120, fig. 145.

1972 Strauss, Konrad. "Keramikgefässe, insbesondere Fayencegefässe auf Tafelbildern der deutschen und niederländischen Schule des 15. und 16. Jahrhunderts." *Keramik-Freunde der Schweiz. Mitteilungsblatt* no. 84: 22, pl. 3, fig. 1.

1972 Kahr, Madlyn. "Delilah." *AB* 54: 284.

1973 Stangel, Andrew Laurie. "The Cartographic Symbolism in Jan van Eyck's *Annunciation* in the National Gallery of Art, Washington, D.C." *Comitatus* 4: 41–48, repro. 44, 45.

1973 Koller, Manfred. "Der Albrechtsmeister und Conrad Laib. Technologische Beiträge zur Tafelmalerei des 'Realistischen Stiles' in Österreich." *Österreichische Zeitschrift für Kunst und Denkmalpflege* 27: 52.

1974 Walker, John. *Self-Portrait with Donors*. Boston: 115.

1974 Meiss, Millard. *French Painting in the Time of Jean de Berry. The Limbourgs and their Contemporaries*. New York: 446.

1974 Birkmeyer, Karl. Review of *The Ghent Altarpiece and the Art of Jan van Eyck* by Lotte Brand Philip. In *AB* 56: 286.

1975 Collier, James Mitchell. "Linear Perspective in Flemish Painting and the Art of Petrus Christus and Dirk Bouts." Ph.D. diss., University of Michigan: 62–63, fig. 16.

1975 NGA: 124, repro. 125.

1975 Ward, John. "Hidden Symbolism in Jan van Eyck's *Annunciations*." *AB* 57: 196–208, repro.

1976 Sterling, Charles. "Jan van Eyck avant 1432." *RArt* no. 33: 9, 11.

1976 Walker: 120, repro. 121.

1977 Williams, Carolyn. "Jan van Eyck's *Annunciation*. An Iconographical Study." M. A. thesis, University of Delaware.

1978 Bernardini, Cecilia. *Jan van Eyck*. Rome: 12, pl. 20.

1978 Panhans-Bühler, Ursula. *Eklektizismus und Originalität im Werk des Petrus Christus*. Vienna: 71, fig. 4.

1979 Châtelet, Albert. *Van Eyck*. Bologna: 40, 42, pl. 7.

1980 Dhanens, Elisabeth. *Hubert and Jan van Eyck*. Antwerp: 355, 358, fig. 221.

1981 O'Meara, Carra Ferguson. "Isabelle of Portugal as the Virgin in Jan van Eyck's Washington Annunciation." *GBA* 6ᵉ pér. 97: 99–103, figs. 1–2.

1981 Lyman, Thomas. "Architectural Portraiture and Jan van Eyck's Washington Annunciation." *Gesta* 20/1: 263–271, fig. 1.

1982 Purtle, Carol J. *The Marian Paintings of Jan van Eyck*. Princeton: 40–58, 60, 75, figs. 26, 28–29.

1983 Giltay, J. Review of *Hubert and Jan van Eyck* by Elisabeth Dhanens. In *Simiolus* 13: 56–57.

1984 Lane, Barbara G. *The Altar and the Altarpiece. Sacramental Themes in Early Netherlandish Painting*. New York: 45–47, fig. 28.

Flemish School, Imitator of

probably early twentieth century

1942.16.2 (699)

Saint Bernard with Donor
reverse: *Saint Margaret*

Oak, 58.8 x 23.3 (23 1/8 x 9 3/16) painted surface: 57.5 x 22.1 (22 5/8 x 8 11/16) painted surface, reverse: 57.8 x 22.3 (22 3/4 x 8 3/4)
Chester Dale Collection

Technical Notes: The panel is made of a single piece of oak, cut tangentially, rather than radially.[1] There are unpainted edges on all sides of both front and back, and a barbe or raised edge of paint where the designs end. The ground layer on both sides is pale yellow in color and extends beyond this painted edge. There is a fine, dry underdrawing visible with infrared reflectography and with the naked eye, especially on the front of the panel. The paint is thinly applied; however, an underpainting of a light iron-red color under the blue-green robe of the donor and the saint's prayer book gives these areas a thicker build-up of paint. Cross-sections taken from front and back were analyzed by Hermann Kühn of the Doerner Institut, Munich, in 1963. The painting was further analyzed at the Gallery in 1983–1984 by means of x-ray fluorescence, microscopy of crushed pigment samples, and microscopy of cross-sections (see commentary below).

A fine, predominantly vertical crackle penetrates both paint and ground layers. A fair amount of abrasion of the paint layers has occurred along these cracks. Traces of paint layers now partially missing are visible under the microscope in the brown and green areas of the front and in the background of the back. There are small scattered areas of inpainting. In 1943 the front and back of the panel were cleaned and a layer of black paint was removed from the back, revealing the figure of Saint Margaret. Remnants of this black paint can still be found on the back, and there are some rather similar residues on the front as well.[2]

Provenance: M. Dubois, Amiens. (Galerie Sedelmeyer, Paris.) Private collection, New York. (American Art Association, New York, 17 and 18 May 1934, no. 132, repro., as by Gerard David.)[3]

IN ITS STYLE this painting approaches some works produced at the end of the fifteenth century along the Franco-Flemish border.[4] However, an accumulation of evidence strongly suggests that it is the work of a skillful modern imitator of early Flemish paintings. Microscopic and spectral analysis of cross-sections

undertaken by the Doerner Institut, Munich, and at the Gallery[5] showed that the lead white used lacks the impurities of silver and gold found in this pigment before the late nineteenth or early twentieth century and that the green is made up of an uncharacteristic mixture of ultramarine, ochre, and lead white.[6] The yellow tone of the ground and the fact that it extends beyond the barbe also tend to arouse suspicion.

Before this technical analysis was undertaken, Friedrich Winkler drew attention to the similarities between the Gallery's panel and a group of acknowledged early twentieth-century imitations of early Flemish paintings.[7] In one of these documented imitations, a *Mystic Marriage of Saint Catherine* exhibited in London in 1927 (fig. 1), the trees are strikingly close to those in the Gallery's panel and the eyes and soft, full lips are formed in a very similar manner.[8] Apart from stylistic considerations, the butter-yellow, rather than white or gray, hue of the saint's habit is suspicious.[9] The donor's placement in the corner of the panel with his fingers just protruding above the frame derives from bust-length portraits produced by Rogier van der Weyden and Memling and seems inconsistent with the three-quarter length of the presenting saint or with the landscape setting.[10] The figure of Saint Margaret, particularly the arrangement of her cross and book, depends rather literally on that of the same saint in Van der Goes' Portinari altarpiece (fig. 2), while her head seems to derive from the neighboring figure of Saint Mary Magdalene.[11] Although the pastiche quality of the Gallery's painting is not as marked as that of the *Mystic Marriage of Saint Catherine*, the bulk of the evidence suggests that the painting is a modern imitation rather than the product of a provincial school.

M. W.

Notes

1. Because of the angle at which the panel was cut, it proved impossible to measure the growth rings for dendrochronological dating.

2. The patient and perceptive work of Laurent Sozzani, Sarah Fisher, Beatrix Graf, and Eugena Ordonez of the department of painting conservation and of Barbara Miller, conservation scientist, served as the basis for these notes.

3. This provenance is given in the catalogue of the American Art Association sale, but could not be verified.

4. Compare, for example, the wings with a grisaille *Noli me Tangere* from the Abbey of Saint Riquier published by Nicole Reynaud, "Un *Christ jardinier* de l'École de Picardie," *RLouvre* 29 (1979), 359–361, figs. 1, 2, and a triptych now

Fig. 1. Imitator of Flemish School, *Mystic Marriage of Saint Catherine*, present location unknown [photo: Copyright *Country Life*]

Fig. 2. Hugo van der Goes, *Portinari Altarpiece*, right wing, Florence, Galleria degli Uffizi [photo: Copyright A.C.L. Brussels]

divided between the Thyssen-Bornemisza Collection, Lugano, and the National Gallery, London; Charles Sterling, "La peinture sur panneau picarde et son rayonnement dans le nord de la France au XVᵉ siècle," *BSocHAF* (1979), figs. 44 a–c.

5. The samples analyzed at the Doerner Institut were taken from the saint's crozier, his habit near his proper right hand, and the trees near the left edge, and, on the reverse, from the pages and cover of Saint Margaret's book. The samples analyzed at the Gallery were taken in the areas of the orange-red underpainting in the donor's robe and the saint's book, the exposed ground on the front of the panel, and other areas.

6. The presence of zinc and barium in the white areas as shown by x-ray fluorescence was equally suspicious. Whether the ultramarine is natural or synthetic is not entirely clear. The yellow in all the samples appeared to be an iron oxide, which Hermann Kühn believed to be yellow ochre; reports in curatorial files.

7. Letters of 16 August and 28 December 1956, 29 November 1957, and 21 January 1958 in curatorial files.

8. For this painting, lent by Dorus Hermsen and exhibited as the work of the Master of the Baroncelli Portraits, see *Flemish and Belgian Art, 1300–1900* [exh. cat., Royal Academy of Arts] (London, 1927), 159, no. 86, and Georges Hulin de Loo, "A propos de pastiches modernes à l'Exposition de Londres," Académie Royale de Belgique, *Bulletin de la Classe des Beaux-Arts* 9, nos. 6–8 (1927), 45–48. According to Hulin de Loo, to whom the unnamed imitator explained the genesis and history of the *Mystic Marriage*, that picture was not made with intent to deceive.

9. Spectral analysis of samples taken from the habit suggested that yellow ochre and lead white were used. Cleaning tests in 1983 confirmed the butter-yellow hue of the garment.

10. The use of the left margin of the painting to frame the donor's head is very similar to the 1472 *Portrait of Gilles Joye* by Memling in the Clark Art Institute, Williamstown; Friedländer, vol. 6 (1971), no. 72, pl. 114. Donors with presenting saints in a landscape are most likely to be half-length, even in a composite triptych to which wings were added later, like the one in the Musée de la Chartreuse, Douai, Sterling 1979, fig. 51 (as in n. 4).

Imitator of Flemish School, *Saint Bernard and Donor*,
1942.16.2

Imitator of Flemish School, *Saint Margaret*,
1942.16.2 (reverse)

Franco-Flemish Artist

1937.1.23 (23)

Profile Portrait of a Lady

c. 1410
Wood (cradled), 53 x 37.6 (20⁷/₈ x 14¹³/₁₆)
 painted surface: 52 x 36.6 (20¹/₂ x 14³/₈)
Andrew W. Mellon Collection

Technical Notes: The panel supporting the paint surface has been thinned, set into another panel with a 5 mm rim all around, and then cradled. The panel supporting the paint surface has an old, repaired split running from the bottom edge up through the hat to the right of center. Although the present painted surface comes to the edge of this panel, what appear to be the original ground and support occupy a slightly smaller area (48.6–48.8 x 31.7–32.1 cm) clearly visible in the x-radiograph (fig. 1). The pronounced horizontal crackle within this smaller area does not extend beyond its borders. This crackle pattern and the tear-like appearance of another disturbed area at the bottom left, visible in the x-radiograph, suggest that the ground may have been laid on paper or parchment.

Infrared reflectography reveals what appears to be an underdrawn design delineating the ear, some hairpins, and individual strands of hair in the coil over the lady's ear. These delicate strands follow the line of the coil, rather than forming the horizontal bands of crimping visible on the surface. Traces of an underdrawn brocade pattern were also detected in the robe during examination with infrared reflectography.

Microscopic examination shows extensive repaint.[1] The profile and the eye, nostril, lips, and ear have been repainted, though they seem to correspond to the old outline visible underneath. The gold of the pins is repaint. The hat is totally repainted over heavy damage. The back of the coiffure is totally repainted. The white fur and collar appear to be old, but with some repainted areas. Whereas most of the gold on the robe is new, the abraded blue of the robe is apparently not repainted except for a damage in the left corner. Most of the gold on the beads is new, yet there are residues of old gold underneath. The necklace and belt are apparently made of metallic foil, possibly attached by small nails or brads in the case of the necklace. There are scattered damages in the background, which appears to have been entirely toned over to bring it into conformity with what are presumably later additions at left, right, and top edges.

Provenance: Henry Valentine Stafford Jerningham, 9th Baron Stafford [d. 1884] (sale Christie's, London, 30 May 1885, no. 373, as *Blanche, daughter of Henry IV of England*). James Gurney (sale, Christie's, London, 12 March 1898, no. 7, as *Blanche, daughter of Henry IV of England*). M. de Villeroy, Paris (sequestered property, sold Galerie Georges Petit, Paris, 28–29 April 1922, no. 34, repro., as School of Verona, *Portrait of a Lady*). (Duveen Brothers, London and New York, 1922–1923.) Clarence H. Mackay, Roslyn, New York, 1923–1935. (Duveen Brothers, New York.) Purchased January 1937 by The A. W. Mellon Educational and Charitable Trust, Pittsburgh.

Exhibitions: New York, Duveen Galleries, 1924, *Early Italian Paintings*, no. 38, as Pisanello. // New York, Knoedler & Co., 1935, *Fifteenth Century Portraits*, no. 1, as *Isotta degli Atti, wife of Sigismondo Malatesta da Rimini* by Pisanello.

THIS ELEGANTLY STYLIZED PAINTING is claimed as one of the extremely rare surviving independent portraits from before about 1425. It is the only portrait of a woman within this small group.[2] Such very early portraits were often copied because of the political importance of their sitters and the value of the images for dynastic, propaganda, or antiquarian reasons. Hence, they must be evaluated with particular caution. Nevertheless, the style and costume of the Gallery's painting as well as its physical characteristics, traceable in spite of several restorations, indicate that it was indeed executed shortly after 1400.

Documentary evidence confirms that independent portraits, including portraits of women, were produced in northern Europe around 1400, though their number was probably rather limited. This evidence includes mention of portraits used in marriage negotiations during these years. In 1414 John the Fearless commissioned Vranque of Malines to paint his daughter, Catherine of Burgundy, whom he hoped to marry to Henry V of England.[3] Chroniclers report that Henry V was very pleased with a portrait of Catherine of Valois, daughter of Charles VI of France, painted from life, brought to him by ambassadors negotiating for that marriage in 1418.[4] Portraits were valuable in other types of diplomatic exchanges. In 1413 Jean Malouel was working on a portrait of John the Fearless commissioned by that prince as a gift for the King of Portugal.[5] Contemporary inventories only rarely mention independent portraits. Margaret of Flanders' inventory included "1 tableau de bois a ymaige de medame, pendant a une chainette d'argent,"[6] and the only independent portraits mentioned in the inventories of Jean

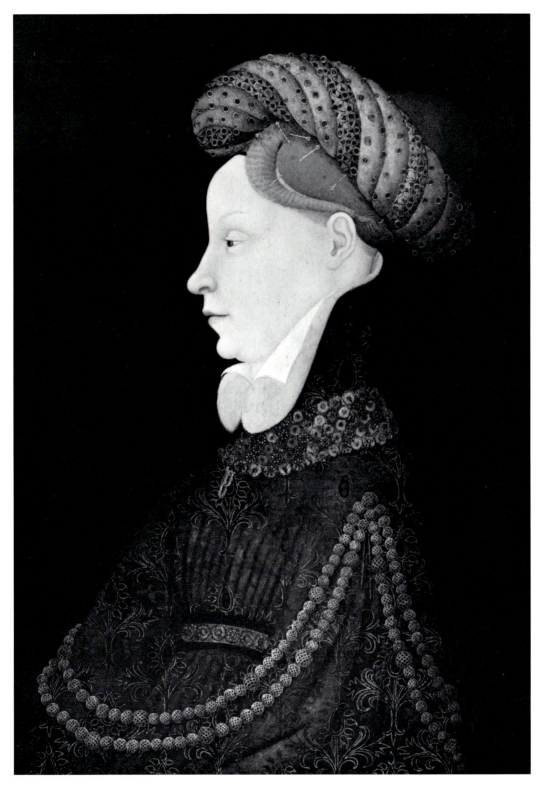

Franco-Flemish Artist, *Profile Portrait of a Lady*, 1937.1.23

de Berry's rich collection were the quadriptych of portraits "au vif" of King Charles, King John, the Emperor, and King Edward of England.[7]

In its use of a profile pose, the *Portrait of a Lady* agrees with the known early independent portraits from the circle of the French court. The subjects of these portraits were princes or rulers, and the profile pose, with its clear outline and avoidance of the viewer's gaze, presented an easily recognizable image of authority.[8] However, comparison among this group is complicated by questions of originality and repetition.

A portrait type, once created, tended to be repeated, and a portrait created in another context, such as that of a devotional image, might be repeated as an independent easel painting.[9] The possibility that the *Portrait of a Lady*, too, is a repetition of an existing portrait type should not be discounted. Costume, style, and painting techniques must be the basis for judgment of its authenticity as an International Style portrait.

No other contemporary versions of the type can be traced. The earliest record of the pose, features, and costume of the lady is a drawing by George Perfect

Fig. 1. Franco-Flemish Artist, *Profile Portrait of a Lady*, 1937.1.23, x-radiograph

Fig. 2. Franco-Flemish Artist, *Profile Portrait of a Lady* (photograph from Galerie Georges Petit, Paris, sale 28–29 April 1922, no. 34) [photo: NGA]

Harding (d. 1853), the English copyist of historical portraits, presumably made in the early nineteenth century and now lost.[10]

A number of distortions have resulted from successive restorations of the *Portrait of a Lady*. The most recent restoration took place in 1922–1923 after Duveen acquired the painting. Comparison of the painting's present state with the photograph in the Villeroy sale catalogue (fig. 2) strongly suggests that changes made at that time were intended to support Duveen's attribution to Pisanello. A careful drawing made in 1883 by Sir George Scharf, based on George Perfect Harding's watercolor copy, provides confirmation of these changes as well as additional information (fig. 3).[11] The 1922 photo and Scharf's sketch show that the present smooth beehive hairstyle projecting above the turban is an addition. Significantly, this bulbous projection is analogous to the hairstyle in the portrait by

Pisanello in the Louvre, usually identified as Margherita Gonzaga.[12] The profile was also altered when the picture was in Duveen's hands, although the gentler contours evident in the 1922 photograph and in Scharf's drawing probably reflect an earlier restoration. It is very probable that the shape of the turban was also exaggerated and the coils and stripes added at this time. The pattern of raised circles in the headdress should also be regarded as an addition of uncertain date; an unrelated design of tightly spaced holes is visible in the x-radiograph (fig. 1).[13] Other evidence for earlier tampering with the painting includes the gold beads revealed by the 1922–1923 cleaning, but evidently overpainted in the earlier records. Thus the ends of the tassel pinning the beads to the lady's shoulder are still visible in Scharf's drawing and in the 1922 photograph, and some of the overpainted beads can even be made out in the photograph (figs. 2, 3).

The painting's dimensions seem also to have been adjusted, possibly at a fairly early date. The uneven surface, the crackle pattern, and above all, the evidence of the x-radiograph, suggest that the original ground and paint have been mounted on a larger panel and the background extended. In the x-radiograph, what ap-

Fig. 3. Sir George Scharf, Sketchbook SSB 101, fols. 31v–32, London, National Portrait Gallery [photo: National Portrait Gallery]

pear to be the original margins of the painting hem the figure in more closely on all sides, coming just to the edge of the headdress at the top. There are some indications that paper or parchment was part of the support.[14]

In summary, the painting had evidently been extensively restored before 1922–1923, when it was cleaned, restored again, the hairstyle extended in the back, and the panel set into another support and cradled. The severely damaged headdress was originally smaller and without the repeated curves of the present coil formation. The margins of the picture probably originally framed the design more closely. The painting's present hard effect, particularly in the profile, has undoubtedly been accentuated by successive restorations.

Despite these distortions, the physical characteristics of the picture are in keeping with a date shortly after 1400. That the figure seems to have filled the original field of the picture to the margins agrees with the other portraits of the period and with the sensibility of the International Style. The combination of painting and metal-working techniques, one of the hallmarks of the International Style,[15] is evident in the metallic foil overlaid with glazes of pigment in the collar and belt and presumably also in the applied jewel or heraldic device that would have hung from the collar.[16] The tightly spaced holes in the headdress visible in the x-radiograph may also originally have held some applied metalwork. The use of such techniques points to a date in the early fifteenth century; their use in a copy made out of antiquarian interest seems most improbable.

The costume is more consistent with a date of about 1410 to 1420 than at first appears to be the case. During this period, broad chokers with pendant jewels were worn by both men and women. Beads pinned at the shoulder and draped over the body occur on the calendar pages of the *Très riches heures* and in other depictions of court life.[17] The fur collar turned down to reveal an undergarment appears to be a version of the somewhat flatter collar worn by Isabeau of Bavaria and her attendants in the presentation miniature of a manuscript of Christine de Pizan's works, Harley 4431, in the British Library.[18] The sausagelike coil of hair over the temple and ear resembles Jeanne de Boulogne's hairstyle on her statue from the Sainte-Chapelle, Bourges, as recorded in a drawing by Holbein (fig. 4). The original form of the headdress, as suggested by the holes traceable in the x-radiograph, probably resembled the dotted effect of the jewelled horned rolls or *bourrelets* worn by Isabeau and her ladies in the presentation miniature.[19] Holbein's drawing of the statue of Jeanne de Boulogne shows what such a configuration would have looked like in profile.

Fig. 4. Hans Holbein the Younger, *Jeanne de Boulogne, Duchess of Berry*, Basel, Öffentliche Kunstammlung, Kupferstichkabinett [photo: Öffentliche Kunstsammlung]

General stylistic characteristics also suggest a date in the early fifteenth century. The artist renders details realistically, yet organizes the whole design in a pattern of curves. The three-quarter view of the lady's body does not project the figure in space as much as it complicates the pattern of curving lines and permits costume details to be more fully depicted.

Although the painting was attributed to Pisanello following its reappearance in the 1920s, George Hill and George Martin Richter first raised the question of a northern origin,[20] an opinion that was put forward more positively by Bernhard Degenhart in 1940.[21] Since then the painting has generally been accepted as a Franco-Flemish work from the first quarter of the fifteenth century.[22] The suggestion, first made by Panofsky, that the painting was produced in close proximity to the Limbourg brothers is certainly plausible.[23] In view of its repainted condition and the scarcity of comparable material, however, it is not possible to hazard a more specific attribution than the circle of predomi-

nantly Netherlandish artists working for the Valois house and its branches.

The identity of the sitter also remains unknown, though she must have been a person of considerable stature and political significance to justify the painting of an independent portrait. The traditional identification as Blanche of Lancaster, eldest daughter of Henry IV of England,[24] is not implausible as far as this princess' dates are concerned. She was married to Ludwig, Count Palatine and son of the Emperor Ruprecht, in Cologne in 1402. She died in 1409 at the age of seventeen and was buried in the Stiftskirche of Neustadt-an-der-Weinstrasse.[25] The Franco-Flemish character of the portrait is hard to reconcile with the fact that Blanche seems to have lived in the Rhineland after her marriage. While such a portrait could have been painted at the English court before the princess's marriage, it would then have to represent a child of ten. The age of the sitter in this portrait is difficult to judge, but in general one may question whether the somewhat remote profile view, with its associations of authority, would not be used to depict a woman of dynastic or political weight rather than a young candidate for marriage. Isabeau of Bavaria, Margaret of Flanders, Yolande of Anjou, and Margaret of Bavaria occupied such positions of stature in the troubled years of the early fifteenth century and are likely candidates for the subject of this portrait.

M. W.

Notes

1. The paint has not been analyzed to determine whether it is oil or tempera based. However, the present paint layer appears to be oil based, with the texture of the white paint in the hair suggesting the use of an emulsion medium there, according to Kay Silberfeld who undertook the technical examination of the painting.

2. In his important article on early portraiture, Sterling 1959, 289–312, cites as the surviving independent painted portraits from this period, in addition to the *Portrait of a Lady*: *John the Good of France* in the Louvre; *Archduke Rudolf IV of Austria* in the Dom- und Diözesanmuseum, Vienna; *Louis II of Anjou* in the Bibliothèque Nationale, Paris; *Richard II of England* in Westminster Abbey; and *Wenceslaus, Duke of Brabant and Luxembourg* in the Thyssen-Bornemisza collection.

3. C. A. J. Armstrong, "La politique matrimoniale des ducs de Bourgogne de la Maison de Valois," *Annales de Bourgogne* 40 (1968), 10–11.

4. L. Douët-d'Arcq, *La Chronique d'Enguerran de Monstrelet*, 3d ed. (Paris, 1859), 295, and Jean de Waurin, *Recueil des chroniques et anchiennes istories de la Grant Bretaigne, à present nommé Engleterre*, ed. William Hardy (London, 1868), 252, referred to as "la figure painte au vif de madame Katherine."

5. Sterling 1959, 302–304, 311. Meiss and Eisler 1960, 239–240 and figs. 7, 8, suggest an attribution to Malouel for

a lost portrait of John the Fearless with hands raised in prayer, known from an eighteenth-century drawing.

6. Taken in 1405; C. Dehaisnes, *Documents et extraits divers concernant l'histoire de l'art dans la Flandre, l'Artois, et le Hainaut avant le XVᵉ siècle*, 2 vols. (Lille, 1886), 2: 913. This portrait was part of the contents of a chest "ouquel sont plusiers biens lesquels Lyele jadis femme de chambre de feue ma dite dame des a lui appartient." This, and the reference to the portrait of Catherine of Burgundy, I owe to Jeffrey C. Smith.

7. Jules Guiffrey, *Inventaires de Jean duc de Berry (1401–1416)*, 2 vols. (Paris, 1896), 2: no. 1077. The portrait of John the Good in the Louvre may have been part of this quadriptych; Millard Meiss, *French Painting in the Time of Jean de Berry. The Late Fourteenth Century and the Patronage of the Duke* (London, 1967), 75. We do not know whether the gallery of portraits at the duke's castle of Bicêtre, destroyed in 1411, was made up of portraits on panel; see Meiss 1967, 74, and Paul Durrieu, "Les tableaux des collections du Duc Jean de Berry," *Bibliothèque de l'École des Chartes* 79 (1918), 268–269.

8. Bauch 1963, 106, cites several instances of portraits in a devotional or other context where a ruler is shown in profile and subordinate figures in three-quarter view. For the importance of these portraits as political documents, see Raymond Cazelles, "Peinture et actualité politique sous les premiers Valois: Jean le Bon ou Charles, Dauphin," *GBA* 6ᵉ pér. 92 (1978), 53–65, identifying the portrait in the Louvre as the young Charles V rather than John the Good.

In Italy the profile view was retained through the fifteenth century, especially for portraits of women; see John Pope-Hennessy, *The Portrait in the Renaissance* (New York, 1966), 35–50.

9. The watercolor of *Louis II of Anjou* in the Bibliothèque Nationale may well be a copy made at mid-century; see J[ean] A[dhémar] and F[rançoise] G[ardey], "Encore le portrait de Louis II d'Anjou conservé au Cabinet des Estampes de la Bibliothèque Nationale, 1400 ou 1460?" *GBA*, 6ᵉ pér. 92 (1978), 66–68, figs. 1, 2. The posthumous portrait of *Wenceslaus, Duke of Brabant and Luxembourg* probably derives from a devotional context; Sterling 1959, 300, fig. 191.

10. Formerly in the collection of Doyne C. Bell, sale, Christie's, London, 5 February 1889, no. 104, as Blanche, daughter of Henry IV (bought by Sir George Scharf). I have been unable to locate this watercolor, but its appearance is known from a careful copy by Scharf (notebook SSB 107, ff. 31v–32, the page dated 17 September 1883, in the National Portrait Gallery, London; fig. 3). In his penciled commentary, Scharf states that the portrait represents Blanche and that George Perfect Harding's watercolor copy was enlarged from a miniature. A later note in ink records his observation that 1937.1.23, when it appeared in Lord Stafford's sale, was "exactly like" the watercolor copy. If Harding's drawing was indeed based on a miniature, the miniature must also have recorded a damaged and restored state of the Gallery's painting. Lorne Campbell kindly brought Scharf's drawing to my attention.

11. See n. 10. Scharf also sketched the *Portrait of a Lady* with color notations in his copy of the catalogue of the Stafford sale (copy in the National Portrait Gallery, London).

12. Giovanni Paccagnini, *Pisanello* (London, 1973), fig. 124.

13. These holes are filled with a dense material and to-

gether outline a shape that is smaller than the present headdress all around. The headdress has evidently undergone several transformations. The catalogue of the Gurney sale describes it as a fur cap, and the Villeroy sale catalogue refers to "un bonnet rouge bordé de fourrure blanche." On his drawing after Harding, Scharf describes the headdress as brownish white patterned with gay colors. Under the microscope, it is evident the orange foliate design now seen in some of the coils extends through the whole headdress.

14. See Technical Notes.

15. Meiss 1967, 140–143 (as in n. 7), and Erich Steingräber, "Nachträge und Marginalien zur französisch-niederländische Goldschmiedekunst des frühen 15. Jahrhunderts," *Anzeiger des Germanischen Nationalmuseums* (1969), 30–35.

16. Four small holes indicate that a pendant was attached here. This emblem would probably have helped signal the lady's identity.

17. Compare the calendar page for May in particular; Meiss 1974, fig. 543.

18. Erich Steingräber, *Antique Jewelry* (New York, 1957), fig. 79, datable c. 1410–1415. Anne, Duchess of Bedford wears a later and wider version of the fur collar with turned down shirt in a miniature in the Bedford Hours probably painted about the time of her marriage in 1423; Marcel Thomas, *The Golden Age: Manuscript Painting at the Time of Jean de Berry* (New York, 1979), pl. 23.

19. For the construction of *bourrelets*, see Margaret Scott, *The History of Dress Series. Late Gothic Europe 1400–1500* (London, 1980), 87.

20. Hill 1929, 13, and Richter 1929, 139.

21. Degenhart 1940, 38.

22. Berenson 1947 acknowledged the possibility that the painting had a northern origin. The Pisanello attribution has found some recent adherents; see Brenzoni 1952, 186–188, with reservations, and Sindona 1962, 39–40.

23. Panofsky 1953, 82. The relationship to the Limbourgs was taken up by Winkler 1959, 188–189; Sterling 1959, 304; Keller 1967, 20–21; and Białostocki 1972, 189.

24. See under Provenance and n. 10.

25. Walther Holtzmann, "Die englische Heirat Pfalzgraf Ludwigs III.," *Zeitschrift für die Geschichte des Oberrheins* N.F. 43 (1930), 19–20. For Blanche's tomb in the Stiftskirche, see A. Eckhardt, *Kunstdenkmäler von Bayern. Regierungs Bezirk Pfalz. I Stadt und Bezirkamt Neustadt a. H.* (Munich, 1926), esp. 78. Portraits of Blanche and the Pfalzgraf Ludwig are included in a fresco of the Last Judgment in the choir of the Stiftskirche; Eckhardt, 68–70. However, this image of the English princess does not relate to the Gallery's portrait either in features or costume (photograph in National Portrait Gallery, London, and Historisches Museum der Pfalz, Speyer, no. 726).

On Blanche of Lancaster, see also Ulla Diebel, "Eine pfälzische Krone in der Münchner Schatzkammer," *Korrespondenzblatt des Gesamtvereins der deutschen Geschichts- und Altertumsverein* 76 (1928), cols. 32–40. Troescher 1966, 82–84, proposes Margaret of Bavaria as the sitter. While this is possible, his reasons are not valid, especially his claim that her turbanlike headdress refers to John the Fearless' captivity under the Turks after Nikopolis.

References

1924 Offner, Richard. "A Remarkable Exhibition of Italian Paintings." *The Arts* 5: 257, repro. 259.

1925 Venturi, Adolfo. "Antonio Pisano of Verona, called Pisanello." *Conn* 71: 196–197, repro. 199.

1925 Venturi, Adolfo. "Per il Pisanello." *L'Arte* 28: 36–37, fig. 1.

1925 Venturi, Adolfo. *Grandi artisti italiani.* Bologna: 222–226, fig. 77.

1925 Valentiner, W. R. "The Clarence H. Mackay Collection." *International Studio* 81: 335–337, repro.

1926 Valentiner, W. R. *The Clarence H. Mackay Collection. Italian Schools.* New York: not paginated, no. 1.

1927 Van Marle, Raimond. *The Development of the Italian Schools of Painting.* 19 vols. The Hague, 8: 104–105, 152, 206.

1929 Hill, George F. *Dessins de Pisanello.* Paris and Brussels: 13.

1929 Singleton, Esther. *Old World Masters in New World Collections.* New York: 99–103, repro.

1929 Richter, George Martin. "Pisanello Studies—II." *BurlM* 55: 139.

1929 Cortissoz, Royal. "The Clarence H. Mackay Collection." *International Studio* 94: 32–33.

1930 Valentiner, W. R. *Unknown Masterpieces in Public and Private Collections.* New York: not paginated, no. 9, repro.

1930 Martinie, A.-H. *Pisanello.* Paris: 25–26, 30, pl. 12.

1931 Venturi, Adolfo. *North Italian Painting of the Quattrocento. Emilia.* Florence and New York: 17–18, pl. 5.

1932 Berenson, Bernhard. *Italian Pictures of the Renaissance.* Oxford: 462.

1933 Venturi, Lionello. *Italian Paintings in America.* 3 vols. New York and Milan. 1: not paginated, pl. 128.

1937 Frankfurter, Alfred M. "New Items in the Mellon Collection." *ArtN* 35 (13 February): 11, repro. 9.

1937 Cortissoz, Royal. *An Introduction to the Mellon Collection.* Privately printed: 16.

1937 *Pantheon* 19: 129, repro.

1940 Degenhart, Bernhard. *Antonio Pisanello.* Vienna: 38, fig. 4 (2d ed. Turin, 1945: 39–40, 69, pl. 4).

1941 NGA: 156–157.

1941 *Duveen Pictures in Public Collections of America.* New York: not paginated, no. 27, repro.

1945 "Italian Paintings in the Andrew W. Mellon Collection, National Gallery of Art, Washington." *Conn* 115: repro. 113.

1947 Berenson, Bernhard. Letter to Max J. Friedländer. In *Maandblad voor beeldende Kunsten* 23, no. 5: 100–101, repro.

1949 Sterling, Charles. *Les peintres primitifs.* Paris: 24, fig. 19.

1949 Ring, Grete. *A Century of French Painting 1400–1500.* London: 199, no. 64, pl. 27.

1949 Mellon (reprinted 1953, 1958): xi, 13, repro.

1952 Brenzoni, Raffaello. *Pisanello pittore.* Florence: 186–188, pl. 76.

1953 Panofsky. *ENP*: 82, 171, 392, fig. 92.

1958 Coletti, Luigi. *Pisanello.* Milan: 28, no. 23, pl. 39.

1959 Winkler, Friedrich. "Ein frühfranzösisches Marienbild." *JbBerlin* 1: 188–189.

1959 Sterling, Charles. "La peinture de portrait à la cour de Bourgogne au début du XV^e siècle." *Critica d'Arte* 6: 289, 299, 304, 306, 308, 312, fig. 193.

1960 Meiss, Millard, and Colin Eisler. "A New French Primitive." *BurlM* 102: 234.

1962 Sindona, Enio. *Pisanello*. Paris: 39–40, 123, pl. 137.

1963 Bauch, Kurt. "Bildnisse des Jan van Eyck." *Heidelberger Akademie der Wissenschaften. Jahresheft 1961/1962*. Wiesbaden: 122. Repr. in Kurt Bauch, *Studien zur Kunstgeschichte*. Berlin, 1967: 103.

1963 Scheller, Robert W. *A Survey of Medieval Model Books*. Haarlem: 111.

1963 Seligman, Germain. *Merchants of Art 1880–1960*. New York: 121.

1963 Journet, René. "Deux retables du quinzième siècle à Ternant (Niévre)." *Annales littéraires de l'Université de Besançon* 49 (Archéologie 14): 10.

1963 Châtelet, Albert, and Jacques Thuillier. *French Painting from Fouquet to Poussin*. Lausanne: 29.

1964 Kreuter-Eggemann, Helga. *Das Skizzenbuch des 'Jaques Daliwe'*. Munich: 32, fig. 41.

1966 Laclotte, Michel. *Primitifs français*. Paris: 23, pl. XI.

1966 Troescher, Georg. *Burgundische Malerei*. Berlin: 82–84, 386, pls. 71, 72.

1966 Castelnuovo, Enrico. *Il gotico internazionale in Francia e nei Paesi Bassi* (I Maestri del Colore). Part 2, Milan: not paginated, pl. XIV.

1967 Keller, Harald. *Italien und die Welt der höfischen Gotik* (Sitzungsberichte der wissenschaftlichen Gesellschaft an der Johann Wolfgang Goethe-Universität Frankfurt/Main, 3, 1964). Wiesbaden: 20–21, fig. 15.

1968 Meiss, Millard. *French Painting in the Time of Jean de Berry. The Boucicaut Master*. London: 153.

1972 Dell'Acqua, Gian Alberto, and Renzo Chiarelli. *L'Opera completa del Pisanello*. Milan: 96, no. 79, repro.

1972 Białostocki, Jan, et al. *Spätmittelalter und beginnende Neuzeit* (Propyläen Kunstgeschichte). Berlin: 189, no. 49, fig. 49.

1974 Meiss, Millard. *French Painting in the Time of Jean de Berry. The Limbourgs and their Contemporaries*. New York: 228, 246–247, 281, 471, 474, fig. 606.

1975 NGA: 134, repro. 135.

Jan Gossaert

c. 1478–1532

Jan Gossaert was probably born around 1478. He is often called Mabuse after his birthplace in Maubeuge in Hainaut, a town in present-day France. Nothing is known about his early training, though it is sometimes suggested that he worked in Bruges. Gossaert is first mentioned in Antwerp in 1503 when he became a master in the painters' guild. He presented pupils to the guild in 1505 and 1507. By 1508 Gossaert was in service to Philip of Burgundy, an illegitimate son of Philip the Good, and when, in October 1508, Philip set out on a diplomatic mission to the Vatican, his entourage included Jan Gossaert. Surviving from this trip are drawings of antique statuary and architectural monuments that the artist made for his patron.

Sometime after July 1509 Gossaert returned from Rome to service in Philip's castle in Middelburg. Jacopo de' Barbari was also working for Philip at this time; later, when Gossaert worked for Margaret of Austria at Malines, he stayed at the home of sculptor Conrad Meit. In 1517 Philip of Burgundy was appointed Bishop of Utrecht and Gossaert seems to have gone to Utrecht with him. After Philip's death in 1524 the artist entered the service of Philip's half-brother Adolph of Burgundy, but also continued to receive commissions from other private patrons such as Jean Carondelet, Chancellor of Flanders, and King Christian II of Denmark, who had fled to the Netherlands in 1523. Gossaert spent many of his final years in Middelburg and died there before 13 October 1532.

Through a series of dated or documented works beginning with the drawings he made in Rome in 1508/1509, Jan Gossaert's artistic career can be followed in some detail. The earliest paintings, such as the signed *Adoration of the Magi*, c. 1510 (National Gallery, London), or the *Malvagna Triptych*, c. 1511 (Galleria Regionale, Palermo), show a virtuoso technique and a thorough assimilation of Netherlandish predecessors such as Hugo van der Goes and Jan van Eyck, as well as of the graphic art of Albrecht Dürer and the mannerist paintings of his contemporaries in Antwerp. Jan Gossaert's greatest importance for the history of Netherlandish painting, however, lies in the fact that he was the first to produce paintings that combined classical style and classical subject matter. He is the first "Romanist," whose example paved the way for subsequent journeys by Netherlandish artists to Italy. For example, the *Neptune and Amphitrite* of 1516 (Bode-Museum, East Berlin) shows classically proportioned nude figures (influenced in part by Dürer) in an architectural setting intended as an archaeologically accurate reconstruction of a Greek temple. The humanist bent of both the artist and his patron, Philip of Burgundy, is evident in the fact that, for the first time, Gossaert signed the painting in Latin, *Joannes Malbodius*, that is, Jan of Maubeuge. The taste for mythological subjects depicted in appropriate architectural settings is to be seen in many of Gossaert's paintings, such as the *Danaë* of 1527 (Alte Pinakothek, Munich).

Gossaert's religious paintings also combine Italianate figure poses, antique ornaments, and distinctly Netherlandish Madonna types. Jan Gossaert was a superb portraitist who invested his sitters with a clarity of pose and an imposing air of self-assurance, achieving what Cuttler calls "a monumentalization of the particular."

J.O.H.

Bibliography
Friedländer. Vol. 8. 1930 (vol. 8, 1972).
Glück, Gustav. "Mabuse and the Development of the Flemish Renaissance." *AQ* 8 (1945): 116–139.
Jean Gossaert dit Mabuse. Exh. cat. Museum Boymans–van Beuningen and Groeningemuseum. Rotterdam and Bruges, 1965.
Herzog, Sadja. "Jan Gossaert called Mabuse (ca. 1478–1532): A Study of his Chronology with a Catalogue of his Works." Ph.D. diss., Bryn Mawr College, 1968.
Herzog, Sadja. "Tradition and Innovation in Gossaert's Neptune and Amphitrite and Danae." *Bulletin Museum Boymans–van Beuningen* 19 (1968): 25–41.

1952.5.40.a–b (1119)

Saint Jerome Penitent

c. 1509/1512
Probably oak, two panels, each 86.7 x 25.3 (34⅛ x 10)
 painted surface: 86.7 x 24.5 (34⅛ x 9⅝)
Samuel H. Kress Collection

Inscription:
In the middle ground of the right panel, on a small stone:

Technical Notes: Each panel consists of a single board with vertical grain. Both panels have been planed down to a thickness of 0.2 cm and were laminated onto a second wood panel. After being separated by Mario Modestini in 1950 the panels were cradled and narrow strips of wood were added to the right and left sides of each panel. The paintings were restored by Modestini in 1950 and a few areas were again treated by him in 1956.

Although the support is in plane, x-radiographs indicate rather long vertical splits, three in each panel. These have been filled and retouched. Examination with infrared reflectography reveals scattered areas of underdrawing in the drapery and the landscape to the right of Jerome's left hand. Underdrawing is intermittently visible; there may be more that is not registering due to gray pigment, containing carbon black, in the upper paint layer that would register as opaque. Variations in transparency under infrared reflectography suggest that a number of different pigments were used to create the grisaille effect.

The panels are in fairly good condition. There is moderate abrasion in the hands and chest of Saint Jerome and to a lesser extent in areas of the sky, drapery and flesh. There is scattered retouching throughout the sky of both panels as well as in the lion and the face of Saint Jerome. To the right of Jerome's head and shoulders are several scratches.

The "yellow glazes" in the figure of Jerome mentioned by Eisler and others are actually discolored restorations probably applied to mask areas of abrasion.

Provenance: John M. Romadka, Prague and Milwaukee [d. 1898], by 1858. Mrs. John M. Romadka, his widow [d. 1936]. Mary Tekla Romadka, Pasadena, California.[1] (Duveen Brothers, New York, by 1945.) Samuel H. Kress Foundation, New York, 1949.

Exhibitions: New York, Durlacher Galleries, 1945, *An Exhibition of Painting and Sculpture of Saint Jerome*, no. 9. // Flint, Michigan, Flint Institute of Art, 1945, *Exhibition of Paintings by Old Masters*, no. 4. // Glens Falls, New York, Crandall Public Library, 1945, *Ten Masterpieces of Art*, no. 2. // New York, Duveen Art Galleries, 1946, *An Exhibition of Flemish Paintings of the Fifteenth and Early Sixteenth Centuries*, no. 8.

FRIEDLÄNDER in 1916 and Winkler in 1921 both listed a lost Saint Jerome by Gossaert that may well be identical with the Gallery's panels.[2] In 1930 *Saint Jerome Penitent* was published by Friedländer as the work of Gossaert, with the caveat that the work was known to him only through a photograph.[3] Since then, the attribution has been universally accepted. During the cleaning and restoration of what was thought to be a single panel, following its purchase in 1949 by the Samuel H. Kress Foundation, it was discovered that *Saint Jerome Penitent* was composed of two separate panels. Suida then proposed that the panels were the exterior wings of an altarpiece that had as its center panel Gossaert's *Agony in the Garden* in Berlin (fig. 1).[4] The height of the Berlin panel (85 centimeters) is virtually the same as that of the Gallery's panels (86.4 centimeters), and the 12.2 centimeter difference in width can easily be accounted for by the frame.[5] The interior wings are missing. Suida's proposed reconstruction is now generally accepted.

The iconography of Jerome's penitence is rooted in a specific incident in the saint's life. Sometime between 374 and 379 A.D., Jerome retired to the desert of Chalcis to live the life of a hermit. In a letter he wrote: "oh how often, when I was living in the desert, in that lonely waste, scorched by the burning sun, which affords to hermits a savage dwelling place, how often did I fancy myself surrounded by the pleasures of Rome . . . I remember that often I joined night to day with my wailing and ceased not from beating my breast till tranquility returned to me at the Lord's behest."[6] This and other passages provided the textual foundation for depictions of Jerome as a penitent. The most common image, which is an essentially Italian creation, shows the saint in the wilderness kneeling in front of a crucifix. This iconographic motif began to move into northern Europe during the late fifteenth and early sixteenth centuries. One of the earliest Northern examples is Dürer's engraving of c. 1496–1497 (Bartsch 61), which shows the saint kneeling before a small crucifix and accompanied by his lion.[7] Panofsky stressed the direct adoption of northern Italian sources by Dürer.[8] In painting, the penitent Jerome occurs infrequently in the Netherlands, though several examples from the Ghent-Bruges school are known.[9]

In Gossaert's panels a further elaboration upon the theme is provided by the motif of the cross growing out of the tree trunk. Herzog discusses the legends of the Tree of Life and the Tree of Knowledge and demonstrates that the tree in Gossaert's painting is the True Cross, associated with the Tree of Knowledge that emerges from the Tree of Life (*lignum vitae*). The tree is an emblem of both death and salvation; Saint Jerome

Jan Gossaert,
Saint Jerome Penitent,
1952.5.40.a-b

in his self-mortification attempts to follow Christ and achieve redemption. That this tree occurs first in Italian rather than Netherlandish art is for Herzog further proof that the panels date just after Gossaert's Italian sojourn.[10]

In the middle ground there are scenes from the life of Saint Jerome which involve his lion and would have been known to Gossaert through *The Golden Legend* or other accounts of the saint's life. At the left the lion recovers the ass that belonged to Jerome's monastery and had been stolen by traders. At the upper right the lion, who was thought to have eaten the ass, is exonerated and welcomed back to the monastery of Jerome.[11]

Thematically, the juxtaposition of the *Agony in the Garden* as the central panel of an altarpiece with *Saint Jerome Penitent* on the exterior wings is quite possibly unique; no other examples have come to light. There is a definite congruence between Christ's isolated vigil on the eve of his arrest and Jerome's attempts as a hermit to control his visions and endure pain.[12] The unusual iconography suggests a specific commission possibly due to the presence of a theological advisor or to the particular devotion of the patron. Both panels are of outstanding quality and marked by flinty, highly finished surfaces and virtuoso brushwork.

While critics, with one exception,[13] have been unanimous in dating *Saint Jerome Penitent* to Gossaert's first period of activity, c. 1503–1513, there has been some discussion as to the exact date and relationship of the panel to the artist's trip to Italy. Von der Osten placed the painting before 1508/1509, arguing that the anthropomorphic lion would not be imaginable after Gossaert's trip to Italy. He also saw in the landscape a feeling for nature close to the Danube School or the Lower Rhenish art of Jan Joest.[14] The

Fig. 1. Jan Gossaert, *Agony in the Garden*, Berlin, Staatliche Museen Preussischer Kulturbesitz, Gëmaldegalerie [photo: Jörg P. Anders]

authors of the Rotterdam-Bruges catalogue put the panels and the Berlin *Agony in the Garden* contemporary with or slightly later than the *Holy Family* altarpiece in the Lisbon Museum, a painting usually dated as early as 1504.[15] Friedländer dated the *Saint Jerome Penitent* to c. 1512,[16] and this date has found general acceptance.[17] Held associated the panels with Gossaert's early drawings, made in Rome in 1508/1509 and Cuttler put the panels immediately after the Italian journey.[18] Eisler implied a date shortly after 1509, in part because of the similarities to a woodcut of *Saint Jerome Penitent*, by Lucas Cranach, dated 1509.[19]

Herzog believes that the panels were painted after Gossaert's trip to Italy, but is less inclined to propose a specific date and puts them in the period 1509/1510–1512.[20] For Herzog, the rounded forms and concern with the manipulation of light effects found in Gossaert's earliest securely datable works, the drawings made in Rome,[21] are also to be found in the *Saint Jerome Penitent*. He finds additional evidence for an early date in the iconography of Jerome's penitence, which is more common in Italy than in Flanders. When compared to the drawings from Gossaert's Roman period and his other early works, such as the *Adoration of the Magi* (National Gallery, London), or the altarpiece of the Virgin and Child (Galleria Regionale, Palermo),[22] there is no question that the *Saint Jerome Penitent* and the *Agony in the Garden* in Berlin are early. But in view of the imprecision surrounding the dating of Gossaert's work, Herzog's general assignment of the painting to the period 1509–1512 is the most sensible.

A free copy of *Saint Jerome Penitent* appears on the exterior wings of an altarpiece on the London art market in 1981, which was attributed to the Master of Amiens. The central panel of the altarpiece depicts a night Nativity, and groups of angels are on the inner wings.[23]

J.O.H.

Notes

1. Unverified. Provenance is as given in exh. cat. Duveen Art Galleries 1946 and Eisler 1977.

2. Friedländer 1916, 188; Winkler 1921, 412. In the absence of measurements, provenance, or other distinguishing characteristics it is not clear whether the pictures are the same as *Saint Jerome Penitent*.

3. Friedländer 1930, 154, no. 22.

4. Suida 1951, 198; the Berlin panel is no. 551A; oak, 85 x 63 cm. Unfortunately, there are no known points of correspondence in the provenance of the two paintings. See *Gemäldegalerie Berlin, Staatliche Museen Preussicher Kulturbesitz, Katalog der ausgestellten Gemälde des 13–18. Jahrhunderts* (Berlin, 1975), no. 551A, 179–180; Rüdiger Klessmann, *The Berlin Museum: Paintings in the Picture Gallery, Dahlem–West Berlin* (New York, 1971), 132.

5. Herzog 1969, 67, suggests that both panels were trimmed slightly and therefore that the frame was somewhat narrower than the present dimensions suggest. The panels do appear to have been cut, though the losses probably do not exceed 1–2 cm.

6. F. Wright (trans.), *Select Letters of Saint Jerome* [The Loeb Classical Library] (Cambridge, Mass., 1953), 66–69.

7. Reproduced and discussed in Charles Talbot, ed., *Dürer in America: His Graphic Work* [exh. cat. National Gallery of Art] (Washington, 1971), 118, no. 10.

8. Erwin Panofsky, *The Life and Art of Albrecht Dürer* 4th ed. (Princeton, 1955), 77. Although the attribution is not absolutely secure, mention should be made of a painted *Saint Jerome Penitent* in an English private collection, on loan to the Fitzwilliam Museum, Cambridge. Fedja Anzelewsky, *Albrecht Dürer. Das malerische Werk* (Berlin, 1971), 122–123, no. 14, pls. 12–15, accepts the work as autograph and dates it c. 1495. David Carritt, "Dürer's 'St. Jerome in the Wilderness,'" *BurlM* 99 (1957), 365, called this the first German representation of the theme. The saint is accompanied by his lion and kneels in front of a crucifix that grows out of a tree stump.

9. Herzog 1969, reproduces a *Saint Jerome Penitent* by Adriaen Isenbrant in the John G. Johnson Collection, Philadelphia Museum of Art, and a panel by Aelbrecht Bouts in the Musées Royaux des Beaux-Arts, Brussels, figs. 7, 8 respectively. To this could be added panels by Gerard David in the Städel'sches Kunstinstitut, Frankfurt, and the National Gallery, London, Friedländer, vol. 6, part 2 (1971), nos. 220–221, pl. 226, and panels attributed to the Master of the Saint Lucy Legend, Friedländer, vol. 6, part 2 (1971), Supp. 241–243, pl. 239. A *Saint Jerome Penitent* by Memling is in the Öffentliche Kunstsammlung, Basel, Friedländer, vol. 6, part 1 (1971), no. 43, pl. 93.

10. Herzog 1969, 68–70. We should note that both Dürer's engraving and the painting attributed to him show the crucifix growing out of a tree; see above n. 8. Given Gossaert's admiration and emulation of Dürer's art it is possible that Gossaert's use of this Italianate device was reinforced by the work of his German colleague. Dürer's example also demonstrates that the motif was available in the North prior to Gossaert's trip to Italy.

11. See Ryan and Ripperger, *The Golden Legend*, 2: 589–591.

12. Herzog 1969, 64, notes that both Christ and Saint Jerome are beardless and that both scenes are united by the theme of prayer.

13. Frankfurter 1951, 115, believes that the altarpiece was painted for Philip of Burgundy on the occasion of his becoming Bishop of Utrecht in 1517. Frankfurter sees Jerome as having the features of Philip and the church in the background as based on Saint Maarten's Cathedral in Utrecht. I find neither suggestion tenable.

14. Osten 1961, 457.

15. Exh. cat. Rotterdam-Bruges 1965, 53.

16. Friedländer 1930, 154, no. 22.

17. Folie 1951, 84; Winkler 1962, 151; Kuretsky 1974, 573; NGA 1975, 156.

18. Held 1933, 137–138; Cuttler 1968, 428.

19. Eisler 1977, 80. The Cranach woodcut is reproduced in Tilman Falk, ed., *The Illustrated Bartsch. Sixteenth-Century German Artists. Hans Burgkmair the Elder, Hans Schäufelein, Lucas Cranach the Elder* (New York 1980), 11: 381, no. 63 (284).

20. Herzog 1969, esp. 64, 70. Compare also Herzog 1968, 60–62, 210–213. In both discussions he cites Glück as dating the panels prior to the Roman trip because of the lion's physiognomy; in actuality, it is Osten 1961 who holds this opinion. Herzog 1968, saw the Dürer monogram accompanied by the date 1513, which he thought might be contemporary with the painting and thus a *terminus ante quem*. The date is no longer visible and was not mentioned in Herzog's article of 1969. Photographs in the curatorial files made prior to the restoration in 1956 show a complete monogram and configuration of marks that could be read as a date. The photograph in Friedländer 1930, pl. 23, shows neither monogram nor date.

21. For reproductions and discussions of the drawings, see exh. cat. Rotterdam-Bruges 1965, cat. nos. 45–48.

22. Friedländer, vol. 8 (1972), no. 12, pl. 20 and no. 2, pl. 4.

23. Wood, center panel: 114.3 x 82 cm; wings: 74.3 x 30.5 cm each. I am grateful to Lorne Campbell for bringing this painting belonging to David Carritt Limited to my attention.

References

1916 Friedländer, Max J. *Von Eyck bis Bruegel*. Berlin: 188.

1921 Winkler, Friedrich. "Gossaert, Jan." In Thieme-Becker 2: 412.

1930 Friedländer. Vol. 8: 154, no. 22, pl. 23 (vol. 8, 1972: 93, no. 22, 120, pl. 21).

1933 Held, Julius. "Overzicht der Litteratuur betreffende Nederlandsche Kunst." OH 50: 137–138.

1933 Smits, K. *De Ikonographie van de Nederlandsche Primitieven*. Amsterdam: 187.

1945 Glück (see Biography): 127, fig. 8.

1945 Breuning, Margaret. "Portraying St. Jerome." *The Art Digest* 19 (15 March): 21.

1945 Louchheim, Aline. "Saint Jerome. Variations on a Theme." *ArtN* 44 (15–31 March): 10, 31, repro.

1945 Anon. "Old Masters Feature Flint Victory Show." *The Art Digest* 19 (15 September): 8, repro.

1951 Kress: 198, no. 87, repro. 199.

1951 Folie, Jacqueline. "Les Dessins de Jean Gossaert dit Mabuse." *GBA* 6ᵉ pér. 38 (appeared 1960): 84.

1951 Frankfurter, Alfred. "Interpreting Masterpieces: Twenty-four Paintings from the Kress Collection." *ArtNA* 50: 114–115, repro. 109, 115.

1960 Broadley, Hugh. *Flemish Painting in the National Gallery of Art*. Washington: 7, 28, repro. 29.

1961 Osten, Gert von der. "Studien zu Jan Gossaert." *De Artibus Opuscula XL. Essays in Honor of Erwin Panofsky*. New York: 457, fig. 1.

1961 Seymour, Charles, Jr. *Art Treasures for America. An Anthology of Paintings & Sculpture in the Samuel H. Kress Collection*. London: 86, fig. 79.

1962 Winkler, Friedrich. "Aus der ersten Schaffenzeit des Jan Gossaert." *Pantheon* 20: 150–151, fig. 11.

1965 *Jean Gossaert dit Mabuse*. Exh. cat. Museum Boymans–van Beuningen and Groeningemuseum. Rotterdam and Bruges: 53.

1965 Bruyn, Josua. "The Jan Gossaert Exhibition in Rotterdam and Bruges." *BurlM* 107: 463.

1968 Cuttler. *Northern Painting*: 428.

1968 *The Picture Gallery. Summary Catalogue of Paintings in the Dahlem Museum*. Berlin: 51, no. 551A.

1968 Herzog (see Biography): 60–62, 210–213, no. 5, pl. 6.

1969 Herzog, Sadja. "Gossaert, Italy and the National Gallery's Saint Jerome Penitent." *StHist* 3: 59–73, figs. 1–5.

1969 Osten, Gert von der, and Horst Vey. *Painting and Sculpture in Germany and the Netherlands 1500 to 1600*. Harmondsworth: 156.

1972 Hand, John Oliver. *Joos van Cleve and the Saint Jerome in the Norton Gallery and School of Art*. West Palm Beach, Florida: not paginated, fig. 2.

1974 Kuretsky, Susan. "Rembrandt's Tree Stump: An Iconographic Attribute of St. Jerome." *AB* 56: 573–574, fig. 4.

1975 NGA: 156, repro. 157.

1975 *Gemäldegalerie Berlin, Staatliche Museen Preussischer Kulturbesitz, Katalog der ausgestellten Gemälde des 13.–18. Jahrhunderts*. Berlin: 179–180, no. 551A.

1976 Walker: 134, figs. 137, 138.

1977 Eisler: 78–81, figs. 73–75.

1967.4.1 (2316)

Portrait of a Merchant

c. 1530
Probably oak, 63.6 x 47.5 (25 x 18³⁄₄)
Ailsa Mellon Bruce Fund

Inscriptions:
On the paper at upper left: *Alrehande Missiven* (miscellaneous letters)
On the paper at upper right: *Alrehande Minuten* (miscellaneous drafts)
On ring on sitter's index finger: *IS*
On pin on hat: *IAS* intertwined.

Technical Notes: The painting is in excellent condition and contains only a few scattered retouchings on the sitter's sleeves, the papers on the back wall, and the left page of the ledger in the foreground. Several changes are visible: the sitter's hat was originally broader and his hair longer at the back; the cord that hangs in front of the papers at the upper right has been shortened. Underdrawing is visible in the sitter's hands and sleeves and in the papers hanging on the rear wall. The reverse of the panel has been planed down and coated with a thin layer of paint.

Provenance: The Marquesses of Lansdowne, London and Bowood, Wiltshire (by 1866).[1] (Thos. Agnew & Sons, London.)

Exhibitions: London, British Institution, 1866, *Exhibitions of Works by Ancient Masters*, no. 70.[2] // London, Royal Academy of Arts, 1884, *Exhibition of Works by the Old Masters*, no. 288 as Holbein. // London, Thos. Agnew & Sons, 1954–1955, *Loan Exhibition of the Lansdowne Collection*, no. 17. // Bruges, Groeningemuseum, 1956, *L'Art*

flamand dans les collections britanniques et la Galerie Nationale de Victoria, no. 33. // Brussels, Musées Royaux des Beaux-Arts de Belgique, 1963, *Le siècle de Bruegel: La peinture en Belgique au XVI^e siècle*, no. 112.

THIS SUPERB PORTRAIT depicts a man of commerce writing in a ledger and surrounded by the tools of his trade. On the back wall between the two batches of papers are balls of twine and an "eared" dagger.[3] In the foreground, from the left, are: a shaker for talc or sand (used to dry ink), a magnifying glass (?), scissors, an ink pot, a pile of large coins, a pair of scales with a weight and a gold coin in the pans, and a leather-bound book and a metal receptacle for the red sealing wax, paper, and quill pens. This "occupational" portrait, a distinctly Northern type, is preceded by such works as Gerard David's *Portrait of a Goldsmith* (Kunsthistorisches Museum, Vienna), and Quentin Massys' portraits of Erasmus (Royal Collection, Hampton Court) and Pieter Gillis (collection of the Earl of Radnor, Longford Castle).[4] Here, however, it is difficult to be very precise about the sitter's occupation. Although the painting has often been called a portrait of a banker, the general appellation of merchant is probably the more accurate. There is nothing that would identify the sitter specifically as a banker. In the sixteenth century, however, merchants who dealt in commodities or in wholesale trade were likely to be financiers and to deal with money in some manner as money-changers, issuers of bills of exchange, or lenders of money.[5]

Two possible clues to the identity of the sitter are provided by the letters *IS* found on the ring worn on the index finger and the pin made from the letters *IAS* worn on the beret. In 1957 Van Puyvelde suggested that the sitter could be a Jerome or Jeronimus Sandelin, who was a tax collector in Zeeland and eventually became receiver-general of Zeeland for the West Scheldt region. Jeronimus Sandelin is mentioned in documents dating between 1539 and 1557, the earliest being seven years after Gossaert's death. Puyvelde's hypothesis was that Sandelin's brilliance as an administrator would have manifested itself early and that he would have occupied other positions in the government prior to 1539.[6] Rosenberg accepted Puyvelde's identification as highly probable.[7] While it certainly merits serious consideration, great caution must be exercised, for the evidence is circumstantial. First, there are no documents putting Sandelin in Zeeland at the time Gossaert was alive, though it is likely that he would have been there. Second, it is possible that Gossaert was commissioned to paint the portrait of someone who came from outside the Middelburg area. Last, the vicissitudes of sixteenth-century orthography

should make one wary of accepting an *I* as the first letter of Jerome or Jeronimus (Hieronymous), though such a spelling is possible. In the absence of hard evidence, the identification of the sitter remains conjectural.

While the overwhelming majority of critics attribute the *Portrait of a Merchant* to Jan Gossaert, the attribution has not gone unchallenged. Ambrose, the author of the 1897 catalogue of the Lansdowne Collection, accepted Crowe's attribution to Marinus van Reymerswaele,[8] and in 1961 Von der Osten also published the picture as a work by Marinus. For Von der Osten, neither the coloring, the compressed composition, nor the sitter's momentary glance were typical of Gossaert's style; he suggested instead that Marinus van Reymerswaele painted the portrait around 1520, at the moment he was emerging from the influence of Massys.[9] Subsequent authors have reaffirmed Gossaert's authorship and pointed out that the manner in which the drapery and hands are painted are practically signatures of Gossaert's style.[10] The momentary glance and somewhat aloof character of the sitter are also to be found in other late portraits by Gossaert such as the *Portrait of a Young Man*, formerly in the Van Beuningen Collection, Vierhouten, or the probable *Self-Portrait* in the Currier Gallery of Art, Manchester, New Hampshire.[11]

The *Portrait of a Merchant* must be placed in Gossaert's last years, probably around 1530, and thus may be compared to other late works such as the Vierhouten *Portrait of a Young Man*, the *Danaë* of 1527 (Alte Pinakothek, Munich), and the *Portrait of a Man*, Gemäldegalerie, Berlin.[12] In contrast to the relative simplicity of Gossaert's other late portraits, the *Portrait of a Merchant* is quite elaborate in its emphasis on accessories and suggests that even in his last years he was interested in experimenting with new compositions. This portrait is one of Gossaert's most impressive achievements. The massive triangle of the sitter's body dominates the space and the many small objects. Surfaces are beautifully rendered, while the gray-violet shadows on the face and hands suggest an almost Leonardesque *sfumato*.

Merchants, financiers, and tax collectors in the Netherlands during the early sixteenth century were regarded with a certain ambivalence. They were, on the one hand, an essential part of the economic dynamism and prosperity found in northern Europe in the first decades of the century. On the other hand, they were considered the cause of many abuses and their un-Christian traits of greed, usury, and immorality were satirized in paint and in print by Massys, Erasmus, and others. Gossaert's *Portrait of a Merchant* is

Jan Gossaert, *Portrait of a Merchant*, 1967.4.1

free from satire, yet the cool, remote portrayal creates a psychological distance and an almost stoic monumentality.[13]

Gossaert's *Portrait of a Merchant* seems to have had a decisive influence on certain of Hans Holbein the Younger's depictions of merchants, in particular the *Georg Gisze* of 1532 (Gemäldegalerie, Berlin). It has been suggested that Holbein might have seen the panel when he stopped in the Netherlands in 1532 on his way to England.[14]

An old copy of the *Portrait of a Merchant*, virtually the same size as the original, is in the John G. Johnson Collection, Philadelphia Museum of Art.[15] At the time of the British Institution exhibition of 1866 a copy was made by Sir George Scharf in a sketchbook now in the National Portrait Gallery, London.[16]

J.O.H.

Notes

1. First exhibited in this year, see under Exhibitions.

2. I am indebted to Lorne Campbell for providing the correct citation. The catalogue was unavailable to me. The date of the exhibition is sometimes erroneously given as 1886.

3. The dagger was identified by Helmut Nickel, curator of arms and armor, Metropolitan Museum of Art, New York, letter of 27 September 1979 in the curatorial files. "Eared daggers are thought to be of Hispano-Moresque origin and were produced during the fifteenth and first half of the sixteenth century." Nickel tentatively suggested that the cockle-shell on the "ear" of the dagger was associated with a badge of Santiago de Compostela. Van Puyvelde 1957, without citing a source, suggests that the dagger identifies the sitter as a member of the minor nobility.

4. The David is reproduced in Friedländer, vol. 6, part 2 (1971), no. 224, pl. 227. The Massys portraits are reproduced in Lorne Campbell, et al., "Quentin Massys, Desiderius Erasmus, Pieter Gillis and Thomas More," *BurlM* 120 (1978), 722.

5. In the London exhibition of 1884 the painting was entitled "The Banker" and this has remained the traditional title. However, several authors such as Grossmann 1957 and Voet 1973 have pointed out that "merchant" would be a better designation than "banker." For a good general discussion of the function of merchants in the sixteenth century see Voet 1973, 249–350. On 275 he notes that in Antwerp in the sixteenth century the Dutch and French terms *coopman* and *marchand* applied to persons engaged in commodity trading as well as to those who dealt principally with money. The more specific terms financier or banker seem not to have been current. Voet stresses the degree to which merchants dealt with both mercantile and financial matters.

6. Puyvelde 1957 was not aware of 1967.4.1 and so his discussion centered on the copy in the Johnson Collection, Philadelphia, which he accepted as autograph. He mentions a certain A. Sandelin, secretary of the Council of Holland, who on 30 May 1526 wrote a letter to the Count of Hoogstraeten. Perhaps wisely, Puyvelde does not attempt to connect this with the letter A in the sitter's beret.

7. Rosenberg 1967, 42.

8. Ambrose 1897, 60, citing Crowe's opinion.

9. Osten 1961, 474. Marinus van Reymerswaele's beginnings are obscure and his activity as a portraitist is almost nonexistent; the Johnson Collection copy of the *Portrait of a Merchant* was attributed to Marinus in the Bruges exhibition of 1902. See Friedländer, vol. 12 (1975), 136.

10. Verhaegen in the catalogue of the Brussels 1963 exhibition; Rosenberg 1967, 42–43.

11. Herzog 1968, 312–315, no. 53, makes this comparison. The portraits are reproduced in Friedländer, vol. 8 (1972), pls. 48, 49.

12. Reproduced in Friedländer, vol. 8 (1972), pls. 42, 46. It was thought that the coins might be useful in dating the picture. In a letter of 18 May 1977, H. Enno van Gelder of the Koninklijk Kabinet van Munten, Penningen en Gesneden Stenen, The Hague, identifies the gold coin on the triangular pair of scales as a Spanish *dobla excelente* bearing the likeness of Ferdinand and Isabella. These coins were minted from 1492 onward, but the lack of detail does not permit a precise dating. The thin silver coins were used as currency during the first half of the sixteenth century.

13. There are, of course, great dangers inherent in attempts to analyze or interpret facial expressions in Renaissance portraits. For the lack of expression as a possible indication of *tranquillitas*, a manifestation of inner harmony and a Stoic virtue, see William Heckscher, "Reflections on Seeing Holbein's Portrait of Erasmus at Longford Castle" in *Essays in the History of Art Presented to Rudolf Wittkower* (London, 1967), 130–131.

14. Grossmann 1957; Holman 1980.

15. Sweeny 1972, no. 2051, wood, 64.2 x 48.3 cm.

16. Sketchbook SSB 77, fol. 30v–31, page dated 21 August 1866. I am very grateful to Lorne Campbell for bringing this drawing to my attention.

References

1884 Richter, J. Paul. "The Dutch and Flemish Pictures at Burlington House." *The Academy* 25 (12 January): 34.

1897 Ambrose, G. *Catalogue of the Collection of Pictures belonging to the Marquess of Lansdowne, K.G.*: 60, no. 115.

1954 Sutton, Denys. "Pictures from the Lansdowne Collection." *Country Life* 2 (December): 1959, repro.

1954 Marlier, Georges. *Erasme et la peinture flamande de son temps*. Damme: 273–274.

1955 "Londra: Attività delle Gallerie." *Emporium* 121 (May): 229, repro.

1957 Grossmann, Fritz. "Flemish Paintings at Bruges." *BurlM* 99: 4–5.

1957 Puyvelde, Leo van. "Un portrait de marchand par Quentin Metsys et les percepteurs d'impôts par Marin van Reymerswael." *RBAHA* 26: 9.

1961 Osten, Gert von der. "Studien zu Jan Gossaert." *De Artibus Opuscula XL. Essays in Honor of Erwin Panofsky*. New York: 474, fig. 18.

1967 Rosenberg, Jakob. "A Portrait of a Banker (Jerome Sandelin?) by Jan Gossaert called Mabuse." *StHist* 1: 39–43, repro.

1968 Herzog (see Biography): 137, 312–315, no. 53, pl. 63.

1972 Sweeny, Barbara. *John G. Johnson Collection. Catalogue of Flemish and Dutch Paintings*. Philadelphia: 43.

1972 Friedländer. Vol. 8: 113, Add. no. 164, pl. 57.

1973 Voet, Leon. *Antwerp, The Golden Age.* Antwerp: 252, repro. 253.

1975 NGA: 158, repro. 159.

1977 Silver, Larry. "Power and pelf: a new-found *Old Man* by Massys." *Simiolus* 9: 76, fig. 15.

1978 Broadley, Hugh, and John Oliver Hand. *Flemish Painting in the National Gallery of Art.* Washington: 7, 26, repro. 27.

1980 Grosshans, Rainald. *Maerten van Heemskerck. Die Gemälde.* Berlin: 35, fig. 141.

1980 Holman, Thomas. "Holbein's Portraits of the Steelyard Merchants: An Investigation." *JMMA* 14: 141, fig. 2.

1981.87.1 (2852)

Madonna and Child

c. 1532
Probably oak, 34.4 x 24.8 (13 ½ x 9 ¾)
Gift of Grace Vogel Aldworth in memory of her Grandparents Ralph and Mary Booth

Inscriptions:
In the lower right foreground, between the hem of the Virgin's robe and the book: ⊞

Technical Notes: The painting is in very good condition except for the upraised hand of the Madonna, which is entirely repainted. There are small losses in the background and small losses in the shoulder and abdomen of the Christ Child. Infrared photography and infrared reflectography reveal underdrawing in the face and legs of the Infant and the face of the Madonna. Only a small portion of the Madonna's drapery at the extreme left shows underdrawing. On the reverse is the paper sticker from the Kleinberger Galleries exhibition of 1929 and at the lower left a partially destroyed red resinous seal, which may be read as / VAN DIEMEN / & CO. LA HAYE. At the upper right is a red resinous seal with an unidentified heraldic design.

Provenance: (Van Diemen & Co., The Hague.) Ralph and Mary Booth, Detroit and Grosse Point, Michigan, August 1922. By descent to William and Virginia Vogel, their daughter, Milwaukee, 1949. Grace Vogel Aldworth, their daughter, Chicago, by 1977.[1]

Exhibitions: New York, F. Kleinberger Galleries, 1929, *Flemish Primitives*, no. 80. // Antwerp 1930, *Trésor de l'art flamand du Moyen Age au XVIII^me siècle*, no. 183. // Rotterdam, Museum Boymans–van Beuningen, and Bruges, Groeningemuseum, 1965, *Jean Gossaert dit Mabuse*, no. 42.

THE PAINTING must be placed late in Gossaert's career; this is evident from the style and is also suggested by the existence of a replica (art market, Brussels) that

bears a signature and the date 1532, the year of the artist's death.[2] Although Gossaert treated the theme of the Madonna and Child many times during his career, several aspects of this painting are highly unusual. This is the only version set in a domestic interior and one of the very few showing full-length figures. Herzog characterizes the artist in his last year as still inventive but moving away from his usual guiding principles.[3] In particular, Herzog points to this painting's anatomical weaknesses, peculiar facial expressions, and the Madonna's agitated drapery.

Without discounting Herzog's observations, it is possible to see several of these tendencies as simply the continuation of the diverse elements that comprise Gossaert's style. For here, as in other of religious works by Gossaert, vocabularies and devices of Italy and the Netherlands are combined. The muscular, expressive body of the Christ Child is derived from Italian models, while his face was probably inspired by the works of Albrecht Dürer,[4] as can also be seen in another late work, the *Madonna and Child in a Landscape* in the Cleveland Museum of Art (fig. 1). The classical architecture seen through the window is also Italianate. Similar architecture occurs in only one other painting by Gossaert, a *Holy Family* in the Museo Provincial de Bellas Artes, Bilbao, which is also dated very late.[5] The minutely wrought yet fantastic metalwork of the throne joins Gothic elements and Italianate motifs and recalls the fascination of the mannerists in Bruges and Antwerp with elaborate ornamentation and highly polished surfaces. In Gossaert's own pictures, such as the *Altarpiece of the Virgin and Child* (Galleria Regionale, Palermo), the *Deësis* (Prado), or the *Virgin and Child* (Museu Calouste Gulbenkian, Lisbon),[6] there is ample evidence of his love of meticulously rendered metalwork. Further ties to the mannerist style can be seen in the rather contrived and elegant gesture of the Madonna's arm and the agitated complexity of the drapery folds that swirl around her. The Virgin's canny, suspicious glance is also seen in Gossaert's late portraits, such as 1967.4.1, *Portrait of a Merchant* (q.v.).

The painting technique is that of a virtuoso who is in full command of his craft. Especially interesting is the manner in which the Madonna's blue robe was painted. The technique is almost the reverse of the usual procedure. The white ground was covered with successively darker shades of paint, the darkest forming the shadows. Highlights, however, were not applied over the blue paint; rather, a very pale blue pigment was delicately stippled over the ground to form the lightest areas. An unusual amount of control and forethought is evident in this approach. It is also inter-

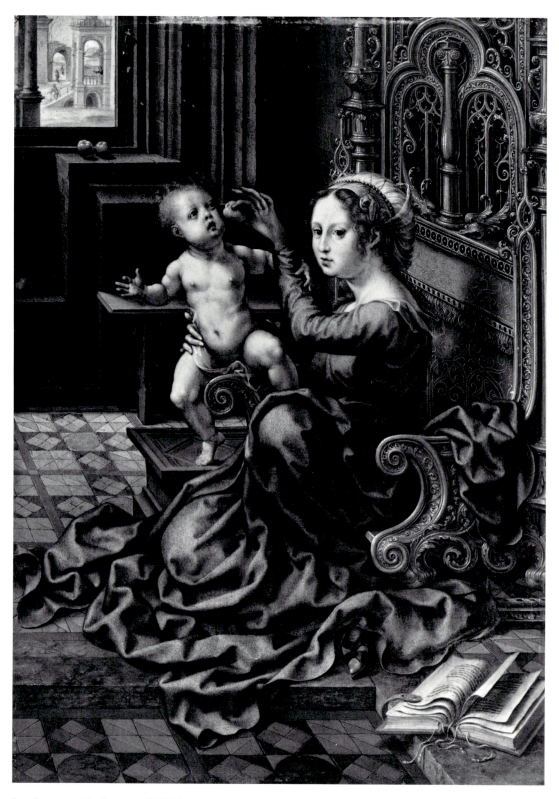

Jan Gossaert, *Madonna and Child*, 1981.87.1

esting that the floor tiles correspond approximately to a grid incised into the ground, since incising of perspective lines is found more often in Italian than in Netherlandish paintings.[7]

Symbolically, the ornate throne functions as a *Sedes Sapientiae* for the Virgin; the apple presented to Christ as well as those on the ledge at the back of the room mark him as the new Adam who will redeem the world's sin through his death on the Cross. In this regard the Infant's outstretched arms may be seen as anticipating Christ's posture at the Crucifixion.

The painting did not enter the literature until 1929, when it was exhibited in New York.[8] By the following year it was accepted as the "apparent original" by Friedländer, who also recognized the panel dated 1532 as a copy. A second replica (present location unknown) was listed by Friedländer as a "weak copy."[9] A third copy, dated 1532, is in a private collection in Cleveland, Ohio.[10]

J.O.H.

Notes

1. I am extremely grateful to Grace Vogel Aldworth and Mrs. William Vogel (letter of 20 December 1983 in curatorial files) for information on the provenance.

2. Wood, 34.4 x 25.4 cm, inscribed *IOANNES MAL PINGEBAT 1532*. See Friedländer, vol. 8 (1972), no. 28b, pl. 30. The painting is discussed by Ernst Weisz, *Jan Gossert dit Mabuse* (Parchim i. M., 1913), 124, and Achille Segard, *Jean Gossaert dit Mabuse* (Brussels and Paris, 1923), 68–69, as being in a private collection in America. I am indebted to George Shackelford for bringing the painting's location to my attention.

3. Herzog 1968, 162.

4. In discussing the *Madonna and Child*, dated 1531, in the Cleveland Museum of Art, Walter Gibson, "Jan Gossaert de Mabuse: Madonna and Child in a Landscape," *BCMA* 61, 291–292, calls attention to the close similarity of Gossaert's Child to the infant in Dürer's *Madonna and Child* of 1512 (Kunsthistorisches Museum, Vienna) and the brush drawing of a *Head of a Child* (Louvre, Paris). The same comparisons of facial type are valid for the National Gallery's *Madonna and Child*.

5. Friedländer, vol. 8 (1972), Add. 163. This comparison was pointed out in exh. cat. Rotterdam-Bruges 1965. The Bilbao painting is no. 26 in that catalogue.

6. Friedländer, vol. 8 (1972), no. 2, pl. 5; no. 19, pl. 24; and no. 37, pl. 35.

7. These observations were made by Ann Hoenigswald of the National Gallery's painting conservation staff during her examination of the painting in January 1982.

8. The catalogue of the Kleinberger Gallery exhibition mentions that the painting had a certificate from Max J. Friedländer.

9. Friedländer, vol. 8 (1972), no. 28a, 34 x 25 cm, pl. 30.

10. Wood, 36.4 x 26.6 cm. The Madonna's expression and the way in which the date is written suggest that the model was the copy cited in n. 2 above rather than Gossaert's original. I am grateful to Walter Gibson for first bringing this painting to my attention and to Paula DeCristofaro for technical information.

References

1930 Friedländer. Vol. 8: 40, 57–58, no. 28, pl. 26 (vol. 8, 1972: 37, 94, no. 28, pl. 30).

1961 Osten, Gert von der. "Studien zu Jan Gossaert." *De Artibus Opuscula XL. Essays in Honor of Erwin Panofsky*. New York: 455.

1968 Herzog (see Biography): 156–157, 162, 318–319, no. 56, pl. 68.

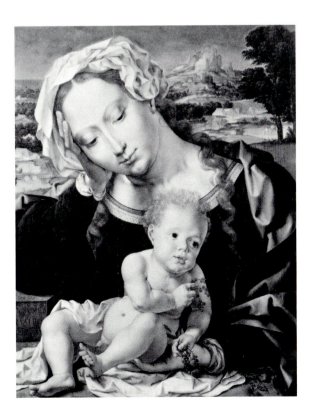

Fig. 1. Jan Gossaert, *Madonna and Child in a Landscape*, Cleveland, Ohio, The Cleveland Museum of Art, John L. Severance Fund [photo: The Cleveland Museum of Art]

Maerten van Heemskerck

1498–1574

Maerten (or Maarten) van Heemskerck was born in 1498, the son of Jacob Willemsz. van Veen, a farmer. The artist is named after Heemskerk, the village of his birth, which lies a short distance to the north of Haarlem. According to Carel van Mander, whose *Schilder-Boek* of 1604 is an important source of information, Heemskerck first studied with Cornelis Willemsz. in Haarlem and then with Jan Lucasz. in Delft. The work of neither artist is known to us. Between 1527 and 1530 Heemskerck worked with Jan van Scorel during the period that Scorel resided in Haarlem and was ostensibly attracted by the new manner of painting that Scorel had brought back from Italy. Heemskerck himself remained in Haarlem until at least May of 1532, at which point he set off for Rome, arriving there by July 1532.

While in Rome Maerten van Heemskerck made accurate, conscientious sketches of antique ruins and statues; he was influenced by Raphael and contemporary artists such as Michelangelo and Salviati. It is also likely that on his way home, in late 1536 or early 1537, Heemskerck stopped in Mantua and viewed the work of Giulio Romano. By 1537 Heemskerck was back in Haarlem, where he was to remain for virtually the rest of his life. He was married twice, and the wealth of his second wife ensured his secure financial and social standing in the community. Heemskerck belonged to the Haarlem Guild of Saint Luke; he was a minor official in 1551 and 1552 and deacon of the Guild in 1554. When the Spanish laid siege to the city of Haarlem in 1572, the artist was given permission to live in Amsterdam. Maerten van Heemskerck returned to Haarlem the following year and died at the age of seventy-six on 1 October 1574.

There are no true juvenilia, but Heemskerck's biography provides a basis for dividing the oeuvre into three unequal segments. The paintings produced in Haarlem between 1527 and 1532, which closely emulate the works of Jan van Scorel, comprise the first. The portraits of Pieter Bicker and Anna Codde (Rijksmuseum, Amsterdam) of 1529 are the earliest dated pictures by Heemskerck. Several paintings date from 1532, including a portrait of Heemskerck's father in the Metropolitan Museum, New York, but the most important of these is a depiction of *Saint Luke Painting the Virgin* in the Frans Halsmuseum, Haarlem. According to its inscription it was presented to the members of the painters' guild on the occasion of Heemskerck's departure for Rome.

A second group is composed of paintings produced during his stay in Italy. The *Rape of Helen* in The Walters Art Gallery, Baltimore, dated 1535, twice, is a panoramic landscape filled with ancient ruins and recognizable monuments. Dated 1536, *Venus and Cupid in Vulcan's Forge* (National Gallery, Prague) reveals what will be key elements in Heemskerck's style, the absorption of Italian art and antique sculpture, in this instance Baldassare Peruzzi's fresco of the same subject in the Farnesina, Rome, and antique reliefs such as that of *Vulcan and the Cyclopes Making Achilles' Shield* in the Palazzo dei Conservatori, Rome.

The third and largest group consists of those works produced after his return to Haarlem in 1537. Maerten van Heemskerck was a prolific painter and even if, as reported by Van Mander, much was lost in the iconoclastic uprising of 1566, many pictures have survived. The artist was adept at painting religious and mythological scenes as well as portraits. Between 1538 and 1542 he painted a mammoth altarpiece, crammed with figures, for the church of Saint Lawrence in Alkmaar, now in the cathedral in Linköping, Sweden. Other religious works include the brilliantly theatrical *Deposition* altarpiece of 1559/1560 in the Musées Royaux des Beaux-Arts, Brussels, and expansive depictions of *The Baptism of Christ* of 1563 in the Herzog Anton Ulrich-Museum, Braunschweig, and the *Four Last Things* of 1565 in the Royal Collection, Hampton Court. Heemskerck's mythological paintings are often emblematic or allegorical in character and result from contact with Dutch scholars and humanists such as Dirck Volkertsz. Coornhert or Hadrianus Junius. For example, *Momus Criticizing the Creations of the Gods,*

dated 1561 (Bode-Museum, East Berlin), has been related to an emblem book by Junius. Other paintings such as the lyrically exuberant *Triumph of Bacchus* (Kunsthistorisches Museum, Vienna), probably painted just after the artist's return from Italy, seem to be free from overt moralizing. Heemskerck was an excellent portraitist, more traditional and subdued than in his religious and mythological paintings; he seems to have favored a three-quarter length format. Of particular interest for its spontaneity and mannerist spatial effects is the *Self-Portrait*, dated 1553, in the Fitzwilliam Museum, Cambridge.

Maerten van Heemskerck's importance lies in large part in his "Romanism." He brought to the North classical subject matter as well as a conception of the human body inspired by Italian High Renaissance and mannerist art. Heemskerck's brand of Romanism was widely disseminated through the medium of prints, for he produced numerous designs that were executed by professional engravers and were apparently quite popular.

J.O.H.

Bibliography

Friedländer. Vol. 13. 1936 (vol. 13, 1975).
Veldman, Ilja. *Maerten van Heemskerck and Dutch Humanism in the sixteenth century.* Maarsen, 1977.
Grosshans, Rainald. *Maerten van Heemskerck. Die Gemälde.* Berlin, 1980.

1961.9.36 (1398)

The Rest on the Flight into Egypt

c. 1530
Probably oak (cradled), 57.7 x 74.7 (22³/₄ x 29)
Samuel H. Kress Collection

Technical Notes: The panel consists of two boards with horizontal grain.[1] There are losses along the join line of these two boards. In the flesh tones, the areas of deep red, and in the buildings at the distant right, there is extensive blistering and it is possible that the painting was exposed to excessive heat. There are numerous small losses in the torso of the Christ Child. Examination with infrared reflectography reveals underdrawing, which appears to be brush. Contours and fold lines in the drapery are loosely defined; hatching is not visible (fig. 1). The Virgin's arm has been lowered from its under-

drawn position and the fingers of her proper right hand were originally longer (fig. 2). The painting was restored in 1984/1985.

Provenance: Heinrich Wilhelm Campe, Leipzig [d. 1862]. Heinrich Vieweg, Braunschweig [d. 1890], his grandson.[2] Heirs of Heinrich Vieuwig (sale, Berlin, Lepke's, 18 March 1930, no. 49, as Jan van Scorel). Antonio von Riedemann, Meggen, Switzerland. (Frederick Mont, New York.) Samuel H. Kress Foundation, New York, 1952.

Exhibitions: Basel, Öffentliche Kunstsammlung (Kunstmuseum), 1945, *Meisterwerke holländischer Malerei des 16. bis 18. Jahrhunderts*, no. 78, as *Madonna and Child* by Jan van Scorel. // Utrecht, Centraal Museum, 1955, *Jan van Scorel*, no. 25, as *Madonna and Child* by Jan van Scorel.

ALTHOUGH THIS PAINTING has often been catalogued as a Madonna and Child, it should also be considered as a representation of the Rest on the Flight into Egypt. From the late fifteenth century onward, the image of the Madonna and Child begin to dominate depictions of this apocryphal theme[3] and, as noted by Eisler, the theme was treated quite freely in the sixteenth century.[4] The donkey that grazes at the distant right and the windswept figure who may be Joseph, albeit young and beardless, support the identification of the scene as a Rest on the Flight. An iconic rather than narrative emphasis is stressed, in part through the attributes associated with the infant Christ. That Christ is seated on a crystal world-globe surmounted by a cross implies his dominion over heaven and earth,[5] while the butterfly that he holds is a traditional symbol of the Resurrection.[6] Thus, even in his infancy, Christ's redemption of mankind through his death on the cross is foreshadowed.

The Rest on the Flight into Egypt presents a classic problem in connoisseurship. The painting has been attributed to both Jan van Scorel and Maerten van Heemskerck and dated to the period when the two artists were closest to each other. Following his voyage to the Holy Land and stay in Venice and Rome, Jan van Scorel had returned to Utrecht by May of 1524. Political and religious unrest in Utrecht caused Scorel to go to the city of Haarlem, where he lived and worked from late April 1527 until late September 1530.[7] He was joined by Maerten van Heemskerck, who had come from Delft expressly to learn Scorel's new, Italian-inspired manner of painting. According to Van Mander, Heemskerck succeeded so well that his paintings were all but indistinguishable from those of Scorel.[8] Heemskerck was only three years younger than Scorel and their relationship was probably not strictly that of master and pupil, especially since Heemskerck had

Fig. 1. Infrared reflectogram assembly of a detail of *The Rest on the Flight into Egypt*, 1961.9.36 [infrared reflectography: Molly Faries]

Fig. 2. Infrared reflectogram assembly of a detail of *The Rest on the Flight into Egypt*, 1961.9.36 [infrared reflectography: Molly Faries]

Maerten van Heemskerck, *The Rest on the Flight into Egypt*, 1961.9.36

previously apprenticed with artists in Haarlem and Delft.

When it first entered the literature in 1881, *The Rest on the Flight into Egypt* was called by Scheibler and Bode a late work by Jan van Scorel.[9] At the time of the Vieweg sale, Winkler attributed the painting to Scorel, comparing it to the *Magdalene* in the Rijksmuseum, Amsterdam.[10] Friedländer concurred in the attribution.[11] Suida and Shapley catalogued *The Rest on the Flight into Egypt* as a work painted by Scorel around 1530.[12] They emphasized the similarity to the Rijksmuseum *Magdalene* as well as its Venetian and Italian mannerist antecedents, such as Michelangelo, Beccafumi, and Granacci. Subsequent authors who accept the attribution of the Gallery's painting to Scorel include Cuttler, von der Osten, and Eisler, who found the picture more mannered than other of Scorel's works.[13]

Wescher was the first to assert the countervailing view that *The Rest on the Flight into Egypt* was actually by Maerten van Heemskerck.[14] He saw connections with Heemskerck's early works, *Saint Luke Painting the Virgin* (Frans Halsmuseum, Haarlem) and *Judah and Tamar*, formerly in Berlin. Wescher maintained that the landscape exists in a single plane and the style in general does not have Scorel's loose, painterly manner and southern (that is, Italian) light. After an initial confusing association with Scorel, Hoogewerff attributed the Gallery's panel to Heemskerck.[15] At the time of the Jan van Scorel exhibition in Utrecht, Bruyn, Houtzager (the author of the catalogue entry), and Levie all thought that *The Rest on the Flight into Egypt* was an early Heemskerck, similar to the Haarlem *Saint Luke* and the *Judah and Tamar* yet comparable in format and composition to Scorel's Rijksmuseum *Magdalene*.[16] Recent scholarship has overwhelmingly supported Heemskerck as the author of the painting. Heemskerck specialists Grosshans, Veldman, and Harrison[17] and Scorel scholar Faries[18] as well as Snyder, Filedt Kok and Kloek are unanimous in attributing *The Rest on the Flight into Egypt* to Heemskerck.[19]

An analysis of *The Rest on the Flight into Egypt* in comparison with Heemskerck's early works and with pictures from Scorel's Haarlem period confirms Heemskerck's authorship and at the same time illustrates the degree to which he emulated Scorel's manner. Of the works generally accepted as being from Scorel's Haarlem period, the most instructive for comparative purposes are the *Magdalene* (fig. 3) in the Rijksmuseum, Amsterdam, the *Baptism of Christ* in the Frans Halsmuseum, Haarlem, and the *Madonna of the Wild Roses* in the Centraal Museum, Utrecht.

In its original shape, without the added strip across the top, the seated figure juxtaposed to the landscape background in the Rijksmuseum *Magdalene* is strikingly close to *The Rest on the Flight into Egypt* in format and composition.[20] Yet it is also evident that the paintings are by two different hands. In the *Magdalene*, the conception of space is rational and orderly; the horizon line is low and the middle ground assists in establishing the coherent progression from foreground to background. The body of the Magdalene is placed parallel to the picture plane. The total effect is one of ordered calm. In *The Rest on the Flight into Egypt*, the arrangement of forms is more energetic and less orderly. The horizon line is rather high. There is no true middle ground, but rather an abrupt contrast of dark foreground and light background. The brushwork in the background especially is looser and more active than Scorel's.

Essentially the same differences can be observed between *The Rest on the Flight into Egypt* and the Haarlem *Baptism of Christ*.[21] In Scorel's Haarlem painting the figures are integrated into a cohesive, unified landscape with a definite middle ground. As in the Rijksmuseum *Magdalene*, rocks are more crisply rendered, colors are more saturated, and the "handwriting" of the foliage is different from that in the Gallery's painting.

With the *Madonna of the Wild Roses* in Utrecht there are similarities in the facial type of the Child and, as noted by Faries, in the position of the Christ Child's legs.[22] A donkey and standing male figure in the distance recall the background of the Gallery's picture and suggest that this too might be a Rest on the Flight into Egypt.[23] The Utrecht painting in other regards is very different in conception and broader in execution.

Fig. 3. Jan van Scorel, *Magdalene*, Amsterdam, Rijksmuseum [photo: Rijksmuseum-Stichting]

Fig. 4. Maerten van Heemskerck, *Saint Luke Painting the Virgin*,
Haarlem, Frans Halsmuseum [photo: Frans Halsmuseum]

An examination of the works definitely by or generally attributed to Maerten van Heemskerck reveals several direct comparisons with *The Rest on the Flight into Egypt*. The *Family Group* in the Staatliche Gemäldegalerie, Kassel, had been attributed to Jan van Scorel. It has been recognized as a work by Heemskerck and most recently identified as a portrait of a Haarlem nobleman Pieter Jan Foppesz. and his family, with whom Heemskerck lived around 1529/1530, the probable date of the painting.[24] The twisting, muscular body, bright blond curls, general facial structure but especially the mouth and upturned nose and short broad thumbs of the nearly naked infant at the far right of the Kassel portrait are echoed in the Christ Child in the Gallery's picture. Essentially the same infant recurs in one of the cornerstones of Heemskerck's Haarlem period, the *Saint Luke Painting the Virgin* of 1532 in the Frans Halsmuseum (fig. 4).[25] Here, as in the Gallery's panel, the Christ Child is shown sitting on a world globe, but his body is slightly more muscular and his pose is more energetic. The Madonna's spade-shaped face and sidelong glance directly relate to the Madonna's face in *The Rest on the Flight into Egypt*.[26] In both paintings the line of the headdress echoes the curve of the face; this is in contrast to the Rijksmuseum *Magdalene* and Utrecht *Madonna of the Wild Roses* where Scorel uses the headdress more as a device for

framing the head. In general the forms are a bit more sculptural and contrasts of light and dark sharper in the Haarlem *Saint Luke* panel, but this may in part be due to an attempt to render the light effects of the torch held by the angel.

Further comparisons are to be found in the *Judah and Tamar*, signed and dated 1532 (present location unknown).[27] Tamar's facial type is the same as that found in the Gallery's painting and the Haarlem *Saint Luke*. Moreover, the relation of figure to background, the absence of a definite middle ground, the landscape's high horizon line, classically inspired ruins, and active, wind-swept figures are all elements found in *The Rest on the Flight into Egypt*.[28]

The Rest on the Flight into Egypt can be separated from Jan van Scorel's works on the level of technique. Jan van Scorel's paintings exhibit extensive underdrawing, much of which can be seen with the naked eye, and this underdrawing has been carefully studied with infrared reflectography by Molly Faries.[29] The rather minimal underdrawing visible in the Gallery's panel bears no relation to Scorel's. When Heemskerck's paintings, such as the *Saint Luke Painting the Virgin*, are examined with infrared reflectography, underdrawing is either not visible or minimal and thus there would seem to be a difference in technique between Heemskerck and Scorel.[30]

From the above comparisons it is evident that *The Rest on the Flight into Egypt* is a work from Maerten van Heemskerck's Haarlem period. While the differences between Heemskerck and Scorel have been stressed, it should be reiterated that this painting consciously seeks to copy Scorel's style. It is conceivable that *The Rest on the Flight into Egypt* may have been painted while Heemskerck was in Scorel's atelier and would date around 1530.[31] Since Maerten van Heemskerck often signed his works, the absence of a signature raises the question of whether the painting might have left the studio as a Scorel. The signed and dated works of 1532, the Haarlem *Saint Luke Painting the Virgin* and the *Christ as the Man of Sorrows* (Museum voor Schone Kunsten, Ghent), are marked by figures that are more sculptural, muscular, and dramatic, qualities that are found increasingly in Heemskerck's later work.

Friedländer mentioned a replica of *The Rest on the Flight into Egypt* that was on the market in Cologne in 1936.[32]

J.O.H.

Notes

1. Examination did not disclose the piece of canvas covering the board in the landscape area mentioned by Eisler 1977, 86.

2. Scheibler and Bode 1881, 212, record the painting as being in the Vieweg collection; for Heinrich Campe see Winkler 1930, 73, 78.

3. See 1937.1.43, Gerard David, *The Rest on the Flight into Egypt*, nn. 2, 3.

4. Eisler 1977, 87.

5. See Percy Ernst Schramm, *Sphaira Globus Reichsapfel. Wanderung und Wandlung eines Herrschaftszeichens* (Stuttgart, 1958), 55–108.

6. Grosshans 1980, 96. Engelbert Kirschbaum, et al., *Lexikon der christlichen Ikonographie*, 8 vols. (Rome, Freiburg, Basel, and Vienna, 1968–1976), 4: col. 96, s.v. *Schmetterling*.

7. Molly Faries, "Jan van Scorel, Additional Documents from the Church Records of Utrecht," *OH* 85 (1970), 4–5.

8. Van Mander, *Schilder-Boek*, fol. 244v–247.

9. Scheibler and Bode 1881, 212.

10. Winkler 1930, 78; Winkler also wrote the entry in the 1930 Vieweg sale catalogue.

11. Friedländer, vol. 12 (1935), 202, no. 327. He repeated his belief that the painting was by Scorel in a letter of 4 November 1955 to William Suida in the curatorial files.

12. Kress 1956, 164. They also proposed that Agathe van Schoonhoven was the model for the Madonna and that the picture might have been the one seen by Marcantonio Michiel in the house of Gabriele Vendramin, Venice. Both suggestions are unsubstantiated.

13. Cuttler 1968, 452; Osten and Vey 1969, 183, who compares the figures to animated sculpture; and Eisler 1977, 86–88.

14. Wescher 1938, 221–223.

15. Hoogewerff 1923, 141, no. 20, under atelier and

works made by assistants, listed the painting as another example of the *Virgin and Child* in the Staatliche Gemäldegalerie, Kassel, itself generally considered to be from Scorel's workshop. Hoogewerff 1941/1942, 303, 305.

16. Bruyn 1954, 54; Levie 1955, 248; exh. cat. Utrecht 1955, 43–44, no. 25, catalogued under Jan van Scorel, but discussed in the entry as early Heemskerck. However, a letter of 11 July 1957 from Fern Rusk Shapley to Guy Emerson states that Houtzager, in conversation, had later concluded that *The Rest on the Flight into Egypt* was by Jan van Scorel.

17. Grosshans 1980, 47–48, 96–97, no. 8; Ilja Veldman, letter to the author of 22 September 1983; and Jefferson Harrison, letter to the author of 5 December 1983. Mr. Harrison graciously shared portions of his dissertation in progress, which extensively analyzes *The Rest on the Flight into Egypt*. Harrison's differentiation of the styles of Scorel and Heemskerck can be found in "Maerten van Heemskerck and Alkmaar. A Painting Reattributed and a Relationship Clarified between the Painter and His Patrons," *Kennemer Contouren. Uit de geschiedenis van Alkmaar en omgeving* (Zutphen, 1979), 91, 94.

18. Letter to the author of 12 August 1977; Faries 1982, 124–125, 129, nn. 21, 22. While a Senior Fellow at the Center for Advanced Study in the Visual Arts in the autumn of 1981, Faries examined the painting several times under laboratory conditions.

19. James Snyder, letter to the author of 5 June 1976; Jan Piet Filedt Kok in conversation after examining the painting 3 June 1983; Wouter Kloek in conversation 13 October 1983.

20. Faries 1982, n. 22, was the first to note that *The Rest on the Flight into Egypt* was nearly identical in size to the Rijksmuseum *Magdalene*. Without the strip at the top, the Rijksmuseum painting measures appx. 55.5 x 76.5 cm. See Friedländer, vol. 12 (1975), no. 338, pl. 182. Exh. cat. Utrecht 1955, 42, no. 23.

21. Friedländer, vol. 12 (1975), no. 317, pl. 173. Exh. cat. Utrecht 1955, 39–40, no. 19.

22. Exh. cat. Utrecht 1955, no. 26. A replica is in the Gemäldegalerie, Berlin, reproduced in Friedländer, vol. 12 (1975), no. 329, pl. 179. Jefferson Harrison in his unpublished comments on the Gallery's panel in the curatorial files stresses the similarity to the facial type of the Child in the Utrecht *Madonna*. Faries 1982, 129, n. 22, observes the similarities to the surface and underdrawn positions of the Child in the Utrecht painting.

23. See the comments in exh. cat. Utrecht 1955, 44, no. 26.

24. Grosshans 1980, 99–103, no. 11, color pl. 1, pl. 11. The painting was first attributed to Heemskerck by C. H. de Jonge, "Vroege werken van Maerten van Heemskerck," *OH* 49 (1932), 158, fig. 7. The identification of Foppesz. is based on the coat-of-arms on the man's signet ring; see J. Bruyn and M. Thierry de Bye Dólleman, "Maerten van Heemskercks *Familiegroep* te Kassel: Pieter Jan Foppesz. en zijn gezin," *OH* 97 (1983), 13–22.

25. Grosshans 1980, 109–116, no. 18, color pl. II, pl. 19.

26. J. R. J. van Asperen de Boer, "A Technical Study of Some Paintings by Maerten van Heemskerck," paper delivered at the conference on "Color and Technique in Renaissance Painting," Temple University, Philadelphia, 22–23 September 1980, observes similarities between the Gallery's Madonna and the underlying position of the Madonna's head in Heemskerck's painting. The same relationship was also noted by Faries, Center for Advanced Study in the Visual

Arts talk of 3 December 1981, and her summary report (July 1982) on underdrawing in Gallery paintings.

27. Grosshans 1980, 105–106, no. 14. The painting was last recorded as being in the Jagdschloss Grunewald, Berlin; prior to that it was at Sanssouci, Potsdam.

28. The *Baptism of Christ* (Gemäldegalerie, Berlin) displays the same loosely painted landscape and abrupt juxtaposition of foreground and background. This work, which seems to have been modelled on Scorel's *Baptism of Christ* in Haarlem, is placed before 1532 by Grosshans 1980, 98–99, no. 10, pl. 10.

29. Molly Faries, "Underdrawings in the workshop production of Jan van Scorel—A study with infrared reflectography," *NKJ* 26 (1975), 89–228. Included are reflectograms of the *Magdalene*, 95, fig. 3, and the *Baptism of Christ*, 107, fig. 13b.

30. In her letter of 12 August 1977 Faries reports that underdrawing could not be made visible in either the *Saint Luke Painting the Virgin* or the Berlin *Baptism of Christ*.

31. The notion that the Gallery's painting was produced in Scorel's studio grows out of conversations with Faries. See Faries 1982, 129, n. 22. Her letter of 12 August 1977 advances the idea that Heemskerck was paraphrasing Scorel's Haarlem works; thus the Berlin *Baptism of Christ* was derived from the Haarlem *Baptism*, and the *Crucifixion* in The Detroit Institute of Arts, which is tentatively attributed to Heemskerck by Faries, is related to a *Crucifixion* composition created during the Haarlem period. Harrison also sees *The Rest on the Flight into Egypt* as painted in Scorel's shop and he attributes the Detroit *Crucifixion* to Heemskerck.

Distinguishing Scorel from Heemskerck during the time that both were in Haarlem is a delicate and often difficult task. Reznicek 1983, 42–43, figs. 1, 2, compares the head of the Gallery's Madonna to the *Young Scholar* of 1531 in the Museum Boymans–van Beuningen, Rotterdam, which is usually attributed to Scorel. He seems to imply that the situation is sufficiently complicated so either painting might be by Scorel or Heemskerck. Grosshans does not include the Rotterdam *Young Scholar* in his catalogue, but Faries and Harrison attribute the painting to Heemskerck and Faries observes that no underdrawing was detected with infrared reflectography.

In a communication to the author of 8 June 1984 Faries stressed the complicated and unclear nature of underdrawing in Heemskerck's works. For example, Faries has found underdrawing in the Detroit *Crucifixion*, but this is an isolated example. Few related works have been studied and thus connections with other works attributed to the early Heemskerck are difficult to establish. J. R. J. von Asperen de Boer 1980 (as in n. 26 above) underscores the differences in Heemskerck's painting techniques and their possible experimental nature.

32. Friedländer, vol. 14 (1937), 129, 64 x 77 cm, listed as a fairly exact replica.

References

1881 Scheibler, Ludwig, and Wilhelm Bode. "Verzeichniss der Gemälde des Jan van Scorel." *JbBerlin* 2: 212.

1923 Hoogewerff, G. J. *Jan van Scorel. Peintre de la renaissance hollandaise.* The Hague: 141, no. 20.

1930 Winkler, Friedrich. "Die Sammlung Vieweg." *Pantheon* 5: 78, repro. 73.

1930 Deusch, Werner R. "Die Sammlung Vieweg-Braunschweig." *Die Kunstauktion* [*Die Weltkunst*] 4 (23 February): 1–2, repro.

1935 Friedländer. Vol. 12: 202, no. 327 (vol. 12, 1975: 123, no. 327, pl. 178).

1938 Wescher, Paul. "Heemskerck und Scorel." *JbBerlin* 59: 221–223, fig. 2.

1941/1942 Hoogewerff, G. J. *De Noord-Nederlandsche Schilderkunst.* 5 vols. The Hague, 4: 303, 305, fig. 143.

1954 Bruyn, Josua. "Enige werken van Jan van Scorel uit zijn Haarlemse tijd (1527–1529)." *Bulletin van het Rijksmuseum* 2: 54.

1955 Levie, Simon H. "De copie van een Bewening." *OH* 70: 248.

1956 Kress: 164, no. 64, repro. 165.

1968 Cuttler. *Northern Painting:* 452, fig. 620.

1969 Osten, Gert von der, and Horst Vey. *Painting and Sculpture in Germany and the Netherlands 1500 to 1600.* Baltimore: 183, pl. 163.

1975 NGA: 322, repro. 323.

1977 Eisler: 86–88, fig. 85.

1980 Grosshans, Rainald. *Maerten van Heemskerck. Die Gemälde.* Berlin: 47–48, 96–97, no. 8, pl. 8.

1982 Faries, Molly. "Two Additional Panels from Jan van Scorel's Workshop: Comments about Authorship." *Le Dessin sous-jacent dans la peinture. Colloque IV; 29–30–31 Octobre 1981.* Louvain-la-Neuve: 124–125, 129.

1983 Reznicek, E. K. J. Review of *Maerten van Heemskerck. Die Gemälde* by Rainald Grosshans. In *OH* 97: 42, 45, fig. 1, detail.

Adriaen Isenbrant

active 1510–1551

There are no extant signed or documented works by Adriaen Isenbrant (or Ysenbrant). In 1902, Hulin de Loo assigned to Isenbrant a group of paintings that were first given to the Haarlem artist Jan Mostaert and later to the "pseudo-Mostaert." Hulin de Loo's attribution has found general acceptance and accords with our meager knowledge of Isenbrant.

Adriaen Isenbrant was first mentioned in 1510 when he became a master in the Bruges painters' and saddlemakers' guild. He was recorded as a stranger, but his native town was not mentioned. Between 1516/1517 and 1547/1548 he was listed numerous times as a *vinder* or minor official of the guild and in 1526/1527 and 1537/1538 was a *gouverneur* or financial officer. He was married twice, and his second wife bore three daughters. Isenbrant died in his house in Bruges shortly before 21 July 1551.

Adding to our knowledge is Sanderus' *De Brugensibus eruditionis fama claris libri duo*, published in Amsterdam in 1624. Sanderus, citing the earlier authority Dionysius Hardwijn (1530–1604/1605), describes Adriaen Isenbrant of Bruges as a disciple of Gerard David and skilled in portraiture and the depiction of nude figures. Since there is no documentary evidence that Isenbrant was ever a pupil of David, the term "disciple" should perhaps not be taken literally.

Many paintings attributed to Isenbrant are definitely the work of a Bruges artist and are marked by an overwhelming reliance on the art of Gerard David. Isenbrant, however, tends to replace David's somber colors with a warmer, smokier palette and uses more *sfumato* modeling in the faces. Isenbrant frequently quotes as well from the works of earlier masters such as Jan van Eyck and Hugo van der Goes. There are also affinities with the pictures of his contemporaries in Bruges, Ambrosius Benson and Lancelot Blondeel. A considerable range of quality in the pictures grouped around Isenbrant's name indicates a large workshop as well as other copyists and followers.

Friedländer assembled a small core of works which serve as benchmarks for Isenbrant's style. Of these the only picture to bear a date is the altarpiece of the *Adoration of the Magi* of 1518, formerly in the Church of Saint Mary, Lübeck, and now destroyed. A diptych consisting of the *Seven Sorrows of the Virgin* (Church of Our Lady, Bruges), and a panel showing the donor, Joris van de Velde, his wife, children, and name saints (Musées Royaux des Beaux-Arts, Brussels), have been dated 1518 because the robe Van de Velde wears indicates his membership in the Confraternity of the Holy Blood for that year. Van de Velde did not die until 1528 and it is possible that the robe simply commemorates his earlier affiliation with the organization. Consequently, only the most tentative chronology can be established for this artist.

Despite our incomplete knowledge, however, Isenbrant, along with Benson and Blondeel, emerges as one of the principal representatives of the final conservative phase of painting in Bruges in the sixteenth century. J.O.H.

Bibliography

Hulin de Loo, Georges. *Bruges. Exposition de tableaux flamands des XIVᵉ, XVᵉ, et XVIᵉ siècles. Catalogue critique.* Ghent, 1902: LXIII–LXVII.
Friedländer. Vol. 11. 1933 (vol. 11, 1974).
Parmentier, R. A. "Bronnen voor de Geschiedenis van het Brugsche Schildersmilieu in de XVIᵉ Eeuw. IX: Adriaan Isenbrant," *RBAHA* 9 (1939): 229–265.
Janssens de Bisthoven, A. "Een nieuw datering voor twee aan Isenbrant toegeschreven schilderijen." *Miscellanea Jozef Duverger.* 2 vols. Ghent, 1968, 1: 175–185.
Wilson, Jean. "Adriaen Isenbrant Reconsidered. The Making and Marketing of Art in Sixteenth-Century Bruges." Ph.D. diss., The Johns Hopkins University, 1983.

1978.46.1 (2724)

The Adoration of the Shepherds

Probably 1520/1540
Probably oak (cradled), 74.6 x 57 (29⁷/₁₆ x 22⁷/₁₆)
Ailsa Mellon Bruce Fund

Inscription:
At base of ornament on the square column at right: *N 21*

Adriaen Isenbrant, *The Adoration of the Shepherds*, 1978.46.1

Technical Notes: The painting is composed of two boards with vertical grain. The original panel has been mounted on a second piece of wood and thin wood strips have been attached around the edges. The painting is in generally good condition, but there is scattered abrasion and small losses throughout. There are small losses along the join line and around all edges. Infrared reflectography reveals underdrawing in the figures and architecture (fig. 1). In some instances the changes in the underdrawing are paralleled by changes in the paint layer, as, for instance, in the increased base of the square column at the extreme left and the corresponding adjustment in the hem of the Virgin's robe.

Provenance: (Kleinberger Gallery, Paris.) (Paul Cassirer, Amsterdam, by June 1936.) (Rudolf Heinemann, New York, by 1937–January 1975.) (Feilchenfeldt, Zürich.)[1]

THE ICONOGRAPHIC PROGRAM of *The Adoration of the Shepherds* is extensive and for the most part traditional. The adoration of the Child by Mary, Joseph, and the angels is basically Brigantine in type, the Infant's nakedness emphasizing his poverty and humility. Like his Netherlandish predecessors Hugo van der Goes in the *Portinari Altarpiece* (Uffizi, Florence), and Petrus Christus in the National Gallery's *Nativity* (q.v.), Isenbrant stresses the association with the Incarnation and the Eucharist. The bundle of wheat in the foreground refers to both Bethlehem and the "living bread" of the Eucharist. The body of the Christ Child, lying on a white cloth and placed on top of a basket, becomes the *corpus verum*, the object of veneration in the sacrament of the first mass celebrated by Mary, Joseph, and the angels.[2] The basket is thus transformed into a small altar. Incorporated into this image is the theme of the Adoration of the Shepherds, the first manifestation of the deity in human form to man.[3] Two consecutive episodes from the Gospel of Luke are represented; in the distant landscape the Annunciation to the Shepherds takes place as they tend their flocks by night (Luke 2:8–14); this is followed by the arrival of the shepherds at the manger to worship the Christ Child (Luke 2:15–20) shown in the foreground. The shepherds are often depicted as musicians; in Isenbrant's painting the one at the left plays a bladder pipe.[4]

The architecture also functions symbolically. The classical temple is a ruin beginning to be overrun by vegetation; its decay is emblematic of the decline of pagan religion after the birth of Christ. At the upper right is a triangular timbered roof, a seeming incongruity among the masonry; it refers to the stable or manger mentioned in the Gospel of Luke. This use of antique architecture, found in quattrocento Italian painting, as for example in Botticelli's *Adoration of the*

Fig. 1. Infrared reflectogram assembly of a detail of *The Adoration of the Shepherds*, 1978.46.1 [infrared reflectography: Molly Faries]

Magi in the National Gallery,[5] indicates Isenbrant's awareness of Renaissance architectural symbolism.

Other motifs are more typically Northern. At the upper left is a statue of Moses with the tablets of the law, an allusion to the transition from Old to New Testament and the new era that begins with the Nativity. The owl perched on a log at the upper right is subject to various interpretations, most of them negative; here it is most likely a symbol of evil and darkness, and the Jews in particular.[6] The meaning of the *N?I* symbol incorporated into the ornament is not clear; possibly it refers to *Nativitas Iesu*.[7]

An interesting and rather unusual motif is found in the landscape: on a hill not far from the shepherds and their flocks a group of robed and hooded figures dance around a large bonfire. This motif seems to be confined to Netherlandish Adorations and Nativities of the late fifteenth and early sixteenth centuries and seems to have a folkloric rather than textual basis. Although its precise meaning is unclear, both Ewing and Beatson, working independently, have associated the shepherds dancing around a fire with the winter solstice. The "dying" and subsequent "birth" of the sun were associated with the birth of the Messiah, who is often equated with the sun.[8]

By virtue of its superior style, composition, and execution, *The Adoration of the Shepherds* stands above the hundreds of paintings attributed to Isenbrant. The picture was not known to Friedländer when he first wrote on Isenbrant, but was listed in the supplement to *Die altniederländische Malerei*, published in 1937.[9] Isenbrant's works have not been studied in a thorough and systematic manner, though recently Jean Wilson has examined the workshop practices of Gerard David, Isenbrant, and Ambrosius Benson.[10]

One of the hallmarks of Isenbrant's style is its dependence on the works of Gerard David. The most immediate precedent for *The Adoration of the Shepherds* is found in the center panel of David's *Nativity* altarpiece in the Metropolitan Museum, New York (fig. 2).[11] Not only was the typical Davidian type of Virgin with an oval, solid head and small chin taken over, but even the pattern of folds in the kerchief is very similar. The figures of Mary, Joseph, and the Child are arranged in a similar but not identical manner and both pictures prominently display a sheaf of wheat in the foreground. Whereas David placed the Child in a crib filled with straw, Isenbrant, perhaps to emphasize further Christ's poverty, placed him atop a woven straw basket of the kind often used by David.

Several other influences are operating here as well. The elaborate ornament of acanthus leaves, simulated metalwork, putti, birds, monkeys, and a caryatid in armor demonstrates the absorption in the North of classically inspired Italianate decoration. A similar love of ornament is found in the paintings of Isenbrant's compatriot in Bruges, Lancelot Blondeel,[12] but it is also possible that Isenbrant was familiar with the decorative extravagance of the Antwerp mannerists or the kind of Italianate metalwork used by Jan Gossaert.[13] The compositionally assertive but spatially ambiguous architecture is similar to the structures found in the Adorations produced by the Antwerp mannerists from the 1520s onward.[14]

It is all but impossible to establish a viable chronology for Isenbrant's paintings. The assimilation of mannerist elements from Bruges and Antwerp in *The Adoration of the Shepherds* suggests that the earliest likely date is in the 1520s. The picture thus may be roughly contemporary with the 1518 triptych of the *Adoration* formerly in Lübeck[15] and the *Seven Sorrows of the Virgin* diptych in Bruges and Brussels,[16] which can be dated between 1518 and 1528. Stylistically, there is nothing to rule out a date in the 1530s or 1540s.

Although an exact replica of *The Adoration of the Shepherds* is not known, the general design was used by Isenbrant in several other Nativities, notably the

Fig. 2. Gerard David, *The Nativity*, center panel, New York, The Metropolitan Museum of Art, The Jules Bache Collection, 1949 (49.7.20a) [photo: The Metropolitan Museum of Art. All rights reserved]

small triptych in the Metropolitan Museum[17] and single panels in the Mayer van den Bergh Museum, Antwerp, and the Öffentliche Kunstsammlungen, Basel.[18] None of these is as large or as complex as the National Gallery's painting.

<div style="text-align: right">J.O.H.</div>

Notes

1. I am indebted to Walter M. Feilchenfeldt and Mrs. Rudolf Heinemann for information on the provenance.

2. See Ursula Nilgren, "The Epiphany and the Eucharist: On the Interpretation of Eucharistic Motifs in the Medieval Epiphany Scenes," *AB* 49 (1967), 311–316; Joel Upton, "Devotional Imagery and Style in the Washington *Nativity* by Petrus Christus," *StHist* 7 (1975), 49–79, esp. 66–68; Panofsky, *ENP*, 1953, 333–334.

3. See Réau, *Iconographie*, vol. 2, part 2, 231–236; Gertrud Schiller, *Iconography of Christian Art*, 2 vols. (Greenwich, Conn., 1971), 1: 84–88.

4. I am indebted to Helen Hollis, Division of Musical Instruments, National Museum of American History, Smithsonian Institution, for identifying this instrument. The bladder pipe is a wind instrument in which a reed or pipe is enclosed by a bladder; the bladder serves as a wind reservoir. See Stanley Sadie, ed., *The New Grove Dictionary of Music and Musicians*, 20 vols. (London, 1980), 2: 770–771. Isenbrant used a bladder pipe in the Nativities in Antwerp and Basel; see n. 18 below.

5. 1937.1.22; Shapley 1979, 81–83, pl. 53. In Botticelli's painting the triangular wooden roof is similar to the roof of an early Christian basilica and is perhaps a further allusion to Christianity supplanting paganism. It is less easy to say whether Isenbrant intended this meaning as well. On architectural symbolism, see Rab Hatfield, *Botticelli's Uffizi "Adoration"* (Princeton, 1976), 56–57.

6. See Heinrich Schwarz and Volker Plagemann, s.v. "Eule," *Reallexikon zur deutschen Kunstgeschichte*, 7 vols. (Stuttgart and Munich, 1937–1981), 6: cols. 267–322, esp. cols. 272–278, 284–292. An owl also appears in 1961.9.23, *The Nativity* by Juan de Flandes (q.v.). The bird's penchant for inhabiting ruins, mentioned in the Bible (Psalm 102:6; Isaiah 34:11), is particularly appropriate to the decaying temples painted by Juan de Flandes and Isenbrant.

7. A possible analogy is to be found in the Portinari Altarpiece by Hugo van der Goes, in which the letters *P. N. S. C.* and *M. V.* carved into the tympanum of the portal of the palace of David have been interpreted by Panofsky as standing for *Puer Nascetur Salvator Christus* and *Maria Virgo*, respectively. See Panofsky, *ENP*, 1953, 334.

8. Réau, *Iconographie*, vol. 2, part 2, 214, in discussing the date of 25 December, points out that this is also the feast date of the solar god Mithra, and of the Roman Saturnalia. In patristic literature Christ is called the "true sun" by Saint Cyprian and the "new sun" by Saint Ambrose. The comparison of the Messiah to the sun and the proximity of Christmas to the winter solstice are noted by Réau. Ewing 1978, 78, discusses the motif of shepherds dancing around a bonfire in connection with Jan de Beer's *Nativity* in the Wallraf-Richartz-Museum, Cologne, and sees de Beer as the source for both 1978.46.1 and the roundel at the upper left of Patinir's *Assumption of the Virgin* (John G. Johnson Collection, Philadelphia Museum of Art). To the examples he lists on page 92,

n. 11, I would add the appearance of this motif on the inner right wing of the Nativity attributed to the Master of Amiens on the art market, London (see n. 23 under Gossaert's *Saint Jerome Penitent*, 1952.5.40.a–b). Dan Ewing, letter of 3 October 1981 in the curatorial files, sees the dancing shepherds as part of a larger tradition that is separate from the motif of the bonfire. Elizabeth Beatson has investigated the motif of figures dancing around a fire in fourteenth- and fifteenth-century manuscripts. She stresses the connection between the Roman feast of *sol invictus* and Christ as *sol iustitiae*. I am indebted to Mr. Ewing and Mrs. Beatson (in conversation, 16 May 1981) for sharing their research with me.

9. Friedländer, vol. 14 (1937), 125; vol. 11 (1974), 102, Supp. 309.

10. Wilson, 1983. Wilson has been able to establish several stylistic groupings among the numerous works attributed to Isenbrant. The Gallery's painting is discussed as a characteristic example of "Style I", the work of a single hand, which includes such works as *The Nativity* (Öffentliche Kunstsammlung, Basel) and the *Mass of Saint Gregory* (Prado, Madrid). The ten paintings that constitute Style I are listed in her Appendix I, 191–192.

11. Friedländer, vol. 6, part 2 (1971), no. 160, pl. 164.

12. For example, Blondeel's altarpiece of the *Legend of Saints Cosmos and Damian* of 1523 (Church of Saint James, Bruges), Friedländer, vol. 11 (1974), no. 298, pls. 185–187; *Saint Luke Painting the Virgin*, 1545, (Groeningemuseum, Bruges), Friedländer, vol. 11 (1974), no. 299, pl. 188.

13. For reproductions of Antwerp mannerist paintings see Friedländer, vol. 11 (1974), esp. pls. 2, 5, 9, 37, 38, 68, 88. For Gossaert, see Friedländer, vol. 8 (1972), esp. pls. 5, 17, 27, 28, 35.

14. The Adoration of the Magi was one of the most popular subjects for artists in Antwerp in the early sixteenth century, perhaps because it permitted a show of exotic types and lavish costumes. In some instances, particularly in the Adorations of the Pseudo-Bles, the temple assumes grandiose proportions and dwarfs the figures. See Friedländer, vol. 11 (1974), pls. 1, 2.

15. Friedländer, vol. 11 (1974), no. 125, pl. 103. Jean Wilson, in conversation of June 1982, expressed doubts about the attribution to Isenbrant and suggested that the altarpiece might be by a member of the Benson family.

16. Friedländer, vol. 11 (1974), no. 138, pls. 115–117. Janssens de Bisthoven 1968 (see Biography), 175–185, dates the panels to 1518 on the basis of the emblem of the Confraternity of the Holy Blood worn by the donor. However, Joris van de Velde did not die until 1528 and the diptych could have been produced between 1518 and 1528. Hulin de Loo 1902 (see Biography), 64, believed the panels were commissioned by Van de Velde's widow and dated between 1528 and her death in 1535. This view was challenged by Friedländer, vol. 11 (1974), 49.

17. Friedländer, vol. 11 (1974), no. 124, pls. 101, 102.

18. Friedländer, vol. 11 (1974), nos. 147, 148, pl. 123.

References

1937 Friedländer. Vol. 14: 125 (vol. 11, 1974: 102, Supp. 309, pl. 202).

1978 Ewing, Dan. "The Paintings and Drawings of Jan de Beer." 2 vols. Ph.D. diss., University of Michigan, 1: 78, 160; 2: fig. 94.

1983 Wilson (see Biography): 20–28, 191–192, pl. 17.

Juan de Flandes

active 1496–1519

Juan de Flandes' career is fairly well documented in the records of his Spanish patrons, yet little is known about his background and artistic training. He is first mentioned in 1496 in the accounts of Isabel the Catholic, Queen of Castile. In 1498 he is described as court painter, and the accounts indicate that he remained in her service until her death in 1504. He was in Salamanca in 1505, since he contracted to paint an altarpiece for the chapel of the University of Salamanca, a project that apparently occupied him for more than two years. By 1509 he had settled in Palencia, where he was commissioned by the bishop, Juan Rodriguez de Fonseca, to paint eleven scenes from the life of Christ to enlarge an existing sculpted retable in the cathedral of Palencia. The date of the completion of these panels is not clear. Juan de Flandes' wife is mentioned as a widow on 13 December 1519.

The paintings still in place on the high altar of Palencia cathedral and a predella fragment with Saints Apollonia and Mary Magdalene preserved at the University of Salamanca are the basis for the attribution of several other works to the painter. These include the scenes from the life of Christ formerly decorating the retable of the main chapel of San Lázaro, Palencia, now divided between the Prado and the National Gallery (1961.9.22–25), and the bulk of the small panels for the oratory made for Isabel the Catholic and presumably left incomplete at her death (including the *Temptation of Christ*, 1967.7.1; see also Michel Sittow, *The Assumption of the Virgin*, 1965.1.1). Parts of a dismembered altarpiece devoted to the life of John the Baptist (Museum Mayer van den Bergh, Antwerp, the Cleveland Museum of Art, the Musée d'Histoire et d'Art, Geneva, and a private collection, Madrid) have been attributed to him on the basis of style. One of these panels has been shown to come from the royal charterhouse of Miraflores near Burgos, which strongly suggests that the painter is identical with the enigmatic Juan Flamenco, recorded as having painted an altarpiece of the Baptism with five panels in Miraflores from 1496–1499. An *Adoration of the Magi* in Cervera de Pisuerga, incorporating a portrait of King Ferdinand of Aragon, presumably dates from the time immediately after Juan de Flandes' arrival in Spain.

While the names Juan de Flandes and Juan Flamenco point to the painter's Flemish origins, his family name is unknown and his activity before arriving in Spain untraced. If the inscriptions *Juan Astrat* on the backs of two of the small panels made for Queen Isabel refer to him, they could be a hispanicized version of a name like Jan van der Straat. Juan may have studied in Ghent, as the Cervera de Pisuerga *Adoration* and the Saint John panels in particular show clear connections to the Ghent painters Joos van Ghent, Hugo van der Goes, and the illuminators in the circle of the Master of Mary of Burgundy, particularly the Master of the First Prayerbook of Maximilian. Like these painters, he frequently enlivened his backgrounds with delicate narrative vignettes. While his feeling for space and light is sophisticated, a tendency to divide space into a succession of thin planes becomes a mannerism in his late works. His paintings demonstrate an extremely refined sense of color, with a preference for rather acid hues.

Questions of attribution and workshop production in the paintings given to Juan remain unresolved. The theory that he worked in collaboration with several painters should be weighed against the probability that his style changed quite radically after his arrival in Spain. Because he worked on a project over a period of years, a single commission such as the oratory for Isabel the Catholic or the Saint John altarpiece may demonstrate a marked stylistic evolution. In any case, he clearly adapted his style in response to the stimulus of southern art and the landscape and light of Spain as well as to the demands of the large multi-compartmented Spanish retable.

M.W.

Bibliography
Justi, Carl. "Juan de Flandes. Ein niederländischer Hofmaler Isabella der Katholischen." *JbBerlin* 8 (1887): 157–169.
Bermejo, Elisa. *Juan de Flandes*. Madrid, 1962.

Folie, Jacqueline. "Les oeuvres authentifiées des primitifs flamands." *BInstPat* 6 (1963): 241–244.

Vandevivere, Ignace. *Primitifs flamands. Corpus. La cathédrale de Palencia et l'église paroissiale de Cervera de Pisuerga.* Brussels, 1967.

De Coo, Josef, and Nicole Reynaud. "Origen del retablo de San Juan Bautista atribuido a Juan de Flandes." *AEA* 52 (1979): 125–144.

FOUR PANELS FROM THE SAN LÁZARO ALTARPIECE

1961.9.22 (1382)

The Annunciation

c. 1508–1519
Wood (cradled), 110.2 x 81 (43⅜ x 31⅞)
 painted surface: 110.2 x 78.4 (43⅜ x 30⅞)
Samuel H. Kress Collection

Technical Notes: The softwood panel was cradled in 1953 when the painting was being treated by Mario Modestini. A thick layer of hemp in a glue sizing and three horizontal battens on the back were presumably removed at that time. These elements are visible in x-radiographs of 1961.9.22 and 1961.9.23 made before cradling and are still present on the Prado panels from the same altarpiece.[1] The painting was also cleaned and restored in 1953/1954. This painting and 1961.9.23 had previously been cleaned by William Suhr in 1952.[2] The *Annunciation* may have been trimmed very slightly on the sides, but without removing the unpainted edges here. The panel has also been cut at top and bottom within the painted image and .5 cm wide strips added to these edges.[3] The panel is made up of vertically joined boards; however, the joins cannot be readily discerned, in part because of the edging strips at top and bottom. The ground layer includes fibrous strands, probably also hemp. Very little underdrawing could be made visible when this painting was examined with infrared reflectography. Apart from small localized losses, the painting is in excellent condition.

Provenance: Altarpiece of the *capilla mayor*, church of San Lázaro, Palencia, commissioned c. 1508, until c. 1945.[4] Arcadio Torres Martín, Palencia, 1950–1951.[5] (Frederick Mont, New York, 1952.) Samuel H. Kress, New York, 1953.

Notes
1. The nail holes that secured the battens are also visible in the x-radiographs of 1961.9.24 and 1961.9.25, though the battens themselves had already been removed from these panels. X-radiographs of all four panels in the Gallery and of the Prado panels also show an irregular row of holes above the center of the panels that have been filled with a dense substance. Their function is unclear. However, since the actual holes are not visible on the back of the Prado panels, they must lie below the isolating fibrous layer. In a forthcoming article in the *Boletín del Museo del Prado*, María del Carmen Garrido and Martha Wolff discuss the structure and technique of the eight panels in greater detail.
2. Eisler 1977, 186–187.
3. The original unpainted edges have been removed at top and bottom. Although it is difficult to determine how much, if any, of the design has been cut away, the difference of approximately 14 cm in the height of the painted image between the *Adoration of the Magi* and the *Baptism* (1961.9.24 and 1961.9.25), which retain their unpainted edges, and the six panels removed from San Lázaro relatively recently suggests that the six were rather substantially cut down; see under 1961.9.25, *The Baptism of Christ.*
4. See Brans 1953, 32, for the state of San Lázaro and the cessation of services there shortly after September 1945.
5. In 1950 and 1951, Egbert Haverkamp-Begemann saw six panels from the San Lázaro altarpiece—*The Annunciation* and *The Nativity* and the four panels now in the Prado—in the house of Sr. Torres Martín in Palencia; conversations of 3 February 1984 and 24 July 1984. I am most grateful to him for information concerning the provenance of the San Lázaro panels.

1961.9.23 (1383)

The Nativity

c. 1508–1519
Wood (cradled), 111.8 x 80.6 (44 x 31¾)
 painted surface: 110.5 x 79.3 (43½ x 31¼)
Samuel H. Kress Collection

Inscriptions:
On angel's banderole: *GLOR / ... INECELSIS DEO ED ... / ...*

Technical Notes: The panel is made up of four vertical members. The unpainted edges have been trimmed slightly at the sides and have been cut off at top and bottom where edging strips about .5 cm wide have been added. The painting was cleaned in 1952. In 1953/1954, the panel was cradled and the painting cleaned and restored in the same manner as 1961.9.22. The ground is prepared with the same fibrous material used in the *Annunciation.* Infrared reflectography reveals a brush underdrawing employing evenly spaced hatching strokes in several areas, including the body of the Christ Child, the hands of the Virgin, and the ox and ass. There are some changes in the painted contours of the Christ Child and the Virgin's hair. A split along one of the joins running upward through the Christ Child's ear and the manger has been filled and inpainted. Apart from this split, some small, localized losses, and some abrasion in the lower left portion of the Virgin's mantle, the painting is in excellent condition.

Provenance: Same as the *Annunciation,* 1961.9.22.

1961.9.24 (1384)

The Adoration of the Magi

c. 1508–1519
Wood (cradled), 126 x 82 (49 5/8 x 32 1/4)
 painted surface: 124.7 x 79 (49 1/8 x 31 1/8)
Samuel H. Kress Collection

Technical Notes: The panel was cradled and the painting cleaned and restored in 1953/1954 in the same manner as the *Annunciation*, 1961.9.22. Although the edges of the panel were probably planed slightly to neaten them, the panel retains its unpainted margins. The lower margin has been trimmed somewhat, however. The panel has four vertical members and was originally prepared in the same way as 1961.9.22. However, x-radiographs of this painting and *The Baptism of Christ* made before they were cradled show that the horizontal battens had already been removed, though the nail holes are still visible. A broad brush underdrawing is visible with infrared reflectography, particularly in the face of the Virgin, the body of the Christ Child, and the face of the kneeling magus. A point and radiating circles incised into the ground indicate that the aureole around the star was made with a compass. The painting is in good condition. There are numerous small local losses throughout, as well as a larger loss through the nose of the Christ Child and more general abrasion along the top and bottom edges.

Provenance: Altarpiece of the *capilla mayor*, church of San Lázaro, Palencia, commissioned c. 1508, until at least 1761. (Frederick Mont, New York, 1952.)[1] Samuel H. Kress, New York, 1953.

Notes
 1. In 1952 all four panels now in the Gallery were with Frederick Mont in New York; see letter of 28 October 1952 from Chandler R. Post to Mont in curatorial files.

1961.9.25 (1385)

The Baptism of Christ

c. 1508–1519
Wood (cradled), 125.3 x 81.1 (49 3/8 x 31 7/8)
 painted surface: 124.2 x 79 (48 7/8 x 31 1/16)
Samuel H. Kress Collection

Technical Notes: The panel was cradled and the painting cleaned and restored in 1953/1954. Like 1961.9.24, *The Adoration of the Magi*, this panel retains its unpainted margin on all sides, though the edges have been planed down to give a neat appearance, and the bottom edge is not as wide as those on the other three sides. The preparation of the panel itself, which is made up of four vertical members, is the same as the other panels from the San Lázaro altarpiece. The fully worked out underdrawing in this scene is easiest to detect in the figure of Christ where wide, evenly spaced hatching strokes were made visible with infrared reflectography. The concentric rings around the dove of the Holy Ghost were incised into the ground with a compass. A number of artist's changes have become visible with time: the height of the tower to the right of Christ's head was lowered and the angle and position of Saint John's right hand were changed. The painting is in good condition. Losses along the joins in the boards, particularly at the left, small localized areas of loss throughout, and some larger losses in the drapery hanging down the Baptist's back have been filled and inpainted. The inpainting is now somewhat discolored.

Provenance: Same as *The Adoration of the Magi*, 1961.9.24.

THESE FOUR PANELS and four more preserved in the Prado, *The Raising of Lazarus*, *The Agony in the Garden*, *The Ascension*, and *Pentecost* (figs. 1, 2, 3, 4), are the remains of the high altar from the main chapel of San Lázaro, Palencia. In December of 1508, the bishop and chapter of the cathedral of Palencia granted Don Sancho de Castilla the patronage of this chapel, to be built at the east end of the parish church of San Lázaro.[1] All of the surviving panels except two, *The Adoration of the Magi* and the *Baptism*, were still decorating the high altar of San Lázaro as recently as 1945, although in a confused arrangement flanking a copy of a Holy Family by Andrea del Sarto and in a frame possibly dating from the eighteenth century.[2] That the eight paintings are fragments from the retable of Don Sancho de Castilla's chapel is virtually confirmed by an act of the chapter of Palencia cathedral dated 1761 and discovered by Vandevivere. It makes note of the deteriorated state of "el Retablo de la Capilla mayor sita en Parroquial de San Lázaro, et que es de Patronato de Don Sancho" and makes provision for a new tabernacle for the altarpiece ("un Tabernaculo muy decente").[3]

The name of the painter Juan de Flandes is apparently not mentioned in documents concerning the chapel's endowment. However, there can be no doubt that he was the author of the paintings because of their close connection in composition, style, and scale to the documented panels of the high altar of Palencia cathedral (fig. 5). The contract between bishop Juan Rodriguez Fonseca and Juan de Flandes for the paintings of the cathedral retable is dated 19 December 1509, but payments for them and alterations in the structure of the retable continued through the 1510s, even after the death of Juan de Flandes in 1519.[4] Since the 1508

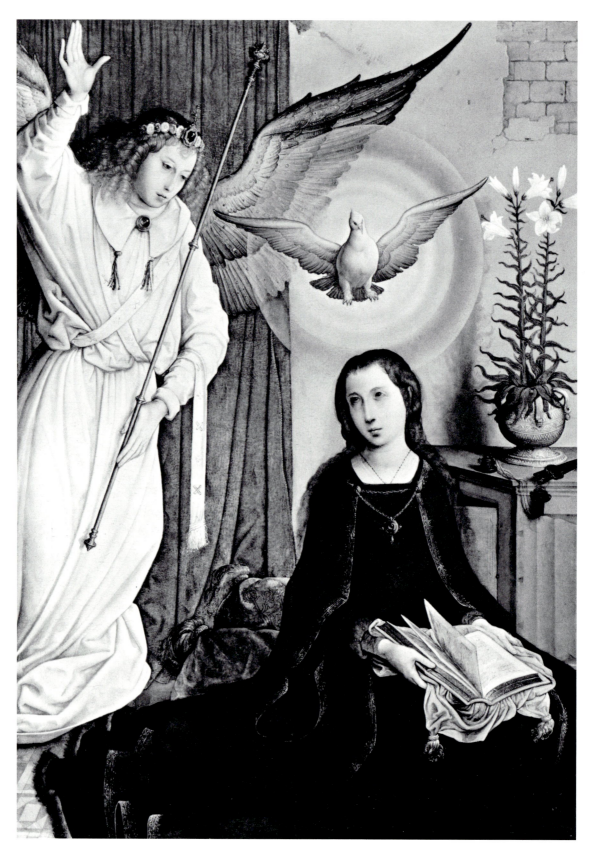

Juan de Flandes, *The Annunciation*, 1961.9.22

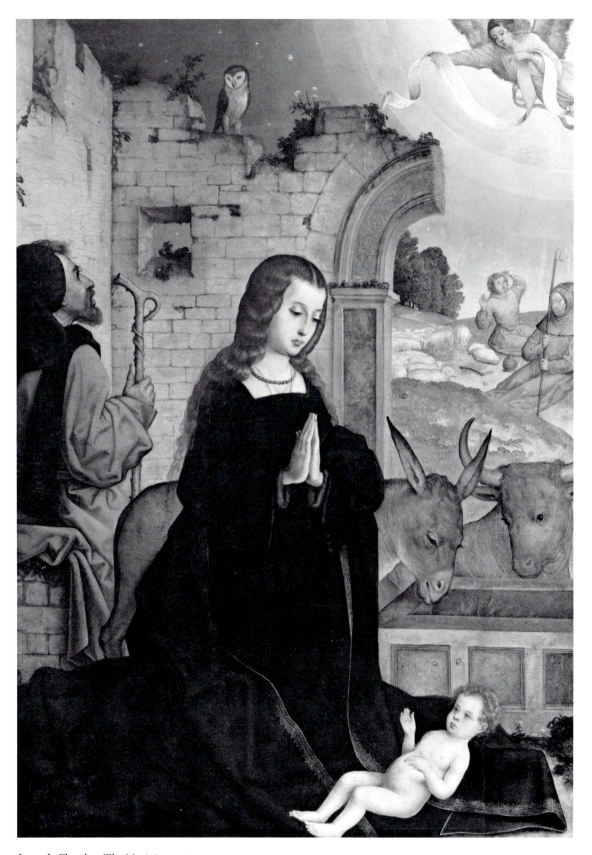

Juan de Flandes, *The Nativity*, 1961.9.23

Juan de Flandes, *The Adoration of the Magi*, 1961.9.24

Juan de Flandes, *The Baptism of Christ*, 1961.9.25

Fig. 1. Juan de Flandes, *The Raising of Lazarus*, Madrid, Prado [photo: Prado]

Fig. 2. Juan de Flandes, *The Agony in the Garden*, Madrid, Prado [photo: Prado]

document granting Don Sancho de Castilla the *capilla mayor* of San Lázaro probably coincides with only the initial stages of planning for the chapel's decoration, it is not clear whether the bishop or Don Sancho brought the painter to Palencia.[5] In any case, Don Sancho de Castilla would have known the painter's work at the court of the Catholic kings, since he had served as *ayo* (governor) to their son, Prince Juan of Asturias.[6] The two Palencia altarpieces must have been planned, and were probably executed, concurrently.[7]

The San Lázaro cycle probably included other painted or sculpted scenes in addition to the eight in the Gallery and the Prado, since it is unlikely that *The Agony in the Garden* was the only Passion subject. A *Visitation* with a clerical donor in the Prado, formerly in the sacristy of San Lázaro, has frequently been considered part of Don Sancho's retable, but its considerably smaller scale and workshop character make this improbable.[8]

The panels would originally have been mounted in an elaborate wooden structure filling the space above the altar, as does the retable still in place in Palencia cathedral. In keeping with the customary practice for such retables—and contrary to the usual fifteenth-century Flemish usage—the panels would not have been painted in their frames. Rather, the whole surface of the panel was prepared with a white ground and the area that would be visible through the framing elements was then painted.[9] *The Adoration of the Magi* and the *Baptism* still retain portions of their unpainted edges on all sides.[10] These two panels, which were not part of the ensemble as adapted to frame the copy after del Sarto, are approximately 14 centimeters taller than the other six. These six were most likely cut down when they were reframed, perhaps to accommodate the Holy Family, or because of damage at top and bottom. Thus the whole group probably originally had a more pronounced vertical effect.

In this mature adaptation to the Spanish retable form, Juan de Flandes limits each narrative episode to a few figures that are readily legible within a large ensemble, while still referring to his own earlier treatments of the same subjects and to his roots in Flemish panel painting and illumination. The interior space of the *Annunciation* is restricted by the curtain and wall, which isolate the figures and push them forward. Yet

Fig. 3. Juan de Flandes, *The Ascension*, Madrid, Prado [photo: Prado]

Fig. 4. Juan de Flandes, *Pentacost*, Madrid, Prado [photo: Prado]

the compositional type, with the Virgin sitting humbly on the ground and the angel swooping in with one arm raised in urgent proclamation, occurs frequently in the circle of the Master of Mary of Burgundy.[11] In the *Nativity* and the *Adoration*, screenlike architectural members also push the large figures forward, yet the pale, delicately painted vignettes of the shepherds and the retinue of the kings recall similar subordinate figures in Ghent painting.[12] The *Baptism* is related to the central panel from Juan de Flandes' earlier Saint John altarpiece from the royal charterhouse of Miraflores.[13] However, the textures and recession of the landscape are simplified, and the figures are closer to the front plane and more brittle. *The Raising of Lazarus* and *Pentecost* in the Prado show a similar adaptation of corresponding compositions from the small panels from Isabel the Catholic's oratory.[14]

Despite the more compressed space of the San Láza-ro panels, Juan de Flandes displays in them his characteristic subtlety and transparency of color. His highly individual fusion of Flemish tradition with the requirements of the Spanish retable is especially evident in the device of the aureoles repeated in five of the scenes.

Their geometric form emphasizes the surface of the panels, while their vibrant colors intensify the luminous effect of the whole. In contrast, the figures in the Palencia cathedral retable are more firmly modeled, even to the point of caricature, and the surrounding space is more fully worked up. Since the two ensembles were almost certainly planned concurrently, this difference may reflect the distinct conditions of the two commissions[15] or the subtle evolution that Juan's repertory of stock ingredients continued to undergo.

M.W.

Notes

1. This document (Palencia, archives of the cathedral, armario X, legajo 1, no. 5) is published in part by Vande-vivere 1967, 45. For Don Sancho de Castilla's endowment of the chapel, see also Esteban Ortega Gato, "Blasones y Ma-yorazgos de Palencia," *Publicaciones de la Institución "Tello Téllez de Meneses"* no. 3 (1950), 57–58.

2. According to Justi 1887, 167, who first published these paintings, the six flanked a copy of a Holy Family by Andrea del Sarto so that on either side there were three paintings, one above the other in the following order: *Ascension, Agony in the Garden,* and *Pentecost* on the left and *Nativity, Annunciation,* and *Raising of Lazarus* on the right. Justi called the

Fig. 5. Palencia, Cathedral, *High Altar* [photo: Archivo Mas, Barcelona]

framing structure modern, but Post 1933, 45, described it as seventeenth- or eighteenth-century.

3. Palencia, acts of the cathedral chapter, in volume for 1760–1762, f. 75–75v. of the year 1761; Vandevivere 1967, 45.

4. Vandevivere 1967, 30–40, 66–67.

5. Ortega Gato 1950, 57, notes that Juan and Bartolomé de Solórzano were involved in the construction of Don Sancho's chapel and that the latter was one of the architects of the cathedral.

6. Ortega Gato 1950, 55–56.

7. Eisler 1977, 186 suggested that two panels from the San Lázaro retable depended upon Dürer's Small Woodcut Passion, issued in book form in 1511. However, of the two subjects he cites, the connection between the two Ascensions (fig. 4 and Bartsch 50) is so general that Dürer need not be presumed as a model. The *Deposition* cited by Eisler as forming part of the San Lázaro retable must be the one in a private collection in Madrid, apparently intended for the cathedral retable from the evidence of the panel's structure; Vandevivere 1967, 59–61, pl. 173. In any case, while the cloth supporting Christ's limp body may derive from Dürer's woodcut (Bartsch 42), the disposition of the figures is wholly in Juan de Flandes' own idiom.

8. 52 x 36 cm, acquired in 1928; Eisler 1977, text fig. 39. Gudiol 1957, 113, fig. 2, published an *Annunciation* now at

Bob Jones University, Greenville, South Carolina, which he felt was a companion piece to the Prado *Visitation*, both being the remains of a separate altarpiece from San Lázaro.

9. Compare Eisler 1959, 131–132, and Vandevivere 1967, 2–4.

10. Although there are no documents specifically linking the *Adoration of the Magi* and the *Baptism* to the San Lázaro altarpiece, the evidence of style and, above all, the structure of the panels make this a virtual certainty. The four vertically aligned boards, the type of isolating fibrous layer, the arrangement of the battens affixed by large nails, and the row of holes above the center of the panel as visible in the x-radiographs of all eight panels of the group confirm this. Compare the slightly different structure of the panels from the cathedral retable; Vandevivere 1967, 2–5, pls. 88, 152, 168, 169. Bolts rather than nails were used to attach the battens to the cathedral panels.

11. In the Hours of Engelbert of Nassau, Oxford, Bodleian Library, Douce 219, by the Master of Mary of Burgundy, Otto Pächt, *The Master of Mary of Burgundy* (London, 1948), pl. B, and in the *Curial Breviary* attributed to the Master of the First Prayerbook of Maximilian, Glasgow University, Hunterian Library, ms. S.2.15, Patrick de Winter, "A Book of Hours of Queen Isabel la Católica," *BCMA* 67 (1981), fig. 71. As Eisler pointed out, 1977, 187, the scissors case on the cupboard behind the Virgin probably refers to her days spent spinning or weaving and praying in the Temple at the time of the Annunciation.

12. For example, in the background of paintings by Hugo van der Goes; Friedrich Winkler, *Das Werk des Hugo van der Goes* (Berlin, 1964), figs. 1, 13, 18, 151. The background vignettes are both more complex and more evanescently painted in Juan's earlier *Adoration* at Cervera de Pisuerga; Vandevivere 1967, pls. 190a, 195. The owl, a symbol of evil, seems to sound a warning note in the *Nativity*; compare the owl in the *Entombment* from the Palencia cathedral retable, Vandevivere 1967, pl. 51. For owl symbolism see Jakob Rosenberg, "On the Meaning of a Bosch Drawing" in *De Artibus Opuscula XL: Essays in Honor of Erwin Panofsky*, ed. Millard Meiss (New York, 1961), 422–426.

13. De Coo and Reynaud 1979, 125–144, fig. 5.

14. Figs. 2, 5, and Bermejo 1962, pls. 5, 18.

15. That the panels in Palencia cathedral were commissioned as enlargements to a sculpted retable may have influenced Juan de Flandes' formal choices.

References

1887 Justi, Carl. "Juan de Flandes, ein niederländischer Hofmaler Isabella der Katholischen." *JbBerlin* 8: 167.

1908 Justi, Carl. *Miscellaneen aus drei Jahrhunderten spanischen Kunstlebens*. 2 vols. Berlin, 1: 324.

1909 Mayer, August L. "Studien zur Quattrocento-malerei in Nordwestkastilien." *RfK* 32: 519.

1913 Mayer, August L. *Geschichte der spanischen Malerei*. 2 vols. Leipzig, 1: 149.

1917 Moreno Villa, José. "Un pintor de la reina católica." *Boletín de la Sociedad Española de Excursiones* 25: 281.

1926 Winkler, [Friedrich]. "Juan de Flandes." In Thieme-Becker 19: 279.

1932 H[ulin] de L[oo], [Georges]. *Trésor de l'art flamand du moyen âge au XVIIIᵉ siècle. Mémorial de l'exposition d'art flamand ancien à Anvers. 1930*. 2 vols. Paris, 1: 51.

1933 Post, Chandler Rathfon. *A History of Spanish Painting.* 14 vols. Cambridge, Mass., 4, part 1: 45, 50.

1950 Revilla Vielva, Ramón. "Retablo Mayor de la Santa Iglesia Catedral de Palencia." *Publicaciones de la Institución "Tello Téllez de Meneses"* no. 5: 98.

1952 Brans, Jan V. L. *Isabel la Católica y el arte Hispano-Flamenco.* Madrid: 96–98, pl. 43.

1952 Museo del Prado. *Catálogo.* Madrid (and later editions): 204.

1953 Brans, Jan V. L. "Juan de Flandes, pintor de la Reina y de Castilla." *Clavileño* 4, no. 21: 29, 32.

1954 Sánchez Cantón, Francisco Javier. "Las adquisiciones del Museo del Prado en los años 1952 y 1953." *AEA* 27: 5.

1955 Gudiol Ricart, José. *Pintura Gótica.* In *Ars Hispaniae.* 22 vols. Madrid, 9: 259–260.

1956 Kress: 13, 108, 110, repro. 109, 111, 112, 113.

1957 Gudiol, José. "Oeuvres inédites de Jean de Flandres." *Miscellanea Prof. Dr. D. Roggen.* Antwerp: 116, 118.

1958 Post, Chandler Rathfon. *A History of Spanish Painting.* 14 vols. Cambridge, Mass., 12, part 2: 615, 618, 620, 622–625, figs. 262, 263.

1958 Gaya Nuño, Juan Antonio. *La pintura española fuera de España (historia y catálogo).* Madrid: 148, nos. 761, 762.

1959 Sánchez Cantón, Francisco Javier. *The Prado.* New York: 138.

1959 Kress: 264–267, repro.

1959 Brans, Jan V. L. *Vlaamse schilders in dienst der Koningen van Spanje.* Louvain: 55.

1959 Eisler, Colin. "Juan de Flandes's Saint Michael and Saint Francis." *BMMA* n.s. 18: 130.

1962 Puyvelde, Leo van. *La peinture flamande au siècle de Bosch et Breughel.* Paris: 353.

1962 Bermejo, Elisa. *Juan de Flandes.* Madrid: 28–31, 44, pls. 36–39.

1963 *Sammlung Heinz Kisters. Altdeutsche und altniederländische Gemälde.* Exh. cat. Germanisches Nationalmuseum. Nuremberg: 14–15, under no. 76.

1964 Anzelewsky, Fedja. "Der Meister der Lübecker Bibel von 1494." *ZfK* 27: 57.

1965 Held, Julius S. "*The Bearing of the Cross* Hitherto Attributed to Juan de Flandes." *AQ* 38: 31.

1967 Vandevivere, Ignace. *Primitifs flamands. Corpus. La cathédrale de Palencia et l'église paroissiale de Cervera de Pisuerga.* Brussels: 44–47.

1969 Osten, Gert von der, and Horst Vey. *Painting and Sculpture in Germany and the Netherlands 1500 to 1600.* Harmondsworth: 142.

1975 NGA: 182, 184, repro. 183, 185.

1976 Lurie, Ann Tzeutschler. "Birth and Naming of St. John the Baptist Attributed to Juan de Flandes: A Newly Discovered Panel from a Hypothetical Altarpiece." *BCMA* 63: 127, fig. 21.

1977 Eisler: 185–188, figs. 187–190.

1978 Rogers, Millard F., Jr. *Spanish Paintings in the Cincinnati Art Museum.* Cincinnati: 12.

1979 De Coo, Josef, and Nicole Reynaud. "Origen del retablo de San Juan Bautista atribuido a Juan de Flandes." *AEA* 52: 140–141, figs. 7, 9.

1967.7.1 (2331)

Temptation of Christ

c. 1500/1504
Wood, 21.3 x 16 (8³⁄₈ x 6⁵⁄₁₆)
 painted surface: 21 x 15.5 (8¹⁄₄ x 6¹⁄₈)
Ailsa Mellon Bruce Fund

Technical Notes: The panel is made of a single piece of wood. All four corners are slightly worn and chipped. There are nicks in the center of all four sides, probably resulting from the way the painting was mounted at some point. The painted surface is bordered by a gold band, which seems to be original. Beneath it is what appears to be a layer of pale gray bole.[1] No underdrawing is visible with infrared reflectography. Removal of labels formerly affixed to the back of the panel[2] revealed old inscriptions, one below the other, on the panel itself: *Luca di . . . d . . .* in black ink; *Gerardo van der [M]eir . . .* in blue crayon; and 2 in black ink.[3] The painting is in very good condition, with some loss in the corners and some minimal inpainting, particularly along the crackle in the sky.

Provenance: Queen Isabel of Castile, castle of Toro, Zamora province [d. 1504]. Diego Flores, by 13 March 1505, possibly as agent for Margaret of Austria.[4] Margaret of Austria, Regent of the Netherlands, Mechelen, inventories of 1516 and 1524 [d. 1530].[5] Emperor Charles V, her nephew [d. 1558] given by him to his wife Isabel of Portugal [d. 1539], along with several other panels from Isabel of Castile's retable made up into an altarpiece.[6] King Philip II of Spain, his son, Madrid, inventory 1598, no. 45 [d. 1598].[7] Oderisio de Sangro, Prince of Fondi, Naples (sale, Galerie Sangiorgi, Rome, 22 April–1 May, 1895, no. 738, with no. 738bis, *The Marriage at Cana,* as Bolognese school, bought in), until at least 1897.[8] (Stefano Bardini, Florence, in 1899.) Vernon J. Watney, Cornbury Park, Oxfordshire, from 1899 [d. 1928].[9] Oliver Vernon Watney, his son, Cornbury Park, Oxfordshire (sale, Christie's, London, 23 June 1967, no. 32, together with no. 33, *The Marriage at Cana*). (Thos. Agnew & Sons, Ltd., 1967.)

Exhibitions: London, Royal Academy of Arts, 1908, *Winter Exhibition,* no. 12, as Gerard David.

THE THREE TEMPTATIONS of Christ by the devil (Matthew 4:1–10; Luke 4:1–13) are set in an extensive landscape. In the foreground the devil, dressed in a brown robe, challenges Christ to turn stones into bread. From the top of the high mountain at the left he offers him the kingdoms of the world, and from the pinnacle of the Temple on the right he tempts Christ to throw himself down unharmed.[10] The Temptation of Christ occurs among the multiple scenes of fifteenth-century Spanish retables, though without a convincing

Fig. 1. Master of the Dresden Prayerbook, *Temptation of Christ*, detail, Breviary of Isabel the Catholic, Add. Ms. 18851, fol. 71, London, British Library [photo: Copyright British Library]

attempt at a unified landscape space.[11] The episode, though unusual in fifteenth-century Netherlandish panel painting and illumination, does appear in the Breviary of Isabel the Catholic in the British Library (fig. 1). In the miniature the gestures of Christ and the devil, the arrangement of the three scenes in a unified landscape, and the individual landscape elements closely resemble those in Juan de Flandes' panel. It is quite possible that Juan de Flandes drew on this and several other scenes in the Breviary, since the manuscript, illuminated in Bruges, was probably given to Isabel in 1497 by Francisco de Rojas to commemorate the double marriage of the queen's children to the children of the emperor Maximilian.[12]

The National Gallery's panel is one of forty-seven small panels of the same size that were listed among the possessions of Isabel the Catholic in the castle of Toro after her death in 1504. The list of subjects indicates that the series depicted the lives of Christ and the Virgin, with two panels devoted to apostles and archangels.[13] The individual panels were appraised and sold separately. Thirty-two of them were bought by Diego

Flores, treasurer of Margaret of Austria, early in 1505 and passed into her collection. By 1516 two of this group, *The Ascension* and *The Assumption*, had been made into a separate diptych and were recorded in the inventory of Margaret of Austria's collection as being the two by the hand of Michiel, that is Michel Sittow, who at that time worked at the Regent's court.[14] The other thirty panels were described in the inventory of 1516 as being stored in a wooden box.[15] By the inventory of 1524 their number had been reduced to twenty-two, and after this second inventory, eighteen of these were framed in a diptych decorated with Margaret's arms, with two more, *The Temptation* and *The Marriage at Cana*, framed separately and placed atop the diptych.[16] This private altarpiece of Margaret of Austria passed into the Spanish royal collection, and fifteen of the panels are still in the Palacio Real, Madrid.

Carl Justi first linked this group in the Palacio Real with the list of scenes belonging to Isabel the Catholic and attributed them to Juan de Flandes on the basis of their similarity to his documented retable in the cathedral of Palencia.[17] A number of missing scenes have since been identified in other collections.[18] Gustav Glück first recognized that *The Temptation of Christ* and its long-time companion piece from the Fondi collection, *The Marriage at Cana*, were part of this series.[19]

Although the intended arrangement and function of the series are not clear from the list of scenes drawn up after Isabel's death, the panels were probably designed to form a small-scale retable of many compartments. However, as they were valued and sold separately, it is most likely that they were still unframed at the time of Isabel's death.[20] As Carl Justi first pointed out, the series may have been left incomplete at that time, as still more scenes could have been added to the sequence, most notably the Resurrection.[21] The possibility that more scenes were projected, together with the number of panels now missing, makes it impossible to determine the formal interrelationships that would have linked the different parts of the narrative.

The series presents a number of problems that would repay a full study of all the surviving panels within the context of Juan de Flandes' development. In the surviving panels the events of the life of Christ and the Virgin are presented as dramatic episodes within extraordinarily detailed architectural or landscape settings. The extent of the narrative sequence and its emphasis on the miracles and public life of Christ follows the tradition of large-scale Spanish retables of many compartments. Yet the scale of the figures, the realistic settings, the wealth of subordinate narrative detail,

Juan de Flandes, *The Temptation of Christ*, 1967.7.1

Fig. 2. Juan de Flandes, *Entry into Jerusalem*, Madrid, Palacio Real [photo: Patrimonio Nacional]

Fig. 3. Juan de Flandes, *Adoration of the Magi*, detail, Cervera de Pisuerga, parish church [photo: Copyright A.C.L. Brussels]

and the degree of finish all recall Flemish panel painting and book illumination. Moreover, some of the scenes find close parallels in the Breviary of Isabel the Catholic, as noted above.[22] The apparent inclusion of portraits of Isabel of Castile and Ferdinand of Aragon in *The Multiplication of Loaves and Fishes* in the Palacio Real seems to underscore the intimate devotional character of the series.[23] The series has yet to be studied in relation to Isabel's personal piety.

The surviving panels, apart from those by Sittow, though relatively unified in conception, also present problems of attribution that have not yet been fully studied. They show fairly marked variations in the facial types, including that of Christ, as well as in the scale of the figures, the density of the modeling, and so on. In the first comprehensive publication of the panels, Sánchez Cantón singled out a group that he felt was weaker and not by Juan de Flandes himself: *Christ on the Sea of Galilee, Christ in the House of Simon, The Last Supper* (Apsley House), *The Agony in the Garden* (private collection), *The Taking of Christ, The Mocking of Christ, Christ before Pilate, Christ Appearing to His Mother* (Bode-Museum), and *The Carrying of the Cross* (Kunsthistorisches Museum).[24] He also placed

The group isolated by Sánchez Cantón is very generally characterized by softer, deeper shadows, smaller-scale, rather doughy figures, and a less complex spatial recession, though these elements are present in varying degrees within the group. In several of the panels Christ or the apostles have halos. Garments are picked out with gold in the Apsley House *Last Supper*. However, a reexamination of Isabel's series in the light of what can now be deduced about Juan's development would probably point more to a continuous and relatively rapid evolution of a single artist than to multiple hands. Thus, the pleating of drapery folds, the ovoid, boneless faces and fuzzy hair, and the general *sfumato* effect of *Christ on the Sea of Galilee* and *The Entry into Jerusalem* (fig. 2) have much in common with Juan's presumed early work in the Cervera di Pisuerga *Adoration of the Magi* (fig. 3).[27] Other scenes like the *Noli me Tangere* suggest a transition toward the more attenuated, still figures associated with Juan's documented *The Raising of Lazarus* and *The Three Marys at the Tomb* somewhat apart from the main group by Juan de Flandes.[25] MacLaren added *The Entry into Jerusalem* to Sánchez Cantón's group, while returning *Christ Carrying the Cross* to Juan himself.[26]

works and may represent the same stage in his career as the *Beheading* in Geneva from the reconstructed altarpiece of Saint John the Baptist.[28] Juan de Flandes may indeed have worked on the series of small panels during the whole course of his employment for Isabel the Catholic, from the time when he was first recorded in her service in 1496 until her death in 1504. *The Raising of Lazarus* (fig. 4) probably represents the furthest extension of his development within the series, anticipating the same scene from the San Lázaro retable.[29]

The Temptation of Christ is entirely convincing as a work of Juan's own hand and probably falls towards the latter part of his development within the series for Isabel the Catholic. The landscape is already treated as a succession of thin, overlapping planes, a tendency that became a mannerism in the artist's later works in Palencia.

<div align="right">M.W.</div>

Notes

1. A survey of the condition of the unpainted edges of all the panels belonging to the series would probably provide some information on their framing history. Thus, in *Christ Appearing to His Mother with the Redeemed of the Old Testament* in London, one of four not sold in 1505, a whitish chalk ground extends over the unpainted edges at top and sides. A gold border, said to be a recent addition, was removed in 1967–1968; see MacLaren 1952 (2d ed. 1970), 42. *Christ and the Samaritan Woman* in the Louvre, the only panel bought by the head of the pages in 1505, has both an unpainted edge and a gold border apparently added within the painted image and now partially removed and overpainted.

2. In addition to two typed descriptive labels, one stating, "... bought by J.W. from Bardini, the dealer, in Florence, in 1899...," and a label from Thos. Agnew & Sons, Ltd., no. 28505, these are a label from the Royal Academy Winter exhibition, 1908, and smaller stickers with 55 in ink and *HAB*/72A in ink. The labels are now in the curatorial files.

3. The second inscription most probably refers to Gerard van der Meire, a documented Ghent painter to whom many

Fig. 4. Juan de Flandes, *Raising of Lazarus*, Madrid, Palacio Real [photo: Patrimonio Nacional]

early Netherlandish paintings were attributed in the nineteenth century; see J. A. Crowe and G. B. Cavalcaselle, *The Early Flemish Painters: Notices of their Lives and Works*, 2d ed. (London, 1872), 147–154.

4. Sánchez Cantón 1930, 97–103.

5. André Joseph Ghislain le Glay, *Correspondance de Maximilien I^{er} et de Marguérite d'Autriche...*, 2 vols. (Paris, 1839), 2: 481–482.

6. For the document listing goods sent by Charles V to Isabel of Portugal, see Rudolf Beer, "Acten, Regesten und Inventare aus dem Archivo General zu Simancas," *JbWien* 12 (1891), CXX–CXXIII. Beer places the undated document in 1526, the year of Charles V's marriage to Isabel of Portugal, and considers the list to represent wedding presents. Sánchez Cantón 1930, 106, disputes the dating of the shipment before Margaret's death.

7. Rudolf Beer, "Inventare aus dem Archivo del Palacio zu Madrid," *JbWien* 14 (1893), X.

8. According to Glück 1905, 228.

9. According to label cited in n. 2 above.

10. For the Temptation of Christ, see Réau, *Iconographie*, 2, part 2: 304–309, and K. Smits, *De Iconografie van de nederlandsche primitieven* (Amsterdam, 1933), 72.

11. Examples of the Temptation in Spanish retables include Dello Delli's retable for the old cathedral of Salamanca (Miguel Gómez-Moreno and Francisco Javier Sánchez Cantón, "El retablo de la Catedral vieja de Salamanca," *AEA* 4 [1928], 1–24, fully illustrated), and the Ciudad Rodrigo retable by Fernando Gallego and his assistants (Eisler 1977, 162–177, figs. 152–177).

12. For the Breviary, British Library Add. Ms. 18851, see most recently Thomas Kren in *Renaissance Painting in Manuscripts: Treasures from the British Library* [exh. cat. The J. Paul Getty Museum] (Malibu, 1983), 40–48, no. 5. The manuscript contains the arms of Rojas, the ambassador of Ferdinand and Isabel who negotiated the double marriage, and of Isabel and her two children. When the book was illuminated and whether the illustrations were planned with the queen in mind are subjects for further study. See also under 1965.1.1, Sittow, *The Assumption of the Virgin*.

13. The fullest treatments of the series are: Sánchez Cantón 1930, 97–132, giving the 1505 list of scenes, their purchasers, and later history; MacLaren 1952 (2d ed. 1970), 41–47, under no. 1280; and Bermejo 1962, with complete illustrations of the known scenes by Juan de Flandes.

14. Le Glay 1839, 2: 481–482 (as in n. 5 above) and Heinrich Zimerman and Franz Kreyczi, "Urkunden und Regesten aus dem k.u.k. Reichs- Finanz- Archiv," *JbWien* 3 (1885), XCIII–CXXIII. See also 1965.1.1, Sittow, *The Assumption of the Virgin*.

15. "Deans une layette de sapin," Le Glay 1839, 2: 482.

16. "Item en une petite boite en forme de liette de bois il y a 22 petiz tableaux, fait, comme il semble, tout d'une main...," Zimerman and Kreyczi 1885, C. A marginal note in the 1524 inventory states that eighteen of the panels were framed in this way, with *The Temptation* and *The Marriage at Cana* framed separately: "... garniz tout a l'entour d'argent doré, semé de rosettes et fiullages...." Two unframed panels remained in the wooden box, Zimerman and Kreyczi, C, n. 60. See also the document enumerating Charles V's gifts to his wife cited in n. 6 above and Philip II's inventory, in which the silver frame is fully described, Beer 1893, X (as in n. 7 above).

17. Carl Justi, "Juan de Flandes: Ein niederländischer Hofmaler Isabella der Katholischen," *JbBerlin* 8 (1887), 157–165.

18. Aside from the fifteen panels in the Palacio Real, Madrid, the following scenes belong to the series: *The Temptation*, 1967.7.1; *The Marriage at Cana*, Metropolitan Museum of Art, The Belle and Jack Linsky Collection, New York; *Christ and the Samaritan Woman*, Louvre, Paris; *The Last Supper*, Apsley House, London; *Agony in the Garden*, private collection (severely damaged); *Crowning with Thorns*, The Detroit Institute of Arts; *Carrying of the Cross*, Kunsthistorisches Museum, Vienna; *Christ Nailed to the Cross*, Kunsthistorisches Museum, Vienna; *Christ Appearing to His Mother with the Redeemed of the Old Testament*, National Gallery, London; *Christ Appearing to His Mother*, Bode-Museum, East Berlin; *Ascension* (Michel Sittow), private collection, England; *The Assumption of the Virgin* (Michel Sittow), 1965.1.1.

The Coronation of the Virgin attributed to Michel Sittow in the Louvre has also been considered to be part of the series, as this subject is included in the 1505 list; Nicole Reynaud, "La Couronnement de la Vierge de Michel Sittow," *RLouvre* 17 (1967), 345–352, repro. in color opp. 348. However, its larger dimensions (26 x 19.7 cm; painted surface 24.5 x 18.3 cm) and the differences in paint handling between it and Sittow's *Ascension* and *Assumption* raise questions as to its position in the series; see under 1965.1.1.

19. Glück 1905, 228.

20. First mentioned in 1505 as "en un armario todas estas tablicas, yquales todas," Sánchez Cantón 1930, 99. MacLaren 1952, 23, suggested that *armario* might refer to a folding altarpiece. However, it is more probable that this word refers to a cupboard; see also MacLaren 1952 (2d ed. 1970), 44, 47.

21. Justi 1887, 162. A few of the subjects seem to overlap; hence MacLaren 1952 (2d ed. 1970), 43–44, suggests that the Berlin *Christ Appearing to His Mother* may have been painted as an alternative to *Christ Appearing to His Mother with the Redeemed of the Old Testament* now in London. *The Taking of Christ* and the lost panel representing the moment immediately preceding it, cited in the 1505 list by the text of John 18:8 (Sánchez Cantón 1930, 100), would also be redundant.

22. Later Flemish illumination also provides a parallel in form, in the quadriptych by Simon Bening in the Walters Art Gallery, Baltimore; Marcia Kupfer-Tarasulo, "Innovation and Copy in the Stein Quadriptych of Simon Bening," *ZfK* 42 (1979), 274–298, figs. 1–4.

23. Sánchez Cantón 1930, 25, and Egbert Haverkamp-Begemann, "Juan de Flandes y los Reyes Católicos," *AEA* 25 (1952), 245–246; Bermejo 1962, pl. 1.

24. Sánchez Cantón 1930, 119–132.

25. Sánchez Cantón 1930, 123.

26. MacLaren 1952, 23 (2d ed. 1970, 43). Hulin de Loo 1932, 50, disputed Sánchez Cantón's division of the panels into two groups.

27. The delicately painted vignettes of tubby horses and riders in the background of the *Adoration* and of *The Entry into Jerusalem* and *Christ before Pilate* are also closely comparable; Ignace Vandevivere, *Primitifs flamands. Corpus. La cathédrale de Palencia et l'église paroissiale de Cervera de Pisuerga* (Brussels, 1967), pls. 226–230, and Bermejo 1962, pl. 9.

28. Bermejo 1962, pl. 16, and Ann Tzeutschler Lurie,

"Birth and Naming of St. John the Baptist Attributed to Juan de Flandes: A Newly Discovered Panel from a Hypothetical Altarpiece," *BCMA* 63 (1976), 118–135, figs. 16, 19, 22. For the connection between the reconstructed altarpiece and one made by "Juan Flamenco" for the royal charterhouse of Miraflores in 1496–1499, see Biography and Josef de Coo and Nicole Reynaud, "Origen del retablo de San Juan Bautista Atribuido a Juan de Flandes," *AEA* 52 (1979), 125–144.

29. Bermejo 1962, pl. 40; see also under 1961.9.25.

Although the small panels may display a broad range of Juan's style, differences in quality are still evident, so that the possibility of more than one hand, apart from Sittow's documented participation, should not be excluded. Thus figures with rather flat faces and small pinched eyes appear in several panels close to Juan's mature work: *The Multiplication of Loaves and Fishes*, *Christ and the Samaritan Woman*, and *Pentecost*; Bermejo 1962, pls. 1, 4, 18. Distinctive foreshortened figures modeled in opalescent tones appear in several panels: *The Multiplication of Loaves and Fishes* (the mother in the foreground), *The Taking of Christ* (Malchus), and *Christ Nailed to the Cross*; Bermejo 1962, pls. 1, 9, 12. This may mean that more than one painter worked on one panel; further, Juan probably experimented with a repertory of styles and types within a single panel. Infrared reflectography would probably provide a key to these variations. Thus, while no underdrawing is visible in the *Temptation* with infrared reflectography, the panel in the National Gallery, London, is fully and carefully underdrawn (Davies 1970, pl. VI), while *The Marriage at Cana* in the Metropolitan Museum is more freely underdrawn and the attenuated figures standing at extreme right and left are inserted without underdrawn preparation. I am very grateful to Maryan Ainsworth and Guy Bauman for information on the latter panel.

References

1905 Glück, Gustav. "Kinderbildnisse aus der Sammlung Margaretens von Österreich." *JbWien* 25: 228.

1908 Justi, Carl. *Miscellaneen aus drei Jahrhunderten spanischen Kunstlebens.* 2 vols. Berlin, 1: 316–319.

1926 Winkler, [Friedrich]. "Juan de Flandes." In Thieme-Becker 19: 278–279.

1930 Sánchez Cantón, Francisco Javier. "El retablo de la Reina Católica." *AEA* 6: 97–98, 120.

1931 Isherwood Kay, H. "Two Paintings by Juan de Flandes." *BurlM* 58: 197–201.

1931 Sánchez Cantón, Francisco Javier. "El retablo de la Reina Católica (Addenda et corrigenda)." *AEA* 7: 149–150, pl. 2.

1932 H[ulin] de L[oo], [Georges]. In *Trésor de l'art flamand du moyen âge au XVIIIᵉ siècle. Mémorial de l'exposition de l'art flamand à Anvers 1930.* 2 vols. Paris, 1: 50–51.

1933 Winkler, Friedrich. Notes to Gustav Glück. *Aus drei Jahrhunderten europäischer Malerei.* Vienna: 322.

1933 Post, Chandler Rathfon. *A History of Spanish Painting.* 14 vols. Cambridge, Mass., 4, part 1: 39.

1950 Sánchez Cantón, Francisco Javier. *Libros, tapices y cuadros que coleccionó Isabel la Católica.* Madrid: 185.

1952 MacLaren, Neil. *National Gallery Catalogues. The Spanish School.* London: 24 (2d ed. Revised by Allan Braham. London, 1970: 45).

1962 Bermejo, Elisa. *Juan de Flandes.* Madrid: 12, 41, pl. 2.

1965 Eisler, Colin T. "The Sittow Assumption." *ArtN* 64 (September): 53.

1969 Walker, John. *Self-Portrait with Donors: Confessions of an Art Collector.* Boston and Toronto: 42–44.

1970 Davies, Martin. *Primitifs flamands. Corpus. The National Gallery London.* 3 vols. Brussels, 3: 9.

1975 NGA: 184, repro. 185.

1981 [Demus, Klaus, Friderike Klauner, and Karl Schütz]. Kunsthistorisches Museum. *Flämische Malerei von Jan van Eyck bis Pieter Bruegel der Ä.* Vienna: 176.

1982 Kauffmann, C. M. *Victoria and Albert Museum. Catalogue of the Paintings in the Wellington Museum.* London: 78–79.

1984 Bauman, Guy C. In *The Jack and Belle Linsky Collection in the Metropolitan Museum of Art.* New York: 60–63.

Lucas van Leyden

1489/1494–1533

As his name implies, Lucas van Leyden was born in Leiden. There is some controversy over the date of his birth. Carel van Mander in *Het Schilder-Boek* of 1604 says that Lucas was born in 1494 and thus his earliest dated engraving, *Mohammed and the Monk Sergius*, 1508, is the work of a fourteen-year-old prodigy. Opinion is divided over the question of Lucas' status as a *wunderkind* and several scholars believe it more likely that he was born around 1489. There is no confirming documentary evidence for either date. Lucas is mentioned in 1514 in the register of the civil guard in Leiden, and in 1515 and 1519 his name is listed among the crossbowmen of that city. Sometime around 1515 he married the daughter of a Leiden magistrate. Albrecht Dürer's diary entry and his silverpoint drawing of Lucas (Musée Wicar, Lille) confirm that the two artists met each other in Antwerp in 1521. According to Van Mander, Lucas made a second journey through the southern Netherlands, perhaps in 1527, when he met Jan Gossaert in Middelburg. If we believe Van Mander, the artist's health deteriorated drastically following this trip and Lucas, who thought he had been poisoned by an envious colleague, was often ill and bedridden. Lucas died in Leiden in the summer of 1533.

Van Mander states that Lucas studied first with his father Hugo Jacobsz., and then with Cornelis Engebrechtsz. Although Hugo Jacobsz. is documented in Leiden by 1480, there are no extant works that can be given to him with certainty. Hugo Jacobsz. has been identified as the Master of the Turin Crucifixion or the Master of the Saint John Panels, but this is based on the similarities with Lucas' early engravings and it is hard to tell in which direction the influence runs. Engebrechtsz'. influence on Lucas seems to have been limited to the occasional motif.

One of the greatest graphic artists of the sixteenth century, Lucas van Leyden produced engravings, woodcuts, and drawings. His dated engravings run between 1508 and 1530, and their chronology has been worked out in some detail. The chronology of his paintings is less complete; there are fewer dated works and more attributions. *The Adoration of the Magi* (Barnes Collection, Merion, Pennsylvania), is generally accepted as an early Lucas, painted c. 1500–1510, as is *Lot and His Daughters* (Louvre, Paris), of c. 1509. The earliest dated painting is the *Virgin and Child with the Magdalene and a Donor* of 1522 in the Alte Pinakothek, Munich. The *Last Judgment* altarpiece in the Stedelijk Museum, Leiden, was commissioned in 1526 and probably installed in the church of Saint Peter, Leiden, by 1527. *Moses Striking the Rock* (Museum of Fine Arts, Boston), is signed with an *L* and dated 1527. Finally, the *Healing of the Blind Man of Jericho* (The Hermitage Museum, Leningrad) is signed and, according to Van Mander, was originally dated 1531. An additional fifteen to twenty paintings are attributed to Lucas.

The two major influences upon the art of Lucas van Leyden are Albrecht Dürer and, from at least the early 1520s, Jan Gossaert. The inclusion of elements from the Antwerp mannerists and from Italianate sources are evidence of Lucas' concern with keeping abreast of the latest developments. Apart from his considerable technical skill, Lucas was a master of the observed fact who easily inserted genre or secular elements into religious works, and a composer, especially in his late paintings, with the ability to create spatial settings of breadth, cohesiveness, and even grandeur. It is not surprising that Lucas van Leyden was very popular in the seventeenth century and had a decided influence upon Rembrandt.

J.O.H.

Bibliography

Friedländer, Max J. *Lucas van Leyden*. Berlin, 1963.
Vos, Rik. *Lucas van Leyden*. Bentveld and Maarsen, 1978.
Vos, Rik. "The Life of Lucas van Leyden by Karel van Mander." *NKJ* 29 (1978): 459–507.

After Lucas van Leyden, *The Card Players*, 1961.9.27

After Lucas van Leyden

1961.9.27 (1387)

The Card Players

Probably c. 1550/1599
Linden[1] (cradled), 55.2 x 60.9 (21³/4 x 24)
Samuel H. Kress Collection

Technical Notes: The painting, composed of two boards with the grain running horizontally, is very badly damaged and extensive retouching is present throughout. The largest areas of loss are in the robe of the man at the far right, the sleeves of the seated woman at the center, and in the face of the man standing behind her. X-radiography suggests that generally the losses exist in both the paint and ground layers. Examination with infrared reflectography reveals underdrawing (discussed below). The painting was cleaned and restored by Mario Modestini in 1954.

On the reverse is a reattached label, with the following in italic script: *et is ferrarius ante xit / acrí ingenio. / G. C. Beiriu* (?)

Provenance: (Van Diemen Gallery, Berlin, by 1923.) (Sale, Christie's, London, 20 May 1926, no. 269, as Van Leyden.) (Probably Asscher and Welker, London, 1926.)[2] (Galerie Julius Böhler, Munich, c. 1929.)[3] (Tomas Harris Gallery, London, by 1935.) Private Collection, Switzerland, by 1945. (Frederick Mont, New York.) Samuel H. Kress Foundation, New York, 1951.

Exhibitions: London, Tomas Harris Gallery, 1935, *Exhibition of Early Flemish Paintings*, no. 19, as Lucas van Leyden. // Basel, Öffentliche Kunstsammlung (Kunstmuseum), 1945, *Meisterwerke holländischer Malerei des 16. bis 18. Jahrhunderts*, no. 43, as Lucas van Leyden.

THE ATTRIBUTION of *The Card Players* to Lucas van Leyden is due primarily to Friedländer who initially dated the painting to c. 1520 and later, in his monograph on Lucas, proposed a date of c. 1525 on the basis of a comparison with the facial types in Lucas' engraving of *Virgil in a Basket*.[4] Hoogewerff, Suida and Shapley, and Cuttler follow Friedländer in accepting the painting as autograph.[5] However, the overwhelming majority of scholars who have discussed the painting have rejected the attribution to Lucas van Leyden. In 1961 Judson termed it a copy of the later sixteenth century.[6] Winkler, in the editorial notes to Friedländer's monograph, suggests that the panel is probably a copy of a lost work by Lucas.[7] This is essentially the view put forward by Held, Reznicek-Buriks, Eisler, and Vos.[8] In 1976 the Gallery's attribution was changed to "After Lucas van Leyden." In a careful discussion of the painting, augmented by a study of the infrared and x-radiograph photographs, Filedt Kok found that both the underdrawing and the painted surface were significantly different from those of paintings accepted as autograph. He was reticent as to whether *The Card Players* replicated a lost Lucas or was a work in the style of Lucas, but he suggested that the style of the garments and the nearly caricatured facial types point to a German artist working in the later sixteenth century.[9]

When it is compared to autograph paintings such as *Joseph and Potiphar's Wife* of c. 1512 (Museum Boymans–van Beuningen, Rotterdam), or the *Virgin and Child with the Magdalene and a Donor* of 1522 in the Alte Pinakothek, Munich,[10] there can be no doubt that *The Card Players* is a copy. Even making allowances for its damaged condition, Lucas' subtlety of coloring, vigor of brushwork, and surety of draftsmanship are absent. The underdrawing revealed through infrared reflectography (fig. 1) bears no relationship to Lucas and, as one might expect of a copy, consists of contour lines and large areas of parallel hatching that show no evidence of change or experimentation.[11] That the support of the painting is linden strengthens Filedt Kok's assertion that the artist may be German. Copies are notoriously hard to date, yet I tend to agree with those who date this painting to the mid or late sixteenth century.

The Card Players belongs to a type of work that was undoubtedly moralizing. Gambling, whether at cards or at dice, was condemned by ecclesiastical and civil authorities alike. The Church denounced those at the Crucifixion who threw dice for Christ's robe and many municipalities passed laws that made card playing within city walls a crime.[12] Satirists such as Erasmus and Sebastian Brant portrayed card playing in a bad light.[13] Card games often took place in unsavory surroundings that were conducive to both amorous dalliance and cheating. In this regard it is perhaps significant that in the Gallery's panel two men and two women are playing and that, from the exchange of glances between players and kibitzers, cheating and collusion seem likely. Several authors have commented

on the prominence of the still life in the background and it is possible that in the original painting the objects functioned symbolically.[14]

Lucas van Leyden dealt with the subject of card players several times in the course of his career. *The Fortuneteller* (Louvre, Paris), of c. 1509[15] is the earliest work on this theme; it was followed by paintings of card players in the Thyssen-Bornemisza Collection, Lugano, of c. 1515 and the collection of the Earl of Pembroke, Wilton House, of c. 1517.[16] In composition and use of an interior setting the Gallery's panel most resembles the Wilton House *Card Players*, yet if the greater amount of space and the influence of Dürer are true reflections of the original and not proclivities of the copyist, then the panel may echo a work of Lucas van Leyden from the period around 1520.

<div style="text-align:right">J.O.H.</div>

Notes

1. The identification of the wood as linden (*Tilia*) was made by Josef Bauch, Ordinariat für Holzbiologie, Universität Hamburg, in 1977; Filedt Kok 1978, 132, identifies the support as poplar while Eisler 1977, 85, lists it as oak.

2. The copy of the 20 May 1926 sale catalogue in the Frick Art Reference Library, New York, is annotated "Asscher".

3. John Sunderland, Witt Librarian, Courtauld Institute of Art, London, in a letter of 4 August 1967 to Peter C. Kinney, researcher for Eisler, reports that the painting was with Böhler by 1929.

4. Friedländer, vol. 10 (1932), 95; Friedländer 1963, 62.

5. Hoogewerff 1939, 259; Kress 1956, 118; Cuttler 1968, 443.

6. Judson 1961, 347.

7. Friedländer 1963, 62, n. 28.

8. Held 1966, 447; Reznicek-Buriks 1965, 245; Eisler 1977, 85, called the painting "After Lucas van Leyden"; Vos 1978, 106.

9. Filedt Kok 1978, 128–132. The painting is captioned, fig. 135, "Style of Lucas van Leyden (copy after?)."

10. Reproduced in Friedländer, vol. 10 (1973), no. 119, pl. 95, and no. 114, pl. 91.

11. This should be compared to the underdrawings reproduced in Filedt Kok 1978.

12. See M. Wurfbain, "De genreschilderijen van Lucas van Leyden," *Antiek* 13 (1978/1979), 205, on the prohibition in the Netherlands of card playing inside the city walls. Proposed identifications of the game being played in the Gallery's painting are neither satisfactory nor verifiable. Eisler 1977, 85, identifies the game as Primero, but does not give solid bibliographic references. Albert Morehead, letter of 12 August 1957 to Fern Shapley in the curatorial files, tentatively identifies the game as *pair et sequence*, which seems to have grown out of Primero.

13. Erasmus, *The Praise of Folly*, tr. John Wilson 1668 (Oxford, 1931), 80; Edwin Zeydel, trans., *The Ship of Fools by Sebastian Brant* (New York, 1962), chap. 77, "Of Gamblers," 255–258. In conjunction with the Gallery's painting

the lines on page 256 are particularly interesting: "And many women are so blind / That they forget their sex and kind / And know not that propriety / Forbids such mixed society."

14. Reznicek-Buriks 1965, 245, for example, believes that the still life faithfully copies Lucas' original conception. Comparison is made to the *Madonna and Child* of c. 1528 in the National Gallery, Oslo (Friedländer, vol. 10 [1973], no. 124, pl. 98), which contains in the foreground a pot of flowering strawberries. Some of the still-life elements in *The Card Players* can be interpreted symbolically. The flowers at the left were identified in 1966 by Noel Smith, the Gallery's horticulturist, as a species of lily-of-the-valley (*Convallaria*). The lily symbolizes virginity and purity and is given not only to the Virgin Mary, but also to virgin martyrs and saints who were pious and chaste in their youth. See Elizabeth Haig, *The Floral Symbolism of the Great Masters* (London, 1913), 24, 32, 198–199, 211–212, 222–223, 234. The stoppered carafe on the shelf at right is a traditional emblem of the purity of the Virgin, occurring frequently in Netherlandish paintings, beginning with the work of Jan van Eyck. See Panofsky, *ENP*,

Fig. 1. Infrared reflectogram assembly of a detail of *The Card Players*, 1961.9.27 [infrared reflectography: Molly Faries]

1953, 144. These symbols of purity and chastity are in ironic juxtaposition to the actions of the card players. The white ceramic jar and wooden boxes are too generalized to permit interpretation. However, the presence of a stoppered carafe, white ceramic jar, and wooden box in the *Saint Jerome* attributed to Jan van Eyck (The Detroit Institute of Arts) is tantalizing. Ingvar Bergström, "Medecina, Fons et Scrinium.

A Study in Van Eyckean Symbolism and Its Influence in Italian Art," *Konsthistorisk Tidskrift* 26 (1957), 1–20, discusses the significance of these objects. The jar is labeled "Tyriaca," a medieval medicine, and Bergström identifies the box as a *scrinium deitatis*, or container of the Host. In "Disguised Symbolism in 'Madonna' Pictures and Still Life," *BurlM* 97 (1955), 346, n. 44, Bergström notes that the combination of the carafe and wooden box with an apple is an iconographic unit that occurs often in fifteenth- and sixteenth-century paintings. Although Bergström's analysis is not wholly convincing, the still-life components in Lucas van Leyden's original picture may be part of this tradition.

15. Friedländer, vol. 10 (1973), Supp. 172, pl. 110.

16. Friedländer, vol. 10 (1973), Add. 181, pl. 111, and 141, pl. 109, respectively.

References

1932 Friedländer. Vol. 10: 95, 137, no. 142, pl. 87 (vol. 10, 1973: 54, 84, no. 142, pl. 109).

1935 Fell, H. Granville. "From Gallery and Mart." *Conn* 96: 171, repro.

1939 Hoogewerff, G. J. *De Noord-Nederlandsche Schilderkunst.* 5 vols. The Hague, 3: 259.

1956 Kress: 118, no. 45, repro. 119.

1958 Nicolson, Benedict. *Hendrick Terbrugghen.* London: 84.

1960 Baird, Thomas P. *Dutch Painting in the National Gallery of Art.* Washington: 26, repro. 27.

1961 Judson, J. Richard. Review of *Hendrick Terbrugghen* by Benedict Nicolson. In *AB* 43: 347.

1963 Friedländer, Max J. *Lucas van Leyden.* Berlin: 62–63.

1965 Reznicek-Buriks, E. I. Review of *Lucas van Leyden* by Max J. Friedländer. In *OH* 80: 244–245.

1966 Held, Julius S. Review of *Lucas van Leyden* by Max J. Friedländer. In *AB* 48: 447.

1968 Cuttler. *Northern Painting*: 443.

1975 NGA: 202, repro. 203.

1977 Eisler: 85–86, fig. 84.

1978 Vos, Rik. *Lucas van Leyden.* Bentveld and Maarssen: 106, repro. 107.

1978 Filedt Kok, Jan Piet. "Underdrawing and other technical aspects in the paintings of Lucas van Leyden." *NKJ* 29: 128–132, figs. 135, 136, 137.

1979 Rosenbaum, Allen. *Old Master Paintings from the Collection of Baron Thyssen-Bornemisza.* Exh. cat. International Exhibitions Foundation. Washington: 114.

1980 Gibson, Walter. Review of Lucas van Leyden studies in the *NKJ* 29 (1978). In *Simiolus* 11: 108.

Quentin Massys

c. 1465/1466–1530

Quentin Massys (alternative spelling Quinten or Quintin Metsys or Matsys) was born in Louvain, the son of a blacksmith. On 10 September 1494 Massys declared to the magistrates of Louvain that he was twenty-eight years old. Thus he must have been born sometime between September 1465 and September 1466. There is no record of Massys having been trained as a painter in Louvain. Later biographers such as Van Mander have suggested that he was self-taught or that he began by coloring woodcuts.

Massys was first mentioned as a painter in 1491 when he entered the Guild of Saint Luke in Antwerp, the city that was to be his home until his death in 1530. He never held office in the Guild, but presented pupils in 1495, 1501, 1504, and 1510. A few paintings, such as the *Madonna and Child* in the National Gallery, London, the *Madonna and Child* in the Musées Royaux des Beaux-Arts, Brussels, and the *Saint Christopher* in the Koninklijk Museum, Antwerp, are considered early works and show the influence of Memling and Dirck or Aelbrecht Bouts. The earliest documented work is the large *Saint Anne Altarpiece* (Musées Royaux des Beaux-Arts, Brussels), which is signed and dated 1509 and was commissioned in 1507 by the confraternity of Saint Anne in Louvain for its chapel in the church of Saint Peter. This was followed by the *Saint John Altarpiece* (Koninklijk Museum, Antwerp), ordered in 1508 by the carpenter's guild for its chapel in Antwerp Cathedral and completed in 1511. Massys' versatility can be seen in two signed and dated works, the *Portrait of an Old Man* of 1513 in the Musée Jacquemart-André, Paris, which revives in the North the Italianate profile portrait and derives from Leonardo's grotesques, and the *Moneychanger and His Wife* of 1514, in the Louvre, which is self-consciously archaic, relating to works by Jan van Eyck and Petrus Christus. Collaboration with the eminent landscapist Joachim Patinir resulted in *The Temptation of Saint Anthony* (Prado, Madrid), and the *Virgin and Child with a Lamb* (Poznań Muzeum Narodowe), which can

be dated between 1515 and 1524, the year Patinir died.

Massys was an outstanding portraitist and in 1517 he was commissioned by Erasmus and Pieter Gillis, town clerk of Antwerp, to depict both men in a diptych that was given to Sir Thomas More; the portrait of Gillis is now in the collection of the Earl of Radnor, Longford Castle. It has been recently ascertained that the portrait of Erasmus is the panel in the Royal Collection, Hampton Court, and not the picture in the Galleria Nazionale d'Arte Antica, Palazzo Barberini, Rome. Massys' late style can be seen in *The Adoration of the Magi*, probably 1526 (Metropolitan Museum, New York), and the *Madonna and Child*, initialed and dated 1529, in the Louvre. In 1531, shortly after the artist's death, two of his many children, Jan and Cornelis, entered the Antwerp Guild; they went on to become painters of note. However, the extent, if any, to which they collaborated in their father's paintings is uncertain.

Quentin Massys was the leading painter of Antwerp and one of the outstanding Netherlandish artists of the sixteenth century. Technically assured, his style is internally consistent yet is made up of many diverse elements: archaic quotations of past masters, the works of his Netherlandish contemporaries, Albrecht Dürer, and Italian art, in particular that of Leonardo da Vinci. Massys is one of the first painters to treat secular themes, and his special mixture of sophistication, irony, and moral satire is a complement to the writings of the humanists and intellectuals of his day.

J.O.H.

Bibliography
Friedländer. Vol. 7. 1929 (vol. 7, 1971).
Bosque, Andrée de. *Quentin Massys*. Brussels, 1975.
Campbell, Lorne, et al. "Quentin Massys, Desiderius Erasmus, Pieter Gillis and Thomas More." *BurlM* 120 (1978): 716–724.
Silver, Larry. *The Paintings of Quinten Massys, with Catalogue Raisonné*. Montclair, New Jersey, 1984.

1971.55.1 (2561)

Ill-Matched Lovers

c. 1520/1525
Probably oak, 43.2 x 63 (17 x 24 13/16)
Ailsa Mellon Bruce Fund

Technical Notes: The painting is in good condition. There is repaint along the join of the two horizontal boards. The face and body of the fool as well as the faces of the woman and the old man contain small, scattered areas of repaint. A portion of the woman's chest, above the bodice, has been repainted, and a painted crackle pattern has also been added. The fool appears to have two pupils in his proper left eye. The pupil at the right is more like the other eyes in the painting and is probably the original. The left pupil might be a remnant of an abraded shadow or an old restoration. On the reverse, at lower right corner, is a partially destroyed red resinous seal.

Provenance: Probably Steven Wils the younger, Antwerp [d. 1628], inventory of 6 July 1628, no. 62.[1] Probably Herman Neyt, Antwerp [d. 1642], inventory of 15–21 October 1642, no. 4.[2] Count James-Alexandre de Pourtalès-Gorgier, Paris [d. 1855]. Heirs of Count James-Alexandre de Pourtalès-Gorgier (sale, Paris, 27 March 1865, no. 176). Countess de Pourtalès.[3] Count Edmond de Pourtalès, Paris, by 1888 [d. 1895].[4] By descent to Countess de Pourtalès, Paris.[5] Count Bismarck, Paris and New York, by the late 1940s.[6] (Spencer A. Samuels, New York, by 1969.)

Exhibitions: Bruges, Hôtel de Gouvernement Provincial, 1902, *Exposition des primitifs flamands et d'art ancien*, no. 359.

MASSYS' DEPICTION of an old man duped and fleeced by a younger woman belongs to the general category of unequal or "ill-matched" couples, which can also include the pairing of old women and young men. The theme can be traced in literature to antiquity and the comedies of Plautus, and occurs with some frequency during the Middle Ages and the Renaissance. There are very few pictorial representations of the ill-matched lovers until the late fifteenth century, when, in northern Europe, it appears in prints by the House-book Master and Israhel van Meckenem. The motif achieved great popularity during the first half of the sixteenth century. In addition to the Netherlandish examples there are numerous paintings by Lucas Cranach the Elder and his school as well as by other German artists. French and Italian examples are rarely encountered.[7]

Massys' painting makes elegantly clear the meanings of the theme. First, there is the idea that old age, especially lecherous old age, leads to foolishness. The English proverb "no fool like an old fool," has its equivalent in the Dutch "hoe ouder hoe sotter" and the German "Alter schutzt vor Torheit nicht."[8] The pervading folly of the situation is further underscored by the fool who participates in the deception; this is something of an innovation by Massys, for in other representations the fool is present as an observer or commentator.[9] Second is the notion that under the auspices of Dame Venus women's sexual powers cause men to behave absurdly and to lose both their wits and their money.[10] The deck of cards can allude to competition of the sexes, morally loose or amorous behavior, and the gain or loss of money through gambling. These ideas were very popular in northern Europe in the late fifteenth century and Marlier, Stewart, Silver, and others have identified abundant literary sources for Massys' painting in Sebastian Brant's *Ship of Fools*, Erasmus' *Praise of Folly* and *Colloquies*, and in morality plays and *rederijker* poems.[11] Massys' *Ill-Matched Lovers* is an important visual depiction of the kind of moralizing satire that could be found in Antwerp, especially in the circle of Erasmus. Several authors have stressed that the secular subject matter is a forerunner of the increasing predominance given to the genre elements in the works of Jan van Hemessen, Marinus van Reymerswaele, and the artist's sons Cornelis and Jan Massys.[12]

The *Ill-Matched Lovers* demonstrates Massys' ability to assimilate elements from both Northern and Italian art. The half-length composition, which is almost standard for this subject, is found in the depictions of unequal couples by the Housebook Master and Israhel van Meckenem as well as in paintings by Cranach and his shop.[13] The German compositions, however, tend to be vertical. Marlier and Silver point out that the young woman holding the old man's chin and even her facial features derive from Lucas van Leyden's woodcut *The Prodigal Son* of c. 1519.[14] Both works include a fool.

Many critics have pointed out that the distorted leering visage of the old man is derived from the caricatures of Leonardo da Vinci, in particular the face at the far left of the drawing of *Five Grotesque Heads* in Windsor Castle (fig. 1). The same face appears on the right interior wing of Massys' *Saint John Altarpiece* of 1508–1511, in the Koninklijk Museum, Antwerp. Leonardo himself seems to have created a composition of *Ill-Matched Lovers*, known to us only from a drawing attributed to Joris Hoefnagel in the Albertina, Vienna, and a painting, now lost, by a follower of Massys in which several grotesque figures are added to the original couple to form a *Festive Party*.[15] While it is evident that copies of Leonardo's works were available

Quentin Massys, *Ill-Matched Lovers*, 1971.55.1

Fig. 1. Leonardo da Vinci, *Five Grotesque Heads*, pen and ink, 260 x 205 mm, Windsor Castle, The Royal Library. Copyright reserved. Reproduced by gracious permission of Her Majesty Queen Elizabeth II. [photo: Royal Library, Windsor Castle]

in Antwerp in the early sixteenth century, the exact mode of transmission remains unknown to us.

The *Ill-Matched Lovers* is almost unanimously considered the only autograph version of this theme; only Broadley questioned the attribution to Massys, finding the crowded composition atypical.[16] Silver assigns the painting to the years 1522–1523 on the basis of stylistic similarities with Massys' figures in the *Temptation of Saint Anthony* of c. 1522, in the Prado, Madrid. However, the absence of hard evidence makes it difficult to support so narrow a date.[17] The dependence on Lucas van Leyden's *Prodigal Son* woodcut would tend to put the panel after c. 1519. Since the modeling of the skin tones is not as heavy as that in the *Adoration of the Magi* of 1526 (Metropolitan Museum, New York), perhaps the most acceptable and usable date for the *Ill-Matched Lovers* is c. 1520/1525.[18] One cannot entirely rule out a late date, though the female facial type is different from that of the Virgin in the *Madonna and Child* of 1529 in the Louvre.[19]

Copies of the *Ill-Matched Lovers* exist in a private collection in Switzerland[20] and in the Bibliothèque de l'Université de Liège, Château de Colonster, Liège.[21] The Liège panel, distinguished by a still life of food in the foreground, has been dated to c. 1575. The influence of Quentin Massys' composition can also be seen in paintings of the ill-matched couple in Douai,[22] and the Koninklijk Museum, Antwerp,[23] that are in the manner of his son Jan.

J.O.H.

Notes

1. Denucé 1932, 49. "Item. een stucxken van Meester Quinten, daer een jonge vrouwe den ouden man om de bourse vryt." Several authors, beginning with Hymans 1888, 205, and including Cohen 1904, 71–72, Speth-Holterhoff 1957, 16, and Bosque 1975, 194, have associated the *Ill-Matched Lovers* with the *Card Players* by Massys which was in the collection of Peeter Stevens, Antwerp, in the first half of the seventeenth century and is described in Alexander van Fornenberg's 1658 biography of Massys, *Den Antwerpschen Protheus, ofte Cyclopschen Apelles....* From Van Fornenberg's careful description, which reads in part, "Het Derde is een Stuck van vier Figuren, twee Mans-persoonen, ende twee Vroukens, staende om een Tafel, sijn doende met een uytheyms spel meest in Polen en Duyts-landt bekent" (quoted from Briels 1980, 192, n. 149), it is clear that another painting was in Stevens' collection.

2. Denucé 1932, 94. "Een stuck van Quinten, wesende een out man met jonge vrouwe ende eene sot, in ebbenhoute lyste, gen. no. 4."

3. Unverified, but annotated in the copy of the sales catalogue in the NGA.

4. Mentioned as owner in Hymans 1888, 205.

5. Spencer A. Samuels, in conversation 11 July 1984, stated that the painting remained with the Pourtalès family until after World War II.

6. Spencer A. Samuels, in conversation 11 July 1984 and 20 May 1985. It has not been possible to identify clearly Count Bismarck.

7. Stewart 1979 discusses at length the literary sources for the theme and catalogues the various types of Northern representations of ill-matched couples in the late fifteenth and early sixteenth centuries. Special mention must be made of an ill-matched couple by Jacopo de' Barbari in the John G. Johnson collection, Philadelphia Museum of Art. The panel, which depicts a young woman with an old man, is dated 1503 and hence would be the earliest known painted example in the North; however, it seems to have had little effect on subsequent images.

8. Stewart 1979, 55.

9. The fool as observer or commentator is found in Jacob Cornelisz. van Amsterdam's painting of c. 1511 of a *Young Woman Selling Spectacles to an Old Man* (Museum van Oudheden, Groningen), in Lucas van Leyden's woodcut of c. 1519, *The Prodigal Son*, and in an etching after Lucas of c. 1520–1530, a *Love Triangle in a Bedroom* with a fool and a figure of Death.

10. For the deleterious influence of Dame Venus see Stewart 1979, 47–50; the closely related theme of the Power of Women (*Weibermacht*) is discussed in Larry Silver and Susan Smith, "Carnal Knowledge: The Late Engravings of Lucas van Leyden," *NKJ* 29 (1978), esp. 251–254, 286–287, giving further bibliography on the subject. The symbolism of the

playing cards is touched upon by Silver 1974, 113–114, who notes that the topmost card is appropriately in the suit of hearts. See also Stewart 1979, 68. The association of the ill-matched lovers with death can be seen in Alciati, *Emblematum Flumen Abundans*, facsimile of the Lyons edition of 1551 (London, 1871), 127, which depicts under the heading *AMOR. Senex puellam amans* a man lying on a sepulchre, an owl on his chest, and in the distance at left an old man embracing a young girl. I owe this observation to Lynn Jacobs, NGA department of northern european painting intern, summer 1979.

11. Marlier 1954, esp. 229–232; Stewart 1979, 23–24, 68–71; Silver 1974, esp. 115–123; Panofsky 1969, 214. Brising 1909 is perhaps the first to associate the Gallery's painting with Erasmus.

12. Boon 1942; Friedländer 1947; Gert von der Osten and Horst Vey, *Painting and Sculpture in Germany and the Netherlands 1500 to 1600* (Harmondsworth, 1969), 151.

13. For reproductions of the drypoint by the Housebook Master, the engravings by Van Meckenem, and the paintings by Cranach and his shop, see Stewart 1979, 139–161. Silver 1974, 109, believes that the theme of the ill-matched couple developed independently in Germany and that Massys' painting does not owe anything to Cranach. Stewart 1979, 144–145, seems to agree. Friedländer 1947, 116, sees Cranach learning about the theme during his stay in the Netherlands in 1508/1509; however, the earliest ill-matched couple by Cranach is a panel in the Szépmüvészeti Muzeum, Budapest, dated to c. 1520–1522 (Stewart 1979, 144, cat. no. 14).

14. Marlier 1954, 235; Silver 1974, 111–112.

15. On the Leonardo drawing and related works see Silver 1974, 109–111, figs. 7–10. Both Silver and Stewart believe that Leonardo's ill-matched couple was influenced by Van Meckenem's engravings. Cohen 1904 was apparently the first to note the possible influence of Leonardo's caricatures on the *Ill-Matched Lovers*.

16. Broadley 1961, 147–148.

17. Silver 1974, 106–107. The Prado *Temptation of Saint Anthony* is the result of collaboration between Massys, who did the foreground figures, and Joachim Patinir, who painted the panoramic landscape and secondary figures. The dating of the painting to c. 1522 is dependent in large part, therefore, upon an analysis of Patinir's stylistic development. See Robert A. Koch, *Joachim Patinir* (Princeton, 1968), 21, 31–32, 44, 49–51.

18. Bosschère 1907 dates the painting late; Baldass 1933 puts the picture after 1514, but does not consider it to be among the very late works; Mallé 1955 dates the panel 1525–1530; Cuttler 1968 tentatively proposes c. 1515–1520; NGA 1975 gives c. 1515/1525; Bosque suggests 1520–1523; and Stewart 1979 accepts Silver's dating.

19. Bosque 1975, 219, fig. 72.

20. Canvas, 48 x 65 cm. A photograph is in the NGA curatorial files.

21. Inv. no. 1, oak, 76.2 x 64 cm. Exh. cat. Brussels 1963, no. 168, and Bosque 1975, 194–195. See also Stewart 1979, 146, no. 19.

22. Wood, 72 x 115 cm. Repro. in Stewart 1979, 147, no. 20, and Mirimonde 1962, 554, fig. 11.

23. Inv. no. 566, 41 x 56 cm. See *Catalogue descriptif. Maîtres anciens* (Antwerp, 1970), 160, repro. Mirimonde 1962, 555, fig. 12. This painting, which is mentioned frequently in the literature, was attributed to Quentin Massys and associated with the inventories of Steven Wils (1628) and Herman de Neyt (1642) as well as possibly with the picture described by Van Fornenberg in 1658. See above, n. 1. However, Hymans 1888 described the Antwerp painting as an old copy of the *Ill-Matched Lovers*.

References

1867 Michiels, Alfred. *Histoire de la peinture flamande.* 10 vols. Paris, 4: 338–339.

1883 Branden, F. J. van den. *Geschiedenis der Antwerpsche Schilderschool.* Antwerp: 68–70.

1888 Hymans, Henri. "Quentin Matsys," *GBA* 2ᵉ pér. 38: 205.

1902 Hulin de Loo, Georges. *Bruges. Exposition de tableaux flamands des XIVᵉ, XVᵉ, et XVIᵉ siècles. Catalogue critique.* Ghent: 101, no. 359.

1902 Hymans, Henri. "L'Exposition des primitifs flamands à Bruges." *GBA* 3ᵉ pér. 28: 303.

1903 Friedländer, Max J. *Meisterwerke der niederländischen Malerei des XV. und XVI. Jahrhunderts auf der Ausstellung zu Brügge 1902.* Munich: 24, pl. 64.

1903 Friedländer, Max J. "Die Brügger Leihausstellung von 1902." *RfK* 26: 155.

1904 Cohen, Walter. *Studien zu Quentin Metsys.* Munich: 71–72.

1905 Valentiner, W. "Oeuvres satiriques de Quentin Metsys." *Les Arts anciens de Flandre* 1: 2.

1907 Bosschère, Jean de. *Quinten Metsys.* Brussels: 116–117, 134.

1908 Brising, Harald. *Quinten Matsys und der Ursprung des Italianismus in der Kunst der Niederlande.* Leipzig: 34, 50, no. 33, pl. 42.

1921 Delen, A. J. J. *De Ontwikkelingsgang de Schilderkunst te Antwerpen.* Antwerp: 28–29.

1924 Winkler, Friedrich. *Die altniederländische Malerei.* Berlin: 206.

1926 Delen, A. J. J. *Metsys.* Brussels and Paris: 78–79, pl. 23.

1929 Friedländer, Max J. "Meister Quentins Persönlichkeit." *Cicerone* 21: repro. 574.

1931 Marle, Raimond van. *Iconographie de l'art profane.* 2 vols. The Hague, 2: 477.

1932 Denucé, Jan. *The Antwerp Art Galleries: Inventories of the Art-Collections in Antwerp in the 16th and 17th Centuries.* The Hague: 49, 94.

1933 Baldass, Ludwig. "Gotik und Renaissance im Werke des Quinten Metsys." *JbWien* N.F. 7: 150–151, 173.

1934 Friedländer. Vol. 7: 63, no. 54, pl. 51 (vol. 7, 1971: 33, 66, no. 54, pl. 54).

1938 Wescher, Paul. "Ein 'Ungleiches Liebespaar' von Hans von Kulmbach." *Pantheon* 22: 378.

1942 Boon, Karel G. *Quentin Massys.* Amsterdam: 53, repro. 56.

1947 Friedländer, Max J. "Quentin Massys as a Painter of Genre Pictures." *BurlM* 89: 116.

1950 Larsen, Erik. "Un Quentin Metsys inconnu à New York." *RBAHA* 19: 172.

1954 Marlier, Georges. *Erasme et la peinture flamande de son temps.* Damme: 228–234.

1955 Mallé, Luigi. "Quinten Metsys." *Commentari* 6: 106.

1957 Speth-Holterhoff, S. *Les Peintres flamands de cabinets d'amateurs au XVII^e siècle*. Brussels: 16.

1961 Broadley, Hugh. "The Mature Style of Quinten Massys." Ph.D. diss., New York University: 146–148, 222–223, pl. 26a.

1962 Mirimonde, A.P. de. "Jan Massys dans les musées de province français." *GBA* 6^e pér. 60: 555–556, fig. 10.

1962 Puyvelde, Leo van. *La Peinture flamande au siècle de Bosch et Brueghel*. Paris: 301.

1963 *Le Siècle de Bruegel*. Exh. cat. Musées Royaux des Beaux-Arts de Belgique. Brussels: 133, no. 168.

1968 Cuttler. *Northern Painting*: 423, fig. 567.

1968 Faggin, Giorgio. *La pittura ad anversa nel Cinquecento*. Florence: 16, fig. 13.

1969 Panofsky, Erwin. "Erasmus and the Visual Arts." *JWCI* 32: 214.

1970 Musée Royal des Beaux-Arts. *Catalogue descriptif. Maîtres anciens*. 3d ed. Antwerp: 160, no. 566.

1970 Virdis, Caterina Limentari. "Moralismo e satira nella tardo produzione di Quentin Metsys." *Storia dell'arte* 20: 21, fig. 2.

1974 Pigler, Andor. *Barockthemen*. 2d ed. 3 vols. Budapest, 2: 568.

1974 Silver, Lawrence. "*The Ill-Matched Pair* by Quinten Massys." *StHist* 6: 105–123, fig. 1.

1975 NGA: 218, repro. 219.

1975 Bosque. (see Biography): 194, fig. 236.

1977 Silver, Larry. "Power and pelf: A new-found *Old man* by Massys." *Simiolus* 9: 68, fig. 7.

1977 Silver, Larry. Review of *Quentin Metsys* by Andrée de Bosque. In *BurlM* 119: 444.

1979 Stewart, Alison. *Unequal Lovers. A Study of Unequal Couples in Northern Art*. New York: 68–71, 146, no. 18, fig. 40.

1980 Briels, J. "Amator Pictoriae Artis. De Antwerpse kunstverzamelaar Peeter Stevens (1590–1668) en zijn Constkamer." *JbAntwerp*: 192–194, fig. 25.

1984 Silver, Larry. (see Biography): 10, 24, 79, 143–145, 223–224. no. 35, pl. 129.

Master of Frankfurt

c. 1460 – active 1520s

The Master of Frankfurt was born in or close to 1460; we know this because his age is given as thirty-six on *The Artist and His Wife* (Koninklijk Museum, Antwerp), which is dated 1496. He was active in Antwerp between 1493 and the 1520s. The master's sobriquet derives from two altarpieces originally located in Frankfurt and it was first thought that he was a German. His style, however, is that of a Netherlander. On the basis of the master's acquaintance with the art of Jan van Eyck and Hugo van der Goes, Friedländer suggested that he came from Ghent, while Hoogewerff stressed the master's associations with Lower Rhenish art. Valentiner proposed that the master was identical with Jan de Vos, who became a member of the Antwerp Guild in 1489; Delen proposed Hendrick van Wueluwe, who entered the Guild in 1483 and died in 1533. The second hypothesis has found a greater degree of acceptance.

Four paintings form the core of the Master of Frankfurt's oeuvre. The *Festival of the Archers* (Koninklijk Museum, Antwerp), was probably painted shortly before 1493 for the Antwerp archer's guild. *The Artist and His Wife* (Koninklijk Museum, Antwerp) is dated 1496. The *Altarpiece of the Crucifixion* (Städel'sches Kunstinstitut, Frankfurt) was probably painted on or shortly before the death of the donor in 1504. The *Altarpiece of the Holy Kindred* (Historisches Museum, Frankfurt), commissioned by the Dominican church in Frankfurt, is dated to c. 1505 because of its proximity to the crucifixion altarpiece. About fifty paintings have been attributed to the Master of Frankfurt with varying degrees of certainty.

The Master of Frankfurt was a skilled and talented painter whose early works are essential to an understanding of the state of painting in Antwerp at the end of the fifteenth century, about which there is a paucity of hard information. His later pictures show an ability to incorporate the stylistic and compositional devices of his younger and more progressive compatriots.

J.O.H.

Bibliography
Friedländer. Vol. 7. 1929 (vol. 7, 1971).
Hoogewerff, G. J. *De Noord-Nederlandsche Schilderkunst.* 5 vols. The Hague, 1939, 3: 19–25.
Valentiner, W. R. "Jan de Vos, The Master of Frankfurt." *AQ* 7 (1945): 197–215.
Delen, A. J. J. "Wie was de 'Meester van Frankfort?' *Miscellanea Leo van Puyvelde.* Brussels, 1949: 74–88.
Goddard, Stephen. "The Master of Frankfurt and his Shop." Ph.D. diss., University of Iowa, 1983.
Goddard, Stephen. "Documents Concerning Hendrik van Wueluwe." *JbAntwerp* (1983): 33–52.
Goddard, Stephen. "The Man with a Rose, a new attribution to the Master of Frankfurt (Hendrik van Wueluwe reconsidered)." *JbAntwerp* (1983): 53–83.

1976.67.1 (2701)

Saint Anne with the Virgin and the Christ Child

c. 1511/1515
Oak (cradled), 73.5 x 57.5 (28 15/16 x 22 10/16)
 painted surface: 72.5 x 56.7 (28 9/16 x 22 6/16)
Gift of Mr. and Mrs. Sidney K. Lafoon

Technical Notes: The painting, composed of two boards, was restored in 1979–1981 and is now in secure condition. Numerous small losses have been inpainted, and extensive losses in Saint Anne's green robe as well as the gold cloud that surrounds God the Father have been repainted.[1]

Examination with infrared reflectography reveals large amounts of underdrawing in the figures. The manner of underdrawing in the drapery (fig. 1) is somewhat different than that in the faces and hands. There are changes in the position of Saint Anne's and the Virgin's hands and in the heads of the Christ Child and the Virgin. The absence of major pentimenti suggests that changes were made at the drawing stage.[2]

Provenance: Private collection, Budapest. Mr. and Mrs. Sidney K. Lafoon, Washington, by or shortly before 1954.

SEATED IN A LANDSCAPE are Saint Anne, the Christ Child, and the Virgin. Above the Christ Child are the dove of the Holy Ghost and the figure of God the Father. In the distance lie a harbor and fortified buildings. The combination of Saint Anne, the Virgin,

and the Christ Child, known in German as *Anna Selb-dritt*, forms an iconographic unit that was enormously popular in northern Europe in the late fifteenth and early sixteenth centuries. This popularity was due in part to the fact that the devotion to Saint Anne paralleled the doctrine of the Immaculate Conception of the Virgin, which became part of the liturgy in the late fifteenth century.[3]

The countless images of the *Anna Selbdritt* grouping produced in Germany and the Netherlands may be divided into two compositional types. The first may be called hieratic and shows a monumental figure of Anne holding the Virgin and Child in her lap or with the Virgin seated at her feet. Saint Anne's status as the mother of the Virgin is emphasized. A good example is the center panel of the *Saint Anne Altarpiece* by Gerard David and workshop (1942.9.17, q.v.). *Saint Anne with the Virgin and the Christ Child* exemplifies the second type, which might be called trinitarian. Here Saint Anne and the Virgin are nearly equal in size and importance and the Infant Christ is held between them. Anne and Mary share in the care and instruction of Christ. It is interesting that this grouping is juxtaposed to the traditional triumvirate of Father, Son, and Holy Ghost that is presented vertically.

There is no mention of *Saint Anne with the Virgin and the Christ Child* in the literature and no record of it having been exhibited prior to its entering the National Gallery of Art. Nonetheless, there is little doubt that this is a fine and typical work by the Master of Frankfurt. The attribution is based primarily on the proximity to one of the master's canonical works, the *Altarpiece of the Holy Kindred* (fig. 2) of c. 1505 in the Historisches Museum, Frankfurt. The gentler and

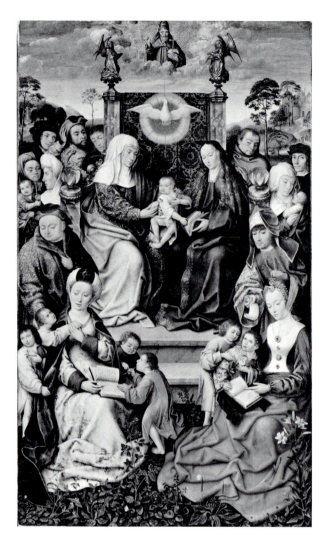

Fig. 2. Master of Frankfurt, center panel of the *Altarpiece of the Holy Kindred*, Frankfurt, Historisches Museum [photo: Historisches Museum]

Fig. 1. Infrared reflectogram assembly of a detail of *Saint Anne with the Virgin and the Christ Child*, 1976.67.1 [infrared reflectography: Molly Faries]

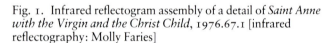

more softly modeled facial types reflect the influence of younger, more progressive artists working in Antwerp. In particular, the face of the Virgin is very close to the feminine visages of Joos van Cleve in the period around 1511 and her robe recalls those worn by Quentin Massys' Madonnas.[4] I date *Saint Anne with the Virgin and the Christ Child* to c. 1511–1515, while Goddard places it among the late works, c. 1518.[5]

Although there are no replicas of the Gallery's painting, the composition was used several times by the Master of Frankfurt and his shop. The center panel of a triptych in the Bode-Museum, East Berlin, is particularly close, though it seems to be a product of the workshop.[6]

J.O.H.

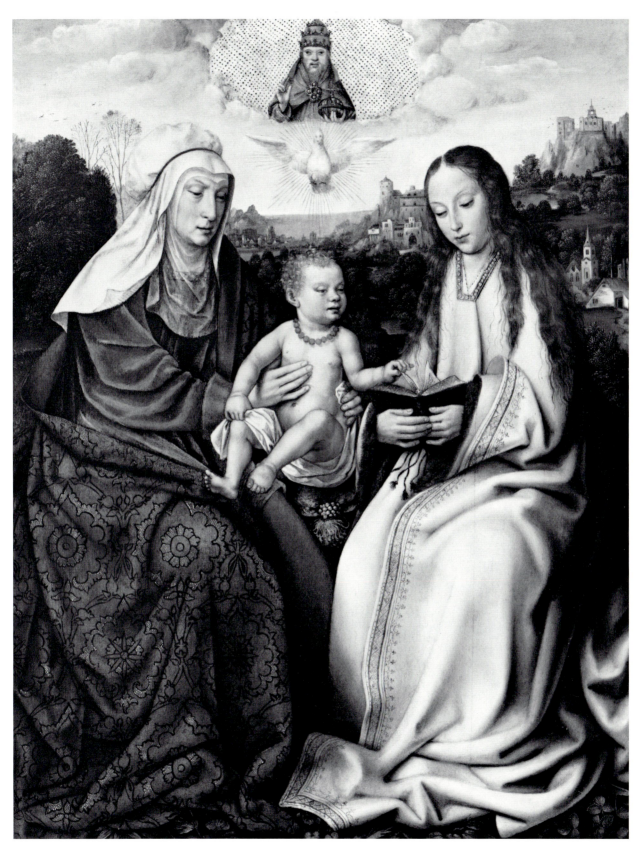

Master of Frankfurt, *Saint Anne with the Virgin and the Christ Child*, 1976.67.1

Notes

1. Hoenigswald 1982, 55–62. The painting was restored at least twice in the past and a memorandum of a conversation between Arthur Wheelock, curator of northern baroque painting at the Gallery, and Mr. and Mrs. Sidney Lafoon on 30 June 1976 in curatorial files mentions the restoration by Harold Cross in 1955.

2. Hoenigswald 1982, 56.

3. Hand 1982, esp. 48–50, and accompanying notes which give bibliography on the iconography of Saint Anne.

4. Hand 1982, 47–48.

5. Hand 1982, 48; Goddard 1983, 110–111, 389, no. 78.

6. Friedländer, vol. 7 (1971), no. 130, pl. 102, as the Master of Frankfurt; the center panel is reproduced in Hand 1982, pl. 9.

References

1982 Hand, John Oliver. "*Saint Anne with the Virgin and the Christ Child* by the Master of Frankfurt," *StHist* 12: 43–52, figs. 1, 6.

1982 Hoenigswald, Anne. "*Saint Anne with the Virgin and the Christ Child*. Technical Investigation and Treatment." *StHist* 12: 55–65, figs. 1–8.

1983 Goddard. (see Biography): 110–111, 153–154, 389, no. 78, fig. 136.

Master of the Prado *Adoration of the Magi*

active probably third quarter of the fifteenth century

Hulin de Loo first isolated the work of this painter from the general production of Rogier van der Weyden's workshop, hypothesizing that it was by the young Hans Memling while a member of Rogier's shop. However, the paintings attributable to this hand, five scenes from the infancy of Christ in Madrid, Washington, Birmingham, and Glasgow and another scene from the life of Saint Francis whose present whereabouts are unknown, are instead by a contemporary of Memling. This painter may indeed have belonged to Van der Weyden's workshop, since his paintings display a familiarity with Rogier's mature work, particularly the Columba altarpiece now in the Alte Pinakothek, Munich. He must have been of the same generation as Memling and the Master of the Saint Catherine Legend, the latter very possibly identical with Rogier's son Pieter van der Weyden. His paintings employ many of the motifs found in their paintings. He has here been named after *The Adoration of the Magi* in the Prado, which formed the centerpiece of Hulin de Loo's group of attributed works and is itself based on the central panel of the Columba altarpiece.

M.W.

Bibliography
Hulin de Loo, Georges. "Hans Memlinc in Rogier van der Weyden's Studio." *BurlM* 52 (1928): 160–177.
Friedländer, Max J. "Ein Jugendwerk Memlings." *Pantheon* 7 (1931): 185–186.

1961.9.28 (1389)

The Presentation in the Temple

c. 1470/1480
Oak, 59 x 48.1 (23 4/16 x 18 15/16)
 painted surface: 57.9 x 47.8 (22 13/16 x 18 13/16)
Samuel H. Kress Collection

Technical Notes: The panel is composed of two vertical members with a join approximately 18 cm from the left edge. There are unpainted edges at top and bottom and on the right side. The left side has been cut and a narrow strip affixed at the edge. It is not clear how much, if any, of the design has been cut off at this side. The back of the panel is covered by a thin layer of wax. Removal of a small area of wax indicated that the panel has probably been thinned. The back of the panel appears to be beveled on all sides except on that corresponding to the front right edge.

Both architecture and figures are prepared with free, angular underdrawing in what appears to be black chalk, and guidelines for the architecture at the left are incised into the ground. The paint surface is in excellent condition, with only a few small areas of loss and little abrasion.

Provenance: Count Johann Rudolf Czernin von Chudenitz, Vienna, by 1823 [d. 1845].[1] The counts Czernin, Vienna. Count Eugen Czernin von Chudenitz, Vienna, until about 1954. (Georges Wildenstein and Co., New York, by 1954.) Samuel H. Kress, New York, 1955.

Exhibitions: Vienna, Wiener Secession, 1930, CX. *Ausstellung der Vereinigung bildender Künstler Wiener Secession: Drei Jahrhunderte vlämische Kunst 1400–1700*, no. 31.

AS RECOUNTED in Luke 2:22–38, after the birth of Christ, Mary and Joseph traveled to the Temple in Jerusalem in order to accomplish the ritual of purification after childbirth and to present their firstborn son to the Lord as required by the law of Moses.[2] In the Temple they encountered the aged and devout Simeon, who recognized the Christ Child as the Messiah, as did the prophetess Anna. Simeon is shown taking the Christ Child from the Virgin, who offers him at the altar, while the prophetess Anna raises her hand in wonder. Joseph holds a basket with the pair of doves, which were the offering required to redeem a firstborn son. One of the fashionably dressed girls holds a candle in honor of the Purification of the Virgin.[3]

The Presentation in the Temple is very often included in narrative cycles devoted to the Virgin or the infancy of Christ. The architectural setting and the placement and characterization of the figures in the Gallery's painting derive from Rogier van der Weyden's Columba altarpiece in the Alte Pinakothek, Munich.[4] The relationship to the Columba altarpiece was recognized in 1841 by Passavant.[5] In his catalogue of Van der Weyden's paintings, Friedländer attributed the *Presentation* to an excellent follower working about 1470, who developed in parallel with Memling.[6] In 1928 Hulin de Loo noted that two other panels, an *Adoration of the Magi* in the Prado (fig. 1) and a fragmentary

Annunciation now in the Burrell Collection, Glasgow (fig. 2), were related in size and style and similarly dependent on the Columba altarpiece, and he linked them with the *Presentation* as parts of a portable altarpiece devoted to the infancy of Christ.[7] He considered that the variations on Rogier's prototype in all three panels pointed toward Memling's compositions and that the two fashionably dressed girls in the *Presentation* were painted with particular elegance and sensitivity. Hence he concluded that the presumed infancy altarpiece was the work of Memling while still in Rogier's workshop and that the figures in contemporary dress were added by Rogier himself. This conclusion has been widely accepted, though there has been some disagreement on the attribution of the two girls to Rogier.[8] Hulin's hypothesis would place the panels by or about 1464, the year of Rogier's death. To this group of three infancy scenes, Friedländer added a *Nativity* now in the Birmingham City Museums and Art Gallery (fig. 3) and a *Rest on the Flight into Egypt*, also in the Burrell Collection (fig. 4).[9]

A re-examination of these five panels shows that Hulin de Loo's attribution of the group to the young Memling cannot be supported. Nor is it necessary to explain the portrait figures by the intervention of another hand, let alone that of Rogier van der Weyden.

Instead the five panels seem to be the work of a talented southern Netherlandish painter active in the last third of the century and strongly influenced by Rogier van der Weyden. He probably knew the work of Memling and was in contact with the Master of the Saint Catherine Legend, the latter possibly identical with Rogier's son Pieter van der Weyden. The connections to Memling are found mostly in details, such as the shape of the basket carried by Joseph in the *Presentation* or the facial type of the black magus in the *Adoration*.[10] However, the *Rest on the Flight*, a subject not found in the surviving oeuvre of Van der Weyden, is clearly related to the tiny vignette in Memling's *Seven Joys of the Virgin* in Munich.[11] Connections with the Master of the Saint Catherine Legend include the floor tiles in the *Presentation* and the landscape to the right of the Virgin's head in the Prado *Adoration*, as well as certain similarities in the drawing of the figures noted below.[12] I know of only one other painting apparently by the same hand, a panel depicting an episode from the life of Saint Francis formerly in a Belgian private collection.[13] Others may come to light as Van der Weyden's workshop practice and legacy are studied in greater depth.

Although there is no documentary evidence concerning Memling's training or artistic activity before he established himself in Bruges in 1465, it is presumed

Fig. 1. Master of the Prado *Adoration of the Magi*, *Adoration of the Magi*, Madrid, Prado [photo: Prado]

Fig. 2. Master of the Prado *Adoration of the Magi*, *Annunciation*, Glasgow, Burrell Collection

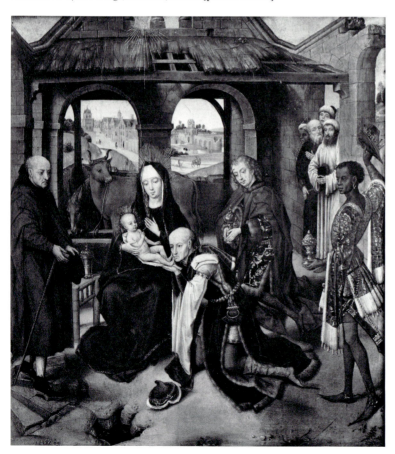

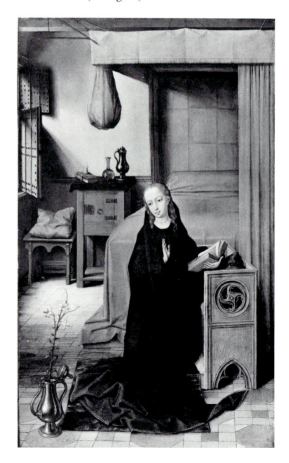

Master of the Prado *Adoration of the Magi, The Presentation in the Temple*, 1961.9.28

Fig. 3. Master of the Prado *Adoration of the Magi, Nativity*, Birmingham, Birmingham City Museum and Art Gallery [photo: By permission of the Birmingham City Museum and Art Gallery]

Fig. 4. Master of the Prado *Adoration of the Magi, Flight into Egypt* Glasgow, Burrell Collection

that he was associated with Rogier van der Weyden before the latter's death in 1464.[14] In any case, Memling's earliest datable work, the *Last Judgment* altarpiece in Gdansk, completed by early 1473, reveals both a knowledge of Van der Weyden's compositions and a suave style already consistent with the younger master's mature works.[15] This style cannot be reconciled with the group of paintings outlined above. In contrast to the fine brushstrokes found in the work of Memling and of some of Van der Weyden's followers, this group is characterized by a relatively expressive application of paint. Architecture is quite freely painted so that the ground layer shows through in many areas, while some details, such as the edges of bricks, are strongly highlighted. Skies are brushed in with thick strokes perpendicular to the horizon.[16] Facial features and hands are frequently emphasized by a dark contour line. The underdrawing, too, is angular and forceful (fig. 5).[17] The large heavy-lidded eyes and tapering knobby fingers favored by this painter also suggest an effort to achieve a stronger expression.

In spite of the evident stylistic relationship among the five infancy scenes and the repetition of settings and types such as that of Saint Joseph, some slight differences are detectable among them. In comparison to the other three panels, the *Adoration of the Magi* and the

Rest on the Flight into Egypt are somewhat more tightly worked up and more precious in their figure types, particularly that of the Virgin. While this could be explained by the participation of another artist, it seems to me more likely that the paintings are the results of different stages of the same artist's development.

The panels do not necessarily come from a single altarpiece. Their dimensions are similar, though the *Annunciation* has been cut at the left and the *Presentation* probably also trimmed slightly at the left. The backs of the panels do not provide a sure guide to their original arrangement, since the reverse of the Birmingham *Nativity*, painted to simulate marble, is the only one which appears to be undisturbed.[18] Nevertheless, the *Nativity* and the *Presentation* may well have formed part of the same ensemble because both contain figures of donors added over the background. The younger girl in the Gallery's *Presentation* was painted over the architecture, as is clear from the x-radiograph and from infrared reflectography (fig. 5). Her companion was part of the underdrawn design, but probably not as a figure in contemporary dress; her underdrawn veil and projecting headdress resemble those worn by the maid in the corresponding scene from Rogier's Columba altarpiece.[19] The x-radiograph of the Birming-

Fig. 5. Infrared reflectogram assembly of a detail of *The Presentation in the Temple*, 1961.9.28 [infrared reflectography: Molly Faries]

Fig. 6. Master of the Prado *Adoration of the Magi, Nativity*, x-radiograph of a detail, Birmingham City Museum and Art Gallery [photo: By permission of the Birmingham City Museum and Art Gallery]

ham painting shows that the lady behind Joseph was added over the landscape (fig. 6). Her elegant costume with its crisply pleated veil, now overpainted with a nondescript brown habit, must have been a close counterpart to that of the two girls in the *Presentation*. That these figures are indeed donors is confirmed by what appears to be the tip of the lady's praying hands visible above Joseph's shoulder in the x-radiograph. The distinctive character of these portrait figures as signaled by Hulin de Loo is thus explained by their being inserted in a more conventional narrative. If the Washington and Birmingham panels do indeed come from the same altarpiece, it may have been a triptych, perhaps including the *Annunciation* in Glasgow as the left wing.

The Gallery's *Presentation* should probably be dated about 1470 or perhaps a little later, based on such elements of the girls' costume as the flat laced bodice of the younger girl and the wide constricting belt of the elder.[20] Moreover, the brittleness with which the figure of Simeon is drawn and the caricatured quality of his flat profile are akin to the work of the Master of the Saint Catherine Legend[21] and other Brussels painters in the generation after the death of Rogier van der Weyden.

M.W.

Notes

1. Böckh 1823, 294–295. I have been unable to find the basis for the statement made by Eisler 1977, 59–60, that Czernin probably purchased the painting from Edward Solly.

2. See Dorothy C. Shorr, "The Iconographic Development of the Presentation in the Temple," *AB* 28 (1946), 17–32.

3. For the Church's commemoration of these events, celebrated in the Western church on 2 February, the feast of Candlemas, see Shorr 1946, 18–19.

4. Friedländer, vol. 2 (1967), 69–70, 100, no. 49, pls. 70, 72.

5. Passavant 1841, 19. I am grateful to Lorne Campbell for bringing this reference to my attention. Waagen 1847, 186, first linked the painting to Memling, but later (1866, 1: 306) considered it to be a workshop copy after Rogier's great altarpiece, an opinion repeated by Crowe and Cavalcaselle 1872, 219, and Voll 1906, 287.

6. Friedländer, vol. 2 (1924), 119, no. 85 (1967, 77, 101, no. 85). He had earlier related it stylistically to the 1473 triptych of Jan de Witte now in Brussels; Friedländer 1903, 14.

7. Hulin de Loo 1928, 160–177. For these two panels, see Friedländer, vol. 6a (1971), 15–16, 57, nos. 99A and C. The Prado *Adoration of the Magi*, no. 1558, from the Escorial, measures 59.5 x 54.6 cm. The *Annunciation*, first mentioned in the Wynn Ellis collection (see Wells 1975, 13, no. 5), has been cut at the left and now measures 58.4 x 35.5 cm (painted surface). For a cleaned state photograph showing the hand and scepter of Gabriel, see Friedländer [1947], 3.

8. Those who accept the Memling attribution include: Friedländer, vol. 6 (1928), 18–20, no. 99, and vol. 14 (1937), 102 (vol. 6a, 1971, 15–16, 36, 57); Glück 1930, 77; Baldass 1930, 132, considering the *Presentation* to be the work of one hand (in 1942, 39–40, Baldass seemed to question the panels' place in Memling's early work); Vollmer 1930, 375; Destrée 1930, 163; exh. cat., Bruges 1939, 65–66, under no. 21; Kress 1956, 128, 130, questioning the attribution of the girls to another hand; Seymour 1961, 63–64; Walker 1964, 102; Corti and Faggin 1969, 93, and Deroubaix 1978/1979, 157–158.

De Tolnay 1941, 200, attributed the *Presentation* to Vrancke van der Stockt. Hull 1981, 96, 131, considered that the author of the panels knew the works of both Rogier and Memling. Davies 1972, 228, expressed some reservations about the attribution, as did Eisler 1977, 57–60, who nevertheless concluded that the *Presentation* "may be the first known work of Memling."

9. For the *Rest on the Flight*, see Friedländer, vol. 6 (1928), 21, 122, no. 32, and 1931, 185–186, sold with the Schiff collection, Paris, 1905. The panel measures 59.7 x 51.7 cm. For Friedländer's attribution of the *Nativity* to this group, see Thos. Agnew & Sons, Ltd, *The Heathcoat Amory Collection* [exh. cat. The Fermoy Art Gallery] (King's Lynn, 1965), no. 1. The panel measures 58.4 x 49.5 cm.

10. Hulin de Loo enumerated these connections, 1928, 165–172.

11. Friedländer, vol. 6a (1967), 50, no. 33, pls. 82, 84. Memling's panorama also includes the miracle of the wheatfield, shown in the distance of the Glasgow *Rest on the Flight*.

12. On the Master of the Saint Catherine Legend, see Deroubaix 1978/1979, 153–172. I am grateful to Lorne Campbell for bringing this reference to my attention. The floor tiles in the *Presentation* also appear, for example, in the Master of

the Saint Catherine Legend's *Annunciation* in Florence, in the Louvre *Annunciation* attributed to Rogier, and in several Madonnas by Memling and his school; Deroubaix, 160. The section of the landscape with a ruined city wall also occurs in an *Adoration of the Magi* by the Master of the Saint Catherine Legend, Deroubaix, fig. 5.

13. Photo A.C.L. A48398; repro. Patrick de Winter, "A Book of Hours of Queen Isabel la Católica," *BCMA* 67 (1981), fig. 164.

14. See Rogier van der Weyden and Hans Memling Biographies.

15. The altarpiece was en route to Florence in April of 1473 when it was seized by ships of the Hanseatic League and carried off to Gdansk. The inscription on one of the tombstones, *IC IAC . . . ANNO DOMI[NI] CCC LXVII* has been interpreted as containing a reference to the year 1467, possibly connected with the altarpiece's execution; see Jan Białostocki, *Primitifs flamands. Corpus. Les Musées de Pologne* (Brussels, 1966), 55–123, pls. LXXX–CCXXXI, and K. B. McFarlane, *Hans Memling*, ed. Edgar Wind (Oxford, 1971), esp. 25–27.

16. X-radiographs show that in both the *Adoration* and *Nativity* the distant buildings have been brought up over the rather untidy edge of the sky.

17. The Prado *Adoration* is the only other painting of the group for which reflectograms were available. They are markedly close to those of the *Presentation* in the way the architecture, faces, and other elements are underdrawn and in the forceful, angular strokes. For underdrawing in paintings by Memling, see under 1937.1.41, *Madonna and Child with Angels*, n. 12, fig. 2, and 1952.5.46, *Saint Veronica*, figs. 1–2.

18. There are some traces of what appears to be a white ground layer on the back of the *Annunciation*, as well as patches of red and green paint that could be part of an original paint layer. The back is also beveled, including the trimmed edge. The *Rest on the Flight* is cradled. The *Presentation* has apparently been thinned (see Technical Note). The back of the *Adoration*, which has what appears to be a relatively recent bevel all around, is covered by a thin buff-colored layer, evidently not original. Visible where this has been scratched away is a dark reddish brown preparation, which may or may not share the marbleized effect of the Birmingham panel.

Evelyn Silber and Stewart Meese of the Birmingham City Museums and Art Gallery, Richard Marks of the Burrell Collection, Hugh Stephenson of the Glasgow Art Gallery and Museum, and María del Carmen Garrido of the Museo del Prado provided much kind assistance in connection with the panels in their care, for which I am very grateful.

19. See n. 4 and also the Magdalene in Rogier's Braque triptych; Friedländer, vol. 2 (1967), 65–66, no. 26, pls. 47–48.

The man whose head and shoulders alone are visible at the right was probably also added during the course of work, though the indications are less clear here. Although his head is apparently not underdrawn, what look like underdrawn lines for the column behind him run through his right cheek.

20. This type of square-necked dress with front lacing may have been a fashion primarily for children; Margaret Scott, *The History of Dress Series. Late Gothic Europe 1400–1500* (London, 1980), 186–189. In a letter of 29 June 1982, in the curatorial files, she notes that the few examples that she has found of "this type of dress, on girls and women,

do tend to point to the 1470s, or even into the 1480s"; she cites Van der Goes' Portinari altarpiece and Memling's Donne triptych, Reyns triptych dated 1480, Moreel triptych in Bruges, and the Saint Ursula shrine (see her figs. 122, 123, 127 and Friedländer, vol. 6a [1971], pls. 21, 72, 77). She compares the cut of the elder girl's bodice and belt to those of the wife in the triptych of Jan de Witte in Brussels, dated 1473 (her fig. 121).

21. Compare the elderly men in the Master of the Saint Catherine Legend's Bruges *Last Supper*; *Anonieme Vlaamse Primitieven* [exh. cat. Groeningemuseum] (Bruges, 1969), 89–90, no. 40, repro. opp. 88.

References

1823 Böckh, Franz Heinrich. *Merkwürdigkeiten der Haupt- und Residenz-Stadt Wien und ihrer nächsten Umgebungen; ein Handbuch für Einheimische und Fremde.* 2 vols. Vienna, 1: 295.

1841 Passavant, J. D. "Beiträge zur Kenntniss der altniederländischen Malerschulen des 15ten und 16ten Jahrhunderts." *Kunstblatt* no. 5: 19.

1847 Waagen, Gustav Friedrich. "Nachträge zur Kenntniss der altniederländischen Malerschulen." *Kunstblatt* no. 47: 186.

1866 Waagen, Gustav Friedrich. *Die vornehmsten Kunstdenkmäler in Wien.* 2 vols. Vienna, 1: 306, no. 27.

1872 Crowe, J. A., and G. B. Cavalcaselle. *The Early Flemish Painters: Notices of their Lives and Works.* 2d ed. London: 219.

1889 Leprieur, Paul. "Des répliques de l'Adoration des Mages d'Utrecht." *La Chronique des Arts et de la Curiosité* no. 40: 316.

1903 Friedländer, Max J. *Meisterwerke der niederländischen Malerei des XV. u. XVI. Jahrhunderts auf der Ausstellung zu Brügge 1902.* Munich: 14.

1906 Voll, Karl. *Die altniederländische Malerei von Jan van Eyck bis Memling.* Leipzig: 287.

1908 *Katalog der Graf Czernin'schen Gemälde-Galerie in Wien.* Vienna: 5, no. 27.

1924 Friedländer. Vol. 2: 119, no. 85 (vol. 2, 1967: 77, 101, no. 85, pl. 106).

1928 Hulin de Loo, Georges. "Hans Memlinc in Rogier van der Weyden's Studio." *BurlM* 52: 160–177, pls. III B, IV A.

1928 Kaines Smith, S. C. "An Isenbrant for Birmingham." *BurlM* 53: 243.

1928 Friedländer. Vol. 6: 18–20, 133, no. 99B (vol. 6a, 1971: 15–16, 57, no. 99B, pl. 125).

1930 Glück, Gustav. "Drei Jahrhunderte vlämischer Kunst." *Belvedere* 9: 77, fig. 50.

1930 Eisler, Max. "The Exhibition of Three Hundred Years of Flemish Art in Vienna." *Apollo* 11: 188–189.

1930 Baldass, Ludwig. "Drei Jahrhunderte flämische Malerei." *Pantheon* 5: 132, repro. 131.

1930 V[ollmer], H[ans]. "Memling." In Thieme-Becker 24: 375.

1930 Destrée, Jules. *Roger de la Pasture - Van der Weyden.* 2 vols. Paris and Brussels, 1: 162–163, pl. 110.

1931 Friedländer, Max J. "Ein Jugendwerk Memlings." *Pantheon* 7: 186.

1933 Museo del Prado. *Catálogo de las Pinturas.* Madrid: 400–401.

1936 Wilczek, Karl. *Katalog der Graf Czernin'schen Gemäldegalerie in Wien.* Vienna: 100–101, no. 27, fig. 18.

1937 Friedländer. Vol. 14: 102, no. 99.

1938 Hulin de Loo, Georges. "Rogier van der Weyden." In *Biographie Nationale de Belgique.* 29 vols. Brussels, 27: col. 241.

1939 *Exposition Memling.* Exh. cat. Musée Communale. Bruges: 65–66.

1941 Tolnay, Charles de. "Flemish Paintings in the National Gallery of Art." *MagArt* 34: 200.

1942 Bergmans, Simone. "Visages du passé." *Apollo. Chronique des beaux-arts* no. 12: 5–8.

1942 Baldass, Ludwig von. *Hans Memling.* Vienna: 40.

[1947] Friedländer, Max J. *Memling.* Amsterdam: 10–11.

1952 Bergmans, Simone. *La peinture ancienne, ses mystères, ses secrets.* Brussels: 86–87.

1953 Panofsky. ENP: 479.

1956 Kress: 11, 128, 130, repro. 129, 131.

1956 Walker, John. "The Nation's Newest Old Masters." *National Geographic Magazine* 110, no. 5: not paginated, repro.

1960 *Flanders in the Fifteenth Century: Art and Civilization.* Exh. cat. The Detroit Institute of Arts: 139.

1961 Seymour, Charles, Jr. *Art Treasures for America.* London: 63–64, 213, pls. 57, 58.

1962 Neugass, Fritz. "Die Auflösung der Sammlung Kress." *Die Weltkunst* 32, no. 1: 4.

[1964] Walker: 102, repro. 103.

1965 Thos. Agnew & Sons Ltd. *The Heathcote Amory Collection.* Exh. cat. The Fermoy Art Gallery. King's Lynn: 5.

1969 Corti, Maria, and Giorgio T. Faggin. *L'opera completa di Memling.* Milan: 93, no. 17, repro.

1972 Davies, Martin. *Rogier van der Weyden.* London: 228.

1975 Biermann, Alfons W. "Die Miniaturenhandschriften des Kardinals Albrecht von Brandenburg (1514–1545)." *Aachener Kunstblätter* 46: 63, 273.

1975 NGA: 232, repro. 233.

1975 [Wells, William]. *Treasures from the Burrell Collection.* Exh. cat. Hayward Gallery. London: 13.

1977 Eisler: 57–60, figs. 52, 53.

1978/1979 Deroubaix, Christiane. "Un triptych du Maître de la Légende de Sainte Catherine (Pieter van der Weyden?) reconstitué." *BInstPat* 17: 157–158, 160, 166–168.

1981 Hull, Vida Joyce. *Hans Memlinc's Paintings for the Hospital of Saint John in Bruges.* New York and London: 96, 131.

1981 Winter, Patrick M. de. "A Book of Hours of Queen Isabel la Católica." *BCMA* 67: 408, 427, fig. 95.

Master of Saint Giles

active c. 1500

The Master of Saint Giles takes his name from two paintings in the National Gallery, London, *Saint Giles and the Hind* and the *Mass of Saint Giles*. These and the two panels in Washington, *Episodes from the Life of a Bishop Saint* and the *Baptism of Clovis* (1952.2.14 and 15), are sections of a dismembered altarpiece and together form the basis for reconstruction of the painter's oeuvre. Details of costume in the altarpiece sections indicate that the work dates from about 1500. References to Parisian sites suggest that it was made in Paris. The meticulous rendering of texture and light in the paintings attributable to this master has been cited as evidence of his Netherlandish background. More specific Netherlandish connections include his adaptation, in Madonnas in the Lehman Collection, New York, and the Musée des Beaux-Arts, Besançon, of Madonna types developed by Rogier van der Weyden. He was also the author of a portrait of Archduke Philip the Fair in the Sammlung Oskar Reinhart, Winterthur, which appears to be the original version of one of the most common portrait types of this prince. Nevertheless it is not clear whether the Master of Saint Giles was a French painter with Netherlandish training or a Netherlander who emigrated to France.

The surviving paintings attributed to him may have been produced in a relatively short time span. Comparison of the four altar panels in London and Washington shows that he worked with the help of an assistant in the case of the *Episodes from the Life of a Bishop Saint* (1952.2.14). Some paintings, notably the two saints in the Abegg Stiftung, Bern, are characterized by more massive, simple forms, which may be more pronouncedly French.

The work of the Master of Saint Giles, like that of Michel Sittow, the Master of Moulins, or, in part, of Joos van Gent, represents an international extension of the Netherlandish school.

M.W.

Bibliography

Tschudi, Hugo von. "London. Die Ausstellung altniederländischer Gemälde im Burlington Fine Arts Club." *RfK* 16 (1893): 105–106.

Friedländer, Max J. "Der Meister des hl. Ägidius." *Amtliche Berichte aus den königl. Kunstsammlungen* 34 (1912/1913): 187–189.

Friedländer, Max J. "Le Maître de Saint Gilles." *GBA* 6ᵉ pér. 17 (1937): 221–231.

Master of Saint Giles and Assistant

1952.2.14 (1097)

Episodes from the Life of a Bishop Saint

c. 1500
Oak (cradled), 63.2 x 47.5 (24⁷/₈ x 18¹¹/₁₆)
 painted surface: 61.5 x 47 (24¹/₄ x 18¹/₂)
Samuel H. Kress Collection

Inscriptions:
Inscribed under paint layer on wall of Hôtel-Dieu at right:
 [L?]oste . .

Technical Notes: The panel has two vertical joins approximately 19 and 30 cm from the left margin. It was thinned and cradled sometime before 1937. There are no traces of the grisaille of Saint Giles formerly on the back of the panel.[1] The painting is in general in excellent condition. A few localized losses have been inpainted, notably at the right margin and in the sky between the two gables of the Hôtel-Dieu. Yet, in general there is little abrasion and the brushstrokes appear crisp and precise.

Examination with infrared reflectography showed underdrawing in both the architecture and figures. In the area of the portal, the underdrawn design was quite closely followed by the paint layers, though some perspective lines were also drawn at the level of the buttress figures. The four foreground figures facing the bishop were especially fully underdrawn (fig. 1). In the figures in the middle distance, the underdrawn line was often more readily visible with the naked eye than with infrared reflectography.

Provenance: Chevalier Alexandre de Lestang-Parade, Aix-en-Provence, by 1823.[2] Count Melchior de Lestang-Parade, Aix-en-Provence (sale, Hôtel Drouot, Paris, 19–20 May 1882, nos. 105, 106, as anonymous fifteenth century). Baron E. de Beurnonville, Paris (sale, Hôtel Drouot, Paris, 21–22 May 1883, nos. 43, 44, as Burgundian School, fifteenth century). M. Watel, Paris, 1883.[3] (Paris art market, by 1937.)[4] (Georges Wildenstein and Co., Paris and New York, 1938–1946.) Samuel H. Kress, New York, 1946–1952.

THIS PANEL and 1952.2.15, *The Baptism of Clovis*, together with *The Mass of Saint Giles* and *Saint Giles and the Hind* in the National Gallery, London,[5] are the remains of an altarpiece containing multiple references to French kingship and to the city of Paris. Despite the complex associations of the panels, their meaning remains elusive because of the fragmentary nature of the surviving parts and the unusual selection of details of setting and narrative. The altarpiece as a whole is discussed below in relation to *The Baptism of Clovis*. The identification of these events from the life of a bishop saint presents particular difficulties, however.

A stern-faced bishop is shown standing in front of a cathedral with his hand raised in blessing and his retinue arrayed behind him. Of the crowd before him, the figures in the right foreground are particularly prominent: the man who kneels as a supplicant at the feet of the bishop, the woman who kneels or crouches with her baby, and the boy standing beside her. In the center background a possessed man is cured of a demon. Other figures approach with gestures of amazement or prayer. They include a blind street musician with his youthful guide[6] and a lame man. The simulated sculpture of Saint Giles in an arched niche formerly in the back of this panel does not survive (fig. 2).[7]

The setting for this narrative has long been recognized as the square in front of Notre-Dame in Paris.[8] Julius Held demonstrated the accuracy with which this setting was recorded. He noted that the bishop stands not on the steps of the west front of Notre-Dame itself, but on those of the smaller adjacent church of Saint-Jean-le-Rond, which served as a baptistry. The square building on the right with tracery windows at its corner is the Hôtel-Dieu with its chapel. Both the Hôtel-Dieu and Saint-Jean-le-Rond were still standing in the eighteenth century and are known from engravings.[9] The three west portals of Notre-Dame are shown steeply foreshortened, with a view of the quai along the Seine and the Left Bank visible beyond them.

Held identified the main episode depicted in the Gallery's painting as Saint Remy converting the Arian bishop Genebaut and the subordinate scene in the background as the healing of the possessed blind man of Chermizy.[10] He regarded the white cloth around the head of the kneeling figure as a reflection of the Oriental character of the bishop's Arian heresy. The explanation of the two Washington panels as episodes from the life of Saint Remy and hence pendants to the two Saint Giles scenes in London found general acceptance.[11] However, in 1965 William Hinkle, who did not believe that 1952.2.15 represented the baptism of King Clovis by Saint Remy, suggested that the bishop saint was Saint Loup or Leu of Sens.[12] He pointed out that the feasts of Saint Leu and Saint Giles fall on the same day, 1 September, and that they are the joint

church of Paris, but that this was an appropriate setting for Saint Leu, as Paris was a suffragan see of Sens.[13] He proposed that 1952.2.14 was a votive panel showing children, cripples, and epileptics propitiating Saint Leu, and that it was intended to be displayed separately from the other three surviving panels, probably in the Parisian church of Saint Leu-Saint Gilles.[14]

While the episodes depicted in the Gallery's painting are not inconsistent with the cult of Saint Leu, they are not sufficiently specific in themselves to identify the bishop saint.[15] They might equally apply to Saint Remy, to whom numerous incidents of miraculous healing and eloquent mediation were attributed.[16] It is also possible that the picture represents the conversion of the Parisian nobleman Lisbius by Saint Denis, who was the city's first bishop.[17] Moreover, the nature of the link between the accurately depicted sites and the narratives is not entirely clear from this or from the other surviving panels. Although there are some points of difference between this and the other panels, notably in the type of niche framing the grisaille, there are not sufficient grounds for considering it a separate votive panel to Saint Leu. Dendrochronological examination

Fig. 2. Master of Saint Giles and Assistant, *Saint Giles* (grisaille formerly on the reverse of 1952.2.14) [photo: NGA]

Fig. 1. Infrared reflectogram assembly of detail of *Episodes from the Life of a Bishop Saint*, 1952.2.14 [infrared reflectography: Molly Faries]

patrons of the Parisian church of Saint Leu-Saint Gilles. More specifically, Saint Leu was invoked against the *mal de peur*, or fearfulness in children, and epilepsy, and Hinkel stressed the role of children and possessed people in the crowd. He argued further that Saint Remy would not be depicted outside the metropolitan

Master of Saint Giles and Assistant, *Episodes from the Life of a Bishop Saint*, 1952.2.14

showing that the right boards of both Washington panels came from the same tree makes this all the more unlikely.[18] Unless new information on the lost parts of the altarpiece or its commission comes to light, the identity of the bishop saint cannot be definitely determined.

This picture stands somewhat apart from the other panels because of stylistic differences. For Hinkle these differences resulted from its function as a separate votive panel.[19] However, the more solid forms of *The Episodes from the Life of a Bishop Saint* and the lack of the complex, richly textured surfaces found in the other three panels seem to be due to another painter assisting the Master of Saint Giles. The underdrawing in the foreground figures of the two Washington panels is closely comparable (fig. 1 above and fig. 8 under 1952.2.15), suggesting that the same painter laid in the design. The types and the painting technique of the main figures approximate those of the Master of Saint Giles, particularly in the furrowed face of the bishop and in the way the hands of the bishop and kneeling man are delineated with an angular, brown contour. Yet the handling in general is drier. In the subordinate figures and also in the architecture, a tendency toward smooth, simplified form is evident. Whereas the Master of Saint Giles applied paint with broken fluid strokes, making numerous changes even in the upper paint layers,[20] the brushstrokes here are more precise, employing stippled modeling, and there are no changes in the paint layer. The figures placed far back in the architectural setting typify what must be the difference between two hands: in the *Baptism* a few quick strokes define the man seated in a doorway at the left margin, while in this painting the figures at the distant quai or on the roof of the Hôtel-Dieu are carefully rounded and outlined. The second painter has a more pronouncedly French character, but his adaptations to the style of the Master of Saint Giles in this painting would make it difficult to identify his hand elsewhere.

M.W.

Notes

1. Friedländer 1937, 223, noted that the panels had been recently cradled. The thinness of the panel, .5 cm, makes it most probable that the grisaille was planed away rather than split. The intact panels in London are .7–8 cm thick.

2. [Porte] 1823, 147.

3. According to Champeaux 1883, 187.

4. Friedländer 1937, 223.

5. With Saint Peter and a bishop saint depicted in grisaille on their respective backs. For the London panels, see especially Davies 1945, 71–72 (3d ed. 1968, 107–113), and David Bomford and Jo Kirby, "Two Panels by the Master of Saint Giles," *National Gallery Technical Bulletin* 1 (1977), 49–56.

6. See Hellerstedt 1983, 171, who links the musician and his guide to a tradition of such figures.

7. Splits and joins visible in the photographs of the grisailles formerly on the backs of the Gallery's panels make it clear that the *Saint Giles* was on the back of the *Episodes from the Life of a Bishop Saint* and the *Saint Denis* on the back of *The Baptism of Clovis*.

8. Champeaux 1883, 187.

9. Held 1932, 6–10, fig. 4, and Erlande-Brandenburg and Kimpel 1978, fig. 16. 1952.2.14 has frequently been cited as a document of the original state of the sculpture on the west front of Notre-Dame; see references below.

10. Held 1932, 3.

11. For example, Davies 1939, 27, Seymour 1961, 66, and Réau, *Iconographie*, vol. 3, part 3, 1146, accept Held's identification of the kneeling figure as the Arian bishop. More frequently the scene has been identified in general terms as Saint Remy blessing the people.

12. Hinkle 1965, 130–133. For Saint Leu, see Thurston and Attwater, *Butler's Lives of the Saints*, 3: 459–460; Eugène Grésy, "Iconographie de Saint-Loup empruntée principalement aux monuments de l'art local," *Bulletin de la société d'archéologie, sciences, lettres, et arts du département de Seine-et-Marne* 4 (1867), 65–71; and Réau, *Iconographie*, vol. 3, part 2, 825–826.

13. He correctly pointed out that the cloth wound around the head of the kneeling figure was not an Oriental turban, but a kerchief meant to go under the furry hat that the man has placed on the step. Compare the headgear of the distant man who appears to the left of Clovis' head in *The Baptism of Clovis*, 1952.2.15.

14. See Hinkle 1965, 139–144. He regarded the other three panels as forming a stationary triptych. Other proposals for the arrangement of the four panels are discussed in the following entry. One of the children is probably the blind musician's guide, as Hellerstedt points out; see n. 6 above.

15. It seems probable too that this subject, like the other three surviving panels, represents a specific narrative.

16. For the miracles of Saint Remy, see Thurston and Attwater, *Butler's Lives of the Saints*, 4: 1–3; Richier, *La vie de Saint Remi*, ed. W. N. Bolderston (Oxford, 1912); and William M. Hinkle, *The Portal of the Saints of Reims Cathedral: A Study in Medieval Iconography* (New York, 1965), esp. 44–52.

The four figures in the right foreground may indeed refer to the story of Genebaut, bishop of Laon, who after long penitence received forgiveness through Saint Remy for having fathered two children, aptly named Larron and Volpille, while holding high church office; Richier, *Saint Remi*, 210–226. In a sixteenth-century tapestry in Reims, Genebaut is shown in clerical dress, however; M. Sartor, *Les tapisseries, toiles peintes & broderies de Reims* (Reims, 1912), 146–147, fig. 67.

17. An incident from his life would be appropriate because of the grisaille formerly on the back of *The Baptism of Clovis*. The story of Lisbius' conversion, denunciation by his pagan wife Larcia, and martyrdom is summarized by Hinkle 1965, 118–121. This scene is not among the more frequently illustrated episodes in the life of Saint Denis, however; for illustrated cycles of his life, see Charlotte Lacaze, *The "Vie de Saint Denis" Manuscript (Paris, Bibliothèque Nationale, Ms. fr. 2090–2092)* (New York and London, 1979), 87–122.

18. See Appendix I.

19. Hinkle 1965, 140, 144. He attributed both paintings to the Master of Saint Giles, but felt that this panel showed "a more astringent linear quality and a harsher light and shade, in contrast to the enveloping glazes and softer modelling in the other panels." The distinction he made between the courtly figures of the other three panels and the "contemporary Parisian townspeople" results, I think, from a difference in hand rather than function.

Friedländer 1937, 230, perceived a certain dryness in both panels now in Washington, and Sterling 1942, 51, raised the question of the collaboration of a French assistant in both these panels.

20. See Bomford and Kirby 1977, 49–56, and the following entry.

References

1823 [Porte, Jean-Baptiste-François]. *Aix ancien et moderne, ou Description des Édifices sacrés et profanes, Établissemens, Monumens antiques, du moyen âge et modernes, Bibliothèques, Cabinets, Promenades d'Aix, etc., etc.* Aix-en-Provence: 147.

1841 Gaszynski, C. In *Mémorial d'Aix* (13 June): 2.

1883 Champeaux, Alfred de. "Deux vues de la Cité de Paris au XVe siècle." *La Chronique des Arts et de la Curiosité* no. 23: 186–187.

1907 Reinach, Salomon. *Répertoire de peintures du moyen âge et de la renaissance (1280–1580)* 2 vols. Paris, 2: 665, no. 2, repro.

1912/1913 Friedländer, Max J. "Der Meister des hl. Ägidius." *Amtliche Berichte aus den königl. Kunstsammlungen* 34: 187–188.

1921 Conway, Martin. *The Van Eycks and their Followers.* London: 190.

1931 Lemoisne, P. A. *Die gotische Malerei Frankreichs vierzehntes und fünfzehntes Jahrhundert.* Leipzig: 113.

1932 Held, Julius. "Zwei Ansichten von Paris beim Meister des heiligen Ägidius." *JbBerlin* 53: 3–10, 12, 14, fig. 1.

1934 Jong, Johannes Assuerus Bernardus Maria de. *Architectuur bij de Nederlandsche Schilders vóór de Hervorming.* Amsterdam: 53–54, fig. 47.

1937 Friedländer, Max J. "Le Maître de Saint-Gilles." *GBA* 6e pér. 17: 223–225, 230, figs. 6, 9.

1938 Sterling, Charles. *La peinture française: les primitifs.* Paris: 135, fig. 171.

1938 Dimier, Louis. "Les primitifs français." *GBA* 6e pér. 20: 234–235.

1939 Réau, Louis. *La peinture française du XIVe au XVIe siècle.* Paris: 14, figs. 11, 12.

1939 National Gallery, London. *Supplement to the 1929 Catalogue Including Accessions to the End of 1937.* London: 27.

1942 Sterling, Charles. *Les peintres du moyen âge.* Paris: 51, 64, pl. 141.

1945 Davies, Martin. *National Gallery Catalogues. Early Netherlandish School.* London: 71–72 (2d ed., 1955: 82–83; 3d ed., 1968, 108–109).

1946 Davies, Martin. *Paintings and Drawings on the Backs of National Gallery Pictures.* London: xi.

1949 Ring, Grete. *A Century of French Painting 1400–1500.* London: 33, 230, no. 240b., repro. 25.

1949 Hébert, Michèle. "Les monuments parisiens dans l'oeuvre du Maître de Saint Gilles." *Fédération des sociétés historiques et archéologiques de Paris et de l'Île-de-France. Mémoires* 1: 213–214, 224–231, pl. 10.

1950 "Meister des hl. Agidius." In Thieme-Becker 37: 6–7.

1951 Kress: 15, 186–188, no. 82.

1954 Tietze, Hans. *Treasures of the Great National Galleries.* New York: 117, 123–124.

1959 Réau. *Iconographie.* Vol. 3, part 2: 1146.

1959 Sauerländer, Willibald. "Die kunstgeschichtliche Stellung der Westportale von Notre-Dame in Paris." *Marburger Jahrbuch für Kunstwissenschaft* 17: 22.

1961 Seymour, Charles Jr. *Art Treasures for America.* London: 66–67, 202, 218, fig. 59.

1963 Châtelet, Albert, and Jacques Thuillier. *French Painting from Fouquet to Poussin.* Geneva: 92–93.

1964 Walker: 108, repro. 305.

1965 Hinkle, William M. "The Iconography of the Four Panels by the Master of Saint Giles." *JWCI* 28: 110, 130–133, pls. 19, 21e–f.

1966 Hinkle, William M. "The King and the Pope on the Virgin Portal of Notre-Dame." *AB* 48: 6, 7, fig. 6.

1966 Laclotte, Michel. *Primitifs français.* Paris: 45.

1967 Greenhill, Eleanor S. "The Provenance of a Gothic Head." *AB* 49: 103–104, 106, fig. 15.

1973 National Gallery, London. *Illustrated General Catalogue.* London: 444.

1975 NGA: 224, repro. 225.

1977 Eisler: 239–243, fig. 230, text figs. 53, 54.

1978 Erlande-Brandenburg, Alain, and Dieter Kimpel. "La statuaire de Notre-Dame avant les destructions révolutionnaires." *Bulletin Monumental* 136: 217, 222, 230, 264, fig. 4.

1983 Hellerstedt, Kahren Jones. "The blind man and his guide in Netherlandish painting." *Simiolus* 13: 171, fig. 11.

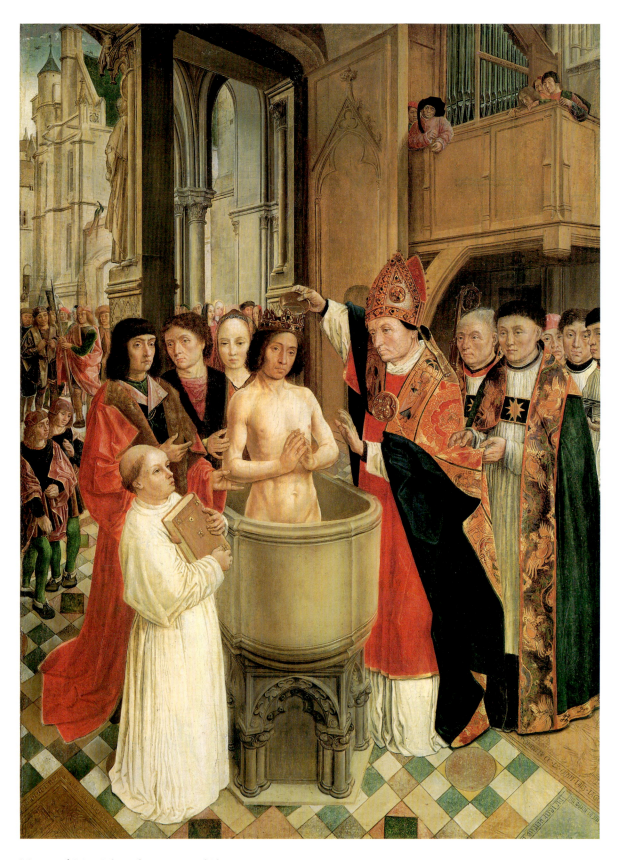

Master of Saint Giles, *The Baptism of Clovis*, 1952.2.15

Master of Saint Giles

active c. 1500

1952.2.15 (1098)

The Baptism of Clovis

c. 1500
Oak (cradled), 63.3 x 46.7 (24⅞ x 18⅜)
 painted surface: 61.5 x 45.5 (24¼ x 18)
Samuel H. Kress Collection

Technical Notes: Like 1952.2.14, the panel was thinned and cradled sometime before 1937, leaving no traces of the grisaille formerly on the back. There are two vertical joins approximately 15 and 30 cm in from the left edge and a split approximately 39 cm from the left edge. These correspond to the joins and split on the grisaille of Saint Denis, presumably destroyed (fig. 1). The paint surface is in good condition. There is some fill and inpainting along the split where it extends down through the head of the priest holding the bishop's robe. There are many scattered small losses in the paint and ground layer, with a larger loss in the lower right corner. Rather extensive abrasion has resulted in the loss or breaking up of some of the fine highlights and transparent glazes in areas such as the heads of the priests at the right and of the king, queen, and man to her left. Two small losses, to the left of the left eye and beside the right eyebrow of the queen, have probably not altered her expression unduly.[1] The somewhat disturbed appearance of the surface is due in part to extraordinarily extensive changes in every area of the painting, including a complete reworking of the setting and a repositioning of the heads of most of the foreground figures. These changes were made at all stages of the painting process, in the underdrawing and in the lower and upper paint layers, and are discussed in the text below.

Provenance: Same as 1952.2.14.

THE BAPTISM OF CLOVIS and 1952.2.14, *Episodes from the Life of a Bishop Saint*, have been together as companion pieces since the early nineteenth century.[2] They originally had figures of a beheaded bishop saint, presumably Saint Denis, and Saint Giles, painted in grisaille on their respective backs (fig. 1 above and fig. 2 under 1952.2.14). The size of the panels, the type of setting, their execution, and the selection of grisaille figures all link them to *Saint Giles and the Hind* and the *Mass of Saint Giles* in the National Gallery, London (figs. 2 and 3),[3] as was first recognized by Salomon Reinach and Max Friedländer.[4] The London panels depict the two best-known episodes from the life of

Saint Giles: the accidental wounding by the hunting party of Wamba, king of the Goths, of the hind whose milk nourished Saint Giles at his hermitage near Arles, and the miraculous pardon of King Charles of France, through the mediation of Saint Giles during the celebration of mass.[5] Different versions of the second episode identify the king as Charles Martel or, anachronistically, as Charlemagne. In the London painting he is identified as Charlemagne by the imperial form of his double-arched crown.[6] These two panels, which were reunited in the National Gallery, London, only in 1933, have grisaille figures of Saint Peter and a bishop saint resembling the main figure in 1952.2.14 on their respective backs (figs. 4, 5). A number of factors, most notably the apparent lack of narrative scenes corresponding to the grisailles of Saint Peter and Saint Denis, suggest that other panels once existed. Although several reconstructions of the altarpiece have been suggested, it is difficult to form a clear idea of its arrangement without the missing sections.

This panel shows the baptism of an adult king by a bishop. A woman stands immediately behind the king, while two courtiers beside her appear to take a more active role in supporting him. The scene is set just inside the doorway of a church, and other courtiers look on from the porch and from the organ loft above. Julius Held first recognized the setting as the Sainte-Chapelle, the chapel attached to the royal palace on the Île-de-la-Cité in Paris.[7] The painting shows a mixture of elements from the upper and lower chapels. Thus the alternating lozenges of fleurs-de-lis and castles on the socle of the trumeau in the painting are those of the lower chapel, which is also the source for the porch opening at ground level. The statue on the trumeau is the blessing Christ from the entrance to the upper chapel, however, not the Madonna and Child from the lower entrance.[8] The height of the window, the attached supports framing it, and the cornice below resemble those of the upper chapel.[9] The underdrawing and first paint layers made visible in infrared reflectography and x-radiography accurately portray the lower chapel, however (figs. 6, 7). Thus, the arcade, which was the first design for the upper right corner of the picture, corresponds to the northwest corner of the lower chapel, rendered precisely as it appears to a person standing within the chapel about ten feet from the portal and opposite the south jamb of the door.[10] The placement of the arcade

Fig. 1. Master of Saint Giles and Assistant, *Saint Denis* (grisaille formerly reverse of 1952.2.15) [photo: NGA]

and the details of capitals and moldings are recorded with a degree of accuracy equal to that of the depiction of Notre-Dame, Paris, in the *Episodes from the Life of a Bishop Saint* and of the royal abbey of Saint-Denis in the *Mass of Saint Giles*. Why the architecture was transformed to approximate the upper chapel is not clear, but perhaps, with its direct access from the palace, this was considered a more appropriate royal setting than the lower chapel.

The portraitlike rendering of architectural settings in three of the panels may well result from the commission rather than from the painter's own tendencies. Setting does not play the same role in any of the other surviving paintings by the Master of Saint Giles.[11]

While the choice of such specific settings must be related to the narratives depicted and to the circumstances of the commission, the precise nature of the connection is unclear. The subject of this panel has usually been interpreted as the baptism of Clovis.[12] This Merovingian king of the Franks was converted through the efforts of his wife Clothilde and Saint Remy, bishop of Reims, who baptized him.[13] He thus became the first Christian monarch of France and, in the eyes of his descendants, the first to enjoy God's

Fig. 2. Master of Saint Giles, *Saint Giles and the Hind*, London, National Gallery [photo: Reproduced by courtesy of the Trustees, The National Gallery, London]

Fig. 3. Master of Saint Giles, *The Mass of Saint Giles*, London, National Gallery [photo: Reproduced by courtesy of the Trustees, The National Gallery, London]

Fig. 4. Master of Saint Giles and Assistant, *Saint Peter* (reverse of *The Mass of Saint Giles*), London, National Gallery [photo: Reproduced by courtesy of the Trustees, The National Gallery, London]

Fig. 5. Master of Saint Giles, *A Bishop Saint* (reverse of *Saint Giles and the Hind*), London, National Gallery [photo: Reproduced by courtesy of the Trustees, The National Gallery, London]

special relationship with the French monarchy. For, according to tradition, at his baptism the chrism required to anoint the royal catechumen was missing, whereupon, at Saint Remy's prayer, a dove bearing a vial of holy oil descended from heaven. The ampoule and holy oil used for the consecration of French kings were claimed to be those miraculously given at Clovis' baptism.[14] Another tradition whereby the fleur-de-lis device was sent to Clovis from heaven through the intermediary of a holy hermit further enhanced his position as a founder of the special privileges of French kings.[15]

William Hinkle has questioned this identification of the subject of the Gallery's painting, since the miracle of the holy ampoule is not depicted here. He suggested that the painting represented instead the baptism of the Parisian nobleman Lisbius by Saint Denis, who was formerly depicted in grisaille on the back of this same panel.[16] While the omission of the dove descending with the holy ampoule is puzzling, the baptism of an adult French king can only represent Clovis. That the catechumen is a king of France is indicated by his crown with its large fleur-de-lis ornaments and flat jewel-studded surface closely resembling the French

coronation crown. It is less accurately portrayed here than is the crown worn by Charlemagne in the London *Mass of Saint Giles*—to which the double arches of the imperial crown have been added—but must nevertheless belong to the same type.[17] While a dove or, more rarely, an angel is usually shown bringing the holy ampoule, a number of other representations of the event lack dove or ampoule.[18] It is possible too that one of the lost panels was devoted to the miracle of the holy chrism.[19] Moreover, in the Gallery's painting it is the cleansing rather than the anointing aspect of the Baptism ritual that is represented.

In this context it is noteworthy that this painting is especially closely linked with the *Mass of Saint Giles*. In both, the interior of a royal church is depicted with a tilted ground plane permitting the inclusion of much historicizing detail. The panels feature Clovis and Charlemagne, both symbols and protectors of the French monarchy and its special relation to God.[20] Both scenes contain references to the canonized Louis IX: his major building project of the Sainte-Chapelle in this painting and the ciborium above his tomb visible behind the high altar in the *Mass of Saint Giles*.[21] These two panels, in particular, with their emphasis on

Fig. 6. Infrared reflectogram assembly of detail of *The Baptism of Clovis*, 1952.2.15 [infrared reflectography: Molly Faries]

the central sacraments of Baptism and the Eucharist, may have expressed the close connection between the king of France, the "most Christian king," and the Church.

The original arrangement of the altarpiece is far from clear, in spite of the links that can be made between the scenes of baptism and communion, between the two episodes from the life of Saint Giles, and between the front and back of the various panels. The grisaille reverses strongly suggest that the altarpiece had movable wings. On none of the panels do the front and the back depict the same saints, and the inclusion of Saint Peter and Saint Denis among the grisaille figures suggests that other, presumably narrative, panels are missing. Although the reverse of the *Episodes from the Life of a Bishop Saint* presents additional difficulties in that it shows Saint Giles in an arched niche with a shallow molding rather than in a plain rectangular niche, it may be significant here that the artist evidently experimented with different arched niches on the reverse of *Saint Giles and the Hind*.[22]

Julius Held suggested that the panels formed two complementary diptychs.[23] Friedländer proposed that the panels flanked the lost middle section of a triptych, with two narrative scenes on each wing.[24] His arrangement did not take into account the arched niche formerly on the back of 1952.2.14. Martin Davies questioned Friedländer's proposal. He felt that the perspective of the niches implied a central position for *Saint Giles and the Hind* and a position on the right-hand side for the *Mass of Saint Giles*, as the figure of Saint Peter on its reverse turns slightly to the right. He first proposed that the two London panels occupied these positions in a triptych with fixed wings, while the Washington panels belonged to a separate altarpiece,[25] but by 1968 gave up this idea, stating that "it seems best to have reserves about all the suggestions put forward so far."[26] In 1965 Hinkle proposed that 1952.2. 14 was a separate votive panel dedicated to Saint Leu while the other three panels made up a triptych with fixed wings.[27] Eisler tentatively suggested six scenes in two registers, allowing for a row of arched niches at the

top, and assuming that the altarpiece was stationary.[28] Given that the ensemble cannot be reconstructed from the surviving panels, Eisler's proposal of an upper register with grisaille saints in arched niches is useful, though it seems likely that the panels were movable.

Apart from the question of the presumed missing panels and their arrangement, the parts of the altarpiece cannot be adequately interpreted given our present lack of knowledge about the commission and its destination. Hinkle suggested that the panels were made for the church of Saint Leu-Saint Gilles in Paris, just within the Porte Saint-Denis.[29] If the miracle-working bishop depicted in 1952.2.14 and on the back of *Saint Giles and the Hind* (fig. 5) should not be Saint Leu, then there would be little justification for their placement in this church. Montesquiou-Fezensac and Gaborit-Chopin raise the question of whether the panels might have constituted the *table peint* protecting the gold decoration of the high altar at Saint-Denis.[30] However, there is no evidence to support this hypothesis, beyond the portrait of the abbey and its treasures in the London painting. Indeed, the unusual choice of narratives and settings, the complex royal references, and the multitude of portraitlike onlookers suggest that the patron or patrons belonged to high official circles.[31] With the exception of the abbot Saint Giles, the altarpiece seems to be dedicated to bishop saints and celebrates their miracles, especially those in support of the kings of France. The altarpiece may have been commissioned by a high ecclesiastical official or body possibly to express ties to the monarchy.[32] In any case, judging by the costume shown in all four panels, the altarpiece must have been painted about 1500.[33]

<div align="right">M.W.</div>

Notes

1. Eisler 1977, 242, suggested that her dour expression was due to restoration.

2. Alexandre de Lestang-Parade, in whose collection they are first mentioned, was an amateur miniature painter active in Paris and Aix-en-Provence; Georg Kasper Nagler, *Neues allgemeines Künstler-Lexicon*, 22 vols. (Munich, 1835–1852), 7: 466.

3. Nos. 1419 and 4681, with painted surfaces measuring 61.5 x 46.5 (24¼ x 18¼) and 61.5 x 45.5 (24¼ x 18) respectively; see Davies 1945, 71–72 (3d ed. 1968, 107–113), and David Bomford and Jo Kirby, "Two Panels by the Master of Saint Giles," *National Gallery Technical Bulletin* 1 (1977), 49–56. The *Mass of Saint Giles* was first recorded in the collection of the Duc de Tallard in 1752 by Dezallier d'Argenville, *Voyage pittoresque de Paris*, 2d ed. (Paris, 1752), 213, and in his sale, Paris, 22 March 1756, no. 132, as by Dürer. No mention of the other London panel is known before the Thomas Emmerson sale, Christie's, London, 27 May 1854, no. 63.

4. Reinach 1907, 2: 665, 744, and Friedländer 1913, cols. 187–188.

Fig. 7. Master of Saint Giles, *The Baptism of Clovis*, 1952.2.15, x-radiograph

5. Réau, *Iconographie*, vol. 3, part 2, 593–597 and V. Mayr in *Lexikon der christlichen Ikonographie*, 8 vols. (Freiburg-im-Breisgau, 1968–1976), 5: cols. 51–54. Saint Giles, who is said to have died about 720, was the first abbot of the monastery of Saint-Gilles in Provence.

6. Hinkle 1965, 111–112, and Robert W. Scheller, "Imperial themes in art and literature of the early French renaissance: the period of Charles VIII," *Simiolus* 12 (1981/1982), 8–10. See also n. 17 below.

7. Held 1932, 10–13. Champeaux 1883, 187, had identified the setting as the interior of Notre-Dame.

8. Compare the view out of the lower portal in Held 1932, fig. 5. For the upper porch and its trumeau statue, see Bildarchiv Marburg +1 131 435.

9. The painting lacks the richly decorated dado of the upper chapel; see Jean Bony, *French Gothic Architecture of the 12th and 13th Centuries* (Berkeley, Los Angeles, and London, 1983), fig. 363. Held 1932, 11, noted that the organ of 1493 was replaced in 1550 with a larger one known to have been placed against the entrance wall of the upper chapel.

10. I am much indebted to Caroline Bruzelius and Stephen Murray for the identification of the underdrawn architecture (letter of 19 July 1983 and statement transmitted by Molly Faries, both in curatorial files).

This is the most striking of several changes made in the

setting and accessories of the Gallery's painting. Its effect can only be fully understood on comparing the drawing and painting with the actual view from the chapel entrance; however, see also Bony 1983, fig. 366 (as in n. 9 above). In earlier stages of work on the painting the view through the portal ended in a crenellated wall rather than in the palace buildings now represented (fig. 8): a row of figures, larger in scale than those presently visible through the portal, stood in front of this wall. To suggest the portal of the more lofty upper chapel, the painter simply reduced the scale of these figures. Thus the painted moldings and columns of the porch agree with the actual view through the doorway of the lower chapel, but the scale of the figures, particularly those visible through the north side of the door, is now much reduced.

Among changes in other areas, the king stood in a hexagonal font on which a scene of the Baptism of Christ was underdrawn (fig. 9) and a hexagonal canopy or tabernacle, apparently corresponding to the shape of the font, was underdrawn above the king's head. X-radiography indicates that the wall and arcade were also prepared in paint.

11. For the painter's oeuvre, see Friedländer 1937, 221–231.

12. First suggested in the catalogue of the Beurnonville sale; see provenance under 1952.2.14.

13. The baptism of Clovis probably took place about 490; for the historical Clovis, see Georges Tessier, *Le Baptême de Clovis* (Paris, 1964).

14. The earliest account of Clovis' baptism to include this miracle is the late ninth-century *Life of Saint Remy* by Hincmar; see Francis Oppenheimer, *The Legend of the Sainte Ampoule* (London, n.d.), 27–37.

15. Sandra Hindman and Gabrielle M. Spiegel, "The Fleur-de-lis Frontispieces to Guillaume de Nangis's *Chronique Abregée*: Political Iconography in Late Fifteenth-Century France," *Viator* 12 (1981), 381–400.

16. Hinkle 1965, esp. 113–124, as part of the most comprehensive study yet devoted to the iconography of the four panels. For Hinkle the setting of the *Mass of Saint Giles* in the abbey of Saint-Denis rather than in the cathedral of Orléans argues for a dependence upon the text of the *Life of Saint Denis* by Yves, a fourteenth-century monk of the abbey, in which this exceptional location is mentioned. By extension, the subject of the baptism scene and its Parisian setting would necessarily derive from the same text. I find that in all four panels the principle linking setting and narrative is unclear, but doubt that this principle would have been supplied by close adherence to the more circumstantial aspects of a specific text.

The adult Lisbius was baptized in Paris, while the baptism of Clovis took place in Saint Remy's see of Reims. Yet the Sainte-Chapelle's function as the palatine chapel may have determined its use as the setting here. Accounts of Clovis' baptism stress the procession from the royal palace to the church, the way having been decorated by Queen Clothilde; see Richier, *La vie de Saint Remi*, ed. W. N. Bolderston (Oxford, 1912), ll. 3819–3872.

The reason the chrism could not be found varies from one account to another; see Colette Beaune, "Saint Clovis: histoire, religion royale et sentiment national en France à la fin

Fig. 8. Infrared reflectogram assembly of detail of *The Baptism of Clovis*, 1952.2.15 [infrared reflectography: Molly Faries]

du moyen âge" in *Le métier d'historien au moyen âge: études sur l'historiographie médiévale,* ed. Bernard Guenée (Paris, 1977), 146. It is interesting that the box of holy oils held by the deacon at the extreme right of the Gallery's painting was apparently an afterthought. X-radiography and infrared reflectography show that the cope of the figure holding the bishop's robe originally extended over most of the area now occupied by the box.

17. For this and related French royal crowns, see Danielle Gaborit-Chopin, "Les couronnes du sacre des rois et des reines au trésor de Saint-Denis," *Bulletin Monumental* 133 (1975), 165–174. The double arches added to the crown in the London panel and the different forms and connotations of ducal, royal, and imperial crowns are discussed by Scheller as in n. 6 and in "Ensigns of authority: French royal symbolism in the age of Louis XII," *Simiolus* 13 (1983), esp. 103–115.

18. From her work on illustrations of the *Grandes Chroniques de France,* Anne D. Hedeman cites the following representations without reference to the holy ampoule in copies of the *Chroniques.* Brussels, Bibliothèque Royale, Ms. 2, fol. 2 (c. 1390–1410) and Ms. 5, fol. 13 (c. 1330–1340). Paris, Bibliothèque Nationale, Ms. fr. 2605, fol. 13 (Master of Marguérite d'Orléans, c. 1425); Ms. fr. 10135, fol. 13 (c. 1380–1400, from the library of Charles VI); and Ms. fr. 20352–53, fol. 6v. (Master of the Cité des Dames and other hands, c. 1410–1420); letter of 5 March 1984 in curatorial files.

Eisler cites a woodcut illustration of the baptism and victories of Clovis from a 1488 edition of *La Mer des Histoires* in which the dove and ampoule are also omitted from the baptism scene proper; Eisler 1977, 242, text fig. 52. However, on the right side of the woodcut an angel brings the fleur-de-lis to the hermit while a dove descends with what appears to be the holy ampoule.

19. Eisler 1977, 242, also made this suggestion.

20. On the cult of the uncanonized "Saint Clovis," see Beaune 1977, 139–156 (see n. 16 above). For the cult of Charlemagne, who was canonized in 1165, see Mireille Schmidt-Chazan, "Histoire et sentiment national chez Robert Gaguin" in *Le métier d'historien au moyen âge: études sur l'historiographie médiévale,* ed. Bernard Guenée (Paris, 1977), 279–280, and Jacques Monfrin, "La figure de Charlemagne dans l'historiographie du XVe siècle," *Société de l'Histoire de France. Annuaire-Bulletin* (1964/1965), 67–78.

21. Davies 1945 (3d ed. 1968, 111), and Alain Erlande-Brandenburg, "Le tombeau de Saint Louis," *Bulletin Monumental* 126 (1968), 7–12.

22. A shallow arched niche, which appears to be incised and possibly also underpainted, is visible with infrared photography; Bomford and Kirby 1977, fig. 4. The incised outline of another, narrower, pointed arch is discernible in raking light. I am most grateful to Alistair Smith and David Bomford of the National Gallery, London, for help in examining the panels in their care.

23. Held 1932, 3

24. Friedländer 1937, 223–224, fig. 6.

25. Davies 1945, 71–72 (2d ed. 1955, 83).

26. Davies 1945 (3d ed. 1968, 108).

27. Hinkle 1965, 139–144, pls. 25A and B; see also under 1952.2.14.

28. Eisler 1977, 242, text figs. 53–54.

29. Hinkle 1965, 133–139.

30. Montesquiou-Fezensac and Gaborit-Chopin 1973/ 1977, 3: 98 and 2: 294, with extracts from the abbey's accounts recording payments for the *tabula picta* of the high altar.

A rather startling artist's change in the London *Mass of Saint Giles* made visible by infrared reflectography may, coincidentally, relate to the panel for the high altar mentioned in the abbey accounts. Figures of Christ on the cross and the mourning Virgin are underdrawn where the accurately rendered gold altar frontal now appears. In type of underdrawing they resemble the Baptism scene on the font of the *Baptism of Clovis* (fig. 8). Conceivably this underdrawing may record a panel or wings depicting the Crucifixion displayed on the high altar on less festive occasions. Alternatively, the underdrawn Baptism and Crucifixion scenes may have been pictograms for the main events to be painted on the panels. The nature and extent of changes on the four panels need further study before any conclusions can be drawn. Technical examination of other works by the Master of Saint Giles would help determine whether such changes result from the artist's usual working procedure or from the particular conditions of the commission.

31. The *hausmark* on the grisaille of Saint Peter may refer to the altarpiece's commissioner (Eisler 1977, 243, suggested that it referred to the artist's first name).

32. I am grateful to the participants in the symposium on French and Burgundian art held at the Gallery's Center for Advanced Study in the Visual Arts in 1983–1984 for their stimulating discussion of these panels.

33. Letter of 20 September 1983 from Stella Mary Newton in curatorial files; she is inclined to date the costume in the very first years of the sixteenth century.

Fig. 9. Infrared reflectogram assembly of detail of *The Baptism of Clovis,* 1952.2.15 [infrared reflectography: Molly Faries]

References

1823 [Porte, Jean-Baptiste-François]. *Aix ancien et moderne, ou Description des Édifices sacrés et profanes, Établissemens, Monumens antiques, du moyen âge et modernes, Bibliothèques, Cabinets, Promenades d'Aix, etc., etc.* Aix-en-Provence: 147.

1841 Gaszynski, C. In *Mémorial d'Aix* (13 June): 2.

1883 Champeaux, Alfred de. "Deux vues de la Cité de Paris au XVᵉ siècle." *La Chronique des Arts et de la Curiosité* no. 23: 186–187.

1907 Reinach, Salomon. *Répertoire de peintures du moyen âge et de la Renaissance (1280–1580).* 2 vols. Paris, 2: 744, no. 2, repro.

1912/1913 Friedländer, Max J. "Der Meister des hl. Ägidius." *Amtliche Berichte aus den königl. Kunstsammlungen* 34: 187–188.

1921 Conway, Martin. *The Van Eycks and their Followers.* London: 190.

1931 Lemoisne, P. A. *Die gotische Malerei Frankreichs vierzehntes und fünfzehntes Jahrhundert.* Leipzig: 113.

1932 Held, Julius. "Zwei Ansichten von Paris beim Meister des heiligen Ägidius." *JbBerlin* 53: 3–4, 10–15, fig. 2.

1934 Jong, Johannes Assuerus Bernardus Maria de. *Architectuur bij de Nederlandsche Schilders vóór de Hervorming.* Amsterdam: 54.

1937 Friedländer, Max J. "Le Maître de Saint-Gilles." *GBA* 6ᵉ pér. 17: 223–231, figs. 6, 10.

1938 Sterling, Charles. *La peinture française: les primitifs.* Paris: 135, fig. 170.

1938 Dimier, Louis. "Les primitifs français." *GBA* 6ᵉ pér. 20: 234–235.

1939 National Gallery, London. *Supplement to the 1929 Catalogue Including Accessions to the End of 1937.* London: 27.

1939 Réau, Louis. *La peinture française du XIVᵉ au XVIᵉ siècle.* Paris: 14, fig. 10.

1942 Sterling, Charles. *Les peintres du moyen âge.* Paris: 51, 64, pl. 140.

1944 Luttervelt, R. van. "Chineesche zijden stoffen en tapijten in Europa in vroeger eeuwen." *Maandblad voor beeldene Kunsten* 20: 45–46, fig. 1.

1945 Davies, Martin. *National Gallery Catalogues. Early Netherlandish School.* London: 71–72 (2d ed. 1955: 82–83; 3d ed. 1968: 108–109).

1946 Davies, Martin. *Paintings and Drawings on the Backs of National Gallery Pictures.* London: xi.

1949 Ring, Grete. *A Century of French Painting 1400–1500.* London: 33, 230, no. 240a, fig. 40.

1949 Hébert, Michèle. "Les monuments parisiens dans l'oeuvre du Maître de Saint Gilles." *Fédération des sociétés historiques et archéologiques de Paris et de l'Île-de-France. Mémoires* 1: 213–214, 231–235, pl. XI.

1950 "Meister des hl. Ägidius." In Thieme-Becker 37: 6–7.

1951 Kress: 15, 186–189, repro. no. 83.

1951 Frankfurter, Alfred M. "Interpreting Masterpieces." *ArtNA* 50, no. 7: 112–113, repro. 107.

1954 Tietze, Hans. *Treasures of the Great National Galleries.* New York: 117, 123–124, pl. 197.

1959 Réau. *Iconographie.* Vol. 3, part 3: 1146.

1961 Seymour, Charles Jr. *Art Treasures for America.* London: 66–67, 202, 218, fig. 60.

1963 Châtelet, Albert, and Jacques Thuillier. *French Painting from Fouquet to Poussin.* Geneva: 92–93.

1964 Walker: 108–109, repro.

1965 Hinkle, William M. "The Iconography of the Four Panels by the Master of Saint Giles." *JWCI* 28: 110, 113–124, 127, 129–130, 139–144, pls. 21g–h, 22b–c, 25A–B.

1966 Laclotte, Michel, *Primitifs français.* Paris: 45, pl. XXXVI.

1973 National Gallery, London. *Illustrated General Catalogue.* London: 444.

1973/1977 Montesquiou-Fezensac, Blaise de, and Danielle Gaborit-Chopin. *Le Trésor de Saint-Denis.* 3 vols. Paris, 3: 105, pl. 93a.

1975 NGA: 224, repro. 225.

1977 Eisler: 239–243, fig. 231, text figs. 53, 54.

Master of the Saint Lucy Legend

active c. 1480–c. 1510

The Master of the Saint Lucy Legend was named by Max J. Friedländer for an altarpiece in the church of Saint James, Bruges, which is dated 1480 and depicts three scenes from the life of Saint Lucy. A second painting recognized by Friedländer as by the same hand is the *Virgin and Child with Female Saints* in the Musées Royaux des Beaux-Arts, Brussels. With these two works as the foundation, twenty-five to thirty-five paintings have been attributed by Friedländer and others to the Master of the Saint Lucy Legend.

The master was active in Bruges from the 1480s into the early years of the sixteenth century. His style is marked by certain stereotyped facial types for both men and women, crisply rendered architectural detail and decorative patterning, and a preference for bright, clear colors that are often acidic. The belfry in Bruges is often depicted in his paintings, and Nicole Veronee-Verhaegen has proposed a chronology for several paintings based on changes in the belfry's appearance between 1483 and 1501. Ann Roberts has suggested that the master is Jan de Hervy who was active in Bruges and died before 1512.

The master is allied to the art of Hans Memling, but also borrows from Jan van Eyck and Rogier van der Weyden as well as from Dirck Bouts and Hugo van der Goes. The master's influence extended outside the boundaries of Flanders. Several of his paintings have Spanish provenances, and it has been suggested that the artist spent time in Spain and may have trained Spanish painters in his Bruges studio. A large altarpiece commissioned by the Confraternity of the Têtes-Noires in Tallinn, Estonia, still in that city's museum, has been attributed to the Master of the Saint Lucy Legend.

J.O.H.

Bibliography:
Friedländer, Max J. "Die Brügger Leihausstellung von 1902." *RfK* 26 (1903): 84–85.
Friedländer. Vol. 6. 1928 (vol. 6, part 1, 1971: 41–43, and part 2, 1971: 123–124).
Verhaegen, Nicole. "Le Maître de la légende de Sainte Lucie. Précisions sur son oeuvre," *BInstPat* 2 (1959): 73–82.
Anonieme Vlaamse Primitieven. Exh. cat. Groeningemuseum. Bruges, 1969: 47–54.
Roberts, Ann. "The Master of the Legend of Saint Lucy: A Catalogue and Critical Essay." Ph.D. diss., University of Pennsylvania, 1982.

1952.2.13 (1096)

Mary, Queen of Heaven

c. 1485/1500
Probably oak (cradled), 201.5 x 163.8 ($79^3/_8$ x $64^1/_2$)
 painted surface: 199.2 x 161.8 ($78^7/_{16}$ x $63^3/_4$)
Samuel H. Kress Collection

Inscriptions:
On the sheet of music held by the angel to the left of the Virgin's head: *A/ve regina celorum mr regis[?]*
On the sheet of music held by the angel to the right of the Virgin's head: *A/Tenor ve/regina*

Technical Notes: The support consists of six boards with vertical grain. X-radiographs show that the joins are reinforced with dowels. A smooth white ground is present.[1] The presence of a barbe on all sides indicates that the panel is very close to its original size and was painted in an engaged frame. In general, the painting is in very good condition, but there are numerous small losses throughout and somewhat larger losses in the upper paint layers of the landscape. Some retouches have darkened. Examination with infrared reflectography reveals extensive underdrawing, discussed below. The painting was cleaned and restored in 1950–1951 and a very small area of flaking paint was restored in 1962.

Provenance: Probably Don Pedro Fernández de Velasco, Count of Haro and Constable of Castile [d. 1492] for the convent of Santa Clara, Medina de Pomar, near Burgos, until at least 1934.[2] Raimundo Ruiz y Ruiz, Madrid.[3] (French & Company, New York, by c. 1947.) Samuel H. Kress Foundation, New York, 1949.

THE VIRGIN'S corporeal assumption into heaven is depicted. She stands on a crescent moon, a golden aureole behind her, surrounded by angels in brightly colored and embroidered robes. Some of the angels assist in her ascent, others sing and play musical instruments. At the top, ringed by clouds, are the enthroned figures of God the Son and God the Father holding a

crown between them. The dove of the Holy Ghost hovers over the crown.

Mary, Queen of Heaven is of great interest to musicologists. Not only does the painting depict Renaissance instruments with great accuracy, but it also mirrors contemporary performance practices. The music-making angels can be divided into two groups, those accompanying the Virgin and those clustered around the "inner heaven" of the enthroned Trinity. Emanuel Winternitz points out that the ensemble around the Virgin is a mixed consort composed of "loud" instruments (trumpets and shawms) and "soft" instruments (vielle, lute, and harp).[4] Immediately above and flanking the Virgin are four singing angels; two of the angels hold books bearing legible words and music. This music, which is the source of the painting's title, has been identified as a setting of the Marian antiphon, "Ave Regina Caelorum, Mater Regis."[5] The antiphon is very similar to a motet, "Ave Regina Caelorum, Mater Regis," by Walter Frye (died 1474/1475), an English composer whose works were popular on the continent, particularly at the Burgundian court.[6]

In terms of contemporary performance, Winternitz has noted that the eight instrumentalists would overpower the four singers around the Virgin.[7] The upper region corresponds more closely to actual usage. At the right the six instrumentalists are all playing "soft" instruments: recorders, lute, dulcimer, and harp. They are balanced at the left by eleven singers, divided into two groups. The uppermost group of five winged angels appears younger than the lower group of six wearing embroidered copes and *clipei*. It has been suggested that the upper group is a *Kinderchor*.[8] Both groups have one book of music each, suggesting that here too the music is antiphonal and polyphonic. The music held by the angel in the lower group is somewhat legible, and Kathleen McGhee has cautiously suggested that it may be a countertenor part to the "Ave Regina Caelorum" sung by the angels next to Mary.[9]

Three facets of Marian iconography are represented in this large and colorful painting. The first theme is that of the Immaculate Conception; the crescent moon and the radiance behind her identifies Mary as the Woman of the Apocalypse, mentioned in Revelation 12:1. Although the notion that Mary had been conceived free from sin was long-standing, it received special impetus in 1476 when Pope Sixtus IV instituted the Feast of the Immaculate Conception.[10] Indulgenced prayers quickly followed. As Eisler points out, the Immaculate Conception was especially popular in Spain.[11]

The second theme represented is the corporeal Assumption of the Virgin into heaven. This event, which took place three days after her death, also emphasizes her purity. *Mary, Queen of Heaven* is unusual in that the death of the Virgin and her open tomb are not depicted, as usually the case with images of the Assumption. Eisler sees the landscape, normally reserved for the Virgin's sarcophagus, as representing the earthly paradise, cleansed at the time of her death.[12]

The third theme, shown at the top of the painting, is the Coronation of the Virgin or, strictly speaking, the incipient coronation since Mary is not yet present in heaven. The Coronation is the logical conclusion of Mary's Dormition and Assumption, for in heaven her body and soul are reunited and she is glorified by the Trinity.[13] Early representations show the Virgin being crowned by Christ, but by the early fifteenth century the coronation by all three members of the Godhead appears with some frequency.[14] The tiled floor and brocaded cloth on the throne recall the *Deësis* in the Ghent Altarpiece, while the representation of the Trinity is similar to that found in contemporary manuscripts.[15]

As noted by Eisler, the general arrangement probably derives ultimately from fourteenth-century representations of the Assumption of the Virgin. These Italian depictions usually show the Virgin full-face, with her hands in the same prayerful attitude as in the Gallery's panel. Moreover, the Virgin is often accompanied by angels singing and playing instruments.[16] The unusual iconographic program may be the result of a specialized commission. Both Eisler and Roberts emphasize the veneration given the immaculately conceived Virgin in Spain, reinforcing the tradition that the panel was a Spanish commission, specifically for the convent of Santa Clara in Medina de Pomar.[17]

Examination of the underdrawing with infrared reflectography emphasizes the originality and importance of *Mary, Queen of Heaven*. The underdrawing is quite vigorous, extensive, and varied in its effects and techniques. The greater portion is done with a brush. A wide brush was used for figure placement and general indications of drapery (fig. 1), while parallel hatching, often indicating shadows, in the drapery folds was done with a finer brush. In other areas, such as the figures at the top of the panel, the underdrawing seems to have been made with a harder medium, perhaps chalk (fig. 2). A surprising degree of change occurred between the initial layout and the final painted surface. For instance, the figure of the angel playing a harp at the upper left was originally drawn vertically and full-face rather than in profile (fig. 3). At the upper right the wing of an angel playing a vielle was originally placed over the head of an angel playing a shawm. The angels on either side of the Virgin show changes in the position of the eyes and facial contours, and the entire

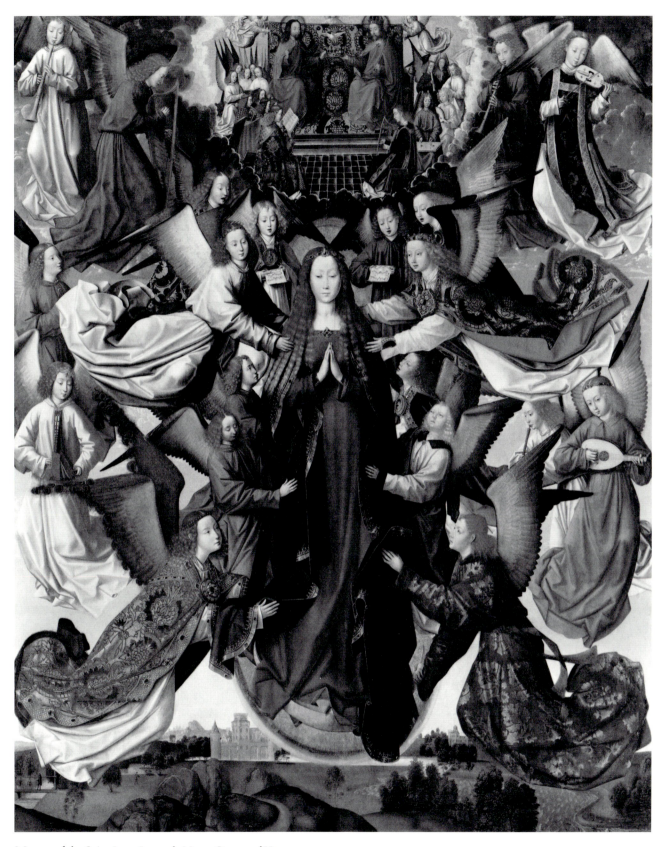

Master of the Saint Lucy Legend, *Mary, Queen of Heaven*, 1952.2.13

position of a head has been altered. The Virgin's eyes and nose have been shifted and her hands have been moved down and to the left. There are traces of what appear to be angels' wings in the landscape at the bottom (fig. 4).

The underdrawing strongly suggests that the composition was worked out on the panel without recourse to a predetermined pattern or design, perhaps because the specific iconographic requirements of the commission necessitated creating an original composition. The panel is without known precedent in early Netherlandish painting. I have found no representations that incorporate the Immaculate Conception, the Assumption, and the Coronation of the Virgin, that predate *Mary, Queen of Heaven*.

In 1946 Friedländer attributed *Mary, Queen of Heaven* to a Bruges or Ghent artist working about 1480;[18] three years later he suggested the Master of Evora, a Portugese artist active in the late fifteenth century.[19] In 1947 Valentiner attributed the panel to the Master of the Saint Lucy Legend and Suida first published it under this attribution in 1951.[20] Since then the attribution to the Lucy Legend Master has

Fig. 1. Infrared reflectogram assembly of a detail of *Mary, Queen of Heaven*, 1952.2.13 [infrared reflectography: Molly Faries]

Fig. 2. Infrared reflectogram assembly of a detail of *Mary, Queen of Heaven*, 1952.2.13 [infrared reflectography: Molly Faries]

Fig. 3. Infrared reflectogram assembly of a detail of *Mary, Queen of Heaven*, 1952.2.13 [infrared reflectography: Molly Faries]

Fig. 4. Infrared reflectogram assembly of a detail of *Mary, Queen of Heaven*, 1952.2.13 [infrared reflectography: Molly Faries]

been almost unanimously accepted, and with it a date of c. 1485 to 1500.[21]

Verhaegen sees stylistic affinities with the work of the Master of the Morrison Triptych, in particular with a pair of shutters depicting the *Adoration of the Shepherds* and the *Adoration of the Magi* from an altarpiece donated in 1503/1504 to the Church of the Holy Savior, Valladolid.[22] Verhaegen emphasizes the fact that both the Morrison and Lucy masters worked for Spanish patrons and suggests that the latter might have journeyed to Spain. Roberts believes that because of the heavy reliance on Spanish compositional and iconographic types the painting was executed in Spain by the Master of the Lucy Legend. She dates the picture to c. 1491/1492, based in part on the 1492 death date of the putative patron Don Pedro Fernández de Velasco.[23] For Eisler, several of the angels' faces are the work of a studio assistant who could have been Spanish or have had a knowledge of Italian art; Roberts does not see two hands.[24] I believe it is possible to discern the hand of at least one assistant. In particular, the angels just above the lowest ones flanking the Virgin have faces that are homelier and more individually characterized than the types usually used by the Master and may point to a Dutch or even Lower Rhenish artist. J.O.H.

Notes

1. Kress 1951, 182, states that the paint was applied directly to the panel without an intervening ground; this error is repeated by Walker 1963, 106, but corrected in Eisler 1977, 63, n. 6.

2. According to notes from the Kress Foundation records, now in the curatorial files, an escutcheon at the top of the purportedly original frame once bore the arms of Don Pedro Fernández de Velasco, Count of Haro and Constable of Castile (c. 1425–1492). An old photograph in the curatorial files shows a space at the top of the frame where the arms may have been. Eisler 1977, 61, thinks the frame is original and made in Spain; the Gallery's frame and painting conservators suggest that the frame is not original, but includes portions of an old frame. The records of French & Company indicate only that the painting was "said to have been the gift of a Constable of Castile to a convent near Burgos founded by his daughter and suppressed in the nineteenth century," correspondence of 19 July 1967 to Eisler and Eisler 1977, 63. The most convincing suggestion for the painting's original location is made by Roberts 1983, 92–95, who places it in the chapel of the Immaculate Conception in the convent of Santa Clara in Medina de Pomar, near Burgos. Don Pedro's daughter, Doña Leonor, was abbess of the convent. Don Pedro had begun construction of the chapel in 1460 and his son finished paying for it. Roberts cites a description of a painting in the convent in 1934 that accords in terms of dimensions, style, and subject matter with *Mary, Queen of Heaven*; this is contained in Garcia Sáinz de Baranda 1934, 88: "Otra *tabla flamenca* atribuida a Van der Weiden, de unos dos metros de alta, por 1,50 de ancha que tiene por asunto la Asuncion de la Virgen obra maestra llena de colorido y expresion." The identification would seem to be strengthened by the fact that the painting is not mentioned in Jacques Lavalleye, *Primitifs flamands. Corpus. Collections d'Espagne* 2 vols. (Antwerp, 1953–1958), although another painting from the same convent is catalogued, 2: 17. Lavalleye states, 2: 7, that he visited the province of Burgos in 1954.

3. Letter of 19 July 1967 from Robert Davis, French & Company, to Dale Kinney, assistant to Colin Eisler, in curatorial files. I am grateful to Colin Eisler for making this letter available.

4. Starting with the ensemble around the Virgin, the instruments on the left in descending order are: alto (or tenor?) shawm, Gothic harp, trumpet (only partially visible), and portative organ. From the top on the right are: soprano (treble?) shawm, vielle, soprano (or treble) shawm, and lute. The identification of the instruments is based on Winternitz 1963, 459–463; Chrisman and Fowler 1965, 93–98; and Mirimonde 1976, 42–51.

5. Kress 1951, 182, cites Mirella Levi d'Ancona as the first to recognize the text as "Ave Regina Caelorum." Kathleen McGhee, in an unpublished paper written in 1982 for the department of music, University of Maryland, cautions against confusing this "Ave Regina" with a second and more famous antiphon, "Ave Regina Caelorum, Ave Domina." I am indebted to Miss McGhee for making her paper available to me.

6. For Walter Frye see Kenney 1964. There is no evidence that Frye himself was ever in Europe. Frye's "Ave Regina" is discussed and analyzed in Sylvia Kenney, "Contrafacta in the Works of Walter Frye," *Journal of the American Musicological Society* 8 (1955), 182–202, as an example of a secular song provided with a sacred text. Kenney 1964, 67–75, discusses Frye's "Ave Regina" and compares it, 154, with the music in *Mary, Queen of Heaven*; compare Carapezza 1975, esp. 139–152. McGhee 1982 extensively analyzes the music in *Mary, Queen of Heaven* and notes the several comparisons and similarities to Frye's "Ave Regina." She points to a certain eclecticism in the music depicted by the Saint Lucy Legend master and observes, 22, that the composer Jacob Obrecht who was at Saint Donatian at Bruges in the 1480s paraphrased Frye's "Ave Regina" in a similar manner. Frye's "Ave Regina" is depicted in paintings by the Master of the Embroidered Foliage, an artist active in Brussels at the end of the fifteenth century. The paintings are a *Madonna and Child with Angels* (R. Grog collection, Paris), repro. Friedländer, vol. 4 (1969), no. 88, pl. 83, and the center panel of the altarpiece of the *Virgin with Angels* (Church of Santa Maria degli Angeli, Polizzi Generosa, Sicily), repro. Friedländer, vol. 4 (1969), Supp. 129, pl. 111. Frye's music in these paintings is discussed by Kenney 1964 and Carapezza 1975.

7. Winternitz 1975, 230.

8. Chrisman and Fowler 1965, 98.

9. McGhee 1982.

10. Mirella Levi d'Ancona, *The Iconography of the Immaculate Conception in the Middle Ages and Early Renaissance* (New York, 1957), esp. 11–13; Réau, *Iconographie*, vol. 2, part 2, 76–83.

11. Eisler 1977, 62.

12. Eisler 1977, 62. In n. 13 he cites Georg Troescher, *Burgundische Malerei* (Berlin, 1966), pls. 64, 66–67, for early representations of the Assumption and Coronation of the Virgin, and Manuel Trens, *María. Iconografía de la Vir-*

gen en el Arte Español (Madrid, 1946), 156–157, for six-teenth-century Spanish paintings of the Assumption of the immaculately conceived Virgin. Suzanne Stratton, "The Immaculate Conception in Spanish Renaissance and Baroque Art," Ph.D. diss., New York University, 1983, 88–167, has challenged the belief that Spanish Assumptions with the crescent moon under the Virgin's feet always refer to the Immaculate Conception; q.v. 1965.1.1, Sittow, *The Assumption of the Virgin*, n. 9. Stratton does not discuss 1952.2.13 except to note, 116, that it may have been modeled on an earlier Netherlandish example.

13. Philippe Verdier, *Le Couronnement de la Vierge* (Montreal and Paris, 1980); Réau, *Iconographie*, vol. 2, part 2, 621–626.

14. Réau, *Icongraphie*, vol. 2, part 2, 623, notes that the coronation by the Trinity occurs in Spain, Italy, and France in the first years of the fifteenth century.

15. For example, a similar image can be found in the Croy breviary by the Master of James IV of Scotland, Vienna, Österreichische Nationalbibliothek, Cod. 1858, fol. 97v., repro. Friedrich Winkler, *Die flämische Buchmalerei des XV. und XVI. Jahrhunderts* (Leipzig, 1925), 126, pl. 74.

16. Eisler 1977, 62; see Henk van Os, *Marias Demut und Verherrlichung in der sienisischen Malerei 1300–1450* (Kunsthistorische Studiën van het Nederlands Historisch Instituut te Rome, 1) (The Hague, 1969), esp. 145–156, pls. 13, 14a, 15–20, 112, 116, 127–128.

17. See under Provenance; Eisler 1977, 63, n. 26 for mention of other convents in Burgos; Roberts 1983, esp. 156–159. Ann Roberts, letter of 6 June 1983 in the curatorial files, points out that Doña Leonor, daughter of the Count of Haro, became abbess of the convent at Medina de Pomar in 1491 and suggests a direct relationship to the commission or delivery of the Gallery's painting. See Julián Garcia Sáinz de Baranda, *Apuntes historicos sobre la ciudad de Medina de Pomar* (Burgos, 1917), 199. I am grateful to Dr. Roberts for this reference and information.

18. Certificate dated April 1946 in the curatorial files.

19. Letter of 11 March 1949 to French & Company in the curatorial files.

20. W. R. Valentiner, letter of 25 August 1947 to French & Company in the curatorial files; Kress 1951, 182.

21. Goldblatt 1961, 42, 44, attributes the painting to Michel Sittow.

22. Verhaegen 1959, 81–82. The Valladolid wings are catalogued and reproduced in Friedländer, vol. 7 (1972), 44, 70, no. 84, pl. 74, who expressed some doubts about the attribution to the Master of the Morrison Triptych. See also *L'Art flamand dans les collections espagnoles* [exh. cat. Groeningemuseum] (Bruges, 1958), 52–56, nos. 24–27.

23. Roberts 1983, 92–95, 152–159; she draws attention, 158, to the angel at the lower right grasping the horn of the moon as a motif that has no precedent in Northern art, but which occurs frequently in Spanish Assumptions. See also n. 14.

24. Eisler 1977, 63; Roberts 1983, 220.

References:

1934 Garcia Sáinz de Baranda, Julián. *Medina de Pomar. Como Lugar Arqueológico y Centro de Turismo de las Merindades de Castilla-Vieja.* Alcala de Henares: 88.

1951 Kress: 182, no. 80, repro. 183.

1951 Frankfurter, Alfred. "Interpreting Masterpieces.

Twenty-four Paintings from the Kress Collection." *ArtNA* 50, no. 7: 101–102, repro. 104, 101.

1952 Walker, John. "Your National Gallery of Art after 10 Years." *National Geographic Magazine* 101: 76, repro. 100.

1959 Verhaegen, Nicole. "Le Maître de la Légende de sainte Lucie. Précisions sur son oeuvre." *BInstPat* 2: 81–82.

1960 Broadley, Hugh. *Flemish Painting in the National Gallery of Art.* Washington: 6, 26, repro. 27 (rev. ed. 1978).

1961 Goldblatt, Maurice. *Deux grands maîtres français.* Paris: 42, 44, pl. 21.

1961 Baudouin, Frans. "Der Meister des Bartholomäusaltares und die südniederländische Malerei des 15. Jahrhunderts." *Wallraf-Richartz-Jahrbuch* 23: 357–358.

1961 Verhaegen, Nicole. "Un important retable du Maître de la Légende de sainte Lucie conservé à Tallinn." *BInstPat* 4: 143.

1963 Winternitz, Emanuel. "On Angel Concerts in the 15th Century: A Critical Approach to Realism and Symbolism in Sacred Painting." *The Musical Quarterly* 49: 263, 459–460, pl. 5 (repr. in *Musical Instruments and their Symbolism in Western Art.* New York, 1967: 145–149, pls. 66, 67).

1963 Walker: 106, repro. 107.

1964 Kenney, Sylvia. *Walter Frye and the Contenance Angloise.* New Haven and London: 153–155, pls. 6–9.

1964 Gaya Nuño, Juan. *Pintura europea perdida por España, de van Eyck a Tiépolo.* Madrid: 27, no. 32, pl. X.

1965 Chrisman, Jo, and Charles B. Fowler. "Music Performance in a Renaissance Painting." *Music Educators' Journal* (November/December): 93–98, pls. I–VIII and cover.

1965 Eisler, Colin. "The Sittow Assumption." *ArtN* 64 (September): 35–37, fig. 6.

1969 Rensch, Roslyn. *The Harp. Its History, Technique and Repertoire.* London: 56–57.

1970 Meyer-Baer, Kathi. *Music of the Spheres and the Dance of Death.* Princeton: 170–171, fig. 82.

1971 Friedländer. Vol. 6, part 2: 115, Add. 277, pl. 257.

1975 NGA: 226, repro. 227.

1975 Fischer, Pieter. *Music in Paintings of the Low Countries in the 16th and 17th Centuries.* Amsterdam: 8, repro. 9, 10.

1975 Winternitz, Emanuel. "Secular Musical Practice in Sacred Art." In *The Secular Spirit: Life and Art at the End of the Middle Ages.* Exh. cat., The Metropolitan Museum of Art. New York: 230, repro. 231.

1975 Carapezza, Paolo. "Regina angelorum in musica picta. Walter Frye e il 'Maître au Feuillage Brodé.'" *Revista italiana di musicologia* 10: 135–136, 152–154, pl. 4.

1976 Mirimonde, A. P. de. "Le sablier, la musique et la danse dans les 'Noces de Cana' de Paul Véronèse." *GBA* 6ᵉ pér. 88: 134.

1976 Larsen, Erik. Review of Friedländer, vol. 6, 1971. In *Art Journal* 35: 298.

1976 De Vos, Dirk. "Nieuwe toeschrijvingen aan de Meester van de Lucialegende alias de Meester van de Rotterdamse Johannes op Patmos." *OH* 90: 157.

1976 Mirimonde, A. P. de. "La musique chez les peintres de la fin de l'ancienne école de Bruges." *JbAntwerp*: 42–51, figs. 17–23.

1977 Eisler: 61–63, figs. 54, 55.

1981 Châtelet, Albert. *Early Dutch Painting.* New York: 227, no. 102.

1982 Roberts, Ann. (See Biography): 92–95, 154–159, 185, 190, 194, 202–207, 219–222, cat. no. 7, figs. 13, 14.

Hans Memling

active by 1465–1494

Hans Memling or Memlinc was born in the Middle Rhenish town of Seligenstadt. He is first recorded in Bruges in 1465, when he acquired citizenship. He was active in that city, working largely for the merchant class and resident foreign communities, until his death on 11 August 1494. His compositions and figure types show a debt to Rogier van der Weyden, and Vasari called him a disciple of Rogier. It has therefore been assumed that he worked in Van der Weyden's Brussels workshop in the years preceding that master's death in 1464. Memling's art shows little or no trace of his German heritage, but there is no documentary evidence to indicate whether he received his artistic training in Germany or Flanders or how old he was upon settling in Bruges.

Memling is named in inscriptions on the original frames of two paintings, *The Mystic Marriage of Saint Catherine* and the triptych of Jan Floreins, both in the Saint John's Hospital, Bruges, though these inscriptions seem to have been restored or renewed. A relatively large group of paintings has been attributed to Memling on the basis of style. Among these a number are dated or dateable, including the *Virgin and Child with Donor and Saint Anthony* in Ottawa, inscribed with the date 1472, possibly transposed from the original frame; *The Last Judgment* in Gdansk, which was shipped from Bruges early in 1473; *The Mystic Marriage of Saint Catherine* and the Floreins triptych in the Saint John's Hospital, Bruges, both dated 1479; the Reyns triptych and the *Portrait of a Woman*, both in the Saint John's Hospital and dated 1480; the devotional diptych with Martin van Nieuwenhove in Bruges, dated 1487, and the Lübeck Crucifixion altarpiece, dated 1491. McFarlane has shown that the Donne triptych in the National Gallery, London, long placed c. 1468 and considered to mark the beginning of Memling's early maturity, can be dated as late as c. 1480.

In spite of the number of dated paintings, relatively little stylistic development can be discerned in Memling's work. The problem of placing undated works is complicated by his tendency to repeat established compositions and types, and by the probable intervention of assistants.

Memling was the dominant painter in Bruges at the end of the fifteenth century, and his work provided a fitting summation of his predecessor's achievements.

M.W.

Bibliography

Weale, W. H. James. *Hans Memlinc*. London, 1901.
Friedländer. Vol. 6. 1928 (vol. 6a, 1971).
Baldass, Ludwig von. *Hans Memling*. Vienna, 1942.
Folie, Jacqueline. "Les oeuvres authentifiées des primitifs flamands." *BInstPat* 6 (1963): 225–229.
McFarlane, K. B. *Hans Memling*. Ed. Edgar Wind. Oxford, 1971.

1937.1.41 (41)

Madonna and Child with Angels

After 1479
Oak (cradled), 58.8 x 48.0 (23 1/8 x 18 7/8)
 painted surface: 57.6 x 46.4 (22 5/8 x 18 1/4)
Andrew W. Mellon Collection

Technical Notes: The panel is composed of two boards aligned vertically with a join 34.2 cm from the left edge. It is mounted on a thin secondary panel of the same wood as the cradle. There are numerous very small losses, especially at the top left and top right corners and the bottom of the right angel's robe. Losses along the splits and the join have been filled and inpainted. The Madonna's features and some of the outlines of her robe have been strengthened. In general the numerous tiny strokes of inpainting make the picture appear to be in more pristine condition than is actually the case.

The figural group and the landscape are underdrawn in what seems to be black chalk; see commentary below.

Provenance: Probably Leopold Friedrich Franz, Prince of Anhalt, Gotisches Haus, Wörlitz, near Dessau [d. 1817].[1] Probably Leopold Friedrich, Prince of Anhalt [d. 1871]. Friedrich I, Duke of Anhalt, by 1872 [d. 1904]. Friedrich II, Duke of Anhalt, until 1927. (Hugo Perls, Berlin, 1927.)[2] Mannheimer collection, Amsterdam, 1927. (Duveen Brothers, London and New York, 1927.) Purchased November 1927 by Andrew W. Mellon, Washington. Deeded 5 June 1931 to The A. W. Mellon Educational and Charitable Trust, Pittsburgh.

Hans Memling, *Madonna and Child with Angels*, 1937.1.41

Exhibitions: Bruges, Hôtel de Gouvernement Provincial, 1902, *Exposition des primitifs flamands et d'art ancien*, no. 79. // New York, F. Kleinberger Galleries, Inc., 1929, *Loan Exhibition of Flemish Primitives*, no. 22.

THIS IS one of several versions of one of Memling's most characteristic compositions, repeated with variations by him and his workshop. The most authoritative treatment of the Madonna and Child type is found in *The Mystic Marriage of Saint Catherine* in Bruges,[3] in which the atmosphere of a heavenly court also receives the most grand expression. In the Gallery's painting the music-making angels introduce the idea of Christ's sacrifice, in addition to offering praise and emphasizing the queenly aspect of the Virgin. The angel at the left gives the Christ Child an apple, the token of his role as the new Adam.[4] The eucharistic vestments worn by this angel[5] and the grapevine in the molding of the arch underline the theme of Christ's sacrifice. The snail and salamander at the base of the grapevine symbolize Mary's virginity.[6] The two sculpted figures atop the columns represent King David, the ancestor of Christ, and Isaiah,[7] who foretold the virgin birth.

Fig. 1. Hans Memling, *Madonna and Child with Angels*, Florence, Galleria degli Uffizi [photo: Copyright A.C.L. Brussels]

Closest to the National Gallery's painting in the disposition of the figures, arch, throne, and landscape are the central section of a triptych in the Kunsthistorisches Museum, Vienna,[8] and a painting in the Uffizi (fig. 1).[9] The arrangement of the enthroned Madonna and Child with music-making angels in an archway recalls a Boutsian composition in the Capilla Real, Granada.[10] In Memling's three paintings, the arch carries sculpture that comments on the enthroned figures and also serves to divide the space into a succession of richly shadowed recesses.

Friedländer and Panofsky, among others, considered the Gallery's version to be earlier than the paintings in Vienna and Florence, which include putti holding garlands and a more agitated windblown canopy; these Italianate elements suggest a date toward the end of Memling's career for these two works.[11] However, a number of factors indicate that the Gallery's painting is not Memling's first formulation of the composition of the Madonna and Child in an arch. Figures and architectural elements are combined in an awkward, additive manner in comparison with the more organic spatial arrangement of the Vienna painting in particular. While the carving on the molding of the arch is very similar to that in the Uffizi painting, even to the inclusion of the snail and salamander, in the Gallery's painting these details lack the crispness and play of light characteristic of Memling's most careful work. The snails in the Uffizi painting are shown crawling on the roots of the vine, yet this detail has been omitted in the Gallery's painting. In comparison to the version in Vienna, the faces of the Madonna and angels have a blandness and fixity that also suggest less careful execution rather than an early working out of the subject. The gesture of the Christ Child is less strongly motivated in relation to the angel offering an apple and may be compared to the static blessing gesture of the Christ Child in the Jacob Floreins altarpiece.[12]

Earlier in this century several authors including Kaemmerer, Weale, Voll, and Friedländer expressed reservations about the attribution of the Gallery's painting to Memling himself. However, following Friedländer's acceptance of the painting in his 1928 catalogue, it has been universally regarded as autograph.[13] Since the degree to which Memling collaborated with assistants is at present not known, the Gallery's painting should be retained as a work by Memling, but considered a rather routine production of the master.[14] The weak effect of the whole is increased by numerous small retouches, yet some passages, such as the red and gold dalmatic and the viol of the angel at the left, are very fine.

The group of paintings showing the Madonna and

Child with angels in an arch should probably be dated after *The Mystic Marriage of Saint Catherine* in Bruges of 1479. The Gallery's painting is presumably contemporary with and may even be later than the paintings in Vienna and Florence, that is, toward the end of Memling's career.

M.W.

Notes

1. This prince built the Gotisches Haus and its English park and was an active collector, adding early German and Netherlandish paintings to the family holdings; see C. Rost, "Der alte Nassau-Oranische Bilderschatz und sein späterer Verbleib," *Jahrbücher für Kunstwissenschaft* 6 (1873), 52–93, esp. 78–79, listing early catalogues of the collection. The descriptions in the early catalogues of the Anhalt-Dessau collection are not sufficiently specific to identify the *Madonna and Child with Angels*.

2. According to a note on a photograph in the Friedländer archive, R.K.D., The Hague.

3. Friedländer, vol. 6a (1971), no. 11, pls. 41–43, and Paul Coremans with René Sneyers and Jean Thissen, "Memlinc's Mystiek Huwelijk van de H. Katharina. Onderzook en Behandeling," *BInstPat* 2 (1959), 83–94.

4. The connection with the Fall is more explicit in the related Vienna triptych, which includes Adam and Eve on the reverse of the shutters, Friedländer, vol. 6a (1971), no. 9, pl. 32.

5. McNamee 1963, 143, noting that this angel wears the deacon's dalmatic and the other angel wears an alb, thus reserving the role of celebrant for the Christ Child.

6. For the snail, S. Braunfels, s.v. "Schnecke," *Lexikon der christlichen Ikonographie*, 8 vols. (Freiburg-im-Breisgau, 1972), 4: 99. Among other associations, the salamander can symbolize chastity; Robert Koch, "The Salamander in Van der Goes' *Garden of Eden*," *JWCI* 28 (1965), 324.

7. A saw is the attribute of Isaiah; see Réau, *Iconographie*, vol. 2, part 1, 365–367.

8. See n. 4 above.

9. Friedländer, vol. 6a (1971), no. 61, pl. 105.

10. Van Schoute 1963, 29–35, no. 94, pl. 31a; attributed by Wolfgang Schöne to Dieric Bouts the Younger, *Dieric Bouts und seine Schule* (Berlin and Leipzig, 1938), 183–184, no. 71. See also a drawing sold in Munich, Karl Hartman sale, Helbing, 30 May 1905, no. 73, repro., as Rogier van der Weyden, and Petrus Christus' two paintings of the *Madonna and Child Enthroned in a Porch* in Madrid, Friedländer, vol. 1 (1967), pls. 88–89.

11. Friedländer, vol. 6 (1928), 30 (vol. 6a, 1971, 53); Panofsky 1953, 349–350, and de Tolnay 1941, 181–182.

12. Friedländer, vol. 6a (1971), no. 66, pl. 109. K. B. McFarlane, *Hans Memling*, ed. Edgar Wind (Oxford, 1971), 31, 59, dates the completion of the altarpiece after the plague of 1489–1490 in which Jacob Floreins died, as his wife is dressed as a widow.

13. Kaemmerer 1899, 134, Weale 1903, 76, 104, Friedländer 1903, 83, and Voll 1909, 136. In an expertise dated 9 March 1927, Friedländer called the painting an autograph replica of the one in Florence (Friedländer archive, R. K. D., The Hague). In *Die altniederländische Malerei*, vol. 6 (1928), 30, he also held it to be autograph and dated it earlier than the paintings in Vienna and Florence.

Fig. 2. Infrared reflectogram assembly of *Madonna and Child with Angels*, 1937.1.41 [infrared reflectography: Molly Faries]

14. Infrared reflectography of the *Madonna and Child* shows very free and open underdrawing strokes in the landscape, in the near wings of both angels, and, to a lesser extent, where the angels' wings join shoulder and upper arm (fig. 2). In the figure of the Madonna and the rest of the angels' drapery, underdrawing made visible by infrared reflectography is confined largely to long, straight strokes to which the surface contours conform. This difference in the underdrawing may indicate that the forms of the Madonna and angels were already relatively fixed, but that Memling was varying and reworking the wings and landscape. An infrared photograph of the Madonna in the Uffizi (A.C.L. 2669LB) shows repeated strokes for folds and widely spaced hatching lines for areas of shadow in the underskirt of the Virgin's robe, comparable to underdrawing in the Bruges *Mystic Marriage of Saint Catherine*; see Johannes Taubert, "Beobachtungen zum schöpferischen Arbeitsprozess bei einigen altniederländischen Malern," *NKJ* 26 (1975), 61–68, figs. 17–18. Compare also the underdrawn drapery in 1952.5.46, *Saint Veron-*

ica (fig. 1). Dominique Hollanders-Favart discusses analogous differences in types of underdrawing in Memling's devotional diptychs, "A propos de l'élaboration du diptych van Nieuwenhove de Hans Memling," *Le Dessin sous-jacent dans la peinture. Colloque IV* (Louvain-la-Neuve, 1982), 103–106.

References

1872 Crowe, J. A., and G. B. Cavalcaselle. *The Early Flemish Painters: Notices of Their Lives and Works.* 2d ed. London: 273, 280.

1899 Kaemmerer, Ludwig. *Memling.* Bielefeld and Leipzig: 134, fig. 116.

1901 Weale, W. H. James. *Hans Memling.* London: 76, 104.

1902 Hulin de Loo, Georges. *Bruges. Exposition de tableaux flamands des XIVe, XVe, XVIe siècles. Catalogue critique.* Ghent: 18, no. 79.

1902 Hymans, Henri. "L'Exposition des primitifs flamands à Bruges." *GBA* 3e pér. 28: 288 (repr. as a book, Paris, 1902: 56).

1903 Weale, W. H. James. "The Early Painters of the Netherlands as Illustrated by the Bruges Exhibition of 1902." *BurlM* 2: 35.

1903 Friedländer, Max J. "Die Brügger Leihausstellung von 1902." *RfK* 26: 83.

1904 Benoit, François. "Un Gérard David inconnu." *GBA* 3e pér. 32: 321.

1909 Voll, Karl. *Memling* (Klassiker der Kunst). Stuttgart and Leipzig: 136, repro. 178.

1910 Wurzbach, Alfred von. "Memling." In *Niederländisches Künstler-Lexikon.* 3 vols., Vienna and Leipzig. 2: 138, 143, 144.

1913 Durand-Gréville, E. "Notes sur les primitifs néerlandais du Louvre." *GBA* 4e pér. 10: 426.

1924 Vioux, Marcelle. *Memling.* Paris: 69.

1928 Hulin de Loo, Georges. "Hans Memlinc in Rogier van der Weyden's Studio." *BurlM* 52: 171.

1928 Friedländer. Vol. 6: 30, 127, no. 60, pl. 34 (vol. 6a, 1971: 21, 53, no. 60, pl. 104).

1930 *International Studio* 97 (December): repro. 28.

1930 V[ollmer], H[ans]. "Memling." In Thieme-Becker 26: 375–376.

1934 Huisman, Georges. *Memlinc.* Paris: 146.

1935 Tietze, Hans. *Meisterwerke europäischer Malerei in Amerika.* Vienna: 334, no. 135, fig. 135.

1937 Jewell, Edward Alden. "Mellon's Gift." *MagArt* 30: repro. 72.

1937 Cortissoz, Royal. *An Introduction to the Mellon Collection.* Privately printed: 34.

1941 *Duveen Pictures in Public Collections of America.* New York: not paginated, no. 178, repro.

1941 NGA: 132, no. 41.

1941 Tolnay, Charles de. "Flemish Paintings in the National Gallery of Art." *MagArt* 34: 181–182, 200, fig. 10.

1942 Baldass, Ludwig von. *Hans Memling.* Vienna: 22, 43, no. 70, fig. 70.

1945 Comstock, Helen. "A Memling for the Nelson Gallery of Art." *Conn* 116: 37.

1949 Mellon: 57, repro.

1953 Panofsky. *ENP:* 349–350, 507, fig. 481.

1955 Verhaegen, Nicole. "Notes à propos de Jean Gossart et d'une 'Tentation de S. Antoine.'" *BMRBA* 4: 181.

1960 Broadley, Hugh. *Flemish Painting in the National Gallery of Art.* Washington: 24, repro. 25 (rev. ed. 1978).

1961 Birkmeyer, Karl M. "The Arch Motif in Netherlandish Painting of the Fifteenth Century: A Study in Changing Religious Imagery." *AB* 43: 110–111, fig. 29.

1963 McNamee, M. B. "Further Symbolism in the Portinari Altarpiece." *AB* 45: 143, fig. 2.

1963 Van Schoute, Roger. *Primitifs flamands. Corpus. Grenada.* Brussels: 77.

1962/1963 Mirimonde, A. P. de. "Les anges musiciens chez Memling." *JbAntwerp:* 14, 53.

1964 Denis, Valentin. "Memling." In *Encyclopedia of World Art.* 16 vols. New York, London, and Toronto, 9: col. 733.

1968 Cuttler. *Northern Painting:* 175, fig. 217.

1969 Rensch, Roslyn. *The Harp: Its History, Technique and Repertoire.* London: 55, pl. 18a.

1969 Pauwels, H. In *Anonieme Vlaamse Primitieven.* Exh. cat. Groeningemuseum. Bruges: 45–46.

1969 Corti, Maria, and Giorgio T. Faggin. *L'opera completa di Memling.* Milan: 107, no. 78, repro.

1971 Ward, John L. "A Proposed Reconstruction of an Altarpiece by Rogier van der Weyden." *AB* 53: 29.

1972 Campbell, Lorne. Review of *Hans Memling* by K. B. McFarlane. In *Apollo* 96: 564.

1975 NGA: 230, repro. 231.

1976 Walker: 130, no. 126, repro.

1977 Eisler: 59, under K2088 (1961.9.28).

1984 Lane, Barbara G. *The Altar and the Altarpiece. Sacramental Themes in Early Netherlandish Painting.* New York: 32, fig. 21.

1937.1.42 (42)

Portrait of a Man with an Arrow

c. 1470/1475
Probably oak, 31.9 x 25.8 (12⁹/₁₆ x 10³/₁₆)
 painted surface: 31.3 x 25.1 (12⁵/₁₆ x 9⁷/₈)[1]
Andrew W. Mellon Collection

Technical Notes: Comparison with the x-radiograph shows that the bottom and left edges have been filled and extended over what was originally unpainted wood (fig. 1). Thus the sitter's hand originally occupied the corner of the painting, with his fingertips at the painting's margin. X-ray fluorescence indicates the presence of modern pigments such as cadmium yellow, zinc white, and Prussian blue in the extended portions of the hand and along all four edges. At some point after these extensions were made the original panel was set into a new mount visible on all four sides as exposed wood.[2] The face, hair, and hat are in good condition with some scattered areas of abrasion and inpainting in the sitter's proper left cheek.

The background was originally a bright blue-green, but the surface layer has discolored, accounting for its present dark appearance. Patches of bright blue are still visible under the microscope, especially at the edge of the hair.[3] The light

Hans Memling, *Portrait of a Man with an Arrow*, 1937.1.42

appearance of the background in the x-radiograph is apparently due to the thick layer of azurite in this area. In the x-radiograph the background shows a wide traction crackle not visible on the surface. A change in the contour of the sitter's hair at the right is visible in infrared photographs and, more clearly, in infrared reflectography. The boundary of the hair was moved further to the right here.

Provenance: British private collection, until 1895.[4] (Bourgeois, Cologne, 1895.)[5] Baron Albert Oppenheim, Cologne, from 1895 [d. 1912].[6] (F. Kleinberger and Co., New York, 1912–1916.)[7] Michael Dreicer, New York, from 1916 [d. 1921]. The Metropolitan Museum of Art, New York, bequest of Michael Dreicer, 1921 (acc. no. 22.60.45). Mrs. Dreicer Whyte, widow of Michael Dreicer, by March, 1933.[8] (M. Knoedler & Co., New York, by 1936.) Purchased February 1936 by The A. W. Mellon Educational and Charitable Trust, Pittsburgh.

Exhibitions: Bruges, Hôtel de Gouvernement Provincial, 1902, Exposition des primitifs flamands et d'art ancien, no. 70. // Brussels, Hôtel Goffinet, 1912, Exposition de la miniature, no. 2031.

THIS IS a relatively early portrait by Memling, probably painted about 1470 to 1475. The sitter wears Burgundian dress, a black doublet under a brown *robe* with padded and extended shoulders. His tall, black cap has an upturned rim to which is pinned a badge of the Virgin and Child on a crescent moon.[9] Although the vertical accent of the tall cap is now scarcely visible, the very dark blue-green background was originally brighter and in stronger contrast to the figure. Since the painted surface has been slightly extended at the bottom and left edges, the sitter's hand must originally have occupied the corner of the picture, with the fingers resting on the frame, possibly even overlapping the frame as in Memling's *Portrait of a Woman* in the Saint John's Hospital, Bruges.[10] The position of the hand would be comparable to that in Memling's *Portrait of a Young Man* in the Accademia, Venice (fig. 2). This would result in a rather cramped and ambiguous placement of the golden arrow, raising the possibility that the arrow, though very old, was not part of the original conception of the portrait.[11]

Fig. 1. Hans Memling,
Portrait of a Man with an Arrow,
1937.1.42, x-radiograph

The precise meaning of the arrow is unclear. In a number of other fifteenth-century Netherlandish portraits, sitters also hold an arrow as an attribute. These are: Rogier van der Weyden's portrait of Antoine de Bourgogne, the illegitimate son of Philip the Good, in Brussels;[12] the *Man with an Arrow* in the Koninklijk Museum voor Schone Kunsten, Antwerp;[13] and a full-length portrait of Charles the Bold in a copy of the *Statutes of the Order of the Golden Fleece* in the British Library.[14] The arrows in these portraits may not all be of the same type, nor can it be assumed that they all convey the same associations. Thus the man in the Antwerp portrait holds an oversize arrow,[15] while the subjects of the other three portraits carry what seem to be ordinary longbow arrows. Helmut Nickel has suggested that oversize arrows held by armed men are a sign of military authority, pointing to depictions of such arrows held by military commanders in narrative contexts where their leadership role is clear, as well as to surviving oversize elaborately decorated ceremonial arrowheads.[16]

The ordinary arrows in the context of a portrait are more difficult to interpret. In 1926 Wilhelm Stein advanced the theory, in relation to the Antwerp portrait whose sitter he identified as Jean Lefèvre de Saint Remy, that the arrow referred to the sitter's role as judge of a tournament.[17] This suggestion was repeated by Buttin, Nickel, and Kantorowicz.[18] While some Burgundian chroniclers do mention the judge of a tournament throwing down an arrow to stop combat,[19] the judge's signal is much more frequently described as given with a baton (*baston*).[20] Another possibility is that the arrows refer to the archery guilds, which played an important role in most cities and small towns in the Netherlands in the fifteenth century, and more specifically to the position of king of the guild awarded in an annual shooting competition.

The award most frequently went to a member of the guild, but it was not uncommon for a prince or dignitary to enter and win the competition. Thus Antoine de Bourgogne was king of the Guild of Saint Sebastian in Bruges in 1463,[21] and Charles the Bold was king of the Brussels archers guild from 1466 to 1471.[22] A tradition of portraits of kings of archery guilds holding arrows as a badge of office from the seventeenth century on gives weight to the possibility that the fifteenth-century portraits can be seen in this context.[23] In any case, the arrow was, in all probability, added at some time after completion of the painting in reference to a newly acquired honor.

In its present state, the Gallery's portrait includes no armorial bearings or other specific indications of the sitter's identity. Nevertheless, Ernst Kantorowicz put

Fig. 2. Hans Memling, *Portrait of a Man*, Venice, Accademia [photo: Alinari]

forward the hypothesis that he is Francesco d'Este, based on comparison to Francesco's features in documented portraits, one by Rogier van der Weyden in the Metropolitan Museum[24] and another in a miniature in the Este family iconography in Rome.[25] Francesco d'Este was born about 1429, the illegitimate son of Lionello d'Este, marquess of Ferrara, and was a member of the Burgundian court for most of his career. The portrait by Rogier would show him as a young man, his features interpreted in Rogier's austere and elegant late portrait style. While the features of the sitter in the Gallery's portrait—the high-bridged aquiline nose, projecting lower lip, and prominent rounded chin—do show some similarity to the less idealized portrait of Francesco in the Este iconography, the extreme rarity of securely identified fifteenth-century portraits makes it rash to identify a sitter based on facial features alone.

The *Man with an Arrow* has been unreservedly accepted as the work of Memling.[26] It is closest to his portraits of Tommaso and Maria Maddalena Portinari in the Metropolitan Museum in the set of the head and shoulders, in the attention to the volume of the head, and in the fineness of detail and texture, an analogy that suggests a date of 1470 to 1475.[27]

M.W.

Notes

1. These dimensions include the areas that have been filled and extended; see Technical Notes.

2. Two portraits in the Metropolitan Museum, *Portrait of a Man* by Dieric Bouts (acc. no. 14.40.644) and *Portrait of an Old Man* by Memling (acc. no. 14.40.648), which were together with the *Portrait of a Man with an Arrow* in a British private collection and in the Oppenheim collection, have also been set into new panels. Friedländer 1919/1920, 107–108, reported that the portraits were all in one frame when Oppenheim acquired them.

3. The composition of the background is very similar to that of the Portinari portraits by Memling in the Metropolitan Museum; Friedländer, vol. 6a (1971), nos. 69–70, pls. 112–113.

4. According to a letter of 17 November 1912, from Friedländer to Kleinberger in the archives of the department of European paintings, Metropolitan Museum, under Bouts, *Portrait of a Man* (acc. no. 14.40.644); information kindly supplied by Lorne Campbell.

5. Friedländer letter cited in preceding note.

6. Letter cited in n. 4.

7. Sold to Dreicer 5 January 1916, according to information in the Kleinberger archive, department of European paintings, Metropolitan Museum; information kindly transmitted by Mary Sprinson de Jesús.

8. I am grateful to Mary Sprinson de Jesús for this information; letter of 6 September 1979 in curatorial files.

9. This pin may reflect a particular devotion on the sitter's part or his membership in a confraternity.

10. Friedländer, vol. 6a (1971), no. 94, pl. 123. For Memling's use of illusionistic devices that appear to extend beyond the picture plane, see Jan Białostocki, "Modes of Reality and Representation of Space in Memlinc's Donor Wings of the *Last Judgment* Triptych," *Essays in Northern European Art Presented to Egbert Haverkamp-Begemann on his Sixtieth Birthday* (Doornspijk, 1983), 38–42.

11. That the arrow is painted over the blue-green background tends to support this notion. X-ray fluorescence pointed to the presence of azurite (for the background), lead white, lead tin yellow, and vermilion in the arrow feather, pigments consistent with an early date. Modern pigments were found in the lower part of the arrow where the design was extended; see Technical Notes.

12. Friedländer, vol. 2 (1967), no. 37, pl. 58. Lorne Campbell has positively identified the sitter, "Rogier van der Weyden's 'Portrait of a Knight of the Golden Fleece': The Identity of the Sitter," *BMRBA* 21 (1972), 7–14.

13. Probably a replica of a lost painting by Rogier van der Weyden or his workshop; Friedländer, vol. 2 (1967), no. 44, pl. 65. Stein 1926, 21–24, identified the subject as Jean Lefèvre de Saint Remy, king of arms of the Order of the Golden Fleece, through an interpretation of the inscriptions on the banderolles and clock. This identification was challenged by Wuyts 1969, 67–95. Most significantly, among other arguments adduced by Wuyts, the subject does not wear the blazon that was the king of arms' badge of office.

14. Ms. Harley 6199, fol. 69, probably executed shortly after 1481; see Paul Durrieu, *La miniature flamande* (Brussels and Paris, 1921), 58–59, pl. LVIII.

15. Wuyts 1969, 65–66, 81–83. He also holds a dagger.

16. Nickel 1968, 61–90. He describes the arrow in the Antwerp portrait as an ordinary arrow, however, 78.

17. Stein 1926, 22–23; see n. 13 above for problems with this identification of the sitter.

18. Buttin 1954, 57–64 (apparently unaware that Stein had suggested Lefèvre as the subject of the Antwerp portrait); Nickel 1968, 83–85; and Kantorowicz 1939/1940, 178.

19. Lefèvre de Saint Remy describes Philip the Good throwing down an arrow to end combat in a tournament in 1435, *Chronique de Jean Le Fèvre, seigner de Saint-Remy . . .*, 2 vols. (Paris, 1876–1881), 2: 318–319, and a similar usage is mentioned in Antoine de la Sale, *L'Hystoire et plaisante cronique de Petit Jehan de Saintre et de la jeune dame des Belles Cousines* (Paris, 1843), 173, both quoted by Buttin 1954, 62–63.

20. See other examples quoted by Buttin 1954, 60–63, as well as Lefèvre de Saint Remy's description of the "pas de la Fontaine de Plours," "Épître de Jean le Fèvre, Seigneur de Saint-Remy," ed. F. Morand in *Société de l'Histoire de France. Annuaire-Bulletin* (1884), 216, 221, 223, 228. Buttin's argument that *baston* is a generic term for arrow does not seem to be sufficient explanation for these descriptions.

21. Henri Godar, *Histoire de la gilde des archers de Saint Sébastien de la ville de Bruges* (Bruges, 1947), 114, 518. I am grateful to Professor Paul Rosenfeld for bringing this and the following reference to my attention.

22. Alphonse Wauters, "Notice historique sur les anciens sermens ou gildes d'arbalétriers, d'archers, d'arquebusiers, et d'escrimeurs de Bruxelles," *La Belgique Communale* 1 (1847), 1048.

23. For Bruges archers, see Godar 1947, fig. 61. For kings of the Bruges guild of crossbowmen, Andre Vanhoutrywe, *De Bruges Kruisbouggilde van Sint-Joris* (Handzame, 1968), pls. 31–32; in addition to holding a crossbow bolt, these victorious competitors wear a jewelled prize as a pendant. Membership in these guilds was restricted to citizens of Bruges.

24. Kantorowicz 1939/1940, 178, an identification first proposed by Stein 1936, 30–31, who, however, misidentified the portrait by Rogier van der Weyden in the Metropolitan Museum as that of Lionello d'Este. For Rogier's portrait, see Friedländer, vol. 2 (1967), no. 23, pl. 44.

25. Biblioteca Nazionale Centrale Vittorio Emanuele, Ms. Vitt. Eman. 293, probably compiled in or shortly after 1476; repro. Kantorowicz 1939/1940, fig. 32b.

26. Only Huisman 1934, 149, and Wilenski 1960, 686, contested the attribution to Memling. Hulin de Loo 1902, 17, no. 70, supported the attribution to Memling while stating that it had been questioned.

27. See n. 3 above. Memling's portraits probably fall between the sitters' marriage in 1470 and their portraits on Van der Goes' Portinari altarpiece of c. 1475/1476; see Friedrich Winkler, *Das Werk des Hugo van der Goes* (Berlin, 1964), 24.

References

1899 Kaemmerer, Ludwig. *Memling*. Bielefeld and Leipzig: 20–21, fig. 16.

1900 Nieuwbarn, M. C. *Hans Memling*. Leipzig: no. 52, repro.

1900/1901 Voll, Karl. Review of *Memling* by Ludwig Kaemmerer. In *Kunstchronik* N.F. 12: 115.

1902 Hymans, Henri. "L'Exposition des primitifs flamands à Bruges." *GBA* 3e pér. 28: 292, repro. opp. 294, etching by J. Vyboud (repr. as a book, Paris, 1902: 60).

1902 Hulin de Loo, Georges. *Bruges. Exposition des*

tableaux flamands des XIV^e, XV^e, et XVI^e siècles. Catalogue critique. Ghent: 17, no. 70.

1903 Weale, W. H. James. "The Early Painters of the Netherlands as Illustrated by the Bruges Exhibition of 1902." BurlM 1: 336.

1903 Friedländer, Max J. "Die Brügger Leihausstellung von 1902." RfK 26: 82.

1903 Mont, Pol de. L'Evolution de la peinture néerlandaise aux XIV^e, XV^e et XVI^e siècles et l'exposition de Bruges. Haarlem: no. 106, repro.

1904 Molinier, Émile. Collection du Baron Albert Oppenheim. Tableaux et objets d'art. Paris: 10, no. 25, pl. XXII.

1906 Voll, Karl. Die altniederländische Malerei von Jan van Eyck bis Memling. Leipzig: 188–189, 225.

1909 Voll, Karl. Memling (Klassiker der Kunst). Stuttgart and Leipzig: 21, repro.

1910 Wurzbach, Alfred von. "Memling." In Niederländisches Künstler-Lexikon. 3 vols. Vienna and Leipzig, 2: 140.

1912 Fierens-Gevaert. "Correspondance de Belgique. L'Exposition de la miniature à Bruxelles." GBA 4^e pér. 7: 194–195.

1916 Friedländer, Max J. Von Eyck bis Bruegel. Berlin: 179.

1919/1920 Friedländer, Max J. "About some of Hans Memling's Pictures in the United States." Art in America 8: 107–108, fig. 2.

1922 Wehle, Harry B. "The Michael Dreicer Collection." BMMA 17: 100, 102, repro.

1924 Metropolitan Museum of Art. Catalogue of Paintings. 7th ed. Compiled by Bryson Burroughs. New York: 221 (8th ed. 1926: 233; 9th ed. 1931: 241).

1926 Stein, Wilhelm. "Die Bildnisse von Roger van der Weyden." JbBerlin 47: 30–31.

1928 Friedländer. Vol. 6: 44, 131, no. 85 (vol. 6a, 1971, 28–29, 56, 130, no. 85, pl. 119).

1927–1929 Fierens-Gevaert, Hippolyte, and Paul Fierens. Histoire de la peinture flamande des origines à la fin du XV^e siècle. 3 vols. Paris and Brussels, 3: 62, 72.

1930 V[ollmer], H[ans]. "Memling." In Thieme-Becker 24: 376.

1934 Huisman, Georges. Memlinc. Paris: 149.

1935 Fierens, Paul. Memling. Paris: no. 13, repro.

1937 Cortissoz, Royal. An Introduction to the Mellon Collection. Privately printed: 35.

1939 Bazin, Germain. Memling. Paris: 20, pl. 6.

1939/1940 Kantorowicz, Ernst H. "The Este Portrait by Roger van der Weyden." JWCI 3: 178, fig. 32c.

1941 NGA: 132, no. 42.

1941 Tolnay, Charles de. "Flemish Paintings in the National Gallery of Art." MagArt 34: 186, 200, repro. 187.

1941 Held, Julius S. "Masters of Northern Europe in the National Gallery." ArtN 40 (June): 11, repro. 13.

1949 Mellon: 58, repro.

1954 Buttin, Charles. "La flèche des juges du camp." Armes anciennes 1: 59, pl. XX.

1960 Wilenski, R. H. Flemish Painters, 1430–1830. New York: 686.

1968 Nickel, Helmut. "Ceremonial Arrowheads from Bohemia." JMMA 1: 78, fig. 31.

1968 Whinney, Margaret. Early Flemish Painting. New York and Washington: 89, pl. 55.

1969 Corti, Maria, and Giorgio T. Faggin. L'opera completa di Memling. Milan: 111, no. 111, repro.

1969 Wuyts, L. "Aantekeningen bij een vermeend portret van Jean Lefèvre door Rogier van der Weyden." JbAntwerp: 82, fig. 14.

1975 NGA: 230, repro. 231.

1976 Walker: 131, repro., no. 127.

1952.5.46 (1125)

Saint Veronica
Reverse: *Chalice of Saint John the Evangelist*

c. 1470/1475
Oak, 31.2 x 24.4 (12¼ x 9⁹⁄₁₆)
 painted surface: 30.3 x 22.8 (11¹⁵⁄₁₆ x 9)
 painted surface, reverse: 30.2 x 23 (11⁷⁄₈ x 9¹⁄₁₆)
Samuel H. Kress Collection

Technical Notes: The panel is composed of a single piece of wood which has been unevenly trimmed at the top edge. It is approximately .5 cm thick at the bottom edge. The painting on the front of the panel is in excellent condition, with only a few scattered small losses. There are some small areas of abrasion in the sky. The back is in less good condition, having received a number of nicks and scratches as well as more abrasion. However, the chalice and snake are well preserved with only a few small losses. The front of the panel was cleaned and restored in 1982 and the reverse cleaned and restored in 1983.

The figure of Saint Veronica is fully underdrawn in what appears to be black chalk (fig. 1), but infrared reflectography revealed minimal underdrawing in the landscape. The underdrawing on the reverse is free and cursory, providing a more general guide for the painted design, including the shadow cast by the chalice (fig. 2).

Provenance: Probably Bernardo Bembo, Venice or Verona [d. 1519]. Probably Pietro Bembo, his son, Padua [d. 1547].[1] Nicolai Demidoff, San Donato, near Florence [d. 1828].[2] Anatole Demidoff, Prince of San Donato, his son, San Donato, near Florence (sale, Paris, 3 March 1870, no. 204, repro., etching by Rajou). Private collection, Italy, until c. 1928.[3] (Matthiesen Gallery, Berlin.) (Paul Cassirer, Berlin.)[4] Baron Heinrich Thyssen-Bornemisza, Villa Favorita, Lugano-Castagnola, by 1930. (M. Knoedler & Co., New York, 1950–1951.)

Exhibitions: Munich, Neue Pinakothek, 1930, *Sammlung Schloss Rohoncz*, no. 222 // Munich. Alte Pinakothek, 1931 // Washington, National Gallery of Art, 1983, *Raphael and America*, no. 78.

THIS PANEL was evidently once part of a small winged altarpiece. With a slight turning gesture, Saint

Hans Memling, *Saint Veronica*, 1952.5.46

Hans Memling, *Chalice of Saint John the Evangelist*, 1952.5.46 (reverse)

Fig. 1. Infrared reflectogram assembly of detail of *Saint Veronica*, 1952.5.46 [infrared reflectography: Molly Faries]

Veronica displays the kerchief miraculously imprinted with Christ's face. Her pose seems to acknowledge other elements of the design at her right-hand. On the back of the panel, a wall with a niche containing the chalice of Saint John the Evangelist is painted in the cool, subdued tones characteristic of an altarpiece exterior. In all probability the painting was part of a diptych, the left half of which was the *Saint John the Baptist* now in the Alte Pinakothek, Munich (figs. 3, 4).[5] This suggestion was first made in 1930 by Rudolf Heinemann, who also linked the panels to a diptych recorded as belonging to the Bembo family in the early sixteenth century.[6] While Heinemann's suggestion has found many supporters, the documents regarding the Bembo panels are not without contradictions. The fact that the reverse of the Gallery's panel shows the attribute of Saint John the Evangelist rather than of the Baptist and that the reverse of the Munich painting shows a skull in a rectangular rather than a rounded niche has led to a number of other hypotheses.

The first mention of the presumed diptych is a letter of 31 August 1502 written by Carlo Bembo on behalf of his father, Bernardo, to Isabella d'Este, and accompanying a loan of some paintings to her in Mantua. Included in the shipment were a Saint John and a Veronica together, both the work of a Northern artist.[7] About three decades later, after the death of Bernardo Bembo, two Flemish paintings are more specifically described as a diptych and given to Memling in Mar-

cantonio Michiel's notes on the paintings belonging to another of Bernardo's sons, the celebrated poet Pietro Bembo: "El quadretto in due portelle del San Zuan Baptista vestito, cun lagnello che siede in un paese da una parte, et la nostra donna cun el puttino da laltro in un altro paese, furona de man de Zuan Memglino,

Fig. 2. Infrared reflectogram assembly of detail of *Saint Veronica* (reverse), 1952.5.46 [infrared reflectography: Molly Faries]

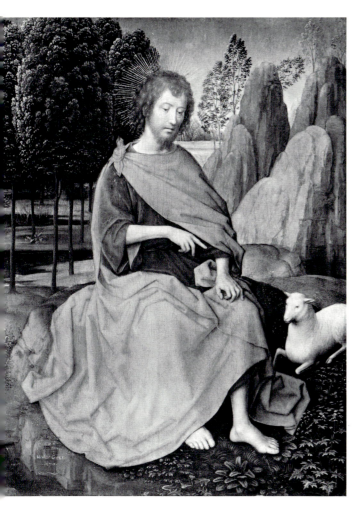

Fig. 3. Hans Memling, *Saint John the Baptist*, Munich, Alte Pinakothek [photo: Bayerische Staatsgemäldesammlungen]

Hans Memling, *Saint Veronica*

Fig. 4. Hans Memling, *Saint John the Baptist* (reverse), Munich, Alte Pinakothek [photo: Bayerische Staatsgemäldesammlungen]

lanno 1470, in salvo el vero."[8] Finally, Jacopo Morelli, the early nineteenth-century Venetian archivist who first published Marcantonio Michiel's notes in 1800, stated that he had seen what he presumed was the wing with the Baptist described by Marcantonio in a Venetian private collection in 1801. Morelli described it as having a death's head and the inscription MORIERIS on the reverse.[9] Lorne Campbell, in publishing Morelli's note, points out that his description corresponds to the reverse of the Munich painting as revealed in a recent cleaning, but that the precise basis for the link with the Bembo diptych remains unclear.

Taken together, these documents contain some contradictions. It is not obvious that the northern Saint John and Saint Veronica mentioned in Carlo Bembo's letter of 1502 formed a diptych, nor that the Baptist was the saint represented. Moreover, while Michiel's description of a robed Baptist with a seated lamb in a landscape can be readily linked with the Munich painting,[10] his identification of the other wing as a Madonna and Child seems to exclude the Gallery's painting. Sterling suggested, apparently without knowing the 1502

Fig. 5. Hans Memling, *Floreins Triptych* (exterior), Bruges, Sint-Janshospitaal [photo: Copyright A.C.L. Brussels]

letter, that Memling painted pendant diptychs, one representing the Baptist and the Madonna and Child and the other Saint John the Evangelist and Saint Veronica.[11] While resolving the problem of the Evangelist's chalice, this suggestion does seem to strain the bounds of probability, especially in view of the formal unity between the Munich and Washington panels. The alternate possibility, that Michiel confused the Veronica with the Madonna and Child, at first appears equally improbable. Yet, as Jennifer Fletcher pointed out in a recent study of Marcantonio Michiel, the diarist's grasp of religious iconography and the lives of the saints in particular is frequently shaky. Her suggestion of the thought process by which Michiel could have substituted the Veronica for the Madonna is plausible.[12]

The formal unity between the Munich and Washington panels is the most important evidence for the diptych, however. The dimensions of the two saints' images are the same,[13] and the landscape is continuous across the two panels. The pool of water visible between the foreground hillocks and the craggy rocks at the right of the *Saint John* continues across into the *Saint Veronica*. In each panel the elements that mark the stages of the landscape recession appear at the same

level and are treated in the same manner. Thus the broad-leafed plants in the foreground give way to finer sprays of vegetation, and a rocky promontory topped by feathery trees fills the middle distance across the panels. The scale of the figures in relation to the landscape is the same, and their slightly turning poses are complimentary. The clear, bright colors of the Baptist's red cloak and Veronica's blue mantle dominate the landscape, while very similar purple-grays determine the subdued tones of each exterior. In addition to these formal consonances, the pairing of the Baptist and Saint Veronica is entirely in keeping with Memling's practice of repeating and varying his own compositions. The same two saints, in very similar poses, are paired on the closed wings of the Floreins triptych in Bruges, dated 1479 (fig. 5).[14]

Saint Veronica was a legendary personage whose name and cult are connected with the *vera icon*, or *sudarium*, a cloth imprinted with Christ's features and venerated as a relic in Saint Peter's in Rome from at least the middle of the twelfth century.[15] Saint Veronica's popularity increased through the fifteenth century. It was thought that the miraculous image was created when the saint wiped Christ's face with her kerchief as he carried the cross to Calvary. She is usu-

ally depicted holding her kerchief before her so that the head of Christ regards the viewer, either with the serene and abstracted gaze of the *Salvator Mundi*, as here, or in the aspect of the Passion, crowned with thorns. Images of the miraculous portrait were supposed to be safeguards against violent death, and Saint Veronica herself was a protectress against sudden death without benefit of the sacraments.

Memling's pairing of Saint Veronica with Saint John the Baptist emphasizes Christ's role as redeemer, as Vida Hull has pointed out in the context of the Floreins triptych.[16] In the presumed Bembo diptych, Saint John gestures towards the Lamb of God, which is both his own attribute and the symbol of Christ's sacrifice, while Saint Veronica displays the icon of Christ the Saviour. These christological symbols, especially the large *sudarium*, assume greater prominence through the reserved gestures and downcast eyes of the saints.[17] The reverse of the presumed diptych remains difficult to interpret. Possibly it connected the need for redemption with the more personal anxieties of the diptych's owner. Certainly the death's head and inscription *MORIERIS* (you will die) sound a direct note of warning. Wolfgang Kermer has suggested that the highly unusual depiction of the chalice of Saint John the Evangelist may have had anti-demonic associations.[18] As far as the problem of the rectangular and arched niches is concerned, it is evident from the few diptychs that survive intact that the backs of these small, personal altarpieces were not governed by conventions of formal unity. One or the other back may have been painted, and in cases where both were decorated, they were not necessarily equivalent images.[19]

Apart from the evidence of the added inscription on the Munich panel and the date reported by Michiel, the Munich and Washington panels should be considered on stylistic grounds to be among Memling's relatively early works. They must precede the Floreins triptych of 1479, in which the same figure types are treated with the more complex play of light and shade and more elongated proportions of the artist's later paintings.[20]

Memling's conception of figures in a landscape, as well as the stylized plants and foliage of these two panels, may be reflected in the young Raphael's *Saint George and the Dragon*, 1937.1.26 in the National Gallery, and *Canigiano Holy Family* in the Alte Pinakothek, Munich.[21] A more specific Italian reflection of the presumed diptych, and further evidence of its early Italian provenance, is a Raphaelesque portrait in Munich, which repeats the landscape of the *Saint John the Baptist*.[22]

M.W.

Notes

1. See commentary below.

2. According to catalogue of the Demidoff sale, 3 March 1870, no. 204.

3. According to Friedländer 1928, 125.

4. According to Friedländer 1930, no. 27.

5. No. 652, 31.6 x 24.4 cm (30.5 x 23.1, painted surface, front), approximately .5 cm thick at bottom edge; added inscription *H. V. D. GOES / 1472* at lower right. A painted verso showing a skull in a rectangular niche with the inscription *MORIERIS* chiseled in the wall below was revealed in a recent cleaning, see [Peter Eikemeier] 1983, 341. I am indebted to Dr. Eikemeier and the staff of the Alte Pinakothek for their gracious help with queries about the Munich painting.

6. Rudolf Heinemann-Fleischmann 1930, 66.

7. "... mando etiam per el dito portatore ala S.ᵃ uostra un San Ziouani et una Veronica adinsime ambi lauor oltramontano che credo non spiacere a la S.ᵃ uostra di uedere. ..." The letter was published by Vittorio Cian, "Pietro Bembo e Isabella d'Este Gonzaga. Note e documenti," *Giornale storico della letteratura italiana* 9 (1887), 85–86; see also Campbell 1981, 468–471, who summarizes the documents relating to the presumed diptych and adds important new material.

Bernardo Bembo was at that time away from Venice on a diplomatic mission. Carlo Bembo died in 1503. For the Bembo family see *Dizionario biografico degli italiani* (Rome, 1966), 8: 103–109 and 133–151.

8. "The little painting with two wings of Saint John the Baptist clothed, with a lamb that sits in a landscape on one side, and Our Lady with the little Child on the other [side] in another landscape, by the hand of Hans Memling, year 1470, this being true;" D. Jacopo Morelli, *Notizia d'opere di disegno* (Bassano, 1800), 17, and Theodor von Frimmel, *Der Anonimo Morelliano* (*Quellenschriften für Kunstgeschichte und Kunsttechnik*) N.F. 1 (Vienna, 1896), 86. Pietro Bembo's paintings were then in Padua. Jennifer Fletcher, "Marcantonio Michiel: his friends and collection," *BurlM* 123 (1981), 461, dates Michiel's notice of Pietro Bembo's collection in the 1520s or early 1530s.

9. Campbell 1981, 471. The painting was then in the possession of the Abate Alvise Celotti. In 1819/1820 it was acquired by King Max I of Bavaria in Mannheim.

10. It was, in fact, first linked to the Munich painting by Gustavo Frizzoni, *Notizia d'opere di disegno pubblicata et illustrata da D. Jacopo Morelli*, 2d ed. (Bologna, 1884), 44.

11. Sterling 1952, 127, n. 33, noting that a Saint John on Patmos could be paired with the *Saint Veronica*. This suggestion was taken up by Shapley and Shapley 1957, 122, 132. C. Brown 1981, 27, also suggested that the Bembo family owned two Memling diptychs, one comprised of the Munich and Washington panels and another resembling the reconstituted diptych of the *Madonna and Child with Saints* and *Saint John the Baptist and a Donor* in the Louvre (Friedländer, vol. 6a [1971], no. 15, pl. 54).

Hull 1981, 124, 140, thought a triptych made up of panels of equal size with the Madonna and Child in the center was another possibility. In this case, the wings would not close over the center, which seems improbable given the painted backs.

12. Fletcher 1981, 604–605. Noting that the Veronica is not common in Venetian art, she suggests that, when writing up his notes, he recalled seeing a seated woman with some-

thing involving a head in her lap and guessed that it was the Madonna. If the Munich panel were indeed joined in a diptych with a Madonna and Child, then both the saint's pose and Michiel's description indicate that the Madonna would, of necessity, be on the right side. That she should occupy the less honored *sinister* half of a diptych is unusual, a rare example being a grisaille diptych in the Louvre, probably after Jan van Eyck; repro. Charles Sterling, "Jan van Eyck avant 1432," *RArt* no. 32 (1976), fig. 52.

13. See Technical Notes and n. 5 above.

14. Friedländer, vol. 6a (1971), no. 2, pls. 4, 7.

15. An earlier tradition connected Veronica and the image with the woman cured of an issue of blood. For Saint Veronica, see K. Pearson, *Die Fronica* (Strasbourg, 1887); Ernst von Dobschütz. *Christusbilder* (*Texte und Untersuchungen zur Geschichte des altchristlichen Literatur* N.F. 3) (Leipzig, 1899), 197–260; and Réau, *Iconographie*, vol. 2, part 3, 1314–1317.

16. Hull 1981, 126–128.

17. According to Eisler 1977, 56, the pool, which is especially prominent in the Munich panel, probably refers to the Baptism of Christ, while the winding road behind Saint Veronica may refer to the road to Calvary. It is noteworthy that such narrative references are much more explicit in the Floreins triptych, where a vignette of the Baptism occupies the background of one wing and a ship, perhaps the one in which the legendary Saint Veronica and her kerchief traveled to Rome, is shown in the background of the other.

18. Kermer 1967, 187, 293–294. This attribute of Saint John the Evangelist refers to a miracle performed by him on the island of Ephesus. The high priest of the Temple of Diana wished to test the power of the Evangelist's faith by having him drink from a poisoned cup. After blessing the cup, the saint drank the poison without harm; see Ryan and Ripperger, *The Golden Legend*, 1: 61. The coiling snake represents the poison leaving the cup. Prayers and charms with associations of exorcism which are connected with this episode in the legend of Saint John may have been more current in Germany than in the Netherlands; Gustav Gugitz, *Fest- und Brauchtumskalender fur Österreich, Süddeutschland und die Schweiz* (Vienna, 1955), 162–163.

The Evangelist's symbol may also refer to the name saint of the diptych's first owner. However, there is no basis for the supposition, raised by Kermer 1967, 187, and Eisler 1977, 56, that this was Jan Floreins, who made his profession as a brother of the Saint John's Hospital, Bruges, in 1479.

19. The back of Hugo van der Goes' diptych of the Fall of Man in the Kunsthistorisches Museum, Vienna, may be analogous to the presumed diptych in function and appearance; on one reverse Saint Genevieve, protectress against the plague and fever, is depicted in grisaille, while a coat of arms formerly decorated the other. See [Klaus Demus, Friderike Klauner, and Karl Schütz], Kunsthistorisches Museum, *Katalog der Gemälde-Galerie. Flämische Malerei von Jan van Eyck bis Pieter Bruegel d. Ä.* (Vienna, 1981), 189–192, repro.

20. The Munich and Washington panels have been consistently dated before the Floreins triptych; for example, Hull 1981, 124–126. Panofsky 1953, 498, found the landscape of the *Saint John* to be more advanced than that of the Veronica panel and suggested a possible prototype by Hugo van der Goes.

That the diptych could have been dated on its lost original frame is suggested both by Michiel's report of a specific date and by the inscription added to the Munich panel. A date in the early 1470s is certainly in accord with Lorne Campbell's

observation that Bernardo Bembo could have acquired the diptych during his embassy to the court of Charles the Bold from 1471 to 1474; Campbell 1981, 471.

21. Washington 1983, 153–157, 196–197, pl. 12, and Shearman 1983, 25, for the *Saint George*; von Sonnenburg 1983, 26, for the *Holy Family*. Brown supposes that Pietro Bembo took the diptych to the court at Urbino in 1506 and that Raphael saw it there. It is also possible that Raphael had access to another, similar devotional work by Memling.

22. Von Sonnenburg 1983, 26, and 107–108, figs. 121, 126. The porphyry columns framing the figure suggest the influence of Memling's portrait convention as well.

References

1872 Crowe, J. A., and G. B. Cavalcaselle. *The Early Flemish Painters: Notices of their Lives and Works.* 2d ed. London: 299.

1916 Friedländer, Max J. *Von Eyck bis Bruegel.* Berlin: 178.

1928 Friedländer. Vol. 6: 125, no. 46 (vol. 6a, 1971: 52, 130, no. 46, pl. 95).

1930 Friedländer, Max J. In *Unknown Masterpieces in Public and Private Collections.* Ed. by W. R. Valentiner. London: unpaginated, no. 37, repro.

1930 "La vie artistique à l'étranger." *Le Bulletin de l'art ancien et moderne* 58: 416, repro. 415.

1930 Mayer, August L. "Die Ausstellung der Sammlung 'Schloss Rohoncz' in der Neuen Pinakothek, München." *Pantheon* 6: 297, repro. 305.

1937 Heinemann, Rudolf. *Stiftung Sammlung Schloss Rohoncz.* 2 vols. Lugano-Castagnola, 1: 104–105, no. 281, pl. 68.

1939 Bazin, Germain. *Memling.* Paris: pls. 10, 11.

1942 Baldass, Ludwig von. *Hans Memling.* Vienna: 20, 42, no. 57, fig. 57.

1949 Alexander, H. G. "The Thyssen-Bornemisza Collection at Lugano." *Conn* 123: 30, fig. VI.

1950 Krönig, Wolfgang. "Geertgens Bild Johannes des Täufers." *Das Münster* 3: 198.

1951 Frankfurter, Alfred M. "Interpreting Masterpieces." *ArtNA* 50, no. 7: 102, 111, repros. 102, 105.

1952 Sterling, Charles. *La Nature morte de l'antiquité à nos jours.* Paris: 27, 127.

1953 Panofsky. *ENP:* 498.

1954 Ferguson, George. *Signs and Symbols in Christian Art.* New York: pl. XI.

1957 Shapley, Fern Rusk, and John Shapley. *Comparisons in Art: A Companion to the National Gallery of Art, Washington, D. C.* New York: 122, 132, repro.

1959 Kress: 284–285, repro.

1960 Broadley, Hugh T. *Flemish Painting in the National Gallery of Art.* Washington: 5, 22, repro. 23.

1960 *Flanders in the Fifteenth Century: Art and Civilization.* Exh. cat. Detroit Institute of Arts. 1960: 144.

1961 Seymour, Charles, Jr. *Art Treasures for America.* London: 62–63, 213, pls. 55, 56.

1962 Neugass, Fritz. "Die Auflösung der Sammlung Kress." *Die Weltkunst* 32: 4.

1967 Kermer, Wolfgang. *Studien zum Diptychon in der sakralen Malerei von den Anfängen bis zur Mitte des sechzehnten Jahrhunderts.* 2 vols. Ph.D. diss. Eberhard-Karls-Universität, Tübingen, 1: 184–187, 292–294; 2: 139–141, no. 139, figs. 178, 179.

1969 Corti, Maria, and Giorgio T. Faggin. *L'opera completa di Memling.* Milan: 104, no. 59b, pl. 51.

1971 McFarlane, K. B. *Hans Memling*. Ed. Edgar Wind. Oxford: 45, fig. 132.

1975 NGA: 232, repro. 233.

1977 Eisler: 55–57, figs. 50, 51.

1978 Chastel, André. "La Véronique." *RArt* no. 40/41: 75, 82.

1979 Rosenbaum, Allen. *Old Master Paintings from the Collection of Baron Thyssen-Bornemisza*. Exh. cat. International Exhibitions Foundation. Washington: 116.

1981 Hull, Vida Joyce. *Memlinc's Paintings from the Hospital of Saint John in Bruges*. New York and London: 123–128, 140–141, figs. 44, 45.

1981 Brown, Clifford M. "Un tableau perdu de Lorenzo Costa et la collection de Florimond Robertet." *RArt* no. 52: 27–28, fig. 4.

1981 Campbell, Lorne. "Notes on Netherlandish pictures in the Veneto in the fifteenth and sixteenth centuries." *BurlM* 123: 471, fig. 15.

1981 Fletcher, Jennifer. "Marcantonio Michiel, 'che ha veduto assai.'" *BurlM* 123: 604–606.

1983 Shearman, John. "A drawing for Raphael's 'St. George.'" *BurlM* 125: 25.

1983 [Peter Eikemeier], *Alte Pinakothek München. Erläuterung zu den ausgestellten Gemälden*. Munich: 341.

1983 Sonnenburg, Hubertus von. *Raphael in der Alten Pinakothek*. Exh. cat. Bayerische Staatsgemäldesammlungen. Munich: 107–108.

1983 Shearman, John. *The Early Italian Pictures in the Collection of her Majesty the Queen*. Cambridge: 210.

1984 Gould, Cecil. Review of John Shearman, *The Early Italian Pictures in the Collection of her Majesty the Queen*. In *Apollo* 119: 225.

Antonis Mor

c. 1516/1520–c. 1575/1576

Antonis Mor van Dashorst, frequently referred to by the Spanish form of his name, Antonio Moro, was a native of Utrecht. The evidence concerning Mor's birth and death dates is ambiguous. A document dated 17 April 1576 mentioning his son in the role of heir to his estate has recently been interpreted to mean that Antonis had died by this date. The early biographers Van Mander and Buchelius state that he died a year before the massacre called the Spanish Fury (4 November 1576), but give different accounts of his age at death, fifty-six or fifty-nine. His birthdate has therefore been calculated as c. 1516/1520.

Mor was a pupil of Jan van Scorel in Utrecht. The only certain early work by him is the double portrait of the Canons Cornelis van Horn and Antonis Taels, signed and dated 1544, in the Gemäldegalerie, Berlin. In 1547 he registered as a master with the guild of Saint Luke in Antwerp. By 1549 he was painter to Antoine Perrenot de Granvelle, bishop of Arras and later Cardinal and a key figure in the Habsburg court. Mor's next known works are the portraits of Granvelle and of the Duke of Alba, in the Kunsthistorisches Museum, Vienna, and the Hispanic Society, New York, respectively, both dated 1549. They show Mor already in command of the type of formal state portraiture that he was to practice at several European courts. Mor may have accompanied Granvelle to the imperial Diet in Augsburg in 1548 when Titian was also in Augsburg working for Charles V, which would account for the influence of Titian's portrait types on these early works. Mor's work for Granvelle evidently recommended him to Prince Philip of Spain, the future Philip II, and to his family, for in the next few years he traveled to Spain, Portugal, and Italy painting members of the Habsburg family. His portrait of Queen Mary of England, signed and dated 1554, was presumably painted in England in connection with her marriage to Prince Philip that year.

Mor seems to have lived primarily in Utrecht, where he owned property, but to have divided his time between that city and Antwerp and Brussels. Toward the end of his life he moved his household from Utrecht to Antwerp. The date of this move is unclear; however, he seems to have been settled in Antwerp by 1573.

Mor's portraits of princes and courtiers exercised a strong influence on subsequent state portraiture, particularly in Spain. His somewhat less reserved portraits of middle-class sitters influenced painting in Antwerp. Mor also produced a number of religious works.

M.W.

Bibliography

Buchelius, Arnoldus. "*Res Pictoriae*." Ed. G. J. Hoogewerff and J. Q. van Regteren Altena. *Quellenstudien zur holländischen Kunstgeschichte*. Vol. 15. The Hague, 1928.

Mander, Carel van. *Het Schilder-Boeck*. Haarlem, 1604.

Marlier, Georges. "Antonis Mor van Dashorst (Antonio Moro)." Académie Royale de Belgique. Classe des Beaux-Arts. *Mémoires*. Series 2. 3 Fasc. 2 (1934).

De Vries, A. B. *Het Noord-Nederlandsch Portret in de Tweede Helft van de 16ᵉ Eeuw*. Amsterdam, 1934.

Friedländer. Vol. 13. 1936 (vol. 13, 1975).

Frerichs, L. C. J. *Antonis Moro*. Amsterdam, 1947.

Wijburg, W. A., Jr. "Antonie Mor van Dashorst 'vermaard schilder van Utrecht' en zijn naaste familie." *De Nederlandsche Leeuw* 76 (1959), cols. 230–248.

1937.1.52 (52)

Portrait of a Gentleman

1569
Wood, transferred to canvas, 119.7 x 88.3 (47¹/₈ x 34³/₄)
Andrew W. Mellon Collection

Inscriptions:
At upper left: *Antonius mor pingebat a. 1569*

Technical Notes: The painting has been transferred from a panel to a canvas support.[1] The original support was composed of three boards joined vertically. The background, originally very thinly painted, is now somewhat abraded and has been rather heavily inpainted, perhaps to give it a more finished appearance. In addition, a strip about one inch wide has been repainted along the margin of the painting on all sides. Inpainting is also evident in two vertical strips along the former join lines, in the beard of the sitter to the left of his mouth where there is a rather large loss, and in small scat-

Antonis Mor, *Portrait of a Gentleman*, 1937.1.52

tered patches on his forehead, cheeks, and hands. The signature and date appear to be original, though the signature has been reinforced.

Provenance: Probably Sir Peter Lely, London [d. 1680] (sale, London, 18 August 1682).[2] George John, 2d Earl Spencer, Althorp House, Northamptonshire, by 1822.[3] The Earls Spencer, Althorp House. Albert Edward John, 7th Earl Spencer, Althorp House, until 1927. (Duveen Brothers, New York.) Purchased February 1930 by Andrew W. Mellon, Washington. Deeded 28 December 1934 to The A. W. Mellon Educational and Charitable Trust, Pittsburgh.

Exhibitions: Manchester, 1857, *Exhibition of Art Treasures*, no. 513. // London, South Kensington Museum, 1866, *Special Exhibition of National Portraits Ending with the Reign of King James the Second*, no. 186. // Manchester, Corporation of Manchester Art Gallery, 1897, *Exhibition of the Royal House of Tudor*, no. 126. // London, Whitechapel Art Gallery, 1904, *Dutch Exhibition*, no. 140. // London, Royal Academy of Arts, 1907, *Exhibition of Works by the Old Masters*, no. 8. // London, Royal Academy of Arts, 1927, *Flemish and Belgian Art, 1300–1900*, no. 231.

THE IDENTITY of the sitter is unknown, yet form and accessories link this work to the tradition of court portraiture, of which Mor was a leading exponent. The massive hunting dog conveys aristocratic and princely associations.[4] Gold chains are a traditional sign of honor and might have been bestowed on the sitter by a prince.[5] The standing three-quarter length pose also suggests the sitter's high social position, as Mor favored more informal seated poses for his middle-class subjects.[6]

When in the Spencer collection, this painting was considered to be a self-portrait.[7] Comparison with Mor's self-portrait of 1558 in the Uffizi shows not only a lack of correspondence in the features, but a fundamental difference in the presentation of the sitter, which is direct and modest in the case of the artist seated before his easel and reserved and haughty in the Gallery's portrait.[8] Based on the mistaken assumption that the painting was a self-portrait, it was commonly dated in the early 1550s, yet the treatment of the figure in space agrees with the date of 1569 that was revealed when the portrait was cleaned.[9] In comparison to Mor's earlier portraits in which the poses are aligned with the frontal plane, the pose here is freer, as evident in the sitter's more relaxed silhouette and in the arm thrust out akimbo, emphasized by the play of highlights on the gray sleeve.[10] In its combination of aristocratic elegance and ease the *Portrait of a Gentleman* anticipates Flemish portraiture of the next century, notably that of Van Dyck.

The discovery of the date does not provide a firm indication of where the portrait was painted, however. About 1569 Mor moved his household from Utrecht to Antwerp, having commuted between Utrecht and the southern Netherlands in the preceding years. Frerichs maintained that the portrait was painted during a trip to England in 1568/1569, based on the mistaken assumption that the 1568 *Sir Henry Lee* in the National Portrait Gallery, London, would have been painted in England.[11]

A drawing of the head from the Gallery's portrait in colored chalks with watercolor is in the Musée Jacquemart-André, Chaalis, and has been cited both as Mor's preparatory study for the portrait[12] and as a copy after the portrait by a sixteenth-century French artist.[13] The technique of the drawing does not justify either supposition. Indeed the regular cross hatching, strong contrast of dark and light in the face, and generalized treatment of ear and hair are not characteristic of a sixteenth-century drawing.[14] Another copy of the head, on paper laid down on panel, was sold at Christie's in 1954.[15]

M.W.

Notes

1. Presumably the painting was transferred after Duveen acquired it, when it was also cleaned and restored. In the catalogue of the 1927 Royal Academy exhibition, no. 231, and in earlier catalogues it is described as on panel.

2. "A Man with a Gold Chain and a Dog," 3 ft 5 in by 2 ft 9 in, is listed after Antonis Mor's name in the handlist for the sale of Sir Peter Lely's collection; "Sir Peter Lely's Collection," *BurlM* 83 (1943), 187. Lely's collection also included a self-portrait, among other works by Mor. Dallaway's notes to Walpole's *Anecdotes* 1826, 1: 240, first connected the painting, then in the Spencer collection, with the item in the Lely sale.

Joanna Woodall has made the interesting suggestion that the picture may be identical with a three-quarter length portrait by Mor in the Orléans collection, in conversation, 4 February 1985; see Louis-François Dubois de Saint-Gelais, *Description des Tableaux du Palais Royal . . .* (Paris, 1727), 62–63, as the portrait of a Spaniard from the collection of Monsieur, that is, Philippe de France, Duke of Orléans, d. 1701. This may be the picture sold with part of the Orléans collection in London in April 1793, no. 49 for 15 guineas, as a self-portrait by Mor; see Waagen 1854, 2: 501. Christiaan Kramm (1857–1864) first linked the reference in the 1793 Orléans sale to the portrait then in the Spencer collection. However, there are a number of discrepancies between Dubois de Saint-Gelais' relatively precise description and the Gallery's painting. Thus Dubois de Saint-Gelais does not mention chains of honor, sword, or dagger, but does describe a signet ring on the hand resting on the dog's collar. I am grateful to Joanna Woodall for her comments on the painting.

3. Dibdin 1822, 1: 262–263.

4. The portraits of Charles V with a hound by Seisenegger and Titian, in Vienna and Madrid respectively, are most notable among court portraits with hunting dogs; John Pope-Hennessy, *The Portrait in the Renaissance* (New York, 1966),

171–172, figs. 190–191. Other examples include Cranach's 1514 portrait of Duke Henry the Pious of Saxony in Dresden (Max J. Friedländer and Jakob Rosenberg, *The Paintings of Lucas Cranach* [Amsterdam, 1978], no. 60, fig. 60) and Bronzino's portrait of Guidobaldo della Rovere, Duke of Urbino, in the Pitti Palace (Andrea Emiliani, *Il Bronzino* [Milan, 1960], pl. 11). Socially restrictive hunting regulations may account in part for the aristocratic associations of portraits with hunting animals; see Scott A. Sullivan, "Rembrandt's 'Self-Portrait with a Dead Bittern,'" *AB* 62 (1980), 236–243. In Mor's portrait of Cardinal Granvelle's fool in the Louvre, the inclusion of one of the Cardinal's hunting dogs heightens the irony of this full-length image; Friedländer, vol. 13 (1975), no. 377, pl. 185.

5. Julius S. Held, *Rembrandt's 'Aristotle' and other Rembrandt Studies* (Princeton, 1969), 35–37.

6. Philippot 1965, 173–174.

7. Dibdin 1822, 1: 262–263. Ellis Waterhouse suggested that this notion may have resulted from the 2d Earl Spencer's interest in portraits of artists; letter of 7 August 1980 and note in curatorial files.

8. Friedländer, vol. 13 (1975), no. 358, pl. 178.

9. See for example von Loga 1907/1909, 112, Marlier 1934, 22, and Friedländer, vol. 13 (1936), 172, no. 354 (vol. 13, 1975, 102), who dated it c. 1555 though he had earlier doubted that it was a self-portrait, in Friedländer 1907, 378.

The signature and date were first recorded in the catalogue of the 1927 Royal Academy exhibition, though the picture was still assumed to be a self-portrait. This assumption was corrected in NGA 1941, 135, by Frerichs 1947, 39, and in most later literature on the painting.

10. See Philippot 1965, 173–174.

11. Frerichs 1947, 57, and Groeneveld 1981, 115. Friedländer had assumed that Mor traveled to England in 1568/1569); vol. 13 (1975), 65. Actually, Lee was in Antwerp in March 1568; see Roy Strong, *National Portrait Gallery. Tudor and Jacobean Portraits*, 2 vols. (London, 1969), 1: 190–191, no. 2095, repro. frontispiece.

12. Marlier 1934, 81–83, 96–97, nos. 11–12.

13. Louis Dimier, *Histoire de la peinture de portrait en France au XVI siècle*, 2 vols. (Paris and Brussels, 1924/1925), 1: pl. 50; 2: 207, no. 816; and Albert Châtelet and Jacques Thuillier, *French Painting from Fouquet to Poussin* (Geneva, 1963), 136, color repro. 132, as by Pierre Dumoûtier *l'oncle* without reference to the Gallery's painting.

14. Egbert Haverkamp-Begemann noted that the drawing technique is reminiscent of the eighteenth century; letter of 21 September 1980 in curatorial files.

15. Christie's, London, 10 December 1954, no. 126, from the collection of John Scott-Taggart; photo in curatorial files.

References

1822 Dibdin, Thomas Frognall. *Aedes Althorpianae; or an Account of the mansion, books, and pictures, at Althorp; the residence of George John earl Spencer, K.G.* 2 vols. London, 1: 262–263, repro. opp. 262.

1823 *Catalogue of the Pictures at Althorp, the seat of the Right Honorable the Earl Spencer, K.G.*. Northampton: 23.

1826 Walpole, Horace. *Anecdotes of Painting in England. . . .* 2d ed. Ed. James Dallaway. 5 vols. London, 1: 240.

1831 *Catalogue of the Pictures at Althorp House in the County of Northampton, with occasional Notes, Biographic and Historical.* London: no. 271.

1836 Passavant, J. D. *Tour of a German Artist in England.* 2 vols. London, 2: 35.

1854 Waagen, Gustav Friedrich. *Treasures of Art in Great Britain. . . .* 4 vols. London, 3: 457.

1857–1864 Kramm, Christian. *De levens en werken der hollandsche en vlaamsche Kunstchilders beeldhouwers, graveurs, en bouwmeesters. . . .* 7 vols. Amsterdam, 4: 1160–1161.

1860 Bürger, W. [Théophile Thoré] *Trésors d'art en Angleterre.* Brussels and Ostende: 173–174.

1861 Blanc, Charles. *Histoire des peintres de toutes les écoles. École hollandaise.* 2 vols. Paris, 1: 4, 8, repro. 1 (engraving of head).

1906 Pierre-Marcel, René. "Collection du Comte Spencer." *Les Arts* 60 (Dec.): 8, repro. 5.

1907 Friedländer, Max J. "Die Winterausstellung der Royal Academy in London 1907." *RfK* 30: 378.

1907/1909 Loga, Valerian von. "Antonis Mor als Hofmaler Karls V. und Philipps II." *JbWien* 27: 112, pl. XXII.

1910 Hymans, Henri. *Antonio Moro son oeuvre et son temps.* Brussels: 114–115.

1926 Tipping, H. Avray. *English Homes.* 9 vols. London, 9: repro. 315.

1927 Benkard, Ernst. *Das Selbstbildnis vom 15. bis zum Beginn des 18. Jahrhunderts.* Berlin: XXXVIII–XXXIX, 24–25, pl. 31.

1931 L. S. "Antonis Mor." In Thieme-Becker 25: 111.

1934 Marlier, Georges. "Antonis Mor van Dashorst (Antonio Moro)." Académie Royale de Belgique. Classe des Beaux-Arts. *Mémoires.* Series 2. 3. Fasc. 2: 22, 79–83, 96–97, no. 11, fig. 11.

1936 Friedländer. Vol. 13: 172, no. 354 (vol. 13, 1975: 102, 118, no. 354, pl. 176).

1937 Cortissoz, Royal. *An Introduction to the Mellon Collection.* Privately printed: 35–36.

1941 NGA: 135, no. 52.

1941 *Duveen Pictures in Public Collections of America.* New York: not paginated, no. 190, repro.

1941 Tolnay, Charles de. "Flemish Paintings in the National Gallery of Art." *MagArt* 34: 189–191, 200, figs. 20–22.

1947 Frerichs, L. C. J. *Antonio Moro.* Amsterdam: 39, 57, repro. 52.

1947 Friedländer, Max J. "Frans Pourbus der Ältere." *OH* 57: 65–66, fig. 6.

1949 Mellon: 66, repro.

1953 De Vries, A. B. "Antonio Moro." *Les arts plastiques.* Series 6. 3: 206, fig. 95.

1960 Wilenski, R. H. *Flemish Painters 1430–1830.* New York: 168, 608, pl. 428.

1962 Müller Hofstede, Justus. "Zur frühen Bildnismalerei von Peter Paul Rubens." *Pantheon* 20: 286–287, fig. 13.

1962 Puyvelde, Leo van. *La peinture flamande au siècle de Bosch et Breughel.* Paris: 264, fig. 142.

1965 Philippot, Paul. "Le portrait à Anvers dans la seconde moitié du XVIe siècle." *BMRBA* 14: 173, fig. 4.

1972 Ragghianti, Carlo. "Pertinenze francesi nel cinquecento." *Critica d'Arte* 19, n.s. 122: 46, 73, fig. 53.

1975 NGA: 244, repro. 245.

1978 De Meyere, J. A. L. "Utrechtse schilderkunst in de tweede helft van de 16de eeuw." *Jaarboek Oud-Utrecht*: 145, fig. 26.

1981 Groeneveld, Elizabeth E. H. "Een herziene biographie van Anthonis Mor." *JbAntwerp*: 115.

Follower of Antonis Mor

1961.9.79 (1631)

Portrait of a Young Man

1558
Probably oak (cradled), 97.5 x 69.9 (38³/₈ x 27¹/₂)
Samuel H. Kress Collection

Inscriptions:
At upper left: · Æ · S · 20 / Aº · 1558

Technical Notes: The panel, which is composed of three vertical members, was cradled in 1955 when it was cleaned and restored by Mario Modestini. It is in very good condition, with losses and inpainting largely confined to the joins and to some scratches in the lower left corner. There is some abrasion in the face. An adjustment in the angle of the sitter's proper left arm is visible in raking light. Examination with infrared reflectography shows a number of changes between the underdrawing and the painting of the costume. The collar of the leather doublet was lower, as was the position of the buttons; the waist was higher and the position and angle of the vertical cuts in the doublet different. Chains of honor underdrawn around the sitter's neck were not painted.

Provenance: Probably Prince Karl Anton von Hohenzollern-Sigmaringen [d. 1885].[1] Prince Leopold von Hohenzollern-Sigmaringen, his son [d. 1905]. Prince Wilhelm August Karl von Hohenzollern-Sigmaringen, his son [d. 1927]. Fürstlich Hohenzollernsches Museum für Wissenschaft und Kunst, Sigmaringen. (A. S. Drey, Munich and New York, 1928–1929.) (M. Knoedler & Co., Inc., 1929–1934.) (Robert Frank, Ltd., 1934.)[2] Baron Heinrich Thyssen-Bornemisza, Villa Favorita, Lugano-Castagnola, by 1937 [d. 1947]. Baroness Gabrielle Bentinck-Thyssen, his daughter, 1947–1952. (M. Knoedler & Co., Inc., by 1952.)[3] Samuel H. Kress, New York, 1952.

Exhibitions: Munich, Alte Pinakothek, 1928, no cat. // New York, A. S. Drey, 1928, *Flemish Primitives Formerly in the Collection of the Prince of Hohenzollern-Sigmaringen*, as Mor. // New York, M. Knoedler & Co., Inc., 1932, *Naval and Military Portraits*, no. 9, as Mor.

THE TWENTY-YEAR-OLD SITTER'S creamy leather doublet, decorated with a pattern of fine and long slashes, and his sleeves and breeches of muted purple-gray form a striking color harmony against the neutral gray background. Details such as the doublet's curling edges, the buttons, and the gleaming hilts of sword and dagger are rendered with a crisp and rather decorative touch. The artist evidently had some trouble with the arm placed akimbo, since he changed its contour, sharpening the angle of the elbow without conveying the ease the gesture implies.[4]

The elegance and reserve of the sitter and his pose with the near arm grasping the edge of a summarily indicated table owe much to Antonis Mor, to whom the portrait was previously attributed. Beginning with the portrait of his patron Granvelle, dated 1549, in the Kunsthistorisches Museum, Vienna, Mor used the corner of a table as an anchor for a standing figure shown in three-quarter view.[5] However, the Gallery's portrait lacks the tension that Mor sets up between richly textured surfaces and rather rigid, planar poses. The decorative treatment of details and flatter modeling of the face here result in a more flaccid image lacking the intensity with which Mor's sitters confront the viewer.

Colin Eisler first questioned the attribution of this portrait to Mor.[6] He suggested that it belonged to the international style of the mid-sixteenth century and might well be the product of a Netherlandish artist working at a foreign court. However, the pose, together with the portrait's relatively early date and the way the sleeves and hands are modeled, point to an artist within Mor's sphere of influence and probably working in the Netherlands.[7]

The identification of the sitter as Count Willem IV van den Bergh, put forward by J. A. G. C. Trosée, rests on the fact that the property of the Van den Bergh family was inherited by the Princes of Hohenzollern-Sigmaringen, the first recorded owners of the portrait.[8] The date and age inscribed on the painting agree with the birthdate of this Dutch nobleman, a brother-in-law of William the Silent.[9] While the sitter's aristocratic bearing would be appropriate for a portrait of the young count, this identification requires confirmation through a secure portrait of Van den Bergh or positive evidence that the portrait entered the Hohenzollern-Sigmaringen collection through the Van den Bergh family.

M.W.

Notes
1. See Reiffel 1924, 59. The painting is not mentioned in F. A. von Lehner, *Fürstlich Hohenzollernsches Museum für Wissenschaft und Kunst, Verzeichniss der Gemälde* (Sigma-

Follower of Antonis Mor, *Portrait of a Young Man*, 1961.9.79

ringen, 1871; 2d ed., 1883), suggesting either that it was acquired after 1883 or that it hung in some other property of the family.

2. I am grateful to Nancy C. Little, Librarian, M. Knoedler & Co., Inc., for this information; letter of 14 February 1984 in curatorial files.

3. See preceding note.

4. The painting has probably been trimmed slightly at the bottom, since the lower edge of the table and hand are missing. The possibility that the painting was originally full-length should not be entirely excluded, but seems unlikely.

5. Friedländer, vol. 13 (1975), 64, 101, pl. 344.

6. Eisler 1977, 96. Jacques Foucart also questioned the attribution to Mor, note of 21 March 1975, in curatorial files.

7. In a letter of 6 February 1984, Paul Philippot suggests that the portrait is, in all probability, a good contemporary copy after Mor.

8. Trosée 1929, 6.

9. Trosée states that he was born 24 December 1537. For this nobleman, see also *Nieuwe Nederlandsch Biographisch Woordenboek*, 10 vols. (Leiden, 1910–1937), 8: cols. 81–84. According to Drs. R. R. A. van Gruting, Stichting Huis Bergh (letter of 10 September 1984 in curatorial files), a note of Albertus Hermans (d. 1874), Pastor of Boxmeer, another former property of the counts of Bergh, mentions a portrait similar to the Gallery's but full-length, which was at Boxmeer before 1861. However, Dr. Peter Kempf, Curator of the Fürstlich Hohenzollernsches Museum in Sigmaringen, could provide no information on how the painting entered the museum in Sigmaringen (letter of 17 February 1984 in curatorial files).

References

1924 Reiffel, Franz. "Das Fürstlich Hohenzollernsche Museum zu Sigmaringen: Gemälde und Bildwerke." *Städel-Jahrbuch* 3–4: 59.

1929 Trosée, J. A. G. C. *Het eerste Tijdvak van het Verraad van Graaf Willem van den Bergh (Gelre. Werken*, no. 18). Arnhem: 6, frontispiece.

1931 *The Arts* 17: repro. cover.

1932 *Parnassus* 4, no. 4: 20, repro.

1936 Friedländer. Vol. 13: 172, no. 359, pl. 66 (vol. 13, 1975: 102, no. 359, pl. 179).

1937 Heinemann, Rudolf. *Stiftung Sammlung Schloss Rohoncz*. Lugano-Castagnola: 107, pl. 98.

1956 Kress: 132, repro. 133.

1959 Kress: 288, repro.

1975 NGA: 246, repro. 247.

1977 Eisler: 96, fig. 83.

Netherlandish Artist

1943.7.7 (744)

The Healing of the Paralytic

c. 1560/1590
Oak (cradled), 107.8 x 76 (42½ x 29⅞)
Chester Dale Collection

Technical Notes: The panel consists of three boards with vertical grain. A wedge-shaped piece of wood in the upper right-hand corner appears to be an old restoration. The painting is in relatively good condition. There is moderate abrasion in the most thinly painted areas. Heavy abrasion in the beard of the paralytic has been repainted. There is darkened repaint in the wedge at the upper right and along the two vertical join lines. An A-shaped scratch at the lower left was inpainted in 1967.

Provenance: Sale, Christie's, London, 11 April 1924, no. 89, as Jan van Hemessen, purchased by Lacey.[1] (Spink & Son, London.)[2] (Ehrich Galleries, New York, by 1925.) W. Lever (sale, American Art Association, Anderson Galleries Inc., New York, 18 April 1934, no. 54, as Jan van Hemessen). Chester Dale, New York, April 1934.

THE PAINTING illustrates one of the miracles performed by Christ, which is recounted in the Gospels of Matthew, Mark, and Luke. The fullest version is that found in Mark 2:1–12. While Christ was preaching in Capernaum, a paralytic was brought to him, but because of the crowd it was necessary to cut a hole in the roof of the building and lower him down to Christ. After forgiving him his sins, Christ healed his paralysis and ordered, "rise, take up your pallet and go home." The earlier portion of the parable is depicted in the background, where at the left is a building with figures clustered around a hole in the roof, at whose entrance Christ gestures over the prone paralytic. This miracle is represented infrequently in northern European art of the fifteenth and sixteenth centuries and is often confused with depictions of Christ at the Pool of Bethesda (John 5:2–9), where a paralytic is also healed.[3]

While *The Healing of the Paralytic* was sold in 1924 as a work by Jan van Hemessen, the strongest support for the attribution was offered a few years later by Paul Wescher. Wescher considered the painting to be of high quality and dated it late in Hemessen's career, after his putative stay in Haarlem from 1551, where he was influenced by Jan van Scorel and Maerten van

Heemskerck. He compared the picture to *Christ Driving the Money-Changers from the Temple*, dated 1556 (Musée des Beaux-Arts, Nancy).[4] No other critical discussion of the painting has been published, though Puyvelde accepted the attribution to Hemessen.[5] Burr Wallen does not consider the painting to be an autograph Hemessen.[6]

The Healing of the Paralytic appears to be the only known painting by this as yet unidentified artist. There is a dearth of useful comparative examples, and attempts to associate the painting with the work of known artists or to localize the style have produced what are at best tentative and often divergent opinions. The color has been compared with that of Cornelis van Dalem,[7] and some details to Pieter Aertsen's pictures.[8] The most interesting connections, however, are with paintings grouped around Pieter Pourbus the Elder (c. 1523/1524–1584) who was born in Gouda, but was active in Bruges.[9] In 1978 Henri Defoer found similarities between the Gallery's panel and the depiction of *Saints Crispin and Crispinian* (fig. 1) that is on the reverse of the *Baptism of Saint Eustace* in the museum "Het Catharina-Gasthuis," in Gouda.[10] These panels are considered part of an altarpiece painted for the church of Saint John, Gouda, by Pourbus.[11] There is a certain degree of similarity between the saints and the paralytic in the figure types and in the muscularity of the legs and arms, though hands and faces are different. Paul Huvenne also connects the Gallery's picture with the *Saints Crispin and Crispinian* panel, but does not think that both are by the same artist.[12] Wouter Kloek suggests similarities to the work of Lambert van Noort (c. 1520–1571) who was active primarily in Antwerp.[13] There are some points of comparison, specifically with Van Noort's *Christ Washing the Disciples' Feet* (fig. 2), signed and dated 1560, in the Koninklijk Museum, Antwerp.[14] The bulky, muscular figures and the short cropped hair of several of the disciples is generally comparable, but not close enough to assist in the attribution of the Gallery's painting.[15]

It would appear, then, that *The Healing of the Paralytic* should be associated with a figural style of the 1560s. However, a dendrochronological examination of the panel conducted by Josef Bauch indicated a tree with a probable felling date of 1584^{+x}_{-2}.[16] Martha Wolff observes that the drapery in the Gallery's painting is more crisply rendered than in the examples cited above. This stiffer and crisper drapery style is more

Fig. 1. School of Gouda (?), *Saints Crispin and Crispinian*, Gouda, Museum Het Catharina Gasthuis [photo: Bob de Wit]

characteristic of the 1580s, as seen in the works of an artist like Anthonis Blocklandt.[17] One way of explaining the discrepancy is to suggest that *The Healing of the Paralytic* was painted by an archaizing Nether-landish artist working in the 1580s in a manner of twenty years before. The vertical format and place-ment of a single large figure against a simplified back-ground suggest that it may have been possibly part of a series of panels depicting Christ's miracles. More pre-cise information must await further study and inquiry.

<div align="right">J.O.H.</div>

Notes

1. The word *Lacey* is written in ink in the margin of the Library of Congress copy of the catalogue.

2. Information contained in the Chester Dale papers on file at the National Gallery of Art.

3. See Andor Pigler, *Barockthemen*, 2d ed., 3 vols. (Bu-dapest, 1974), 1: 304–305; the more numerous representa-tions of Christ at the Pool of Bethesda are listed 306–309.

4. Wescher 1929, 40–41.

5. Puyvelde 1962, 190.

6. Letter to the author, 3 January 1984, in the curatorial files, noting some connections with Hemessen's style and suggesting a date in the 1560s. The painting is not discussed in Wallen's dissertation or in his book, *Jan van Hemessen, an Antwerp Painter between Reform and Counter Reformation* (Ann Arbor, 1983).

7. Samuel Nystad, letter of 10 February 1978 to the au-thor, in the curatorial files.

8. Anthony Colantuono, summer intern in the depart-ment of Northern European painting, 1981, compared the clouds to those in the exterior wings of Pieter Aertsen's *Cruci-fixion Altarpiece* of 1546 (Koninklijk Museum, Antwerp), repro. in Friedländer, vol. 13 (1975), no. 293, pl. 144.

9. Roger d'Hulst, letter of 20 March 1977 to the author, was certain that the Gallery's painting was not by Pourbus, while Horst Gerson in a letter of 31 March 1977 thought that Pourbus was a "good guess."

Fig. 2. Lambert van Noort, *Christ Washing the Disciples' Feet*, 1560, Antwerp, Koninklijk Museum voor Schone Kunsten [photo: Copyright A.C.L. Brussels]

Netherlandish Artist, *The Healing of the Paralytic*, 1943.7.7

10. Letter to the author of 19 January 1978.

11. Paul Huvenne, *Pierre Pourbus. Peintre brugeois 1524–1584* [exh. cat. Musée Memling (Hôpital Saint-Jean)] (Bruges, 1984), 189–192, no. 12. Huvenne does not believe that the *Saints Crispin and Crispinian* is by Pourbus, but rather is by an anonymous artist of the School of Gouda.

12. In conversation, 6 October 1983.

13. In conversation, 13 October 1983.

14. Walther Vanbeselaere, *Musée Royal des Beaux-Arts, Anvers. Catalogue Descriptif. Maîtres Anciens* (Antwerp, 1970), 172, no. 449; photo ACL 115735B.

15. The background figures have not provided clues. The closest parallel is found in the scene of the Entombment that occurs in the background of a *Lamentation* (present location unknown, photograph in NGA photographic archives) attributed to the Master of the Prodigal Son, who was active in Antwerp from the 1530s to the 1560s. I have not found similar background figures in other works given to this master. I am indebted to Martha Wolff for bringing this painting to my attention.

16. See Appendix I.

17. In conversation 22 December 1983. For example, *The Adoration of the Shepherds* in the Museum of Fine Arts, Budapest, repro. Marianne Haraszti-Takàs, *The Masters of Mannerism* (New York, 1968), no. 37. For the artist see Ingrid Jost, "Studien zu Anthonis Blocklandt, mit einem vorläufigen beschreibenden Oeuvre-Verzeichnis," Ph.D. diss., Universität Köln, 1960.

References

1929 Wescher, Paul. "Einige neue Bilder zum Werk Jan van Hemessens." *Belvedere* 8: 40–41, repro.

1935 Tietze, Hans. *Meisterwerke europäischer Malerei in Amerika.* Vienna: repro. 150 (also Engl. ed., New York 1939).

1962 Puyvelde, Leo van. *La peinture flamande au siècle de Bosch et Breughel.* Paris: 190.

1965 *Paintings Other than French in the Chester Dale Collection.* Washington: 12, repro.

1975 NGA: 172, repro. 173.

Northern Netherlandish Artist

1952.5.41 (1120)

Adoration of the Magi

Last quarter of fifteenth century
Wood, transferred to canvas, 183 x 164.5 (72 x 64¾)
Samuel H. Kress Collection

Technical Notes: The paint and ground layers were transferred at an unknown date from a panel that had six vertical members, as is evident from traces of the joins still visible in raking light. The present canvas support has been relined. The type of wood making up the original panel is unknown, though a label affixed to the back of the frame states that it was "transferred from an oaken panel."[1] The painting has a smooth white ground with underdrawing to which the painted design conforms quite precisely.

The painting is in good condition. There are some areas of loss and abrasion, particularly at the edges and along the former joins in the panel, in the blue cloak of the Virgin and the area around her head, especially her veil, and in the right wall of the shed, as well as numerous tiny losses throughout. The old inpainting has discolored in these areas.

Provenance: Probably from a convent in the province of Guipuzcoa, Spain.[2] Count Alessandro Contini-Bonacossi, Rome, by 1926.[3] Samuel H. Kress, New York, 1927.

AS A SUBJECT for large altarpieces, the Adoration of the Magi exemplified Christ's kingship over the forces of the world. It was also often the occasion for a splendid display of courtly and exotic figures; toward the end of the fifteenth century in particular, the retinue of the wise men played an important role.

The biblical account of the journey of the wise men, or Magi, to pay homage to the child born king of the Jews (Matthew 2:1–12) was elaborated by later authors, who added much narrative and symbolic detail.[4] Thus the wise men came to be identified as kings, and their number, unspecified in Saint Matthew's account, was given as three. This corresponded to the three gifts of gold, frankincense, and myrrh mentioned in the Bible, as well as to medieval notions of the three continents and the three ages of man. In the Western church their names were Melchior, Casper, and Balthasar; though their order and kingdoms fluctuated, Balthasar was most frequently the Moorish or African king.

A classic version of these legends, the *Liber trium Regum*, written in the late fourteenth century by Jo-

hannes of Hildesheim, describes the setting for the Nativity and Adoration as a shabby little house built on the ruins of the structure in Bethlehem where Christ's ancestor King David was born.[5] In the Gallery's painting the ruin is very summarily indicated by the rough brick wall at the left and probably also by the flower-lined brick walks suggesting the remnants of a formal garden. The placement of the Virgin and Child in this implied enclosure and before the ruined house of David emphasizes the Virgin's queenly role and Christ's dominion over the princes of the world. Johannes of Hildesheim also describes the caravan of the Magi mounted on mules, horses, and camels.[6] In the Gallery's painting the crowd of figures unloading packs, holding monkeys or falcons, or engaged in more warlike activities forms three separate groups, probably each representing the retinue of one of the Magi.[7] To the left of the shed, the brown-hooded figure leaning on a stick and his green- and red-clad companion are probably shepherds, often present in scenes of the Adoration of the Magi.[8] The two figures conferring at the back of the shed may, as Eisler suggested, relate to King Herod and his jealous interest in Christ's birth.[9]

In view of the *Adoration*'s ambitious size and lively detail, it is surprising that no other works by this painter are known. Its Spanish provenance led to the assumption that it was the work of a northerner active in Spain, and since entering the Gallery it has been called "Hispano-Dutch school."[10] However, it contains no clear references to Spanish painting.[11] Instead, the *Adoration of the Magi* shows a distinctive fusion of several currents in northern Netherlandish art toward the end of the fifteenth century. The treatment of faces and hands of the foreground figures as smooth rounded surfaces recalls the few known works by Ouwater and the early Bouts, yet the long facial type and little eyes of these figures are closer to those of a later generation, such as the Master of the Virgo inter Virgines and his followers.[12] In its reliance on a clearly delimited rectangular space at the center, the composition of the *Adoration of the Magi* is related to works of the Master of the Tiburtine Sibyl and the Virgo Master.[13] The crowd of overlapping and straining mounted figures in the background is also close to those in the Virgo Master's paintings of the same subject, though painted in a much harder manner.[14]

In addition to these multiple connections with Dutch painting, the author of the *Adoration* possessed a dis-

tinctive feeling for decorative effect. This is expressed in the combination of large forms and crisp, fanciful detail, and also in the repetition of stereotyped figures. Thus the two attendants in the lower corners who frame the scene are mirror images of each other in pose, though their elaborate costumes have been varied. The repetition of only a few designs for the horses and camels filling the middle ground adds to the decorative effect of the whole.

This painter's apparent familiarity with several currents in northern Netherlandish painting, which he combines in a brittle and eccentric way, suggests that he worked in a provincial area. This could have been in the Netherlands, in Spain, or perhaps even in the Lower Rhine where contacts with Dutch art were extensive. It is difficult to date the picture precisely because of its provincial character, but it was probably painted in the last quarter of the fifteenth century.

<div align="right">M.W.</div>

Notes

1. The label reads: "PP-A2 – a picture representing The Adoration of the Maggi [sic]. An early painting attributed to the Dutch School, said to be painted not later than 1480. Transferred from an oaken panel. From a convent in Spain. Contini – New York, 4-6-1927. $EM, NxN."

2. I have been unable to find the precise basis for the tradition that the picture comes from the Basque province of Guipuzcoa. In a statement in the curatorial files, Robert Quinn analyzed the history and holdings of various monastic establishments in the province, concluding that the most likely candidates for ownership of the *Adoration* were the Convento de Bidaurrete and the Convento de Aránzazu, both in Oñate; see also Eisler 1977, 65–66.

3. See certificate of Roberto Longhi, November 1926, in curatorial files.

4. See Hugo Kehrer, *Die heiligen drei Könige in Literatur und Kunst*, 2 vols. (Leipzig, 1908–1909), and Stephan Waetzoldt, "Drei Könige" in *Reallexikon zur deutschen Kunstgeschichte*, 8 vols. (Stuttgart, 1937–), 4: cols. 476–501.

5. Margaret B. Freeman, *The Story of the Three Kings: Melchior, Balthasar and Jaspar, which was originally written by John of Hildesheim . . .* (New York, 1955), based on an early English translation of the text.

6. Freeman 1955, 13–15.

7. The retinues of the kings are sometimes shown as three distinct processions, as in a panel by the Master of Saint Bartholomew in the Weld Collection; *Kölner Maler der Spätgotik: Der Meister des Bartholomäus Altares, der Meister des Aachener Altares* [exh. cat. Wallraf-Richartz-Museum] (Cologne, 1961), 73–75, no. 10, fig. 23.

8. For example, in Hugo van der Goes' Monforte altarpiece and in his *Adoration of the Magi* known only from copies; Friedländer, vol. 4 (1969), no. 17, pl. 28, no. 20, pl.

34. Eisler 1977, 64, suggested that they were pilgrims in quasi-monastic garb.

9. Eisler 1977, 64–65, suggesting that the jewel-studded gold badge and costume worn by the figure at the right may be that of a messenger, as identified by Helmut Nickel, "The Man beside the Gate," *BMMA* n.s. 24 (1966), 237–244. It seems unlikely that either of these somewhat sinister figures represents Saint Joseph. Eisler suggested that Joseph might have been on another panel, now lost. Other Adorations without Joseph include Stefan Lochner's altarpiece in Cologne cathedral, Alfred Stange, *Deutsche Malerei der Gotik*, 11 vols. (Berlin, 1934–61), 3: 100–103, figs. 122–124, and a triptych by a follower of the Master of the Virgo inter Virgines, Friedländer, vol. 5 (1969), no. 50, pl. 34.

10. See references below. On fifteenth-century Dutch painters working in Spain or the importation of their works in the fifteenth and sixteenth centuries, see Wolfgang Schöne, "Über einige altniederländische Bilder, vor allem in Spanien," *JbBerlin* 58 (1937), 174–181, and K. G. Boon, "De schilder van de triptiek in de Disputacion Provincial te Avila," *Miscellanea Jozef Duverger*, 2 vols. (Ghent, 1968), 1: 110–123.

11. Students of Spanish painting have been unable to perceive Spanish elements in the work; see note by Robert Quinn dated 14 June 1963, referring also to the opinion of José Gudiol, and a letter of 16 August 1982, from Judith Berg Sobré, in curatorial files. In general, students of a particular regional school have tended to disavow the painting. Thus, Max Friedländer maintained that it was Spanish (opinions of 21 March 1937 and November 1938 in curatorial files). K. G. Boon (letter of 29 August 1982 in curatorial files) suggests that the painting may be Westphalian rather than Dutch, citing the work of the Master of 1473, while Paul Pieper (letter of 24 November 1983 in curatorial files) saw no relation to late fifteenth-century German painting.

12. In the work in the Rijksmuseum from which the painter takes his name or in the *Annunciation* in Aachen; repro. Albert Châtelet, *Early Dutch Painting: Painting in the northern Netherlands in the fifteenth Century* (New York, 1981), figs. 123, 126.

13. For example, the Master of the Tiburtine Sibyl's *Augustus and the Tiburtine Sibyl* in Frankfurt and the *Marriage of the Virgin* in the Johnson Collection, Philadelphia, or the Virgo Master's *Virgo inter Virgines*; repro. Châtelet, *Early Dutch Painting*, figs. 121, 122, 126.

14. In paintings in the Carolino Augusteum Museum, Salzburg, and the Johnson Collection, Philadelphia; repro. Châtelet *Early Dutch Painting*, fig. 127, and Friedländer, vol. 5 (1969), no. 52, pl. 35.

15. The *Adoration* parallels the adaptation of Dutch forms in two Germanic copies of a lost Boutsian Madonna in the Metropolitan Museum and the Museo Correr, Venice; see Wolfgang Schöne, *Dieric Bouts und seine Schule* (Berlin and Leipzig, 1938), 136–138, no. 22, pl. 50.

References

1951 Kress: 184, no. 81, repro. 185.
1975 NGA: 174, repro. 175.
1977 Eisler: 64–66, fig. 59.

Northern Netherlandish Artist, *Adoration of the Magi*, 1952.5.41

Bernard van Orley

c. 1488–1541

Bernard van Orley was born in Brussels, probably around 1488. His father, Valentin, was a painter as was his younger brother, Everard, and it is assumed that Bernard was initially taught by his father. The altarpiece of Saints Thomas and Matthias, split between the Kunsthistorisches Museum, Vienna, and the Musées Royaux des Beaux-Arts, Brussels, is signed and is generally regarded as an early work, c. 1512/1515. Bernard became associated with the court early in his career. In 1515 he was commissioned by Margaret of Austria to paint portraits of the children of Philip the Fair. In the same year Van Orley began work on an altarpiece for the Brotherhood of the Holy Cross of the church of Saint Walburga in Veurne (Furnes), which was not installed until 1520. In 1518 the artist was appointed painter to the court of Margaret of Austria. He remained in this position until her death in 1530 and continued to work for Margaret's successor, Mary of Hungary.

Bernard van Orley's first dated work is the portrait of *Dr. George Zelle* of 1519 in the Musées Royaux des Beaux-Arts, Brussels. This was followed by several important dated works: the "Vertu de Patience" altarpiece of 1521, possibly commissioned by Margaret of Austria (Musées Royaux des Beaux-Arts, Brussels); two depictions of the *Holy Family*, one in the Louvre, dated 1521, and one in the Prado, dated 1522. The *Last Judgment* altarpiece (Koninklijk Museum, Antwerp), was completed by 1525. Something of Van Orley's ultimate painting style can be seen in the huge *Crucifixion* triptych in the Church of Our Lady, Bruges, which was begun in the 1530s and remained unfinished at the time of his death. It was completed by Marcus Gheeraerts after 1560 and restored in the late 1580s. These and other paintings illustrate Van Orley's ability to assimilate Renaissance architectural and ornamental elements as well as Italianate figural rhythms into an essentially Netherlandish matrix. It is not known if Bernard van Orley ever journeyed to Italy. His knowledge of Italian art could have come from engravings and, from 1517 on, through direct observation of

Raphael's cartoons for the *Acts of the Apostles* tapestry series, which was woven in Brussels.

Bernard van Orley was the head of a large workshop and, as an artist affiliated with the court, he doubtless depended on his atelier to fill the demand for images. In particular, this included portraits of Margaret of Austria and Charles V, for these exist in numerous replicas. Van Orley was a skilled designer and draftsman, and in many ways his fame as a creator of a High Renaissance style in the North rests as much upon the tapestries he designed from 1518 onward as upon his paintings. He was also a gifted designer in stained glass, as can be seen in the windows in the Chapel of the Holy Sacrament in Saint Gudule, Brussels, which are dated between 1537 and 1540. Bernard van Orley died in Brussels on 6 January 1541.

J.O.H.

Bibliography
Friedländer. Vol. 8, 1930 (vol. 8, 1972).
Terlinden, Charles, et al. *Bernard van Orley 1488–1541*. Brussels, 1943.
Baldass, Ludwig. "Die Entwicklung des Bernart van Orley." *JbWien* N.F. 13 (1944): 141–191.
Farmer, John David. "Bernard van Orley of Brussels." Ph.D. diss., Princeton University, 1981.

1952.5.48 (1127)

The Marriage of the Virgin

c. 1513
Probably oak (cradled), 55.5 x 34 (21 7/8 x 13 3/8)
 painted surface: 54.4 x 33 (top) – 35.1 (bottom) (21 7/16 x 13 3/4)
Samuel H. Kress Collection

Technical Notes: The painting is in very good condition with only small scattered retouchings and a large, repainted loss in the upper left sky. With the possible exception of the bottom edge, the panel has been cut down slightly at the edges, so that portions of the design and barbe are missing. The paint surface narrows on the sides 10 cm from the bottom, suggesting that the frame was irregularly shaped. Examination with infrared reflectography reveals extensive underdrawing through-

Bernard van Orley, *The Marriage of the Virgin*, 1952.5.48

out the figures and architecture (fig. 1). There are numerous minor changes in the figures; the small square windows were originally drawn larger and arched. The painting was cleaned and restored in 1949.

Provenance: Abbot Jacques Coëne, Marchiennes [d. 1542]. (Annesley Gore, London, 1923.)[1] Albert J. Kobler, New York, by 1929.[2] Mrs. Edward A. Westfall, New York, before 1946.[3] (Duveen Brothers, New York, by 1946.) Samuel H. Kress Foundation, New York, 1949.

Exhibitions: New York, F. Kleinberger Galleries, 1929, *Loan Exhibition of Flemish Primitives*, no. 85. // New York, Duveen Art Galleries, 1946, *An Exhibition of Flemish Paintings*, no. 16.

Notes
1. Reproduced in an advertisement for Annesley Gore, Ltd. in *BurlM* 42 (January 1923), V.
2. According to exh. cat. F. Kleinberger Galleries 1929.
3. According to exh. cat. Duveen Art Galleries 1946.

1952.5.47 (1126)

Christ among the Doctors
Reverse: *Putto with Arms of*
Jacques Coëne

c. 1513
Probably oak, 54.9 x 33.3 (21⅝ x 13⅛)
 painted surface: 54.4 x 32.9(top) – 33.3(bottom) (21⁷⁄₁₆ x 13 – 13⅛)
 reverse, painted surface: 54.4 x 32.6(top) – 32.9(bottom) (21⁷⁄₁₆ x 12¹⁵⁄₁₆ – 13)
Samuel H. Kress Collection

Inscriptions:
On the border of the red robe worn by the seated figure at the right: *NVLLE ION. NE. M.* · ·

Technical Notes: The painting is in very good condition. There are small, scattered retouchings, particularly in the

Fig. 1. Infrared reflectogram assembly of a detail of *The Marriage of the Virgin*, 1952.5.48 [infrared reflectography: Molly Faries]

Bernard van Orley, *Christ among the Doctors*, 1952.5.47

Bernard van Orley, *Putto with Arms of Jacques Coëne*, 1952.5.47 (reverse)

upper portions of the architecture and the columns. Remnants of unpainted edges and a barbe indicate that the panel was painted in an engaged frame. A narrowing of the painted surface on the sides 9 cm from the bottom may indicate an irregularly shaped decorative frame. Examination with infrared reflectography reveals extensive underdrawing in both brush and what appears to be pen or chalk. There are large areas of cross hatching in the figures and the architecture. The young Jesus originally stood on a small round dais, and in the upper story of the loggia shallow arches are drawn underneath the horizontal lintel on either side of the portico.

The reverse has suffered more damage than has the front. There are large areas of loss and retouching in the putto's face and thigh and generally in the lower half of the painting. No underdrawing was made visible with infrared reflectography.

Provenance: Same as 1952.5.48.

Exhibitions: New York, F. Kleinberger Galleries, 1929, *Loan Exhibition of Flemish Primitives*, no. 86. // New York, Duveen Art Galleries, 1946, *An Exhibition of Flemish Paintings*, no. 15.

THE MARRIAGE OF THE VIRGIN depicts an event mentioned in apocryphal accounts such as the *Protevangelium of James* or the *Golden Legend*.[1] The mar-riage of Mary and Joseph takes place on the porch of an ornate temple. Mary, who wears a crown, takes Joseph's hand in the gesture of *dextrarum junctio* symbolic of conjugal union. Depictions of the marriage of the Virgin often include her parents, and the figure wearing a kerchief at the extreme left has been identified as Saint Anne.[2]

Christ among the Doctors is based upon the account given in Luke 2: 41–51.[3] The twelve-year-old Jesus is in the temple of Jerusalem, here represented as a loggia-like structure, astonishing with his wisdom the two groups of doctors who flank him. Directly behind Jesus are Mary and Joseph, who have returned from their journey home to seek their son.

The attribution of *The Marriage of the Virgin* and *Christ among the Doctors* to Bernard van Orley has never been questioned and virtually all authors agree with Friedländer in dating the panels as early as c. 1512/1513.[4] The starting point for an analysis of Van Orley's first style is the signed altarpiece of *Saints Thomas and Matthias*, now split between the Kunsthistorisches Museum, Vienna (fig. 2), and the Musées Royaux des Beaux-Arts, Brussels. This altarpiece came from the Church of Notre-Dame du Sablon, Brussels,

Fig. 2. Bernard van Orley, *Saints Thomas and Matthias Altarpiece*, center panel, Vienna, Kunsthistorisches Museum [photo: Kunsthistorisches Museum]

where it was presumably commissioned by the carpenter's guild, and is dated on stylistic grounds c. 1512/1515.[5] Friedländer was able to group several paintings, including the Gallery's panels, around this altarpiece as belonging to Bernard van Orley's first phase of production.[6] There are several points of comparison between the *Saints Thomas and Matthias* altarpiece and the Gallery's panels, among them certain facial types, dramatic yet inarticulate gestures, bright colors and use of *couleur changeant* in certain fabrics, and perhaps most important, the juxtaposition of figures in an exterior setting to elaborate architectural constructions.

The most extensive discussion of *The Marriage of the Virgin* and *Christ among the Doctors* is provided by Farmer.[7] He dates the *Saints Thomas and Matthias* altarpiece as close to 1515 as possible and believes that the Gallery's panels may be Van Orley's earliest extant work, dating to c. 1513. The sources for Bernard van Orley's architecture are diverse. In addition to the work of Brussels painters, Farmer sees in Van Orley's early paintings and drawings the influence of Jan Gossaert's architectural forms, the fantasy of the Antwerp Mannerists, and ceremonial structures that were erected in conjunction with the Joyous Entry of Charles V into Bruges, which took place in 1515. All of these examples derive from the richly decorated and highly ornamental style that distinguished Renaissance art and architecture in such northern Italian cities as Brescia, Pavia, and Milan. The vasiform columns in *Christ among the Doctors* are singled out as a specifically northern Italian motif while Eisler sees the loggia-like setting as possibly of northern Italian inspiration.[8]

The figural and facial types in Van Orley's earliest works cannot be seen as originating wholly in the rather angular and dry style of his predecessors in Brussels such as the Master of Saint Gudule, Colijn de Coter, or the Master of the Legend of Saint Barbara.[9] Rather, there are the similarities with painting in Antwerp, particularly with the male facial types of Quentin Massys.[10] This relationship is not surprising given the closeness of the two cities, and it is significant in this regard that Bernard's father and brother were registered in the painters' guild in Antwerp.[11] Moreover, Farmer finds in Van Orley's female types an awareness of Haarlem artists Geertgen tot Sint Jans or Jan Mostaert, while Eisler sees a similarity to Juan de Flandes, especially in the female attendant to the left of the Virgin in *The Marriage of the Virgin*.[12]

As seen in *Christ among the Doctors* and *The Marriage of the Virgin*, Bernard van Orley's earliest style is at once eclectic and cosmopolitan, assimilating diverse elements from contemporary northern and Italian art.

His youthfulness is revealed only in the somewhat naive expressions and ungainly gestures of his figures.

The coat-of-arms on the reverse of *Christ among the Doctors* indicates that Van Orley was receiving commissions outside the confines of Brussels. J. G. van Gelder identified it as that of Jacques Coëne, abbot of the Benedictine abbey at Marchiennes, not far from Douai in northern France. Coëne was born in Bruges in 1468/1469 and held the position of abbot from 1501 until his death in 1542 at the age of seventy-three.[13] The abbot was an active patron of the visual arts and commissioned several important works during his long career. The Gallery's panels are the earliest paintings that can be identified with Jacques Coëne. Because of their modest size they were probably intended for the abbot's private devotion.[14] Most critics believe these panels functioned as a diptych, though Eisler suggests that they might have belonged to a series depicting the Life of the Virgin.[15] Despite the somewhat unusual juxtaposition of subject matter, I believe the pictures functioned as a diptych.

The abbot was evidently satisfied with Bernard van Orley's work, for the Gallery's panels were followed by four paintings which have been dated to c. 1518/1519 on stylistic grounds. It is probable that they formed two diptychs: *The Emperor Constantine Knighting Saint Martin* (Nelson Gallery of Art, Kansas City, Missouri); *The Virgin and Child with Saint Martin and other Saints* (present location unknown); and *The Birth of Saint John the Baptist*; and *The Beheading of Saint John the Baptist* (present location of both unknown). On the reverse of the Saint Martin panels is a portrait of Coëne, his motto, and a Madonna and Child, while on the reverse of the John the Baptist panels is Coëne's portrait, his motto, and a Man of Sorrows.[16] On the evidence of this and later pictures commissioned by Coëne it seems plausible to suggest that on the reverse of *The Marriage of the Virgin* there might have been a portrait of Jacques Coëne as well as his motto "Finis Coronat."[17]

J.O.H.

Notes

1. Réau, *Iconographie*, vol. 2, part 2, 170–173; Montague Rhodes James, *The Apocryphal New Testament* (Oxford, 1926), "Book of James or Protevangelium," chap. 9, 42.

2. Eisler 1977, 81.

3. Réau, *Iconographie*, vol. 2, part 2, 289–292; see also James, *The Apocryphal New Testament*, the "Gospel of Thomas, Greek Text A," chap. 19, 54–55.

4. Sperling 1929, 240, cites Friedländer as dating the panels to c. 1512; Friedländer, vol. 8 (1930), 167, as c. 1513; Lavalleye 1943, 46, as before 1515; Farmer 1981, 338, no. 90, as c. 1513.

5. Friedländer, vol. 8 (1972), pls. 71–73.

6. Friedländer, vol. 8 (1972), 54–55, nos. 91, 121, pls. 89, 107. See also n. 16 below.

7. Farmer 1981, 63–65, 68–69, 338, no. 90.

8. Farmer 1981, 61; Eisler 1977, 82.

9. For discussion and reproduction of works by these masters see Friedländer, vol. 4 (1969).

10. Farmer 1981, 67–68.

11. Valentin registered in the Antwerp guild in 1512 and registered apprentices in 1516 and 1517; Everard is listed as a master in Antwerp in 1517; see Friedländer, vol. 8 (1972), 51. It has also been suggested that Bernard received some of his training in Mechelen in the shop of Adrian van den Houte. See Hilary Wayment, "A Rediscovered Master: Adrian van den Houte of Malines (c. 1459–1521) and the Malines/Brussels School. III. Adrian's Development and his Relation with Bernard van Orley," OH 84 (1969), 266–269; Farmer 1981, 65–66, has difficulty accepting Wayment's proposal on stylistic and documentary grounds.

12. Farmer 1981, 69; Eisler 1977, 82. Farmer also sees the influence of Cornelis Engebrechtsz., noting that the artist was in Brussels in 1502 and 1506 and putting forward Engebrechtsz.' *Marriage of the Virgin* (present location unknown) as a model of the Gallery's panel; repro. Friedländer, vol. 10 (1973), no. 79, pl. 68.

13. J. G. van Gelder, "Jan van Scorel in Frankrijk en Vlaanderen," *Simiolus* 1 (1966/1967), 5–36, and Van Gelder 1973, 156–176.

14. An earlier image of Jacques Coëne and his coat-of-arms is found on the dedication miniature, fol. 2v, of the *Rituale ad usum monasterii Marchianensis* of 1508 in the Bibliothèque Municipale, Douai; reproduced in Van Gelder, "Scorel in Frankrijk," 17, fig. 15.

15. Eisler 1977, 81.

16. Friedländer vol. 8 (1972), no. 92, pls. 90–91, seems to think that all were part of the same altarpiece. Farmer 1981, 338–339, correctly I believe, separates the works into two diptychs.

17. Jacques Coëne also commissioned from Jean Belle-gambe a triptych of the *Holy Trinity* (Palais des Beaux-Arts, Lille) that bears his arms and is usually dated c. 1515. A second version in the Musée des Beaux-Arts, Alès, is dated after 1530 and is considered by Genaille a probable workshop piece. See Robert Genaille, "L'Oeuvre de Jean Belle-gambe," *GBA* 6e pér. 87 (1976), 20–21, nos. 10–11.

In 1541 three additional chapels were consecrated as part of the abbey at Marchiennes. Jan van Scorel provided altarpieces for each chapel. The surviving segments of these altarpieces and their relationship to the abbey at Marchiennes have been discussed extensively; see Jacques Guillouet, "Un polyptyque de Jan van Scorel peint pour l'Abbaye de Marchiennes," *OH* 79 (1964), 89–98; *Le XVIe siècle européen* [exh. cat. Petit Palais] (Paris, 1965), no. 258; Van Gelder, "Scorel in Frankrijk," 5–36 (as in n. 13); Jacques Guillouet, "Un volet retrouvé du triptyque des 'Onze Mille Vierges' peint par Jan van Scorel," *RLouvre* 22, no. 2 (1972), 79–84; and Van Gelder 1973, 156–176.

Van Gelder 1973, 172, noted a resemblance between the angel holding Coëne's coat-of-arms in Scorel's polyptych depicting scenes from the lives of Saints Stephen and James (Musée "La Chartreuse," Douai), and that on the reverse of *Christ among the Doctors* and inferred that Scorel must have known Van Orley's diptych.

References

1929 "Partial List of Flemish Primitives in Kleinberger Show." *ArtN* 28 (12 October): 5.

1929 "Flemish Show Opens Today at Kleinbergers." *ArtN* 28 (26 October): 12, nos. 85, 86.

1929 Burrows, Carlyle. "Exhibition of Flemish Primitive Painting." *Parnassus* 1 (November): 9.

1930 Friedländer. Vol. 8: 86, 87, 167, no. 90, pls. 74–76 (vol. 8, 1972: 54, 55, 103, no. 90, pl. 88).

1932 H. V. "Orley, Bernart van." In Thieme-Becker 26: 49.

1943 Lavalleye, Jacques. "Le Style du peintre Bernard van Orley." In *Bernard van Orley 1488–1541*. Brussels: 46.

1944 Baldass (see Biography): 145.

1951 Kress: 200, no. 88, repro. 201.

1969 Osten, Gert von der, and Horst Vey. *Painting and Sculpture in Germany and the Netherlands 1500 to 1600*. Harmondsworth: 145.

1973 Gelder, J. G. van. "Scorel, Mor, Bellegambe und Orley in Marchiennes." *OH* 87: 171–172, figs. 16–18.

1975 NGA: 256, repro. 257.

1977 Eisler: 81–82, figs. 76–78.

1981 Farmer (see Biography): 49, 61, 63–65, 68–69, 79, 338, no. 90, figs. 19–21.

Joachim Patinir

c. 1485–1524

Very few facts are known about the life and career of Joachim Patinir (or Patinier). The artist was born in southern Belgium, probably in Bouvignes. His date of birth is unknown; from his appearance in a drawing made in 1521 by Albrecht Dürer, now lost, but engraved by Cornelis Cort and published in 1572, it is thought that he was born around 1485. In 1515 Patinir entered the painters' guild in Antwerp. That Patinir remarried on 5 May 1521 we know from Dürer's diary of his journey to the Netherlands, for the German artist was invited to Patinir's wedding as well as the prenuptial festivities. A document of 5 October 1524 mentions his second wife as a widow.

Patinir's fame and influence rest upon his landscapes. While it is true that all his works contain an identifiable theme, usually religious, the subject is dominated by the panoramic space, the cartographic clarity with which both near and far objects are rendered, and the fantastic rock formations recalling those geologic structures found in Patinir's presumed birthplace along the Meuse River near Dinant and Namur. Patinir's artistic training is unknown, but the decisive influence of Hieronymus Bosch is evident even in his earliest works. In particular, the high vantage point and frequent use of an elevated horizon line are derived from Bosch. Some influence of Gerard David is also discernible and it is possible that Patinir was in Bruges before coming to Antwerp.

In his study of Patinir's oeuvre Koch considered only nineteen paintings to be autograph. None of these pictures is dated and only five bear what appeared to be genuine signatures. Koch divided the work into three groups. The early period consists of four small pictures painted prior to Patinir's entrance into the guild in Antwerp. The middle period, running from 1515 to 1519, contains the bulk of the artist's production. Included in this group is the *Assumption of the Virgin* in the Johnson Collection, Philadelphia, which bears the arms of Lucas Rem, an Augsburg merchant who spent time in Antwerp and probably commissioned the painting in 1516/1517. Only four paintings comprise the late period from 1520 to 1524; of interest is the fact that all four were acquired by Philip II of Spain. Three of the paintings are now in the Prado, Madrid, the *Rest on the Flight*, the *Temptation of Saint Anthony*, and the *Landscape with Charon's Boat*; the *Saint Christopher* is in the Escorial. In the *Temptation of Saint Anthony*, c. 1522, Patinir collaborated with another Antwerp artist, Quentin Massys (q.v.), who executed the figures.

Joachim Patinir's panoramic paintings provided the vocabulary for one of the main currents of landscape painting in the Netherlands in the sixteenth century. Patinir's settings were adopted by his contemporaries, such as Joos van Cleve, and were continued well into mid-century by the Master of the Half-Lengths, Lucas Gassel, and Herri met de Bles. The early works of Pieter Bruegel the Elder also grow out of the Patinir tradition.

J.O.H.

Bibliography
Baldass, Ludwig. "Die niederländische Landschaftsmalerei von Patinir bis Bruegel." *JbWien* 34 (1918): 111–157.
Friedländer. Vol. 9, 1931 (vol. 9, part 2, 1973).
Koch, Robert A. *Joachim Patinir*. Princeton, 1968.

Follower of Joachim Patinir

1961.9.81 (1633)

The Flight into Egypt

c. 1550/1575
Oak, 23.6 x 15 (9⁵/₁₆ x 5⁷/₈)
Samuel H. Kress Collection

Technical Notes: The painting is generally in good condition. Although there is extensive repaint along the edges, traces of a barbe are visible in raking light and in the x-radiograph, which seems to indicate that the panel was not cut down. There is repaint in the cloud at the upper left, the area to the left of the large rock, and the sky at right. There is retouching in the rock formations. The x-radiograph (fig. 1) discloses underneath the Holy Family what appears to be a large kneeling figure.

Provenance: Imperial collection, Belvedere Palace, Gemäldegalerie, Vienna, by 1783;[1] Kunsthistorisches Museum, Gemäldegalerie, Vienna, c. 1891 until 1952. (Frederick Mont, New York.) Samuel H. Kress Foundation, New York, September 1953.

THE STORY of the Flight into Egypt is recounted in Matthew 2: 13–15.[2] From the late eighteenth until the late nineteenth century this panel was attributed to Herri met de Bles. In 1882 Engerth found the style close to the manner of Joachim Patinir, though Scheibler is credited with first attributing the picture to Patinir in the Kunsthistorisches Museum catalogue of 1896.[3] In 1907 The Flight into Egypt was given to an archaizing follower of Patinir. This idea was essentially restated by Baldass who dated the panel to c. 1550 and thought that the figures and the landscape were contemporary with each other.[4] Koch also dated the painting to c. 1550 on the basis of the figure style, which he identified as Italianate and somewhat in the style of Correggio.[5] Eisler accepted the attribution to a later follower of Patinir. He observed that the figures are too large for the surrounding landscape and suggested that the artist had utilized a segment from one of Patinir's horizontal compositions and combined it with Italianate figures.[6]

The landscape elements in The Flight into Egypt continue the Patinir tradition, and the painting can be associated with other works by followers of Patinir.[7] The linear, textural handling of the tall rocks behind the Holy Family, however, recalls the rocky landscapes produced by Lucas van Valckenborch in the 1580s and 1590s,[8] though an attribution to Valckenborch cannot be sustained.[9]

A single source for the figures of the Holy Family has not been found, but possible Italian prototypes seem to come from the end of the century rather than the middle. The pose of the Madonna and Child resembles that found in a painting attributed to Lelio Orsi (1511–1587),[10] while the round faces and sweet expressions of the group recall the works of il Cavaliere d'Arpino (1568–1640) or Francesco Vanni (1563–1610);[11] Pietro Mera (c. 1550–1639) has also been suggested.[12] The donkey is almost an exact duplication of the donkey in Annibale Carracci's Rest on the Flight into Egypt in the Hermitage.[13]

The small size of the panel implies but does not prove execution by a single hand. The discrepancy in scale between the figures and the landscape, along with the kneeling figure (Saint Francis or Saint Jerome?)[14] visible under the Holy Family in the x-radiograph raises the possibility that the figures now visible were added later. There is, however, no way of determining this with certainty. Given the unusual combination of stylistic elements, a precise dating of The Flight into Egypt is not possible. A date in the third quarter of the sixteenth century would take into account the strength of Patinir's influence as well as the more progressive tendencies in landscape and figures.

J.O.H.

Notes

1. The earliest mention of the painting is Mechel 1783, 167, no. 77. On the reverse of the panel are five paper labels: 23; II.D.u.N. II. 20 (this refers to the painting's location in the Belvedere Palace, that is, on the second floor, German and Netherlandish gallery, second room); *Aus dem Inventar des Gemäldegalerie gestrichen. Wien 11 Februar 1952.*; *Kunsthistorisches Museum in Wien / Direktion der Gemäldegalerie* stamped, *K 1970* in pencil; 2 St : 37:/ A.N.S. / N:37; *Gemälde Galerie des Allerh. Kaisershauses. No. 953,* crossed out in red ink.

2. Réau, *Iconographie*, vol. 2, part 2, 273–276.

3. Engerth 1884, 30, no. 691; Schaeffer, Wartenegg, and Glück 1896, 15, no. 664.

4. Schaeffer and Glück 1907, 154, no. 664; Baldass 1938, 128, no. 664. Ernest Buschbeck of the Kunsthistorisches Museum, letter of 16 May 1955 to John Walker in the curatorial files, agrees with Baldass' opinions.

5. Koch 1968, 84, no. 34.

6. Eisler 1977, 90.

7. Koch 1968, 47, grouped the painting with the *Temptation of Christ*, Bearsted collection, National Trust, Upton House, Banbury, and *The Flight into Egypt*, Museo Arte Cataluña, Barcelona, as works that continue Patinir's style after his lifetime. The Gallery's panel is similar to a small *Landscape with Saint Jerome* from Patinir's workshop in the Mayer van den Bergh Museum, Antwerp, repro. Koch 1968, no. 29, fig. 34. Although there are similarities in scale and in the manner in which the foreground rocks are rendered, the two panels are not by the same hand, and the Mayer van den Bergh painting appears earlier. Faggin 1968, 30, 40, n. 25, attributed both this and the Gallery's panel to Matthijs Cock. I am grateful to Hans Nieuwdorp and his staff for allowing me to examine the painting at length.

8. Specific examples are the landscape dated 1582 in the Rijksmuseum, Amsterdam, the landscape dated 1583 in the Gemäldegalerie, Berlin, and the landscape with miners' huts dated 1595 in the Prado. They are reproduced in Heinrich Franz, *Niederländische Landschaftsmalerei im Zeitalter des Manierismus* (Graz, 1969), figs. 248, 249, 247. See also Alexander Wied, "Lucas van Valckenborch," *JbWien* N.F. 31 (1971), 199–200, nos. 33–37. Perhaps the earliest landscape of this type is the small roundel monogrammed and dated 1576 in the Victoria and Albert Museum, London; see Wied 1971, no. 23, 198, fig. 192.

9. Alexander Wied, letter of 24 February 1984 to the author in the curatorial files, stated that *The Flight into Egypt* had nothing to do with Valckenborch. Walter Gibson, letter of 16 April 1984; Robert Koch, letter of 28 March 1984; Wouter Kloek and Jan Piet Filedt Kok, letter of 4 May 1984; and Joaneath Spicer, letter of 6 April 1984 (all letters in the curatorial files) were unanimous in denying an attribution to Lucas van Valckenborch.

Fig. 1. *The Flight into Egypt*,
1961.9.81, x-radiograph

10. *Madonna and Child*, location unknown; repro. *Critica d'Arte*, no. 122 (March–April 1972), 63, fig. 39. This observation was made by Rachel Cropsey Simons, summer intern, department of Northern European painting, 1983.

11. See Herwarth Röttgen, *Il Cavalier d'Arpino* [exh. cat. Palazzo Venezia] (Rome, 1973), esp. color pls. 38, 72, figs. 13, 29, 38. I am indebted to Richard Spear for suggesting both these artists as possible sources.

12. Sydney J. Freedberg, in conversation, March 1984. See Franca Zava Boccazzi, *La Basilica dei Santi Giovanni e Paolo in Venezia* (Padua 1965), 292–294, fig. 191; Georgio Faggin, "Pietro Mera: Un Paesaggio," *Arte Veneta* 18 (1964), 172–173.

13. Repro. Vladimir Levinson-Lessing, *The Hermitage, Leningrad. Baroque and Rococo Masters* (London 1965), no. 3. This observation was made by Rachel Cropsey Simons.

14. The identification of the figure as Saint Francis is suggested in part by what was tentatively identified as a crucifix in the sky to the left of the large vertical rock; this image is visible only with infrared reflectography. Saint Jerome was suggested by Egbert Haverkamp-Begemann in a note, 1 July 1984.

References

1783 Mechel, Christian von. *Verzeichniss der Gemälde der Kaiserlich Königlichen Bilder Gallerie in Wien*. Vienna: 167, no. 77 (French ed., 1784).

1845 Krafft, Albert. *Catalogue de la galerie de tableaux impériale et royale au Belvédère à Vienne*. Vienna: 213, no. 23 (German ed., 1849).

1866 Waagen, Gustav Friedrich. *Die vornehmsten Kunstdenkmäler in Wien*. Vienna: 183, no. 20.

1880 "Notizen." *ZfbK* 15: 128, repro. after 128, etching by H. L. Fischer.

1884 Engerth, Edouard von. *Kunsthistorische Sammlungen des allerhöchsten Kaiserhauses, Gemälde*. 3 vols. Vienna, 2: 29–30, no. 691.

1896 Schaeffer, August, W. von Wartenegg, and Gustav Glück. *Kunsthistorische Sammlungen des allerhöchsten Kaiserhauses. Führer durch die Gemälde-Galerie. Alte Meister. II. Niederländische und Deutsche Schulen*. Vienna: 15, no. 664.

1899 Frimmel, Theodor von. *Geschichte der Wiener Gemäldesammlungen*. 2 vols. Leipzig, 1: 465, no. 664.

1903 Suida, Wilhelm. *Wien. Moderner Cicerone*. 2 vols. Stuttgart, Berlin and Leipzig, 1: 98, as Patinir.

1907 Schaeffer, August, and Gustav Glück. *Kunsthistorische Sammlungen des allerhöchsten Kaiserhauses. Die Gemäldegalerie. Alte Meister*. Vienna: 154, no. 664.

1911 Preyer, David. *The Art of the Vienna Galleries*. Boston: 91.

1938 Baldass, Ludwig. *Katalog der Gemäldegalerie*. Vienna: 128, no. 664.

1946 Weissenhofer, Anselm. *Wiener Madonnen*. Vienna: 20–21, fig. 21.

1956 Walker: 140, no. 54, repro. 141.

1968 Koch, Robert A. *Joachim Patinir*. Princeton: 47, 84, no. 34, fig. 68.

1968 Faggin, Giorgio T. *La pittura ad Anversa nel Cinquecento*. Florence: 40, fig. 68.

1975 NGA: 262, repro. 263.

1976 Walker: 135, no. 134, repro. 134.

1977 Eisler: 90–91, fig. 79.

Follower of Joachim Patinir, *The Flight into Egypt*, 1961.9.81

Michel Sittow

c. 1469–1525/1526

Michel Sittow was born about 1469 of German-Scandinavian stock in the Hanseatic port city of Reval, now Tallinn, in Estonia. He probably received his earliest training in Reval from his father, also a painter, yet his apprenticeship in Bruges and years of work for Queen Isabel of Castile and for allied courts gave his art a Flemish and cosmopolitan flavor.

Sittow began his apprenticeship in Bruges about 1484. The assumption that he studied with Memling rests only on that artist's position as the leading painter in Bruges and on Sittow's use of Memling's Madonna types. Sittow's apprenticeship would have ended about 1488. He did not register as a master with the Bruges guild and his whereabouts are unknown before 1492 when he entered the service of Isabel the Catholic. Sittow appears to have been identical with the painter "Melchior Aleman" also mentioned in Isabel's household accounts.

At the Spanish court he was prized as a portrait painter. He is known to have collaborated with Juan de Flandes on the series of small panels of the lives of Christ and the Virgin for Isabel, producing at least *The Ascension* (private collection, England) and *The Assumption* (1965.1.1). While he remained in Isabel's service until her death in 1504, he was apparently absent from Spain after late 1502. Suggestions that he visited the courts of Margaret of Austria and Henry VII of England shortly after 1502 cannot be substantiated, though the portrait of Henry VII in the National Portrait Gallery, London, has been attributed to him. He was in Brabant at the end of 1505 or early in 1506, working for Philip the Fair. He returned to Reval in 1506 to settle his inheritance and remained there, receiving membership in the artists' guild late in 1507 and marrying in 1509. He was called away from Reval in 1514 to paint the portrait of Christian II of Denmark, the future husband of Margaret of Austria's niece, Isabella. Sittow then began a second, shorter period of service at the court of Margaret of Austria and her nephew Charles V in the Netherlands. This was interrupted by a brief trip to Spain to negotiate the

salary still owed him. By 13 July 1518, when he married again, Sittow was back in Reval. He lived there, a prosperous and respected citizen, until his death between 20 December 1525 and 20 January 1526.

While Sittow's movements and patrons are well documented, we know little about his early style, and very few of the paintings described as by him in the inventories of Margaret of Austria and Charles V survive. The body of work attributed to him in recent years contains a number of problems of attribution and dating.

M.W.

Bibliography
Friedländer, Max J. "Ein neu erworbenes Madonnenbild im Kaiser-Friedrich-Museum." *Amtliche Berichte aus den königl. Kunstsammlungen* 36 (1915): cols. 177–183.
Friedländer, Max J. "Neues über den Meister Michiel und Juan de Flandes." *Der Cicerone* 21 (1929): 249–254.
Johansen, Paul. "Meister Michel Sittow, Hofmaler der Königin Isabella von Kastilien und Bürger von Reval." *JbBerlin* 61 (1940): 1–36.
Winkler, Friedrich. "Zittoz, Miguel." In Thieme-Becker. 1947, 36: 531–534.
Trizna, Jazeps. *Primitifs flamands. Contributions. Michel Sittow, peintre revalais de l'école brugeoise (1468–1525/1526).* Brussels, 1976.

1937.1.46 (46)

Portrait of Diego de Guevara(?)

c. 1515/1518
Oak (cradled), 33.6 x 23.7 (13¼ x 9⁵⁄₁₆)
Andrew W. Mellon Collection

Technical Notes: The panel has been thinned, attached to a secondary panel, and cradled. An x-radiograph made in October 1949 shows a different cradle with wider members than the one now in place. The portrait is, at present, painted to the edges of the panel on all sides, but this was not originally the case. The wood and the paint surface are reconstructed at the left and right edges. Narrow, irregular strips added to either side are clearly visible in the x-radiograph (fig. 1). The strips are both joined to the original panel at slight angles similar to the angle of several vertical splits in the panel,

Michel Sittow, *Portrait of Diego de Guevara (?)*, 1937.1.46

Fig. 1. Michel Sittow,
Portrait of Diego de Guevara (?),
1937.1.46, x-radiograph

which suggests that the splits and the damage necessitating the additions were caused by the same stress. In addition to the reconstructed sections of the painting on these two strips, the paint surface has also been extended to cover the original unpainted margins at top and bottom. Before these extensions the height of the painted surface was approximately 31.6 cm, as indicated by traces of a barbe. The original paint surface itself is in very good condition, apart from inpainting along the splits.

The x-radiograph also shows an important artist's change in the costume. The top of the brocade doublet was originally lower, as was the neckline of the white shirt. The shirt filled a wider square opening now partially covered by the fur collar. Since the cross of the Order of Calatrava is apparently painted over the brocade and its edges do not overlap the present placement of the fur collar, it must have been added in the course of work on the painting.

Provenance: Probably Don Diego de Guevara, Brussels [d. 1520]. Probably heirs of Don Diego de Guevara.[1] Probably Mencía de Mendoza, Marchioness of Zenete, third wife of Hendrik III of Nassau and subsequently wife of Fernando de Aragon, Duke of Calabria and viceroy of Valencia, castle of Ayora, province of Valencia [d. 1554; inventories 1548 and 1554].[2] Infante Don Sebastián Gabriel de Borbón y Braganza, Pau [d. 1875]. Heirs of Don Sebastián Gabriel de Borbón y Braganza, Pau, 1876.[3] Mme. Maurer, Madrid, by 1915.[4] (Leo Blumenreich, Berlin.)[5] (P. & D. Colnaghi, Ltd., London, 1929.) (M. Knoedler & Co., London and New York, 1929–1930). Purchased March 1930 by Andrew W. Mellon, Washington. Deeded 28 December 1934 to The A. W. Mellon Educational and Charitable Trust, Pittsburgh.

Exhibitions: New York, M. Knoedler & Co., 1930, *A Loan Exhibition of Sixteen Masterpieces*, no. 14.

This sensitive portrait, together with a *Madonna and Child* by Sittow in the Gemäldegalerie, Berlin (fig. 2), once formed a devotional diptych. The dimensions of the two panels correspond, and the sitter places one hand on a stone parapet that is covered by part of the same carpet more prominently displayed in the Berlin *Madonna and Child*.[6] Their attribution to Sittow, first made by Friedländer, is confirmed by comparison with his documented work, notably the *Assumption*, 1965.1.1, painted with a similar fluid touch and attention to effects of light.[7] In the implied continuity of space between the Madonna and donor, the diptych follows the tradition of Memling, with whom Sittow probably studied in Bruges.[8] Yet Sittow endows the subject with a more intense pathos. The Madonna's head and shoulders fill the panel. She holds the Christ Child up before her, and his curiously inert pose, together with the goldfinch he clutches, may refer to his Passion.[9] The donor's rapt contemplation of the Madonna and Child, a convention with such devotional paintings, is here conveyed with a poignant melancholy.[10]

Sittow worked for the Habsburg rulers of the Netherlands at several points during his peripatetic career, and strong circumstantial evidence suggests that this diptych was painted for and represents a valued member of the Habsburg court, Don Diego de Guevara. In his *Comentarios de la Pintura*, Diego's illegitimate son, Felipe de Guevara, refers to "dos retratos de Don Diego de Guevara, mi Padre, la una de mano de Rugier, y la otra de Michel, discípulo de dicho Rugier."[11] Furthermore, a portrait of Don Diego de Guevara forming half of a small devotional diptych is listed in two inventories of the collection of Mencía de Mendoza. The collection of this Spanish noblewoman was transported from the Netherlands to Spain following the death of her first husband Hendrik III of Nassau in 1538.[12] The painter's name is not mentioned in her inventories, and the description is rather generalized: the Madonna holds her son in her arms and Don Diego de Guevara wears a robe with fur trim. Yet the dimensions given in the 1548 inventory, which appears to describe the two paintings together with their frame, correspond to the Berlin and Washington panels, assuming a frame

Fig. 2. Michel Sittow, *Madonna and Child*, Berlin, Staatliche Museen Preussischer Kulturbesitz, Gemäldegalerie [photo: Jörg Anders]

Michel Sittow, *Portrait of Diego de Guevara (?)*

Fig. 3. Michel Sittow, *Portrait of a Princess*, Vienna, Kunsthistorisches Museum [photo: Kunsthistorisches Museum]

one of two *Contadores Mayores de Cuentas* for Castile in September of 1517.[18] Another sign of favor was his appointment by Charles to the wardenship (*clavaría*) of the Order of Calatrava in 1517.[19] Don Diego de Guevara must also have been an important collector and patron of the arts. This can be deduced from scattered references to works from his collection, the most famous being the *Arnolfini Wedding Portrait* by Van Eyck that he presented to Margaret of Austria, Regent of the Netherlands.[20]

Don Diego could have encountered Sittow and commissioned the diptych before the painter left the Habsburg court to return to his native Reval in 1506 or after he was called back in c. 1514 to 1517/1518.[21] However, the dating and interpretation of the diptych is complicated by its relation to other enigmatic portraits by Sittow.

The Berlin *Madonna* must be considered in relation to other paintings by Sittow that show strikingly similar facial features. These are a portrait in the Kunsthistorisches Museum, Vienna (fig. 3),[22] and a *Mary Magdalene* in Detroit.[23] The assumption that the Vienna painting is a portrait of a historically important personage is supported by the subject's fashionable dress and by the fact that there were two old copies of the painting in the Ambras collection.[24] The halo and the indirect, downcast gaze suggest that she is presented in the guise of a saint.[25] Friedländer, on the basis of the alternating *K*s and roses of her necklace and the cockleshells decorating her bodice, identified the lady in the Vienna painting as Katherine of Aragon. This identification has found wide acceptance.[26] Katherine, who was born in 1486, lived at the English court after her brief marriage to Arthur, Prince of Wales, in 1501. The correspondence of the Spanish ambassador attests to her admiration for the portraiture of Sittow, her mother's court painter.[27] Moreover, the inventories of Margaret of Austria indicate that Sittow sometimes depicted his princely patrons in the guise of sacred figures.[28] However, Friedländer's identification is not confirmed by comparison with reliable portraits of Katherine. A miniature in the National Portrait Gallery, London, attributed to Lucas Horenbout, shows a woman with a longer face, a Spanish hairstyle draped over the ears, a higher hairline, and more protruding, full lips.[29]

The striking similarity of facial features in the Vienna *Lady*, the Berlin *Madonna*, and the Detroit *Magdalene* defies explanation. Sittow may have brought the features of the lady represented in the Vienna painting into conformity with his pervasive ideal of feminine beauty, or the Detroit and Berlin sacred figures may be idealized repetitions of the same portrait type. The latter possibility would affect the meaning of the Berlin-

about 2½ inches wide around each.[13] The presumption that these early accounts refer to the Berlin and Washington panels is supported by the cross of the Order of Calatrava embroidered on the sitter's brocade doublet and partially hidden by the richly furred robe, for Don Diego was indeed a member of this Spanish order.[14]

Diego de Guevara, whose family came from Santander in northern Spain, must have arrived at the Burgundian court as a young man in the last decades of the fifteenth century. On 29 January 1521, the Constable of Castile, in a letter to the Emperor Charles V, referred to the recent death of Don Diego and praised his more than forty years of service to the house of Burgundy.[15] In the course of his career, he enjoyed numerous positions of trust in the households of Philip the Fair and Charles V. He was a *maître d'hôtel* in the household of Philip the Fair in 1501[16] and was first *maître d'hôtel* to Queen Joanna of Castile during the voyage of Philip and Joanna to Spain in 1506.[17] Entrusted with several diplomatic missions to Spain and England, he became

Washington diptych, since its commissioner would presumably have wished to express reverence for the lady as well as for the Virgin. Whether or not such an implied relationship can be reconciled with the decorum of early sixteenth-century devotional imagery,[30] it would not militate against the identification of the sitter as Diego de Guevara, since he and Sittow looked to the same patrons in Spain and the Netherlands.

The dating of the interrelated paintings is also difficult to determine because the painter's few surviving works do not show a clear stylistic development. The costume of the sitters and Sittow's documented travels provide the surest framework for dating. The Gallery's portrait has generally been considered a product of Sittow's later period of activity at the court of Margaret of Austria.[31] Such a date does indeed seem most likely and is in accord with the sitter's costume.[32] A date during Sittow's later period of activity at the Habsburg court finds further support in the cross of Calatrava, evidently added in the course of work on the picture. If the sitter is indeed Diego de Guevara, the addition of this emblem may reflect his appointment to a high position in that Order in 1517.

M.W.

Notes

1. Steppe 1982, 217–218, notes that there was a dispute over the estate of Don Diego because he had made two wills. The beneficiary of the first will was his half-brother Pedro de Guevara and of the second his illegitimate son Felipe de Guevara, still a minor at the time of his father's death. Professor Steppe also states that the diptych now divided between Berlin and Washington was acquired by Mencía de Mendoza through the agency of Don Pedro. In a letter of 20 October 1981, Steppe notes that he has found the will of Don Diego (in curatorial files; see also Steppe 1982, 214–215, n. 7). Steppe's publication of this and other documents related to Diego de Guevara and his circle is anticipated with the greatest interest by students of early sixteenth-century patronage.

2. Archivo del Palau, Barcelona, *Marquesado del Zenete*, Legajo 122, inventory of 1548, "Item, un retablico pequenyo de dos tablas; en la una esta una pintura de Nuestra Señora con su hijo en brassos y en la otra don Diego de Guevara con una ropa enforrada . . . , tiene la pintura todo a la redonda una orla de oro; tiene de alto la pintura media vara y de ancho las dos tres palmos e medio"; see Steppe 1967, 39, n. 80 and 1982, 218, n. 17, in which the entry from the inventory taken after Mencía's death is also quoted, "Item un retaule ab dos portes, en la una porta esta pintada la verge Maria ab son fill en los brasos y en laltra esta pintada don Diego de Guevara ab una roba forrada de pells." Apparently an artist's name was noted in these inventories only when it could be read on the work itself; see Steppe 1967, 13. These inventories have not yet been published in their entirety. Mencía de Mendoza's heir was Don Luis de Requesens (d. 1576).

3. *Catalogue abrégé des tableaux exposés dans les salons de l'ancien asile de Pau appartenant aux héritiers de feu Mgr*

l'Infant don Sébastien de Bourbon et Bragance (Pau, 1876), 71, no. 631, as by Holbein. I am grateful to Nicole Reynaud for her help in locating this catalogue.

4. See Friedländer 1915, 179, and Sánchez Cantón 1930, 117.

5. Friedländer 1929, 254.

6. No. 1722, 32 x 24.5 cm (painted surface), also with a Spanish provenance; Gemäldegalerie 1978, 414. I am grateful to Rainald Grosshans for facilitating my study of the panel in his care. While the original width of the Gallery's painting cannot be determined, due to the added segments, the height of the original painted surface was 31.6 cm; see Technical Notes above.

An old copy of the *Madonna* was in a private collection in Verdun in 1974 (information from curatorial files, Gemäldegalerie). A portrait formerly belonging to Alexander Stahlberg, Hannover, and described as almost identical to the Gallery's painting in exh. cat. Mechelen 1958, no. 85, is related only in terms of age and general facial type of the sitter; sold Lempertz, Cologne, 8–10 May 1969, no. 33, pl. 9. I am grateful to Hans Georg Gmelin of the Niedersächsisches Landesmuseum, Hannover, for help in locating this painting.

7. The two panels were first linked in Friedländer 1915, 179–181, where he also identified their author with the documented Master Michiel. The attribution of the two to Sittow has been universally accepted; see references below.

8. Compare Memling's diptych of Martin van Nieuwenhove in the Hospital of Saint John, Bruges; Friedländer, vol. 6a (1971), no. 14, pls. 52–53.

9. See Herbert Friedmann, *The Symbolic Goldfinch: Its History and Significance in European Devotional Art* (Washington, 1946), 7–9, 54–55.

10. For the significance of the worshipper's unfocused gaze, see James Snyder, "Jan van Eyck and the Madonna of Chancellor Nicolas Rolin," *OH* 82 (1967), 165–166.

11. Don Felipe de Guevara, *Comentarios de la Pintura*, ed. Antonio Ponz (Madrid, 1788), 181–182, written c. 1560 to 1563. Felipe de Guevara goes on to state that the portrait by Rogier was made ninety years earlier and that by Michiel more than sixty years earlier ("la de Rugier debe haber cerca de sus noventa años que está hecha, y la de Michel mas de sesenta"). This reference occurs in a passage praising the color and technique of the old Flemish masters. De Guevara does not mention the location of the portraits. His statement that Rogier van der Weyden painted his father probably resulted from the common tendency to attribute early paintings to only a few masters. Bruyn 1978, 214, suggests that the other portrait may have been by Memling, presumably Sittow's teacher.

12. See Provenance and nn. 1-2 above. On Mencía de Mendoza, see J. K. Steppe, "Mencía de Mendoza et ses relations avec Érasme, Gilles de Busleyden et Jean-Louis Vivès" in *Scrinium Erasmianum*, 2 vols. (Leiden, 1969), 2: 449–471 and A. Staring, "Vraagstukken der Oranje-Iconographie," *OH* 67 (1952), 144–156.

13. The Valencian *vara* is approximately .99 yards and the *palmo* approximately 8.9 inches; see J. H. Alexander, *Universal Dictionary of Weights and Measures . . .* (Baltimore, 1850), 79–80, 118.

14. During this period the Order of Calatrava was administered directly by the crown and was no longer a semimonastic community defending Christianity in Spain; see Francis Gutton, *La chevalerie militaire en Espagne, l'Ordre de Calatrava* (Paris, 1955), 118–123.

In the membership book of the Confraternity of the Seven Sorrows of the Virgin founded in the church of Saint Géry, Brussels, Don Diego's arms are superimposed on the red cross of Calatrava, which terminates in a fleur-de-lis at each point; Brussels, Archives de la Ville, no. 3413, fol. 118v, with the date 1520 and Don Diego's motto *hors du conte*.

I have been unable to find an explanation for the thistle buttons; the thistle may have been a personal device adopted by the sitter.

15. Letter of Don Iñigo Hernández de Velasco to Charles V; see Constantin von Höfler, "Zur Kritik und Quellenkunde der ersten Regierungsjahre K. Karls V.: III. Abteilung: Das Jahr 1521," *Denkschriften der Kaiserlichen Akademie der Wissenschaften. Philosophisch-Historische Classe* 33 (1883), 52. I am most grateful to Paul Rosenfeld of Rutgers University, Newark, for this and other references to the career of Don Diego de Guevara.

16. Louis Prosper Gachard, *Collection des voyages des souverains des Pays-Bas*, 4 vols. (Brussels, 1876–1882), 1: 127, 349.

17. Gachard, 1: 410, 453. For an account of the important role played by de Guevara following Philip the Fair's untimely death on this voyage, see Steppe 1982, 209–218, esp. 211, based in part on an unpublished history of the de Guevara family.

18. Thus he was sent to England in 1507 and again in 1514; see *Calendar of State Papers, Spanish*, vol. 1, *Henry VII, 1485–1509*, ed. G. A. Bergenroth (London, 1862), 425–426, and *Supplement* (London, 1868), 116, and *Letters and Papers, Foreign and Domestic, of the Reign of Henry VIII*, ed. J. S. Brewer, 21 vols. (London, 1864), 2, part I: 44, 73. For his role as a *Contador Mayor de Cuentas*, or receiver of the royal revenues, see Gachard, 1: 442, 521. This position may have been a source of the confusion of de Guevara with Diego Flores, treasurer of Margaret of Austria, who acted as agent for the purchase of the Sittow and Juan de Flandes panels from the estate of Isabel the Catholic (see 1967.7.1). This misidentification, first made by Carl Justi, *Miscellaneen aus drei Jahrhunderten spanischen Kunstlebens*, 2 vols. (Berlin 1908), 1: 317, was corrected by Sánchez Cantón 1930, 103, 117, and Steppe 1967, 20.

19. Alonso de Santa Cruz, *Crónica del Emperador Carlos V*, 5 vols. (Madrid, 1920–1925), 1: 98–99; this was the second highest elected position. For the hierarchy of the Order, see Joseph F. O'Callaghan, "'Difiniciones' of the Order of Calatrava Enacted by Abbot William II of Morimond, April 2, 1468," *Traditio* 14 (1958), 231–268.

A glimpse of the maneuvering for the wardenship is provided by the report of the English ambassador to the court of the Netherlands, dated 7 June 1517, that another courtier, Juan de la Nucha, was complaining of ill treatment, for "as he was an ancient knight of the Order of Calatrava, he had been promised a commandery soon to fall vacant. It had not been given to him, but to Don Diego de Gavaro [sic]," *Letters and Papers . . . Henry VIII*, 2, part 2: 1069.

20. On his collection, see Steppe 1967, 20, 39, n. 78.

21. See Biography. Trizna 1976, 52–55, maintains that Sittow returned to Reval in 1517, though the first mention of his reappearance in Reval is the notice of his remarriage on 13 July 1518. Trizna also claims that Sittow could not have encountered Don Diego during his earlier stay before 1506 due to the latter's absence in Spain at that time. However, de Guevara had apparently returned to the court of Philip the

Fair, then in Brussels, by February of 1505; *Correspondencia de Gutierre Gomez de Fuensalida, Embajador en Alemania, Flandres e Inglaterra (1496–1509)*, ed. Duque de Berwick y de Alba (Madrid, 1907), 330. Further, a still earlier encounter in Spain is also probable, as de Guevara was a member of Margaret of Austria's household when she traveled to Spain to marry Prince Juan; Max Bruchet, *Marguerite d'Autriche, Duchesse de Savoie* (Lille, 1927), 22.

22. No. 5612, from the Ambras collection; [Klaus Demus, Friderike Klauner, and Karl Schütz], Kunsthistorisches Museum, Katalog der Gemäldegalerie, *Flämische Malerei von Jan van Eyck bis Pieter Bruegel d. Ä.* (Vienna, 1981), 282–284, repro.

23. Trizna 1976, 53–54, 98, pl. XVI. The same preparatory study may have been used for this painting and for the Berlin *Madonna* since the contours of hair, ear, and cloak correspond very closely.

24. See 1981 Vienna catalogue, 284 (as in n. 22). For one of these copies, without a halo, see Günther Heinz and Karl Schütz et al., Kunsthistorisches Museum, *Porträtgalerie zur Geschichte Österreichs von 1400 bis 1800* (Vienna, 1976), 202–203, no. 171, fig. 34, as Katherine of Aragon.

25. Bruyn 1978, 213, pointing out that the Detroit *Magdalene* has the same type of halo. Although the originality of the halo in the Vienna painting has been doubted Karl Schütz kindly informs me that microscopic and other examination of the Vienna painting establishes that the halo is original; letter of 3 December 1985, in curatorial files.

26. Friedländer 1915, 180–183, considered the roses to be emblems of the English royal house of Tudor and the shells to be associated with the Spanish pilgrimage site of Santiago de Compostela. This identification was accepted by Glück 1933, 106–107; Trizna 1976, 32–36, 96; Bruyn 1978, 213; and, with reservations, in the Vienna catalogue (as in n. 22). It was rejected by Weinberger 1948, 248–249, and Roy Strong, *National Portrait Gallery, Tudor and Jacobean Portraits*, 2 vols. (London, 1969), 1: 40.

27. When, in August of 1505, she was shown two portraits of Margaret of Austria sent as part of the negotiations for a proposed marriage with the widowed Henry VII of England, she remarked that Michel would have made them much better, "que mejor y mas cierta y perfectamente las pintura Michel . . . ," quoted by Trizna 1976, 31, and Glück 1933, 106.

28. Heinrich Zimerman and Franz Kreyczi, "Urkunden und Regesten aus dem k.u.k. Reichs-Finanz-Archiv," *JbWien* 3 (1885), XCVII, for a lost diptych by Sittow with the Madonna and Margaret of Austria and her first husband, Prince Juan, as Saint Margaret and Saint John the Evangelist.

29. Probably painted c. 1525; see Roy Strong, *The English Renaissance Miniature* (London, 1983), fig. 17. For other reliable portraits of Katherine, see Strong 1969, 1: 39–40, as in n. 26 and *Dictionary of British Portraiture*, 4 vols., ed. Richard Ormond and Malcolm Rodgers (London, 1979–1981), 1: 21. The youthful Katherine may also be the subject of a portrait by Juan de Flandes in the Thyssen collection; J. C. Ebbinge-Wubben in *The Thyssen-Bornemisza Collection* (Castagnola, 1969), 169–172, no. 147, pl. 82.

30. The convention of depicting contemporary sitters in the guise of sacred figures deserves further study. The Madonna as well as saints may have been treated this way. Thus Van Mander's report that Gossaert painted portraits of the wife and child of his patron Adolf of Burgundy as the Ma-

donna and Child has been tentatively identified with a painting in the Metropolitan Museum; Pauwels, Hoetink, and Herzog 1965, 151, 383, no. 22, repro.

31. Johansen 1940, 16, implied a date during his Spanish period. Winkler 1943, 99, dated it c. 1500; Sass 1971, 295, and Bruyn 1978, 214, also favor an early date. Friedländer 1915, 181, dated the diptych about 1515, as did Weinberger 1947, 248; Trizna 1976, 53–54; and Steppe 1982, 218. Baldass 1935, 78, who was unaware of Sittow's return to Reval, dated it c. 1520.

The persistent tendency to date the diptych before 1506 is due to its close connection in terms of quality and modeling, as well as type, to the Vienna lady, commonly given an early date because of the age of the presumed sitter, Katherine of Aragon. Yet, as noted above, she may not be its subject. Moreover, the assumption of Sittow's trip to England in 1505, which would have given him the opportunity to paint such a portrait, is itself predicated on the attribution to him of the *Henry VII* in the National Portrait Gallery, London (Trizna 1976, 31–32, 96, pl. 11). This last attribution seems unwarranted. Baldass 1935, 78, pointed out that the portrait was not given to Sittow in Margaret's inventory, whereas he is specified as the author of several other works in her collection. He compared it instead to early portraits by Massys. See also Campbell 1977, 225. The other dated portrait by Sittow, the *Christian II* in Copenhagen, generally identified as the work the artist was instructed to paint on his way back from Reval, also presents problems. X-radiography shows that it was painted over a portrait of the young Charles V, unlikely to have been available to Sittow during his brief stop in Denmark. The portrait is thus probably a version of the documented portrait of the Danish king; see Sass 1976, 1–14, and Bruyn 1978, 213.

32. For the costume compare the portraits of Charles V originated by Van Orley c. 1515–1517, Friedländer, vol. 8 (1972), 63, 110–111, nos. 142–143, pl. 120. See also letters from Stella Mary Newton of 15 May 1980 and from Margaret Scott of 16 January 1984 in curatorial files.

References

1915 Friedländer, Max J. "Ein neu erworbenes Madonnenbild im Kaiser-Friedrich-Museum." *Amtliche Berichte aus den königl. Kunstsammlungen* 36: 179–181.

1922 Mayer, August L. *Geschichte der spanischen Malerei.* Leipzig: 147.

1926/1928 Falck, G. "Mester Michiel og Kunstmuseets Portraet of Christiern II." *Kunstmuseets Åarsskrift* 13–15: 129–133, repro.

1929 Friedländer, Max J. "Neues über den Meister Michiel und Juan de Flandes." *Der Cicerone* 21: 249, 254, repro. 253.

1929 Siple, E. S. "Art in America—Messrs. Knoedler's Exhibition." *BurlM* 55: repro. opp. 326.

1930 Wilenski, R. H. "A Recent Loan Exhibition in New York (at Messrs. Knoedler's Galleries)." *Apollo* 11: repro. opp. 32.

1930 "Old Masters in New York Galleries." *Parnassus* 2 (January): 4.

1930 Sánchez Cantón, Francisco Javier. "El retablo de la Reina Católica." *AEA* 6: 117.

1931 Winkler, Friedrich. "Master Michiel." *Art in America* 19: 248, 252, fig. 5.

1931 Sánchez Cantón, Francisco Javier. "El retablo de la Reina Católica (Addenda et corrigenda)." *AEA* 7: 151–152, pl. IV.

1933 Glück, Gustav. "The *Henry VII* in the National Portrait Gallery." *BurlM* 63: 105, 107.

1933 Post, Chandler Rathfon. *A History of Spanish Painting.* 14 vols. Cambridge, Mass., 4, part 1: 34–35.

1935 Baldass, Ludwig. "The Portraiture of Master Michiel." *BurlM* 67: 77–82, pl. IB.

1939 Richardson, E. P. "Three Paintings by Master Michiel." *AQ* 2: 108, fig. 9.

1940 Johansen, Paul. "Meister Michel Sittow, Hofmaler der Königin Isabella von Kastilien und Bürger von Reval." *JbBerlin* 61: 1, 16–18, fig. 5.

1940 Contreras, Juan de. *Historia del arte hispánica.* Barcelona: 282, fig. 279.

1941 Tolnay, Charles de. "Flemish Paintings in the National Gallery of Art." *MagArt* 34: 187, 189, 200, fig. 19.

1943 Winkler, Friedrich. "Neuentdeckte Altniederländer III: Michiel Sittow." *Pantheon* 31: 99, fig. 4.

1945 Benesch, Otto. *The Art of the Renaissance in Northern Europe.* Cambridge, Mass.: 75, fig. 42.

1947 Winkler, Friedrich. "Zittoz, Miguel." In Thieme-Becker 36: 531–533.

1948 Weinberger, Martin. "Notes on Maître Michiel." *BurlM* 90: 248.

1949 Mellon: 59, no. 46.

1952 Haverkamp-Begemann, Egbert. "Juan de Flandes y los reyes católicos." *AEA* 25: 241.

1953 Kehrer, Hugo. *Deutschland in Spanien: Beziehung, Einfluss, und Abhängigkeit.* Munich: 138, fig. 69.

1958 Gaya Nuño, Juan Antonio. *La Pintura española fuera de España.* Madrid: 305, no. 2665.

1958 *Margareta van Oostenrijk en haar hof.* Exh. cat. Mechelen: 10, under no. 85.

1958/1959 Richardson, E. P. "*Portrait of a Man in a Red Hat* by Master Michiel." *Bulletin of the Detroit Institute of Arts* 38: 80.

1962 Puyvelde, Leo van. *La peinture flamande au siècle de Bosch et Breughel.* Paris: 355–356, pl. 41.

1965 Eisler, Colin T. "The Sittow Assumption." *ArtN* 64 (September): 52–53, fig. 8.

1965 Pauwels, H., H. R. Hoetink, and S. Herzog. *Jan Gossaert genaamd Mabuse.* Exh. cat. Museum Boymans–van Beuningen and Groeningemuseum. Rotterdam and Bruges: 69, under no. 5.

1967 Steppe, J. K. "Jheronimus Bosch. Bijdrage tot de historische en de ikonografische studie van zijn werk." In *Jheronimus Bosch. Bijdragen bij gelegenheid van de herdenkstentoonstelling te 's-Hertogenbosch.* Eindhoven: 14, 39.

1968 Gudlaugsson, S. J. "Sittow (Zittoz)." In *Kindlers Malerei Lexicon.* 6 vols. Zurich, 5: 363.

1969 Osten, Gert von der, and Horst Vey. *Painting and Sculpture in Germany and the Netherlands 1500 to 1600.* Harmondsworth: 142, fig. 137.

1971 Sass, Else Kai. "A Portrait of King Christian II as a Young Prince." *The Antiquaries Journal* 51, part 2: 294–295.

1973 Gilbert, Creighton. *History of Renaissance Art, Painting, Sculpture, Architecture, throughout Europe.* New York: 366, fig. 457.

1975 NGA: 328, repro. 329.

1976 Lurie, Ann Tzeutschler. "The Birth and Naming of St. John the Baptist Attributed to Juan de Flandes. A Newly Discovered Panel from a Hypothetical Altarpiece." *BCMA* 63: 131.

1976 Trizna, Jazeps. *Primitifs flamands. Contributions. Michel Sittow, peintre revalais de l'école brugeoise (1468–1525/26).* Brussels: 53–54, 61, 96–97, cat. no. 18, 105, pl. XV.

1976 Sass, Else Kai. "Autour de quelques portraits de Charles Quint." *OH* 90: 12.

1977 Campbell, Lorne. Review of *Michel Sittow . . .* by Jazeps Trizna. In *Apollo* 105: 225.

1978 Bruyn, Josua. Review of *Michel Sittow . . .* by Jazeps Trizna. In *OH* 92: 214.

1978 Staatliche Museen Preussischer Kulturbesitz. Gemäldegalerie. *Catalogue of Paintings, 13–18th Century.* 2d ed. Berlin-Dahlem: 414, under no. 1722.

1979 Westrum, Geerd. *Altdeutsche Malerei.* Munich: 50.

1982 Steppe, J. K. "Het overbrengen van het hart van Filips de Schone van Burgos naar de Nederlanden in 1506–1507." *Biekorf. Westvlaams Archief* 82: 218, repro. 212.

1985 Haverkamp-Begemann, Egbert. "Paintings by Michiel Sittow Reconsidered." In *Rubens and his World. Bijdragen Opgedragen aan Prof. Dr. Ir. R.-A. d'Hulst. . . .* Antwerp, 1985: 4–5, 8, fig. 4.

1965.1.1 (1928)

The Assumption of the Virgin

c. 1500
Wood, 21.3 x 16.7 (8³⁄₈ x 6⁹⁄₁₆)
 painted surface: 21.1 x 16.2 (8⁵⁄₁₆ x 6³⁄₈)
Ailsa Mellon Bruce Fund

Technical Notes: The panel consists of a single piece of wood with a vertical grain. The painted surface comes to the edge of the panel at the bottom, but there are unpainted margins on the other three sides. A thin band estimated to be lead white runs along the left and top edges of the painted surface. A nick in the panel at the top edge slightly to the right of center has been filled. The x-radiograph shows a very dense layer, probably containing lead white, applied over all with diagonal parallel strokes. Its purpose is unclear.[1] Contrary to Jazeps Trizna's statement,[2] the painting is in very good condition. There are some small areas of loss and inpainting in the Virgin's blue robe, at the edge of the paint surface, and along the vertical crackle pattern.

Provenance: Queen Isabel of Castile, castle of Toro, Zamora province [d. 1504]. Diego Flores, by 13 March 1505, possibly as agent for Margaret of Austria.[3] Margaret of Austria, Regent of the Netherlands, Mechelen, inventories of 1516 and 1524 [d. 1530].[4] Jules Quesnet, Paris, by 1904.[5] Private collection, Zürich, from about 1941.[6] (Feilchenfeldt, Zürich, by 1964.)

Exhibitions: Paris, Musée du Louvre and Bibliothèque Nationale, 1904, *Exposition des primitifs français*, no. 111, as a follower of the Master of Moulins.

THIS SMALL PANEL from a group of forty-seven scenes illustrating the lives of Christ and the Virgin, painted for Queen Isabel the Catholic, depicts the Virgin's corporeal Assumption into heaven. Through his masterly use of light and space, Sittow transforms the conventional symbols of the Assumption into natural phenomena. The pink and lemon-colored light breaking through the clouds substitutes for the more usual rays of the Madonna clothed in the sun. Similarly, the silver-gray mantle draped over the angels' hands serves as a mandorla setting off the figure of the youthful Virgin. Below her a rich plain and bare hills are minutely rendered in delicate shades of blue while the lilac, chartreuse, and orange robes of the angels add a more complex harmony to the effects of color and light.

The notion of the corporeal assumption of the Virgin had an apocryphal rather than a biblical basis, and was an expression of the honor due to Mary as the bearer of Christ.[7] The Gallery's picture has been called a combined depiction of the Assumption, Immaculate Conception, and Coronation of the Virgin.[8] While the doctrine of the Immaculate Conception had many adherents in Spain about 1500, including Isabel and Ferdinand, "los reyes católicos," the Gallery's painting should not be taken as an explicit reference to this belief. Whereas the crescent moon and other attributes of the woman clothed in the sun as described in the Revelation of Saint John came to be specifically linked with the Immaculate Conception in the late sixteenth century, in the late fifteenth and early sixteenth century they were given to the Virgin in a number of devotional settings including that of the Assumption.[9] Furthermore, such an explicit doctrinal statement would be inappropriate to the extended narrative series of which this panel was a part. Nor should the painting be considered a representation of the Coronation, known to have been the subject of a separate panel within the series.[10] The angels holding the crown above the Virgin indicate her heavenly role in a more general sense. In Spanish Assumptions the Virgin is frequently shown crowned by angels. Examples include an *Assumption* in the Prado by an anonymous master[11] and a panel from a retable attributed to Pedro Berruguete.[12]

The painter of the forty-seven small panels is not mentioned in the inventory drawn up after Isabel the Catholic's death in 1504.[13] However, in the 1516 inven-

Michel Sittow, *The Assumption of the Virgin*, 1965.1.1

tory of Margaret of Austria's collection, into which a group of the panels had passed, two are singled out as a diptych: "les deux qui estoient faiz de la main de Michiel sont estez prins pour faire ung double tableau."[14] These two are described as the Assumption and the Ascension. In the late nineteenth century, Justi linked the items in Isabel's inventory with a group of surviving panels, attributing them to Juan de Flandes based on that artist's documented works (see Juan de Flandes, *Temptation of Christ*, 1967.7.1). Justi also recognized Michiel to be Michel Sittow, known from documents to have worked for Isabel the Catholic and later for Margaret of Austria.[15] It was not until 1929 that Friedländer recognized the Gallery's panel as one of the two mentioned as being by Sittow in Margaret of Austria's inventory.[16] Winkler later identified the *Ascension* in the Earl of Yarborough's collection (fig. 1).[17]

Sittow's contributions to Isabel of Castile's series of panels probably date from about 1500 or shortly thereafter. The entire series must have been painted between 1496, when Juan de Flandes first appears in the Queen's employment, and her death in 1504. Sittow himself probably left Spain in 1502, which may account for his much smaller share in the work on the retable.[18]

The *Ascension* and the *Assumption* are the only surviving securely documented works by Sittow and as such are cornerstones of our knowledge of his style. They are also outstanding as narrative subjects in the oeuvre of a painter now known primarily for his Madonnas and portraits, and they provide evidence of his sure and extremely delicate treatment of the figure in space.[19]

Sittow's *Assumption* probably influenced Joachim Patinir's painting of the same subject in the Johnson Collection, Philadelphia.[20] Here angels also hold out the Virgin's mantle to frame her figure, though without the shimmering effect of Sittow's version. Patinir could have seen the *Assumption* and the other narrative scenes in Margaret of Austria's collection in Mechelen.

Several early copies after the *Assumption* are known. One is with Julius Weitzner in London. It was included in a sale at Christie's in 1983, but was not sold.[21] Another, on copper and without the landscape, belonged to Francis Cabanach, Jackson Heights, New York, in 1969.[22] A third, rather free, copy was in a Madrid collection.[23]

M.W.

Notes

1. The back of the panel is bare wood and is inscribed *FR* at upper right and *Marie S^{tre} 12 juin*. . . in the center, along with other illegible notations.

2. Trizna 1976, 90.

3. Sánchez Cantón 1930, 97–103.

4. André Joseph Ghislain le Glay, *Correspondance de Maximilien I^{er} et de Marguérite d'Autriche*. . . , 2 vols. (Paris, 1839), 2: 481–482.

5. See exh. cat. Paris 1904, no. 111.

6. Letter of 31 October 1960 from Mrs. Walter Feilchenfeldt, in curatorial files.

7. Réau, *Iconographie*, vol. 2, part 2, 597–599, 615–624 and H. W. van Os, *Marias Demut und Verherrlichung in der sienesischen Malerei 1300–1450*, Kunsthistorische Studiën van het Netherlands Historisch Instituut te Rome 1 (The Hague, 1969), 147–156.

8. Post 1933, 470; Lépicier 1956, 76; Eisler 1965, 34–37; and Schiller 1980, 4: 2, 151.

9. Suzanne Stratton, "The Immaculate Conception in Spanish Renaissance and Baroque Art," Ph.D. diss., New York University, 1983, 88–167, who dates this change to the 1580s. She cites, among other evidence, the treatise of Johanus Molanus, *De historia SS. imaginum et picturarum provero earum usu contra abusus* (Louvain, 1568), 393–394, in which he describes the correct depiction of the Immaculate Conception as the Virgin *tota pulchra*, while also acknowledging the Meeting at the Golden Gate as a less correct way of illustrating this dogma. According to another passage in Molanus, representations of the Assumption should show the Virgin with the traits of the Apocalyptic Woman. Noting that the crescent moon was also used in representations of the Madonna of the Rosary and other devotional themes, Stratton stresses the importance of an image's context for the interpretation of these attributes.

10. Sánchez Cantón 1930, 97–101. This entry in the list is frequently identified with a panel now in the Louvre; see n. 19 below.

11. No. 2515, on deposit in the Museo de Santa Cruz, Toledo; Post 1933, 4: 470–473, fig. 182.

12. Post 1947, 9: 114–117, fig. 31, then in the Ruiz collection, Madrid.

13. Sánchez Cantón 1930, 97–103.

14. Le Glay 1839, 2: 481–482. This diptych also has a separate entry in the same inventory, "Ung double tableaul de la main de Michiel de l'Assumpcion de Nostre-Seigneur et de celle de Nostre-Dame; qui a une coustode couverte de cuyr"; le Glay 1839, 2: 481. See also Heinrich Zimerman and Franz Kreyczi, "Urkunden und Regesten aus dem k.u.k. Reichs-Finanz-Archiv," *JbWien* 3 (1885), C, n. 60. The two are also described as a diptych in the 1524 inventory, but without mention of the artist; Zimerman and Kreyczi 1885, CXIX.

15. Carl Justi, "Juan de Flandes, ein niederländischer Hofmaler Isabella der Katholischen," *JbBerlin* 8 (1887), 157–165.

16. Friedländer 1929, 249–254. Winkler 1926, 278, had earlier attributed the painting, then linked to the Master of Moulins, to Juan de Flandes, without recognizing its connection to Isabel's series.

17. Winkler 1931, 175–178.

18. See also Josef de Coo and Nicole Reynaud, "Origen del retablo de San Juan Bautista Atribuido a Juan de Flandes," *AEA* 52 (1979), 346, n. 7, and Trizna 1976, 25–27. Eisler 1965, 34, dates it in the late 1490s.

19. *The Coronation of the Virgin* in the Louvre has frequently been considered another contribution by Sittow to Isabel's retable; Reynaud 1967, 345–352, color pl. opp. 348. A Coronation of the Virgin was listed in Isabel's inventory

Fig. 1. Michel Sittow, *Ascension*, private
collection, England [photo: A.C.L.
Brussels, by permission of owner]

and was among those panels assigned the highest value. It
was not among the panels acquired by Margaret of Austria.
The Louvre panel, 26 x 19.7 cm (24.5 x 18.3 painted surface)
is significantly larger than the other panels given the small
scale of the works (*The Ascension* measures 21.5 x 16 cm),
though a Coronation panel would perhaps have occupied a
more prominent place in the projected altarpiece and hence
have been somewhat larger. However, apart from the ques-
tion of its place in the series, I find the handling of the paint to
be less fluid and transparent than that of the *Assumption* and
Ascension, especially in view of the comparable visionary
subject. In my opinion, a more likely candidate for another
figural composition by Sittow is the extraordinary miniature
of Saint John on Patmos, in the Breviary of Isabel the
Catholic, British Library, Add. Ms. 18851, fol. 309. This
miniature, though sometimes attributed to Gerard David, is
relatively isolated in the context of late fifteenth-century
Flemish manuscript illumination; see Thomas Kren in *Re-
naissance Painting in Manuscripts: Treasures from the Brit-
ish Library* [exh. cat. The J. Paul Getty Museum] (Malibu,

1983), 40–48, no. 5, color pl. V. The liquid touch and re-
fined, luminous effects, as well as the handling of the clouds,
the saint's upturned face, and his distinctive corkscrew curls,
support an attribution to the artist of the *Ascension* and
Assumption.

20. Koch 1968, 9–10, 29–30, 75, cat. no. 9, figs. 20,
22–25; with the arms of the Augsburg merchant Lucas Rem.
Koch dates it c. 1516/1517, and links it to purchases in Ant-
werp mentioned in Rem's diary for this period. He notes
"compositional similarities" to 1965.1.1. The multiple nar-
rative scenes surrounding the Assumption may also be re-
lated to the concept of Isabel's retable.

21. Christie's, London, 2 December 1983, no. 89, repro.

22. Acquired in South America; photograph in NGA cura-
torial files.

23. The figure of God the Father has been added above the
Virgin and a putto added below; photograph in the Fried-
länder archives, R. K. D., The Hague, with notation "Herrero-
Madrid" on the verso. This copy may be identical with the
one mentioned by Friedländer 1929, 254.

References

1904 Bouchot, Henri. *L'Exposition des primitifs français*. Paris: not paginated, pl. 81.

1904 Lafenestre, Georges. "L'exposition des primitifs français." GBA 3ᵉ pér. 32: 127.

1904 Durrieu, Paul. "L'exposition des primitifs français." *Revue de l'art ancien et moderne* 16: 419.

1904 Fry, Roger. "The Exhibition of French Primitives." *BurlM* 5: 369–370, repro. 371.

1926 Winkler, [Friedrich]. "Juan de Flandes." In Thieme-Becker 19: 278–279.

1929 Friedländer, Max J. "Neues über den Meister Michiel und Juan de Flandes." *Der Cicerone* 21: 249–254, 115–118, 132, pl. 25.

1930 Sánchez Cantón, Francisco Javier. "El retablo de la Reina Católica." AEA 6: 101–105, 132, pl. 25.

1931 Winkler, Friedrich. "Neue Werke des Meisters Michiel." *Pantheon* 7: 175–178.

1931 Kay, H. Isherwood. "Two Paintings by Juan de Flandes." *BurlM* 58: 200–201.

1931 Winkler, Friedrich. "Master Michiel." *Art in America* 19: 247–248, 252, fig. 2.

1931 Sánchez Cantón, Francisco Javier. "El retablo de la Reina Católica (Addenda et corrigenda)." AEA 7: 150.

1932 H[ulin] de L[oo], [Georges]. In *Trésor de l'art flamand du moyen âge au XVIIIᵐᵉ siècle. Mémorial de l'exposition de l'art flamand ancien à Anvers 1930.* 2 vols. Paris, 1: 50.

1933 Post, Chandler Rathfon. *A History of Spanish Painting*. 14 vols. Cambridge, Mass., 4: 35, 38, 470.

1935 Baldass, Ludwig. "The Portraiture of Master Michiel." *BurlM* 67: 77–81.

1939 Richardson, E. P. "Three Paintings by Master Michiel." *AQ* 2: 103.

1940 Johansen, Paul. "Meister Michel Sittow, Hofmaler der Königin Isabella von Kastilien und Bürger von Reval." *JbBerlin* 61: 2, 16–17, 35, fig. 8.

1943 Winkler, Friedrich. "Neuentdeckte Altniederländer III: Michel Sittow." *Pantheon* 31: 98.

1947 Winkler, F[riedrich]. "Zittoz, Miguel." In Thieme-Becker 36: 531, 533.

1948 Weinberger, Martin. "Notes on Maître Michiel." *BurlM* 90: 251.

1950 Sánchez Cantón, Francisco Javier. *Libros, tapices y cuadros que coleccionó Isabel la Católica.* Madrid: 188.

1952 MacLaren, Neil. *National Gallery Catalogues. The Spanish School.* London: 22, 24–25 (2d ed. rev. by Allan Braham, 1970: 42–43, 45–46).

1953 Michel, Edouard. *Musée National du Louvre. Catalogue raisonné des peintures du moyen âge, de la renaissance et des temps modernes. Peintures flamands du XVᵉ et du XVIᵉ siècle.* Paris: 182.

1956 Lépicier, Augustin-Marie. *L'Immaculée Conception dans l'Art et l'Iconographie.* Spa: 76, pl. 4.

1958 Gaya Nuño, Juan Antonio. *La Pintura española fuera de España.* Madrid: 305, no. 2662.

1958 *Margareta van Oostenrijk en haar hof.* Exh. cat. Mechelen: 10, under no. 86.

1959 Brans, Jan V. L. *Vlaamse Schilders in dienst der Koningen van Spanje.* Louvain: 44, 189.

1961 Goldblatt, Maurice H. *Deux grands maîtres français, le Maître de Moulins identifiés, Jean Perréal.* Paris: 42, fig. 18.

1962 Bermejo, Elisa. *Juan de Flandes.* Madrid: 11.

1962 Puyvelde, Leo van. *La peinture flamande au siècle de Bosch et Breughel.* Paris: 355, 455–456.

1963 Folie, Jacqueline. "Les oeuvres authentifiées des primitifs flamands." *BInstPat* 6: 245–246, fig. 36.

1965 Eisler, Colin T. "The Sittow Assumption." *ArtN* 64 (September): 34–37, 52–54, fig. 1.

1966 "Chronique des arts." *GBA* 6ᵉ pér. 67 (February): 46, no. 179, repro.

1967 Reynaud, Nicole. "Le Couronnement de la Vierge de Michel Sittow." *RLouvre* 17: 345–351, fig. 3.

1968 Gudlaugsson, S. J. "Sittow (Zittoz)." In *Kindlers Malerei Lexicon.* 6 vols. Zurich, 5: 363.

1968 Koch, Robert A. *Joachim Patinir.* Princeton: 30.

1969 Walker, John. *Self-Portrait with Donors: Confessions of an Art Collector.* Boston and Toronto: 42–44.

1970 Davies, Martin. *Primitifs flamands. Corpus. The National Gallery London.* 3 vols. Brussels, 3: 9, 11.

1975 NGA: 330, repro. 331.

1976 Trizna, Jazeps. *Primitifs flamands. Contributions. Michel Sittow, peintre revalais de l'école brugeoise (1468–1525/26).* Brussels: VIII, 25–28, 73, 91–92, pls. 1–3.

1976 Lurie, Ann Tzeutschler. "The Birth and Naming of St. John the Baptist Attributed to Juan de Flandes. A Newly Discovered Panel from a Hypothetical Altarpiece." *BCMA* 63: 119, 129, 132, 133, fig. 26.

1977 Campbell, Lorne. Review of *Michel Sittow . . .* by Jazeps Trizna. In *Apollo* 105: 225.

1978 Bruyn, Josua. Review of *Michel Sittow . . .* by Jazeps Trizna. In *OH* 92: 212–213.

1980 Schiller, Gertrud. *Ikonographie der christlichen Kunst.* 6 vols. Gütersloh, 4, part 2: 151, 257, fig. 743.

1981 [Demus, Klaus, Friderike Klauner, and Karl Schütz]. Kunsthistorisches Museum. *Flämische Malerei von Jan van Eyck bis Pieter Bruegel der Ä.* Vienna: 176.

1982 Kauffmann, C. M. *Victoria and Albert Museum. Catalogue of the Paintings in the Wellington Museum.* London: 78.

1984 Bauman, Guy C. In *The Jack and Belle Linsky Collection in the Metropolitan Museum of Art.* New York: 62–63.

1984 Haverkamp-Begemann, Egbert. "Paintings by Michiel Sittow Reconsidered." In *Rubens and his World. Bijdragen Opgedragen aan Prof. Dr. Ir. R.-A. d'Hulst. . . .* Antwerp, 1985: 8.

Rogier van der Weyden

c. 1399/1400–1464

Rogier van der Weyden or, in French, Rogier de le Pasture, was born in Tournai in 1399 or 1400. He died in Brussels on 18 June 1464. On 5 March 1427, Rogier began an apprenticeship with Robert Campin (q.v.) that lasted four years. On 1 August 1432 he was received as a master in the painters' guild of Tournai. By April 1435 he is recorded as being in Brussels, and in March 1436 Rogier is mentioned as official painter of the city of Brussels, though exactly when he was appointed to this post is unknown. It is generally assumed that Rogier made a trip to Rome in the Jubilee year of 1450, as reported by Fazio in *De Viris Illustribus*, written in 1456.

There are no signed or dated works by Rogier van der Weyden. Three extant paintings can be associated with the name Rogier van der Weyden by means of documents. Antonio Ponz, writing in the late eighteenth century, described a triptych then still in the Charterhouse of Miraflores, Spain, and transcribed a document recording the gift of this altarpiece by *Magistro Rogel, Magno et Famoso Flandresco*, to the monastery by King John II of Castile in 1445. A triptych from Miraflores in the Gemäldegalerie, Berlin, and another version divided between the Capilla Real, Granada, and the Metropolitan Museum, New York, correspond to Ponz's description. While the autograph quality of the Berlin altarpiece was formerly doubted, the underdrawing, as revealed by infrared reflectography, shows extensive changes that attest to its status as a first version and make it probable that it is the painting referred to in the document cited by Ponz. In a 1574 inventory of works sent to the Escorial by Philip II, the *Crucifixion* (Escorial, Nuevos Museos) is listed as having come from the Charterhouse of Scheut, near Brussels. It is known that Rogier gave pictures and money to the Charterhouse and a recently published document indicates that when the *Crucifixion* was sold from Scheut in 1555 it was recorded as having been donated by *magistro Rogero*. The reasonable assumption is that the painting was given by Rogier to the Charterhouse sometime after its foundation in 1454. The *Descent from the Cross* in the Prado is also mentioned as being by *Maestre Rogier* in the 1574 inventory of works sent to the Escorial. The painting was probably commissioned by the crossbowmen's guild for the Chapel of Our Lady Outside the Walls in Louvain. A copy of the painting, dated 1443, suggests that Rogier's picture was finished and installed by this date.

Despite a paucity of information, it nonetheless has been possible to construct a large, relatively well-defined oeuvre for Rogier. Along with Jan van Eyck, Rogier van der Weyden must be considered the greatest Netherlandish artist of the fifteenth century. His compositional inventiveness and emotional intensity had an overwhelming impact on Netherlandish and German art during the second half of the fifteenth and well into the sixteenth century.

J.O.H.

Bibliography

Destrée, Jules. *Roger de la Pasture van der Weyden*. 2 vols. Paris and Brussels, 1930.
Rolland, P. "Les Impératifs historiques de la biographie de Roger." *RBAHA* 18 (1949): 145–161.
Panofsky. *ENP*. 1953: 155–158, 248–302.
Feder, Theodore. "A Reexamination Through Documents of the First Fifty Years of Roger van der Weyden's Life." *AB* 48 (1966): 416–431.
Davies, Martin. *Rogier van der Weyden*. London, 1972.
Soenen, M. "Un renseignement inédit sur la destinée d'une oeuvre bruxelloise de Van der Weyden, le *Calvaire* de la chartreuse de Scheut." *Rogier van der Weyden, Rogier de le Pasture*. [Exh. cat. Musée Communal de Bruxelles] 1979: 126–128.

1937.1.44 (44)

Portrait of a Lady

c. 1460
Oak, 37 x 27 (14¹/₁₆ x 10⁵/₈)
 painted surface: 34 x 25.5 (13³/₈ x 10¹/₁₆)
Andrew W. Mellon Collection

Technical Notes: The panel is composed of a single board with vertical grain. There is an unpainted margin on all sides

Fig. 1. Rogier van der Weyden, *Portrait of a Lady*, 1937.1.44, x-radiograph

Provenance: Probably Leopold Friedrich Franz, Prince of Anhalt, Gotisches Haus, Wörlitz, near Dessau [d. 1817].[2] Probably Leopold Friedrich, Prince of Anhalt [d. 1871]. Friedrich I, Duke of Anhalt [d. 1904]. Friedrich II, Duke of Anhalt, Gotisches Haus, Wörlitz and Herzogliches Schloss, Dessau, until 1925. (Bachstitz Gallery, The Hague, 1925.)[3] (Duveen Brothers, London and New York, 1926.) Purchased December 1926 by Andrew W. Mellon, Washington. Deeded 30 March 1932 to The A. W. Mellon Educational and Charitable Trust, Pittsburgh.

Exhibitions: Bruges, Hôtel de Gouvernement Provincial, 1902, *Exposition des primitifs flamands et d'art ancien*, no. 108. // London, Royal Academy of Arts, 1927, *Flemish and Belgian Art 1300–1900*, no. 33. // New York, F. Kleinberger Galleries, 1929, *Loan Exhibition of Flemish Primitives*, no. 8.

TOWARD THE END of his career, Rogier van der Weyden was particularly concerned with the problem of the portrait, as suggested by the number of surviving examples datable between about 1450 and his death in 1464. Of these the Gallery's *Portrait of a Lady* is the only autograph portrait of a woman.[4]

The almost abstract elegance characteristic of Van der Weyden's late portraits is brilliantly realized here in a balance of pattern and form. A red belt relieves the severity of the lady's black robe, which is trimmed with dark fur bands at the neck and wrists. The background is a deep blue-green. Although the sitter is placed at a slight angle, the balanced, interlocking diagonals of her décolletage, arms, and veil give her pose a frontal and hieratic effect. The smooth, almost shadowless volume of the head is accentuated against the relatively flat field of the veil.

There are very few external indications of date for Rogier's late portraits. The inscription on the reverse of the portrait of *Philippe de Croÿ* in Antwerp includes a title that the sitter used by 1454 and gave up by 1461.[5] In his portrait in Brussels the *Grand Bâtard Antoine* is depicted wearing the collar of the Golden Fleece that he received in 1456.[6] In addition, a relative chronology is suggested by the development in costume in the male portraits toward a broad chest, padded shoulders, and hair cut to cover the temples and forehead.[7] At the same time, Rogier's work shows an increasing emphasis on the plane and his figures become more brittle and abstracted.[8] Within the framework suggested by these observations, it is possible to suggest a general sequence for the late portraits. The Gallery's portrait should be placed toward the end of this group.[9] The degree to which the surface of the panel is asserted seems comparable to the portraits of *Philippe de Croÿ* and of the *Grand Bâtard Antoine*, for which

of the panel and a slight barbe at the edge of the painted surface. Incised lines at the edge of the painted surface were probably guidelines for the application of the ground. The painting is in excellent condition. It was cleaned about the time it left the Anhalt collection[1] and received a surface cleaning in 1980. There is a fine overall crackle pattern and some inpainting along the crackle. A few small, local losses on the lady's veil and kerchief, on her proper right sleeve, and to the left of her ear have been inpainted. There is some abrasion in the ear.

No underdrawing was made visible by infrared reflectography apart from a single stroke within the fur collar and parallel to its edge on the right side and another horizontal stroke in the little finger of the top hand. The lady's silhouette was originally even more slender than at present, since the thickly applied paint of the background extends into the area of the belt on either side. This change is visible in raking light, while the extreme slenderness of the original silhouette is evident in the x-radiograph (fig. 1).

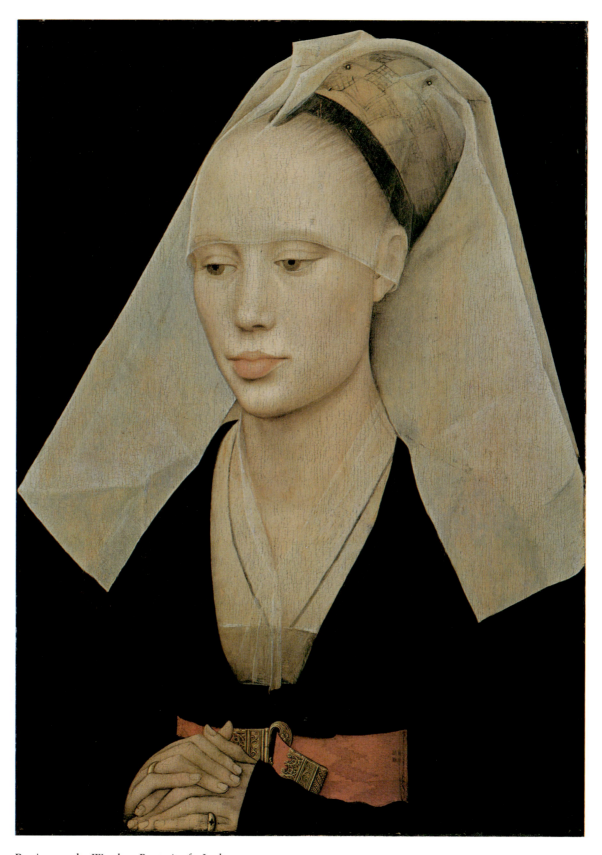

Rogier van der Weyden, *Portrait of a Lady*, 1937.1.44

dates between about 1456 and 1461 can be derived. The portrait of *Laurent Froimont* in Brussels and the *Madonna and Child* in Caen, which it presumably accompanied, can be placed somewhat earlier.[10] The figures exist more freely in space, the features are less abstracted, and the texture and luminosity of the skin are more precisely detailed; the costume and hairstyle of the Froimont portrait also support an earlier date. These observations suggest a date about 1460 for the *Portrait of a Lady*, though the possibility of a date at the very end of Rogier's career cannot be excluded.[11]

The hands, placed at the edge of the painting as though resting on the frame, indicate that the *Portrait of a Lady* is an independent portrait, not part of a devotional diptych or triptych. It is possible that it formed a pendant to a portrait of the sitter's husband, though no such pairs by Rogier van der Weyden can be reconstructed. The choice of Van der Weyden, who seems to have been a favored court portraitist toward the end of his career,[12] and the reserve, even hauteur, expressed in the set of the head and the downward gaze, suggest that the lady portrayed belonged to the nobility. Her identity is likely to remain unknown.[13] There are no heraldic devices on the back of the uncradled panel, and the lady's features and costume cannot be linked with an identified portrait. Indeed, it is difficult to isolate the individual quality of the sitter's features, as they have evidently been refined through the process of idealization to which all of Rogier's late portrait subjects were submitted.[14]

The Gallery's portrait has frequently been compared to the *Portrait of a Lady* in the National Gallery, London.[15] However, it is difficult to see the London portrait as a product of Rogier's own hand, despite its evident high quality. The bright color scheme, the more emphatic projection of the figure in space, and the particularity of texture and light all suggest a shift of emphasis from that found in Rogier's late portraits.

A *Portrait of a Lady* employing a related portrait type was sold with the Halifax collection in 1947.[16] A free copy of the Gallery's portrait, probably of modern origin, was on the art market in 1931.[17]

M.W.

Notes

1. According to a note on Friedländer's photograph of the painting, "III.1926/Gereinigt Duveen Mellon," in Friedländer archive, R.K.D., The Hague.

2. For the activity of this prince as a collector, see C. Rost, "Der alte Nassau-Oranische Bilderschatz und sein späterer Verbleib," *Jahrbücher für Kunstwissenschaft* 6 (1873), 52–93. The numerous portraits in the Anhalt collection are not very precisely described in the early catalogues. However, Lorne Campbell has suggested that 1937.1.44 may be identical with no. 1318, "Dirk Bouts (?), Weibliches Por-

trät in schwarzer Kleidung mit rothem Gürtel," in the bedroom of Duke Franz in the Gotisches Haus; Wilhelm Hosäus, *Wörlitz. Ein Handbuch für die Besucher des Wörlitzer Gartens und die Wörlitzer Kunstsammlungen*, 2d ed. (Dessau, 1883), 40.

3. See *ArtN* (10 October 1925), 6 and (24 October 1925), 1.

4. For portraits by Rogier, see most recently Campbell 1979, 56–67.

5. Friedländer, vol. 2 (1967), no. 39, pl. 63; Campbell 1979, 58, and 1980, 85–86. Hulin de Loo had previously supposed that Philippe de Croÿ used the title *seigneur de Sempy* from 1459, "Diptychs by Rogier van der Weyden," *BurlM* 43 (1923), 57.

6. Friedländer, vol. 2 (1967), no. 37, pl. 58. See Lorne Campbell, "Rogier van der Weyden's 'Portrait of a Knight of the Golden Fleece': The Identity of the Sitter," *BMRBA* 21 (1972), 7–14.

7. Hulin de Loo 1923, 53–58 and Hulin de Loo, "Diptychs by Rogier van der Weyden," *BurlM* 44 (1924), 179–189.

8. Rogier's late style is analyzed by Schulz 1971, 63–116.

9. Most authors have dated the portrait in the 1450s; see Friedländer, vol. 2 (1924), 101 (1967, 66); Holmes 1926, 127; Tietze 1935, 127; Schöne 1938, 61; Beenken 1951, 73; Panofsky 1953, 294; and Cuttler 1968, 125. Hulin de Loo 1902, no. 108, and 1938, col. 241, and Campbell 1980, 78, have implied a date at the end of Rogier's career. With the exception of Hymans 1902, 294; Voll 1906, 73, 289; and Reinach 1907, 2: 484, no. 2, the portrait has been universally accepted as autograph. Firmenich-Richartz 1897, 385, and Wauters 1900, 60–61, suggested an attribution to Hugo van der Goes.

10. In the Musées Royaux des Beaux-Arts, Brussels, and the Musée des Beaux-Arts, Caen; Friedländer, vol. 2 (1967), nos. 30–31, pls. 53, 52.

11. Dendrochronological examination of the panel, undertaken by Peter Klein, provides additional support for a late date; see Appendix I.

Margaret Scott, letter of 13 December 1980 in curatorial files, notes that the lady's costume, with its tight-fitting bodice and sleeves yet relatively narrow neck opening, would have been the height of fashion in aristocratic circles in the early 1450s (compare the illustrations to the *Roman de Girart de Roussillon*, Vienna, Österreichische Nationalbibliothek, cod. 2549, transcribed 1448; L. M. J. Delaissé, *La Miniature Flamande*, exh. cat. Bibliothèque Royale [Brussels, 1959], no. 45, pl. 22). Factors that could explain the retention of this dress in a portrait of a slightly later period include conservative taste on the part of the sitter, aesthetic considerations governing the artist, or the somewhat lower social status of the sitter, though the latter seems unlikely because of the portrait's air of elegance. The adjustment in the waist (see Technical Notes and fig. 1) suggests that the slenderness of the lady's silhouette was something of an issue.

12. Campbell 1979, 63.

13. Wilhelm Stein's attempt to identify the sitter with Marie de Valengin, illegitimate daughter of Philip the Good, was based upon a supposed resemblance to Philip's features, Stein 1926, 13–14.

14. As Lorne Campbell has pointed out (1979, 62, and 1980, 10), in the Gallery's portrait Rogier placed the ear high in order to give an uninterrupted contour to throat and chin.

15. Friedländer, vol. 2 (1967), no. 34, pl. 56, and Davies 1968, 170–171, no. 1433. For the comparison of the two portraits, see especially Holmes 1926, 122–128.

16. Sold Christie's, London, 12 December 1947, no. 23; repro. *Pantheon* 22 (1938), 366. Another version of this portrait is in the J. W. Frederiks collection, on loan to the Museum Boymans–van Beuningen, Rotterdam; photograph Friedländer archives, R. K. D., The Hague.

17. Photograph in curatorial files.

References

n.d. Wauters, A. J. *Die vlämische Malerei.* Leipzig: 64.

1897 Firmenich-Richartz, E. "Hugo van der Goes. Eine Studie zur Geschichte der altvlämischen Malerschule." *Zeitschrift für christliche Kunst* 9: 385.

1899 Friedländer, Max J. In *Ausstellung von Kunstwerken des Mittelalters und der Renaissance aus Berliner Privatbesitz.* Exh. cat. Kunstgeschichtlichen Gesellschaft. Berlin: 7.

1900 Wauters, A. J. *Le Musée de Bruxelles. Tableaux anciens. Notice, guide et catalogue.* Brussels: 60–61.

1902 Hulin de Loo, Georges. *Bruges. Exposition des tableaux flamands des XIVᵉ, XVᵉ, et XVIᵉ siècles. Catalogue critique.* Ghent: 25, no. 108.

1902 Hymans, Henri. "L'Exposition des primitifs flamands à Bruges." *GBA* 3ᵉ pér. 28: 294, repro. 293. (Repr. as a book, Paris, 1902: 62, repro. 59.)

1903 Weale, W. H. James. "The Early Painters of the Netherlands as Illustrated by the Bruges Exhibition of 1902." *BurlM* 1: 202, repro. 209.

1903 Friedländer, Max J. *Meisterwerke der niederländischen Malerei des XV. und XVI. Jahrhunderts auf der Ausstellung zu Brügge 1902.* Munich: 6, no. 12, pl. 12.

1903 Friedländer, Max J. "Die Brügger Leihausstellung von 1902." *RfK* 26: 71.

1906 Voll, Karl. *Die altniederländische Malerei von Jan van Eyck bis Memling.* Leipzig: 73, 289.

1907 Reinach, Salomon. *Répertoire de peintures du moyen âge et de la Renaissance (1280–1580).* 2 vols. Paris, 2: 484, no. 2, repro.

1908 Laban, Ferdinand. "Ein neuer Roger. Begleitworte zu seiner Veröffentlichung." *ZfbK* N.F. 19: 58, 60, 64, repro. 55.

1913 Winkler, Friedrich. *Der Meister von Flémalle und Rogier van der Weyden.* Strasbourg: 53–55, 176.

1916 Friedländer, Max J. *Von Eyck bis Bruegel.* Berlin: 175.

1921 Conway, Sir Martin. *The Van Eycks and their Followers.* London: 136.

1923 Burger, Willy. *Roger van der Weyden.* Leipzig: 50–51, 70, pl. 48b.

1924 Friedländer. Vol. 2: 41, 101, no. 29A, pl. 28 (vol. 2, 1967: 26, 66, no. 29A, pl. 55).

1925 *ArtN* 24 (10 October): 6.

1925 *ArtN* 24 (24 October): 1.

1926 *ArtN* 24 (2 January): 3.

1926 *ArtN* 24 (23 January): 6.

1926 *ArtN* 24 (30 January): 1, repro.

1926 Holmes, Sir Charles. "Portraits by Roger van der Weyden." *BurlM* 48: 122–128, pl. B.

1926 Destrée, Jules. "Roger van der Weyden (Roger de la Pasture)." *RArt* 49: repro. 145.

1926 Hulin de Loo, Georges. "Robert Campin or Rogier van der Weyden? Some Portraits Painted between 1432 and 1444." *BurlM* 49: 273.

1926 Stein, Wilhelm. "Die Bildnisse von Roger van der Weyden." *JbBerlin* 47: 13–14.

1927 Demonts, Louis. "L'Exposition d'art flamand à la Royal Academy de Londres." *GBA* 5ᵉ pér. 15: 262.

1928 Hulin de Loo, Georges. "Hans Memlinc in Rogier van der Weyden's Studio." *BurlM* 52: 172–177, pl. 4B.

1928 Jamot, Paul. "Roger van der Weyden et le prétendu Maître de Flémalle." *GBA* 5ᵉ pér. 18: 276–277, repro. 281.

1929 Singleton, Esther. *Old World Masters in New World Collections.* New York: 166–168, repro.

1929 Burrows, Carlyle. "Exhibitions of Flemish Primitive Painting." *Parnassus* 1 (November): 6–9, repro.

1930 Destrée, Jules. *Roger de la Pasture van der Weyden.* Paris and Brussels: 180–181, pl. 137.

1935 Tietze, Hans. *Meisterwerke europäischer Malerei in Amerika.* Vienna: 127, repro. 333.

1937 Cortissoz, Royal. *An Introduction to the Mellon Collection.* Privately printed: 34–35.

1938 Schöne, Wolfgang. *Dieric Bouts und seine Schule.* Berlin and Leipzig: 61.

1938 Hulin de Loo, Georges. "Rogier van der Weyden." In *Biographie Nationale de Belgique.* 29 vols. Brussels, 27: col. 241.

1939 Mather, Frank Jewett, Jr. *Western European Painting of the Renaissance.* New York: 77, fig. 43.

1941 *Duveen Pictures in Public Collections of America.* New York: not paginated. No. 169, repro.

1941 Tolnay, Charles de. "Flemish Paintings in the National Gallery of Art." *MagArt* 34: 186, 200, fig. 18.

1941 Held, Julius S. "Masters of Northern Europe, 1430–1660, in the National Gallery." *ArtN* 40 (June): 11, repro. 13.

1941 NGA: 214, no. 44.

1942 Winkler, F[riedrich]. "Rogier van der Weyden." In Thieme-Becker 35: 472, 475.

1945 Davies, Martin. *National Gallery Catalogues. Early Netherlandish School.* London: 112, under no. 1433 (2d ed., 1955: 127; 3d ed., 1968: 171).

1948 Davenport, Millia. *The Book of Costume.* 2 vols. New York, 1: 306, no. 819, repro.

1948 Puyvelde, Leo van. *The Flemish Primitives.* Brussels: 27, pl. 45.

1948 Musper, Theodor. *Untersuchungen zu Rogier van der Weyden und Jan van Eyck.* Stuttgart: 23–24, 59, fig. 66.

1949 Mellon: 55, repro.

1950 Winkler, Friedrich. "Rogier van der Weyden's Early Portraits." *AQ* 13: 215.

1951 Beenken, Hermann. *Rogier van der Weyden.* Munich: 73–75, fig. 92.

1952 Tolnay, Charles de. "Remarques sur la Joconde." *La Revue des Arts* 2: 23–24.

1953 Panofsky. *ENP*: 292, 295, 477, fig. 367.

1954 Davies, Martin. *Primitifs Flamands. Corpus. The National Gallery, London.* 3 vols. Brussels and Antwerp, 2: 198, under no. 60.

1954 Tietze, Hans. *Treasures of the Great National Galleries.* New York: 112, 124, pl. 196.

1966 Frinta, Mojmír S. *The Genius of Robert Campin.* The Hague: 81.

1967 Eckardt, Götz. *Die Schönheit der Frau in der europäischer Malerei.* Berlin: 11, pl. 11.

1968 Cuttler. *Northern Painting*: 125, fig. 145.

1968 Whinney, Margaret. *Early Flemish Painting*. New York and Washington: 66, pl. 29.

1970 Blum, Shirley Neilsen. Review of *The Genius of Robert Campin* by Mojmír Frinta. In *AB* 52: 435.

1971 Fingerlin, Ilse. *Gürtel des hohen und späten Mittelalters*. Munich: 198.

1971 Schulz, Anne Markham. "The Columba Altarpiece and Roger van der Weyden's stylistic development." *MünchnerJb*, series 3. 22: 104, fig. 39.

1972 Davies, Martin. *Rogier van der Weyden*. London: 222, 241, pl. 107.

1972 Schabacker, Peter H. Review of *Rogier van der Weyden* by Martin Davies. In *AQ* 35: 424.

1973 Campbell, Lorne. Review of *Rogier van der Weyden* by Martin Davies. In *Apollo* 98: 64.

1974 Künstler, Gustav. "Vom Entstehen des Einzelbildnisses und seiner frühen Entwicklung in der flämischen Malerei." *Wiener Jahrbuch für Kunstgeschichte* N.S. 27: 47–48, fig. 13.

1975 Kerber, Ottmar. "Rogier van der Weyden." *Giessener Beiträge zur Kunstgeschichte* 3: 48–49, 61.

1975 NGA: 374, repro. 375.

1977 Eisler: 58, under K2088 (1961.9.28).

1979 Campbell, Lorne. "L'art du portrait dans l'oeuvre de Van der Weyden." In *Rogier van der Weyden. Rogier de le Pasture*. Exh. cat. Musée Communal de Bruxelles: 58, 62, repro. 60.

1980 Campbell, Lorne. *Van der Weyden*. New York: 9–10, 78, pl. 7.

1980 Scott, Margaret. *The History of Dress Series. Late Gothic Europe, 1400–1500*. London: 163, 165, 167, 241, fig. 93.

1966.1.1 (2310)

Saint George and the Dragon

c. 1432/1435

Wood, 15.2 x 11.8 (6 x 4⅝) painted surface: 14.3 x 10.5 (5⅝ x 4⅛)

Ailsa Mellon Bruce Fund

Technical Notes: The picture is painted on a panel with a vertical grain, which is set into a larger panel with vertical grain, which in turn is mounted on another panel with horizontal grain. The painting is in good condition. A vertical split left of center runs the length of the panel, and small flakes of paint have been lost along the split. Minor treatment was administered to the lower portion of the split in 1976 to increase the security and adhesion of the paint.

On the reverse of the panel are two seals and a small piece of paper (fig. 1). The paper bears an inscription in what may be a sixteenth-century German hand: *A°7 / Videatur et pondere- / tur ab arte reperitis*, and in a different hand: *albrictür*.[1] The seal at the upper left seems to bear the words BUREAU BERLIN and an intertwined monogram FR; the seal could indicate Royal Prussian possession between the time of

Fig. 1. Reverse of *Saint George and the Dragon*, 1966.1.1

Frederick the Great and the middle of the nineteenth century, or it could simply be a customs seal. The seal at the lower right corner bears a coat of arms that has been identified with a high degree of probability as that of the Polish family Grudna-Grudzinski.[2]

Provenance: Possibly Grudna-Grudzinski family, Poznan. General de Plaoutine, Leningrad, by 1902, Nice, by 1917, and London, by 1920.[3] Lady Evelyn Mason [d. 1944], cousin of General de Plaoutine's wife, London, purchased 1923.[4] Mrs. L. A. Impey, her daughter, Chilland, Hitchin Abbas, near Winchester, by inheritance (sale, Sotheby's, London, 16 March 1966, no. 1).

Exhibitions: London, Burlington Fine Arts Club, 1920, *Pictures and English Furniture of the Chippendale Period*, no. 30, as Hubert van Eyck. // London, Royal Academy of Arts, 1927, *Flemish and Belgian Art 1300–1900*, no. 20, as attributed to Hubert van Eyck. // London, Royal Academy of Arts, 1953–1954, *Flemish Art 1300–1900*, no. 1, as attributed to Hubert van Eyck. // Winchester-Southampton, Winchester College and Southampton Art Gallery, 1954, *Pictures from Hampshire Houses*, no. 13, as attributed to Hubert van Eyck. // Bruges, Groeningemuseum, 1956, *L'Art flamand dans les collections britanniques et la Galerie Nationale de Victoria*, no. 1, as attributed to Hubert van Eyck. // London, Thos. Agnew & Sons, Ltd., 1957, *European Pictures from an English County*, no. 41, as Hubert van

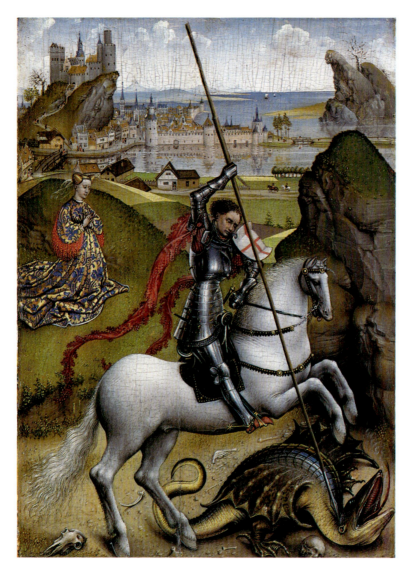

Rogier van der Weyden, *Saint George and the Dragon*, 1966.1.1

Eyck. // Brussels, Musée Communal de Bruxelles, 1979, *Rogier van der Weyden. Rogier de le Pasture*, no. 3Y, as Rogier van der Weyden.

ACCORDING TO LEGEND, Saint George was a Roman soldier of the third century and a native of Cappadocia. He was martyred in 303 A.D. The theme of Saint George's struggle with the dragon, a rather late development, did not appear until the eleventh or twelfth century. Probably the most popular account is contained in *The Golden Legend*, which gives two versions of the story. In one, George slays the monster in a single blow. Alternatively, the dragon is only hurt and the princess, who was to have been devoured, is able to lead the dragon by a girdle tied round its neck. Afterward, the dragon was paraded in front of the townspeople and then slain by Saint George.[5] In the Gallery's painting it appears that the dragon is not being killed in one blow, but only wounded and pinned to the earth with the lance point.

Although the high quality of *Saint George and the Dragon* has been acknowledged ever since it entered the literature in 1902, its precise attribution remains controversial. It was first given to Hubert van Eyck, an untenable appellation that persisted in exhibition catalogues into the 1950s, or associated with Jan van Eyck and with a lost Saint George.[6] The main lines of criticism have involved a discussion of whether the painting was by Robert Campin, Rogier van der Weyden, or some unidentified figure who is allied with one or both men. Winkler was probably the first to give the painting to Campin and was followed by Schneider and de Tolnay.[7] Devigne gave the panel to an artist in the entourage and under the influence of Campin, an opinion favored by Panofsky.[8] The prevalent attribution is that put forward by Hulin de Loo who suggested that the *Saint George and the Dragon* is the work of Rogier van der Weyden, perhaps executed during his years of apprenticeship with Campin, and that the awkwardnesses in the painting are those of a beginner.[9] Beenken,

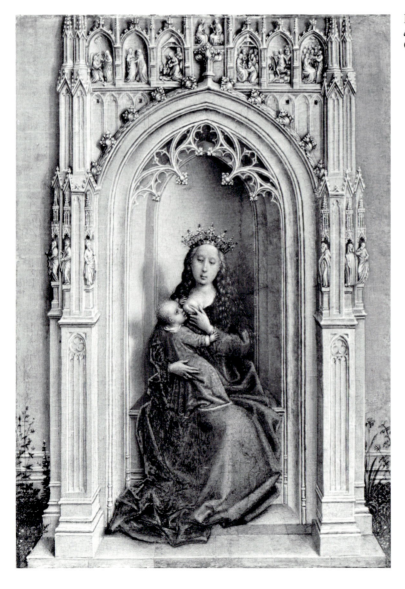

Fig. 2. Rogier van der Weyden, *Madonna and Child*, Lugano, Thyssen-Bornemisza Collection [photo: Brunel]

Baldass, Van Gelder, and Davies also consider the panel to be early Rogier.[10] In 1937 Friedländer also attributed it to Rogier, but his opinion is somewhat clouded by the fact that at that time he was under the influence of Renders' theories on the unity of Rogier van der Weyden and the Master of Flémalle.[11]

Beenken in 1940 was the first to suggest that the *Saint George and the Dragon* and the *Madonna and Child* (fig. 2) in the Thyssen-Bornemisza collection, Lugano, were originally pendants. This view is not accepted by all, but the recent monograph on Rogier van der Weyden by Davies cautiously classes both paintings as "immature originals" by Rogier and asserts that they probably formed a diptych.[12] Subsequent critics have challenged both the association of the two panels and the attribution of *Saint George and the Dragon* to Rogier van der Weyden.[13]

The measurements of the panel on which the Saint George is painted correspond so closely to those of the Thyssen *Madonna and Child* that the almost inevitable assumption is that the two panels were conjoined in some manner, probably as a diptych.[14] With diptychs, it is traditional to place the Virgin and Child on the viewer's left, but this arrangement has George galloping awkwardly off toward the right.[15] It is conceivable that the two panels were placed back to back or that one functioned as a cover for the other. Iconographically, the association of Saint George and the Virgin had chivalric and political implications in the early fifteenth century and was popular to some degree in Burgundy, though more so in England.[16] The possibility that both pictures were part of a larger ensemble should not be excluded, though there is no evidence for this.[17] Whatever its original disposition it is almost certain that *Saint George and the Dragon* was used for private devotion.

A variety of compositional and stylistic influences operate on *Saint George and the Dragon*. First, there are correspondences with manuscript illumination of the late fourteenth and early fifteenth centuries. Several scholars have noted similarities between the depiction of Saint George in the hours of the Maréchal de Boucicaut (fig. 3) and the Gallery's panel; those similarities, such as the pose of the horse, are shared with other painted and manuscript depictions of the scene.[18] Additional connections with manuscripts may be seen in the distinctive "parenthetical" mountains that occur in the *Flight into Egypt* miniature of the *Très Belles Heures* of Jean de Berry by Jacquemart de Hesdin.[19]

Second, the strong influence of Jan van Eyck can be seen in the "optical" manner of rendering surfaces and the delight in shimmering light effects, such as the reflections on George's armor and the dragon's scales.

Fig. 3. The Boucicaut Master, *Saint George and the Dragon*, Boucicaut Hours, Ms. 2, fol. 23v, Paris, Musée Jacquemart-André [photo: Bulloz]

Eyckian influence has long been recognized as a component of the early style of Rogier van der Weyden.[20] Moreover, a possible relationship exists between the Gallery's painting and a *Saint George and the Dragon* by Van Eyck that was bought for King Alfonso of Aragon in 1444 and sent from Valencia to Naples. The lost original may be reflected in Pedro Nisart's *Saint George and the Dragon* (fig. 4), commissioned in 1468, in the Museo Diocesano, Palma de Mallorca.[21] Nisart's painting is in general compositional accord with the Gallery's panel, especially in its detailed background of fortified buildings, water, and high horizon. The Gallery's picture deviates from Nisart's in small but significant details, such as the way in which the dragon is attacked with the lance.[22]

As regards the art of Robert Campin, comparison can be made to the landscape in the background of the *Nativity* in the Musée des Beaux-Arts, Dijon, though the two paintings do not appear to be by the same

Fig. 4. Pedro Nisart, *Saint George and the Dragon*, Palma de Mallorca, Museo Diocesano [photo: Mas, Barcelona]

hand.[23] In general Campin's works do not have the delicacy and the sense of fantasy found here.

The closest and yet most frustrating comparisons are to be found in the works attributed to Rogier van der Weyden. The possible association of the Gallery's picture and the *Madonna and Child* in the Thyssen-Bornemisza collection has already been discussed. The second most immediate point of comparison, in terms of style, format, and date, is with the two small pictures depicting the *Madonna and Child* and *Saint Catherine* in the Kunsthistorisches Museum, Vienna.[24] Here, too, a Virgin and Child in an architectural setting are juxtaposed with an image of a saint in a landscape setting. Although the landscapes in the Catherine and George panels are similar, it is not certain that the two pictures are by the same artist.[25] Some scholars have questioned the *Saint Catherine* as an autograph Rogier, but this author is prepared to accept both Vienna panels as early works of the master.[26] Further removed in date and style, but still comparable, are the landscape back-

grounds of the *Donor* and *Visitation* panels in the Galleria Sabauda, Turin.[27] Especially similar are the tiny sailing ships and the walled city in the donor panel. The features of Saint George are consonant with some of the visages found in Rogier's oeuvre and to a lesser extent with those of Campin. And while the difference in scale makes comparison difficult, the straight noses rounded at the tip and manner of highlighting found in other male faces in the Prado *Descent* are similar. There is, for example, a resemblance to the Saint John the Evangelist in Rogier's *Descent from the Cross* in the Prado.[28] Unfortunately there are no adult male faces in the earliest works associated with Rogier—the Vienna diptych and the Thyssen *Madonna and Child*.

In sum, the name that can be best associated with the *Saint George and the Dragon* is that of Rogier van der Weyden. On the basis of style and costume the painting may be dated to c. 1432/1435[29] and thus may be the earliest work by Rogier. The most telling argument in favor of the attribution lies in the exceptionally high quality of the panel. Rogier's characteristic linearity may be discerned, in embryo as it were, in the crisp outlines of the horse and the rock formations. The multiple associations with Campin, Van Eyck, and International Style manuscript illumination accord with what one would expect of Rogier at this time, as do the facial types, which are much more Rogerian than Campinesque. Moreover, it seems likely that the panel was allied in some manner with the Thyssen *Madonna and Child*, a work usually given to Rogier. However, the attribution of *Saint George and the Dragon* to Rogier must be made very cautiously, and the possibility of authorship by an unidentified artist working in proximity to Campin and Rogier should not be excluded.[30] Setting aside questions of authorship, *Saint George and the Dragon*, which combines courtly chivalric elegance with a microscopic yet realistic and atmospheric landscape (fig. 5), must be reckoned one of the finest achievements in the history of Netherlandish painting.

J.O.H.

Notes

1. The Latin phrase may be translated, "Look and ponder, from art you will learn." The source of this quotation has not yet been determined. It is possible that the word *albrictür* may refer to Albrecht Dürer and thus reflect an early attribution.

2. Both seals are identified and discussed by Dr. Zimmermann, Director of the Geheimes Staatsarchiv, Berlin, in a letter to Robert Oertel, Director of the Gemäldegalerie, Berlin, 22 January 1966, in the curatorial files. Oertel, in a letter of 9 February 1966, to Carmen Gronau of Sotheby's, also adds to the discussion, noting that the seal at the upper left may be a customs seal. It has not been possible to find men-

tion of 1966.1.1 in the collections of Frederick the Great or the Grudna-Grudzinski family. It should be noted, however, that Joanna of the house of Grudna-Grudzinski married the Russian Grand Duke Constantine on 24 May 1820. She received the title of Princess von Lowicz (Jnowraczlaw) from Czar Alexander. If the painting did belong to the Grudna-Grudzinski family, it is possible that it came to Saint Petersburg through the person of Joanna. Perhaps it was given to her as a wedding present.

3. Phillips 1902, 598, is the earliest mention of the painting being in the Plaoutine collection, Saint Petersburg. Plaoutine still owned the picture in 1920; see *Pictures and English Furniture of the Chippendale Period* [exh. cat. Burlington Fine Arts Club] (London, 1920), no. 30. Mrs. L. A. Impey, letter of 20 August 1984 to the author, in curatorial files, states that Plaoutine emigrated to Nice in 1917 and sent the painting to his wife's cousin in England.

4. Mrs. L. A. Impey, letter of 20 August 1984, to the author in the curatorial files.

5. Réau, *Iconographie*, vol. 3, part 2, 571–576, esp. 576; Thurston and Attwater, *Butler's Lives of the Saints*, 2: 148–150; Ryan and Ripperger, *The Golden Legend*, 1: 232–238.

6. See under Exhibitions. Weale and Brockwell 1912, 161–162, who list it under paintings of doubtful authenticity, quote Phillips 1902 as attributing it to Hubert van Eyck, and Maclagen as reminiscent of the Turin Hours. Phillips 1920 gave the painting to Konrad Witz. For the lost *Saint George* by Van Eyck see n. 19.

7. Winkler 1927, 222; Schneider 1927, 39; de Tolnay 1939, 57.

8. Devigne 1927, 68–69; Panofsky 1953, 425–426, n. 4 specifically cites the disproportion of the horse.

9. Hulin de Loo 1938, col. 233.

10. Beenken 1940, 137, and 1951, 29–30; Baldass 1952, 17, 89, considers it a copy of a lost Campin; Van Gelder 1967, 3, dates it to c. 1420–1425; Davies 1972, 222–223.

11. Friedländer, vol. 2 (1967), 55–56, 89, supp. 130, puts it in the period 1425–1429; Renders 1931, 2: 35, calls it Flémalle or Rogier; Musper 1948, 58, also believes Rogier and the Master of Flémalle are the same person.

12. Davies 1972, 222–223.

13. Schabacker 1972, 423; Périer-d'Ieteren, *Rogier van der Weyden* [Exh. cat. Musée Communal de Bruxelles] (1979), 139–140, suggests that it may be a studio work.

14. The Thyssen panel measures 15.8 x 11.2 cm; painted surface 14.2 x 10.2 cm. See *The Thyssen-Bornemisza Collection. Catalogue of the Paintings* (Castagnola, 1969), 354–356, entry by J. C. Ebbinge-Wubben. The Thyssen picture was in the possession of King Frederick the Great of Prussia and bears on its reverse a seal with an intertwined FR and the words BUREAU BERLIN that is very similar to the seal at the upper left of 1966.1.1. This by itself, however, is not enough to suggest that the pictures were together at one time. Most critics give the Thyssen panel to Rogier, with varying degrees of certainty. John Ward, "A New Attribution for the *Madonna Enthroned* in the Thyssen Bornemisza Collection," *AB* 50 (1968), 354–355, attributes the painting to Campin and dates it to c. 1435.

15. See Wolfgang Kermer, "Studien zum Diptychon in der sakralen Malerei," Ph.D. diss., University of Tübingen, 1967, esp. 166–173, for diptychs pairing the Virgin and a saint. It is by no means an ironclad rule that the Virgin is always placed on the viewer's left.

16. Susan King, "St. George and the Virgin Mary in Fif-

Fig. 5. *Saint George and the Dragon*, detail, 1966.1.1

teenth Century Burgundy: Political and Chivalric Implications," M.A. thesis, University of Maryland, 1977. Richard Vaughan, *Philip the Good* (New York, 1970), 146, notes that in 1435 Pierre de Bauffremont entered a tournament carrying a banner depicting the Virgin on one side and Saint George on the other.

17. The chances of the two panels being part of a polyptych seem rather slim and it is difficult to ascertain what the iconographic program might have been. Another, perhaps more viable suggestion is that the two panels were part of a non-folding triptych; the *Madonna and Child* would be the center panel flanked by Saint George on the left and another mounted, militant saint, such as Saint Martin, on the right. Just such a triptych was painted in the late fourteenth century by the Spaniard Francesco Comes, and is in the Isabella Stewart Gardner Museum, Boston. See Philip Hendy, *European and American Paintings in the Isabella Stewart Gardner Museum* (Boston, 1974), 56–58.

18. Baldass 1952, 17, n. 1, was perhaps the first to associate 1966.1.1 with the Boucicaut Master's miniature. This connection is also made in the entry by Maurice Brockwell in the *Flemish Art 1300–1900* [Exh. cat., Royal Academy of Arts] (London, 1953–1954), 9–10, no. 1, and by Meiss 1974, 243. Representations of Saint George and the dragon abound in the late fourteenth and early fifteenth centuries. The following, while similar to 1966.1.1, are not necessarily direct sources: Modena, Bibl. Estense, Book of Hours, Ms. R.7.3. lat. 842, fol. 240r, Lombard, c. 1387, repro. *Arte Lombarda* 8, no. 2 (1963), 36, fig. 15; London, British Museum, Beaufort Hours, Royal Ms. 2A XVIII; fol. 5v, Flemish master active in England (?) c. 1400, repro. *AB* 22 (1940), fig. 9; Bernardo Martorell, panel painting, Spanish, c. 1438, The Art Institute of Chicago, no. 1933.786, repro. *The Art Institute of Chicago 100 Masterpieces* (Chicago, 1978), 40.

19. Brussels, Bibl. Royale, Ms. 11060/61, fol. 106, repro. Millard Meiss, *French Painting in the Time of Jean de Berry. The Late Fourteenth Century and the Patronage of the Duke* (London, 1967), fig. 188. "Parenthetical" mountains are also encountered in the *Visitation* by the Egerton Master, Madrid, Bibl. Nacional, Vit. 25, No. 1, fol. 12, repro. in Millard Meiss, *French Painting in the Time of Jean de Berry. The Boucicaut Master* (London, 1968), fig. 178.

20. During the first years of Rogier's apprenticeship Jan van Eyck was in Lille, not far from Tournai, and in fact was offered the *vin d'honneur* by the city of Tournai on 18 October 1427. It is also quite probable that in 1432 Rogier, as apprentice or master, would have journeyed to see the newly completed Ghent altarpiece.

21. The lost Van Eyck and Nisart's *Saint George* are discussed at length in Chandler Post, *A History of Spanish Painting* 14 vols. (Cambridge, Mass., 1938), 7, part 2: 615–624. Compare August Mayer, "Neue Dokumente zur Künstlergeschichte des 14. und 15. Jahrhunderts," *Monatshefte für Kunstwissenschaft* 7 (August, 1914), 298; and Cuttler, *Northern Painting*, 248. José Gudiol Ricart, *Ars Hispaniae* 22 vols. (Madrid, 1955), 9: 295, sees French and Italian influence in the background of Nisart's painting. Peman y Pemartin 1969, 37–39, also discusses the relationship between the lost Van Eyck and Nisart's Saint George; he sees 1966.1.1 as a freer version of the lost Van Eyck.

22. Post 1938, 621, cites Pietro Summonte's letter of 1524, which concerns a copy of a Flemish Saint George by the Neapolitan artist Colantonio. The description corresponds to Nisart's painting, especially the following: "his spear, which he had fixed in the dragon's mouth; and the point, having passed completely within, had only to penetrate the skin, which, already swollen, made a kind of bag outside." This detail is also found in an Upper Rhenish *Saint George* of c. 1435–1460 in the Bayerische Staatsgemäldesammlungen, Munich, no. WAF 729. In contrast, the dragon in 1966.1.1 is pinned to the earth in a manner that I have not found in any other representations of this theme. This motif was either an original creation of the artist or was derived from a source, such as manuscript illumination, which is as yet undiscovered. At any rate, it belongs to a different recension.

23. Catalogued and repro. in Davies 1972, 247–248, pl. 155.

24. Davies 1972, 240, pls. 87–88.

25. In the Saint Catherine the rocks appear to be painted more softly, the dotting of trees and grasses is different, and the background is constructed with a greater emphasis on overlapping hills.

26. Panofsky 1953, 251, considers it shopwork; Karl Birkmeyer, "Notes on the Two Earliest Paintings by Rogier van der Weyden," *AB* 44 (1962), 331, n. 16, doubts the attribution; Périer-d'Ieteren, exh. cat. Brussels, 1979, 141, sees the Catherine panel as weaker than its companion and questions whether it and the Saint George might be by the same apprentice.

27. Davies 1972, 236–237, pls. 19–21. The center panel of the dismembered triptych is the *Annunciation* in the Louvre. The pictures are consistently dated early.

28. Davies 1972, 223–226, pls. 1–9.

29. Saint George's armor is comparable to that worn by the "Warriors of Christ" on the inner left wing of the Ghent altarpiece of 1432. Helmut Nickel, curator of arms and armor at the Metropolitan Museum of Art, letter to Martha Wolff of 27 September 1979, in the curatorial files, compares George's armor to that worn by Sir Hugh Halsham on the tomb brass of 1441 in the West Grinstead Church, Sussex, and notes that much English armor was imported from the Netherlands. The closest parallel to the costume of the Princess is found in Jan van Eyck's depiction of Giovanna Cenani, wife of Giovanni Arnolfini, in the double portrait of 1434 in the National Gallery, London. The sleeve of her robe is ornamented with a similar hanging fringe and her *coiffure à cornes*, is comparable, though the Princess wears a transparent veil rather than a white kerchief.

30. This essentially is the opinion put forward by Davies 1972, 223, "But too little is known for any certainty; and I do not think it excluded that these two pictures are by a painter (or two?) separate from Rogier and from Campin." The strongest argument against Rogier's authorship lies in the awkward, unconvincing proportions of the horse, the non-Campinesque character of the work, and—in the eyes of some critics—the incompatibility with the Thyssen panel. If one accepts the hypothesis of a second, unknown artist, then this person must have been gifted with a talent equal to Rogier's and it is curious that there are no other paintings or manuscript illuminations that can be attributed to him.

References

1902 Phillips, Claude. "Impressions of the Bruges Exhibitions." *The Fortnightly Review* N.S. 72: 598.

1912 Weale, W. H. James, and Maurice W. Brockwell. *The Van Eycks and Their Art.* London: 161–162, no. 30.

1920 Phillips, Claude. "Burlington Fine Arts Club. Win-

ter Exhibition." *Daily Telegraph* (18 December): 6.

1921 Fry, Roger. "The Burlington Fine Arts Club." *The New Statesman* 16 (1 January): 392.

1921 Conway, Martin. *The Van Eycks and Their Followers*. London: 63.

1925 Hulin de Loo, Georges. "Quelques notes du voyage. 1. Un document catalan concernant un *Saint Georges* peint par Johannes van Eyck." Académie Royale de Belgique. Classe des Beaux-Arts. *Bulletin* 7, nos. 6–9: 100–104.

1927 Winkler, Friedrich. "Die flämisch-belgische Ausstellung in London." *Der Kunstwanderer* (February): 222.

1927 Demonts, Louis. "L'Exposition d'art flamand à la Royal Academy de Londres." *GBA* 5e pér. 15: 261, repro.

1927 Devigne, Marguerite. "Notes sur l'Exposition d'art flamand et belge à Londres, 1." *OH* 44: 68–69, fig. 1.

1927/1928 Schneider, Hans. "Die Ausstellung flämischer und belgischer Kunst in London." *ZfbK* 61: 39, repro.

1929 Renders, Emile. "The Riddle of the Maître de Flémalle." *BurlM* 54: 292.

1931 Renders, Emile. *La solution du problème van der Weyden Flémalle Campin*. 2 vols. Bruges, 2: 35, pl. 6.

1937 Friedländer. Vol. 14: 84, 85–86, 88, pl. Nachtrag 6 (vol. 2, 1967: 55, 56, 89, supp. 130, pl. 36).

1938 Hulin de Loo, Georges. "Rogier van der Weyden." In *Biographie Nationale de Belgique*. 29 vols. Brussels, 27: col. 233.

1939 Tolnay, Charles de. *Le Maître de Flémalle et les frères van Eyck*, Brussels: 46, 57, no. 9, fig. 19.

1940 Beenken, Hermann. "Rogier van der Weyden und Jan van Eyck." *Pantheon* 25: 129–130, 136–137.

1942 Winkler, F[riedrich]. "Weyden, Rogier van der." In Thieme-Becker 35: 475.

1948 Musper, Theodor. *Untersuchungen zu Rogier van der Weyden und Jan van Eyck*. Stuttgart: 58, pl. 27.

1950 Winkler, F[riedrich]. "Meister von Flémalle." In Thieme-Becker 37: 100.

1951 Beenken, Hermann. *Rogier van der Weyden*. Munich: 29–30, 33–34, 44, fig. 12.

1952 Baldass, Ludwig. *Jan van Eyck*. London: 17, 89.

1953 Panofsky. *ENP*: 425–426, fig. 273.

1953 Gamber, Ortwin. "Harnischstudien: V. Stilgeschichte des Plattenharnisches von den Anfängen bis um 1440." *JbWien* N.F. 14: 78, no. 146.

1954 Sutton, Denys. "Flemish Painting at the Royal Academy." *Les Arts Plastiques* 6th ser. no. 6: 6, 8, 69, fig. 1.

1954 Röthel, H. K. Review of *Rogier van der Weyden*

by Hermann Beenken. In *Kunstchronik* 7: 74–75.

1954 Röthel, H. K. "Die Ausstellung flämischer Malerei in London." *Kunstchronik* 7: 89.

1956 *Winchester Cathedral Record* 25: 25–26, pl. 9.

1956 Weiss, Roberto. "Jan van Eyck and the Italians." *Italian Studies* 11: 12.

1957 Nicolson, Benedict. "Pictures from Hampshire Houses." *BurlM* 99: 273.

1962 Birkmeyer, Karl M. "Notes on the Two Earliest Paintings by Rogier van der Weyden." *AB* 44: 329.

1966 Frinta, Mojmír. *The Genius of Robert Campin*. The Hague: 28, 35.

1966 Frohlich-Bume, L. "Der heilige Georg als Drachentöter von Hubert van Eyck." *Die Weltkunst* 36 (1 March): 171, repro.

1967 Gelder, J. G. van. "An Early Work by Robert Campin." *OH* 82: 3.

1967 C[ott], P[erry] B. In Hugh Broadley. *Flemish Painting in the National Gallery of Art*. Rev. ed. Washington: 4, 16, repro. 17.

1969 Peman y Pemartin, César. *Juan van Eyck y España*. Cadiz: 37–39, fig. 15.

1970 Châtelet, Albert. Review of *French Painting ... by* Millard Meiss. In *RevueArt* no. 8: 83.

1972 Davies (see Biography): 33, 222–223, pl. 86.

1972 Schabacker, Peter H. Review of *Rogier van der Weyden* by Martin Davies. In *AQ* 25: 423.

1974 Meiss, Millard. *French Painting in the Time of Jean de Berry: The Limbourgs and Their Contemporaries*. New York: 243, fig. 754.

1974 Bruyn, Josua. "A New Monograph on Rogier." Review of *Rogier van der Weyden* by Martin Davies. In *BurlM* 116: 540.

1974 Walker, John. *Self-Portrait with Donors*. Boston and Toronto: 41–42.

1975 Smeyers, Maurice. "Een collegeschrift van de oude Leuvense Universiteit (1481–1482). Een codicologisch en iconografisch onderzoek." *Arca Lovaniensis* 4: 281, 285, fig. 12.

1975 NGA: 374, repro. 375.

1976 Walker: 125, pl. 121.

1981 Randall, Richard H. Jr. "Jan van Eyck and the St. George Ivories." *The Journal of the Walters Art Gallery* 39: 41, 44, 47, fig. 2.

1984 Lane, Barbara G. *The Altar and the Altarpiece. Sacramental Themes in Early Netherlandish Painting*. New York: 25–35.

Follower of Rogier van der Weyden

1937.1.45 (45)

Christ Appearing to the Virgin

c. 1475
Probably oak, 163 x 93 (64⅛ x 36⅝)
Andrew W. Mellon Collection

Technical Notes: The panel is composed of four boards with vertical grain. There are extensive small losses and repaint throughout, with large areas of repaint in the foreground and in Christ's left foot. Changes exist above Christ's left hand and in the columns of the window frame at the right.

Provenance: Don José de Madrazo y Agudo, Madrid, by 1856.[1] Don Federigo de Madrazo y Kuntz, his son, Madrid, by inheritance.[2] Marques de Salamanca, Madrid[3] (sale, Paris, 3–6 June 1867, no. 155, as Hugo van der Goes). Don Pedro de Madrazo, Madrid, until 1909.[4] (Durlacher, London, by 1909.) (Duveen Brothers, New York, September 1912.) (Kleinberger, New York, May–June, 1914.)[5] (Duveen Brothers, New York, June, 1914.) Purchased January 1937 by the A. W. Mellon Educational and Charitable Trust, Pittsburgh.

Exhibitions: London, Royal Academy of Arts, 1927, *Flemish and Belgian Art, 1300–1900*, no. 30, as Rogier van der Weyden. // Brussels, Exposition Universelle, 1935, *Cinq siècles d'art Bruxellois*, no. 11, as Rogier van der Weyden.

NOT DESCRIBED in the canonical Gospels, the appearance of the resurrected Christ to the Virgin is to be found in apocryphal writings, the most important and influential of these being the Pseudo-Bonaventura's *Meditations on the Life of Christ*, which was composed in the thirteenth century.[6] The Pseudo-Bonaventura's vivid and emotional account sets the scene in the Virgin's house and describes her as kneeling down to honor Christ. At the beginning of the fifteenth century there was a Northern iconographic type that was based generally on representations of the "Noli me tangere." This type was used by Rogier van der Weyden on the right wing of the Miraflores altarpiece (Gemäldegalerie, Berlin).[7] Rogier's panel does not show Christ carrying a staff and banner, but this feature is found in other representations of the theme. That the banner in the Gallery's painting is green and not the banner of the Resurrection, which is white with a red cross, may be due to an iconographic misunderstanding.[8]

Only Weale and Friedländer attribute *Christ Ap-*pearing to the Virgin to Rogier van der Weyden.[9] Most critics believe that the painting is by an unnamed artist strongly influenced by Rogier, but working at a later date.[10] However, Hulin de Loo and de Tolnay give the panel, either fully or in part, to Vrancke van der Stockt who succeeded Rogier as city painter of Brussels.[11] An *Annunciation* in the Musée des Beaux-Arts, Dijon, which is the same size and was also in the Madrazo Collection, Madrid, has been proposed as a companion piece and published as by Vrancke van der Stockt.[12] Despite the similarities of size and provenance, it is not possible to accept the two panels as part of the same ensemble. Not only are the features different, but the pattern of the floor tiles, the perspectival schemes, and the framing devices are not in accord. In the absence of any documented works by Vrancke van der Stockt, the attribution to him of *Christ Appearing to the Virgin* can neither be proved nor disproved.[13]

Christ Appearing to the Virgin derives in a general way from the right wing of Rogier's Miraflores altarpiece (fig. 1).[14] A version closer in composition and date is one of a pair of shutters in the Metropolitan Museum of Art, New York, attributed to the Master of the Saint Ursula Legend. Also related is a depiction of the same theme in the National Gallery, London, by a follower of Rogier, which is dated between about 1450 and 1475.[15]

The Gallery's panel was painted by an anonymous Netherlandish follower of Rogier van der Weyden and dates to the third quarter of the fifteenth century. It is possible that it functioned as the right wing of an altarpiece. The panel may have been produced in Brussels or even Bruges, but because Rogier's influence was so widespread it is hard to localize the works of his followers. The painting's large size and the fact that it was first recorded in a collection in Spain suggests that it might have been originally destined for a religious institution in Spain.

J.O.H.

Notes
1. *Catalogo de la Galeria de Cuadros del Excmo. Sr. D. José de Madrazo* (Madrid, 1856), 519.
2. Unverified, but very likely; information from Duveen Brothers brochure in the curatorial files.
3. I have been unable to locate the catalogue of his collection, *Catalogo de la galeria de Cuadros de la posesion de Vista-Alegre, de propriedad del Excmo. Sr. Marques de Salamanca* (Madrid, 1865).

Follower of Rogier van der Weyden, *Christ Appearing to the Virgin*, 1937.1.45

Fig. 1. Rogier van der Weyden, *Christ Appearing to the Virgin*, right wing of the Miraflores Altarpiece, Berlin, Staatliche Museen Preussischer Kulturbesitz, Gemäldegalerie [photo: Jörg P. Anders]

4. Duveen Brothers brochure in the curatorial files. Weale 1909, 159, cites the painting as being with Durlacher and mentions the previous owner as Pedro de Madrazo.

5. Kleinberger archives, card no. 9561, department of European painting, Metropolitan Museum. I am grateful to Lorne Campbell for bringing this information to my attention and to Mary Sprinson de Jesús for access to the files.

6. Isa Ragusa and Rosalie Green, *Meditations on the Life of Christ* (Princeton, 1961), 359–360. The basic study of this theme is Breckenridge 1957, 9–32; compare Réau, *Iconographie*, vol. 2, part 2, 554–556.

7. Breckenridge 1957, 22.

8. Christ with the staff and banner of the Resurrection is depicted in a sculpture by Veit Stoss (Nonnberg Abbey, Church of Saint John, Salzburg), and in a painting by an Antwerp mannerist in the Museum of Fine Arts, Richmond, Virginia; repro. Breckenridge 1957, figs. 11, 14.

9. Weale 1909, 159–160; Friedländer, vol. 2 (1924), no. 41. Friedländer's acceptance was somewhat modified by "certain troublesome traits, especially in the head of Christ" that he attributed to a restorer. Examination by the Gallery's conservation staff does not indicate that the head of Christ has been exceptionally altered by restoration.

10. Among those who believe that the painting is by a later follower are: Mather 1917, 149; Destrée 1930, 1: 97–98; Schöne 1938, 64, no. 15; Beenken 1951, 100; Nicole Verhaegen, letter to John Walker, January 1961, in the curatorial files; Davies 1972, 215. Both Destrée and Schöne state that the panel was in the Bache Collection, New York. There is no verification of this.

11. Hulin de Loo 1926/1927, col. 73, sees in the painting a collaboration between Rogier van der Weyden and Vrancke van der Stockt, with Vrancke responsible for the architectural details. De Tolnay 1941, 185–186, considers the picture to be entirely by Vrancke van der Stockt and probably late in date. Panofsky 1953, 463, n. 4, seems to accept an attribution to Vrancke van der Stockt.

12. Friedländer, vol. 2 (1967), Add. 160, pl. 143, 160 x 92 cm. Beenken 1951, 100, cites Winkler as proposing that the Gallery's painting is by Vrancke van der Stockt and is a pendant to the *Annunciation* in Dijon. Davies 1972, 215, found the association of the two pictures "very probable." A. Brunard, "Vrancke Van der Stockt (Successeur de Rogier van der Weyden, en qualité de peintre officiel de la Ville de Bruxelles)," *Bruxelles au XVme siècle* (Brussels, 1953), 83–84, published the Dijon *Annunciation* as by Vrancke, but did not link it to the Gallery's painting or include the latter in his discussion of Vrancke's works.

13. For a discussion of the putative oeuvre of Vrancke van der Stockt, see Hulin de Loo 1926/1927, cols. 66–76; Duverger 1938, 69–70; Brunard 1953, 83–84 (as in preceding note); and Craig Harbison, "A Late 15th Century Flemish Panel Attributed to Vrancke van der Stockt," *Allen Memorial Art Museum Bulletin* 30 (1973), 52–62.

14. Friedländer, vol. 2 (1967), 60, no. 1a, pls. 1, 3.

15. For the New York painting see Harry Wehle and Margaretta Salinger, *New York. The Metropolitan Museum of Art. A Catalogue of Early Flemish, Dutch and German Paintings* (New York, 1947), 76–77, no. 32.100.63B. For the London panel, see Martin Davies, *National Gallery Catalogues. Early Netherlandish School* 3d ed. (London, 1968), 176, no. 1086.

References

1856 *Catalogo de la Galeria de Cuadros del Excmo. Sr. D. José de Madrazo*. Madrid: 126, no. 519.

1909 Weale, W. H. James. "*The Risen Saviour Appearing to His Mother*: a masterpiece by Roger de la Pasture." *BurlM* 16 (December): 159–160, repro.

1912/1913 Wauters, A. J. "Roger van der Weyden." *BurlM* 22: 82.

1917 Mather, Frank Jr. "Christ Appearing to His Mother by Rogier de la Pasture." *Art in America* 5 (April): 149.

1924 Friedländer. Vol. 2: 105, no. 41 (vol. 2, 1967: 68, no. 41, pl. 64).

1926/1927 Hulin de Loo, Georges. "Stockt." In *Biographie National de Belgique*. 29 vols. Brussels, 24: col. 73.

1927/1928 Schneider, Hans. "Die Ausstellung flämischer und belgischer Kunst in London." *ZfbK* 61: 40.

1928 Vaughan, Malcolm. "Roger van der Weyden in America." *International Studio* 90 (July): 42–43, repro. 41.

1930 Destrée (see Biography): 97–98, pl. 18.

1938 Duverger, J. "Stock." In Thieme-Becker 32: 69–70.

1938 Schöne, Wolfgang. *Dieric Bouts und seine Schule.* Berlin and Leipzig: 64, no. 15.

1941 NGA: 214.

1941 Tolnay, Charles de. "Flemish Paintings in the National Gallery of Art." *MagArt* 34 (April): 185–186, fig. 14.

1951 Beenken, Hermann. *Rogier van der Weyden.* Munich: 100.

1953 Panofsky. *ENP:* 463.

1957 Breckenridge, James. "'Et Prima Vidit': The Iconography of the Appearance of Christ to His Mother." *AB* 39: 24.

1972 Davies, Martin. *Rogier van der Weyden.* London: 215.

1973 Campbell, Lorne. "Studies in Early Netherlandish Art." Review of *The Ghent Altarpiece and the Art of Jan van Eyck* by Lotte Brand Philip and *Rogier van der Weyden* by Martin Davies. In *Apollo* 98 (July): 64.

1975 NGA: 376, repro. 377.

1976 Walker: 125, fig. 120.

1981 Grosshans, Rainald. "Rogier van der Weyden. Der Marienaltar aus der Kartause Miraflores." *JbBerlin* 23: 77.

Appendix I

Dendrochronological Analysis of Early Netherlandish Panels in the National Gallery of Art

by Peter Klein

Measurements were taken from panels in the collection whose edges permitted a clear reading of the growth rings and which were large enough to provide a space of about two hundred growth rings. In some cases the measurements taken did not yield concrete results. The measurements were taken by Josef Bauch of the Ordinariat für Holzbiologie, Universität Hamburg, on 15–19 July 1977, and by Peter Klein, Ordinariat für Holzbiologie, Universität Hamburg, on 12–16 September 1983. They were interpreted using the comparative material gathered at the Ordinariat für Holzbiologie.

Peter Klein provided the following explanation of the possibilities and limitations of dendrochronological analysis:

Oak panels were usually cut from the tree trunk with an approximately radial orientation and therefore contain a large number of growth rings. As the sapwood is light colored and perishable it was usually trimmed away by the panel maker. It has recently been determined that in most cases Netherlandish pictures were painted on oak panels of Polish/Baltic origin and the allowance for sapwood growth rings is a statistical average of $15 \pm^{4}_{2}$ years, depending on the age of the particular tree. This allowance is different in trees originating in other parts of Europe.

If no sapwood is present, the felling date can only be approximated by adding to the latest measured growth ring a minimum of 15 sapwood rings. The possible error in the felling date is indicated by the designation $15 \pm^{x}_{2}$, where "15 − 2" accounts for the number of sapwood rings that might be missing, while the "x" stands for an unknown number of missing heartwood rings which may have been trimmed off together with the sapwood.

Determination of the felling date for dated paintings also provides information on the amount of time the wood was customarily stored before being used for a painting. For oak panels of the sixteenth and seventeenth centuries, in most cases the interval between felling and creation of the painting was approximately 5 ± 3 years. The few investigations carried out with signed and dated Netherlandish panels of the fifteenth century do not yet permit such a close estimate. However, present studies performed on fifteenth century panels of the school of Cologne indicate a storage time of 10 to 15 years.[1]

1. See also Peter Klein, "Dendrochronologische Untersuchungen an Eichenholztafeln von Rogier van der Weyden," *Jb Berlin* 23 (1981), 113–123.

	Number of Boards	Number of Growth Rings	Latest Growth Ring	Probable Felling Date	Probable Earliest Use
1. Hieronymus Bosch, 1952.5.33 *Death and the Miser*	I	109	1476[1]	$1492\pm^{x}_{2}$	1502
	II	33	1477[1]		
2. Follower of Pieter Bruegel, 1952.2.19 *Temptation of Saint Anthony*	I	199	1528	$1543\pm^{x}_{2}$	1545
	II	89	1528		
3. Follower of Robert Campin, 1959.9.3 *Madonna and Child with Saints in the Enclosed Garden*	I	250 (220 measured)	1391		
	II	220 (110 measured)	1400		
	III	190 (90 measured)	1391	$1415\pm^{x}_{2}$	1425
	IV	249 (119 measured)	1395		
	V	225 (220 measured)	1390		

[1] Both boards of this panel come from the same tree as all four boards of Bosch's *Prodigal Son* in the Museum Boymans-van Beuningen, Rotterdam.

	Number of Boards	Number of Growth Rings	Latest Growth Ring	Probable Felling Date	Probable Earliest Use
4. Petrus Christus, 1937.1.40 *Nativity*	I	286	1431		
	II	136	1433	1448^{+x}_{-2}	1458
	III	177[2]	1431		
	IV	147[2]	1430		
5. Petrus Christus, 1961.9.10, 1961.9.11					
Portrait of a Male Donor	I	148[3]	1412	1427^{+x}_{-2}	1437
Portrait of a Femle Donor	I	129[3]	1391		
6. Gerard David and Workshop, 1942.9.17 *Saint Anne Altarpiece*					
Right wing:	I	187	1380	1496^{+x}_{-2}	1506
	II	204	1363		
	III	210	1375		
Center panel:	I	113	1477		
	II	253	1478		
	III	172 (44cm not measured)	1481		
	IV	158	1353		
Left wing:	I	190	1480		
	II	218	1387		
	III	79 (15cm not measured)	no dating		

7. After Lucas van Leyden, 1961.9.27
The Card Players
Lindenwood—not readily datable by dendrochronological analysis.

	Number of Boards	Number of Growth Rings	Latest Growth Ring	Probable Felling Date	Probable Earliest Use
8. Master of the Prado *Adoration of the Magi* 1961.9.28					
Presentation in the Temple	I	175	1428		
	II	183[4]	1433	1448^{+x}_{-2}	1458
9. Hans Memling, 1937.1.41 *Madonna and Child with Angels*	I	307	1465	1480^{+x}_{-2}	1490
	II	117	1425		
10. Hans Memling, 1952.5.46 *Saint Veronica*	I	221	1458	1473^{+x}_{-2}	1483
11. Netherlandish Artist, 1943.7.7 *The Healing of the Paralytic*	I	96			
	II	206	1569	1584^{+x}_{-2}	1586
	III	138	1562		
12. Rogier van der Weyden, 1937.1.44 *Portrait of a Lady*	I	265	1438	1453^{+x}_{-2}	1463

Also measured but not yielding concrete results were: Master of Saint Giles and Assistant, *Episodes from the Life of a Bishop Saint* (1952.2.14), Master of Saint Giles, *Baptism of Clovis* (1952.2.15),[5] Michel Sittow, *Diego de Guevara(?)* (1937.1.46), and Flemish School, Imitator of, *Saint Bernard and a Donor* (1942.16.2).

[2] Boards III and IV are from the same tree.
[3] Both panels were cut from the same tree.
[4] Only 153 rings on this board were measured.
[5] Though it was not possible to date these two panels, dendrochronological examination did demonstrate that the right-hand board of each panel came from the same tree.

Appendix II

Examination of Early Netherlandish Paintings in the National Gallery of Art with Infrared Reflectography

by Molly Faries

The infrared reflectography survey of fifteenth- and sixteenth-century Netherlandish and German paintings at the National Gallery of Art was undertaken by Professor Molly Faries (Indiana University, Bloomington) while a fellow at the Center for Advanced Study in the Visual Arts in 1981–1982. The examination of nearly ninety paintings and the preparation of documents were carried out with the help of the curatorial, conservation, and photography staff and permitted many of the findings to be included in this catalogue. At the same time Professor Faries surveyed the fifteenth- and sixteenth-century German paintings in the collection, which resulted in material that will be incorporated in the catalogue of German painting. The Center for Advanced Study in the Visual Arts published her provisional report of this 1981–1982 study with reflectography in *Center 2, Research Reports and Record of Activities*. Other illustrative material and reports resulting from this survey are now in the Gallery's files.

Professor Faries provided the following summary of the technology used for this survey as a guide for the interpretation of the resulting documents:

Since the video equipment employed in this survey was identical to that adapted for this type of study by J. R. J. van Asperen de Boer, the Dutch physicist who developed infrared reflectography in the late 1960s, the results meet current standards. The high resolution video camera is the Grundig FA 70 H, outfitted with a Hamamatsu N 214 infrared vidicon, a TV Macromar 1:2.8/36 mm lens, and Kodak 87 A infrared filter. The display (termed a reflectogram) appears on the Grundig BG 12 monitor. The reflectogram assemblies illustrated in this catalogue were photographed from the monitor screen by Faries while the painting was illuminated with a dimmed quartz lamp, and while using a Canon A-1 35 mm camera and Kodak Plus X film. Infrared reflectography is sensitive to infrared radiation in a range from approximately 900–2000 nanometers, well beyond conventional infrared photography. The N 214 Hamamatsu infrared vidicon, which is capable of "seeing" in this range of the spectrum, has now become a fairly standard component in reflectography systems; and it is part of the equipment that has been in use at the Gallery since this survey.

Capable of penetrating most pigments, infrared reflectography is able to detect any carbon-containing materials—in an underdrawing or underpainting—beneath the surface of a painting. The registration of these normally unseen aspects of a painting can be affected by many factors, however. Underdrawing in colored chalks, brownish paints, or non-carbon inks such as iron gall ink will be penetrated just as the paint layers are. Any carbon blacks in the surface paint, extremely thick paint, dirt in cracks, thick, dark varnish, or dark overpainting will interfere with or obscure the visibility of the underdrawing. Differences in the absorption or reflection of infrared light from different pigments in the overlying paint may cause variations in the intensity with which underdrawing registers. The documents obtained with infrared reflectography must therefore be carefully interpreted.

Underdrawing was revealed in approximately half the paintings examined. Of those works that lacked detectable underdrawings, almost all were small in size or were portraits. The draftsmanship of many underdrawings was distinctive. Reflectography also encountered a variety of underdrawing procedures and materials, sometimes in combination, along with differing degrees of completeness in the compositional layout, and compositional change.

Index of Titles

Jan Gossaert 1952.5.40.a–b(1119) — 99
Saint Veronica/reverse: *Chalice of Saint John the Evangelist*
 Hans Memling 1952.5.46(1125) — 193
Temptation of Christ
 Juan de Flandes 1967.7.1(2331) — 133
The Temptation of Saint Anthony
 Follower of Pieter Bruegel the Elder 1952.2.19(1102)
 — 29
Wife of a Member of the de Hondecoeter Family
 Antwerp Artist 1953.3.4(1178) — 7

Index of Subjects

RELIGIOUS SUBJECTS

A. *Archangels*

Gabriel — 76, 80, 130

B. *Old Testament*

Absalom — 81
Abimelech — 81
Cain and Abel — 42
David — 186
David and Goliath — 81
Expulsion from the Garden of Paradise — 42
Isaac and Jacob — 80
Isaiah — 186
Lord of Sabaoth — 79
Moses — 79, 121
Samson — 80

C. *New Testament*

Adam and Eve — 42, 44
Adoration of the Child — 42
Adoration of the Magi — 125–133, 213–215
Adoration of the Shepherds — 118–122, 131
Anna — 155
Annunciation — 76–86, 124–133
Annunciation to the Shepherds — 120
Assumption of the Virgin — 177–183, 236–240
Baptism of Christ — 125–133
Baptism of Clovis — 163, 169–176
Capernaum — 209
Christ, Miracles of — 209–210
Christ among the Doctors — 218–223
Christ Appearing to the Virgin — 254–257
Coronation of the Virgin — 178, 236
Flight into Egypt — 225–227
Genesis — 42
God the Father — 151
Healing of the Paralytic — 209–210
Immaculate Conception — 152, 178, 236
Madonna and Child, see Virgin and Child
Marriage of the Virgin — 216–223
Mary and Joseph — 41–49, 63–67, 118–122, 155–161, 221
Nativity — 41–49, 124–133
Presentation in the Temple — 155–161
Purification of the Virgin — 155
Rest on the Flight into Egypt — 63–67, 111–117
Sacra Conversazione — 35–40
Seth — 42

Simeon — 155
Temptation of Christ — 133–139
Tree of Life — 44
Trinity — 44, 64, 152, 177–178
Virgin and Child — 35–40, 41–49, 63–67, 69–74, 107–109, 111–117, 151–154, 184–188, 213
Woman of the Apolcalypse — 178

D. *Saints*

Anna Selbdritt — 151–154
Anne — 69–74, 151–154, 221
Anthony Abbot — 29–33, 35–40
Anthony of Padua — 69
Barbara — 35–40
Bernard — 87–89
Bishop — 163–167
Bridget — 42
Catherine — 3–6, 35–40
Denis — 164, 169
Elizabeth of Hungary — 49
George — 246–253
Giles — 163, 169
Jerome — 99–103
John the Baptist — 35–40, 193–201
John the Evangelist — 193–201
Joseph — 42, 44, 64, 120, 130, 155, 221–222, 225
Louis — 163–164
Loup or Leu of Sens — 163, 172
Margaret — 87–89
Martin — 18
Nicholas of Bari — 69–74
Remy — 163–164, 170
Veronica — 193–201

PORTRAITS

Almoner of Antwerp — 14
(?) Blanche of Lancaster — 95
Boghe, Margaretha, Wife of Joris Vezeleer — 57–62
(?) Count Willem IV van den Bergh — 206
Female — 49–55, 90–97, 241–246
(?) Guevara, Diego de — 228–236
de Hondecoeter Family Member — 7–12
de Hondecoeter Family, Wife of a Member of — 7–12
(?) Jerome or Jeronimus Sandelin — 103–107
(?) Lomellini — 49
Male — 25–26, 49–55, 189–193, 202–205, 206–208
Merchant — 103–107

Index of Previous Owners

Thomas Agnew and Sons — 69, 103, 133
Aldworth, Grace Vogel — 107
American Art Association — 87, 209
Anhalt, Friedrich I, Duke of — 184, 242
Anhalt, Friedrich II, Duke of — 184, 242
Anhalt, Leopold Friedrich, Prince of — 184, 242
Anhalt, Leopold Friedrich Franz, Prince of — 184, 242
Asscher and Welker — 17, 142
Bachstitz Gallery — 242
Ball, Hermann — 7
Bardini, Stefano — 133
Belvedere Palace — 225
Bembo, Bernardo — 193
Bembo, Pietro — 193
Bentinck-Thyssen, Baroness Gabrielle
 — 206
Beuronville, Baron E. de — 163, 169
Bismarck, Count — 146
Blumenreich, Leo — 230
Julius Böhler Gallery — 142
Boghe, Margaretha — 57
Booth, Ralph and Mary — 107
Borbón y Braganza, Infante Don Sebastián
 Gabriel — 230
Bourgeois, Cologne — 190
Brown, Alfred — 25
Campe, Heinrich Wilhelm — 111
Cassirer, Paul — 120, 193
Champol, Chartreuse de — 76
Charles V, Holy Roman Emperor — 133
Christie, Manson & Wood Limited — 7, 25, 64, 90, 133,
 142, 209
Coëne, Abbot Jacques — 218, 221
P. & D. Colnaghi and Co. — 64, 230
Contini-Bonacossi — 49, 213
Czernin von Chudenitz, Count Eugen — 155
Czernin von Chudenitz, Count Johann Rudolf — 155
Dale, Chester — 87, 209
Demidoff, Nicolai — 193
Demidoff, Prince Anatole of San Donato — 193
Despuig y Dameto, Cardinal Antonio — 69
Dreicer, Michael — 190
Drey, A. S. — 206
Dubois, M. — 87
Durlacher — 254
Duveen Brothers — 42, 64, 90, 99, 184, 204, 218, 221,
 242, 254
Ehrich Galleries — 209
Einstein, Lewis — 14
Elst, Baron Joseph van der — 17
Emanuel, Prince of Liechtenstein — 57
Feilchenfeldt — 57, 120, 236

Fischhof, Eugene — 69
Flores, Diego — 133, 236
Fondi, Oderisio de Sangro, Prince of — 133
Frank, Robert — 29, 206
Franz Josef II, Prince of Liechtenstein — 57
French & Co. — 177
Fürstlich Hohenzollernisches Museum für Wissenschaft und
 Kunst — 206
Georges Petit Gallery — 90
Gore, Annesley — 218, 221
Grudna-Gruzinski Family — 246
Guevara, Don Diego de — 230
Gurney, James — 90
Tomas Harris Gallery — 142
Heinemann, Rudolf — 29, 120
Hohenzollern-Sigmaringen, Prince Karl Anton von — 206
Hohenzollern-Sigmaringen, Prince Leopold von — 206
Hohenzollern-Sigmaringen, Prince Wilhelm August
 Karl — 206
Hôtel Drouot — 163, 169
Imperial Hermitage Museum — 76
Impey, Mrs. L. A. — 246
Isabel, Queen of Castile — 133, 236
Isabel of Portugal, wife of Emperor Charles V — 133
Kann, Rodolphe — 64
F. Kleinberger Galleries — 120, 190, 254
M. Knoedler and Co. — 25, 29, 64, 76, 190, 193, 206, 230
Kobler, Albert J. — 218, 221
Koester Gallery — 25
Kress Foundation — 3, 17, 25, 29, 35, 49, 99, 111, 124, 125,
 142, 155, 163, 169, 177, 193, 206, 213, 218, 221, 225
Kunsthistorisches Museum, Vienna — 225
Lacey — 209
Lafoon, Mr. and Mrs. Sidney K. — 151
Lansdowne, Marquesses of — 103
Lely, Sir Peter — 204
Lepke's — 111
Lestang-Parade, Chevalier Alexandre de — 163, 169
Lestang-Parade, Count Melchior de — 163, 169
Lever, W. — 209
Liechtenstein, Johann Adam, Prince of — 57
Liechtenstein, Johann Nepomuk, Reigning Prince of — 57
Liechtenstein, Karl Eusebius, Prince of — 57
Mackay, Clarence H. — 90
Madrazo, Don Pedro de — 254
Madrazo y Agudo, Don José de — 254
Madrazo y Kuntz, Don Federigo de — 254
Mannheimer Collection — 184
Margaret of Austria, Regent of the Netherlands — 133, 236
Mason, Lady Evelyn — 246
Matthiesen — 193
Maurer, Madame — 230

Concordance of old-new titles

Artist	Accession No.	Old Title	New Title
Attributed to Antwerp Artist, Sixteenth Century	1953.3.3	*Niclaes de Hondecoeter*	*A Member of the de Hondecoeter Family*
Attributed to Antwerp Artist, Sixteenth Century	1953.3.4	*Wife of Niclaes de Hondecoeter*	*Wife of a Member of the de Hondecoeter Family*
Antwerp Artist, Sixteenth Century	1956.3.2	*Goosen van Bonhuysen*	*Portrait of an Almoner of Antwerp*
Petrus Christus	1961.9.10	*Portrait of a Donor*	*Portrait of a Male Donor*
Petrus Christus	1961.9.11	*Portrait of a Donor's Wife*	*Portrait of a Female Donor*
Jan Gossaert	1967.4.1	*Portrait of a Banker*	*Portrait of a Merchant*
Master of Saint Giles and Assistant	1952.2.14	*Saint Leu Healing the Children*	*Episodes from the Life of a Bishop Saint*
Netherlandish Artist, Sixteenth Century	1943.7.7	*"Arise, and Take Up Thy Bed, and Walk"*	*The Healing of the Paralytic*
Michel Sittow	1937.1.46	*A Knight of the Order of Calatrava*	*Portrait of Diego de Guevara (?)*

Concordance of old-new attributions

Old Attribution	Accession No.	New Attribution
Ambrosius Benson	1953.3.3	Attributed to Antwerp Artist, Sixteenth Century
Ambrosius Benson	1953.3.4	Attributed to Antwerp Artist, Sixteenth Century
Dirck Bouts	1961.9.66	Follower of Dirck Bouts
Pieter Bruegel the Elder	1952.2.18	Antwerp Artist (Matthys Cock?), Sixteenth Century
Pieter Bruegel the Elder	1952.2.19	Follower of Pieter Bruegel the Elder
Gerard David	1942.9.17 a–c	Gerard David and Workshop
Flemish School	1942.16.2	Imitator of Fifteenth-century Flemish School
Flemish School	1956.3.2	Antwerp Artist, Sixteenth Century
Jan van Hemessen	1943.7.7	Netherlandish Artist, Sixteenth Century
Hispano-Dutch School	1952.2.41	Northern Netherlandish Artist, Fifteenth Century
Lucas van Leyden	1961.9.27	After Lucas van Leyden
Master of Flémalle and Assistants	1959.9.3	Follower of Robert Campin
Master of Saint Giles	1952.2.14	Master of Saint Giles and Assistant
Hans Memling	1961.9.28	Master of the Prado *Adoration of the Magi*
Antonis Mor	1961.9.79	Follower of Antonis Mor
Jan van Scorel	1961.9.36	Maerten van Heemskerck
Circle of Rogier van der Weyden	1937.1.45	Follower of Rogier van der Weyden

Concordance of new-old accession numbers

1971.55.1 / 2561 Quentin Massys, *Ill-Matched Lovers*
1976.67.1 / 2701 Master of Frankfurt, *Saint Anne with the Virgin and Christ Child*
1978.46.1 / 2724 Adriaen Isenbrandt, *The Adoration of the Shepherds*
1981.87.1 / 2852 Jan Gossaert, *Madonna and Child*

List of Artists

Antwerp Artist
Antwerp Artist (?)
Antwerp Artist (Matthys Cock?)
Bosch, Hieronymus
Bouts, Dirck
Bruegel, Pieter the Elder, Follower of
Campin, Robert, Follower of
Christus, Petrus
Cleve, Joos van
David, Gerard
Eyck, Jan van
Flemish Artist, Imitator of
Franco-Flemish Artist
Gossaert, Jan
Heemskerck, Maerten van
Isenbrandt, Adriaen

Juan de Flandes
Leyden, Lucas van, after
Massys, Quentin
Master of Frankfurt
Master of the Prado *Adoration of the Magi*
Master of Saint Giles
Master of Saint Giles and Assistant
Master of the Saint Lucy Legend
Memling, Hans
Mor, Antonis
Netherlandish Artist
Northern Netherlandish Artist
Orley, Bernard van
Patinir, Joachim, Follower of
Sittow, Michel
Weyden, Rogier van der